Culture through Objects
Ancient Near Eastern Studies in Honour of P. R. S. Moorey

Peter Roger Stuart Moorey, Oxford 1995

Culture through Objects

Ancient Near Eastern Studies
in Honour of P. R. S. Moorey

Edited by
Timothy Potts, Michael Roaf and Diana Stein

GRIFFITH INSTITUTE OXFORD · 2003

GRIFFITH INSTITUTE PUBLICATIONS

GENERAL EDITOR JOHN BAINES
PUBLISHING CONSULTANT IAN CHARLTON

Culture through Objects

A sequence of papers published by the Griffith Institute, Oxford University
to celebrate Dr P. R. S. Moorey's contributions
to ancient Near Eastern archaeology

The Publishers gratefully acknowledge the generous grant
made by the Kimbell Art Foundation, Fort Worth, Texas,
towards the production costs of this book

ISBN 0 900416 79 3 paperback
 0 900416 80 7 hardback

British Library Cataloguing-in-publication

A catalogue record for this book is available from the British Library

Designed and typeset by Andrew Ivett
Printed and bound in Great Britain by the Cambridge University Press

Table of Contents

Preface

In his lecture at the Ashmolean Museum on 'Hogarth, Lawrence and Woolley,'[1] Roger Moorey ended his talk by quoting Leonard Woolley's 'characteristically terse but memorable' summation of the purpose of the archaeologist's life: 'through the dead-and-gone things, to get at the history and the minds of dead-and-gone men' (C. L. Woolley, *Spadework*, 1953, p. 12). He concluded that this 'is not a bad epitaph for museum curators.' While epitaphs are very much premature here, the endorsement of so unpretentious a 'job description' captures well the modest and unassuming way in which Roger Moorey has gone about expanding our understanding of the ancient Near East—at the same time adding his own name to the list of highly distinguished 'curators' (including Hogarth and Woolley), who have made the Ashmolean their home.

Indeed, there can be no serious student of the archaeology of the ancient Near East who is not familiar with his work. In a long and productive career at the Ashmolean—followed, we hope, by an equally productive 'retirement'—Roger Moorey has made seminal contributions to the understanding of material culture across much of the Near East, from Egypt and the Levant through Syria and Mesopotamia to Iran, and from prehistory to Achaemenid times. His publications have ranged from excavation reports and detailed analyses of particular corpora to synthetic studies and textbooks, as well as some of the most useful popular books on archaeology. His wide command of the primary archaeological evidence has been supplemented by innovative use of scientific analyses and close attention to the historical and other textual evidence. At once a specialist in many things and a generalist of rare breadth and insight, he has for many years been an inspiring example of the 'compleat scholar' to students and colleagues alike.

On a more personal level, anyone who has worked on the antiquities collections of the Ashmolean Museum will have been the recipient of Roger Moorey's gracious hospitality as the facilitator of access to that museum's important holdings. Lunch at a nearby pub is always a particular highlight, providing an opportunity to discuss one's own research (on which he inevi-

1 Delivered at the Ashmolean Museum, Oxford, 10 June 1983 as part of a series on the 'founding fathers' of the Ashmolean Museum

tably has insightful comments) and to tap into his remarkable knowledge of 'who is doing what' in related fields—his erudition worn with a lightness that only adds to its impressiveness. For those of us who lived in Oxford, his regular presence in the Griffith Institute library has been an object lesson in the commitment that lies behind scholarship at the highest level. How he is able to give so much time to others and still be so productive himself has been a constant mystery to those around him.

Roger Moorey's retirement from the Ashmolean Museum as Keeper of Antiquities provides an appropriate milestone at which to celebrate his achievement as one of the leading Near Eastern scholars of his generation, and it is in this that the genesis of the current volume lies. The editors are among his former doctoral students, and for this owe him an especially profound debt. But we know that our sense of gratitude and admiration is shared also by colleagues around the world, as was amply reinforced in the course of preparing this tribute. Indeed, the number of contributors could easily have been multiplied many times.

In conceiving this volume to celebrate Roger Moorey's contributions to Near Eastern archaeology we were hopeful also of producing something that he would enjoy reading. Rather than a conventional Festschrift, with its more or less disparate selection of articles, we decided upon a themed book of invited contributions which would reflect some of our honoree's principal interests. The title *Culture through Objects* was selected in an attempt to capture the underlying objective and methodology that permeates his work in all its various aspects: the conviction that the material remains of ancient societies retrieved through archaeology can provide unique insights into the cultures and people who made them. This is not of course to deny the interest or relevance of other complementary approaches, such as anthropological archaeology and various theoretically-oriented stances. Our aim was simply to reflect the emphasis that has characterized his work.

Within this framework three broad topics were selected as representing recurrent themes within Roger Moorey's work over the years: Tracking Cultural Transfers, Understanding Images, and Materials and Manufacture. Authors were invited to contribute to these sections on the basis of their past and current research interests but the choices of specific topics were their own. We take this opportunity to thank all those who submitted articles for their contributions.

Each section is preceded by an introduction in which we provide a context for the papers that follow by briefly reviewing Roger Moorey's work and how it relates to the direction of recent research. We also offer some

comments on the individual papers, highlighting issues of particular relevance to Roger's publications and possible areas of interest for future research. We have refrained, however, from extended commentary that would be more appropriate to a review.

★ ★ ★

Roger Moorey joined the Ashmolean Museum as Assistant Keeper of Antiquities (with responsibility for the Near Eastern and Egyptian collections) in 1961, directly after graduating from Oxford University with a first in modern history. He became Senior Assistant Keeper in 1973 and Keeper of the Department of Antiquities in 1983, the position he held until his retirement in 2002. In recent years he has served on a number of occasions as Acting Director of the Museum. Upon his retirement, Roger Moorey was appointed Vice-gerent of Wolfson College and awarded a Senior Research Fellowship that is to be followed by an Emeritus Fellowship.

Unusually for Oxford in the early 1960s—when those able enough to obtain an academic post without a doctorate wore this lacuna as a badge of honour—soon after being appointed to the Ashmolean he chose to undertake a doctorate based on an important but poorly-understood group of material in the museum's collection, the Luristan bronzes. Supervised by Max Mallowan, the published version of his thesis (1971) soon became one of the standard references on the subject and established his reputation in the field. During his career Roger Moorey has continued to publish material from the museum's holdings, including the stamp and cylinder seals, terracottas and (the most selfless of tasks) excavation reports on material left unpublished by their excavators (Kish and Deve Hüyük), thereby bringing these forgotten finds back into the mainstream. A series of booklets on ancient Egypt, Iraq, Iran, the Luristan bronzes, the Bible and Archaeology, and the Near East have addressed the museum's increasingly important duty of making its collections accessible to a non-specialist public. In addition he has been responsible for shepherding a number of research students through highly diverse dissertation topics, and since its inception in 1993 has tutored and lectured for the first undergraduate degree in Near Eastern archaeology at Oxford.

As can be seen from the list of publications below, his writings on subjects not related directly to the Ashmolean's collections have ranged even farther in cultural space and time, touching on issues of chronology and ethnicity as well as developments in religion, politics and technology. Among these may be mentioned his work on metalwork and glazed materials; stamp

and cylinder seals; Syro–Palestinian and Mesopotamian terracottas; the 'Royal Tombs' at Ur; early Egyptian-Mesopotamian/Elamite contacts; Iranian metal vessels; Canaanite bronze statuettes; the history of Biblical archaeology; Near Eastern horse-riding, transport and warfare; Achaemenid religious iconography; the historical geography of Iran; and Mesopotamian materials and technology.

Roger Moorey's contribution to Near Eastern archaeology was recognized by his election in 1977 as a Fellow of the British Academy at the early age of 40. He subsequently served as the Chairman of the Archaeology Section from 1987 to 1991 and on the Council of the British Academy from 1991 to 1994. In 2001 he delivered the British Academy Schweich Lectures on Biblical Archaeology with the title 'Idols of the people: miniature images of clay in the ancient Near East'. He has served for many years in various senior capacities on the Councils of the British School of Archaeology in Iraq, the British School of Archaeology in Jerusalem (whose journal *Levant* he edited from 1968 to 1986 and where he served as President from 1991 to 1999), the British Institute for the Archaeology and History of Jordan in Amman, and the British Institute of Persian Studies. He was also a prime mover in the establishment of the British Association for Near Eastern Archaeology in 1982 and has served on its council, organizing the annual conferences in 1988 and 1996.

In 1989 he was awarded the Schimmel Prize by the Israel Museum, Jerusalem for contributions to the archaeology of Eretz Israel and Bible Lands and his *A Century of Biblical Archaeology* received the 1993 award for best popular book from the Biblical Archaeology Society. His authoritative *Ancient Mesopotamian Materials and Industries* was awarded the 1996 James R. Wiseman Book Award of the Archaeological Institute of America. His many contributions to Mesopotamian archaeology were recently acknowledged in the Gertrude Bell Memorial Medal in March 2003, only the fourth time it has been awarded.

In the production of this volume we are greatly indebted to a number of institutions and individuals. Nicole Atzbach provided very able editorial assistance and Andrew Ivett skilfully and efficiently converted the manuscripts into camera ready copy. We are also grateful to all those involved in accepting this volume for publication by the Griffith Institute of Oxford University, in particular Ian Charlton and John Baines. The publication was facilitated by a generous grant from the Kimbell Art Museum, Fort Worth.

Timothy Potts, Michael Roaf and Diana Stein

P. R. S. Moorey
Bibliography 1964–2002

A: THESIS

1966 *An Archaeological and Historical Examination of the 'Luristan Bronzes'.* D.Phil. Thesis, University of Oxford (deposited in the Bodleian Library, Oxford).

B: BOOKS:

(1) AS AUTHOR:

1971 *Catalogue of the Ancient Persian Bronzes in the Ashmolean Museum, Oxford.* Oxford: Oxford University Press.

1974 *Ancient Persian Bronzes in the Adam Collection.* London: Faber and Faber.

1975 *The Making of the Past: Biblical Lands.* Lausanne: Elsevier Publishing Projects SA (various foreign language editions; re-issued with new introduction in 1991, New York: Peter Bedrick Books).

1978 *Kish Excavations 1923–1933.* Oxford: Oxford University Press.

1980 *Cemeteries of the First Millennium B.C. at Deve Hüyük, near Carchemish, Salvaged by T. E. Lawrence and C. L. Woolley in 1913.* BAR International Series, 87. Oxford: British Archaeological Reports.

1981 *Excavation in Palestine.* Guildford, U.K: Lutterworth Press.

1982 Sir Leonard Woolley, *Ur 'of the Chaldees'* (revised and updated by P. R. S. Moorey). London: The Herbert Press.

1984 (with B. Buchanan) *Catalogue of the Ancient Near Eastern Seals, Ashmolean Museum II: The Prehistoric Stamp Seals.* Oxford: Oxford University Press.

1985 *Materials and Manufacture in Ancient Mesopotamia: the Evidence of Art and Archaeology: Metals and Metalwork; Glazed Materials and Glass.* BAR International Series, 237. Oxford: British Archaeological Reports.

1987 K. M. Kenyon, *The Bible and Recent Archaeology* (revised and updated by P. R. S. Moorey). London: British Museum Publications.

1988 (with B. Buchanan) *Catalogue of the Ancient Near Eastern Seals in the Ashmolean Museum III: The Iron Age Stamp Seals.* Oxford: Oxford University Press.

11

1991 *A Century of Biblical Archaeology.* Cambridge: Lutterworth Press (American edition 1992, Louisville, Kentucky: Westminster/John Knox Press).

1994 *Ancient Mesopotamian Materials and Industries: The Archaeological Evidence.* Oxford: Oxford University Press (re-issued with minor corrections in 1999, Winona Lake, Indiana, U.S.A: Eisenbrauns).

(2) As Editor

1978 *Archaeology in the Levant: Essays for Kathleen Kenyon,* (edited with P. J. Parr). Warminster, U.K.: Aris and Phillips.

1979 *The Origins of Civilization: the Wolfson College Lectures 1978.* Oxford: Oxford University Press.

C. Museum Handbooks:

1969 *Archaeology, Artefacts and the Bible.* Ashmolean Museum, Oxford.

1970 *Ancient Egypt.* Ashmolean Museum, Oxford (revised editions 1983, 1988, 1992, 2000).

1974 *Ancient Bronzes from Luristan.* British Museum, London.

1975 *Ancient Iran.* Ashmolean Museum, Oxford.

1976 *Ancient Iraq.* Ashmolean Museum, Oxford.

1987 *The Ancient Near East.* Ashmolean Museum, Oxford (revised edition 1994).

D. Museum Exhibition Catalogue (with Emma C. Bunker, Edith Porada and Glenn Markoe)

1981 The art of ancient Iran. In *Ancient Bronzes, Ceramics and Seals: The Nasli Heeramaneck Collection of Ancient Near Eastern, Central Asiatic, and European Art.* Los Angeles County Museum of Art, 13–137.

E. Articles

1964 An interim report on some analyses of 'Luristan Bronzes'. *Archaeometry* 7: 72–80.

1964 The 'Plano-Convex Building' at Kish and early Mesopotamian palaces. *Iraq* 26: 83–98.

1965 A bronze 'Pazuzu' statuette from Egypt. *Iraq* 27: 33–41.

1966 A re-consideration of the excavations on Tell Ingharra (East Kish) 1923–33. *Iraq* 28: 18–51.

1967　Some ancient metal belts: their antecedents and relatives. *Iran* 5: 83–98. (see also, Some ancient metal belts: a retraction and a cautionary note. *Iran* 7 1969: 155).

1967　Some aspects of incised drawing and mosaic in the Early Dynastic Period. *Iraq* 29: 97–116.

1969　Prehistoric copper and bronze metallurgy in western Iran (with special reference to Luristan). *Iran* 7: 131–53.

1969　(with C. M. Kraay) Two fifth century hoards from the Near East. *Revue Numismatique*, (6ᵉ series) 10: 181–235.

1970　Cemetery A at Kish: grave-groups and chronology. *Iraq* 32: 86–128.

1970　Pictorial evidence for the history of horse-riding in Iraq before the Kassite Period. *Iraq* 32: 36–50.

1971　(with M. J. Aitken and P. J. Ucko) The authenticity of vessels and figurines in the Hacilar style. *Archaeometry* 13: 89–141.

1971　The Loftus hoard of Old Babylonian tools from Tell Sif in Iraq. *Iraq* 33: 61–86.

1971　Towards a chronology for the 'Luristan Bronzes'. *Iran* 9: 113–29.

1972　(with F. Schweizer) Copper and copper alloys in ancient Iraq, Syria and Palestine: some new analyses. *Archaeometry* 14: 177–98.

1973　(with O. R. Gurney) Ancient Near Eastern seals at Charterhouse. *Iraq* 35: 71–81.

1973　Some Syro-Phoenician bronze caryatid stands. *Levant* 5: 83–90.

1974　Ancient Persian bronzes from the Island of Samos. *Iran* 12: 190–95.

1975　Iranian troops at Deve Hüyük in Syria in the earlier fifth century B.C. *Levant* 7: 108–17.

1975　(with R. E. M. Hedges) Pre-Islamic ceramic glazes at Kish and Nineveh in Iraq. *Archaeometry* 17: 25–43.

1975　Some elaborately decorated bronze quiver plaques made in Luristan, c. 750–650 B.C. *Iran* 13: 19–29.

1975　The terracotta plaques from Kish and Hursagkalama, c. 1850 to 1650 B.C. *Iraq* 37: 79–99.

1976　(with J. N. Postgate) Excavations at Abu Salabikh, 1975. *Iraq* 38: 133–69.

1976　The late prehistoric administrative building at Jamdat Nasr. *Iraq* 38: 95–106.

1977　What do we know about the people buried in the Royal Cemetery [at Ur]? *Expedition* 20/1: 24–40.

1978　(with O. R. Gurney) Ancient Near Eastern cylinder seals acquired by the Ashmolean Museum, Oxford, 1963–1973. *Iraq* 40: 41–60.

1978 The iconography of an Achaemenid stamp-seal acquired in the Lebanon. *Iran* 16: 143–54.

1979 Ancient bronzework from Luristan. In *Highlights of Persian Art,* (R. Ettinghausen and E. Yarshater, eds.). Colorado: Westview Press, 19–37.

1979 Aspects of worship and ritual on Achaemenid seals. *Akten des VII. Internationalen Kongresses für Iranische Kunst und Archäologie, Münich. 1976, (Archäologische Mitteilungen aus Iran, Ergänzungsband* 6). Berlin: Dietrich Reimer, 218–26.

1979 Kathleen Kenyon and Palestinian archaeology. *Palestine Exploration Quarterly,* 3–10.

1979 Unpublished Early Dynastic sealings from Ur in the British Museum. *Iraq* 41: 105–20.

1980 Metal wine-sets in the ancient Near East. *Iranica Antiqua* 15: 181–97.

1981 (with C. M. Kraay) A Black Sea hoard of the fifth century B.C. *Numismatic Chronicle* 141: 1–19.

1982 Archaeology and pre-Achaemenid metalworking in Iran: a fifteen year retrospective. *Iran* 20: 81–101.

1982 The archaeological evidence for metallurgy and related technologies in Mesopotamia, c. 5500–2100 B.C. *Iraq* 44: 13–38.

1984 (with S. Fleming) Problems in the study of the anthropomorphic metal statuary from Syro-Palestine before 330 B.C. *Levant* 16: 67–90.

1984 Where did they bury the kings of the IIIrd Dynasty of Ur? *Iraq* 46: 1–18.

1985 Metalwork and glyptic. *The Cambridge History of Iran 2: The Median and Achaemenian Periods,* 856–70.

1985 The Iranian contribution to Achaemenid material culture. *Iran* 23: 21–37.

1986 The emergence of the light, horse-drawn chariot in the Near East, c. 2000–1500 B.C. *World Archaeology* 18: 196–215.

1986 (with J. Boardman) The Yunus cemetery group: haematite scarabs. In *Insight through Images: Studies in Honor of Edith Porada,* (M. Kelly-Buccellati, ed.). Malibu, California: Undena, 35–48.

1987 On tracking cultural transfers in prehistory: the case of Egypt and Lower Mesopotamia in the fourth millennium B.C. In *Centre and Periphery in the Ancient World,* (M. Rowlands et al., eds.). Cambridge: Cambridge University Press, 36–46.

1988 Bronzeworking centres of Western Asia c.1000–539 B.C.: problems and perspectives. In *Bronzeworking Centres of Western Asia c.1000–539 B.C.,* (J. Curtis, ed.). London: Kegan Paul International, 23–32.

1988 Early metallurgy in Mesopotamia. In *The Beginning of the Use of Metals and Alloys,* (R. Maddin, ed.). Cambridge, Mass.: MIT Press, 28–33.

1988 New analyses of Old Babylonian metalwork from Tell Sifr. *Iraq* 50: 39–49.

1988 The Chalcolithic hoard from Nahal Mishmar, Israel, in context. *World Archaeology* 20: 171–89.

1988 The Persian Empire. In *The Cambridge Ancient History Vol. 4, Persia, Greece and the Western Mediterranean, c. 525 to 479 B.C., Plates* (J. Boardman, ed.). Cambridge: Cambridge University Press, 1–94.

1988 The technique of gold-figure decoration on Achaemenid silver vessels and its antecedents. *Iranica Antiqua* 23: 231–46.

1989 The Hurrians, the Mittani and technological innovation. In *Archaeologia Iranica et Orientalis: Miscellanea in Honorem Louis Vanden Berghe I,* (L. de Meyer and E. Haerinck, eds.). Gent: Peeters, 273–86.

1990 Archaeology: from site to sight. *The Israel Museum Journal* 9: 17–24.

1990 From Gulf to Delta in the fourth millennium B.C.: the Syrian connection. *Eretz-Israel* 21, 62★–9★.

1991 The decorated ironwork of the early Iron Age attributed to Luristan in western Iran. *Iran* 29: 1–12.

1992 British women in Near Eastern archaeology: Kathleen Kenyon and the pioneers. *Palestine Exploration Quarterly,* 91–100.

1993 High relief decoration on ancient Iranian metal vessels: development and influence. *Bulletin of the Asia Institute* 7: 131–40.

1993 Iran: a Sumerian El-Dorado? In *Early Mesopotamia and Iran: Contact and Conflict 3000–1600 B.C.,* (J. Curtis, ed.). London: British Museum Press, 31–43.

1994 The true and the false: the case of five 'Neo-Babylonian' terracottas in the Ashmolean Museum, Oxford. In *Beschreiben und Deuten in der Archäologie des Alten Orients: Festschrift für Ruth Mayer-Opificius,* (N. Cholidis et al., eds.). Münster: Ugarit-Verlag, 201–12.

1995 *From Gulf to Delta and Beyond* (The Levi-Sala Lectures 1993), (E.D. Oren, ed.), Beer-Sheva 8. Beer-Sheva: Ben-Gurion University of the Negev Press.

1995 The eastern land of Tukrish. In *Beiträge zur Kulturgeschichte Vorderasiens.* R. M. Boehmer Festschrift, (U. Finkbeiner et al., eds.). Mainz: Philipp von Zabern, 439–48.

1996 A stone replica of an Early Dynastic III royal hairstyle? In *Collectanea Orientalia: Histoire, arts de l'espace et industrie de la terre: Études offertes en*

hommage à Agnés Spycket, (H. Gasche and B. Hrouda, eds.). Paris: Neuchatel, 227–38.

1998 Did easterners sail round Arabia to Egypt in the fourth millennium B.C.? In *Arabia and its Neighbours: Essays on Prehistorical and Historical Developments Presented in Honour of Beatrice de Cardi,* (C. S. Phillips, D. T. Potts. and S. Searight, eds.), Abiel II. Turnhout: Brepols, 189–206.

1998 Material aspects of Achaemenid polychrome decoration and jewellery. *Iranica Antiqua* 33: 155–71.

1999 Bluestones in the Ancient Near East: turquoise and lapis lazuli. In *La Mediterranée de l'Antiquité à l'Islam,* (A. Caubet, ed.). Paris; Louvre, 175–88.

1999 The hammered bronzework of Iron Age Luristan (Iran): problems of chronology and iconography. In *The Iranian World. Essays on Iranian Art and Archaeology presented to Ezat O. Negahban,* (A. Alizadeh, Y. Majidzadeh and S. Malek-Shahmirzadeh, eds.). Tehran: Iran University Press, 146–57.

2000 Iran and the west: the case of the terracotta Persian Riders in the Achaemenid Empire. In *Variato Delectat: Iran und der Westen. Gedenkschrift für Peter Calmeyer,* (R. Dittmann *et al.,* eds.). Münster: Ugarit-Verlag, 469–86.

2001 Clay models and overland mobility in Syria, c. 2350–1800 B.C. In *Beiträge zur Vorderasiatischen Archäologie: Winfried Orthmann gewidmet,* (J.-W. Meyer, M. Novak and A. Pruss, eds.). Frankfurt am Main: Johann Goethe-Universität, 344–51.

2001 The mobility of artisans and opportunities for technology transfer between Western Asia and Egypt in the Late Bronze Age. In *The Social Context of Technological Change: Egypt and the Near East, 1650–1550 B.C.* (A. J. Shortland, ed.). Oxford: Oxbow Books, 1–14.

2002 Novelty and tradition in Achaemenid Syria: the case of the clay 'Astarte Plaques'. *Iranica Antiqua* 37: 203–18.

2002 Third millennium 'Cycladic' stone figurines in northern Mesopotamia? In *Of Pots and Plans: Papers on the Archaeology and History of Mesopotamia and Syria presented to David Oates on his 75th Birthday,* (L. al-Gailani Werr et al., eds.). London: NABU Publications, 227–36.

Culture through Objects

I. Tracking Cultural Transfers

Timothy Potts

> Traditionally there have been two ways of approaching these difficult ques-
> tions: either to propose a particular relationship between southern Meso-
> potamia and adjacent regions [in the Uruk period] and then use the avail-
> able evidence to illustrate it, or to look broadly at the evidence first and
> then attempt to piece together what the precise nature of the relationship
> might have been. I now propose to follow the second approach here . . .
>
> (Moorey, 1995: 6f.)

For anyone familiar with the work of Roger Moorey, this quote, taken from
his discussion of the 'Uruk phenomenon,' will strike a very familiar note.
Indeed it may serve as a broad characterization not only of his work on
cultural interconnections but of his approach to investigating the material
culture of the ancient world generally, one founded on the principle that the
archaeological evidence must carefully be scrutinized and assessed for what-
ever insights it may yield, and that this process should, as far as possible, be
pursued independently of any prior theory or interpretive framework. While
the evidence cannot speak for itself, neither is it our duty to prejudge how it
should be understood, or to privilege one interpretation over another. Theory
and evidence must of course be brought together, but this is a synthesis that
should always remain responsive to fresh evidence and new ways of under-
standing the primary data.

This is an approach that would once have been called 'empiricist' and has
deep roots in Oxford—where Roger Moorey has spent his entire career to
date—extending much beyond the study of archaeology. It is one that would
hardly have needed defending, or even stating, when he first joined the
Ashmolean Museum in 1961. During the following decades, however, the
rise of more methodologically self-conscious approaches to the theory and
practice of archaeology sometimes made it seem as if 'merely' looking care-
fully at the evidence and applying a thoughtful intelligence to its interpreta-
tion was not enough to generate interesting scholarship. It is a testament to
Roger Moorey's extraordinary range and depth of knowledge, and to his
keen sensitivity to the lessons of history, anthropology and other neighbour-
ing disciplines, that his work has continued to be widely used and admired
by scholars of all complexions throughout these debates. Writing in a style

that is persuasive but never polemical, for nearly forty years he has produced a stream of publications that make the case for an empiricist methodology silently but effectively through the cogency of its results.

One of the recurrent themes in these publications has been the tracking of cultural transfers between the various peoples and regions of the Near East. This is of course a subject which has a long pedigree (not all of it now regarded as so noble) back to the birth of Near Eastern archaeology in the 19th century. From the time of Layard, interest in Mesopotamia and other 'lands of the Bible' has been connected with the light that excavation there could shed (or was thought to shed) on that document, and with the role of the 'Orient' in the rise of Greek civilization. The extension of the archaeo-logical record back to Sumerian times and beyond to prehistory provided a material basis for the principle of *ex oriente lux* that suited the then prevailing diffusionist framework. While this principle has been shown to be untenable in numerous ways, the relevance of the Mesopotamian example to the development of complex societies in neighbouring regions continues to be acknowledged today, as does more generally the interest in tracking cultural influences within and beyond the Near East. The presumption of a simple core-periphery duality, however, has been replaced in the past half-century by a more complex picture of multiple levels of regionality, influence and directionality. Technological and other innovation was not necessarily (or even primarily) a feature of the core urban heartlands; and the priority accorded these cultures may reflect the distribution of the textual and other 'big-institution' evidence, rather than the reality as lived in the cultures them-selves. Contact and influence was not only a process of imposition or co-ercion, but also one of critical selection and adoption. As is now obvious to anyone working in this area, the focus has gradually but decisively shifted to explanations that emphasize regionalism over internationalism, indigenous development over diffusion, multiple invention over imitation.

Roger Moorey's work in this area has been responsive to these develop-ments; beyond that—and more distinctively—it has been characterized by his careful selection of questions for investigation that can plausibly be an-swered, or at least clarified, by the material cultural evidence. In this way, while questions that remain open are acknowledged, idle speculation can be avoided. Especially where his work engages with ancient technologies, Roger Moorey has been at the forefront of scholarship combining archaeological data with scientific analysis and relevant textual evidence. 'Any separation of sources is artificial and arbitrary, but there are certain basic differences that mark the individual contributions of documents on the one hand, and material

evidence on the other . . .' (Moorey 1994: 13). As the titles of some of his articles indicate—'Did easterners sail around Arabia to Egypt in the fourth millennium B.C.?'; 'The mobility of artisans and opportunities for technology transfer between Western Asia and Egypt in the Late Bronze Age'—the fact of contact or influence cannot be separated from the practical issue of how it was effected, and on this too he has had much to contribute. Whether looking at Mesopotamian-Egyptian connections, the Uruk expansion into Syria and Iran, or the interpretation of Syro–Palestinian terracottas, his discussion is informed by a close attention to the history of research on the subject. His much-admired analysis of *A Century of Biblical Archaeology* (1991) makes one hope for more in this vein. Across the many subjects he has treated, Roger Moorey's unique ability to synthesize complex issues and bring critical clarity to old chestnuts will ensure that his work too continues to have significant historical interest long after its particular conclusions have been overtaken by fresh discoveries from the soil of the Near East.

★ ★ ★

The contributions to this section are concerned with the broad issue of charting the contacts and influences that occurred between the various cultures and sub-regions of the ancient Near East, and, in one case, between the Near East and the Mediterranean. John Baines explores the question of early state development in late pre-dynastic and First-Dynasty Egypt, a subject dominated in previous generations by the evidence of borrowings from southern Mesopotamia/Elam. While not denying that intrusions took place, more recent scholarship has shifted the onus of change onto indigenous developments, in line with the general trend noted above. As Baines puts it below: foreign elements like cylinder seals, artistic motifs and perhaps the idea of writing 'would not by themselves have transformed the recipient society, which must have been prepared to adopt them and give them its own meaning.' This position, increasingly the consensus view, was anticipated in Moorey's suggestion that the Late Uruk intrusions 'were active in Egypt, not so much in "triggering off" or accelerating social differentials or politico-economic centralization, as in generating new conceptions that sharpened the self-awareness and distinction of already well-established tribal rulers and the favoured elites through whom their power was exercised' (Moorey 1987: 44).

More recently he has noted how in Egypt alone 'the impact of the high status imagery of southern Mesopotamia may be observed modifying the emerging symbolism of local rulers, both those in Upper Egypt, already well

known, and those from Lower Egypt' (Moorey 1998: 200). Two elements
of the emerging imagery he suggests point specifically to Lower Egypt as the
locus of contact: the serekh and the 'palace façade and procession to it' (ibid.
201).

Baines's contribution extends the analysis of this indigenous process fur-
ther, focusing in particular on the distinctive ideological features of Egyptian
society (notably its self-conception as non-urban, and the increasing pre-
occupation among the elite with a 'sacral core' revolving around the gods
and the king) as these may be traced in the decorated palettes, ivories and
other works of elite art of the time; and on how the 'hierarchical demarca-
tion of deities and kings from elite, and of elite from others' evident in this
ideology played a critical role in the cultural and political unification of the
country around Dynasty 0.

In his paper on the spread of writing to Near Eastern societies outside
Mesopotamia, Carl Lamberg-Karlovsky explores the patchy and often be-
lated adoption of the technology of literacy and asks the obvious but largely
ignored question: why did so many societies in close contact with Mesopo-
tamia choose not to adopt it? His suggestion is that writing could be adopted
only in those societies whose cultural structures made it a useful and relevant
ideological and administrative tool. Invented in a politico-religious environ-
ment of 'coercive control,' writing inevitably 'led to more aggressively
directed forms of social integration.' It was not—and could not be—adopted
in cultures that lacked a comparable environment. Thus these peripheral
regions 'rejected the colonialism of their expansionist neighbours and an
early form of globalization in which specific forms of technology require
common structures of society.'

In its emphasis on the element of choice and the determining role of the
potential recipient's cultural/political framework, this view again finds echo
in Roger Moorey's discussion of the Mesopotamia-Egypt connection:

> In Egypt what may have been transferred and accepted is only part of the
> problem; no less interesting is the question of what may have been trans-
> ferred and not accepted. . . The Lower Mesopotamian (Elamite) repertory
> from which I have argued these [Egyptian] motifs came, was much greater,
> alerting us to the exercise of choice in Egypt by the arbiters of religious
> imagery in the mid-Gerzean period.

He goes on to point out that while Mesopotamian cultural intrusions were
active in Egypt, '[t]hey were not active in the same way in Palestine, since a
similarly susceptible political establishment had not yet emerged there . . .'

(1987: 44-6). As with Lamberg-Karlovsky, it is the readiness of the recipient culture, and in particular its political structure, that determines the manner and scope of influence that we see in the archaeological record.

Daniel Potts's contribution analyses in detail a particular category of the soft-stone (chlorite/steatite) vessels from Iran, the Persian/Arabian Gulf and Central Asia that have played a prominent role in the discussion of wide-ranging networks of trade and exchange between these regions and west-ward to Mesopotamia and Syria in the 3rd and early 2nd millennia BC (Amiet 1986; T. Potts 1994: 243-75). Attempting to define more exactly the source region and direction of movement of this type, which is characterized by bowls with zig-zag decoration, Potts's study adds another piece to the complex picture of interaction across the vast domain of greater Iran that has emerged in recent decades.

The understanding of inter-cultural influence and interaction presup-poses a framework of predefined cultural borders. Talk of influence and interaction implies some relevant cultural difference between the parties in-volved in the exchange and thus some awareness of a boundary between them. In practice, however, these two aspects of cultural dynamics are usu-ally in play simultaneously. We decide where the boundaries lie largely by determining the scope and intensity of cultural interaction. Indeed the very same evidence may cause us to adjust both parameters, or leave us free to choose either one for modification. And boundaries on the ground are not the clear lines that we draw on maps. Cultures often fray at the edges, merg-ing with others in ways that defy clear delineation. The Medizing Ionians were probably more the norm than the chauvinist Egyptians (on the latter cf. Baines below pp. 42f., 50).

Archaeological scholarship also tends to have a dynamic of its own which must be taken into account. In much of the Near East, cultures and regions which in the pioneering phase of archaeological investigation were seen as more or less homogeneous have in time been broken down into narrower sub-regions/cultures as more data has become available and as new genera-tions of scholars seek to 'improve' on the results of their predecessors. The normal mode of academic progress (at least in the humanities) is splitting not lumping, drawing distinctions where previously there were none. This no doubt played some role in the shift away from diffusionist explanation of culture change, and that shift probably did as much as anything to foster a regionalist conception of culture: for by removing the supposed inter-regional drivers of cultural development, a sufficiently complex and effective basis for such change had to be sought within the region where it occurred.

If not diffusion, then indigenous development. If indigenous development, then a causally sufficient cultural dynamic within that region. If a causally sufficient cultural dynamic, then a meaningful articulation of cultural integrity at the regional level.

The paper by Piotr Bienkowski argues for a particular regionalist understanding of culture in ancient Jordan from Neolithic to early Islamic times on the basis of the ceramic data from excavation and survey in that country. He provides support and some explanation for this in a reappraisal of the evidence (lacking, as it turns out) for a major north-south artery along the route of the later 'King's Highway.' Most contact and integration, he concludes, took place rather along east-west axes. This 'splitting' into northern and southern regions of varying extents will allow a more precise analysis of how these 'ceramic cultures' relate to the social, ethnic and other parameters of a broader and more integrated definition of culture during these periods.

The problem of modern forgery of antiquities, and the distorting influence its products can have on scholarship, has been an impediment to classical studies since the Renaissance and to the study of Egypt and the Near East since the 18/19th centuries. The development of scientific tests for authenticity during the past century has provided an objective—though rarely definitive—basis for detecting fakes, especially in some media. However, it is only in the past thirty or so years that the greatly heightened sensitivity to issues of provenance history has given this problem the wider prominence it deserves.

The pioneering phase of archaeological research in a new region or culture is often—and quite naturally—characterized by a particular interest in contacts and connections with other better-known cultures that can help situate those discoveries in a spatial and temporal context. This inevitably provides fertile ground for forgers and fantasists, as 'missing links' from the Piltdown Man to the Dorak treasure attest. Genuinely hybrid works showing the influence of more than one culture or style do of course exist, but special attention must be paid to assessing unprovenanced objects that purport to illustrate such connections. It is this task that Oscar Muscarella undertakes in his contribution to the present volume, examining afresh a funerary relief purported to come from Egypt and carved in a style thought by previous scholars to show Greek, Assyrian and especially Achaemenian influence. His conclusion, based on iconographic and stylistic analysis of the scene represented, is that the object is a modern fake and its supposed ancient provenance bogus. From this follows a more general admonition, familiar from Muscarella's other publications, to treat the word-of-mouth

'provenances' provided by local finders, dealers, and even scholars not only as highly questionable, but as positive impediments to scholarship.

In the final contribution to this section John Boardman assembles a small but distinctive corpus of seals, rings and coins from the Near East and Mediterranean which show composite heads with substitute animal parts. Combining motifs and stylistic features that may seem by turns more Greek/ Anatolian and more Persian/Phoenician, this group adds an interesting episode to the complex pattern of borrowing in both directions that ties the classical and eastern lands together. The interaction of Greek art with that of its 'neighbours' from the Iberian peninsula to Pakistan has of course been a recurrent theme in Boardman's work, much of it based—as with the honoree of this volume—upon close scrutiny of a particular category or corpus which yet turns out to yield insights of surprisingly rich breadth.

REFERENCES CITED

Amiet, P.
1986 *L'âge des échanges inter-iraniens 3500-1700 avant J.-C.* Paris: Editions de la Réunion des musées nationaux.

Moorey, P. R. S.
1987 On tracking cultural transfers in pre-history: the case of Egypt and Lower Mesopotamia in the fourth millennium B.C. In *Centre and Periphery in the Ancient World,* (M. Rowlands et al., eds.). Cambridge: Cambridge University Press, 36-46.

1989 The Hurrians, the Mittani and technological innovation. In *Archaeologia Iranica et Orientalis: Miscellanea in Honorem Louis Vanden Berghe I,* (L. de Meyer and E. Haerinck, eds.). Gent: Peeters, 273-86.

1991 *A Century of Biblical Archaeology* (Cambridge: Lutterworth Press (American edition 1992, Louisville, Kentucky: Westminster/John Knox Press).

1994 *Ancient Mesopotamian Materials and Industries: The Archaeological Evidence.* Oxford: Oxford University Press (re-issued with minor corrections in 1999, Winona Lake, Indiana, U.S.A: Eisenbrauns).

1995 *From Gulf to Delta and Beyond* (The Levi-Sala Lectures 1993), (E.D. Oren, ed.), Beer-Sheva 8. Beer-Sheva: Ben-Gurion University of the Negev Press.

1998 Did easterners sail round Arabia to Egypt in the fourth millennium B.C.? In *Arabia and its Neighbours: Essays on Prehistorical and Historical Developments Presented in Honour of Beatrice de Cardi,* (C. S. Phillips, D. T. Potts. and S. Searight, eds.), Abiel II. Turnhout: Brepols, 189-206.

2001 Clay models and overland mobility in Syria, c.2350-1800 B.C. In *Beiträge zur Vorderasiatischen Archäologie: Winfried Orthmann gewidmet,* (J.-W. Meyer, M. Novak and A. Pruss, eds.). Frankfurt am Main: Johann Goethe-Universität, 344-51.

Potts, T. F.
1994 *Mesopotamia and the East, An Archaeological and Historical Study of Foreign Relations ca. 3400–2000 BC.* Oxford University Committee for Archaeology Monograph 37. Oxford: Oxford University Committee for Archaeology.

Early definitions of the Egyptian world and its surroundings

John Baines

John Baines

INTRODUCTION[1]

Many aspects of Egyptian presentations of order and of dominance of the surrounding world underwent fundamental change in the formative period of Naqada III and Dynasty 0, when the Egyptian state itself was founded and delimited (for rough dates see Table 1). The principal artefacts on which these changes can be studied are the familiar, much discussed decorated knives, palettes and maceheads,[2] many of which have no good provenance or were found in secondary and uninformative contexts, so that they must be analysed in terms of internal organization, parallels and approximate chronological sequence. Because the construction of such sequences uses style and the appearance of compositional features that later became standard in art of the dynastic period, such arguments are fragile and often teleological; while these methods would ideally be avoided, this may not be possible. All the artefact genres in question disappeared in the First Dynasty, so that most of the developments I discuss here can only be compared with different types of material, notably royal monuments, from later times.

Essential characteristics of these artefacts include their generally small scale and portability. They exhibit very high levels of craftsmanship and are likely to have been distributed and appreciated among a small group, including the gods for those which were dedicated in temples. Most knives and the earlier palettes are from tombs, while the latest and most highly decorated material seems to come from temples. Their decoration was therefore probably appropriate for a range of contexts and symbolic domains. By contrast, many major types of the dynastic period, such as reliefs and statuary that

1 I presented an initial version of this study at the World Archaeological Congress, Cape Town, January 1999. I am grateful to Andrzej Pydyn and Arkadiusz Marciniak for inviting me to the panel there, to Richard Parkinson for commenting on an early draft and David Wengrow on a late one, and to Matthew Stolper for most kindly enabling me to do final checking, while I was at the Institute for the Humanities of the University of Michigan.
2 Asselberghs (1961) is still the most useful, nearly comprehensive collection of the principal material. Much of the interpretation in the study of Whitney Davis (1992) is problematic. For recent summaries with useful bibliography, see Cialowicz (2001a; 2001b). To avoid overburdening the text, I do not give full references.

Merimda (Delta)	c. 5000
Badari (Nile Valley)	c. 4500
Naqada I ('Amratian', Nile Valley)	c. 4000
Early Buto (Delta)	c. 4000
Ma'adi or Buto-Ma'adi (Delta)	c. 3800
Naqada II ('Gerzean', Nile Valley, later all Egypt)	c. 3500
IIc (Hierakonpolis Tomb 100)	
IId2 (cultural uniformity of Egypt;	
end of Ma'adi culture)	
Naqada III (late predynastic and Dynasty 0)	c. 3250
IIIa2 (Tomb U-j at Abydos)	
IIIb (Dynasty 0)	
Early Dynastic period	c. 2950-2575
First Dynasty (=Naqada IIIb2 or IIIc)	
Second-Third Dynasties	
Old Kingdom	
Fourth-Eighth Dynasties	c. 2575-2150

Palestinian Early Bronze I corresponds roughly to late Naqada II/Naqada III; terminology for Egyptian periods after Kaiser (1990).

Table 1. Predynastic to Old Kingdom Egypt: periods and approximate dates

were in fixed locations, may have a more restricted symbolism because they were highly sacralized and fitted into settings where only priestly—including royal—and divine actors could view them.

The ivories and other artefacts from the Hierakonpolis Main Deposit constitute the largest group of objects of the types I discuss here.[3] Ivories, notably knife handles, provide crucial evidence for the evolving presentation of an achieved order of the world.[4] The quite long time span and significance of the material in the deposit is exemplified by the *Two Dog Palette*, which was already old and had been repaired before it was discarded. The Ashmolean Museum, whose Department of Antiquities has the largest holdings from the deposit, has been an essential part of my teaching and research for nearly 30 years. Twenty of these have been under the generous keepership of Roger Moorey, when there has been an ongoing programme to recover and conserve the Hierakonpolis ivories (Whitehouse 1992). It is therefore a pleasure to dedicate to him a study that ultimately arises from the unique privilege of working with this material.

3 Quibell (1900); Quibell and Green (1902); Adams (1974b); see also valuable remarks of Payne (1993: 4–5).
4 e.g. selection in Adams (1974b); Dreyer (1998); Whitehouse (2002), with refs.

THE PRESENTATION OF THE ORDERED WORLD

I begin with the *Cities Palette* in the Cairo Museum, which comes from near the end of the process under review and exemplifies key aspects of the presentation of order (Figs. 1–2; recent discussion: Dreyer et al. 1998: 173–5). I then move back to earlier developments. Comparable provenanced objects, notably the *Two Dog Palette* (Figs. 3–4; partial study: Baines 1993) and the self-evidently royal *Narmer Palette* (Asselberghs 1961, Figs. 168–169), both from the Hierakonpolis Main Deposit, suggest that this unprovenanced example was dedicated in a temple—it was bought on the market and could come from Hierakonpolis or Abydos—while its iconography shows that it was royal. In a general sense, the presentation and deposition of such an object recorded a king's achievements in creating and sustaining order for, and through the agency of, the recipient deity. By the time of its dedication, the original function of palettes as hard stone grinding surfaces for body paint, was much attenuated, although it may have continued to influence their decoration (O'Connor 2002). The elongated oval form, with its decorated field, had acquired partly cosmological meaning, in the case of the *Narmer Palette* creating a form that presented a juncture between the divine world and the world ordered by divine and royal action, with the forces of disorder banished and neutralized in the lower register, or base area (e.g. Baines 1989: 485–6; 1991a: 98, 104).

Only the bottom third of the *Cities Palette* survives. If this is interpreted according to the norms of slightly later compositions, it is the area which presents the foundations of the order that would be proclaimed, perhaps both heraldically and through an image of victory, in the upper part. One cannot be sure which side of the palette was to be viewed before the other. Comparison with the *Narmer Palette*, where a bull signifying the king butts a city enclosure in the base area beneath the smiting scene, may support a reconstruction in which the side with the cities would have had a scene of dominance above. The side with the 'Libyan' scene might then be the one with the grinding depression. Whether or not this is correct, one should assume some equivalence in a vertical hierarchy between what is shown at the same level on the two sides. The compositions on each side should be partly self-sufficient, in addition to being mutually complementary. I choose an order of reading on the assumption that there was something like a narrative between the two, but the narrative could be reversed.

The first side shows in 'plan' seven enclosures, within which are square shapes that may signify blocks of buildings according to a map-like conven-

John Baines

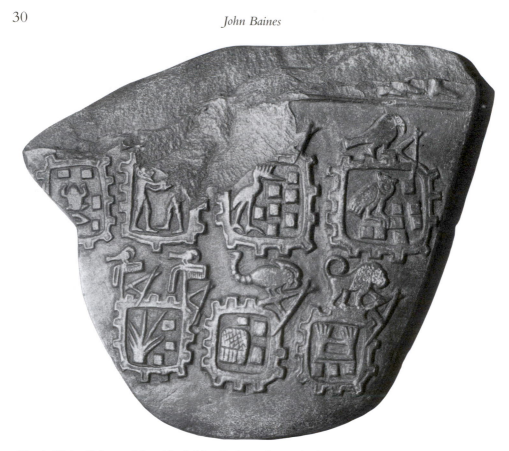

Fig. 1. Cities Palette, cities side. Schist. Perhaps from Abydos. Cairo Museum, CG 14238.
Photograph courtesy of Hirmer Fotoarchiv München.

tion, as well as signs that resemble writing but cannot be read (cf. Dreyer et al. 1998: 173–4). The enclosures are roughly square with rounded corners and have square projections; they probably represent mudbrick walls fortified with salients. Each enclosure has a figure perched on it and juxtaposed with a hoe; the four surviving figures—a falcon, a lion, a scorpion, and a pair of falcon standards—are emblematic of kingship. Parallels show that the animals or standards are hacking the enclosures destructively.[5] Above the enclosures, which are laid out in two rows on a neutral pictorial surface, is a base/register line, on the right end of which are pairs of overlapping human feet at two different scales, probably to be reconstructed as a victor leading a captive. The absence of base lines in the area with the enclosures can be compared,

5 Baines (1985: 42). The analysis of Bietak (1986: 32 with refs.) and others, that the animals are 'founding' cities, disregards both iconographic parallels and rules of pictorial decorum.

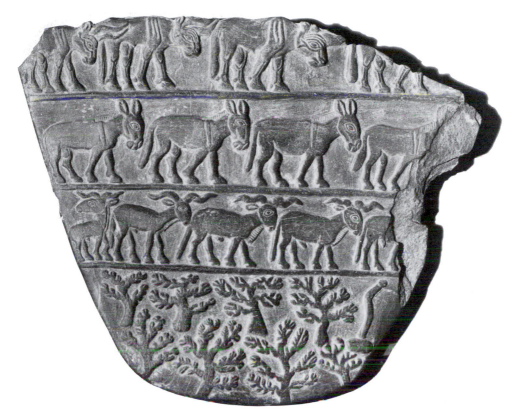

Fig. 2. Cities Palette, animal side. Photograph courtesy of Hirmer Fotoarchiv München.

for example, with the differently proportioned motif at the bottom of the *Narmer Palette*. In symbolic terms, the neutral space on both lacks order.

At the bottom of the other side of the palette is a neutral space with eight trees and one hieroglyph probably reading *ṯḥnw/tjehenu* 'Libya' (for possible locations, see below). The trees may represent a 'Mediterranean', non–Egyptian type.[6] Above are three registers of domestic animals; from bottom to top these are five sheep, four donkeys and four cattle.

The most plausible reading of the surviving parts of the palette is that they assert the defeat of a people or peoples who inhabit fortified settlements, together with the resulting tribute or booty taken from their territory, consisting of the principal species of domesticated animals that were of interest to the Egyptians. The depiction of the trees could possibly signify their destruction, as attested by much later texts and images showing raiding

6 Olives have been suggested, e.g. Asselberghs (1961: 338-9).

accompanied by destruction of the enemy's trees.[7] A more likely explanation, however, is that the trees are tokens of tree crops, probably fruits. Both the animals and the trees would then signify the subservient position of Libya, which would be required after its defeat to deliver tribute of animals and preserved fruits—realistic since these are transportable—or other tree products.

Two essential statements can be read with some confidence off the composition: (*a*) the enemy live in the walled settlements that have given the palette its modern name; and (*b*) order requires the demarcation, destruction and depredation of an 'other'. The animals are not different from those of the Egyptian environment, so the dominated other does not retain alien features. The demarcation between incorporated and unincorporated might therefore appear arbitrary, but it is paralleled much later: Fifth- and Sixth-Dynasty representations again show comparable 'cities' as they are attacked.

The motifs on the two sides of the *Cities Palette* had successors that seem to have been used by two different groups. The display of booty became part of the decoration of royal temples which celebrated the assertion of order and prosperity over disorder, best attested in the Fifth-Dynasty mortuary complex of Sahure (Borchardt 1913: Pls. 1–4), while the attack on the walled enclosure was used by the nonroyal elite to show their participation in events which were ultimately under royal control;[8] the enemy appear to be foreign. In the rare case of Nebhepetre Mentuhotep, the 11th-Dynasty reuniter of Egypt, the king is shown about to smite an Egyptian, with Nubian, Asiatic and Libyan rulers behind (Habachi 1963: 39 Fig. 17); the same king was also probably represented attacking a city.[9] In the New Kingdom kings were again shown attacking fortified settlements, but after the founding king Ahmose (Harvey 1994) these were abroad (Wreszinski 1935; Epigraphic Survey 1986).

7 For example, fruit trees felled to make stockades for Thutmose III's siege of Megiddo: Lichtheim (1976: 33, with refs.); images of trees destroyed in Syria under Ramesses II: Wreszinski (1935: Pl. 65: Luxor, exterior wall of first court). Forcing foreigners to cut down their trees marked their general subjection. In the 6th dynasty Merenre did this to the chiefs of almost treeless areas to the south (Lichtheim 1973, 21–2). In the New Kingdom the 'chiefs of Retjenu' were said to have dragged the timber for the barque of Amun in Thebes, so that they were required to contribute to a central Egyptian symbol of order; see Helck (1957: 1652, 11.13-15; 1961: 197).

8 Discussion and illustration: Groenewegen-Frankfort (1951: 60-2), with Figs.; Jaro√-Deckert (1984: Pls. I, III), 11th Dyn.

9 Gaballa (1976: Fig. 2b); Russmann (2001: no. 17). The yellow flesh colour of the defeated enemies suggests foreigners, conceivably Libyans in view of the lack of heavy garments. Russmann proposes Asiatics.

The *Cities Palette* suggests that important later modes of cultural trans-
mission already existed. The set of seven 'city' enclosures could be excerpted
from a listing of foreign localities that might have been maintained in nar-
rated or in visual form; lists were culturally important by the Early Dynastic
period (Baines 1988). The number of entities chosen was no doubt in part
determined by the compositional space available; the 'signs' and designs in
the enclosures too could have been created ad hoc. Another factor in the
design and number of enclosures could be their relation with the aspects or
manifestations of kingship symbolized by the animals and emblems hacking
at the walls, while seven as a number is likely to be a contributory organizing
principle.[10] In later times standardized lists of conquered people were realized
pictorially as stylized elliptical fortified enclosures containing the names of
the peoples, with an ethnically characterized upper torso protruding to pro-
vide vivid human figures that were normally bound by a single rope in order
to signify the subjection of a set of places.[11] With the *Bull Palette* (Asselberghs
1961: Figs. 166–167), the *Cities Palette* is probably the oldest surviving example
of this convention. Thus, the later form personifies a foreign place—when
specifically captioned normally its ruler—rather than creating a distributed
personification of its assailant.

As a statement about the constitution of societies outside and within
Egypt, the *Cities Palette* and late Old Kingdom successors suggest that, whether
or not cities were a major feature of Egyptian settlement, rulers did not focus
the display of core values around urbanism, but on relations with surround-
ing regions, on the domination or incorporation of outside territory, and on
their depredation of its moveable wealth. They typecast their enemies as
living in 'cities', which neighbours are not likely to have done any nearer
than Syria-Palestine; the city seems particularly inappropriate for the Libya
which is represented on the other side (on its location, see below). Although
the palette's two sides could conceivably relate to different themes, other

10 Rochholz (2002: 242 with n. 1292), citing this example and a public paper by Günter
Dreyer on the origins of the royal titulary. Dreyer (1998: 173-5) reads the grouping of royal
symbols as a kinglist. This raises various problems and I prefer to see them as a set of emblems
of royal power that would relate to a single king. The idea of the kings of a list actively making
an attack has no parallel, and would require that there be a pictorial realization of past 'history'
on a present monument. While Egyptian kings often showed respect for the past and for
particular predecessors, they did not generally invoke the past for action, but claimed the
credit for themselves.
11 First attested in the Middle Kingdom: Smith (1976: 39-41); standard collection: Simons
(1937).

palettes suggest that this is unlikely, so that the treatment of Libya should be seen as deliberate but paradoxical.

A single composition cannot make the case for such a non-urban or anti-urban vision of Egypt, but the *Cities Palette* appears to be comparable in emphasis with other material of its period. So the question arises of how the archaeological record of sites, including urban ones (Kemp 1977), of their distribution across the country, and of artefact types, compares with the reflexive, ideological statements of the palettes and other monuments.

The emergence of a unified complex society

The *Cities Palette* was created in a period of uniformity of material culture in an Egypt that possessed a limited writing system (Dreyer et al. 1998; Baines forthcoming), highly ordered and articulated artistic compositions, and a strong classification of self and other that clustered around the institution of kingship. The palette can be dated in Naqada IIIb, probably around two centuries after the cultural homogenization of Egypt in Naqada IId2 (see e.g. Kaiser 1990; cf. Hendrickx 1996). Because production of objects like these ceased with the First Dynasty (Naqada IIIc), the possible date range is narrow. The palette is probably a little older than an ivory seal of Narmer with another, fuller writing of the word *ṯḥnw* 'Libya' (Baines 1995: 151 Fig. 3.6; Whitehouse 2002: 434 Fig. 4). What was the background out of which the symbolic statements of the palettes and related objects emerged? What implications do these objects have for modelling the early Egyptian unified polity?

Periods and the state

Before Naqada II, none of the cultures of the Nile Valley and Delta, or of the surrounding deserts, displayed more than slight indications of social differentiation, structural inequality or other measures of social complexity. Badari and Naqada I, however, show a focus on elaborate artefacts, and on burial as a locus of display that points toward much later developments, including those of the Egyptian state. By contrast, the Buto-Ma'adi culture of the Delta had a generally lower orientation toward display. From around 4000 BC, the sedentarization of Egypt and developments in material culture progressively separated the Nile Valley and Delta from the surrounding desert with its largely nomadic population, although commonalities with cultures on the Middle Nile (upstream to the confluence of the Blue and the White Nile) diminished relatively slowly (O'Connor 1993: 10–23; Midant-Reynes 2000: 126–41).

Nucleated settlement was associated with insecurity, as is attested by a model enclosure wall with warriors looking over the top found in a Naqada I period grave (Williams 1994). The same idea occurs in a late third-millennium text (Lichtheim 1988: 26). Thus, from early times what constituted urbanism in relative terms had negative associations in the context of a probably acephalous society. These associations may have taken precedence over the positive ideas and ideals of city life common both in other civilizations and in second-millennium and later Egypt.

For the Naqada II period, when social complexity becomes clearly discernible and the distribution of sites changes markedly, town sites are largely inaccessible, but the development of major centres, notably at Hierakonpolis and Naqada, and widespread distribution of specialized products, suggest some nucleation. In the north, the Buto-Ma'adi culture gave way to Naqada II just before the latter culture's transition to Naqada III, which is an internal transformation—and for non-luxury materials an impoverishment—rather than a change in direction. Throughout its duration, Ma'adi shows important connections with Syria-Palestine (e.g. Midant-Reynes 2000: 210–4).

Many scholars suppose that the disappearance of Buto-Ma'adi and expansion of late Naqada II and transition to Naqada III were cultural rather than political phenomena and that political unity did not emerge until perhaps Naqada IIIb/Dynasty 0. This hypothesis of late political unification seems to arise from two principal considerations: in Naqada III there continued to be regional centres such as Hierakonpolis, so that political unity cannot be traced on the ground; and a politically unified late Naqada II or early Naqada III would be earlier than any large polity elsewhere in the region, perhaps in the world, and so may appear anomalous in comparative perspective—the latter point being self-evidently problematic because claims of chronological priority have little meaning. Yet while it is difficult to establish what was the political structure of late Naqada II, its dissemination must have had a driving motivation—presumably including a vision of the lower Nile as in some sense a single entity—and it seems unlikely that a valid material culture and a distinct lifeway like that of Ma'adi would have been superseded completely peaceably (comparable arguments: Kaiser 1990: 290–5). A model of conflict and of domination from the south is therefore plausible. Moreover, southern groups that were in fierce competition with one another would have been impaired in seeking such domination, while only the most northerly region would have had direct access to the Delta.

This cultural and perhaps political unification was quite rapid. In Naqada III there emerged writing, monumental architecture in organic materials

(Friedman 1996) and in brick—of which a structure like Tomb U-j at Abydos (Dreyer et al. 1998) may be a miniaturized reflection—and highly evolved representational and symbolic forms, leading to such later examples as the *Cities Palette*, while other extravagant vehicles of display, such as stone vases, moved toward a peak of development (e.g. Aston 1994). In Dynasty 0, Egypt was a large-scale, administered complex society with a dominant ideology, whose social coherence was not simply that of kinship—in short, it was a state so far as such an entity can be defined (e.g. Baines and Yoffee 1998). The new societal form simplified and commodified unprestigious domains of material culture (cf. Wengrow 2001; Yoffee 2001). While representational display did not focus upon explicitly 'complex' matters, that signifies little because there is no reason why it should have such a focus. Rather, as a product of elites that was progressively more restricted to them, both as creators and as audience, it addressed their concerns, which were increasingly those of royalty and the gods.

Relations with areas outside Egypt

I now review briefly early Egyptian relations with surrounding regions, starting with the most complex case, that of the north-east.

Connections to the north with Syria-Palestine and beyond, which were evident in early Buto (e.g. Faltings 1998) and in the Ma'adi culture, continued in a different form in the first phase of Naqada III. They are often seen as decisive in the emergence of Egyptian civilization. Yet while elements such as cylinder seals, some artistic motifs and conceivably the idea of writing,[12] are ultimately of Syrian, Mesopotamian and/or Iranian derivation, they would not by themselves have transformed the recipient society, which must have been prepared to adopt them and give them its own meanings. That group of stimuli does, however, suggest that there was high-level trade in prestige goods. The only sign of import in quantity from Asia is from Palestine, and the commodity imported is still of high status: Tomb U-j at Abydos, the burial of a ruler of Naqada IIIa2, contained more than a hundred Palestinian wine jars of an export type not known from Palestinian Early Bronze sites (Hartung 2001). This material demonstrates that Egypt had a significant economic impact within the nearest region to the north-east, making the latter

12 I omit what was proposed to be cone mosaic, of which possible finds at Buto were at first seen as strongly diagnostic. Most recently these have been interpreted as evidence for salt production: Wilde and Behnert (2002). They have also been found at Hierakonpolis, in a location where there was no mud brick architecture to which they could have related: Friedman 2000.

something like a periphery of the emergent state. By contrast, the foreign artistic motifs, administrative practices, and materials such as lapis lazuli came from further afield, through Syria rather than Palestine. This distinction is in part one of prestige: things that are complex or of high value are the more significant if they come from very far away.

Rather later in Naqada III, around the beginning of the First Dynasty, Egypt expanded briefly into southern Palestine, where locally made pottery of Egyptian types has been found, as well as the names of some kings, notably Narmer (Levy et al. 1995, with refs.). Unlike material from Egypt itself, these finds come from settlements, showing interaction with the local Early Bronze population. This phase, which may have involved some conquest and 'colonization' (Andelkovic 2002) and is documented also in Egyptian tags with year names, ended around the middle of the First Dynasty (Wilkinson 1999: 152–7).

To the south, Egyptian material culture had overlain that of the Nubian A-Group in the Aswan area probably before the end of Naqada II (Kaiser et al. 1988: 141–4). Significant A-Group polities emerged in northern and southern Lower Nubia.[13] The southern polity, which had a 'royal' cemetery at Qustul, exhibits a high level of social differentiation, with symbols of royalty comparable to those of Egypt, as well as very large tombs of rulers (Williams 1986; O'Connor 1993: 20–3). The royal cemetery, roughly contemporaneous with early Naqada III, was thoroughly vandalized and never reused. At about the same date an Egyptian victory relief was carved at Gebel Sheikh Suleiman, at the northern end of the Second Cataract (W. J. Murnane in Williams and Logan 1987: 282–4). Thereafter, Lower Nubia is an archaeological blank for more than 500 years, when the local population was presumably not in a position to create lasting burials (village settlements are unlikely to be found), while an Egyptian fortress town of the Old Kingdom has been discovered at Buhen near Gebel Sheikh Suleiman (Adams 1977: 170–5; O'Connor forthcoming). Thus, the elimination of the A-Group, which was surely due to Egyptian military activity, created a power vacuum to the south of Egypt, like a vastly extended frontier zone. Assertions of victory over Nubia are known also from the First–Second Dynasties (e.g. Petrie 1901, Pl. 3, 2 = Schott 1950: Fig. 13; Quibell and Green 1902: Pl. 58).

The Egyptian treatment of Libya to the west is likely to have been comparable to that of Nubia. Several scholars have suggested that the principal

13 For Sayala in the north, see Trigger (1965); on the maceheads from there, see Payne (1993: 3-4).

word for Libya (*ṯḥnw*) referred originally to areas immediately west of the
Nile Delta or even within it (e.g. Dreyer et al. 1998: 173–4), but nothing
specific points to this location. The later centre of Libyan population was
Cyrenaica, hundreds of kilometres further west (e.g. papers in Leahy ed.
1990), perhaps together with the western stretches of the Mediterranean
littoral of modern Egypt, which to this day supports a sparse, seminomadic
population that does not consider itself Egyptian (Abu-Lughod 1986). That
entire region has been little explored for its prehistoric archaeology. Much
of the population of Cyrenaica was recently still nomadic (e.g. Peters 1990)
and the same was probably true earlier, so that traces of human occupation
would not be easy to find. It is most economical to assume that early Libya
was in the same area, and this siting fits with the generally high mobility of
prehistoric non-agricultural populations. A people living at such a distance
could have traded animals and some other products with Egypt, but would
seldom have constituted a significant political threat to a settled state of the
type Egypt became (in different circumstances they did constitute a threat in
the late New Kingdom).

Wherever 'Libya' was, the absence of evidence for settled populations,
still less cities west of the Delta, suggests that the depiction on the *Cities
Palette* and comparable monuments characterized a generalized 'other' and
did not aim even at a schematic rendering of a particular area. The assertion
of dominance over Libya thus invoked a formidable, settled enemy far dis-
tant from Egypt, whom the Egyptians could nonetheless easily control and
render tributary. The great distance further asserted that the space between
the two regions was a void that could be traversed but held no threat. This
'ethnographic' characterization of Libya as a polity was not realistic either in
what it said about Libya itself or in what it implied about Egypt.[14]

Finally, east of the Nile Valley was the mountainous Eastern Desert,
which the Egyptians exploited from Badarian times for its mineral resources
but did not settle even where it could have been habitable (Majer 1992).
Graffiti of Narmer in the Eastern Desert (Winkler 1938: 25, Pl. 11, 1), show
a marking of territory for Egyptian exploitation during Dynasty 0, but essen-
tially the area was another void, rather like the region to the west leading
toward Libya.

Thus, early Egypt demarcated itself from its neighbours by creating or
asserting a void in three directions out of four. The fourth direction, toward
Syria-Palestine, which is the only one that is not attested in explicit ideologi-

14 For a possible Second-Dynasty assertion of victory over the 'West', see Quibell (1900:
Pls. 36–38); Baines (1985: 245 with Fig. 144).

cal statements from Naqada III, is the only one to show significant trade and exchange. It is also the only one where there was a pattern of sedentary living in walled settlements, as is presented for a quite different region on the *Cities Palette*, and for places that cannot be located on the *Bull* and *Narmer* palettes. It could be a matter of chance that there is this double contrast between foreign regions and the ways in which they were depicted on the one hand, and the patterning of relations between them and Egypt on the other. Be that as it may, this disjunction between categories of evidence exemplifies how ideological presentation is far more important than specific realities for the design of premier works of art.

Ideology was probably vital to cultural and political unification. Explicit texts containing words for Egypt and its regions are not known until the Early Dynastic period and Old Kingdom,[15] so that one cannot compare the ideology of what the land signified with that attested from later. Whether or not there was a concept or a word for 'Egypt' as an entity when the process of unification began, this must have emerged by the end for there to have been such a strong drive to reach the limits of the land and to suppress regional differences. The terminology of 'Two Lands', which characterizes dynastic Egypt, has often been seen as deriving from two 'kingdoms', perhaps of the Naqada II period, but the archaeological record does not support such an interpretation. Rather, unity arose from a single Nile Valley polity that incorporated a number of other polities and geographical areas. The dualities of Egyptian ideology are more part of a vision of how the cosmos is constituted than a reflection of political divisions. The identification of country and cosmos was fundamental to that vision.

Forms of display

The enrichment and elaboration of forms of display and of rule during Naqada III accompanied major changes in material culture, most strikingly in pottery. The inventory of ceramic forms of Naqada III is more restricted than that of Naqada II, showing an impoverishment in styles and to some extent in execution, together with an increase in average container size (see conveniently Adams 1988: 25 Fig. 10, 29 Fig. 15). The fine black-topped red ware of earlier phases died out by the end of Naqada II, while D-Ware, the major Naqada II style of marl clay containers with mainly representational decoration in red paint, disappeared around the same time, leaving little fine or decorated pottery in production (see further Baines and Wengrow forthcoming).

15 Loprieno (2001: Chapter 2). I am grateful to Antonio Loprieno for further discussion on this point.

Thus, cultural uniformity was concomitant with a restriction on certain forms of display and wealth. Some burials of Naqada III were rich in grave goods, notably stone vases—probably equivalent in part to earlier fine pottery—and a few ripple-flaked knives with carved ivory handles (Midant-Reynes 1987: 220–4, dating from Naqada IId to early Naqada III). There may also have been an increase in the use of metals among the elite, but these are rarely attested, probably in part because they were easily robbed and recycled. These polarizing developments concentrated expressive resources among the wealthy, while some prominent aspects of material culture ceased to be potent expressions of local identities. Decorative themes of the knife-handles and temple votive offerings focus on the achievement of order and on the 'other'. Both of these are represented more often through animals than through human figures, and through combat scenes, most of which are on clearly royal objects. This tendency to restrict subject matter perhaps began in mid-Naqada II. The wall paintings of Hierakonpolis Tomb 100, which is generally dated to Naqada IIc (Kaiser 1990: 289 Fig. 1) and may have belonged to a local ruler, have a full range of motifs including human figures, scenes of ritual slaughter of enemies, hunting, and forms of boats that are otherwise rarely attested (Quibell and Green 1902: Pls. 75–79). While it is difficult to contextualize this composition in relation to later ones, all of these motifs are subsequently known only on objects of the highest prestige; in Naqada III they probably became the privilege of royalty, either to use or to donate to others.

This polarization of wealth and display was contemporaneous with the spread of the Naqada culture and with increased population between the Fayyum and the Delta apex, where the capital city was generally located in later times. This area, which had probably been the population centre of the Ma'adi culture, grew in importance as it became the fulcrum of the two main regions of the country. At first the area did not have a single main site or city, as Memphis later became, but even Memphis seems not to have been large by the standards of such Near Eastern cities as Uruk (Jeffreys and Tavares 1994; Davies and Friedman 1998: 38–44). The distribution of cemeteries suggests that the population here became more concentrated as well as larger. Although living patterns cannot be reconstructed from cemeteries with any precision, the absence of a predominant cemetery points to a rather dispersed mode of settlement. When Memphis emerged in the First Dynasty, the nearby prestige necropolis of Saqqara, which had very few, extremely large tombs, was complemented by the existing, very large

mid-ranking cemetery of Helwan opposite, which appears to have had a slightly subordinate status because it was on the less symbolically favoured east side of the Nile and more distant from the city.[16] This distribution of cemeteries gave the greatest prominence to Memphis, but not in the unified fashion of some later cemeteries of capital cities such as that of New Kingdom Thebes. Older centres in the Nile Valley that had probably been the capitals of regional polities continued to be important, although all of them lost their prominence during the Early Dynastic period. The most evident of these are, from south to north, Hierakonpolis, Naqada and Abydos, as well as perhaps Hiw, upstream from Abydos (Kaiser 1990: 293 with n. 35); other possible centres, for example in the Asyut region, may have been overlooked or obliterated beneath later developments. Abydos retained a unique status as the historical and current burial place of the First-Dynasty kings and continued to be a regional centre until the Fourth Dynasty, but its importance was probably as much symbolic as pragmatic. Like Memphis, it had necropoleis on both sides of the Nile, of very high status at Beit Khallaf and Reqaqna on the west bank and of lesser status at Nag' el-Deir on the east bank (O'Connor 2000: 24–5).

Settlement patterns in the Delta are less clear. Crucial sites such as Buto show a replacement of the Ma'adi culture by Naqada IId2 and III (von der Way 1993: 84–91—some aspects problematic), while textual and symbolic allusions suggest that places like Sais (Baines 1991b: 32–7), which were major cities in later periods, were significant from early. The Delta was probably more urban and nucleated in settlement than much of the Nile Valley, in part because of its very different topography. The wealthy cemetery of Minshat Abu Omar in the far north-eastern Delta may have belonged to a settlement near the frontier related to routes to Palestine (Kroeper and Wildung 1994–2000, without synthesis). The location of this site, which appears to have been a foundation of the rulers of the unified country, fits with a centrally directed settlement policy.

The pattern of settlement in a country is hardly ever close to ideal types of geographical theory and these distributions are no exception. They suggest a relatively even spread of population in the majority of regions, together with a strong but un-nucleated focus on the area of the later capital. This pattern is far from those found in civilizations based on city states.

16 Köhler, see http://www.theage.com.au/breaking/2001/06/12/FFXIWM1KUNC.html. For later sectors at the site, see Saad and Autry (1969); Köhler (2000).

Late predynastic developments: summary

Developments of later Naqada II and Naqada III that are relevant here can be summarized as the homogenization of material culture outlined above, together with a restriction in vehicles of display and a privileging of certain royal and elite media and contexts. The cultural and political unification of Egypt brought a great economic expansion, one indication of which is the maintenance of general physical health through a period of likely conflict and rapid social change, in contrast with patterns found in many parts of the world (Keita 1997). Despite this expansion, there was a progressive impoverishment of the material culture of people below the inner elite, at least in the accessible domain of mortuary archaeology, that peaked in the extreme wealth differentials of the Old Kingdom.

These developments were contemporaneous with the creation of an image of the other that separated Egypt radically from the world around, ostensibly leaving only the north-east, from which significant high-cultural stimuli had come and where it briefly expanded, as a direction with which it had relatively open relations of contact and economic exchange. The country and civilization presented itself as a single, homogeneous entity that encountered diversity and danger beyond rather than within its frontiers—a little like the largest states today. It also projected itself as something akin to a vast rural estate rather than a network of urban centres, even though such centres must have existed. This merging of polity and civilization is perhaps the most distinctive feature of Egypt in many periods. I now review how this pattern, derived from artefact typology and site distribution, can be compared with the representational legacy, of which the *Cities Palette* is a vital late example.

SPECIALIZATION OF IDIOMS OF DISPLAY

As the Naqada culture spread, it brought a stronger general orientation toward display, specifically funerary display, than the Lower Egyptian cultures had possessed. Architecture and its accompanying decoration was probably a major focus, together with elaborate elite lifestyles and perishable accoutrements such as fine cloth and jewellery. Nonetheless, the permanence of the world of the dead, the increasing expenditure on grave goods and tomb structures, and the prominence of the low desert as an environment and a landscape in which display had an almost autonomous meaning, gave great salience to the world of the dead.

Themes and motifs of representational display in Naqada III incorporate this salience almost reflexively. Many objects are decorated with animal scenes,

Figs. 3–4. Two Dog Palette (left: grinding side, right: non-grinding side). Schist. From the Main Deposit at Hierakonpolis. Oxford, Ashmolean Museum E.3924.

some showing hunting and some appearing almost like inventories of animals (notably the Brooklyn knife handle, cf. Kemp et al. 2000: 215, 231 Fig. 14). The most complex compositions, notably the *Two Dog Palette*, create an environment with partly supernatural characteristics, framed by two high-relief wild hunting dogs (*Lycaon pictus*), which were animals of the low desert— the realm of hunting as well as of the dead (Baines 1993; Adams 1974b: no. 327, Pls. 39–40, ivory with a figure of a griffin). Ivory objects with representational decoration, which form the largest category, mostly from temples, have a larger proportion of human figures, mainly in scenes of aggression. The Gebel el-Araq knife handle is an example of the symbolic equivalence of human aggression and animal scenes: one side shows human figures in

combat and the other a hunting scene that mixes human and animal protagonists, the latter part domestic and part wild (Asselberghs 1961: Pls. 38–41; Sievertsen 1992).

There are evident similarities in the symbolism of hunting, victory in battle, and ritualized slaughter of enemies. Hunting and victory were shown with human participants but include kings in indirect forms, such as emblematic animals. Here, the essential creation of the end of the formative period was a dominant anthropomorphic iconography for the king, culminating with the *Narmer* and *Scorpion* maceheads and palette; this complemented rather than replaced the animal forms. An anthropomorphic iconography for figures of deities was probably designed at the same time to interact with figures of the king but not with other human figures; this is not attested until later, probably be-

Fig. 5. The Hunters' Palette. Schist.
Perhaps from Abydos.
British Museum 20792, 20790, Louvre E 11254.
Photograph courtesy British Museum.

Fig. 6. The Hunters' Palette.
Detail from recto of BM 20790.
Drawing from original
by Christine Barratt.

cause deities could only be shown within sacred spaces. The depictions of rituals centring around the king in the largest compositions, such as the *Narmer Palette* (which is still relatively small) similarly possessed meaning in relation to other, more stereotyped ritual scenes of king and deity that could, for example, have adorned temple sanctuaries or have decorated lost, perishable materials and objects like shrines.

While these hypothetical core religious iconographies were developing, battle and defeat of enemies were depicted in relation to the hunt or were symbolized through it. Hunting was an activity of the low desert, the liminal zone between Egypt and the world outside, between the settled and the wild or unsettled, and between the realms of the living and of the dead. The *Hunters' Palette* (Fig. 5–6), which shows a lion hunt conducted by a group of men with, at the top, a small image of a building and an emblematic double bull, probably signifies a hunt under the auspices of a king depicted through those two symbols and not shown as a human figure, because he is a different order of being from those who are present.[17] On the *Battlefield* and *Bull Palettes*, the king himself is shown as a lion devouring an enemy or a bull goring one (Asselberghs 1961: Pls. 86, 93). These compositions are rather freely arranged over a neutral surface, but the painting in Hierakonpolis Tomb 100 shows that the rigid device of the base line existed from earlier. The neutral compositional space on some palettes must contrast with lost compositions that possessed such lines, which probably developed in some of the same contexts where representations of the king with deities evolved. The lines appear to have been introduced progressively to the palettes and maceheads, becoming dominant by the end of Dynasty 0 in compositions in multiple registers on the latest palettes and maceheads.

The adoption of rigid register composition offers an analogy for developments in social hierarchies. The emergent inner–elite contrast with the administrative sub–elite and the undifferentiated mass of other people, whom most monuments evoke only indirectly. In general, the people do not play a major part, because the focus is on the central actors; a little paradoxically, enemies are more widely attested, because they are more significant for propounding the king's violent containment and subjugation of the other.

This world of hunters and of victory is a specialist elite domain, in which preoccupations like dog-breeding were important enough to be incorporated in significant ways (Baines 1993). Some related iconography, such as a

17 Asselberghs (1961: Figs. 122-124); see e.g. Baines (1995: 111-2); detailed interpretation: Gimbel (2002). The building shown with the double bull has a partial parallel in two structures represented on a piece of ivory from the royal tombs at Abydos: Petrie (1901: Pl. 4, 11).

small macehead with alternating figures of a dog with a collar pawing a lion—perhaps also tame—for attention, is playful and appropriate to an in-group.[18] The only major object that includes representations of significant areas within the settled and watered land is the fragmentary *Scorpion Macehead* (Fig. 7), the central sections of which seem to show an agricultural ritual and another ritual in marshland, a favoured internally liminal location of later times (two alternative reconstructions: Gauthier and Midant-Reynes 1995; Cialowicz 1997). Hunting takes place in the low desert, while the symbolically equivalent victory creates a distance from Egypt, past the vast, more or less empty no man's lands of Lower Nubia and the western littoral that render the ordered world ideologically self-contained and discrete.

A striking overall focus of the decoration, and of the objects on which it was carved, is thus aggression. The warlike and ceremonial weapon of the macehead is known in many sizes (Adams 1974a: Pls. 1–6; Cialowicz 1987), while the ivory-handled ripple-flaked knives, although almost certainly not functional (Midant-Reynes 1987), are talismans of the hunt and of battle, some perhaps given by kings to favoured followers. A decorated stone vase shows essentially the same theme in royal guise (Quibell 1900: Pl. 19.1; Baines 1990: 10 Fig. 3). Small ivory cylinders are decorated with repeated motifs of a figure, probably the king, clubbing enemies with a mace (Quibell 1900: Pl. 15); these seem to be sections from votive mace-handles (Payne 1993: 3–4, citing Whitehouse). Aggression symbolically rejects different styles of contact with the world outside, while carrying bleak implications for subjects within Egypt, as is shown by the throttling of the lapwing emblem for 'subject' on the *Scorpion Macehead* (Fig. 7) and by later treatments of the same motif (e.g. Baines 1985: 42, 48–9). It negates any reciprocity there may be between adjacent societies, focusing the new configuration of the state around the single value centre of the king, who is also the intermediary to the gods. In the definition of the single society which makes up the newly formed civilization, what is outside is 'other' and inferior, so that reciprocity would have no meaning; whether Egyptian–foreign relations were in fact as consistently brutal and asymmetrical cannot be known. The elite partake in the ruler's position and derive symbolic status through him, as is shown, for example, by the transfer of power through physical proximity to the king (Baines 1995: 128–33) or by the nonroyal use of originally royal motifs, such as the niche-panelled brick facade, which was an elite form by the First

18 Oxford, Ashmolean Museum E.367; Quibell (1900, Pl. 19, 6). Cialowicz (1987: 46) cites other writers and proposes that the piece was imported from Mesopotamia. It integrates so well with other Egyptian treatments of dogs and lions that this seems very unlikely.

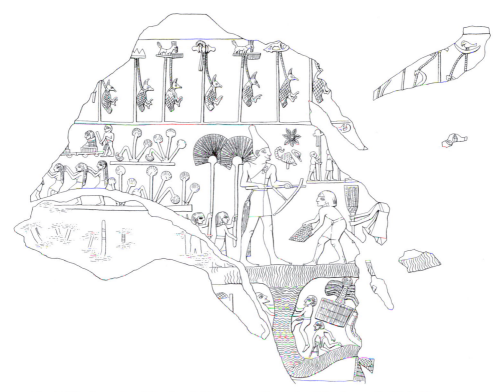

Fig. 7. The Scorpion Macehead. Limestone. From the Hierakonpolis Main Deposit. Oxford, Ashmolean Museum 1896–1908 E.3632. Drawing from original by Marion Cox.

Dynasty after being only royal in early Naqada III (e.g. Kroeper and Krzyżaniak 1992).

These developments in the decoration of small votive and funerary objects cease to be visible around the beginning of the First Dynasty, when display came to focus on monumental tomb complexes; palaces and temples probably had similar importance, but are hardly accessible. These architectural creations, however, cannot have been equivalent to the representational compositions—whose only successors appear to have been in different domains—because large-scale or undecorated material cannot convey the detailed messages of captioned scenes. This shift in domain is an indicator of major change and of the ruling group's progressive arrogation of control of complex symbolic resources, which became almost wholly focused on the centre, where what was most important—principally the cult materials themselves and representations of interaction between the king and the gods— was not displayed publicly or deposited in nonroyal tombs.

THE ESTABLISHMENT AND MATERIAL EXPRESSION OF HIERARCHIES

This increasingly restricted, hierarchical focus of ideology and its representation excluded most of society from access to central concerns and values. Whether the population in general had a strong interest in those values cannot be known, but the king and elite must have intended to motivate the society at least in part through comparable concerns. A comparison of the relative freedom and homogeneity of Naqada II, when D-Ware pottery was deposited in quite a wide range of tombs (and may have been used in other contexts), with the general plainness of even the highest ranking grave goods of the First Dynasty shows a striking withdrawal of symbolic resources (e.g. Emery 1938, 1939, 1949–58), even if it was partially compensated in precious media that are lost through decay of organic materials and through tomb robbery. By the Fourth Dynasty, grave goods had become relatively insignificant as a focus of display even for the elite, whereas funerals appear to have become extremely elaborate (Alexanian 1998; Münch 1997, 2000).

Thus, the elite of the third millennium were in a sense prisoners of the symbolic structures that they and royalty had created. With hindsight, the path that led to the centralization and expenditure on the pyramids began with the emergence of an exclusive focus on the king during the formative period. The social and material forms of control of the country itself that were created then were expressed through such notions as the 'estate'—a royal land grant either for central purposes or for the income and funerary foundations of elite officials—and the province or 'nome', both of which are attested from the First Dynasty onward but had roots perhaps going back to Naqada III or Naqada II (proposed by Dreyer et al. 1998, for Tomb U-j at Abydos). These administrative forms assign areas for agricultural exploitation and for control. Estates are agricultural, while nomes divide the country into sections. The nomes presumably had administrative focal points, but only a few of these are known as sites—generally from later times—and most nomes may not have focused around large towns. Here again, the country was demarcated as far as its boundaries and in theory settled evenly in the interest of the centre. This centralization, which intensified until the Old Kingdom, was no doubt favoured by the ease of river transport, while towns were not much needed for distribution because the river bank offered fairly uniform scope for mooring and shipping. Outside the newly dominant area of Memphis, only Abydos and Hierakonpolis remained as significant regional centres (there may have been others in the Delta). Other important places, such as the frontier post of Elephantine (Dreyer 1986; Ziermann 1993), seem not to

have become significant for elite display until the late Old Kingdom. Here, however, evidence is sparse and institutions such as provincial temples may have counterbalanced the overwhelming focus on the area of the capital (O'Connor 1992). The small dummy pyramids of the Third–Fourth Dynasties, which are spread across much of the country, probably also marked the whole in the service of the centre (Seidlmayer 1996).

During the third millennium, the creation of estates increased the area of agricultural land and, it seems, altered residential patterns, with the newer estate-based forms complementing older, more nucleated settlements (Jacquet-Gordon 1962; Moreno García 1999). At least in ideology, development was away from the urban toward more dispersed and rural forms. It is difficult to assess the accuracy of this picture, which is essentially read off textual evidence and images, and almost impossible to test by fieldwork, but ideologically the emphasis is significant.

The manipulation of settled space accompanied the hierarchical demarcation of deities and king from elite, and of elite from others. This hierarchy was material and spatial—since it is manifested in the patterning of cemeteries and in artefact typologies and distributions—as well as ideological. Ideological concerns seem to have been crucial, if only because it is difficult to imagine that the elite would have accepted to be deprived of symbolic resources to the extent that they were unless this happened in the name of dominant ideas. In relation to these ideas, evidence like that of the palettes gives great weight to the definition of self and other and to the ideology's boundarism. Such ideas continue to be attested from the Early Dynastic period,[19] and Old Kingdom royal monuments are consistent in emphasis with the older material (notably Sahure: Borchardt 1913). During Dynasty 0 there crystallized a system of decorum governing the organization of monuments and their decoration (Baines 1989: 475–6). This system, which was central to Egyptian civilization, had many functions and is manifest in many domains. Its ultimate focus was on the gods and the king, imparting a sacral core to the demarcations of human society. Those demarcations patterned the display focus of death, in addition to the context of temples, which is less well known for early periods. Decorum constrained access to symbolic resources even for members of the elite.

Thus, there was a coherent complex of symbolic and material institutions that encompassed a hierarchical central ideology, differential access to

19 e.g. Petrie (1901: Pl. 4); Quibell (1900: Pls. 36–41); Quibell and Green (1902: Pl. 58); Firth et al. (1935: Pl. 57); Donadoni Roveri and Tiradritti (1998: 265 no. 248).

prestigious domains of material culture, attitudes toward the world outside and action in relation to it, as well as the pattern of settlement within the country. These domains are not homologous; rather, they manifest inter-locking ideologies that drove Egyptian civilization in its formative period.

CONCLUSION

I have viewed the emergence of the Egyptian state primarily through com-plex works of art and artefact types, in order to model a message which the elite proclaimed to itself about Egypt's relations with the world outside. The works say little about the people as a whole. That bias manifests the focus of the central actors, principally the king, whose aim was not to create a gener-alized representation of society but to propound their interests and concerns.

Broader measures of material culture and symbolic action, which might flesh out the arguments from elite objects presented here, would be largely irrelevant to the elite actors' perspective. An essential strategy of elites is to assert in deed and word that their own preoccupations and methods of ad-dressing their concerns are uniquely meaningful, so that what is outside can be ignored. One example cited above is the writing system. The resources invested in this enhanced the potential of administration, which could have been the initial stimulus to the invention, but they also created a high-cultural representational and aesthetic system whose main purpose was to convey complex centripetal meanings to the group who had access to the mostly quite small-scale works embodying it (Baines 1999, forthcoming). That group consisted of the gods, the king, and the elite who possessed the requisite knowledge, saw the objects as they were made, and deposited them in temples or tombs rather than making them public.

Such exclusive high-cultural undertakings characterize ideologies and styles of social complexity that are, I argue with Norman Yoffee (Baines and Yoffee 1998), specific to civilizations. Their institutional underpinnings ex-travagantly mobilize sub-elites to maintain and transmit the necessary skills. These are specialized instances of the differentiation of unequal sectors and roles that are integral to social complexity, and they go beyond what is generally found in nonstate societies, whether complex or not. The bound-arism and territoriality of Egyptian self-definition is incorporated in such forms and asserts, no doubt contrary to the facts, that Egypt was a self-contained and ethnically uniform society—an idealized nation state—and that beyond its sharply defined borders it only entertained normal relations with its cultural or civilizational 'equals', treating them as periphery rather

than as separate, and banishing all other neighbours to nonexistence or to a distant limbo.

This configuration is characteristic of Egyptian civilization and contrasts strongly with the roughly contemporaneous Mesopotamia. In Egypt, state and civilization were coterminous. The civilization's self-image was not urban. Boundarism and territorialism were part of the nonurban vision in a country that seems also in fact to have been comparatively little urbanized. Here, ideology agrees with developments on the ground. Mesopotamia was a civilization of city-states that was not unified and lacked sharp boundaries, both between one state and the next and on its periphery. Together, the two cases exemplify that there is no single trajectory toward, and type of, civilization.

Archaeological evidence contributes to this argument from sites and from artefacts, but other categories of material are also essential to the picture. While that picture lacks the dimension of lived action, works of art and writing provide a complex, reflexive commentary on social processes. Civilizations produce complex legacies that require multidisciplinary study.

I have not offered a definition of social complexity, even as it might be applied to the case of Egypt. Rather, I argue that civilizations as societal types exhibit features that are deliberate products of elites and are additional to the basic level of social complexity, taking ideological and social forms into new domains. From the complex society emerging in Naqada II, Egypt moved to the distinctive civilization which defined itself during Naqada III.

REFERENCES CITED

Abu-Lughod, L.

1986　*Veiled Sentiments: Honor and Poetry in a Bedouin Society*. Berkeley: University of California Press.

Adams, B.

1974a　*Ancient Hierakonpolis*. Warminster: Aris & Phillips.

1974b　*Ancient Hierakonpolis: Supplement*. Warminster: Aris & Phillips.

1988　*Predynastic Egypt*. Shire Egyptology 7. Princes Risborough: Shire Books.

Adams, W. Y.

1977　*Nubia: Corridor to Africa*. London: Allen Lane.

Alexanian, N.

1998　Ritualrelikte an Mastabagräbern des Alten Reiches. In *Stationen: Beiträge zur Kulturgeschichte Ägyptens, Rainer Stadelmann gewidmet* (H. Guksch and D. Polz, eds.). Mainz: Philipp von Zabern, 3–22.

Andelkovic, B.

2002　Southern Canaan as an Egyptian predynastic colony. *Cahiers Caribéens d'Egyptologie* 3/4: 75–92.

Asselberghs, H.

1961　*Chaos en beheersing: documenten uit het aeneolitisch Egypte*. Documenta et Monumenta Orientis Antiqui 8. Leiden: E. J. Brill.

Aston, B. G.
1994 *Ancient Egyptian Stone Vessels: Materials and Forms*. Studien zur Archäologie und Geschichte Altägyptens 5. Heidelberg: Heidelberger Orientverlag.

Baines, J.
1985 *Fecundity Figures: Egyptian Personification and the Iconology of a Genre*. Warminster: Aris & Phillips; Chicago: Bolchazy-Carducci.
1988 An Abydos list of gods and an Old Kingdom use of texts. In *Pyramid Studies and Other Essays Presented to I. E. S. Edwards* (J. Baines, T. G. H. James, A. Leahy and A. F. Shore, eds.). Occasional Publications 7. London: Egypt Exploration Society, 124–33.
1989 Communication and display: the integration of early Egyptian art and writing. *Antiquity* 63: 471–82.
1990 Trône et dieu: aspects du symbolisme royal et divin des temps archaïques. *Bulletin de la Société Française d'Egyptologie* 118: 5–37.
1991a Egyptian myth and discourse: myth, gods, and the early written and iconographic record. *Journal of Near Eastern Studies* 50: 81–105.
1991b On the symbolic context of the principal hieroglyph for 'God'. In *Religion und Philosophie im alten Ägypten: Festgabe für Philippe Derchain zu seinem 65. Geburtstag* (U. Verhoeven and E. Graefe, eds.), Orientalia Lovaniensia Analecta 39. Leuven: Peeters, 29–46.
1993 Symbolic aspects of canine figures on early monuments. *Archéo-Nil* 3: 57–74.
1995 Origins of Egyptian kingship. In *Ancient Egyptian Kingship* (D. O'Connor and D. P. Silverman, eds.), Probleme der Ägyptologie 9. Leiden: E. J. Brill, 95–156.
1999 Scrittura e società nel più antico Egitto. In *Sesh: lingue e scritture nell' antico Egitto—Inediti dal Museo Archeologico di Milano* (F. Tiradritti, ed.), Exhibition catalogue. Milan: Electa, 21–30.
Forthcoming The earliest Egyptian writing: development, context, purpose. In *The First Writing* (S. Houston, ed.), Cambridge: Cambridge University Press.

Baines, J. and Wengrow, D.
Forthcoming Images and the construction of memory in late predynastic Egypt: a framework for the interpretation of Decorated Ware (D-Ware). In *Memorial Volume for Barbara Adams*, (S. Hendrickx et al., eds.).

Baines, J. and Yoffee, N.
1998 Order, legitimacy, and wealth in ancient Egypt and Mesopotamia. In *Archaic States* (G. Feinman and J. Marcus, eds.). Santa Fe: School of American Research Press, 199–260, bibliography 353–419.

Bietak, M.
1986 La naissance de la notion de ville dans l'Egypte ancienne, un acte politique? *Cahiers de Recherche de l'Institut de Papyrologie et Egyptologie de Lille* 8: 29–35.

Borchardt, L. et al.
1913 *Das Grabdenkmal des Königs Saḥзu-Reʿ* II, *Die Wandbilder*. Ausgrabungen der Deutschen Orient-Gesellschaft in Abusir 1902–1908, 7. Leipzig: J. C. Hinrichs.

Cialowicz, K. M.
1987 *Les têtes de massues des périodes prédynastique et archaïque dans la Vallée du Nil*. Zesyty Naukowe Uniwersytetu Jagiellonskiego 829, Prace Archeologiczne 41. Cracow: Jagellonian University.

1997 Remarques sur la Tête de Massue du Roi Scorpion. *Studies in Ancient Art and Civilization* 8: 11–27.

2001a Ceremonial mace heads. In *The Oxford Encyclopedia of Ancient Egypt* (D. B. Redford, ed.). New York: Oxford University Press, I, 256–58.

2001b Palettes. In *The Oxford Encyclopedia of Ancient Egypt* (D. B. Redford, ed.). New York: Oxford University Press, III, 17–20.

Davies, V. and Friedman, R. F.

1998 *Egypt*. London: British Museum Press.

Davis, W.

1992 *Masking the Blow: The Scene of Representation in Late Prehistoric Egyptian Art*. Berkeley: University of California Press.

Donadoni Roveri, A. M. and Tiradritti, F.

1998 *Kemet: alle sorgenti del tempo*. Exhibition catalogue. Milan: Electa.

Dreyer, G.

1986 *Elephantine VIII: Der Tempel der Satet, die Funde der Frühzeit und des Alten Reiches*. Deutsches Archäologisches Institut, Abteilung Kairo, Archäologische Veröffentlichungen 39. Mainz: Philipp von Zabern.

1998 Motive und Datierung der dekorierten prädynastischen Messergriffe. In *L'art de l'Ancien Empire égyptien* (C. Ziegler, ed.). *Actes du colloque organisé au musée du Louvre par le Service culturel les 3 et 4 avril 1998*. Paris: La documentation Française, 195–226.

Dreyer, G., Hartung, U. and Pumpenmeier, F.

1998 *Umm el-Qaab I: Das prädynastische Königsgrab U-j und seine frühen Schriftzeugnisse*. Deutsches Archäologisches Institut, Abteilung Kairo, Archäologische Veröffentlichungen 86. Mainz: Philipp von Zabern.

Emery, W. B.

1938 *The Tomb of Hemaka*. Service des Antiquités de l'Egypte, Excavations at Saqqara. Cairo: Government Press, Bulâq.

1939 *Hor-Aha*. Service des Antiquités de l'Egypte, Excavations at Saqqara. Cairo: Government Press, Bulâq.

1949–58 *Great Tombs of the First Dynasty*. Vol. 1: Service des Antiquités de l'Egypte, Excavations at Saqqara 1. Cairo: Government Press. 3 vols. vols. 2–3: London: Egypt Exploration Society.

Epigraphic Survey

1986 *The Battle Reliefs of King Sety I*. Reliefs and Inscriptions at Karnak 4. Oriental Institute Publications 107. Chicago: The Oriental Institute of the University of Chicago.

Faltings, D.

1998 Ergebnisse der neuen Ausgrabungen in Buto: Chronologie und Fernbeziehungen der Buto-Maadi-Kultur neu überdacht. In *Stationen: Beiträge zur Kulturgeschichte Ägyptens, Rainer Stadelmann gewidmet* (H. Guksch and D. Polz, eds.). Mainz: Philipp von Zabern, 35–45.

Firth, C. M., Quibell, J. E. and Lauer, J. -P.

1935 *The Step Pyramid*. Service des Antiquités de l'Egypte, Excavations at Saqqara. 2 vols. Cairo: IFAO.

Friedman, R.

1996 The ceremonial centre at Hierakonpolis: locality Hk29a. In *Aspects of Early Egypt* (A. J. Spencer, ed.). London: British Museum Press, 16–35.

2000 Ceramic nails. *Nekhen News* 12: 13.

Gaballa, G. A.

1976 *Narrative in Egyptian Art*. Deutsches Archäologisches Institut, Abteilung Kairo. Mainz: Philipp von Zabern.

Gauthier, P. and Midant-Reynes, B.

1995 La Tête de Massue du Roi Scorpion. *Archéo-Nil* 5: 87–127.

Gimbel, D. N.

2002 The Evolution of Visual Representation: The Elite Art of Early Dynas-

tic Laga√ and Its Antecedents in Late Uruk Period Sumer and Predynastic Egypt. Ph.D. diss. (University of Oxford).

Groenewegen-Frankfort, H. A.
1951 *Arrest and Movement: An Essay on Space and Time in the Representational Art of the Ancient near East.* London: Faber and Faber (several reprints).

Habachi, L.
1963 King Nebhepetre Mentuhotp: his monuments, place in history, deification and unusual representation in the form of gods. *Mitteilungen des Deutschen Archäologischen Instituts, Abteilung Kairo* 19: 16–52.

Hartung, U.
2001 *Umm el-Qaab II: Importkeramik aus dem Friedhof U in Abydos (Umm el-Qaab) und die Beziehungen Ägyptens zu Vorderasien im 4. Jahrtausend v. Chr.* Deutsches Archäologisches Institut, Abteilung Kairo, Archäologische Veröffentlichungen 92. Mainz: Philipp von Zabern.

Harvey, S.
1994 Monuments of Ahmose at Abydos. *Egyptian Archaeology* 4: 3–5.

Helck, W.
1957 *Urkunden der 18. Dynastie* Heft 20. Urkunden des Ägyptischen Altertums 4. Berlin: Akademie-Verlag.
1961 *Urkunden der 18. Dynastie: Übersetzung zu den Heften 17–22.* Urkunden des Ägyptischen Altertums: Deutsch. Berlin: Akademie-Verlag.

Hendrickx, S.
1996 The relative chronology of the Naqada culture: problems and possibilities. In *Aspects of Early Egypt* (J. Spencer, ed.). London: British Museum Press, 36–69, bibliography, 159–74.

Jacquet-Gordon, H.
1962 *Les noms des domaines funéraires sous l'Ancien Empire égyptien.* Bibliothèque d'Etude 34. Cairo: IFAO.

Jaro√-Deckert, B.
1984 *Das Grab des Jnj-Jtj.f: Die Wandmalereien der XI. Dynastie.* Deutsches Archäologisches Institut, Abteilung Kairo, Archäologische Veröffentlichungen 12. Mainz: Philipp von Zabern.

Jeffreys, D. G. and Tavares, A.
1994 The historic landscape of early dynastic Memphis. *Mitteilungen des Deutschen Archäologischen Instituts Abteilung Kairo* 50: 143–73.

Kaiser, W.
1990 Zur Entstehung des gesamtägyptischen Staates. *Mitteilungen des Deutschen Archäologischen Instituts, Abteilung Kairo* 46: 287–99.

Kaiser, W., Dreyer, G., Jaritz, H., Krekeler, A., Lindemann, J., Pilgrim, C. von, Seidlmayer, S. and Ziermann, M.
1988 Stadt und Tempel von Elephantine: 15./16. Grabungsbericht. *Mitteilungen des Deutschen Archäologischen Instituts, Abteilung Kairo* 44: 135–82.

Keita, S. O. Y.
1997 Aspects of the Human Biology of Sociohistorical Change in Ancient Upper Egypt. Ph.D. diss. (University of Oxford).

Kemp, B. J.
1977 The early development of towns in Egypt. *Antiquity* 51: 185–200.

Kemp, B. J., Boyce, A. and Harrell, J.
2000 The colossi from the early shrine at Coptos in Egypt. *Cambridge Archaeological Journal* 10: 211–42.

Köhler, E. C.
2000 Excavations in the early dynastic cemetery at Helwan: a preliminary report of the 1998/99 and 1999/2000 seasons. *Bulletin of the Australian Centre for Egyptology* 11: 83–92.

Kroeper, K. and Krzyżaniak, L.
1992 Two ivory boxes from early dynastic graves in Minshat Abu Omar. In *The Followers of Horus: Studies Dedicated to Michael Allen Hoffman* (R. Friedman and B. Adams, eds.). Oxford: Oxbow Books, 207–14.

Kroeper, K. and Wildung, D.
1994–2000 *Minshat Abu Omar: Ein vor- und frühgeschichtlicher Friedhof im Nildelta*. 2 vols. Mainz: Philipp von Zabern.

Leahy, A. (ed.)
1990 *Libya and Egypt: c. 1300–750 BC*. London: SOAS Centre of Near and Middle Eastern Studies and Society for Libyan Studies.

Levy, T. E., Brink, E. C. M. van den, Goren, Y. and Alon, D.
1995 New light on King Narmer and the protodynastic Egyptian presence in Canaan. *Biblical Archaeologist* 58/1: 26–35.

Lichtheim, M.
1973. *Ancient Egyptian Literature: A Book of Readings* I, *the Old and Middle Kingdoms*. Berkeley: University of California Press.
1976 *Ancient Egyptian Literature: A Book of Readings* II, *the New Kingdom*. Berkeley: University of California Press.
1988 *Ancient Egyptian Autobiographies Chiefly of the Middle Kingdom: A Study and an Anthology*. Orbis Biblicus et Orientalis 84. Fribourg: Universitätsverlag; Göttingen: Vandenhocck & Ruprecht.

Loprieno, A.
2001 *La pensée et l'écriture: pour une analyse sémiotique de la culture égyptienne; quatre séminaires à l'Ecole Pratique des Hautes Etudes, Section des Sciences Religieuses, 15–27 mai 2000*. Paris: Cybèle.

Majer, J.
1992 The eastern desert and Egyptian pre-history. In *The Followers of Horus, Studies Dedicated to Michael Allen Hoffman* (R. Friedman and B. Adams, eds.). Oxford: Oxbow Books, 227–34.

Midant-Reynes, B.
1987 Contribution à l'étude de la société prédynastique: le cas du couteau 'Ripple-Flake'. *Studien zur Altägyptischen Kultur* 14: 185–224.
2000 *The Prehistory of Egypt, from the First Egyptians to the First Pharaohs*. Trans. I. Shaw. Oxford and Malden MA: Blackwell.

Moreno García, J. C.
1999 *Ḥwt et le milieu rural égyptien du IIIe millénaire: Economie, administration et organisation territoriale*. Bibliothèque de l'Ecole des Hautes Etudes, Sciences Historiques et Philologiques 337. Paris: Champion.

Münch, H.-H.
1997 Gräber—Spiegel des Lebens? Untersuchung zur Verteilung des funerären Aufwands anhand geschlossener Funde des Alten Reiches aus der Nekropole von Giza, MA diss. (University of Göttingen).
2000 Categorizing archaeological finds: the funerary material of Queen Hetepheres I at Giza. *Antiquity* 74: 898–908.

O'Connor, D.
1992 The status of early Egyptian temples: an alternative theory. In *The Followers of Horus: Studies Dedicated to Michael Allen Hoffman 1944–1990* (R. Friedman and B. Adams, eds.). Egyptian Studies Association Publication 2, Oxbow Monograph 20. Oxford: Oxbow Books, 83–98.
1993 *Ancient Nubia: Egypt's Rival in Africa*. Philadelphia: University Museum, University of Pennsylvania.

2000 Society and individual in early Egypt. In *Order, Legitimacy, and Wealth in Ancient States* (J. E. Richards and M. Van Buren, eds.). New Directions in Archaeology. Cambridge: Cambridge University Press, 21–35.

2002 Context, function and program: understanding ceremonial slate palettes. *Journal of the American Research Center in Egypt* 39.

Payne, J. C.
1993 *Catalogue of the Predynastic Egyptian Collection in the Ashmolean Museum.* Oxford: Clarendon Press.

Peters, E.
1990 *The Bedouin of Cyrenaica: Studies in Personal and Corporate Power.* (J. Goody and E. Marx, eds.). Cambridge Studies in Social and Cultural Anthropology 72. Cambridge: Cambridge University Press.

Petrie, W. M. F.
1901 *The Royal Tombs of the Earliest Dynasties, 1901* II. Egypt Exploration Fund, Memoir 21. London: Egypt Exploration Society.

Quibell, J. E.
1900 *Hierakonpolis* I. Egyptian Research Account, Memoir 4. London: Bernard Quaritch.

Quibell, J. E. and Green, F. W.
1902 *Hierakonpolis* II. Egyptian Research Account, Memoir 5. London: Bernard Quaritch.

Rochholz, M.
2002 *Schöpfung, Feindvernichtung, Regeneration: Untersuchung zum Symbolgehalt der machtgeladenen Zahl 7 im alten Ägypten.* Ägypten und Altes Testament 56. Wiesbaden: Harrassowitz.

Russmann, E. R.
2001 *Eternal Egypt: Masterworks of Ancient Art from the British Museum.* Exhibition catalogue. Berkeley and London: University of California Press; British Museum Press.

Saad, Z. Y. and Autry, J. F.
1969 *The Excavations at Helwan: Art and Civilization in the First and Second Egyptian Dynasties.* Norman: University of Oklahoma Press.

Schott, S.
1950 *Hieroglyphen: Untersuchungen zum Ursprung der Schrift.* Akademie der Wissenschaften und der Literatur (Mainz), Abhandlungen, geistes- und sozialwissenschaftliche Klasse 1950, 24. Wiesbaden: Franz Steiner.

Seidlmayer, S. J.
1996 Town and state in the early Old Kingdom: a view from Elephantine. In *Aspects of Early Egypt* (J. Spencer, ed.). London: British Museum Press, 108–27.

Sievertsen, U.
1992 Das Messer vom Gebel el-Arak. *Baghdader Mitteilungen* 23: 1–75.

Simons, J. J.
1937 *Handbook for the Study of Egyptian Topographical Lists Relating to Western Asia.* Leiden: E. J. Brill.

Smith, H. S.
1976 *The Fortress of Buhen: The Inscriptions.* Excavations at Buhen 2. London: Egypt Exploration Society.

Trigger, B. G.
1965 *History and Settlement in Lower Nubia.* Yale University Publications in Anthropology 69. New Haven: Department of Anthropology, Yale University.

Way, T. von der
1993 *Untersuchungen zur Spätvor- und Frühgeschichte Unterägyptens.* Studien zur Archäologie und Geschichte Altägyptens 8. Heidelberg: Heidelberger Orientverlag.

Wengrow, D.
2001 The evolution of simplicity: aesthetic labour and social change in the Neolithic Near East. *World Archaeology* 33: 168–88.

Whitehouse, H.
1992 The Hierakonpolis Ivories in Oxford: a progress report. In *The Followers of Horus: Studies Dedicated to Michael Allen Hoffman 1944–1990* (R. Friedman and B. Adams, eds.). Egyptian Studies Association Publication 2, Oxbow Monograph 20. Oxford: Oxbow Books, 77–82.

2002 A decorated knife handle from the 'main deposit' at Hierakonpolis. *Mitteilungen des Deutschen Archäologischen Instituts, Abteilung Kairo* 58: 425–46.

Wilde, H. and Behnert, K.
2002 Salzherstellung im vor- und frühdynastischen Ägypten? Überlegungen zur Funktion der sogenannten Grubenkopfnägel in Buto. *Mitteilungen des Deutschen Archäologischen Instituts, Abteilung Kairo* 58: 447–60.

Wilkinson, T. A. H.
1999 *Early Dynastic Egypt.* London: Routledge.

Williams, B. B.
1986 *Excavations between Abu Simbel and the Sudan Frontier I, the A-Group Royal Cemetery at Qustul: Cemetery L.* Oriental Institute Nubian Expedition 3. Chicago: Oriental Institute of the University of Chicago.

1994 Security and the problem of the city in the Naqada period. In *For His Ka: Studies Offered in Memory of Klaus Baer* (D. P. Silverman, ed.). Studies in Ancient Oriental Civilization 55. Chicago: Oriental Institute of the University of Chicago, 271–83.

Williams, B. B. and Logan, T. J.
1987 The Metropolitan Museum knife handle and aspects of pharaonic imagery before Narmer. *Journal of Near Eastern Studies* 46: 245–85.

Winkler, H. A.
1938 *Rock-Drawings of Southern Upper Egypt I: Sir Robert Mond Desert Expedition, Preliminary Report.* Archaeological Survey of Egypt. London: Egypt Exploration Society; Humphrey Milford, Oxford University Press.

Wreszinski, W.
1935 *Atlas zur altägyptischen Kulturgeschichte* II. Leipzig: J. C. Hinrichs.

Yoffee, N.
2001 The evolution of simplicity: review of *Seeing Like a State,* by J. C. Scott. *Current Anthropology* 42: 767–9.

Ziermann, M.
1993 *Befestigungsanlagen und Stadtentwicklung in der Frühzeit und im frühen Alten Reich: Elephantine 16.* Deutsches Archäologisches Institut, Abteilung Kairo, Archäologische Veröffentlichungen 87. Mainz: Philipp von Zabern.

To write or not to write

C. C. Lamberg-Karlovsky

> Look, no trade is free from a director
> Except the scribe's; the director is him.
> But if you know writings, it shall be well with you.
>
> I shall make you love writing more than your Mother;
> I shall present its beauties to you
> Now, it is greater than any trade.
> There is not its like in any land.
>
> (Teaching of Duaf's son Khety
> Egypt, Middle Kingdom, c. 1400 BC)

The development of writing is frequently seen as the prototypical invention, both necessary and sufficient, for the evolution of administrative bureaucracies. It is even regarded as the quintessential signature in the definition of civilization (Childe 1936; Kluckhohn 1960). Writing, whether in ancient Egypt, Mesopotamia, China, or the New World, is frequently portrayed as allowing for the collective management and distribution of staple products, controlling the organization of labour and crafts, glorifying the deeds and genealogy of the rulers, and eventually permitting for the codification of laws, taxes, interest rates, etc. Within an evolutionary perspective writing is seen as an event-like invention; a powerful tool controlled by the elite in processes leading to the centralization of power. The emergence of a bureaucracy implies an organizational hierarchy with individual(s) in control of the administration (in this regard the term 'administrative bureaucracy' is redundant). It is self-evident that bureaucratic control does not necessarily serve the interests of the community, it is as likely to serve specific segments of society in their quests for economic privileges. The power of the written word is well captured by Saussure (1916: 45):

> The written word is so intimately intermingled with the spoken word of which it is an image that it finishes by usurping the principal role. One comes to give as much importance to the representation of the vocal sign as to the sign itself.

59

In Plato's *Phaedrus* King Thamus is approached by Thoth,[1] the Egyptian god credited with the invention of writing. The King states:

> If men learn this, it will plant forgetfulness in their souls;
> they will cease to exercise memory because they rely on that
> which is written, calling things from remembrance no longer
> within themselves, but by means of external marks.

Socrates was to agree with this judgement. Writing, he believed, does not bring wisdom but only the conceit of wisdom. But what was writing before it was correlated with wisdom and/or administrative bureaucracies? The answer to this question involves a short detour into the archaeological evidence for administrative bureaucracies and the evolution of writing.

ADMINISTRATIVE BUREAUCRACY

Written testaments replaced oral testimony and people doubtless began to think of rules and facts, so admired by administrators, not as recorded by texts but as embodied in the texts. Within the context of a bureaucracy writing was both a by-product and an agent of stratification. Typically, archaeologists working in the greater Near East relate writing, cylinder seals, sealing impressions and the standardization of weights and measurements as tools of an administrative bureaucracy. If one adds to the above a hierarchy of settlement regime, one is confronted by the archaeological evidence for the origins of the state (Wright and Johnson 1975).

All of the above are believed to come into being in Mesopotamia in the Uruk Period, the mid fourth millennium, with the emergence of the world's first state. Recent research has challenged this perspective while emphasizing two points:

(1) A notational system of communication precedes the Uruk Period by millennia. Denise Schmandt-Besserat (1992), following the proposal of Pierre Amiet (1966: 70), suggests that simple geometric tokens already offered a system of numeracy in the eighth millennium. Later, complex tokens, incised and of specific shape, provided information pertaining to a specific object. From complex tokens, numbers and objects in the shape of clay tokens, encapsulated within a large clay ball (*bulla*), it was a relatively small

1 The god Thoth, credited with the invention of writing and adept at astronomy and mathematics, had the longest reign of any Egyptian god—7726 years. This was 10 times longer than any other divinity, a tangible credit of his accomplishments.

step to flatten the bulla to form a tablet incised with two-dimensional forms of their earlier three-dimensional prototypes. It is reasonable to suppose that the evolution of a communication system is directly related to the scale of production, consumption and the redistribution of goods within and between distinctive communities. Notational systems of communication, rather than being an invention of the Uruk Period, were a technology of social control that had long fulfilled the need for household and community control of production and labour. Nevertheless, the Uruk Period saw a dramatic change in the scale of that control which, in turn, required a change in the scale of communication systems.

(2) Recent excavations at Neolithic Sabi Abyad, in northern Syria, and re-analysis of materials recovered from Tal-i Bakun, Tell es-Sawaan, and Arpachiyah, add a significant chapter to the history of what Joan Oates (1996: 165–73) has called the 'prehistoric communication revolution'. From the first half of the sixth millennium there is already a limited amount of evidence, from a number of widely distributed sites, for techniques of archiving that utilize seals, sealings, tokens and bullae (Oates 1996; Lamberg-Karlovsky 1999). A theoretical model has been articulated by Marcella Frangipane (2000: 226) that describes the processes involved in what she calls 'the change of administration function in stratified societies: from unequal household control of resources to centralization'. Thus, within the archaeological evidence from the seventh to the fifth millennia:

> It is possible to infer that administrative control [the presence of seals, sealings, and tokens in the seventh/sixth millennia] over the movement of goods in a family economy reflects nascent forms of dependent labor, in which goods were distributed to people outside the household, probably to people working for the family itself. It is no coincidence that in the northern areas at the end of the Ubaid period one finds the first mass-produced bowls [standardized units?] which were subsequently related to the distribution of meals or food rations. . . . [B]y regulating relationships between households, which were probably one-sided, the administrative activities of the northern Ubaid societies [c. 5000 BC] eventually favored the consolidation of vested interests that certain sections of society had by then acquired.
>
> (Frangipane 2000: 227)

The author attempts to posit an evolution from an hypothetical 'egalitarian-collective system' in which there was a 'balance of relationships of equality', to an emerging 'hierarchical system' of 'stratified organizational forms'. Thus, on numerous sixth/fifth millennia Ubaid settlements there is ample evidence

for administrative devices, site hierarchies and architectural features sugges-
tive of the bureaucratic centralization of resources and labor (Jasim 1985).

Differences between the organization of communities, from the Samarran
to the Uruk, become distinctions of scale, not of stage or type. There is a
gradual trajectory toward the centralization of administrative bureaucracies.
Differences in scale, however, do matter and one cannot deny that the Uruk
Period saw a quickening in these scalar differences. Why?

The adoption of writing must be seen in the context of a *chaîne opératoire*.
The scribe was a full-time specialist, much like other full-time specialists
who emerged in the Uruk Period, that is metalsmiths and textile weavers.
The training of these, particularly the scribe, involved specialized institu-
tional training. Scribal schools, staffed by teachers, represented a consider-
able expenditure in time and resources. The net result was a bureaucrat
trained in numeracy (accounting) and literacy. Initially, writing was restricted
to the central agency: first the temple, then the palace and, finally, the pri-
vate manorial household. It was the *specific* role of these institutions (cf. Liverani
1998) in managing: (1) a seasonal forced labour, (2) a monoculture of large-
scale barley production and, (3) an industrial-scale production of textiles
(used for export in long-distance trade), which necessitated the invention of
writing. Within the Uruk Period, the temple economy was almost entirely
dependent upon barley production (which consisted of 90% of the culti-
vated surface in southern Mesopotamia). Saline soils, the late spring flooding
of the rivers and the threat of locusts at harvest time all favoured the planting
of barley, the cereal most resistant to the above threats. The central agency,
the temple, if it was to become successful, was confronted by the necessity of
managing the above three factors. A point was reached in which the scale of
monitoring labour, production and land use required the invention of both
a new technology and a new social institution. It was the coevolution of the
temple and writing that allowed for the revolution of the Uruk Period. The
coevolution of this new technology, writing, invented within the context of
temples that legitimized the new social order, was both advantaged and formed
by an environment both necessary and sufficient for the emergence of Uruk
complexity; agriculture was entirely dependent upon irrigation and domi-
nated by a monoculture of barley production.

It is not my purpose here to review the vast literature pertaining to the
origin and nature of writing. From the cognitive sciences to Palaeolithic
archaeologists attempting to understand the meaning of rock art, there is a
library of books struggling to comprehend the phenomenon of writing. My
concern here is neither with the origin nor the function of early writing. It is

directed more toward why the vast majority of cultures, right up until modern times, even those in contact with the literate, chose *not* to write! For decades I have puzzled over a very specific archaeological context, one that is replicated in numerous geographical regions. The phenomenon I refer to is the well-recognized expansionist tendencies of literate civilizations colonizing a considerable number of foreign and illiterate cultures (Algaze 1993; Stein 1999). Furthermore, why did the indigenous communities that experienced the Uruk (i.e. Godin, Brak, Arslantepe), Proto-Elamite (i.e. Malyan, Yahya, Sialk), and Egyptian (i.e. Nahal Tillah, 'En Besor) expansions cease to write after the Mesopotamian (Algaze 1993; Stein 1999), Proto-Elamite (Lamberg-Karlovsky 1979; Alden 1982) and Egyptian (Kansa 2001; Levy et al. 1995) 'colonies' had (a) been assimilated, (b) gone back home, (c) been conquered or (d) succumbed to another unknown agent?

The situation at Tepe Yahya, in southeastern Iran, is best known to me and is typical of the structure of each of the above expansions: within a region of indigenous culture a foreign complexity, whether Uruk, Proto-Elamite, or Egyptian, is introduced that includes written tablets. It is to be noted that at Tepe Yahya, as on numerous other sites experiencing what some call 'colonization' (Algaze 1993), tokens, square seals and sealings, suggestive of nascent systems of communication and control, already existed within the indigenous community. We shall have more to say regarding Tepe Yahya and the Proto-Elamites below. With the exception of a single region, Khuzistan in southwestern Iran, every settlement 'colonized' by the literate refused to adopt the written tablet as a communication device. Most scholars accept the notion that the Proto-Elamite script evolved in Khuzistan (Susa/Tal-i Ghazir/Choga Mish) under the influence of the earlier Mesopotamian system of writing best documented at Uruk (Nissen, Damerow and Englund 1993; Damerow and Englund 1989). All indigenous communities exposed to literacy, whether the Proto-Elamite culture on the Iranian Plateau, the Uruk in northern Mesopotamia and Anatolia, or the Egyptian in the Levant, refused to assimilate and/or adopt the written sign as a communication device. It is perhaps difficult for us to accept that writing, a technology which we highly prize, would be self-consciously avoided. Perhaps this is why shelves of books discuss the origin, function, and nature of writing while the apparent avoidance of becoming literate is all but ignored. Why?

My answer is both relatively simple and, unfortunately like much in historical narrative, untestable. It distinguishes between voice and writing, between authority and memory, between sound and symbol, and lastly between chief and king. In virtually all regions involving the invention of writing, there

was a shared belief in its existential power; the belief that writing was sacred, of divine origin and fundamental to the maintenance of power, order and justice (Gelb 1952; Baines 1989; Senner 1989). Sumerians and Egyptians credited creative powers to the divine word. Thus, in Mesopotamia a god's word created the object: 'Your [Enlil's] word—it is plants, your word—it is grain, your word—it is floodwaters, the life of the lands'. In like manner the Egyptian god Thoth, during creation, uttered words and magically transformed them into objects. As the creator of writing and speech, Thoth makes no distinction between speech and writing. He assigns to himself the role of administrative keeper of order who functions as the scribe of truth and justice at the time of one's death. There is a relationship here between Thoth, Adam in Genesis 2.19 and the earliest Sumerian lexical texts. To name is to structure an order; to write is to manifest control over that order.

The idea that one captures an understanding of something by naming it is as old as, and not divorced from, the origin of writing. In Sumer among the earliest tablets are lexical texts (Englund 1998). These texts offer lists of different types of trees, stones, animals, birds, fish, wooden, metal and stone objects, topographic features and close to 100 titles and names of professions. These texts were faithfully copied for over 600 years, essentially without change (save for the style of writing). The lists were constructed in the belief that to classify an object was to give the object not only definition but to understand it and hold it under one's control. In much the same manner as the gods created objects by naming them so humans came to classify existence into a pattern, controlling its circumscribed world by reducing the object to the word. A distant hallmark of these lexical texts is found in Genesis 2:19 where Adam gives names to all the creatures.

Writing, wherever it first appears, is seen as functioning as an administrative tool of the elite and is invariably implicated in state origins. Thus, one may distinguish between the authoritative voice of the chieftain and the authoritative text of the king. The voice of a chieftain is more than sound; it is authority. Yet, the authority of a chief is entirely divorced from authorship. Writing, on the other hand, is more than statement; it is memory. Writing offers a permanence of memory that reinforces the power of authority and authorship. The transition from language as sound to writing as symbol is the same as the transition from voice to text and from chief to king. There is a relationship between authorship and authority. Writing is the isolating symbol of power. It isolates the literate and the powerful from those who are illiterate. In virtually every case in which writing is invented, it is not the author but the institutional context of authorship that wields the power.

Initially, wherever one finds writing, the author is anonymous—a tool of administrative power directed by a central authority. In Egypt and Mesopotamia the first texts are statements without a time referent. Texts directed the activities of the present; they rarely referred to the past or the future.

In Mesopotamia and Egypt authorship and authority are one and the same and are found in the context of the temple. What Douglas North and R. P. Thomas (1973: 2) write concerning the rise of the West can also be said for the initial rise of cultural complexity in the ancient Near East: 'Efficient economic organization is the key to growth; the development of an efficient economic organization in Western Europe accounts for the rise of the West'. In Egypt and Mesopotamia it was the temple that was the effective economic organization, developed to serve the revenue-raising needs of the first states. It cannot be accidental that one of the principal tools within the temples, the locus of its invention, is writing. Within Mesopotamia and Egypt the coevolution of the temple, urbanization, and state origins are best seen as resulting, in part, from the invention of this new social technology. Writing was a tool that allowed for coercive control. Writing formed a technology that permitted the politico-religious elites to monitor and control labour as well as the production, consumption and redistribution of food and commodities; that is, textiles, metal, stone etc. Writing both kept track of types of labour and was the genesis of new forms of labour. Record keeping, devoted to labour and food procurement, as well as centrally managed and redistributed ration systems, led to more aggressively directed forms of social integration. As Goody (1986) states, 'writing made change a question of deliberate reform rather than of continuous adaptation'. Thus, writing becomes an autocatalytic system, one responsible for the creation of new forms of social stratification and social control.

In Mesopotamia, when writing departed from the context of the temple, authorship and authority were separated. In tracing the increasing number of institutional contexts in which texts are found—temples, palaces, with entrepreneurs, landlords, court and private households—one traces not the crystallization of state power but the emergence of new forms of private innovation and social interaction beyond the imposition of state-level institutions. Initially, the elite benefit the most from the existence of writing. Kings and pharaohs were largely illiterate but their scribes used texts, on their behalf, as tools for centralizing the control of labour, production and property.

There is a difference, however, between being literate and being literary. At first the literate scribes used writing as a tool, a tool implicated in a social

technology of controlling community labour and production. It took the passing of almost a millennium for the literate (bureaucratic administrators) to become literary (poets, mythologists, diviners, writers of hymns, etc.). This does not mean, however, that the literary texts of the second half of the third millennium in Egypt and Mesopotamia were removed from an institutional context. The literary texts were largely ritual in nature and perhaps best seen as canonical texts of legitimation. Epic poetry, dynastic king lists, divination texts and the recording of events were undertaken to legitimize the authority of king and institution. In Mesopotamia it took well over a millennium for the technology of writing to achieve the status of mirroring speech and over two millennia to simplify its nature through the invention of the alphabet (Gelb 1952).

We laud the ancients for their many accomplishments but hold in special regard their invention of writing. Today writing is seen as a fundamental component of civilization. Without literacy there is neither a future for an individual nor existence for an institution. The invention of writing is seen as one of the most positive and transforming inventions of all time. If so, then why in antiquity and in much of the recent past, did the majority of peoples and cultures, knowing of its existence, resist its adoption? The invention of writing appears to negate Pascal's belief that 'Things are always at their best in their beginning'. We have seen that the invention of writing took place within an institutional context, the temple, involved with the coercive control of monitoring labour and production. We leave aside a consideration as to whether this coercive control was for the greater good of the society or for the greater good of the elite. Evidence, if such were available and it decidedly is not, would probably allow for both interpretations to be true!

We may first ask what impression did the literate make upon the illiterate? Neither Mesopotamian, Egyptian nor Proto-Elamite scribes, in the course of their initial expansions, have a word to say about this. This is as true at 3400 BC as it is at 1000 BC. Turning to more recent times the evidence is ambiguous. Todorov (1999: 14–50) argues that Europeans in the Age of Exploration were able to represent themselves because they possessed writing. Native Americans, on the other hand, were unable to and thus were subject to manipulation. Stephen Greenblatt (1991: 11–12) counters with

> no convincing evidence that writing functioned in the early encounter of European and New World peoples as a superior tool for the accurate perception or effective manipulation of the other. . . . The ability to communicate effectively is a quite different matter from the ability through writing or any other means to perceive and represent reality.

Writing cannot be adopted outside of the context in which it exists. Put another way: one must adopt the social context in which writing exists in order to adopt writing. Writing came to being within the institutional context of temple estates. The whole (temple estates) and its parts (scribes, priests, monumental architecture, rationed labourers, etc.) determine each other. It is in this codetermination that complexity is embedded, a codetermination that is cognate to circular causality. The views of Nelson Goodman (1968) are of relevance. Writing, he believes, organizes cognition within a given context that has prior meaning or knowledge. Thus, for something to be inscribable in a certain way means that life has to be lived in a certain way. Similarly, inscriptive solutions, that is to say advances in the technology of writing, take place in accordance with the problems they address. An understanding of the above offers some clues as to why writing was self-consciously avoided by those in contact with the literate. They simply did not want to adopt the 'otherness' in which writing existed.

To suggest that individuals, and entire cultures, may self-consciously choose not to adopt writing is an unavoidable conclusion derived from the evidence of antiquity. This view stands in stark contrast to our modern perception in which writing is so highly esteemed that the idea of intentional avoidance is not only counterintuitive but beyond belief. Archaeology offers abundant evidence that literate societies were in constant contact with illiterate societies. The adoption of writing was far from the immediate consequence of culture contact. The expansionist tendencies of the Uruk, Proto-Elamite, Egyptian and later Akkadian dynasty brought these literate societies into contact with distinctive cultures that lacked the technology of communication by writing. In only one instance, the Proto-Elamite, can one point to an illiterate culture adopting the technology of writing. Philologists and archaeologists agree that following the Uruk Expansion into Susiana (Khuzistan), the local indigenous culture adopted the Uruk technology of writing, including the methods of numeracy and numerous Uruk logographs, while inventing new signs to suit Proto-Elamite needs (Damerow and Englund 1989). Throughout the Bronze and Iron Ages culture contact between literate and illiterate neighbours was an omnipresent reality, yet most frequently the illiterate neighbours obstinately avoided the adoption of writing. It is also clear that in the sole instance in which an independent system of writing was adopted, the Proto-Elamite, it had a very limited success. After a century or two Proto-Elamite writing was abandoned on the entirety of the Iranian Plateau. It took the passing of several centuries in

Khuzistan, and over a millennium on the Iranian Plateau, before literacy was once again adopted.

More dramatic than the Proto-Elamite case is the instance of the Uruk Expansion to northern Mesopotamia, Anatolia and Iran. Godin Tepe in northern Iran (Weiss and Young 1975), Arslantepe in Anatolia (Frangipane 2001), and Habuba Khabira in northern Syria (Strommenger 1980) offer differing examples of the process of culture contact. At Godin Tepe, an Uruk 'colony' walled off from the rest of the community, but situated within the heart of the settlement, utilized the entire social technology of administrative control: seals, sealings and inscribed tablets. Prior to Godin's contact with the Uruk Culture the community was unfamiliar with any of these artifact types. Following the abandonment of the Uruk 'colony', the indigenous Godin culture did not adopt the use of any of these devices. On the other hand, at Arslantepe the use of local seals and sealings was well known to the indigenous settlement. The excavator makes a point of indicating that prior to contact with the Uruk culture the indigenous society at Arslantepe was one of considerable complexity (Frangipane 2001). Nevertheless, just as at Godin, the indigenous culture at Arslantepe, like all other communities following Uruk contact, fails to adopt writing. Lastly, the case of Habuba Khabira is different from both of the above. This site represents an Uruk town in the middle of a settlement regime of foreign cultures. Excavations uncovered a fortified community replete with an Uruk temple and a complete repertoire of Uruk material culture: ceramics, seals, sealings, bullae and architectural forms. There is no evidence that the local cultures adopted any of these administrative devices and put them to the same use.

Throughout the third millennium there is ample evidence that in different regions, at different times, and within different cultures, literate and illiterate cultures came into protracted contact. In almost every instance we are forced to conclude that the illiterate culture *chose* not to adopt the technology of writing. Why?

Two related reasons, masquerading in a simplicity that camouflages a very considerable complexity, may be suggested. (1) The necessity of a specific context for the adoption of writing has already been alluded to. Meaning is created through context. Wherever writing exists it does so in a very specific cultural context. In Mesopotamia and Egypt writing was associated with specific divinities, associated with temple complexes, and dedicated to an administrative function having to do with the control of labour, production, consumption and redistribution. Thus, the specificity of the context in which writing occurred, from its divine origins to the complex social organization

of the temple community, did not have a comparable cultural environment in the societies that came into contact with it. (2) When things are inscribed in a certain way then life has to be led in a certain way. In an illiterate society the absence of a context for writing makes writing an attribute without meaning. As Roy Harris (2000) has written, 'The sign does not exist outside the context which gave rise to it'.

There are substantial differences in the nature of contractual relations between verbal and written statements. Face-to-face relations among the fewer, less hierarchically structured elites in the illiterate periphery, where kin ties remained stronger in the still tribally based society, sufficed to maintain levels of communication. The adoption of writing in these areas would have upset the balance of power and resulted in the mediation of power through the new symbolic means of writing. Goody (1978) has shown that writing is perceived, even within literate cultures, as imbued with both a pivotal magic and a sacred quality. Goody suggests that the written word causes to be brought about the reality it describes. The written word is seen as a sign containing the power of action; writing can make or prevent things from happening. When something is written down a new reality is created and that reality must be acted upon. In this manner writing maintains an existential power for maintaining political power and order. This simply points out that which we know, regardless of social context: the written word has a powerful authoritative voice. It attains a power of reflexivity in which the sign replaces the picture, the letter becomes disassociated from the word, and the word from the object. The written word establishes a permanence of memory and a predictive future. Writing 'creates' a past in order to provide a context to the accomplishments of the present. Written archives, whether king lists, tax receipts, or judicial decisions, allow one to re-examine past actions and allow for authoritative decisions—new legitimations based on invented traditions of remote antiquity. Textual communities, even without intent, result in the historicizing of the community. Texts offer opportunities for interpreting a past, an interpretive past that becomes a historical 'reality' serving the interests of the present. Of equal significance is the role that writing plays in structuring a predictive future. In Mesopotamia many of the earliest texts detail the labour and agricultural needs for the forthcoming year. Bureaucrats calculated the amount of land to be cultivated in order to predict the harvest necessary to meet future demands. Without exception early texts, whatever their context, served as voices of power and authority imbued with magical, if not sacred, qualities. Texts demanded actions.

Oral tradition may have its power (Vansina 1985) but a comparison of the verbal with the written confronts a scalar difference. Oral tradition lacks the precision in establishing a permanence of memory. It is fashionable today not to differentiate the oral from the written—not to privilege the importance of writing but to simply regard the oral and the written as equal but different systems of communication. Such a view is, I believe, a post-modern fantasy in which cultural differences, oral vs. written traditions, are taken to have the same value and significance in order to structure such differences, and their respective cultures, as equal in complexity. Oral tradition simply would not have informed us of who succeeded Tutankhamun, the rate of interest under Caesar Augustus, or the complete list of attendees at the Treaty of Westphalia. This is not to say that all that is written is believable but it is to say that written texts allow for a reconstruction of greater content and complexity than oral tradition. A century ago Maine (1864) drew a distinction between the oral vs. the written as comparable to the difference between status and contract and between oral agreement and constitution. Such differences are profound.

The absence of a context, whether it be temples, bureaucrats or ruling elites, and the importance of an established oral tradition in which verbal negotiation and amelioration are valued, would weigh heavily against an illiterate culture's ready adoption of writing. The presence of writing, in comparison to its absence, has always been perceived by the literate as a superior achievement. That the Sumerians considered themselves the 'civilizing' agent of the distant periphery is readily evident in a cycle of texts involving a Sumerian king, Enmerkar, and the Lord of Aratta, a far distant land, perhaps somewhere on the Iranian Plateau. The Lord of Aratta sets out four insurmountable challenges that Enmerkar is to overcome. In the battle of wit and cleverness Enmerkar overcomes each challenge. Finally, the messenger of Enmerkar hands the Lord of Aratta an inscribed tablet. Unable to read it the Lord of Aratta stands defeated. The superiority of Enmerkar, and thus of the Sumerians over their distant neighbours, is the message of the poet. The agent of their victory and the tangible evidence of their superiority takes the form of the inscribed tablet.

The invention of a writing technology, wherever it emerged, led to an unprecedented rate of innovation. The coevolution of writing, urbanization, the expansion of the crafts, monumental architecture and an administrative bureaucracy cannot be a coincidence. All of the above features appear in concert and although occurring in different places at different times,

they appear in each instance rather rapidly, whether it be in China, Mesopotamia or Mesoamerica. One can see in this synergistic process the evolution of cultural complexity, a complexity which Adams (2000: 101) correctly perceives as 'essentially technological', a movement toward greater centralization and integration. However, just as there is a reciprocity in the relations between the above features so there also exists a reciprocity between the rulers and the ruled. Too frequently we privilege the politico-religious elites as if their will, and it alone, gave direction to society. The reciprocity and tensions between the wills of the rulers and ruled is well captured by Schortman et al. (1996: 62):

> There is an increasing body of evidence, mostly from sociology, cultural anthropology and history, suggesting that, just as elites have their goals, so do those they seek to dominate. Neither are completely successful in their efforts . . . , and even the humblest social unit has some resources with which it can obstruct the actions of the most powerful.

The invention of writing was a powerful new technology and like many new inventions it had unforeseen consequences. Poetry was one such consequence—not readily predictable from the ledgers of the first bureaucratic accounts. Within the first inscribed tablet was the germ not only of poetry and mythology but the computer, which, in turn, is fostering its own virtual reality.

In discussing the Uruk and Proto-Elamite expansions, we noted that in both instances the literate colonies failed to sustain themselves in foreign lands and that the local populations failed to adopt the technology of writing. Perhaps the reasons why are now more comprehensible. The export of a technology is no guarantee of its success if the social context is not present. A return to the Proto-Elamite settlement at Tepe Yahya offers a case-in-point.

The Proto-Elamite texts from Tepe Yahya are well published by Peter Damerow and Robert Englund (1989). In that volume the authors convincingly demonstrate that the Proto-Elamite texts derive their numerical system and many ideographic forms from the earlier Uruk proto-cuneiform texts. The majority of the texts, 21 of 27, involve the disbursement of grain rations to labourers of varying ranks. A substantially smaller number, four of 27, are concerned with counted objects: sheep/cattle, jugs of beer, bread, and possibly textiles. In their study of the Proto-Elamite texts from Tepe Yahya, the authors come to conclusions of direct relevance to our concern (Damerow and Englund 1989: 62–4):

(1) The similarity of the Proto-Elamite texts from these outlying sites [Yahya, Malyan, Sialk] to those from Susa seems, in fact, less suggestive of political or economic control of these settlements by interests centered in or around Susa—or for that matter any other external center—than of the mundane functioning of more or less independent economic units.

(2) The texts, so far as we have been able to classify them, record however the dispensation of products from agricultural activity, in particular the rationing of quantities of grain to presumable workers under the direction of household administrators, and possibly the disbursement of grain for the purpose of sowing, as we think, unimposing fields. The level of these administrative notations, the size of the recorded numbers of animals and humans and the measures of grain, are without exception entirely within the range of expected *local* activity.

(3) [That] there was no archaeological evidence in Yahya suggesting that this apparent foreign element [Proto-Elamite] had assumed administrative control of the settlement by force might be indicative of a peaceful coexistence between an indigenous population and administrators of foreign origin . . .

(4) The complete absence of references in these texts to the exploited resources of the regions, in particular of metals and stone, suggest that such exploitation, if at all recorded, will have been secondary to primary agricultural activities in the respective settlements . . .

(5) Material remains and to a substantially lesser extent early texts inform us that such societies, which may themselves be termed 'archaic', operated at a stage well removed from that of so-called primitive cultures. The mere fact of a centralized administration, be it local or regional, as well as the quantities of the goods and workers registered in archaic texts document, in our opinion, an at least inchoate form of class division into a functioning administrative elite and laborers, probably within a concomitant shift of ownership of in particular productive land to a small group within the community. *This more advanced organization replaced tribal or simply familial organization in village settings.*

I am in complete agreement with the above save for the very final sentence, which I have italicized. The more 'advanced' organization did not, in fact, replace the indigenous tribal and/or village familial organization. In fact, in this instance the tribal and the familial appear to completely reject that which is deemed more 'advanced'.

The entire social context of the more 'advanced' organization was utterly foreign to local culture and knowledge. It is perhaps not too much to assume

that the Proto-Elamites, in introducing their foreign behaviour, subordinated the local culture to their manner of issuing rations, organizing labour, and distributing property rights. Central to these patterns of behaviour was the technology of writing, a device that allowed for the social control of labour, commodity production, and distribution. Writing offered to those who controlled this technology an opportunity to transform the nature of both labour and property. In doing so writing is directly implicated, as in a causal relationship, to the emergence of a greater complexity in social organization. However, this new technological entity, writing, and its cultural context of social control, did not export very well. Indigenous cultures, whether in Anatolia experiencing the Uruk Expansion or on the Iranian Plateau exposed to the foreign Proto-Elamite element, saw it for what it was: a technological device of social control. The periphery was consistent in its actions: it rejected its adoption. In doing so they rejected the colonialism of their expansionist neighbours and an early form of globalization in which specific forms of technology require common structures of society.

Lastly, it is a special pleasure to prepare this essay in honor of Roger Moorey who has done so much in teaching us about ancient materials and industries. We note that it took over 2000 years, from 3400 BC to 1400 BC for writing to be adopted throughout Greater Mesopotamia and we have offered a reason for its slow spread. Philip Kohl (1989) has written that 'technology transfer' was open and available to all. Perhaps! A Mesopotamian colophon, cited by Saggs (1962: 471) and dated to the Old Babylonian Period, suggests otherwise:

> Let the initiate show the initiate,
> the non-initiate shall not see it.
> It belongs to the tabooed things of
> the Great Gods.

Whether 'technology transfer' within the ancient Near East was open or closed may be a matter of debate. That it was exceptionally slow seems indicated by the evidence. It took metallurgy from 7000 BC to 4000 BC to spread throughout the Near East (Muhly 1988) while horses and wagons were present on the steppes by 4500 BC (Anthony 2000), but did not enter the Near East until almost two millennia later. Other examples, pottery, glass, faience and the use of iron further support the slow diffusion of other significant technologies.[2]

2 My thanks to Mario Liverani, Timothy Potts, Maurizio Tosi and Gary Urton for their helpful comments during the preparation of this paper.

REFERENCES CITED

Adams, R. McC.
2000 Accelerated technological change in archaeology and history. In *Cultural Evolution Contemporary Viewpoints* (G. M. Feinman and L. Manzilla, eds.). New York: Kluwer Academic, 95–117.

Alden, J.
1982 Trade and politics in Proto-Elamite Iran. *Current Anthropology* 23/6: 617–40.

Algaze, G.
1993 *The Uruk World System*. Chicago: The University of Chicago Press.

Amiet, P.
1966 *Elam*. Paris: Archeé Éditeur, CNRS.

Anthony, D.
2000 Eneolithic horse exploitation in the Eurasian steppes: diet, ritual and riding. *Antiquity* 74: 75–86.

Baines, J.
1989 Communication and display: The integration of early Egyptian art and writing. *Antiquity* 63: 471–82.

Childe, V. G.
1936 *Man Makes Himself*. London: Watts and Co.

Damerow, P. and Englund, R. K.
1989 *The Proto-Elamite Texts from Tepe Yahya*. Cambridge: Cambridge University Press.

Englund, R. K.
1998 Texts from the Late Uruk period. In *Späturuk Zeit und Frühdynastische Zeit*, Mesopotamien Annäherungen 1: (J. Bauer, R. K. Englund and M. Krebernik, eds.), Orbis Biblicus et Orientalis 160/1. Fribourg: Universitätsverlag; Göttingen: Vandenhoek & Ruprecht,13–233.

Frangipane, M.
2000 From collective to centralized economies in the Old World. In *Cultural Evolution Contemporary Viewpoints* (G. M. Feinman and L. Manzanilla, eds.). New York: Kluwer Academic, 215–31.
2001 Centralization processes in greater Mesopotamia: Uruk expansion in the climax of systemic interaction among areas of the greater Mesopotamian region. In *Uruk Mesopotamia and its Neighbors* (M. Rothman, ed.). Santa Fe, New Mexico: School of American Research Press, 265–306.

Gelb, I. J.
1952 *A Study of Writing*. Chicago: The University of Chicago Press.

Goodman, N.
1968 *Languages of Art: An Approach to a Theory of Symbols*. Indianapolis: Bobbs-Merrill.

Goody, J.
1978 *Literacy and Traditional Society*. Cambridge: Cambridge University Press.
1986 *The Logic of Writing and the Organization of Society*. Cambridge: Cambridge University Press.

Greenblatt, S.
1991 *Marvelous Possessions: The Wonder of the New World*. Chicago: The University of Chicago Press.

Harris, R.
2000 *Rethinking Writing*. London: Athlone.

Jasim, S. A.
1985 *The Ubaid Period in Iraq*. Oxford: BAR International Series 267.

Kansa, E.
2001 Smitten by Narmer, Ethnicity, Economy and Trade in the Fourth Millennium BCE. Egyptian Presence in Southern Levant, Ph.D. diss. (Harvard University).

Kluckhohn, C.
1960 The moral order in the expanding society. In *City Invincible* (E. Kraeling

and R. M. Adams, eds.). Chicago: The University of Chicago Press, 137–48.

Kohl, P.
1989 The use and abuse of world systems theory: the case of the 'pristine' West Asian state. In *Archaeological Thought in America* (C. C. Lamberg-Karlovsky, ed.). Cambridge: Cambridge University Press, 218–40.

Lamberg-Karlovsky, C. C.
1979 The Proto-Elamites on the Iranian plateau. *Antiquity* 52/205: 114–21.
1999 Households, land tenure, and communication systems in the sixth-fourth millennia of Mesopotamia. In *Urbanization and Land Ownership in the Ancient Near East* (M. Hudson and B. Levine, eds.). Peabody Museum Bulletin 7: 167–203.

Levy, T., Brink, S. C. M. van, Goren, Y. and Allon, D.
1995 New light on King Narmer and the protodynastic presence in Canaan. *Biblical Archaeologist* 58: 26–35.

Liverani, M.
1998 *Uruk: la prima città*. Roma: Laterza.

Maine, H.
1864 *Ancient Law: Its Connections with the Early History of Society*. New York: Scribners.

Muhly, J.
1988 The beginnings of metallurgy in the Old World. In *The Beginnings of Metals and Alloys* (R. Maddin, ed.). Cambridge, Mass.: MIT Press, 9–27.

Nissen, H., Damerow, P. and Englund, R. K.
1993 *Archaic Bookkeeping*. Chicago: The University of Chicago Press.

North, D. and Thomas, R. P.
1973 *The Rise of the Western World*. Cambridge: Cambridge University Press.

Oates, J.
1996 A prehistoric communication revolution. *Cambridge Archaeological Journal* 6: 165–73.

Saggs, H. W. F.
1962 *The Greatness that was Babylon*. London: Sedgwick and Jackson.

Saussure, F. de
1916 *Course in General Linguistics*. New York: McGraw-Hill.

Schmandt-Besserat, D.
1992 *Before Writing*. Austin: University of Texas.

Schortman, E., Urban, P. and Ausec, M.
1996 Comment on R. E. Blanton, et al. *Current Anthropology* 37: 61–3.

Senner, W.
1989 *Origin of Writing*. Lincoln: University of Nebraska.

Stein, G.
1999 *Rethinking World Systems*. Tucson: University of Arizona.

Strommenger, E.
1980 *Habuba Khabira, eine Stadt vor 5000 Jahren*. Mainz: Philipp von Zabern.

Todorov, T.
1999 *The Conquest of America: The Question of the Other*. Norman: University of Oklahoma.

Vansina, J.
1985 *Oral Tradition as History*. Madison: University of Wisconsin Press.

Weiss, H. and Young, T. C.
1975 The merchants of Susa: Godin V and plateau-lowland relations in the late fourth millennium BC. *Iran* 13: 1–17.

Wright, H. and Johnson, G.
1975 Population, exchange and early state formation in southwestern Iran. *American Anthropologist* 77: 267–89.

A soft-stone genre from southeastern Iran: 'zig-zag' bowls from Magan to Margiana

D. T. Potts

INTRODUCTION[1]

It is probably a truism to say that *most* of the finds made on a Bronze Age site in Iran are of local manufacture. This in no way contradicts the image of a region criss-crossed by overland trade routes and trade networks, whether long-distance or local. Nor is such a statement meant in anyway as a criticism of the general trend in scholarship since the late 1960s towards prioritizing trade and exchange in Western Asia. For the imports are indisputably there, be they semi-precious stones, precious metals, base metals, seals or ceramics. But the fact remains, in my opinion, that a quantification of the totality of remains from any site in Iran—if such a thing were possible—would show the imports to represent but a very small percentage of any assemblage studied.

One of the dangers of rushing to study and publish the interesting, exotic imports at a site lies undoubtedly in the very ease with which they are often recognized, for this can unwittingly lead us to ignore other, less sensational categories of material culture which are every bit as interesting if only their true context and interconnections could be recognized. Reluctantly, I must count myself among the offenders who have overlooked just such a body of material at Tepe Yahya. My only consolation is, however, that I have hardly been alone in my ignorance. The material in question consists of two small groups of soft-stone vessel fragments.

1 Roger Moorey's interest in the archaeology of Iran has led him into many byways. From Luristan bronzes and matters Achaemenid, he has ranged widely over subjects as varied as the evolution of metallurgical technology on the Iranian plateau to the historical geography of the western Zagros and the problem of Tukrish. He has always been a keen student of cultural interconnections, at the same time paying strict attention to the cultural context of whatever material he has been addressing. His bibliography bears witness to one of the liveliest minds in Near Eastern archaeology, but it is his uncanny ability to complement the enthusiasm and excitement we all feel when we discover interconnections with a rigorous attention to context and detail that makes Roger's work a cut above the rest. In the following essay, which I dedicate with sincerest affection and admiration for a truly great scholar and a great friend for over 25 years, I hope to take a leaf out of Roger's book and look at another problem of context and interconnection which, had Roger noticed it, would have been solved long before it came to my notice.

At Tepe Yahya, where I had my first experience of field archaeology in Iran, the enormous amount of attention paid to the Intercultural Style or *série ancienne* carved soft-stone vessels with figurative decoration has, undoubtedly, distracted scholars from the rest of the soft-stone corpus discovered there. It was, in fact, not until I had completed my work on the volume devoted to the third millennium remains from Tepe Yahya (D. T. Potts 2001a) that I began to notice the obvious parallels between soft-stone bowls with one, two or three rows of zig-zags below the rim from Tepe Yahya and identical pieces found at sites in Central Asia. As I began to assemble the material, however, it became clear to me that the origins (context) and affinities (interconnections) of what I term the 'zig-zag genres' are not at all what they seemed to be at first sight. The data assembled below lead, I believe, to some unexpected conclusions.

THE ZIG-ZAG GENRES COME TO LIGHT

When Pierre de Miroschedji defined the *série récente* at Susa in 1973 he identified a particular sub-group of 'Bols à décor de lignes ondulées' (1973: 28). In English we might rather describe these undulating lines as zig-zags, the angles of which vary from steep and sharp (Fig. 1.9) to rectangular (Fig. 1.1, 13) or rounded (Fig. 1.10). Thirty years ago all of the known examples of this type came from sites in southern Iran. De Miroschedji pointed to finds from Bampur and Saiyyidabad (near Bampur) in Baluchistan; Shahdad and Tepe Yahya in Kerman; and Tal-i Zohak in eastern Fars, in addition to a single, complete specimen from Susa (Fig. 1.8). Unbeknownst to de Miroschedji, Dales had, just the year before, published an example of identical soft-stone (Fig. 1.2) from the surface of a site with copper slag in the Gardan Reg region of Afghan Seistan. In 1974 Kohl commented upon and illustrated two more Tepe Yahya examples (Fig. 1.13-14) and introduced a related type which should be distinguished from de Miroschedji's original group. Three pieces—including rim fragments from Tepe Yahya and Susa (the latter not included in de Miroschedji's 1973 publication) and a complete bowl from Ur in the Iraq Museum—were characterized by two or three registers of zig-zags on the upper exterior of the vessel combined with a flattened or slightly everted rim, the upper surface of which was incised with a pattern of diagonal lines or a jagged saw-tooth motif (Kohl 1974: Pls. LXIIa-b, LXIIIa). In 1977 V. I. Sarianidi began to publish small sketches of soft-stone bowls with zig-zag decoration (Fig. 1.4) which became better known in the 1980s and early 1990s thanks to a series of additional publications (e.g. Sarianidi

1981, 1984, 1990). Excavations in 1993 at Tell Abraq in the United Arab Emirates brought to light yet another piece of precisely this type (Fig. 1.10) and in 1997 Ali Hakemi published several complete bowls from his excavations at Shahdad (Fig. 1.6-7).

It is now clear that these two broad types—the original category of bowls with zig-zag decoration defined by de Miroschedji, and the second category which shows added decoration on the upper surface of the rim—are found in greater numbers and over a wider area than was originally thought to be the case. For ease of reference I shall simply refer to these as zig-zag genres 1 and 2. Examples of these types of which I am aware are listed in Tables 1 and 2, and illustrated in Figures 1 and 2, respectively. At this point, and in part because many of the upper body and rim fragments are broken in a way which makes it difficult to say whether one, two or three lines of zig-zags are preserved, I have not suggested sub-types based on the number of zig-zag lines; presence or absence of lines intervening between zig-zagging lines; or the angularity, sharpness or roundedness of zig-zags. The main point is simply to bring these obviously similar pieces together in order to highlight the fact that they represent a coherent group which has been largely overlooked in the Western literature.

I emphasize this latter point because it is clear that Sarianidi recognized the genre 1 zig-zag bowls as a diagnostic type, characteristic of what he referred to as the 'Gonur stage (middle)' in Margiana, at least 20 years ago (1981: Fig. 3). Moreover, Sarianidi has long pointed to the presence of identical genre 1 zig-zag bowls both in Margiana and at Tepe Yahya (1984: 12, upper chart, 'Comparative material from Margiane and Tepe Yahya').

Years ago Sarianidi expressed a very decided view on the trajectory of this material. In 1984 he wrote, 'The Tepe Yahya finds', by which he was referring to those with assumed Central Asian affinities,

> comprise but a small fraction of the bulk of local artifacts, thus producing the impression of being imported; yet they are commonest and characteristic of southern Central Asia and Belujistan (Sibri). Evidently, the Bactrian-Margian archaeological complex and Mehrgarh (Sibri) are two offshoots of the same root; hence, such sites as Shahdad and Tepe Yahya IV are the westernmost known points of presumed origin, if not intermediate for tribal migration from West to East during the second millennium BC. (1984: 11)

Here, then, Sarianidi was expressing the view that the genre 1 zig-zag bowls originated in the undefined 'west' and were spread to sites like Tepe Yahya and Shahdad via tribal migrations which, ultimately, carried the same material

	Description	Provenience	Reference
1	rim sherd, double zig-zag	Bampur	During Caspers 1970: Fig. 44a
2	body sherd, double zig-zag	Gardan Reg	Dales 1972: Fig. 11
3	body sherd, double zig-zag	Gonur 1	Sarianidi 1990: Fig. 27.8
4	rim sherd, single zig-zag	Gonur 1	Sarianidi 1977: Fig. 25 = 1981: Fig. 3.1 = 1990: Fig. 28.6
5	deep bowl, single zig-zag, broken, repaired	Saiyyidabad	Stein 1937: Pl. 25
6	complete bowl, double zig-zag	Shahdad	Hakemi 1997: 611, Fj.1
7	complete bowl, single zig-zag	Shahdad	Hakemi 1997: 611, Fj.2
8	complete bowl, single zig-zag	Susa	Miroschedji 1973: Fig. 8.3
9	body sherd, triple zig-zag	Tal-i Zohak	Stein 1936: Pl. 29.29
10	rim sherd, double zig-zag	Tell Abraq	TA 1077, unpublished
11	rim sherd, single zig-zag	Tepe Yahya	Lamberg-Karlovsky 1970: Fig. 23t = Pl. 23E
12	deep bowl, rim missing, triple zig-zag	Tepe Yahya	Lamberg-Karlovsky 1970: Fig. 23j = Pl. 24A
13	rim sherd, double zig-zag	Tepe Yahya	Kohl 1974: Pl. LXIb left = Lamberg-Karlovsky 1988: Fig. 4BB = Pl. VI, upper r.
14	rim sherd, double zig-zag	Tepe Yahya	Kohl 1974: Pl. LXIb right = D. T. Potts 2001a: Fig. 6.14
15	body sherd, double zig-zag	Togolok 1	Sarianidi 1984: 12 = Hiebert 1994: Fig. 9.10.3
16	body sherd, double (?) zig-zag	Togolok 21	Sarianidi 1990: Fig. 28.13

Table 1. Zig-zag genre 1.

northward to Margiana and Bactria. Although this view has been criticized by a number of scholars (e.g. Hiebert and Lamberg-Karlovsky 1992: 3; Jarrige 1994: 307, is noncommittal), Sarianidi remains, in general, convinced that 'new settlers . . . came to Central Asia from . . . faraway western areas' (2001: 423, 430).

His views on the specific affinity of the zig-zag bowls, however, had changed by the time he published *Margiana and Protozoroastrism* in 1998. For there the Russian scholar describes 'steatite vessels with similar "tooth" designs' (which I take to mean the zig-zag bowls described above and illustrated by Sarianidi in a table comparing the finds from Shahdad and those of Bactria-Margiana) as Central Asian 'imports' at Tepe Yahya (1998: 139 and Fig. 71). As a corollary, he asserted that 'there are no grounds to think that steatite objects of Margiana and Bactria were direct imports from the Kerman oasis [Shahdad] or from Tepe Yahya' (1998: 48). Hiebert has adopted a similar

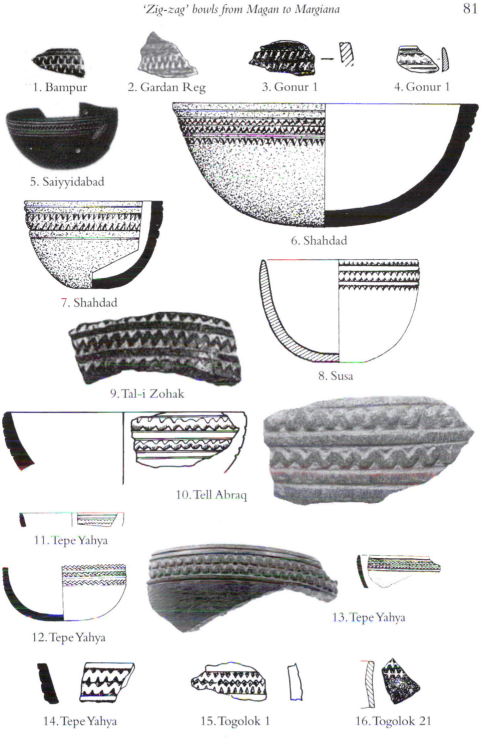

1. Bampur 2. Gardan Reg 3. Gonur 1 4. Gonur 1

5. Saiyyidabad

6. Shahdad

7. Shahdad

8. Susa

9. Tal-i Zohak

10. Tell Abraq

11. Tepe Yahya

12. Tepe Yahya

13. Tepe Yahya

14. Tepe Yahya 15. Togolok 1 16. Togolok 21

Fig. 1. Zig-zag genre 1.

position, but with a twist. In his 1994 monograph on the origins of the Bronze Age civilisation of Bactria and Margiana, Hiebert illustrated a soft-stone body sherd with double-zig zag from Gonur north (Fig. 1.3), attributed to his Period I (c. 2100-1900 BC), as an example of a stone vessel 'locally produced from imported raw materials' (1994: 148, Fig. 9.10.3). The implication of these views, then, is that the examples of zig-zag bowls found outside of the Gonur and Togolok oases were exports from Central Asia. Hiebert's view qualifies this position by suggesting that the soft-stone itself was imported from outside Bactria and Margiana (presumably eastern Iran), whereas the finished products were made at oases like Gonur and Togolok. Is this position defensible?

At the time of writing, it certainly cannot be said that zig-zag bowls are more numerous in Margiana than elsewhere, though the absolute number of known examples precludes anything like a valid statistical assessment. With two published examples from Gonur 1, and a single example each from Togolok 1 and 21, the significance of four Central Asian pieces must be weighed up against that of four examples from Tepe Yahya, two from Shahdad and two from the Bampur region. The single finds from Tal-i Zohak, Susa, Gardan Reg and Tell Abraq can, in all probability, be regarded as imports, but the question remains, was this genre produced in Margiana or in south-eastern Iran? In other words, where is the context, and which way should the arrows be drawn on our mental maps—from Margiana south to Susa, Shahdad, Tepe Yahya, Bampur and Tell Abraq; or from southeastern Iran northwards to Margiana, westwards to Susa, eastwards to Bampur, and southwards to Tell Abraq?

While I think that both Sarianidi and Hiebert are absolutely right to assert that local stone-carving industries existed in Bactria and Margiana, I do not think the zig-zag style bowl genre constitutes one of those products. Even without examining the material from sites such as Gonur and Togolok 15 or 21 at firsthand, it is clear from the published photographs that the vast majority of soft-stone vessels from Margiana—kidney-shaped dishes, round dishes, deep-sided bowls with floral patterns, and square-bodied 'cosmetic' flasks—were incised only lightly. Whether one looks at the floral patterns on finds from Gonur (Sarianidi 1998: Fig. 19.1) or the geometric patterns on the material from Gonur and the Togolok sites, most of the decoration is incised. In contrast, the decoration of the zig-zag bowls is deep and better described as carved than incised. It is true that the rectangular zig-zag carved on two 'Bactrian' flasks from Kabul and Susa in the Louvre (Amiet 1986: Fig. 159.1-2) is reminiscent of the rectangular zig-zag on one of the Tepe

Yahya rim fragments (Fig. 1.13) as well as that found on the piece from Bampur (Fig. 1.1). The vast majority of the soft-stone from Bactria and Margiana, however, bears incised rather than carved decoration.

There is, however, a far more conclusive argument which, in my opinion, tips the scale in favour of an origin for the zig-zag genre bowls at Tepe Yahya in southeastern Iran, rather than a site in the Gonur or Togolok oasis in Margiana. The evidence of zig-zag genre 2, I believe, compels us to view both genres as native to southeastern Iran.

Zig–zag genre 2

Figure 2 illustrates five fragments of what I have termed zig-zag genre 2. Two of these (Fig. 2.1-2) are simple bowls with a single zig-zag framed by upright and pendant incised triangular gouges just below the rim. In addition, the upper rim surface of these pieces is decorated simply with a simple, somewhat sloping (that is, diagonal) series of triangular gouges running off a single incised line. These create the effect of a 'shark's tooth' pattern.

A third bowl (Fig. 2.3), the rim and base of which are preserved, shows a zig-zagging line (remnants of a second one can be seen at the upper edge of the broken base) framed above by an angular, scalloping pattern (that is, similar to the bottom of a zig-zagging line without its upper portion) which is very similar to the decoration seen on the genre 1 bowl from Susa (Fig. 1.8). The Tepe Yahya example has the same 'shark's tooth' decoration on the upper rim surface seen in the previous two examples, as well as a slight indentation below the rim. This latter trait is more exaggerated on two further fragments (Fig. 2.4-5), one of which shows a single zig-zag (Fig. 2.4) and one of which shows three rows of zig-zagging (Fig. 2.5). The first of these two has a pattern of vertical, diamond-shaped gouges arranged side by side on the upper rim surface, whereas the second piece has a band of diagonal hatching along the surface of the rim.

As the two genres discussed here are so obviously related and as genre 2 is known only by individual examples from Susa and Ur, with five specimens attested at Tepe Yahya, I would conclude that southeastern Iran (Tepe Yahya? Jiroft? where new finds have been made by the Iranian Cultural Heritage Organisation) is the likeliest place of manufacture for both genres. Indeed, this point was anticipated some years ago by one of the editors of this volume (T. F. Potts 1994: 266). A fragment from Margiana (Fig. 2.6), which appears to be the same as a piece from Gonur North illustrated by Hiebert (Fig. 2.7), has an angular zig-zag between two concentric lines on the upper rim

D. T. Potts

	Description	Provenience	Reference
1	rim sherd, single zig-zag, triangular gouges above and below zig-zag, 'shark's tooth' pattern on rim surface	Tepe Yahya	Lamberg-Karlovsky 1988: Fig. 3J
2	rim sherd, single zig-zag, triangular gouges above and below zig-zag, 'shark's tooth' pattern on rim surface	Tepe Yahya	Lamberg-Karlovsky 1988: Fig. 4AA
3	rim sherd, single zig-zag, angular scalloped line above zig-zags; disconnected base with traces of a second zig-zag line at break; 'shark's tooth' pattern, concentric line, on rim surface	Tepe Yahya	D. T. Potts 2001a: Fig. 5.22
4	rim sherd, single zig-zag, diamond pattern on rim surface	Tepe Yahya	Lamberg-Karlovsky 1988: Fig. 4Z
5	rim sherd, triple zig-zag, diagonal hatching between two concentric circles on rim surface	Tepe Yahya	Kohl 1974: Pl. LXIIa = Lamberg-Karlovsky 1988: Fig. 3L
6	rim sherd, three raised ridges on body suggest the vessel was lathe-turned, incised rectangular zig-zag between two concentric lines on rim surface	'Margiana'	Sarianidi 1981: Fig. 3.2
7	rim sherd, as 6, = 6?	Gonur North	Hiebert 1994: Fig. 9.10
	not illustrated		
	complete bowl; incised zig-zag between 'shark's tooth' pattern above and below on side of vessel; incised zig-zag on rim surface; photo not clear enough to describe more precisely	Ur	Kohl 1974: Pl. LXIIb
	rim sherd; incised zig-zag below saw-tooth and raised line; zig-zag on rim surface; photo not clear enough to describe more precisely	Susa	Kohl 1974: Pl. LXIIIa

Table 2. Zig-zag genre 2.

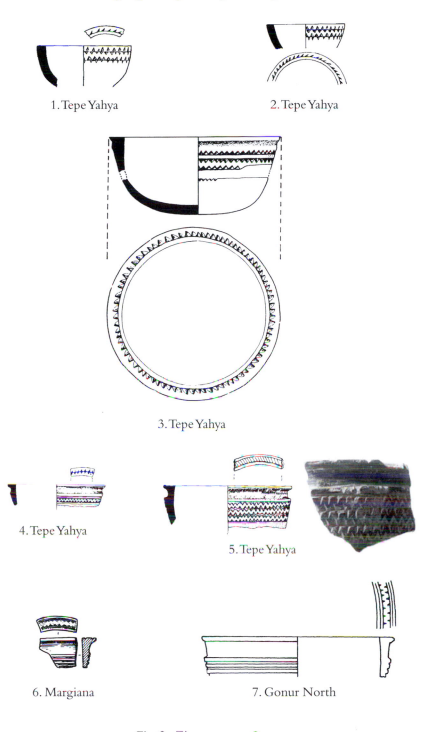

Fig. 2. Zig–zag genre 2.

surface and thus seems related to the zig-zag genre 2 group. On the other hand, the raised ridges below the rim suggest that the vessel was made on a lathe, and in this respect it differs markedly from the Tepe Yahya examples. It may, therefore, be a local, lathe-turned imitation of zig-zag genre 2.

NEITHER SÉRIE RÉCENTE NOR SÉRIE ANCIENNE

Despite the fact that de Miroschedji originally classified the zig-zag bowl from Susa amongst his série récente, in which he has been followed by Hiebert (1994: 148), Lamberg-Karlovsky has assigned the Tepe Yahya examples to the Intercultural Style, or série ancienne (1988). My own view is that, on chronological and typological grounds, neither term should be used for this category. The original term série récente, coined when little was known about the indigenous soft-stone industry of the Oman peninsula, conflated the massive production of this region (characterized particularly by open bowls, straight-sided cups and compartmented vessels decorated with double dotted-circles) with the still poorly understood soft-stone industry of Bactria and Margiana, as represented at Susa most notably by square-based 'cosmetic' flasks. The typical Umm an-Nar-type soft-stone, now widely attested at late third-millennium BC sites throughout Oman and the United Arab Emirates, constitutes the bulk of what de Miroschedji originally considered série récente at Susa. Yet the bowls which have been the topic of the present study clearly bear no resemblance to the southeast Arabian material, lacking in all cases the single or double dotted-circle. On the other hand, the figurative decoration of true Intercultural Style or série ancienne type is similarly missing on the zig-zag bowls. The only real point of comparison is in the deep carving typical of the zig-zagging lines which, as noted above, distinguishes the zig-zag bowls from the bulk of the apparently locally produced soft-stone vessels of Central Asia.

CHRONOLOGY, CONTEXT AND INTERCONNECTIONS

It is difficult to draw firm chronological conclusions about the zig-zag genres but several points suggest themselves. First of all, considering the degree of perturbation encountered at a site like Tepe Yahya, one should not make too much of the contexts in which the examples there have been found and, as Table 3 shows, the possible dates of the relevant contexts range from the late third through the early first millennium BC. Hiebert has assigned the single example from Gonur North (Fig. 1.3) to the period c. 2100-1900 BC (1994: 77, 148-9), while the piece from Tell Abraq comes from a context

Example	Genre	Context	Phase	Approximate date
1.1	1	Bampur, Site Y, level 11	cf. Period IV, 2	c. 2600-2500 BC
1.2.	1	Gonur 1	Gonur phase	c. 2100-1800 BC
1.3.	1	Gonur 1	Gonur phase	c. 2100-1800 BC
1.5	1	Shahdad, grave 37	—	c. 2300-1700 BC
1.6	1	Shahdad, grave 25	—	c. 2300-1700 BC
1.9	1	Tell Abraq, 70/112, 74.84 E, 112.75 N, elev. 7.15, locus 516 (1993)	Wadi Suq III	c. 1600-1400 BC
1.10	1	Tepe Yahya, BW.69.T5.5A	IVB	c. 2300-2200 BC
1.11	1	Tepe Yahya, B.69.T4.4.A.3	IVA	c. 1900-1600 BC
1.12	1	Tepe Yahya, B.70.19	IVB6	c. 2300 BC
1.13	1	Tepe Yahya, B-BW.70.3.1	IVB1	c. 2100 BC
2.1	2	Tepe Yahya, A.75.10	IVB6	c. 2300 BC
2.2	2	Tepe Yahya, A.75.9.1	IVB5	c. 2200 BC
2.3	2	Tepe Yahya, A.75.8.1	IVB2	c. 2100 BC
2.4	2	Tepe Yahya, AN2.73.27.5	IVA	c. 1900-1600 BC
2.5	2	Tepe Yahya, A.70.5.2	III?	c. 800 BC

Table 3. The chronology of zig-zag genres 1 and 2.

datable to c. 1600-1400 BC. Kohl has recently suggested that the zig-zag bowls were produced in both period IVB and IVA at Tepe Yahya (2001: 221). Further, he suggests that the Shahdad graves—where two examples of genre 1 were found—'largely postdate the period of the . . . peak production of the Intercultural Style vessels at Tepe Yahya', while leaving open the possibility that differences between the material from Tepe Yahya and Shahdad could be due to cultural or spatial factors as well (Kohl 2001: 212). I believe the evidence marshalled here allows us to adopt a much simpler position, which may be summarized in the following propositions: (1) The zig-zag bowls post-date the série ancienne/Intercultural Style and indeed represent some of the successors to that production in the local soft-stone industry at Tepe Yahya. (2) The zig-zag bowls overlap in time with the série récente and may post-date it, but are without doubt culturally distinct from it. In my opinion, the zig-zag bowls are products of southeastern Iran in the late third and very early second millennium BC. The true (Omani) série récente,

on the other hand, was the exclusive product of Magan (Oman and the U.A.E.). In contrast, the kidney-shaped vessels decorated with pendant, incised triangles; square-based soft-stone flasks, with both geometric and floral decoration; and tall cups with incised, cross-hatched triangles (cf. T. F. Potts 1994: 266, 'Bactrian group'; examples in e.g. Masimov 1981: Fig. 12.12; Sarianidi 1981: Fig. 4; 1998: Figs. 17-19) were the products of the workshops of Bactria and Margiana.

Once we begin to distinguish these three areas of contemporary soft-stone vessel production in the late third and early second millennium BC—Oman, southeastern Iran, and Bactria-Margiana—it becomes important to think again about the interconnections which the already voluminous literature on the BMAC has highlighted during the past two decades. The discovery of BMAC material at sites like Shahdad, Khinaman, Tepe Yahya, Khurab, Sibri and Quetta (Santoni 1988; Hiebert and Lamberg-Karlovsky 1992; Jarrige 1994; Hiebert 1998); Mari (Beyer 1989); Susa (Amiet 1986); and Tell Abraq (D. T. Potts 1993, 1994, 2000) raises a plethora of issues which space does not permit me to deal with here. What is clear, however, is that the relationships illustrated by this material should not be construed as one-way traffic. The northward movement of the zig-zag genres from southeastern Iran to the oases of Margiana needs to be considered in tandem with other, contemporary evidence, including the appearance of what is almost certainly a linear Elamite inscription on a sherd from Gonur (Klochkov 1998); the iconographic evidence pointing to the worship of the Mesopotamian goddess Nana in Bactria (D. T. Potts 2001b); the Mesopotamian and Elamite antecedents of the iconography found on bronze and silver pins from BMAC contexts (Winkelmann 1998); and the southeast Iranian influences on BMAC glyptic (Winkelmann 1997, 1999). Whether or not the diffusion of BMAC materials into the Indo-Iranian borderlands and southeastern Iran represents a movement or series of movements of Indo-Iranian speakers, the materials just mentioned suggest that significant impulses moved in the opposite direction, into the BMAC heartland, as well.

When we add to this segment of our story the fact that true série récente, such as shallow bowls and compartmented vessels with dotted-circle decoration, was moving out of southeastern Arabia to Tepe Yahya at the very time in which Tepe Yahya seems to have been exporting at least limited numbers of soft-stone vessels to Elam (Susa), Baluchistan (Bampur), Margiana (Gonur, Togolok oases) and Magan (Tell Abraq), while the soft-stone of Bactria and Margiana of the sort described above was moving south to sites like Tepe Yahya (Lamberg-Karlovsky 1988: Fig. 3I, Pl. X, upper; D. T. Potts 2001a:

Figs. 4.38, 5.23-25) and Susa (Miroschedji 1973: Figs. 9.1, 11), then the whole question of redundant production and the 'coals to Newcastle' syndrome arises. What possible use would the oases of Bactria and Margiana, which had their own soft-stone vessel manufacturing industry, have for vessels from southeastern Iran? Similarly, why would vessels from the Oman peninsula travel to southeastern Iran, where soft-stone was abundantly available and clearly utilized by the local population? In this respect I think it would be foolish to adopt a naively utilitarian perspective, rejecting the idea that soft-stone vessels such as those described above would ever circulate between contemporary production areas in southeastern Arabia, southeastern Iran, or Margiana. Gift exchange, the prestige of owning something exotic, and above all the *contents* of the vessels (unguents? aromatics?) rather than the vessels themselves, may have been factors propelling these seemingly simple stone containers from Oman to Susa and Tepe Yahya, from Tepe Yahya to Gonur, Togolok and Tell Abraq.

Importantly, however, we would never have suspected the interconnections reflected in this distribution of material culture, if we had not carefully interrogated the context in which they were found at Tepe Yahya. This is a lesson which so much of Roger Moorey's work has made abundantly clear over the years.

D. T. Potts

REFERENCES CITED

Amiet, P.
1986 *L'âge des échanges inter-iraniens, 3500–1700 avant J.-C.* Notes et documents des musées de France 11. Paris: Éditions de la Réunion des musées nationaux.

Beyer, D.
1989 Un nouveau témoin des relations entre Mari et le monde iranien au IIIème millénaire. *Iranica Antiqua* 24: 109-20.

Dales, G. F.
1972 Prehistoric research in southern Afghan Seistan. *Afghanistan* 25/4: 14-39.

During Caspers, E. C. L.
1970 A note on the carved stone vases and incised grayware. In *Excavations at Bampur, a Third Millennium Settlement in Persian Baluchistan, 1966* (Cardi, B. de, ed.). Anthropological Papers of the American Museum of Natural History 51/3, 319-25.

Hakemi, A.
1997 *Shahdad: Archaeological Excavations of a Bronze Age Center in Iran.* Rome: IsMEO.

Hiebert, F. T.
1994 *Origins of the Bronze Age Oasis Civilization in Central Asia.* American School of Prehistoric Research Bulletin 42. Cambridge, Mass.
1998 Central Asians on the Iranian plateau: A model for Indo-Iranian expansionism. In *The Bronze Age and Early Iron Age Peoples of Eastern Central Asia* (V. H. Mair, ed.). Institute for the Study of Man, 1. Washington, 148-61.

Hiebert, F. T. and Lamberg-Karlovsky, C. C.
1992 Central Asia and the Indo-Iranian borderlands. *Iran* 30: 1-15.

Jarrige, J.-F.
1994 The final phase of the Indus occupation at Nausharo and its connection with the following cultural complex of Mehrgarh VIII. In *South Asian Archaeology 1993* (A. Parpola and P. Koskikallio, eds.). Annales Academiæ Scientiarum Fennicæ B 271, 1. Helsinki, 295-314.

Klochkov, I. S.
1998 Signs on a potsherd from Gonur (on the question of the script used in Margiana). *Ancient Civilizations from Scythia to Siberia* 5: 165-75.

Kohl, P. L.
1974 Seeds of Upheaval: The production of chlorite at Tepe Yahya and an analysis of commodity production and trade in southwest Asia in the mid-third millennium, unpubl. Ph.D. diss. (Harvard University).
2001 Reflections on the production of chlorite at Tepe Yahya: 25 years later. In *Excavations at Tepe Yahya, Iran, 1967–1975: The Third Millennium,* (D. T. Potts, ed.). American School of Prehistoric Research Bulletin 45. Cambridge, Mass., 209-30.

Kohl, P. L. (ed.)
1981 *The Bronze Age Civilization of Central Asia: Recent Discoveries.* Armonk: M. E. Sharpe.

Lamberg-Karlovsky, C. C.
1970 *Excavations at Tepe Yahya, Iran, 1967–1969: Progress Report 1.* American School of Prehistoric Research Bulletin 27, Cambridge, Mass.
1988 The 'Intercultural Style' carved vessels. *Iranica Antiqua* 23: 45-95.

Masimov, I. S.
1981 The study of Bronze Age sites in the lower Murghab. In *The Bronze Age Civilization of Central Asia: Recent Discoveries* (P. L. Kohl, ed.). Armonk: M. E. Sharpe, 194-220.

Miroschedji, P. de.

1973 Vases et objets en stéatite susiens du Musée du Louvre. *Cahiers de la DAFI* 3: 9-79.

Potts, D. T.

1993 A new Bactrian find from southeastern Arabia. *Antiquity* 67: 591-6.

1994 South and Central Asian elements at Tell Abraq (Emirate of Umm al-Qaiwain, United Arab Emirates), c. 2200 BC–AD 400. In *South Asian Archaeology 1993* (A. Parpola and P. Koskikallio, eds.). Annales Academiæ Scientiarum Fennicæ B 271, 2. Helsinki, 615-28.

2000 *Ancient Magan: The Secrets of Tell Abraq.* London: Trident.

2001a *Excavations at Tepe Yahya, Iran, 1967–1975: The Third Millennium.* American School of Prehistoric Research Bulletin 45. Cambridge, Mass.

2001b Nana in Bactria. *Silk Road Art and Archaeology* 7: 23-35.

Potts, T. F.

1994 *Mesopotamia and the East: An Archaeological and Historical Study of Foreign Relations ca. 3400–2000 BC.* Oxford University Committee for Archaeology Monograph 37. Oxford.

Santoni, M.

1988 Aspects matériels des cultures de Sibri et de Mehrgarh VIII (plaine de Kachi, Baluchistan, Pakistan) à la fin du troisième et au début du deuxième millénaires. In *L'Asie centrale et ses rapports avec les civilisations orientales des origines à l'âge du fer* (J.-Cl. Gardin, ed.). Mémoires de la Mission Archéologique Française en Asie Centrale 1. Paris 135-41.

Sarianidi, V. I.

1977 Bactrian centre of ancient art. *Mesopotamia* 12: 97-110.

1981 Margiana in the Bronze Age. In *The Bronze Age Civilization of Central Asia:* *Recent Discoveries* (P. L. Kohl, ed.). Armonk: M. E. Sharpe, 165-93.

1984 Southern Turkmenia and Margiane in the Bronze Age. *Information Bulletin* 7: 5-16.

1990 *Drevnosti strani Margush.* Ashgabat: Ylym.

1998 *Margiana and Protozoroastrism.* Athens: Kapon Editions.

2001 The Indo-Iranian problem in the light of the latest excavations in Margiana. In *Vidyarnavavandanam: Essays in Honour of Asko Parpola* (K. Karttunen and P. Koskikallio, eds.). Studia Orientalia 94. Helsinki, 417-41.

Stein, A.

1936 An archaeological tour in the ancient Persis. *Iraq* 3: 111-230.

1937 *Archaeological Reconnaissances in Northwestern India and Southeastern Iran.* London: Macmillan.

Weeks, L.

1997 Prehistoric metallurgy at Tell Abraq, UAE. *Arabian Archaeology & Epigraphy* 8: 11-85.

1999 Lead isotope analyses from Tell Abraq, United Arab Emirates: New data regarding the 'tin problem' in western Asia. *Antiquity* 73: 49-64.

Winkelmann, S.

1997 Murghabo-baktrische Terrakotten im Archäologischen Museum der Westfälischen Wilhelms-Universität Münster. *Boreas* 20: 151-68.

1998 Bemerkungen zum Grab 18 und den Silbernadeln von Gonur depe. *Archäologische Mitteilungen aus Iran und Turan* 30: 1-16.

1999 Von Formen und Stilen — ein Versuch der Gliederung baktrischer Stempel- und Rollsiegel. *Hallesche Beiträge zur Orientwissenschaft* 28: 112-211.

The north–south divide in ancient Jordan: ceramics, regionalism and routes

Piotr Bienkowski

INTRODUCTION

There have been huge changes in the interpretation of most periods in the archaeology of Jordan in recent years. This is largely due to two linked factors. One is the rejection of simplistic traditional reconstructions of what happened in antiquity and an appreciation that perhaps things were more complex than once thought. Partly this has resulted from the development of intensive survey methods, use of statistics and random sampling, as well as new theoretical approaches and models based more on cycles of indigenous change than on external population movements. It has been recognized that Jordan's varying landscape, highly fertile in parts of the Jordan Valley but with a high proportion of marginal pastoral land and steppe/desert, has perhaps been a factor in its low level of state formation and urbanization. Consequently, the application of models of central place theory and state formation, applicable in Mesopotamia or north Syria, is less valid in Jordan, which requires fresh perspectives on its own terms (Prag 2001). Secondly, there is a growing realization that the data from surface surveys, which has been used to reconstruct settlement patterns, is highly fallible and misleading, and that often on excavation a quite different chronological sequence is found, although excavated evidence too can be localized and unrepresentative (MacDonald 1996; Finkelstein 1998; Bienkowski and Adams 1999).

These factors have resulted in the development of a major research theme which is now being pursued in many periods, that of regional variation: on the one hand, the appreciation that the settlement patterns and material culture of Jordan often really are distinct from those of Palestine and must be studied on their own merits; and on the other, growing identification of regional variations in settlement patterns and material culture *within* Jordan itself, between different regions. This research theme has been independently identified and pursued by scholars working in quite separate chronological periods. Clearly the nature of this regionalism, its causes and effects, is or may be different from period to period. This paper highlights the patterns of regionalism between the Neolithic and Early Islamic periods as reflected

by ceramic and other evidence, and investigates the possible role of the ancient route network in such variation.

A REVIEW OF THE EVIDENCE FOR REGIONAL VARIATION IN JORDAN (NEOLITHIC TO EARLY ISLAMIC)

Regional variation can already be traced in Jordan in the Neolithic period (c. 8300–?4500 BC). Based on lithic and ceramic technology and typology, architectural traits, and 'ritual' evidence, three 'provinces' can be defined, certainly for the seventh millennium BC and perhaps for the whole of the Neolithic (Rollefson 2001): these are the north, the south, and the eastern steppe and desert (where the sites were temporary camps probably inhabited by hunters and gatherers, and later pastoralists). The Pottery Neolithic in particular seems to have been a period of regional 'cultures', with distinctive ceramics: the Yarmoukian in northern Jordan, the Wadi Rabah tradition in the Jordan Valley, and Pottery Neolithic A in southern Jordan.

This pattern continues in the Chalcolithic period (c. ?4500–3600 BC), when areas to the north of the Jordan Valley and in the south show very different material from the 'classic' Chalcolithic of the Jordan Valley at Teleilat Ghassul and Abu Hamid. Kerner (1997) has pointed out that in the Late Chalcolithic, the north Jordan Valley, middle Jordan Valley, south Jordan Valley, Golan and northern plateau, central plateau, and southern Jordan are all distinct cultural entities, with distinctive assemblages of pottery, figurines and metal finds. For example, characteristic V-shaped bowls, a distinctive Chalcolithic 'type fossil' which make up about 60% of the pottery repertoire in most areas, certainly in the north, are virtually missing from southern Jordan. Kerner's impression is that the different regions developed at very different speeds and in different ways (1997: 467–8).

Early Bronze I (c. 3600–3000 BC) in Jordan shows strong regional variation and many of the north-south ceramic distinctions are similar to those in Palestine (for overview, cf. Philip 2001). However, there are specific regional differences in Jordan. The EB I material from the Dead Sea area is a distinct regional group. Long stratified sequences from the Jordan Valley, at Tell Um Hamad and Tell esh-Shuna (North), have confirmed two chronologically distinct phases at each site but significant differences between the two ceramic assemblages demonstrate a high degree of regionalism. In EB II (c. 3000–2750 BC) there was a decline in regionalism with pottery becoming increasingly homogeneous in the southern Levant. However, in general, the settlement patterns of the Early Bronze Age in Jordan (c. 3600–1900

Fig. 1. Map of Jordan showing sites mentioned in text.

BC) show regional differences, not only between the arid and fertile zones but between different areas in these zones, and this is a pattern that repeats itself in future periods, particularly the Iron Age. Harrison's analysis of settlement data in the Madaba plains (1997) suggests poorly integrated settlement systems with significant regional differentiation, essentially a patchwork of settlement which has been termed 'rural complexity' (Schwartz and Falconer

1994), with probable occupation by pastoralist groups in the arid zones of the south and east. Supporting this view of regionalism, survey in north Jordan has suggested that, while the major site of ez-Zeraqon was a regional centre-site during EB II–III, during the entire EBA northern Jordan was part of a distinctive northern Palestinian cultural zone which extended into southern Syria (Kamlah 2001), which again is a pattern that appears in later periods.

There is a close relationship between EB III and IV pottery, certainly in south-central Jordan and in the south Jordan Valley. Nevertheless, as in Palestine there is strong variation in EB IV pottery styles, with four ceramic 'families' known in Jordan (Palumbo and Peterman 1993), although there is a growing consensus to treat these as regional and contemporary, not chronological.

Evidence for Middle and Late Bronze Age (c. 1900–1200/1150 BC) settlement (cf. generally Magness-Gardiner 1997; Strange 2001) comes from the Jordan Valley; the northern and central plateau; the eastern desert (Jawa); from the southern Hauran, where a series of fortified MBA sites has recently been discovered, including Tell Rukais; and even from north-east of the Azraq oasis at Iraq el-Qattafiyat (Eigeland 1997). According to survey evidence, a large proportion of MBA sites continued to be occupied into the LBA (Najjar 1992). However, the greatest number of LBA settlements appear to be concentrated in the north and west, and generally there was a decrease in number from the MBA. Further south in Jordan during the Middle and Late Bronze Ages, the settlement pattern is quite different and the farther south one goes the less evidence there is for any settlement at all. South of the Wadi Mujib (later Moab) there is some MBA evidence from surveys (Miller 1991) and some evidence for LBA sedentary occupation, for example at Balu'a, but this was not a major urban phase (Dearman 1992). South of the Wadi Hasa (later Edom), there was no settled occupation at all in the Middle and Late Bronze Ages (Bienkowski 1992: 5–8). This lack of settled occupation in the south is perhaps not surprising, since Egyptian texts of the second millennium BC imply that the area was inhabited by nomadic pastoralists herding sheep and living in tents, known to them as *shasu* (Kitchen 1992).

The evidence for Iron I (c. 1200/1150–1000 BC) continues that of the Middle and Late Bronze Ages, with several substantial walled settlements in the north, dwindling to nothing in the south (LaBianca and Younker 1995). The lack of continuously occupied settlements in central Jordan and a total lack of any settlement in the south probably reflects a population with an economy based on pastoralism (Dearman 1992: 73).

For the Iron II/Persian period (c. 1000–332 BC) there is fairly dense settlement from north to south and increasing evidence of distinctive regional variations, not only between the recognized 'states' of Ammon, Moab and Edom, but within them too. In general, pottery assemblages from Edom, Moab, Ammon and in the north are all different from each other. Of course there are similarities but styles of painting on ceramics are different, surface finishes are different, simple bowl shapes are different, even bases are different (cf., for example, Hendrix et al. 1997: 170–202). It is possible that some of these variations can be explained as the differences between national assemblages (cf. Herr and Najjar 2001) but within Ammon, Moab and Edom different sites and regions have quite distinct ceramic assemblages: in Edom, for example, clear distinctions can be made between the north, the area around Petra and the south (Bienkowski and Steen 2001). Of course, such variations can be expected of tribal kingdoms (LaBianca and Younker 1995; Bienkowski and Steen 2001), comprising small, isolated settlements, tribally organized and probably with infrequent contact with any (transient?) central administration.

The extent of regional variation in the Roman period (c. 63 BC– AD 324) has not yet been established, although there is no doubt that it existed. Pottery diagnostic of Late Roman contexts in northern and central Jordan, for example at Jarash and Hisban—carinated bowls with a grooved rim—appears to occur in otherwise safe Early Roman contexts in the south (Bienkowski and Adams 1999). Owing to the lack of published stratified Roman-period material, it is still not possible to come to definitive conclusions about the dating of this material and whether its occurrence really does vary from region to region.

The Roman-Byzantine pottery tradition continued through to the early ninth century with only gradual changes (Watson 1992: 244–6; Walmsley 1992b: 256–7 and Fig. 7; 1995: 668; Vries 1998) and the transition from Byzantine to Muslim hegemony (the Muslim 'conquest') appears to have left little immediate material trace. Early Islamic pottery shows clear regional differences. Distinctive eighth-century cream-slipped pottery decorated with red painted lines is very common in northern and central Jordan but completely absent in the south, for example at Humayma and Aqaba, confirming the identification in Arab literary sources of southern Jordan as a separate cultural region (Walmsley 1992a: 381–2; Schick 1998: 90). Ongoing work at Gharandal south of the Wadi Hasa has revealed a sequence from the Nabataean to Mamluk periods (Walmsley 1998) and comparison with the firmly dated sequence of northern Jordan shows the difference in southern

pottery types, with Byzantine-style light orange to reddish blooms and wavy combing continuing well into the Islamic period. Many older surface surveys concluded that much of southern Jordan was sparsely occupied in the Umayyad period, but it is now clear that the region had a separate ceramic tradition (Walmsley 1992a: 381), although recent work in the south-east Arabah still suggests that it was sparsely settled (Smith, Stevens and Niemi 1997: 67). Watson (1992: 246) has concluded, on the basis of the distribution pattern of sixth- and seventh-century pottery types and the distinct division between south and north, that the contacts of northern Jordan were more east–west, extending also into southern Syria, than north–south, despite the continuation of contacts with Egypt evidenced by pottery of Lower Egyptian manufacture found at Pella.

REGIONAL VARIATION AND ANCIENT ROUTES

This rapid survey indicates that in every period from Neolithic to Early Islamic there are clear regional variations detectable in ceramics and/or settlement patterns. These regional variations were invariably north–south: only in the Neolithic, Early Bronze Age and Early Islamic periods was there apparently appreciable settlement in the eastern steppe and desert. Given the topography, climate and variable fertility of the different parts of Jordan, it is perhaps not surprising that any regional variation should be north–south. Nevertheless, the very existence of regionalism in every period requires explanation, particularly since southern Jordan invariably had its own diagnostic characteristics in material culture.

It is difficult to understand the significance of regionalism and whether its causes were the same in every period. Regional variation might relate to cultural self-identification by different groups (Iron Age?), social, economic and political involvement (Middle and Late Bronze Ages?), patterns of communication, or a combination of these and other factors. Perhaps the obvious explanation would be that the major east–west wadis—particularly Wadis Mujib, Dana and Hasa—really did interrupt north–south communication and functioned as regional boundaries (and, in the Iron Age, as political borders). It would be easier to treat this explanation seriously were it not for the widespread acceptance that from early times there was a major north–south route running right through Jordan: the 'King's Highway', more or less corresponding, with some variations, to the modern road of that name (e.g. Oded 1970; Herr 1997: 171). Nevertheless, the notion of the 'King's Highway' as an ancient and traditional main route is not beyond criticism.

It was Nelson Glueck who first proposed the idea of the 'King's High-way' as a single major north-south route dating from the Early Bronze Age to the 20th century AD (1940: 21–2). At the time of his survey of Transjordan in the 1930s, the modern road was called 'Emir Abdullah's road' or, in Arabic, *et-Tariq es-Sultani* ('the Sultan's Road'). Certainly most 19th-century maps indicate a route leading from either Salt or Amman (or both) to Hisban, Madaba, Dhiban, across the Wadi Mujib to Karak and south from there, which roughly follows the route of the modern King's Highway, although none of them called it that (J. M. Miller pers. comm.). But even in the 19th century this was not the only route, nor even necessarily the 'main' route. The Syrian Hajj route, established by the Umayyads as the principal road connecting Mecca with Damascus, is followed by the modern Desert High-way to the east; it was rebuilt in the 16th century AD by the Ottomans as a direct route between Mecca and Constantinople (Petersen 1989). This too was largely replaced by the Hijaz railway in the early 20th century (Daher 1995). Neither of these north-south routes appears to have been in effective use in 1907, when Gertrude Bell described the route of the Ottoman army from southern Syria to Aqaba on its way to quell a rebellion in Yemen (Bell 1908: 13–4). The Ottoman troops marched from Syria on the west side of the Jordan river, crossed at a bridge just north of the Dead Sea, then marched north-east via Salt to Amman, where they boarded the Hijaz railway to Maan. From Maan they had 'a horrible march across a sandy waste' to Aqaba: 'Many hundreds of men and many thousands of camels perished before they reached the gulf, for the wells upon that road are three only (so said the Arabs) and one lies about two miles off the track . . .'

Nineteenth-century explorers used more than one north-south route through Edom (Bartlett 1989: 15–28, 35), but most travellers to Petra used east-west routes from the Wadi Arabah rather than north-south roads through Moab, since Edom was virtually inaccessible from the north, apparently because of hostile tribes (Bartlett 1989: 25–6). The 'King's Highway' does not therefore appear to have been the 'main' road and was certainly only one route of several throughout the 19th century. It is probable that its importance increased with the creation of Transjordan in 1921, since this was a route connecting the major settlements of the new kingdom: it is clear that before 1920 there were no proper roads, only dust tracks, the first paved road being opened in 1921–3 between Amman and Jerusalem. Only by 1929 was every town in Transjordan connected by roads with Amman (Abu Nowar 1989: 225–6). It appears likely—although admittedly speculative—that it was the popularization of Glueck's ancient, biblical and grand title for

the (modern) north–south road that was largely responsible for its being re-named and known henceforth as the King's Highway, and this same name has been applied to the alleged ancient route (cf. also Borstad 2000 for a similar conclusion).

Glueck's view was that the biblical book of Numbers (20:17, 21:22) mentioned a 'King's Highway' (*derek hammelek*) from north to south through Moab and Edom, and in his survey he noticed a concentration of sites along that route, essentially the route of the Roman *Via Nova Traiana*. Miller has argued that there is insufficient evidence for such a route at any period and his Kerak Plateau Survey detected no concentration of sites along the Roman road (1982: 173; 1989: 12). One of the biblical references is to Sinai, not Jordan, suggesting there were in fact various routes which might have been called 'the royal road', the preferred non-specific translation of all biblical scholars prior to Glueck's work (cf. Donnan 1996: 25).

Pre-Roman roads were not paved (nor were many Roman roads paved, cf. Kennedy 1997: 73), so admittedly they are difficult to trace archaeologi-cally,[1] but the evidence of more recent surveys is that there was an inter-woven network of trails and optional routes. Dearman has pointed out two optional routes across the Wadi Mujib at Aroer and at Lehun, both well east of the Roman road; King Mesha of Moab claimed to have rebuilt a highway in the Arnon, also east of the Roman road (Dearman 1997: 206). In the Iraq el-Amir region near Amman, there may be evidence for a series of trails along the edges of wadis, marked by small 'forts' (Ji 2001).

It is usually assumed that the 'King's Highway' was the route for the Arabian trade, which was certainly functioning by the eighth century BC if not earlier, and some have argued for its existence as early as the Late Bronze Age (cf. Bienkowski 1992: 9 n.7). Graf (1992: 256) notes that, after the annexation of Nabataea in AD 106, the Romans incorporated the northern branches of the old incense route into their new road system, the Via Nova Traiana. Nevertheless, that this was the actual route of the Arabian trade is no more than an assumption. The earliest evidence for the actual routes of

1 A new approach to tracing ancient roads is the use of Geographic Information System models, using terrain features such as slope gradient, water sources and natural geographical obstacles to map the most likely natural route between settlements. Initial work has been carried out by Borstad (2000) to validate a model by testing it against existing evidence for the Roman road between Livias and Esbus (Roman Hisban) which was probably built c. AD 130 and two-thirds of which can be reconstructed from surviving physical evidence such as the roadbed, milestones and forts (Ibach in Merling and Geraty eds. 1994: 68–75).

the Arabian trade comes from the Hellenistic period,[2] by which time the routes had changed because at least some of the trade already went by sea (Bowersock 1983: 64; Crone 1987: 18–26). The Nabataean route from Petra to Gaza went through the Negev (Cohen 1982). Syria and Mesopotamia are also mentioned as final destinations, but the route is not specified. We need not envisage a major overland route—Pliny states that frankincense was transported in Roman times through Minaean territory 'along one narrow track' (*Natural History* 12, 54). A possible alternative route was via the Wadi Sirhan to the east (Macdonald 1997); Umm el-Jimal and Bostra would have been conveniently located on that alternative route (cf. Vries 1993: 453).[3] It is clear that the route for the Arabian trade is debatable even for later times when at least there is some scanty evidence.

It has also often been assumed that the 'King's Highway' was part of the Assyrian 'royal road' system and that it was from there that the biblical writers borrowed the name (Oded 1970). There is in fact no evidence at all for actual Assyrian presence anywhere in Jordan. If there was a 'King's Highway', it had nothing to do with the carefully maintained Assyrian 'royal road', which was a network between Assyrian provinces only and not a link to tributary states (Bienkowski 2000); in Assyrian sources, there is no mention of the 'royal road' (*harran or hul šarri*) anywhere west of the Euphrates (Kessler 1997: 131).

Graf (1993: 156–60) attempts to reconstruct a Persian 'royal road' system in Syria-Palestine, including Jordan. From Damascus his proposed route links Bostra, Amman, Hisban, Karak, Busayra, Tawilan, Fardakh and Tell el-Kheleifeh. These are sites which have all allegedly yielded Persian-period finds and which are along the route of the Via Nova Traiana. Graf suggests that the Roman road may have had a Persian predecessor, but much of the evidence is tenuous: there are no specifically Persian-period finds from Karak or Fardakh (which is included only because the name seems to be of Persian derivation) and there is no evidence for an actual road.

2 The earliest definite reference to an Arabian trade is the mid eighth-century BC report by the ruler of Mari and Suhu on the middle Euphrates, describing his interception of a caravan from Saba and Tayma (Cavigneaux and Ismael 1990). This does not really help with the route of the trade and the list of goods carried by the caravan—typical of the north, Phoenicia and even Mesopotamia itself—suggests that it might have been on its way back to South Arabia or in the middle of a trading cycle (Macdonald 1997: 338–40).
3 Note, however, the cautionary comments of de Vries (1998: 237) concerning the exact caravan route.

Perhaps it is time to shift the emphasis quite consciously away from the idea that the most significant route in Jordan prior to the Roman period was a main north-south road. The concept of the 'King's Highway' as the main artery from early times to the present may well be an invention of Glueck's. Considerable evidence from all periods is beginning to suggest that perhaps east-west routes were more significant than those north-south. Neutron activation analysis of pottery from Tell el-Fukhar in northern Jordan shows that from the Middle Bronze Age to the late Iron Age/Persian period there were pottery imports from southern Palestine (McGovern 1997: 423–4), suggesting a route across the highlands of Palestine to either Tell es-Sa'idiyya or Pella, and from there to Irbid and farther east. Koucky (1992: 199–200) has traced two main roads leading west from Pella, as well as roads in other directions. Herr too has stressed east-west contacts rather than those north-south in the Late Bronze and Iron Ages (1997: 171; 2001). Watson (1992: 246) has concluded that in the sixth and seventh centuries AD regional networks in northern Jordan were more east-west than north-south.

Graf similarly has stressed the complex 'transportation lattice' for southern Jordan during the Nabataean and Roman periods, and thinks that focus on the Trajanic road has obscured these alternative routes (1992: 259). There was a complex network of roads in all directions in the Roman period, some of them drawn on ancient maps like the second-century AD *Peutinger Table* (MacAdam 1986: 19–33). There were a number of east-west routes across the Wadi Arabah to the Mediterranean ports and perhaps Egypt. Five or six roads connected to Umm al-Quttain in north-east Jordan, including one to Azraq (Kennedy 1997: 77–80). Nevertheless, the Roman road system existed only under particular circumstances: the maintained roads had imperial strategic considerations which ceased to have relevance outside the Roman period. By the Late Byzantine period much of the military infrastructure had been abandoned and some sections of the Via Nova Traiana were probably defunct, leading to a gradual disappearance of means of communication between regions (Fiema 1993)—perhaps a situation similar to that in other periods. Indeed, the pattern appears to be that 'major' roads through regions were constructed by and maintained for the convenience of powerful central authorities—such as the Roman Via Nova Traiana, and the Umayyad and Ottoman Hajj route—while at other times and for all other purposes there was merely a network of tracks connecting settlements.

All of this is admittedly circumstantial: of course there were some north-south routes—like the Via Nova Traiana—and even the major wadis are passable and are not a total deterrent. The lack of evidence for the existence

of the 'King's Highway' in ancient times is not conclusive, since ancient roads are notoriously difficult to pin down. The Romans may well have constructed the Via Nova Traiana along (part of?) an earlier route. When Ashurbanipal defeated the Arabs during his ninth campaign in the mid-seventh century BC, his inscriptions list the names of the places where the battles took place, in Syria, Ammon, Moab and Edom, implying a north-south route passable by the Assyrian army (cf. Bienkowski 1992: 4–5). The cuneiform tablet excavated at Tawilan, north of Petra in Edom—but written in Harran, 900 km away in north Syria—dating to the accession year of one of the Achaemenid kings named Darius (Dalley in Bennett and Bienkowski 1995: 67–8), implies that whatever Edom's status within the empire, there were no barriers to communication and commerce with the rest of the Persian empire, and long-range north-south travel was clearly possible. Nevertheless, the evidence from northern and central Jordan appears in many periods to reflect east-west contacts across the Jordan river to Palestine (and Egypt?), while southern Jordan seems to have a settlement pattern—and occasionally material remains—more in common with the Negev and Sinai than with northern Jordan (Bienkowski 1992: 7–8; Bienkowski and Steen 2001). This suggests the existence of desert routes across the Wadi Arabah which are documented for the Nabataean/Roman/Byzantine and possibly Iron Age periods but not others (cf. Finkelstein 1995: 155–7).

The nature and amount of contact between regions in antiquity was obviously dependent on the number and types of routes within and between them, and this was undoubtedly a factor in any material variation between regions. Even the Iron Age kingdoms seem to have comprised small, tribally organized isolated settlements with little contact among themselves and with their respective 'capitals'. In Jordan, the borders of the modern state, the modern road system, the known route of the Via Nova Traiana and the north-south distribution of settlements, ancient and modern, have all tended to create a pattern in archaeological thinking that perhaps unconsciously imposes a north-south view of communication in antiquity. Glueck's strong views concerning the 'King's Highway' have been influential in establishing this framework:

> It may be accepted as axiomatic that from the very dawn of history in Transjordan this central track through the country was always the main line of march.
>
> (Glueck 1940: 22)

This was not necessarily the case and perhaps greater emphasis should be placed on the concept of a network of trails between settlements rather than

a main north-south route, except perhaps during the Roman and Umayyad periods. Indeed, the evidence of strong north-south regional variation from the Neolithic to the Early Islamic periods should lead us to consider whether topographical factors made east-west routes and contacts more obvious, convenient and available.

REFERENCES CITED

Abu Nowar, M.
1989 *The History of the Hashemite Kingdom of Jordan I: The Creation and Development of Transjordan: 1920–1929.* Oxford: Ithaca Press.

Bartlett, J. R.
1989 *Edom and the Edomites.* Sheffield: JSOT Press.

Bell, G. L.
1908 *Syria: The Desert and the Sown.* London: Heinemann.

Bennett, C-M. and Bienkowski, P.
1995 *Excavations at Tawilan in Southern Jordan.* Oxford: Oxford University Press.

Bienkowski, P.
1992 The beginning of the Iron Age in southern Jordan: a framework. In *Early Edom and Moab: The Beginning of the Iron Age in Southern Jordan* (P. Bienkowski, ed.). Sheffield: J. R. Collis, 1–12.

2000 Transjordan and Assyria. In *The Archaeology of Jordan and Beyond: Essays in Honor of James A. Sauer* (L. E. Stager, J. A. Greene and M. D. Coogan, eds.). Winona Lake: Eisenbrauns, Harvard: Semitic Museum, 44–58.

Bienkowski, P. and Adams, R.
1999 Soundings at Ash-Shorabat and Khirbat Dubab in the Wadi Hasa, Jordan: the pottery. *Levant* 31: 149–72.

Bienkowski, P. and Steen, E. van der
2001 Tribes, trade and towns: a new framework for the late Iron Age in southern Jordan and the Negev. *Bulletin of the American Schools of Oriental Research* 323: 21–47.

Borstad, K. A.
2000 *Ancient Roads in the Madaba Plains of Transjordan: Research From a Geographic Perspective.* UMI Dissertation Services.

Bowersock, G. W.
1983 *Roman Arabia.* Cambridge: Harvard University Press.

Cavigneaux, A. and Ismail, B. K.
1990 Die Statthalter von Suhu und Mari in 8 Jh. v. Chr. *Baghdader Mitteilungen* 21: 321–456.

Cohen, R.
1982 New light on the Petra-Gaza road. *Biblical Archaeologist* 45: 240–7.

Crone, P.
1987 *Meccan Trade and the Rise of Islam.* Princeton: Princeton University Press.

Daher, R.
1995 The resurrection of the Hijaz railroad line. *Studies in the History and Archaeology of Jordan* 5: 341–9.

Dearman, J. A.
1992 Settlement patterns and the beginning of the Iron Age in Moab. In *Early Edom and Moab: The Beginning of the Iron Age in Southern Jordan* (P. Bien-

kowski, ed.). Sheffield: J. R. Collis, 65–75.

1997 Roads and settlements in Moab. *Biblical Archaeologist* 60/4: 205–13.

Donnan, G.

1996 *The King's Highway*. Amman: Al Kutba.

Eigeland, T.

1997 Understanding the Badia. *Aramco World* 48/6: 8–17.

Fiema, Z. T.

1993 Tuwaneh and the *Via Nova Traiana* in southern Jordan: a short note on the 1992 season. *Annual of the Department of Antiquities of Jordan* 37: 549–50.

Finkelstein, I.

1995 *Living on the Fringe: The Archaeology and History of the Negev, Sinai and Neighbouring Regions in the Bronze and Iron Ages*. Sheffield: Academic Press.

1998 From sherds to history: review article. *Israel Exploration Journal* 48: 120–31.

Glueck, N.

1940 *The Other Side of the Jordan*. New Haven: American Schools of Oriental Research.

Graf, D. F.

1992 Nabataean settlements and Roman occupation in Arabia Petraea. *Studies in the History and Archaeology of Jordan* 4: 253–60.

1993 The Persian royal road system in Syria-Palestine. *Transeuphratène* 6: 149–68.

Harrison, T.

1997 Shifting patterns of settlement in the highlands of central Jordan during the early Bronze Age. *Bulletin of the American Schools of Oriental Research* 306: 1–37.

Hendrix, R. E., Drey, P. R. and Storfjell, J. B.

1997 *Ancient Pottery of Transjordan: An Introduction Utilizing Published Whole Forms—Late Neolithic through Late Islamic*. Berrien Springs: Andrews University Press.

Herr, L. G.

1997 The Iron Age II period: emerging nations. *Biblical Archaeologist* 60/3: 114–83.

2001 Social systems in central Jordan: moving toward the first millennium BC and the earliest Iron Age polities. *Studies in the History and Archaeology of Jordan* 7: 275–84.

Herr, L. G. and Najjar, M.

2001 The Iron Age. In *The Archaeology of Jordan* (B. MacDonald, R. Adams and P. Bienkowski, eds.). Sheffield: Sheffield Academic Press, 323–45.

Ji, C.-H.

2001 Iraq al-'Amir and the Hellenistic settlements in central and northern Jordan. *Studies in the History and Archaeology of Jordan* 7: 379–90.

Kamlah, J.

2001 Patterns of regionalism: the plateau of northern Jordan during the early Bronze Age in light of the Zayraqun survey. *Studies in the History and Archaeology of Jordan* 7: 211–6.

Kennedy, D.

1997 Roman roads and routes in northeast Jordan. *Levant* 29: 71–93.

Kerner, S.

1997 Status, perspectives and future goals in Jordanian Chalcolithic research. In *The Prehistory of Jordan, II: Perspectives from 1997* (H. G. K. Gebel, Z. Kafafi and G. O. Rollefson, eds.). Berlin: Ex Oriente, 465–74.

Kessler, K.

1997 'Royal roads' and other questions of the Neo-Assyrian communication system. In *Assyria 1995* (S. Parpola and R. M. Whiting, eds.). Helsinki: Neo-Assyrian Text Corpus Project, 129–36.

Kitchen, K. A.

1992 The Egyptian evidence on ancient Jordan. In *Early Edom and Moab: The Beginning of the Iron Age in Southern Jordan* (P. Bienkowski, ed.). Sheffield: J. R. Collis, 21–34.

Koucky, F. L.

1992 The environs of Pella: roads, fords, and occupational sites. In *Pella in Jordan 2*, (A.W. McNicoll et al., eds.). Mediterranean Archaeology Supplement 2. Sydney, 199–204.

LaBianca, Ø. S. and Younker R. W.

1995 The kingdoms of Ammon, Moab and Edom: the archaeology of society in Late Bronze/Iron Age Transjordan (ca. 1400–500 BCE). In *The Archaeology of Society in the Holy Land* (T. E. Levy, ed.). London: Leicester University Press, 399–415, 590–4.

MacAdam, H. I.

1986 *Studies in the History of the Roman Province of Arabia: The Northern Sector*. Oxford: BAR-IS 295. Oxford: British Archaeological Reports.

MacDonald, B.

1996 Survey and excavation: a comparison of survey and excavation results from sites of the Wadi al-Hasa and the southern al-Aghwar and northeast 'Arabah archaeological surveys. *Annual of the Department of Antiquities of Jordan* 40: 323–7.

Macdonald, M. C. A.

1997 Trade routes and trade goods at the northern end of the 'incense road' in the first millennium BC. In *Profumi d'Arabia* (A. Avanzini, ed.). Rome: 'L'Erma' di Bretschneider, 333–49.

McGovern, P. E.

1997 A ceramic sequence for northern Jordan: an archaeological and chemical perspective. *Studies in the History and Archaeology of Jordan* 6: 421–5.

Magness-Gardiner, B.

1997 The Middle Bronze Age of Transjordan. In *The Hyksos: New Historical and Archaeological Perspectives* (E. Oren, ed.). Philadelphia: University of Pennsylvania Museum, 303–26.

Merling, D. and L. T. Geraty (eds.)

1994 *Hesban After 25 Years*. Berrien Springs: Institute of Archaeology/Siegfried H. Horn Archaeological Museum.

Miller, J. M.

1982 Recent archaeological developments relevant to ancient Moab. *Studies in the History and Archaeology of Jordan* 1: 169–73.

1989 Moab and the Moabites. In *Studies in the Mesha Inscription and Moab* (J. A. Dearman, ed.). Atlanta: Scholars Press, 1–40.

Miller, J. M. (ed.)

1991 *Archaeological Survey of the Kerak Plateau*. Atlanta: Scholars Press.

Najjar, M.

1992 The Jordan Valley (east bank) during the Middle Bronze Age in the light of new excavations. *Studies in the History and Archaeology of Jordan* 4: 149–53.

Oded, B.

1970 Observations on methods of Assyrian rule in Transjordania after the Palestinian campaign of Tiglath-Pileser III. *Journal of Near Eastern Studies* 29: 177–86.

Palumbo, G. and Peterman, G.

1993 Early Bronze Age IV ceramic regionalism in central Jordan. *Bulletin of the American Schools of Oriental Research* 289: 23–32.

Petersen, A.

1989 Early Ottoman forts on the Darb al-Hajj. *Levant* 21: 97–117.

Philip, G.

2001 The Early Bronze I–III Ages. In *The Archaeology of Jordan* (B. MacDonald,

R. Adams and P. Bienkowski, eds.). Sheffield: Sheffield Academic Press, 163–232.

Prag, K.
2001 The third millennium in Jordan: a perspective, past and future. *Studies in the History and Archaeology of Jordan* 7: 179–91.

Rollefson, G. O.
2001 The Neolithic period. In *The Archaeology of Jordan* (B. MacDonald, R. Adams and P. Bienkowski, eds.). Sheffield: Sheffield Academic Press, 67–105.

Schick, R.
1998 Palestine in the Early Islamic period: luxuriant legacy. *Near Eastern Archaeology* 61/2: 74–108.

Schwartz, G. M. and Falconer, S. E.
1994 Rural approaches to social complexity. In *Archaeological Views from the Countryside: Village Communities in Early Complex Societies* (G. M. Schwartz and S. E. Falconer, eds.). Washington: Smithsonian Institution Press, 1–9.

Smith, A. M., Stevens, M. and Niemi, T. M.
1997 The Southeast Araba Archaeological Survey: a preliminary report of the 1994 season. *Bulletin of the American Schools of Oriental Research* 305: 45–71.

Strange, J.
2001 The Late Bronze Age. In *The Archaeology of Jordan* (B. MacDonald, R. Adams and P. Bienkowski, eds.).

Sheffield: Sheffield Academic Press, 291–321.

Vries, B. de
1993 The Umm el-Jimal project, 1981–1992. *Annual of the Department of Antiquities of Jordan* 37: 433–60.

1998 *Umm el-Jimal: A Frontier Town and its Landscape in Northern Jordan volume I—Fieldwork 1972–1981.* Journal of Roman Archaeology Supplementary Series 26. Portsmouth.

Walmsley, A.
1992a Fihl (Pella) and the cities of north Jordan during the Umayyad and Abbasid periods. *Studies in the History and Archaeology of Jordan* 4: 377–84.

1992b The social and economic regime at Fihl (Pella) between the seventh and ninth centuries. In *La Syrie de Byzance à l'Islam VII^e–VIII^e siècles* (P. Canivet and J-P. Rey-Coquais, eds.). Damascus: Institut Français de Damas, 249–61.

1998 Gharandal (Arindela). In Archaeology in Jordan (V. Egan and P. M. Bikai, eds.). *American Journal of Archaeology* 102: 571–606.

Watson, P.
1992 Change in foreign and regional economic links with Pella in the seventh century AD: the ceramic evidence. In *La Syrie de Byzance à l'Islam VII^e–VIII^e siècles* (P. Canivet and J-P. Rey-Coquais, eds.). Damascus: Institut Français de Damas, 233–48.

Von Bissing's *Memphis Stela*: a product of cultural transfer?[1]

Oscar White Muscarella

The tracking of cultural transfers begins with evidence of objects that stand out from the norm. Exotic materials, new technologies and deviations in form, style or decoration are the tell-tale signs of imports or foreign-inspired products of local manufacture. Their presence alerts us to the existence of outside stimuli which raises questions about the nature of contact and its impact on the recipient culture. Knowing the provenience of these objects, their archaeological context, is fundamental to the investigation which they inspire into cultural exchange and interrelations. Without this information, research is severely hampered but unexcavated objects can still yield valuable, if restricted, insights into the nature of outside stimuli, if evaluated in an appropriate fashion.

In his 1987 article on 'tracking cultural transfers', Moorey explores the question of whether writing and other aspects of early civilization reached Egypt from Mesopotamia along with the import of Uruk-type seals, pottery and iconography that were found in predynastic contexts. Moorey focused his research on excavated material, but he was also aware that insights into the character of cultural exchanges and influences on early state formation in Egypt stem in part from the evidence of unprovenienced products. Numerous ivory and embossed sheet-gold knife handles and large carved slate palettes decorated with figural and floral motifs lack archaeological context. Deemed authentic and assigned to predynastic Egypt on stylistic grounds, they bear witness to the syncretistic tastes of an Egyptian elite. Their selection of certain Near Eastern motifs to decorate native ceremonial and votive objects supports the general conclusion, based on a wider range of evidence, that at the end of the fourth millennium BC, elements of foreign imagery were adopted by an already complex society and adapted to suit its own ends. Lack of context may restrict a full analysis of these unexcavated artefacts but

1 It is a personal pleasure and honour for me to dedicate an article to Roger Moorey about whom many good things can be said, all true. He is a learned and intelligent scholar, he is utterly honest and generous without hesitation to all, and he is a paradigm of what a scholar should be in and outside of scholarship.

provided they are genuine, they contribute to the reconstruction of intercultural contact.

Different by definition, objects of foreign or multicultural inspiration sometimes stretch the boundaries of our existing frame of reference. Excavated material is beyond suspicion. But we are obliged to question the authenticity of unconventional objects that lack provenience and find viable criteria that will serve to increase our knowledge of the genuine and eliminate from the record the false information derived from the fake. Failure to query and investigate the background of such artefacts can lead to a skewed understanding of the culture in which they allegedly originated. The present paper is concerned with one of the many examples where scholars failed to question their sources. To some extent our understanding of Egypt's interaction with areas to the East during the fifth century BC has been embellished by the oversight.

In 1930 Freiherr F. W. von Bissing, an Egyptologist as well as a collector and vendor of antiquities (Bissing 1930; Anthes 1934: 90), published a stone relief (called a 'Totenstele') of yellow limestone (Fig. 1), which he had heard about from a dealer named Cassira based in Egypt. According to Cassira's testimony, presented by von Bissing with conviction, the 'stela' was discovered at Mithrine, the site of ancient Memphis, in 1909. Von Bissing neglects to mention in his 1930 publication that he owned the stela or when he purchased it from Cassira (cf. Parlasca 1972, below).[2] The important fact of the stela's purchase and its implications were therefore consistently overlooked by scholars who cited the relief in subsequent years, accepting it as having derived from Memphis. Indeed, some took for granted that it was excavated there, resulting in the name the *Memphis Stela* by which the object has come to be known in literature (viz. Anthes 1934; C. Picard 1935; Culican 1965: 154; Kyrieleis 1969: 39, 148; Parlasca 1972: 76; Gallo 1993: 273; Martin and Nicholls 1978: 66–7; Ray 1988: 273; Briant 1992: 90–1; 1996: 974; Mathieson et al. 1995).

The *Memphis Stela* is rectangular in shape, measuring 23 cm in height, 45 cm in length and 8 cm in width. Von Bissing described its scenes in some detail (1930: 226–7): the funeral bed, the 'Taburett' at its side, the pair of figures at each end, the horizontal projections on either side that function

2 When did he purchase the relief? In the photo caption for the piece (Abb. 1), its provenance is given as Museum Carnelielaan, den Haag (which fooled me in Muscarella 1980: 26), but nothing in the text explains this caption. Von Bissing (1931: 15) acknowledges ownership of this relief along with another one he claims also came from Memphis. Cassira is mentioned only obliquely (ibid. 17); no date is supplied (see n. 5).

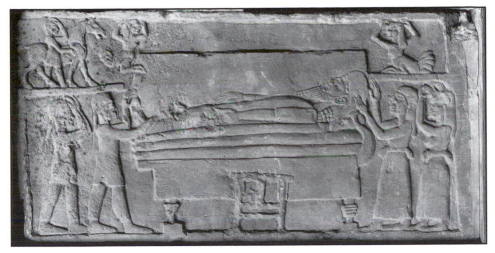

Fig. 1. *Memphis Stela* (Egyptian Museum, Berlin).

both as a roof over the lower figures and as a base for the smaller figures at the top corners. The relief was originally painted with traces of reddish-brown colour still preserved on the face and arms of the deceased, and at the time of purchase, there were also traces of black on his beard.[3]

The corpse is described as lying on three mattresses and the rectangular mass above the bed is thought to be a continuation of the cover that passes under the body and hangs behind the table or stool. The deceased wears a sleeved garment and perhaps shoes. His beard reaches to his breast. His hair bulges at the brow and twisted locks reach his shoulders leaving the ear free. Von Bissing likened the hat to a beret and described the attachments as bands or side flaps that hang down over the second mattress (cf. Bissing 1930: 232).[4]

At the head of the funeral bed are two mourners, both bare-breasted females according to von Bissing because of the bulge on the chest of the rear figure and the mass at their waists which he interprets as rolled-up under-clothing. The left figure caresses the dead man's head, a typical Egyptian gesture according to von Bissing, while the right figure tears at her hair. At the foot of the bed stand two men, apparently without shoes, each wearing a knee-length garment over trousers as well as a hat with an appendage very much like that on the hat of the deceased except that here it clearly hangs

3 Von Bissing's reference to the time of purchase could be understood as an oblique reference to his acquisition of the *Memphis Stela*.
4 In fact, this seems not to be the case, for the flap appears to hang from the back of the hat.

from the back. The two figures visible in the upper corners are described as sirens without further explanation (ibid. 229), possibly because the one at the right seems to have a feathered tail and a clawed front foot. The smaller one to the left overlaps the bed cover to leave room for an open-mouthed horse that is led by a servant with Egyptian hair. He wears a jacket but no trousers, hat or shoes.

Von Bissing noted that his relief was strange and its style coarse (ibid. 229), but as he never doubted its authenticity, these observations did not deter him from attempting to find its place within the artistic traditions of the ancient world. As a relevant comparison, in particular for the presence of mourners in the death scene, he cites a fifth-century BC Egyptian stela with an Aramaic inscription in the Vatican (ibid. 229–30, Fig. 3). The only parallel for the funeral bed with its upturned head section as well as for the stool comes from Neo-Assyrian art; namely, Assurbanipal's garden relief (ibid. 231). Also considered Assyrian in inspiration are the hair and beard of the deceased. Von Bissing refers to a statue of Assurnasirpal II and reliefs of Sargon II from the ninth and eighth centuries BC although he also notes deviations. The typically Assyrian horizontal division of the beard, for example, does not occur on the Memphis relief; a deviation which von Bissing explains as a misunderstanding on the part of the ancient craftsman and construes as evidence for its Egyptian manufacture. Another comparison for the hair and the dead man's hat with what he saw as side flaps leads him to a vessel from the Crimea (ibid. 231, Fig. 4) which appears to show Persians wearing hats with side flaps—unlike those worn by the Persian tribes on the Persepolis reliefs that have only one appendage hanging from the back. The hair of these Persians also compares favourably with that of the deceased and his attendants on the Memphis relief.

The funeral bed, the stool as well as the dead man's hair and beard all suggested an Assyrian background. However, the hats with flaps pointed to a Persian connection, as did the trousers worn by the male mourners on the *Memphis Stela* and the presence of a horse which played an important role in Persia (ibid. 234). The *Memphis Stela* also included Greek and Egyptian elements. The sirens were deemed to be Greek, although von Bissing knew of no parallels (ibid. 235), and the wailing women recalled Egyptian practices, although it appears that they were not unknown among Persians (ibid. 231–2).

Faced with a 'stela' that was said to come from Memphis and had obvious Assyro-Persian comparanda, von Bissing concluded that the dead man was an important Persian resident in Egypt who died during the reign of

Darius the Great, at the end of the sixth century BC, when Achaemenid art still closely adhered to Assyrian prototypes. To him, such works incorporating Persian, Greek and Egyptian elements were not uncommon in Memphis and he presented as evidence other examples, a number of hybrid seal impressions and terracotta figurines of foreigners, all of which were also unprovenienced and privately owned, indeed, some by von Bissing himself (ibid. 234–5).[5]

R. Anthes published the stela in 1934, recording its purchase that year by the Berlin Museum (no. 23721) from von Bissing. He did not doubt that it derived from Memphis (1934: 99). This findspot, the material, the coarse technical execution and the overall style were all indications, he claimed, of its Egyptian origin, although the rest appeared to him to be strange. The shape has no Egyptian parallels, although he calls it a stela, and he notes that the representation of the dead man's right arm rising from behind the body is also un-Egyptian. Anthes refers to the rectangular area over the dead man's head as a 'Bahrtuch' and offers only Greek parallels (ibid. 93, n. 2). Of the figures, only the mourning females could be considered Egyptian and perhaps also the servant beside the horse, unless he wears the same clothes as the male figures below. Anthes does not cite the Vatican stela (ibid. 100) but agrees with von Bissing that the bed and table and the hair and beard are Assyrian in style, and that the clothing worn by the dead man and his two male attendants recall the attire of the Persians and Scythians represented at Persepolis. Their hats, however, he would not compare with those on the Crimean vessel although they could fit into an Iranian or Scythian sphere; to support this view he cites the horse. He too cannot find parallels for the sirens. Thus, non-Egyptian (that is, Assyrian and vaguely Iranian) elements prevail. Because of the lack of Persian elements, Anthes favours an earlier date than von Bissing, placing it before the Achaemenid period, in the Saite Dynasty, 663–525 BC. For him too, the dead man was a foreigner who died and was buried in Egypt (ibid. 101).

5 Von Bissing also published four other photographs at the end of his text, only two of which he mentions in the text (1930: 236). One is his Abb. 6, a clay head, which he says is Achaemenid from Memphis. He compares it with a clay head (Abb. 8) which he says is a Semite (no provenience is given). Both would appear to be forgeries. In the photo credits on p. 238 it transpires that Abb. 5, a clay horseman, Abb. 7, a clay head, and Abb. 8 are in his private collection. The last two are listed in the photo captions as from Memphis and, again, both are surely forgeries. The photo credits fail to mention that Abb. 1, the relief under discussion here, also belonged to von Bissing. I thank Professor Wildung of the Egyptian Museum in Berlin for granting me permission to publish this relief, knowing that I question its authenticity.

C. Picard (1935) accepted that the relief, here now correctly called a 'panneau' rather than a stela,[6] was made of Memphite stone. Like Anthes, he too recognized that the shape of the relief is unknown in Egypt, but he ignored Anthes' disclaimer about the visible rear arm and refers only to the portrayal of one arm which he considers to be conventional (ibid. 93). He compares the scene to that of a Greek prothesis but questions the Greek origin of the sirens, citing for comparison instead a famous relief from Xanthos in the British Museum (ibid. 93). The female mourners may be Egyptian, as von Bissing and Anthes claimed, but Picard points out that they have close analogues on the Phoenician sarcophagus of Ahiram and that the custom of wailing was not confined to Egypt. In fact, he thinks that the model of death is Iranian. In common with his predecessors, Picard recognizes isolated Assyrian elements such as hair style. The horse, he says, belonged to a satrap and is evidence of the syncretistic nature of the relief, which he considers to be a 'rare et précieux' witness to the presence of Persians in Egypt. Picard disagrees with Anthes' early dating, believing the foreign resident to have lived at the time of Cambyses (ibid. 93–4).[7]

W. Culican thought the representation 'from Memphis' to be 'curious', depicting the 'funeral of a Persian or Median noble' (1965: 154–5). To him, the bed and table resemble Assyrian- or Achaemenid-style furniture, likewise for the style of the dead man's hair and beard. However, the dead man's sleeved garment and hat are Median, the male mourners at the foot of the bed are Median or Scyths and the presence of a horse at a burial is a Scythian custom.

H. Kyrieleis, referring only casually to the Memphis grave relief without regard to previous publications (1969: 19), states that it was a Persian-Egyptian relief from Memphis of the fifth century BC. In keeping with his general discussion of furniture, he did not discuss the representations on the relief except to point out (like von Bissing before him) that the best parallel for the funeral bed was that on Assurbanipal's garden relief. To Kyrieleis, the rectangular area over the funeral bed is a cloth characteristic of Persian custom although in support of this claim, he cited not a Persian bed but the cloth covering Persian throne seats (ibid. 148). K. Parlasca accorded the relief only one sentence and a footnote to observe that it derived from Memphis and depicted the laying-out of a Persian from the time around 500 BC (1972: 76

6 Scholars subsequently referred to it either as a stela or a relief.
7 Picard claimed that both von Bissing and Anthes dated the relief to the period of Psammetichus. In fact, only Anthes dated the relief that early. Thus, Picard actually agreed with von Bissing.

with n. 22). He repeated that the relief was found in 1909 and that von Bissing purchased it from Cassira in Cairo, not previously mentioned by von Bissing. When he next referred to the relief, he described it as among the 'most famous archaeological testimonies of the first Persian period . . .' (1979: 318).

In more recent times von Bissing's stela continued to be accepted as an important Egyptian monument from Memphis that merited serious discussion. According to G. T. Martin and R. V. Nicholls (1978: 66–7), it is a stela that represents 'a Persian dignitary in "Median" dress from Memphis'. They note comparisons with the Persepolis reliefs but also bring in Graeco-Persian grave reliefs from Daskylion and elsewhere in Asia Minor and conclude that it 'shows an essentially Greek concept rendered in a Graeco-Persian style.' The relief is considered late sixth century BC in date because in their view the deceased's 'beard and Median dress . . . and the curving profile of the horse's head' reflect the 'conventions developed by Darius at Persepolis.' The authors relate the relief's style and technique to the Vatican stela which, although unexcavated, they also believed originated from Memphis.

In 1980 (36) I too cited the piece, not as a forgery, for I barely looked at it, but as a forgery of provenience because there was no evidence that it derived from an Egyptian site.

In the *Cambridge Ancient History*, J. D. Ray refers to the stela to demonstrate that Egypt was a 'richly cosmopolitan state' (1988: 273). Again, the scene is described as showing 'a foreigner in "Median" costume,' but Ray ventures further to propose an historical interpretation, suggesting that 'the representation could be taken as a likeness of Atiyawahi or his brother' (Egyptian children of a recorded Persian-Egyptian marriage) and that, moreover, 'the artist may have been East Greek.'

P. Briant accepts that the subject of the Memphis relief is a Persian noble, but following Picard, he compares the scene with that of a Greek prothesis (1992: 90–1). Later, he refers to the same relief as an 'intéressant document funéraire' that was found at Memphis and portrays a man clothed as a Persian or Mede (1996: 974). Gallo, in his article on stelae, merely mentions the relief as being from Memphis and depicting the prothesis of a Persian (1993: 273). Finally, we find reference to the *Memphis Stela* in an article by Mathieson et al. (1995: 38). Taking for granted that it comes from Memphis and that it shows the mortuary rites of a Persian, they cite the stela as a parallel to an excavated example (see below) and with that they confer upon the *Memphis Stela* the ultimate stamp of approval.

By following von Bissing's lead in accepting a dealer's *parti pris* statement about the source of an item on sale, scholars have treated the *Memphis Stela* as

an excavated object that needs only to be assigned an ancient date to become a useful index of intercultural connections. The dealer's claim became fact and rendered further investigation into anomalies unnecessary; an example of blind faith that remains quite common in archaeological research of the 20th century.[8] In this particular case, failure to check the reliability of the source and to question aberrations in shape, content and design have affected our perception of Perso-Egyptian interaction and cultural transfer.

Evidence for cross-cultural influence between Egypt and Persia during the fifth century BC is well attested in the written and visual records of the Achaemenid empire. Recent interpretations of Achaemenid art as exemplified, for example, in the writings of Margaret Root (1979), propose that official Achaemenid art was used as a vehicle for propaganda and that images from the court were widely dispersed over the entire empire. A version of the Bisitun relief has been reconstructed from carved stone, and possibly also from glazed brick, fragments found in Babylon and Susa (Seidl 1976, 1999; Canby 1979; Muscarella 1992: 221, n. 14), and it has been suggested that similar pictorial monuments were set up by Darius throughout the Persian empire just as copies of the Bisitun inscription were sent out and indeed have been found in Babylon (Seidl 1999) and Elephantine in Egypt. Achaemenid royal imagery was known in the empire and documented abroad. The scene of the enthroned king, for example, which formed the centre piece of the Apadana façades at Persepolis and the main motif of the door-ways of the Hall of 100 Columns, is found on the inner side of a shield carried by a Persian on the Alexander sarcophagus from Sidon and on seal impressions from Daskyleion (Root 1979: 12, 122).

There are also monuments in which Egyptian and Persian conventions are combined. The *Canal Stelae* of Darius, for example, have one side inscribed in cuneiform and the other in Egyptian hieroglyphics (Root 1979: 61–2). Another example is the *Statue of Darius* found in 1972 at Susa but undoubtedly carved in Egypt from Egyptian stone (Root 1979: 68–9; Muscarella 1992: 219–20, Fig. 50, with bibliography). Its base is essentially Egyptian but traces of multicultural influence are evident in the un-Egyptian representation of the subject peoples, whose hands are raised in prayer or supplication rather than tied behind their backs, and in the misinterpretation of certain motifs such as the bell-shaped headdress worn by the Babylonian which the Egyptian sculptor rendered as the White Crown of Egypt. The

8 For the predisposition of scholars to equate dealers' claims about proveniences with archaeological reports, see Muscarella 2000a: 13–4, passim. See also idem (2000b: 29–37).

statue of the king follows almost exactly the models of the reliefs at Persepolis albeit with a few traditional Egyptian elements such as the back pillar and the short staff held in the closed fist. Whether these Egyptian features would have been typical of Achaemenid royal statues made outside Egypt, like other Egyptian features such as the winged disc and cavetto cornice that appear at Persepolis, cannot be confirmed, for apart from this statue no monumental sculpture of the Persian king has been recovered anywhere. There are five different coloured stone fragments also from Susa (Root 1979: 111–2; Muscarella 1992: 219–20) that depict at least two to four human figures, one or more of which might have come from a royal statue, but their place of manufacture, whether in Susa or in Egypt, remains unknown.

The extent to which Achaemenid court art influenced the non-royal or unofficial art produced in Egypt is difficult to establish. There were Egyptians present in Persia (as attested by the Persepolis Fortification Texts) and Persian and other foreigners in the service of the Persian administration were resident in Egypt. Sometimes there is evidence for marriages between Persians and Egyptians but how much the various different ethnic communities influenced each other is in most cases uncertain.

Speculation about the adoption of Egyptian mortuary practices in Persia was recently revived by a 'said to have been' discovered Persian Princess whose mummified body surfaced in Pakistan. The inscribed wood sarcophagus containing the mummy was claimed to belong to a daughter of Xerxes. The entire unit (mummy, sarcophagus and inscription) is in fact a badly constructed forgery. Nor is there any substance to the claim that Persians practiced embalming in their homeland as Herodotus (I, 140) was incorrectly alleged to have reported; in fact, he states only that they covered their dead with wax before burial. That someone should devise such a ruse, attempt to market it and even succeed in fooling some individuals, suggests that the forgers believed there was a case for documenting that Egyptian practices were adopted by the Persians. Here, of course, the *Memphis Stela* comes to mind,[9] but as a purchased item, it requires careful scrutiny before it can be assimilated into the debate on Persian residents abroad.

9 I became interested in the Memphis relief after my involvement with the so-called Persian Princess, which I determined was a forgery. Because some individuals, including several Zoroastrians in California and several newspapers, asserted that the mummy documented Persian practice of mummification after the Egyptian fashion, I decided to investigate. It was then that I recalled the von Bissing relief in Berlin and began to look into its background (more fully than I did for my 1980 paper!). For the true history and uncovering of the forgery see Romey and Rose (2001). The creators of a TV documentary about the mummy give an inaccurate account.

For comparison and as an objec-
tive control on the stylistic criteria
used to evaluate the *Memphis Stela*,
we now have the advantage of ref-
erence to a similar syncretistic scene,
this one on an excavated funerary
stela from Saqqara (Fig. 2), the ancient
cemetery at Memphis (Mathieson et
al. 1995: 26ff, Fig. 3). Like its genu-
ine counterpart from Saqqara, von
Bissing's stela is made of limestone;[10]
however, its shape and state of pres-
ervation differ. The Saqqara stela is
conventional in form with a rectan-
gular body surmounted by a rounded
top (like the Vatican stela mentioned
above) and apart from the natural ef-
fects of erosion and minor damages
to its edges, is in excellent condition
(Mathieson et al. 1995: 26). The rec-
tangular shape of von Bissing's relief
struck many scholars as odd and, as

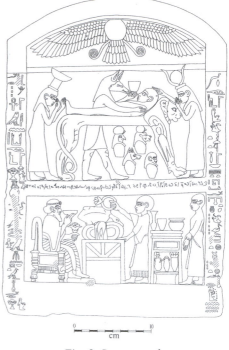

Fig. 2. Saqqara stela
(Mathieson et al. 1995: Fig. 3).

Picard first pointed out, it has more in common with a relief. The evidence
against accepting von Bissing's relief as ancient increases when we compare
its subject matter and iconography with those of the Saqqara stela. Both
monuments depict the burial rites of a prominent foreigner. In the case of
the Saqqara stela, the inscription records that the deceased was of mixed
Persian and Egyptian parentage and the iconography of a mummy and an
enthroned figure in Persian dress (whoever he may be) makes clear that the
family was both well off and well connected. Von Bissing's purchased relief
is not inscribed and the deceased's identification as a Persian of high standing
has been assumed from his beard, attire, furniture, attendant mourners and
the horse.

As hybrid products of Egypto-Persian background, one expects both
monuments to include elements of local (Egyptian) and foreign (Persian)
iconography. Nor should the presence of unparalleled traits surprise us as

10 The Saqqara stela is made of Tura limestone. That of the *Memphis Stela* is described as
yellow but has not been analyzed.

conventions of one culture were often misunderstood by craftsmen from another and, in any case, our perception of the norm is liable to change. On the Saqqara stela only a minority of Persian features appear to be unique: the circlet around the head of the enthroned Persian, the drape and mattress on the chair on which he sits, the torque or ring presented to him, the second offering table and the finger position which seems closer to the Assyrian manner (Mathieson et al. 1995: 30–1). All other elements of the funerary scene can be traced in Late Period Egyptian or Achaemenid art while some, like the winged disk and the lion bier, combine characteristics of both (ibid. 28, 31).

On von Bissing's 'stela' viable and recognizable elements and comparisons are few and imprecisely rendered. The two 'sirens' and the rectangular bed cover have no parallels. The stool/table, although considered Assyrian, is also without analogues and like other sections of the relief seems to have been consciously mutilated to suggest age or conceal poor workmanship.[11] The funerary bed is said to resemble the furniture in Assurbanipal's garden relief, but note the awkward rendering of the headrest, on which the deceased's head rests improperly, and the two differently carved feet. The dead man's hair and beard are fashioned after Assyrian style but with marked differences. His raised rear arm conforms to neither Egyptian nor Persian convention. His hat and those of his male attendants are alternately described as Persian, Scythian or Median. Unlike Scythians and Medes, these men wear tight trousers and their shoes are not adorned with straps. Egyptian and Phoenician parallels have been cited for the two female mourners but there are distinct formal and stylistic differences in posture, clothing and arm positions, notably in the case of the second mourner whose right hand appears unattached above her head. Its large proportion of incomparable traits, lack of provenience, unusual shape and inexplicable damage (see below) all argue against von Bissing's 'stela'. In addition there is the anomaly of craftsmanship. Described as coarse by its owner, the quality and style of von Bissing's 'stela' do not compare with the careful modeling of the Saqqara stela. While subjective and normally of little consequence, this observation does have a bearing on the case at hand when one considers that the deceased in both cases appear to come from wealthy families. The dead man on von Bissing's

11 Deliberate damage to reliefs is usually the result of a politically motivated act of iconoclasm directed at key figures of authority. The funerary monument of a nameless foreign resident in Egypt is unlikely to have aroused such feelings of aggression and, in any case, the damage to the Memphis relief is randomly distributed, affecting not only the face and left hand of the deceased but two of his attendant mourners and a harmless stool/table as well.

'stela' had expensive furniture, attendants and a horse. It is unlikely that his family provided him with an elaborate funeral but could not afford an experienced craftsman or a stone that was better suited to a multi-level composition. The *Memphis Stela* was probably made in Egypt by a craftsman who lived in the early 20th century.

In the current climate of archaeological research, which advocates the use of only verifiable sources of information, objects that come from controlled excavations take precedence over those that do not (Muscarella 2000a). This privileging of excavated material ensures a sound database for research and inevitably casts suspicion on all objects of unknown origin, both genuine and fake. Scholars who want to learn information from unprovenienced objects are obliged to make a case for accepting them as manifestly ancient rather than assuming this on misplaced faith alone. The verdict on the case of von Bissing's relief paradigms the problem. For discussions on Persian-Egyptian relations and shared customs in the fifth century BC, the remarkable funerary stela excavated at Saqqara, not the von Bissing relief, is a source.[12]

REFERENCES CITED

Anthes, R.
1934 Fünf Neuerwerbungen in der ägyptischen Abteilung. *Berliner Museen Berichte aus den Preussischen Sammlungen* 55: 90–101.

Bissing, F. W. von
1930 Totenstele eines persischen Großen aus Memphis. *Zeitschrift der Deutschen Morgenländischen Gesellschaft* NF9: 226–38.
1931 Osiris im Boot. *Zeitschrift für ägyptische Sprache und Altertumskunde* 67: 115–9.

Briant, P.
1992 *Darius. Les Perses et l'empire.* Gallimard.
1996 *Histoire de l'empire perse. De Cyrus à Alexandre.* Paris: Fayard.

Canby, J. V.
1979 A note on some Susa bricks. *Archäologische Mitteilungen aus Iran* 12: 315–20.

Culican, W.
1965 *The Medes and the Persians.* New York.

Gallo, P.
1993 Une stèle 'Hellènomemphite' de l'ex-collection Nahhman. *Bulletin de l'institut français d'archéologie orientale* 93: 265–74.

Kyrieleis, H.
1969 *Throne und Kline.* Berlin.

Martin, G. T. and Nicholls, R. V.
1978 untitled contribution in Oliver Mason, *Carian Inscriptions from*

12 Although not funerary scenes, the Petosiris reliefs from Egypt (of post-Achaemenid date) are also relevant for such discussions. Here we have classic Egyptian-made tomb reliefs with scenes of ethnic Egyptian craftsmen accurately making Achaemenid-style vessels. See Muscarella (1980: 28–9, Pls. VIII–IX).

North Saqqâra and Buhen. London: Egypt Exploration Society, 57–87.

Mathieson, I. et al.

1995 A stela of the Persian period from Saqqara. *Journal of Egyptian Archaeology* 81: 23–41.

Moorey, P. R. S.

1987 On tracking cultural transfers in prehistory: the case of Egypt and lower Mesopotamia in the fourth millennium BC. In *Centre and Periphery in the Ancient World* (M. Rowlands, M. Larsen and K. Kristiansen, eds.). Cambridge: Cambridge University Press, 36–46.

Muscarella, O. W.

1980 Excavated and unexcavated Achaemenian art. In *Ancient Persia: the Art of an Empire* (D. Schmandt-Besserat, ed.). Malibu, California: Undena Press, 23–42.

1992 Fragment of a royal head. In *The Royal City of Susa* (P. O. Harper et al., eds.). New York: Metropolitan Museum of Art, 219–21.

2000a *The Lie Became Great*. Groningen: STYX Publications.

2000b Excavated in the bazaar: Ashurnasirpal's beaker. *Source* 20/1: 29–37.

Parlasca, K.

1972 Eine Gruppe römische Sepulkralreliefs aus Ägypten. *Forschungen und Berichte* 14: 72–8.

1979 Persische Elemente in der Frühptolemäischen Kunst, Akten des VII. internationalen Kongresses für iranische Kunst und Archäologie, Munich, September 7–10, 1976. *Archäologische Mitteilungen aus Iran*, Ergänzungsband 6: 317–23.

Picard, C.

1935 La satrape au tombeau, relief de Memphis. *Revue Archéologique* 6: 92–4.

Ray, J. D.

1988 Egypt 525–404 BC. In *Cambridge Ancient History* 4/2, 254–86.

Romey K. M. and Rose, M.

2001 Saga of the Persian princess. *Archaeology* January/February: 24–5.

Root, M.

1979 *The King and Kingship in Achaemenid Art*. Acta Iranica 19, Series 3, Leiden.

Seidl, U.

1976 Ein Relief Darius' I. in Babylon. *Archäologische Mitteilungen aus Iran* 9: 125–30.

1999 Ein Monument Darius' I. aus Babylon. *Zeitschrift für Assyriologie und Archäologie* 89/1: 101–14.

Disguise and exchange in eastern imagery

John Boardman

The notion of combining human or animal forms, truncating them or substituting parts to create novel creatures or patterns may seem commonplace, but in antiquity its application had fairly clearly defined limits in time and space and gave rise to some interesting examples of the diffusion of forms, which I attempt to sketch in this paper for an old friend. For us both the Ashmolean Museum has been an ever-present inspiration but for the phenomenon under discussion, I have to range beyond even its widely drawn collections; these remain a profound demonstration of the value of the dissemination of artefacts in the interests of education and scholarship, a merit now under threat from unimaginative application of mindless 'principle', but we must hope that the collections will never cease to develop in pursuit of those interests.

There is a wide range of applications of our subject.[1] At its simplest, there is the combination of parts, usually creating something monstrous which may have an identity—the Mesopotamian winged, horned lion-eagle-scorpion monster or the Greek Chimaera—but more often this may seem an artist's *jeu d'esprit*. There can be substitution and multiplication of parts, generally derived from the same creature, best expressed in nomadic art. There can be combinations in which animal parts are made to serve different entities at the same time—bird-beards and the like. This is a conceit which had inspired some amusing and often somewhat risqué picture postcards of about a hundred years ago; I forbear illustration. And there are even whole animal or human images which are composed from the assembly of other animal or even vegetable forms. The last is more a matter for later art and is exemplified by Giuseppe Arcimboldo in the sixteenth century as well as in a number of Mughal paintings of the seventeenth to nineteenth century.

The duplication of animal parts is a mode we associate most readily with the art of nomads and the Scythians, notably the flowing fantasies that can turn antlers into rows of heads or birds. There are many examples from the

1 I have discussed parts of the subject as shown on seals, Greek and Phoenician, in Boardman 1968: 84; 1980a: 113–4; 1984: 85–6. Roes 1935 deals with several of the pieces noted here and I have used her Fig. 2 for my Fig. 8. Figs. 1–5 here are from photographs by Robert L. Wilkins and Fig. 6 is by the author.

Scythian world, none of them easy to date earlier than the sixth century BC. The concept seems essentially foreign to the arts of Mesopotamia, though northwestern Iran sometimes comes close in the arts of Marlik and Hasanlu. It is a design promoted by the decoration of small objects and goes with a readiness to distort figures to suit the field offered by harness or the like. It is not easy to decide when or where it was first evolved—probably in Central Asia since it also informs the Ordos bronzes which had their effect even on the equally foreign arts of Chou China. These, however, have nothing essential to do with the subject and style studied here. Despite some superficial similarity, it was one of the great artistic creations of early man; what we are studying is an entertaining and instructive sideline, at best.

Parts-substitution appears in a very trivial but perhaps significant way in the Near East in ninth/eighth-century Syria where, for example, the substitution of a bird's head for the tuft at the end of a lion's tail appears quite often (Sakcegözü, Zincirli, Carchemish).[2] Influenced by these creatures, the Greeks formed their own monster, replacing the bird's head at the end of the tail with that of a snake. It was probably also from an eastern source, less well documented, that the Greeks at the same time adopted the idea of topping a wing with an animal head, which is far closer to the nomadic style. This combination may have helped inspire the Greeks' view of the Chimaera, which is essentially a winged lion that has a goat's head on the wing tip (more commonly but not always shown as a simple neck and head) and a snake tail. These concoctions first appear around the mid-seventh century, best observed on the pottery of Corinth.[3]

The next and relatively isolated example of parts-substitution has a Persian flavour although it occurs far from the Persian homeland, in Anatolia, on a stamp seal belonging to a well-known class that served the upper classes of the western satrapies, especially in Lydia (Fig. 1).[4] We see a familiar version of the multi-headed lion monster, here with a boar's and a goat's head. But the wing, properly feathered, takes the form of a lion, forelegs and all, in the scheme of the Greek Chimaera's goat. And it might well be that this isolated instance in the class owes no little to the proximity of Greek, Ionian late archaic artists and engravers, who contribute to this class in other ways, since it does not recur on the many other examples of the creature in quite this form.

2 e.g. Akurgal 1968: Pl. 15b, Figs. 64, 78.
3 On such creations, Boardman 1980b: 79.
4 Boardman 1980a: Fig. IV.26; now in the J. Paul Getty Museum, Malibu.

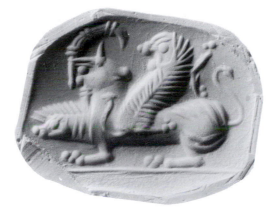

Fig. 1. Impression of chalcedony pyramidal seal.
W. 21 mm. Malibu, J. Paul Getty Museum.

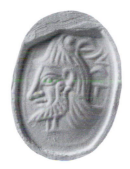

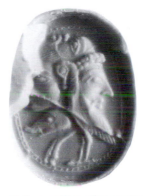

Fig. 2. Impression of cornelian scarab
from Syria. H. 10 mm.
Paris, Bibliothèque Nationale.

Fig. 3. Impression of green jasper
scarab from Tharros. H. 14 mm.
London, British Museum.

The early fifth century sees the introduction of new essays in substitution which were to continue, especially in gem engraving, into the Roman period, where the results are often misnamed *grylli*. The composition is essentially of a human head, but the beard and usually also the neck may be drawn as a long-legged bird. The crown and back of the head are substituted with another head or heads, animal or human, with further confusion of function where ears and hair are involved. One early example occurs on what seems to be a Greek-style scarab that bears a Cypriot inscription and is said to have been found in Syria (Fig. 2). The rest of the head takes the form of a plump bird (rather than a bird-head cap, though such are known later).[5]

5 Paris, Bibl. Nat., Pauvert Coll. no. 89; Boardman 1968: no. 226. A cornelian scarab with a similar device is published by Schlüter et al. 1975: no. 17.

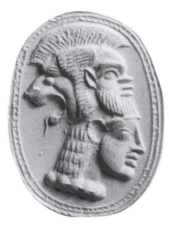

Fig. 4. Impression of green jasper scarab
from Ibiza. H. 14 mm.
Boston, Museum of Fine Arts.

Fig. 5. Impression of green jasper scarab
from Tell Defenneh. H. 20 mm.
London, British Museum.

This type reaches its full expression on several Classical Phoenician scar-
abs that are cut in styles which are late archaic in Greek terms and probably
begin in the late sixth century BC. These scarabs likewise originate within
the Achaemenid Persian empire but they come from areas that are already
permeated by Greek style—indeed, the class was long called Greco-
Phoenician.[6] The scarabs, which are made of green jasper, appear on both
eastern and western (Punic) sites but in this case, at least, there can be no
doubt that the inspiration comes not from the western Mediterranean, but
from those eastern styles, including the Greek, already discussed. Our motif
also draws heavily on Greek subjects such as satyr heads or heads wearing
Greek helmets and other bearded heads (some of which appear negroid) as
well as lion heads, boar foreparts and birds. The one shown here comes from
Tharros in Sardinia (Fig. 3). The bird features here as the ear, beard and neck
of a late archaic Greek head; the crown of the head is a satyr's head (snub-
nosed), the back of the head is formed by another human head, this one
beardless and possibly negroid, and below, emerging from the base of the
head is a boar, whose forelegs seem to define the back of the neck.[7]

The same general formula appears on some ten other examples of this
class that are known to me. This excludes related devices with piles of facing
heads or facing heads composed with profile heads and variations on the

6 The author is preparing a corpus of these scarabs for publication, also now on the internet
(www.beazley.ox.ac.uk).
7 London, British Museum; Walters 1926: no. 428; Boardman 1980a: Fig. IV.26.

janiform theme, human and animal, which are yet more common. Most of those in our scheme are from western sites. This is simply a product of the fact that the Punic cemeteries have been well explored and proved very productive while there are fewer sources, though just as much variety, in the east. Half of the examples include the bird–beard motif. One, from Ibiza, is more Greek than most and lacks the bird but shows a common variant (Fig. 4). The youth's head is deemed helmeted (a motif common for gems in Greece and in this class of scarabs) but the helmet is a combination of a satyr's head and a lion's head, whose mane merges into the helmet crest.[8] Another scarab from Tell Defenneh, an eastern site this time, which lies on the route from the Nile to Palestine and was well visited by Greeks in the sixth century, is more puzzling (Fig.

Fig. 6. Gold ring from Ibiza. L. of bezel 22 mm. Madrid, Archaeological Museum.

5). The bearded warrior wears a helmet formed of a lion head, but a break in the stone prevents us from identifying what was attached to the back of his head, leaving just a hatched area and two hooks at the neck that are difficult to interpret.[9] This motif probably went on being made into the Persian period, though perhaps not beyond the fifth century, and where stylistic features are apparent, they are archaic Greek rather than eastern in origin. Another, and more probable western Phoenician product that bears our motif, is a gold ring in Madrid (Fig. 6), which shows a man's head (Greek style) composed of two birds: the one for the hair bending back to kiss the other, which is a bird–beard. A dolphin appears at the neck–cutoff.[10]

The phenomenon of parts–substitution has other manifestations in the Persian empire but they are far distant from each other. We start near the

8 Boston, Museum of Fine Arts; Boardman 1984: no. 100.
9 London, British Museum; Walters 1926: no. 321.
10 Madrid 35948; Fuentes Estañol 1986: 18, no. 07.01, Fig. 87. The inscription was added in the 3rd/2nd century BC and is obscure. I am indebted to Sebastian Brock for notes on it. The head type with the two birds is long-lived; cf. Furtwängler 1900: Pl. 26.78–80, where the birds are less intimate.

Fig. 7. Silver coin of Gaza. W. 14
mm. Jerusalem, Israel Museum.

home of the Phoenician scarabs and with
a cognate craft—coinage. Achaemenid
motifs are not uncommon on coins of the
later fifth and early fourth century, as well
as several subjects that closely resemble
those on the Phoenician scarabs. At Gaza,
however, there are also composite heads
(Fig. 7). These are essentially lion and
human, but they are sometimes horned and
thus appear to be Achaemenid in inspira-
tion, yet they also include a small lion fore-
part over the human brow, which recalls
sealings from Nippur that we will con-
sider below. There is further complication in the compositions, recently
well-explored by Dr Gitler.[11] Janiform heads are another common motif
with a good Greek/Anatolian pedigree, as well as conjoined animal foreparts
which surely derive from Achaemenid architectural forms that are well known
in the Levant. A speciality of Samaria is the janiform turned into a triple
head.[12]

For other displays of the subject we turn to Persian Babylonia. It appears
in impressions of finger rings with a leaf-shaped bezel. The shape is Greek,
where it is commonest in bronze and was the preferred instrument for seal-
ing, rather than stone seals. The sealings with these composite heads appear
in a hoard found at Ur, now in the British Museum and Philadelphia (where
they have perished in a flood), and recently restudied by Dominique Collon.[13]
The burial must be of around or just before the middle of the fourth century
BC. The designs display several different types of our heads with clear inter-
connections. On the most elaborate there are three very similar types (Fig.
8a–c). On two of these, the head is bearded with a bird-beard, though no
bird legs. Surprisingly, given the origin of these seals, the head is crowned by
either a lion head or an eagle head; behind is a goat head over a fan-shaped
motif (perhaps a peacock's tail). The third, beardless head has a ram's head in
this position and it is crowned by a bird with its neck turned back. There are
also devices with janiform bearded heads topped by a spread-winged bird,
and heads with a ram's head at the neck and a bird with its neck turned back
for the hair.

11 Gitler 2000: 76–7, 81–2, Pls. 1.1, 5, 6 and Pl. 4; Pl. 4.17 is my Fig. 6.
12 Meshorer and Qedar 1999: 109.
13 Collon 1996: 75–76, Fig. 12. cf. Boardman 2000: 156.

Fig. 8. Drawings of sealings from Ur. London, British Museum.

Collon believes that the rings that made the composite-head impressions might all have been the work of one artisan, which seems most probable.[14] This makes their appearance yet more remarkable, since the devices seem not to stem from any local tradition but to be directly inspired by practices elsewhere in the Persian empire. The result, however, is quite idiosyncratic and the style unmistakably influenced by those of the Persian court. The hoard was found in a grave and the impressions, which include copies of Greek coins (of up to a hundred years earlier) and of other small relief objects of Achaemenid type as well as of seals in a great variety of styles, including pure Greek, seem to have been made for record and not for actual sealing of objects or documents (with a very few exceptions, 'used' rather than 'unused' in philatelic terms). Several scholars have surmised that they were a true 'collection', possibly of a seal-engraver, since this would have been the obvious way for him to keep informed about current subjects and styles, and in Ur he would not have been so restricted in his production as he would have been in the Persian homeland. The variety of detail yet uniformity of style might admit the possibility, mooted by Collon, that these are a record of the collector's own skills, accompanying him to his grave.

We are left with the dilemma of the source of the motif in Mesopotamia but another hoard of sealings from a nearby site, Nippur, may hold the answer. This is the archive of the banker Murašû, which is over a generation older than the Ur hoard. Most of the sealings are of familiar Babylonian types, with several Persian motifs also. But a good ten per cent are from finger rings of the type encountered at Ur and they are generally regarded as deriving from the Greek world. Two of them bear something like our motif but with a whole recumbent lion resting on the profile head (Fig. 9); one of them has a bearded head at the back, the other is obscure at this point.[15] The

14 Collon 1996: 78–9, adding other mainly animal studies.
15 Legrain 1925: nos. 971, 972. Bregstein 1996, for discussion of the hoard and the rings, and Pl. 10, Fig. 6, for one of the sealings.

John Boardman

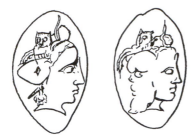

Fig. 9. Drawings of sealings
from Nippur. Philadelphia,
University Museum.

style is Greek, quite unlike the Ur heads, and it is difficult not to deduce that the motif, like the ring type, was introduced from somewhere in the Greek world, possibly no further away than Anatolia. Once it had been introduced— and we cannot say how much earlier than the Nippur hoard this might have been or what variety of forms it might have taken—it inspired a Persianizing treatment on rings of the same type by the seal-engraver of the Ur hoard.

Does this mean that, however unlikely it may have seemed, these composite heads with substitute animal parts were a Greek or Anatolian invention that made its way through the Persian empire, emerging in Babylonia, Phoenicia (scarabs) and in neighbouring states (coins)? It clearly has nothing to do with the nomad practice which was described at the start of this paper: this was a mode with which Greek artists could never cope. On the other hand, the composite heads and substitutes were already familiar in the seventh-century Greek creation of a Chimaera, on the Lydian seal (Fig. 1) that belongs to a series of the late sixth century which was much affected by neighbouring Greek styles, and on the Greek seal with a Cypriot inscription (Fig. 2). Moreover, many of the subjects used in the combinations are commonplace on Greek gems. It was a form of simple surgery, with occasional flights of fantasy (the bird-beard and bird-wig), which well suits much else in archaic Greek glyptic, with its many joined animal parts and whirligigs. If so, this is a rare example of a loan to the east of a formal nature, at a time when other aspects of Greek style, especially the incipient classical style, were also being readily accepted in the Persian empire.

REFERENCES CITED

Akurgal, E.

1968 *The Birth of Greek Art*. London: Methuen.

Boardman, J.

1968 *Archaic Greek Gems*. London: Thames and Hudson.

1980a Greek gem engravers, their subjects and style. In *Ancient Art in Seals* (E. Porada, ed). Princeton: University Press, 101–25.

1980b *The Greeks Overseas*. London: Thames and Hudson (revised in 1999).

1984 *Escarabeos de piedra procedentes de Ibiza*. Madrid: Ministero de Cultura.

2000 *Persia and the West*. London: Thames and Hudson.

Boussac, M.-F. (ed.)

1996 *Archives et Sceaux du Monde Hellénistique*. Bulletin de Correspondance Hellénique Suppl. 29. Paris.

Bregstein, L.

1996 Sealing practices in the fifth century B.C. Muraŝû Archive from Nippur, Iraq. In Boussac (ed.) 1996: 53–63.

Collon, D.

1996 A hoard of sealings from Ur. In Boussac (ed.) 1996: 65–84.

Fuentes Estañol, M. J.

1986 *Corpus de las inscripciones fenicios, punicas y neopunicas de España*. Barcelona.

Furtwängler, A.

1900 *Die antiken Gemmen*. Leipzig/Berlin: Giesecke & Devrient.

Gitler, H.

2000 Achaemenid motifs in the coinage of Ashdod, Ascalon and Gaza from the fourth century BC. *Transeuphratène* 20: 73–87.

Legrain, L.

1925 *The Culture of the Babylonians*. Philadelphia: University of Pennsylvania.

Meshorer, Y. and Qedar, S.

1999 *Samarian Coinage*. Jerusalem: Israel Numismatic Society.

Roes, A.

1935 New light on the *grylli*. *Journal of Hellenic Studies* 55: 232–5.

Schlüter. M. et al.

1975 *Antike Gemmen in deutschen Sammlungen IV (Hannover)*. Wiesbaden: Franz Steiner.

Walters, H. B.

1926 *Catalogue of the Engraved Gems and Cameos in the British Museum*. London: British Museum.

II. Understanding Images

Diana Stein

The Ashmolean Museum, with which Roger Moorey was associated for the duration of his career, has been a major material and inspirational source for his multifarious publications that reach far beyond the mere cataloguing of its contents. Their wide range of subject matter is a reflection of the temporal and geographical span of the museum's Near Eastern collection; their primary purpose to set the record straight, a consequence of its heterogeneous composition.

Extending from Turkey to Iran and from the Neolithic to the Sasanian period, the artefacts displayed in the Draper Gallery derive from a variety of sources: excavations, donations and purchases. In theory, the excavated material forms a class apart as its origin and authenticity are beyond dispute. In practice, however, when one considers the nature of the excavated sample and the circumstances of its recovery, this distinction between artefacts acquired by different means becomes less significant. The museum's holdings of provenanced material from archaeological contexts represents only a selection of the total finds that come from British funded expeditions and the value of the sample is further compromised by uneven methods of excavation that range over a century from the 1870s to the 1980s. Poor control over stratigraphy and unclear recording of sequences, particularly in the case of earlier excavations, have deprived many provenanced objects of their findspots. In publishing these objects from 'controlled' excavations and others, which are not, Roger Moorey's ultimate aim has been to restore each to its proper context, beginning where possible with its source and date and taking into account its relation to other objects of the same category, their manufacture, decoration, distribution and history, before attempting to explain its wider cultural significance.

Throughout his publications, Roger Moorey has applied a 'rigorous consideration of what actually constitutes the available body of evidence' (1975: 19). What might seem an obvious approach today was not common practice in the 1960's at the start of his career. The canvas of ancient Near Eastern history and culture still had sizeable gaps and scholars painted with a larger brush, promoting theories and perspectives that were often based on selec-

tive samples without due regard for their integrity or context. Ethnic identi-
fications of material culture, skewed perceptions of cultural heritage, liberal
interpretations of iconography and the use of misleading nomenclature are
some of the conventions that had not yet been properly addressed. Roger
Moorey has taken up many of these issues in the course of his investigations
of the museum's collection. On several occasions, in connection with his
study of the Luristan bronzes, terracotta plaques and Late Bronze Age tech-
nologies (1970, 1975, 1986, 1989, 1994), he raised questions about the validity
of ethnic and political associations in the archaeological record relating, in
particular, to the Hurrian/Mittanians; a subject that became the focus of
a case study edited by M-Th. Barrelet (1977, 1984). The controversial
subject of the Luristan bronzes (1971a), to which Moorey returned when-
ever there was new data to add to the debate, prompted his reassessment
of conventional explanations for sudden changes in decoration and art
(1974:19-21, 1975: 29). In making a case for a local rather than a foreign
incentive behind the brief phenomenon of the Luristan bronzes, he high-
lighted the problem of biased perspectives and, in this regard, anticipated the
later re-evaluation of Achaemenid culture (e.g. A. Gunter and M. Root in
Schmandt-Besserat 1980) to which he also contributed (1979, 1985, 2002).
The iconography on Near Eastern bronzes, terracottas and seals in the
Ashmolean collection provide ample opportunity for interpretation. In most
cases, Roger Moorey resisted the temptation, but when he succumbed (1975,
1978, 1979, 1999), it was usually the last stage of a holistic study that takes
into account the object's other salient features including shape, material com-
position, manufacture, context and associated finds. As Roger Moorey has
demonstrated on numerous occasions, all these components combined help
to establish clear classifications and contribute to our understanding of ancient
images.

Ultimately, any attempt to restore objects to their wider social and cul-
tural setting involves theories about the place and circumstances of their
manufacture and use, and the meaning of their decoration; theories that
often exceed the limits of the available information. By defining these limits,
Roger Moorey reduced the role of speculation and focused on those possible
interpretations that the evidence would sustain. This and his insistence
upon archaeological and historical controls have rendered his conclusions
more durable than most and likely to withstand new revelations from
future finds. But as one keenly aware of the random nature of the
archaeological record and attuned to evolving methods and lines of in-
quiry, Roger Moorey expected his results to be modified in due course.

The following papers, which deal with different types of images and highlight different aspects of their analysis, can aspire no further.

⋆ ⋆ ⋆

In many cases, the process of setting the record straight requires a review of existing studies and a critical examination of the constructs and frameworks inherited from the past. Roger Moorey, in his effort to bring order to the museum's collection of metal statuary from the Levant (1984), has confronted general issues of typology and classification. The problem of classification begins with the identification of objects. This issue lies at the heart of David Wengrow's study of animal figurines in the prehistoric Near East, which breaks with the analytical conventions applied to Near Eastern art by bringing new methodological debates from the fields of anthropology and prehistoric art to bear on complex matters of identification and interpretation. As, in most instances, we can not be sure what species of animal was represented or whether a realistic portrayal was intended at all, any thesis that arises from the simple identification of subject matter is undermined at its root. More profitable lines of investigation, inspired in part from ethnographic studies, consider the various different ways in which animal figurines can be perceived and focus more on context: where were they deposited, why have they survived and how do they relate to other categories of miniature clay objects. By defining the limits of the evidence, eliminating unwarranted assumptions and redrawing the parameters of inquiry, Wengrow points the way forward out of the circular arguments that have hampered the study of Neolithic figurines and shifts the debate over their significance from one fixed on symbols of ritual and religion to another that revolves around the development of symbolic equivalences and early tokens of barter and exchange.

Problems of identification aside, the next paper by Ellen McAdam sets out to define a clear typology for others to build on. Taking a representative but limited assemblage of Ubaid period, human figurines from excavated sites in southern Mesopotamia, McAdam follows Moorey's advice and divides her sample according to iconographic traits, thereby avoiding 'topographical vagueness, anachronisms and the ambiguities that are introduced when groups are named after excavated sites though they embrace many statuettes from elsewhere' (1984: 70). An examination of the entire assemblage, with its range of attributes, contexts and dates, may not lead to definite conclusions about why the figurines were made and what they meant to their makers, but it does correct widely held misconceptions about their evolution,

decoration, function and use that were formed from less comprehensive in-
spections of selective examples. In citing details of manufacturing techniques
not considered previously, McAdam adds a new dimension to the evaluation
of Ubaid figurines and strengthens their connection with the rituals and
beliefs of a small elite.

The integrity of the images from archaeological contexts that have been
discussed so far is beyond dispute. This is not the case for the unusual, deco-
rated jar published next by Miriam Tadmor. To secure its status and define
its place in time and space, Tadmor tests the form, style and iconography of
the jar against excavated finds and establishes its material composition by
means of a petrographic examination conducted by Yuval Goren (see appendix
to her paper). The outcome of the petrographic analysis confirms that the jar
was made of clay from the southern Shephelah in Israel, but its date depends
on less scientific arguments of comparison. While elements of its shape, style
of decoration and iconography have parallels among Middle Bronze Age
pottery and seals from the Levant, Tadmor also highlights the differences, in
particular, the combination of traits. This honest approach allows the reader
to form an independent judgement of her conclusion that the decorated
storage jar is an unusual example of ancient artistic creativity. Faced with
similar objects of uncertain origin, Roger Moorey likewise turned to scien-
tific means of analysis to supplement the more conventional, art historical
ones (e.g. 1971b, 1984, 1994b). As he acknowledged on several occasions,
however, the results of scientific tests can be inconclusive (e.g. in the case of
thermoluminescence analysis which refers to the date of the last firing) and
are often only useful as part of the combined evidence.

Although neither a philologist nor a 'dirt archaeologist', Roger Moorey
appreciated the potential also of these two disciplines (indeed, he partici-
pated in excavations at Jerusalem with Kathleen Kenyon in1963 and at Abu
Salabikh with Nicholas Postgate in 1975, 1977 and 1981) to increase our
lines of inquiry and supplement the available data. His reassessment of the
Royal Tombs at Ur (1977), for example, is reinforced by his detailed knowl-
edge of the excavations and by references to texts. Following in the same
vein, the next two papers cut across different fields of research to fill out the
background and help explain the significance of specific images. David
Ussishkin re-examines Sennacherib's reliefs of Lachish, where one small,
overlooked detail of iconography suggests a new focus within the illustrated
events that are corroborated in the biblical account and by his own excava-
tions at the site. The paper by John Curtis and Ann Searight focuses on a
class of decorated gold plaques attributed to the Oxus Treasure. In a study

that has many parallels with Moorey's treatment of the Luristan bronzes, John Curtis first confronts questions of origin, authenticity and classification, referring to Ann Searight's drawings and the results of M. R. Cowell's x-ray fluorescence testing of the gold composition (see appendix) as part of the combined evidence. In advocating the integrity of the gold plaques as a corpus, Curtis rests his case on their shared iconography, style and technique, as well as close parallels between elements of iconography shown on the plaques, those illustrated in contemporary monumental art and seals, and objects found among the contents of contemporary graves. Many items of clothing and some of the accessories can be attached to names that appear in texts. This greatly expands the number of references and enables Curtis to make a more measured assessment of the people who commissioned these plaques and the function they served. Identified as part of a hoard on independent grounds of their precious material, range of date and subject matter, the gold plaques of the Oxus Treasure belong to a long tradition of ceremonial deposits that include the decorated metalwork from an excavated shrine at Dum Surkh in the Kuh-i Dasht, to which Roger Moorey referred in his evaluation of the Luristan bronzes (e.g. 1975, 1999), and the Chalcolithic hoard from Nahal Mishmar, on which he contributed valuable insights (1988).

Hoards are by nature often eclectic, comprising objects collected from different places and times. The presence of such objects raises questions about how they reached their destination, what impact, if any, they had on the cultures they encountered along the way, why they survived so long and whether their value changed over time. In the final paper, Margaret Cool Root pursues the life of a solitary cylinder seal from its beginnings in the Neo Babylonian-Achaemenid period to its final deposition in a late Parthian grave at Seleucia-on-the-Tigris. As she charts its transformation from bead to engraved seal and follows the transfer of imagery across stylistic and chronological divides, Root echoes Roger Moorey's call for the need to push the boundaries of conventional thought and rethink conventional frameworks. With this approach, Roger Moorey has altered our perspective and contributed to our understanding of many images from the ancient Near East. His numerous publications will, no doubt, continue to inspire and challenge many generations.

REFERENCES CITED

Barrelet, M-Th. (ed.)

1977 Methodologie et Critiques I: Problèmes concernant les Hurrites. Paris: Centre de Recherche Archéologiques.

1984 Problèmes concernant les Hurrites II. Mémoires n° 49. Paris Éditions Recherche sur les Civilisations.

Moorey, P. R. S.

1970 Pictorial evidence for the history of horse-riding in Iraq before the Kassite Period. *Iraq* 32: 36-50.

1971a *Catalogue of the Ancient Persian Bronzes in the Ashmolean Museum, Oxford.* Oxford: Oxford University Press.

1971b (with M. J. Aitken and P. J. Ucko) The authenticity of vessels and figurines in the Hacilar style. *Archaeometry* 13: 89-141.

1974 *Ancient Bronzes from Luristan.* British Museum, London.

1975 Some elaborately decorated bronze quiver plaques made in Luristan, c.750-650 B.C. *Iran* 13: 19-29.

1977 What do we know about the people buried in the Royal Cemetery [at Ur]? *Expedition* 20/1: 24-40.

1978 The iconography of an Achaemenid stamp-seal acquired in the Lebanon. *Iran* 16: 143-54.

1979 Aspects of worship and ritual on Achaemenid seals. *Akten des VII. Internationalen Kongresses für Iranische Kunst und Archäologie, Münich. 1976, (Archäologische Mitteilungen aus Iran, Ergänzungsband 6).* Berlin: Dietrich Reimer, 218-26.

1984 (with S. Fleming) Problems in the study of the anthropomorphic metal statuary from Syro-Palestine before 330 B.C. *Levant* 16: 67-90.

1985 The Iranian contribution to Achaemenid material culture. *Iran* 23: 21-37.

1986 The emergence of the light, horse-drawn chariot in the Near East, c.2000-1500 B.C. *World Archaeology* 18: 196-215.

1988 The Chalcolithic hoard from Nahal Mishmar, Israel, in context. *World Archaeology* 20: 171-89.

1989 The Hurrians, the Mittani and technological innovation. In *Archaeologia Iranica et Orientalis: Miscellanea in Honorem Louis Vanden Berghe I,* (L. de Meyer and E. Haerinck, eds.). Gent: Peeters, 273-86.

1994a *Ancient Mesopotamian Materials and Industries: The Archaeological Evidence.* Oxford: Oxford University Press (re-issued with minor corrections in 1999, Winona Lake, Indiana, U.S.A: Eisenbrauns).

1994b The true and the false: the case of five 'Neo-Babylonian' terracottas in the Ashmolean Museum, Oxford. In *Beschreiben und Deuten in der Archäologie des Alten Orients: Festschrift für Ruth Mayer-Opificius,* (N. Cholidis et al., eds.). Münster: Ugarit-Verlag, 201-12.

1999 The hammered bronzework of Iron Age Luristan (Iran): problems of chronology and iconography. In *The Iranian World. Essays on Iranian Art and Archaeology presented to Ezat O. Negahban,* (A. Alizadeh, Y. Majid-zadeh and S. Malek-Shahmirzadeh, eds.). Tehran: Iran University Press, 146-57.

2002 Novelty and tradition in Achaemenid Syria: the case of the clay 'Astarte Plaques'. *Iranica Antiqua* 37: 203-18.

Schmandt-Besserat (ed.)

1980 *Ancient Persia: The Art of an Empire.* Maibu: Undena Press.

Interpreting animal art in the prehistoric Near East[1]

David Wengrow

The recent publication of a new and updated edition of Henri Frankfort's *Art and Architecture of the Ancient Orient* (Frankfort 1996), in addition to affirming the seminal nature of that work, highlights the gulf which still separates the study of dynastic cultures in this region from that of their pre-historic precursors. Although Frankfort's first major publication was dedicated to the study of prehistoric pottery (Frankfort 1924), by the end of his career he appears to have accepted a view of Neolithic cultures as a 'somewhat monotonous' prelude to the florescence of Mesopotamian and Egyptian civilization in the 4th millennium BC (Frankfort 1951: 49). This is perhaps less surprising in the case of Mesopotamia than in that of Egypt, given the rudimentary understanding of Neolithic life in the Fertile Crescent of South West Asia prior to the latter half of the 20th century.

Despite the incremental growth since Frankfort's day of a corpus of Neolithic art in the Near East, its study has remained curiously isolated from wider methodological debates in the field of prehistoric art. These have been most extensive in relation to Palaeolithic rock art and have drawn heavily upon cross-cultural studies of material culture by anthropologists (see below, n. 10; also Gosden ed. 2001). Anthropological studies have been particularly instrumental in opening new avenues onto the understanding of art objects and, in particular, their complex roles in non-literate societies. Their importance for art history and archaeology resides in their ability to demonstrate the variety of ways in which form and image may be perceived and in which art objects can mediate processes of human interaction and transformation.

1 The last years of Roger Moorey's teaching career coincided with the introduction of a BA degree in Archaeology and Anthropology at Oxford University. I am among those students who benefited from his willingness to consider the relevance of ideas derived from anthropology to the study of the ancient Near East—an aspect of his contribution perhaps less familiar to others—and to place his vast knowledge at the disposal of a beginner whose approach must at times have seemed unconventional.

In connection with the present paper, I am grateful to the following people for making available to me the figurine collections and archives in their care: Dr Baruch Brandl and Ms Angela Davidzon (Israel Antiquities Authority, Jerusalem), Dr Zeidan Kafafi and Dr Ziad al-Saad (Irbid Museum, Yarmouk University, Jordan), Ms Naomi Korn (Israel Museum, Jerusalem), Ms Alegre Savariego and the late Dr Ornit Ilan (Rockefeller Archaeological Museum, Jerusalem).

Reincorporating art into the wider social and cultural domain often involves liberating its study from what David Howes (1991) has termed 'the tyranny of the visual', moving beyond a narrow focus on the image to consider other forms of sensory experience and activity that may be relevant to its understanding.

Despite a forceful critique by Beatrice Goff (1963: xxxiv–xxxvi), the study of late prehistoric art in the Near East is still often confined within inappropriate analytical conventions developed in relation to dynastic art and epigraphy. The need to study this art initially on its own terms and in its own context is brought home by recent discoveries at Göbekli Tepe and Nevalı Çori in southeastern Turkey (Hauptmann 1993; Schmidt 1998, 1999), which have cast doubt upon traditional expectations regarding the relationship between cultural representation and early state formation. These discoveries require us to set the appearance of monumental relief carving and sculpture-in-the-round back some five millennia prior to the emergence of literate urban civilizations, to the early stages of the Neolithic period (Pre-Pottery Neolithic B).

At least one of the sites in question, Göbekli Tepe, appears to be ceremonial rather than domestic in character and is located at a nexus of topographical contrasts between the foothills of the Taurus Mountains and the flat Harran Plain (Schmidt 2001). The theme of masculinity, which is largely absent from contemporary village art, is extended here to notions of violence and confrontation in depictions of attacking animals, such as lion and boar with male genitalia, on the surface of monoliths with T-shaped capitals (Fig. 1a, b). The extensive use of stone in the art and architecture of Göbekli Tepe forms an aesthetic contrast with the mud-and-plaster based environment of contemporary villages, just as the emphasis on masculinity and monumentality contrasts with the predominance of female imagery in their miniature, plastic art. By contrast with the exposed setting of Göbekli Tepe, Nevalı Çori—where a palimpsest of stone buildings with a comparable array of stone sculpture was found, set back from a residential site—is sheltered on a spur of land beneath a steep limestone escarpment, bordered by a tributary of the Middle Euphrates (Hauptmann 1993: 39). Contrasts between 'high' and 'low' suggested by the form of the surrounding landscape appear to be reinforced metonymically through a monumental animal art comprising birds and composite human-bird forms (creatures living between earth and sky), as well as reptiles and crustaceans (creatures living upon the surface of the earth).

Fig. 1. Stone sculpture from Göbekli Tepe
a: after Beile-Bohn et al. 1998, scale 1:7. b: after Schmidt 1998, scale 1:24.

The remarkable discoveries at Göbekli Tepe and Nevalı Çori highlight the extent to which the development of Neolithic cultures in the Near East has been, until now, a story told in clay (Wengrow 1998). In a series of articles published during the 1970s, Denise Schmandt-Besserat[2] drew attention to the varied and unprecedented uses of this medium in the Early (Pre-Pottery) Neolithic Fertile Crescent. For over a millennium prior to the wide-spread adoption of ceramics, its plastic and thermal qualities were widely employed (inter alia) in the construction of dwellings and in the manufacture of small geometric and figural objects. These miniature objects, which 'swept across the Near East on the coattails of agriculture' (Schmandt-Besserat 1992: 195) during the Pre-Pottery Neolithic B period, are conventionally classified into three categories: anthropomorphic and zoomorphic figurines, and geometric tokens.

Schmandt-Besserat's (1992) contention that the form of certain Neolithic tokens directly prefigures the earliest signs impressed or incised on clay tablets during the 4th millennium BC has been convincingly refuted (e.g. Michalowski 1990, 1994; Zimansky 1993). As Michalowski (1994: 55) points out, the primary fault of her model is to confuse 'the history of individual symbols with the history of writing systems as such'. Its primary virtue, on

2 Schmandt-Besserat 1974, 1977a, 1977b.

the other hand, is to highlight the adoption of clay as a new medium of signification throughout the Fertile Crescent and to link this development to wider changes in Neolithic economy and society (cf. Wengrow 1998).

While the distribution and forms of clay tokens were studied in detail by Schmandt-Besserat, the most recent attempt at a survey of anthropomorphic figurines in the Near East remains the comparative data assembled by Peter Ucko in his (1968) study of predynastic Egyptian figurines. The only Early Neolithic figurines available for consideration by him came from Jarmo and these were fully published only fifteen years later (Broman Morales 1983). Despite the importance assigned to them in a number of recent interpretative works, not least those of Jacques Cauvin (2000, with references to earlier studies), no published survey exists of zoomorphic figurines in the Neolithic Near East. It is currently the case, then, that the most unassuming and inscrutable kinds of miniature clay objects (i.e. tokens) are also the most fully documented in this region.

The present contribution draws attention to a variety of problems encountered, and perspectives generated, during the present author's attempts at compiling a survey of zoomorphic figurines from the published sources.[3] These relate to the archaeological distribution and contexts of clay figurines, in general, and to current assertions regarding the subject matter and classification of animal figurines, in particular. In conclusion, and following an approach advocated by Roger Moorey in his (2001) *Schweich Lectures*, I highlight the importance of considering the contextual, formal and aesthetic relationships between various categories of miniature clay object, which have usually been interpreted in isolation from one another. In doing so I also hope to provide a wider context for the monumental stone sculpture discovered at Göbekli Tepe and Nevalı Çori.

THE DISTRIBUTION, PRESERVATION AND CONTEXT OF PPNB CLAY FIGURINES

Clay figurines, anthropomorphic and zoomorphic, have been identified in varying numbers at PPNB sites throughout the Fertile Crescent, all of which have also produced geometric tokens. Their numerical distribution within this region is far from even, however. There is a striking discrepancy, for

3 To those analysts who rightly emphasize the importance of studying artefacts at first hand, such a synthesis will no doubt seem highly premature and perhaps indulgent. As I will attempt to show, however, the expanding corpus of detailed first-hand studies currently presents the secondary user with a variety of conflicting methods and claims, which constitute a potential obstacle to further understanding. In the absence of any attempt at wider, comparative analysis, this situation seems likely to be compounded in the future.

instance, between the number of miniature clay objects recovered from sites in the Zagros region of western Iran/Iraqi Kurdistan, such as Jarmo (Broman Morales 1983) and Ganj Dareh (Eygun 1992), and from contemporaneous sites in southeastern Turkey and the Levant, which cannot be put down to the scale of excavation. Exposures of between 144 and 500 msq at Ganj Dareh and Jarmo, respectively, produced 990 and 5500 miniature clay objects, while exposures of 1450 and 2050 msq at Jericho (Holland 1982) and Munhata (Garfinkel 1995) in the southern Levant produced only 20 and 129, respectively. At Jericho, imprecise methods of recovery may be considered a factor but even the extensive excavations at Çayönü (c. 4900 msq) in southeastern Turkey have produced only 400 or so items (Broman Morales 1990). Only Nevalı Çori, where excavations are ongoing, has produced comparable numbers of figurines (670) to those at the Zagros sites; this assemblage awaits publication but is said to contain just 6 zoomorphic items and, atypically, many male anthropomorphic examples (Morsch 1998). More common frequencies in the Levant and southeastern Turkey range from a handful to over one hundred,[4] while the limited soundings at Tell Maghzaliyah in northern Iraq produced only eight examples, none zoomorphic (Bader 1993).

In considering how much importance should be attached to this variability, it is necessary to examine in more detail the depositional contexts in which figurines have been found and the site formation processes leading to their preservation. The latter clearly have a bearing on the large number of figurines found at Ganj Dareh (Level D), the entire stratum having been engulfed in a conflagration which baked many of the clay objects solid (Smith 1990). Figurines were dispersed evenly over the site and showed no special association with other kinds of objects or installations such as hearths and ovens (Eygun 1992: 114). At Jarmo, a dense concentration of figurines was recovered from the centre of a 'large ashy area', again suggesting preservation by fire; the deposit also contained an unusually high proportion of obsidian and flint (Broman Morales 1983: 370; cf. Braidwood 1983: 164, Test Sq. J-III).[5]

4 e.g. Abu Gosh (11 figurines reported, c.600 msq exposed; Lechevallier 1978); 'Ain Ghazal (126 figurines reported, c. 200 msq exposed; McAdam 1997); Tell Aswad II West (62 figurines reported, 64 msq exposed; Contenson 1995); Beidha (2 figurines reported, c. 250 msq exposed; Kirkbride 1966, 1968; Cafer Hüyük (2 figurines reported, c. 360 msq exposed; Cauvin 1985); Ghoraifé (56 figurines reported, c.16 msq exposed; Contenson 1995); Gritille (c. 50 figurines reported, c. 350 msq exposed; Voigt 2000).
5 In considering the large number of figurines from this site, its poorly understood stratigraphy should also be taken into account. Despite the fact that ceramics appear in the upper third of the deposit, the excavator has maintained that Jarmo is a one period site

The largest assemblage of clay objects in the Levant derives from the site of Es-Sifiya in Jordan. All of the 475 items were found within a single locus situated at a remove from the main occupation area of the village. The 78 geometric tokens showed clear standardization of form, comprising almost exclusively cones and spheres; the human and animal figurines await publication. The depositional locus, which extends over approximately one metre square, was produced during a single firing episode which baked the artefacts and created the ashy matrix in which they lay. The excavators note that there is 'no evidence to suggest anything other than a single ephemeral activity locus (or its remains)', which they interpret as an in situ production site for clay miniatures:

> As a proposition we suggest that the joint manufacture of geometrics, animal and presumed human figurines at Es-Sifiya not only represents a technological association, but also a shared symbolic and contextual relationship. Rather than being made for some mundane, leisurely end, the circumstances, the number of specimens, and the standardization of the artefacts suggest that there was a specific purpose for their manufacture, and that they were about to be used in a concrete event or transaction.

They also consider the possibility that the assemblage represents only those pieces that were rejected after the firing process (Mahasneh and Gebel 1999: 110).

The majority of figurines from 'Ain Ghazal (126 items) were discovered mixed in with deposits of domestic rubbish, many of which contained ash (McAdam 1997: 136). Schmandt-Besserat suggests that they may have been deposited in hearths and then discarded 'together with the fire's ashes in the general household trash' (Schmandt-Besserat 1997: 52, 54). Most had not been deliberately fired (McAdam 1997: 135). This site has also produced unique evidence for the deposition of clay figurines in a sealed architectural context. Two animal figures, which had been bound with a cord and pierced with flint chips (e.g. Fig. 2a), were found within a tiny sub-floor pit beneath a paving of limestone slabs. A further group of 25 animal figurines, conforming to a standard quadrupedal shape with horns, was concentrated within a

(Braidwood 1983; cf. Oates 1973: 157). Since a significant number of clay figurines derive from these upper deposits (Broman Morales 1983: 372, 376), it is likely that the Jarmo assemblage represents a period of occupation extending beyond the LPPNB and into the early stages of the Pottery Neolithic. This possibility is supported by close similarities with the figurine assemblage from Tepe Sarab near Kermanshah (Broman Morales 1990), which is thought to post-date the Pre-Pottery Neolithic.

a b

Fig. 2. Figurines with binding marks from 'Ain Ghazal. After McAdam 1997. Scale 1:1.2.

house fill; they appeared to be deliberately arranged on their sides and backs around a large piece of clay bearing fingernail impressions (Rollefson and Simmons 1986: 150–3). McAdam (1997: 133, 136) notes that these figurines were unusually well preserved, suggesting 'that they were rapidly and possibly deliberately covered over, probably within a matter of hours.'

Kirkbride (1966: 26) noted that all of the clay objects from Level VI at Beidha (only a handful of which she described) came from a 'burnt, polygonal house' and were therefore baked. At Munhata, Garfinkel (1995: 15–21, Table 2, Figs. 2–5) documents the concentration of clay miniatures— anthropomorphic and zoomorphic figurines as well as geometrics—within a finite zone encompassing roughly 300 msq out of a total exposed area of 2050 msq. Broman Morales (1990: 57–71) observes that compacted soil conditions at Çayönü did not favour the recovery of small clay objects, owing to the 'obligatory smashing of the lumps of consolidated earth' during excavation. She further notes that all of the figurines were baked and derived exclusively from domestic occupation areas, some of which had been subject to post-occupation burning. A single figurine recovered from Cafer Hüyük was found in an ashy deposit near a hearth (Cauvin 1985: 127, Fig. 3.1). All but one of the c. 50 figurines and figurine fragments found at Gritille, on the Upper Euphrates, derived from the ashy soil matrices of pits; the largest groups were found with geometric tokens within roasting pits sealed beneath cobble floors. Voigt (2000: 265; cf. 1985: Fig. 8a–c) suggests that 'a large number of figures were made, placed inside the pit, subjected to fire . . ., and then capped with cobbles.'

To summarize, factors of deposition and preservation as well as accidents of recovery have significantly influenced the observed frequencies of clay

figurines in the PPNB Fertile Crescent. A close association between the preservation of figurines and the presence of burnt deposits is apparent and should serve as a reminder that many unbaked forms may not have survived in the archaeological record (cf. Cauvin 1985: 127). At some sites (e.g. Munhata), but not others (e.g. Çayönü), the distribution of small clay objects appears to have been restricted to a particular area of the settlement. At Es-Sifiya there is clear evidence for the contiguous manufacture of tokens and figurines in large numbers and at Gritille the processes of figurine and token manufacture and deposition in roasting pits appear to have been closely linked. Based on their spatial and temporal concentration, McAdam (1997: 115, 138–9) has similarly suggested that the majority of figurines at 'Ain Ghazal were 'produced in three episodes of activity, each with a tight spatial focus.' Consequently, the relative frequency of clay figurines at a given site cannot be ascertained simply in relation to the area exposed, but may be contingent upon the discovery of localized spaces for manufacture, use and deposition. This observation provides the context for further discussion of the forms, social functions and meanings of these objects.

PERCEIVING CULTURAL FORM:
PROBLEMS IN THE IDENTIFICATION OF ANIMAL FIGURINES

The interpretation of clay animal figurines has contributed to far-reaching assertions regarding religious beliefs, ritual practice and the nature of technological and social change in the Neolithic Near East, notably through the work of Jacques Cauvin. His assertion that cattle occupied a central place in Early Neolithic symbolism, based to a significant extent upon figurine evidence, has been widely accepted[6] and is particularly important in supporting his contention that symbolic transformations preceded technological change in Neolithic society. Wild cattle, it is suggested, were incorporated as symbols into the transformation of social, religious and psychological experience, prior to their incorporation as domesticated animals into the Neolithic economy (Cauvin 1978, 2000: 25–33, 106–8).

Hypotheses regarding the relationship between symbolic and technological change in Early Neolithic society have to some extent overshadowed existing debates concerning the function of animal figurines (cf. McAdam 1997: 139–40). Previous suggestions have included their use as toys, for instruction or in mimetic rites concerned with the multiplication of wild or

6 See, for example, Hodder 1990: 12; Garfinkel 1995: 56; Bar-Yosef 1997; Goring-Morris 2000: 115.

domestic herds. Mary Voigt has recently argued that the latter explanation, advanced by Broman Morales (1983: 376) for Jarmo, cannot be applied to the figurines from Gritille since most represent cattle, while the meat eaten in the village derived largely from domestic caprines. Voigt (2000: 267–9) concludes that cattle figurines served as 'vehicles of magic', the function of which was basically therapeutic: 'to ensure the well-being of the maker(s)'. Ellen McAdam and Denise Schmandt-Besserat have argued independently that, as at Gritille, the majority of animal figurines from 'Ain Ghazal represent cattle (aurochsen or bulls, respectively). While McAdam offers no final explanation for the apparent emphasis upon this species, Schmandt-Besserat (1997: 55) follows Cauvin in attributing it to a long-lived artistic tradition 'in which these animals encapsulate some of the most profound ancient Near Eastern thoughts'.

Given the central position of the 'bull cult' in his wider portrayal of Neolithic society, it is surprising that Cauvin (2000: 106–7) draws upon the figurine evidence from just one site ('Ain Ghazal, in Jordan) to demonstrate its existence. He supplements this discussion with illustrations of 'bull' or 'cattle' figurines from Çayönü, in southeastern Turkey, and from Jericho, in the southern Levant (ibid. 89–90, 106–7, Figs. 32.6–7, 38.1–4). Only one of the two figurines which he illustrates from Çayönü was in fact interpreted by Broman Morales as a bovid in her final report on the clay objects from this site and (contra Cauvin 2000: 89) this was the only figurine so identified there. The second, along with ten more, was identified as 'sheep/goat' (Broman Morales 1990: 58–9). The single 'cattle figurine' illustrated from Jericho by Cauvin was originally published by Holland (1982: 553–6, Fig. 225.1) as 'probably sheep or goat'.

These discrepancies bring into question the procedures by which identifications of figurine subjects are made and evaluated. Analysts have shared a number of basic assumptions on this matter:

(1) Clay figurines constitute end products of a single creative episode and may, therefore, be classified into distinct and meaningful types on the basis of form.
(2) Clay figurines were made with the intention of representing either an animal or human subject from the observable world.[7]

7 Eygun (1992) is exceptional in including a category of mixed human/animal forms in his analysis of the figurines from Ganj Dareh.

(3) The task of identifying a clay figurine is equivalent to finding the species (subdivided by Linnaean conventions) and sex to which it corresponds most closely, often through direct comparison with faunal assemblages.

I will consider these points in reverse order focussing upon figurine studies, based on large assemblages, in which the criteria used in identification have been indicated.

At the outset, it must be noted that while some analysts have drawn comparisons between their data and figurines from contemporaneous sites, none has systematically incorporated such comparisons into their analysis of the material, each relying instead upon her/his own criteria for differentiating various animal species. In her study of animal figurines from 'Ain Ghazal, for instance, Schmandt-Besserat (1997: 49–50) suggests that 'the tails defy nature: bovines are portrayed with a short appendage when, in fact, they are endowed with a long one; goats have a hanging tail which should be up-turned.' By contrast, in her analysis of the figurines from Tepe Sarab and Çayönü, Broman Morales (1990: 3–4, 58–9) assigns typological significance to tail-position as an index of species. Schmandt-Besserat (1997: 49–50) further suggests that animals as diverse as bulls, goats, rams and gazelles are 'easy to distinguish by their horns which reflect a great concern for verisimilitude' in the 'Ain Ghazal assemblage. McAdam (1997: 134), in her detailed study of the same group of figurines, identifies only a single 'sheep/goat' figurine and no gazelle, however. According to Schmandt-Besserat, bovine horns are 'represented as stocky and curving forwards', but Garfinkel (1995: 22) identifies bovine figurines at Munhata by their 'horns tilted upwards'.

McAdam (1997: 131) defines aurochs figurines at 'Ain Ghazal according to 'a curving, almost aquiline muzzle and a blunt, featureless, sub-triangular face', horns which curve 'outwards and forwards' from the head, a body which 'rises to a hump over the shoulders, sloping down to an angular rump' ending in 'a short, pinched-out tail rising above the hump'. Nevertheless, two figurines which had been wrapped in cord and pierced with flint chips (e.g. Fig. 2a) are designated 'bulls' despite their long, flat backs and lack of evidence for horn shape; one entirely lacks a head and has a different tail-form from the other. McAdam's identification of these remarkable figurines has since been followed by Cauvin (2000: 106) and Rollefson (2000: 167), leading to further speculation as to the special status of cattle in the economy and religion of 'Ain Ghazal.[8]

Many commentators take the composition of faunal assemblages as a starting point for the analysis of animal figurines. This is not unreasonable

since the faunal record provides our only indication of the kind of animals with which figurine makers may have been in contact. It becomes problematic, however, when classificatory systems derived from the identification of animal bones are allowed to determine the identification of figurines. This applies to every case in which categories such as 'bovid', 'equid' and 'sheep/ goat' are employed or when an attempt is made to distinguish between wild and domestic figurine forms, often a precarious undertaking even with actual faunal remains (e.g. Morales 1983, 1990 passim; McAdam 1997: 131–4).

It has been widely observed that human classifications of the animal and plant worlds vary considerably between societies and historical periods, as does the appearance of those worlds in the art of different cultures.[9] Any attempt to classify prehistoric art on the basis of subject matter—including the very distinctions between figural and non-figural, human and animal— involves complex issues of identification and interpretation which have been extensively explored in the archaeology of rock art and in the anthropology of art and aesthetics.[10] It is precisely these difficulties of interpretation which make the study of animal art potentially so rewarding, as a window onto the diverse ways in which human groups at different times and places have defined themselves in relation to the non-human world.

The importance of considering such issues in relation to the problem at hand may be illustrated by Jeremy Coote's (1992) account of the production of mud figurines by Pokot children in East Africa during the 1970s (Fig. 3). As in many pastoral societies, certain physical attributes of herd animals are valued above others by Pokot people as signs of health, favour or the status of their owners. Coote (1992: 262) observes that 'the aesthetically central aspects of the physical form of cattle—the fatness of the body, the hump and the horns—have been brought together to produce a form which, though it bears little resemblance to the form of the animals themselves, is in itself aesthetically pleasing.' The possibility that Neolithic animal figurines may have been subject to similar forms of distortion, on the basis of social and aesthetic preference, has not been previously considered. Those PPNB figurines which the Pokot examples most closely resemble have in fact been classified as seated human forms (Broman Morales 1990: Pl. 22d; Contenson

8 Nine of the other figurines published as 'aurochsen' by McAdam do not meet many of her own morphological criteria. See McAdam 1997, catalogue nos. 3077/63E, 3077/63I, 3077/25, 3077/80, 3081/139, 3078/197, 3082/21, 3081/152, 3076/102.
9 See, e.g., Lévi-Strauss 1966; Ingold ed. 1988; Willis ed. 1990.
10 See, e.g., Ucko and Rosenfeld 1967; Ucko ed. 1977; Morphy ed. 1989.

1995: 189, Fig. 127.1–3, 5–8). This classification may of course be correct but the modern comparison serves to illustrate unsuspected difficulties in its evaluation.

The Pokot comparison also indirectly raises the possibility of morphological relationships between human and animal figurines which may be further explored in relation to Point 1 raised above: whether clay figurines constitute end products of a single creative episode. This can only be confirmed in cases where the figurine has been intentionally fired, a fact which is often hard to ascertain owing to the exposure of many figurines to some form of secondary baking (e.g. through deposition in an ash pit). In many cases, figurines left or discarded in morphologically ambiguous states might be better considered as marking constituent stages of modelling processes rather than as distinct or independent types in themselves. This point may be illustrated by the construction of a hypothetical series of manual operations (or *chaîne opératoire*) made up of contemporary figurines found at Çayönü (Fig. 4). From these forms it is possible to envisage the progression from a type of figurine usually considered zoomorphic to a common type of seated, female anthropomorphic figurine.

So far the present discussion has done more to complicate and deconstruct the interpretation of animal figurines than to synthesize the available data. The main obstacle to such a synthesis is the highly fragmentary state in which most figurines are recovered, making so much discourse on their meaning highly speculative. There are, however, striking consistencies in the morphology of PPNB animal figurines which retain their significance in spite of the difficulties associated with species identification.

Judging from the most complete examples in the published corpus, figurine sizes appear similar throughout the Fertile Crescent, ranging with rare exceptions between 35 and 55 mm in length and between 15 and 25 mm in width. Height ranges vary to a greater extent and are also harder to ascertain due to the damaged condition of horns on many figurines. Clay animal figurines were made to stand upright and independently without bases. Activities are not portrayed and facial features are not marked. Despite the identification of many subjects as 'bulls', genitalia are very rarely modelled (see Voigt 2000: 268, Fig. 5b for an exception) and the body is hardly ever marked with paint or any sort of incision that might indicate skin texture or patterning.[11] These characteristics, combined with the fragility of unbaked

11 On the latter points, cf. Broman Morales 1983: 375; Eygun 1992: 114; McAdam 1997: 136; Schmandt-Besserat 1997: 49.

Fig. 3. Cattle figurines, made in the 1970s by Pokot children.
Reproduced from Coote 1992 with permission of the author.

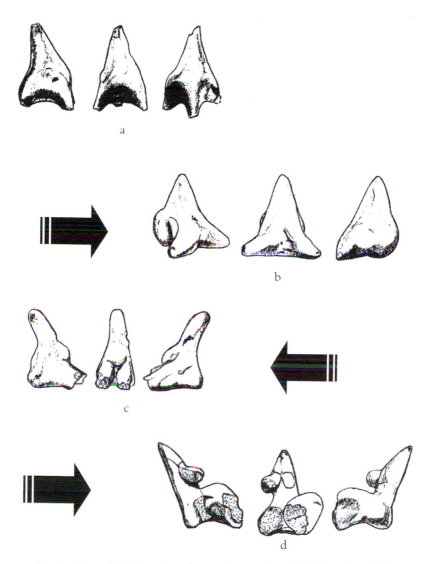

Fig. 4. Hypothetical series of manual operations (chaîne opératoire)
comprising figurines from Pre-Pottery Neolithic B Çayönü.
Individual illustrations after Broman Morales 1990. Scale 1:1.4.

animal figurines, have led a number of commentators to suggest that the majority were not made for any form of long-term use (e.g. as toys or visual spectacles). Rather, the process of forming and deposition may have been at least as significant as the appearance of the finished object.[12]

At a more general resolution than has been adopted in the past, it is also possible to observe significant regularities in the subject matter of PPNB animal figurines throughout the Fertile Crescent. According to published sources, over 70% have been identified as horned quadrupeds of some sort. The remaining minority of identified figurines, with very rare exceptions, are thought to be mammalian forms. Felines have not been identified and a wide range of smaller mammals, birds, crustaceans and reptiles, which would have been common features of the Neolithic landscape, also appear to be almost or entirely absent.[13] Intriguingly, many of these animal subjects are widely present among the monumental sculpture found within stone buildings at Nevali Çori and Göbekli Tepe (e.g. Hauptmann 1993: Figs. 23, 27; Beile-Bohn et al. 1998: Figs. 29, 30, 32, 33; Schmidt 1998: Figs. 10, 13, 15), reinforcing the sense at these sites of a symbolic landscape alien to that of the domestic household.

PERSONS AND OBJECTS:
NOTIONS OF SYMBOLIC EQUIVALENCE IN NEOLITHIC SOCIETY

> 'In the end property is merely the extension of the idea of the person to things.'
> Emile Durkheim, *The Division of Labour in Society* 1984 [1893]: 130

A concern with the rigid classification of clay figurine assemblages into distinct biological taxa has perhaps diverted attention from more rewarding avenues of investigation. One such avenue is highlighted by the recent discovery, at the Late Neolithic site of Tell Sabi Abyad in northern Syria, of an assemblage of human and animal figurines, together with large numbers of clay sealings, in a non-residential storage complex. The restricted distribution of sealings within the complex led the excavators to propose that they were deliberately stored as archives. Their recurrent association with tokens and figurines in two different levels of the site (6 and 3) is more tentatively viewed as an indication that these various items functioned to-

12 cf. Eygun 1992: 116; Broman Morales 1983: 376, McAdam 1997: 138.
13 cf. Broman Morales 1983: 376. A single figurine resembling a lizard was found at Çayönü (Broman Morales 1990: Pl. 21e).

gether in a single administrative system (Akkermans and Duistermaat 1997: 19, 26). This raises the possibility that, long before its use as a medium for the cuneiform writing system, the ability to cast meaning in clay was already mobilized in the objectification and recording of social transactions (Wengrow 1998: 784–5).

As Douglas Bailey (1996: 292–3) has pointed out, the act of figuration is capable of generating symbolic equivalence between things which are in reality different: 'In making figurines, unequal things (people) are made equal and similar; they are placed together within a delimited, visible, understandable category.' This process need not, however, be restricted to relationships between people, and may also extend to the definition of relationships between humans, animals and other valued objects. An understanding of figuration as the creation of symbolic equivalence between different entities would seem consistent with many of the formal and depositional features of Early Neolithic figurines in the Near East described above. These include relationships between human and animal forms as well as geometric tokens suggested by their shared contexts of manufacture and/or deposition, their common medium and, at a more general level, their association throughout early farming villages of the Fertile Crescent during PPNB from the Levant to the forested flanks of the Zagros Mountains.[14]

In further developing this perspective, it seems useful to relate the appearance of figurines and tokens over this vast area to other contemporary transformations taking place on a similar scale. The most striking of these is the adoption of domesticated plants and animals during the late 9th and 8th millennia BC. As Andrew Garrard (1999: 82) has observed, the rapid spread of cultivars 'supports the notion that there were extensive exchange and information networks across south-west Asia during PPNB'. In addition to their value as food resources (which was probably limited to the consumption of meat at this stage; Sherratt 1981), domestic herds constituted new forms of controllable wealth which, because of their mobility, could be rapidly incorporated into existing exchange cycles probably based upon kinship alliances.[15] This is reflected in their remarkable spread throughout the Fertile

14 In this context, we might also note the discovery at 'Ain Ghazal of female figurines which had been impressed with cord (e.g. Fig. 2b) in a similar manner to the two bound and pierced animal figurines from the same site. Such inter-relationships between human and animal forms have to date received little consideration in debates over the meaning and identification of figurines, which have focussed overwhelmingly upon anthropomorphic subjects (e.g. Ucko 1968; Haaland and Haaland 1995; Hamilton et al. 1996).

15 See Flannery 1969; Sherratt 1997: 6-7, 1999; Runnels and Van Andel 1988.

Crescent (Legge 1996), which quickly exceeded the distribution of less easily transportable innovations such as cultivated cereal grains, as well as that of established commodities such as obsidian and marine shells (D. Bar-Yosef 1991; M.-C. Cauvin et al.1998).

As mobile resources, domesticated sheep and goat are likely to have infused existing exchange networks with new variety and scope, altering the scale, pace and structure of human interaction. Originating beyond the established bounds of cultural exchange, they would have transgressed the temporal, spatial and social conventions which regulated the flow of objects between people, constituting a new form of wealth which was not proscribed by existing concepts of equivalence and value. In short, their circulation required the inception of what Arjun Appadurai (1986: 15) would term a new 'regime of value': 'Such regimes of value account for the constant transcendence of cultural boundaries by the flow of commodities, where culture is understood as a bounded and localized system of meanings.'

The contextual, and perhaps also morphological, relationships between human and animal figurines identified at Neolithic villages suggest that they were made and deposited, sometimes along with tokens, in performative acts which established symbolic equivalence between resources regularly mobilized in social exchange. The efficacy of these miniature clay forms may have depended as much upon their ability to augment and sanction the verbal act of exchange as upon their accurate representation of particular items or persons. The presence of such a ritualistic aspect to the conduct of exchanges is likely given the absence of other forms of contract and the lack of a centralized authority to enforce property rights across local and kin groups at this time.

In this connection it is pertinent to consider the wider symbolic applications of clay during PPNB, notably its use with plaster and paint in the revivification of human skulls: an extension of the transformative techniques used in house construction to the symbolic reversal of human mutability. The discovery beneath plastered house floors of articulated skeletons lacking their skulls indicates that some time after the initial burial the skull was exhumed, decorated, and reincorporated into the life of the community. As a portable ritual object, it is likely to have represented the transferable aspect of ancestral heritage (cf. Kuijt 2000). Through its inherent disconnectedness, however, it also embodied a reference to a larger whole: the memory of the body still rooted 'in the immovable ground above and beyond which real economic activity was carried on' (Simmel, cited in Weiner 1992: 33).

CONCLUSION

We can see in the Pre-Pottery Neolithic B period the foundations of a community which established its stability in space, its continuity in time and its control over productive resources through performative acts which linked the reproduction of society to the material fabric of the household (cf. Hodder 1990). This basic core of ideas and the material practices in which it was anchored were retained throughout the Neolithic of the Near East (Wengrow 1998) and are still clearly discernible in the institutions, monuments and myths of dynastic Mesopotamia. From Early Dynastic times down to the Persian conquest, rulers of Mesopotamian cities legitimated their status by providing mud-brick dwellings for divinities and represented themselves as active agents in the process of construction (see e.g. Suter 2000). As 'Houses of the Gods', temples functioned both as an objectification of the ruler's relationship to divine will and as centres of bureaucracy through which the flow of animal and plant resources, manufactured products and human labour was regulated by means of a system of signs inscribed on clay. Just as the beginnings of the temple-estate are discernible in the village communities of the Early Neolithic period, so in the monumental sculpture of Göbekli Tepe we might perceive a distant precursor to other enduring aspects of Mesopotamian political representation. These include the association between masculinity and the power in wild animals, and the rendering of forces encapsulated in this relationship in the enduring medium of stone, as attested in sculpture from the Uruk period Lion Hunt Stele (Amiet 1980: Pl. 40.611) to the monumental palace reliefs and glyptic art of the Neo-Assyrian period (Cassin 1987: 167–213). Simply postulating such continuities has little explanatory value in itself. It does, however, challenge those interested in long-term processes of change to rethink the nature of the transformations which characterized the transition from village to urban society in the Near East.

REFERENCES CITED

Akkermans, P. M. M. G. and Duistermaat, K.
1997 Of storage and nomads: the sealings from Late Neolithic Sabi Abyad, Syria. *Paléorient* 22/2: 17–44.

Amiet, P.
1980 *La glyptique mésopotamienne archaïque* (2nd rev. ed.). Paris: Éditions du Centre national de la recherche scientifique.

Appadurai, A.
1986 Introduction: commodities and the politics of value. In *The Social Life of Things. Commodities in Cultural Perspective* (A. Appadurai, ed.). Cambridge: Cambridge University Press, 3–63.

Bader, N. O.
1993 Tell Maghzaliyah: an early Neolithic site in northern Iraq. In *Early Stages in the Evolution of Mesopotamian Civilization: Soviet Excavations in Northern Iraq* (N. Yoffee and J. J. Clark, eds.). Tuscon and London: University of Arizona Press, 7–40.

Bailey, D. W.
1996 The interpretation of figurines: the emergence of illusion and new ways of seeing. *Cambridge Archaeological Journal* 6/2: 291–5.

Bar-Yosef, D. E.
1991 Changes in the selection of marine shells from the Natufian to the Neolithic. In *The Natufian Culture in the Levant* (O. Bar-Yosef and F. R. Valla, eds.). Ann Arbor, Michigan: International Monographs in Prehistory, 629–36.

Bar-Yosef, O.
1997 Symbolic expressions in later prehistory of the Levant: why are they so few? In *Beyond Art. Pleistocene Image and Symbol* (M. Conkey, O. Soffer, D. Stratmann and N. G. Jablonski,

eds.). California Academy of Sciences Memoir 23. San Francisco: California Academy of Sciences, 161–87.

Beile-Bohn, M., Gerber, Ch., Morsch, M. and Schmidt, K.
1998 Neolithische Forschungen in Obermesopotamien. Gürcütepe und Göbekli Tepe. *Istanbuler Mitteilungen* 48: 5–78.

Braidwood, L. S., Braidwood, R. J., Howe, B., Reed, C. A. and Watson, P. J. (eds.)
1983 *Prehistoric Archaeology along the Zagros Flanks*. Oriental Institute Publications 105. Chicago: Oriental Institute of the University of Chicago.

Braidwood, R. J.
1983 The site of Jarmo and its architecture. In Braidwood et al. (eds.) 1983: 155–207.

Broman Morales, V.
1983 Jarmo figurines and other clay objects. In Braidwood et al. (eds.) 1983: 369–423.

1990 *Figurines and other Clay Objects from Sarab and Çayönü*. Chicago: Oriental Institute of the University of Chicago.

Cassin, E.
1987 *Le semblable et le différent. Symbolism du pouvoir dans le Proche-Orient ancien*. Paris: Découverte.

Cauvin, J.
1978 *Les premiers villages de Syrie-Palestine du IX^{ème} au VII^{ème} millénaire avant J.-C.* Collection de la Maison de L'Orient Méditeranéen Ancien 4. Série Archéologique 3. Lyon: Maison de l'Orient.

1985 Le Néolithique de Cafer Höyük (Turquie): bilan provisoire après quatre campagnes (1978–1983). *Cahier de L'Euphrate* 4: 123–33.

2000 *The Birth of the Gods and the Origins of Agriculture.* Cambridge: Cambridge University Press.

Cauvin, M.-C., Gourgaud, A., Gratuze, B., Arnaud, N., Poupeau, G., Poidevin, J.-L. and Chataigner, C.

1998 *L'obsidienne au Proche et Moyen Orient. Du volcan à l'outil.* BAR-IS 738. Oxford: British Archaeological Reports.

Contenson, H. de

1995 *Aswad et Ghoraifé. Sites Néolithiques en Damascène (Syrie) aux IX^{ème} et VIII^{ème} millénaires avant l'ère chrétienne.* Institut français d'archéologie du Proche-Orient. Beirut: Bibliothèque Archéologique et Historique.

Coote, J.

1992 'Marvels of Everyday Vision': the anthropology of aesthetics and the cattle-keeping Nilotes. In *Anthropology, Art and Aesthetics* (J. Coote and A. Shelton, eds.). Oxford: Clarendon Press, 245–74.

Durkheim, E.

1984 *The Division of Labour in Society* (reprint of 1893 ed.). London: Macmillan.

Eygun, G.

1992 Les figurines humaines et animales de site néolithique de Ganj Dareh (Iran). *Paléorient* 18/1: 109–17.

Flannery, K.

1969 Origins and ecological effects of early domestication in Iran and the Near East. In *The Domestication and Exploitation of Plants and Animals* (P. J. Ucko and G. W. Dimbleby, eds.). London: Duckworth, 73–100.

Frankfort, H.

1924 *Studies in Early Pottery of the Near East I. Mesopotamia, Syria and Egypt, and their Earliest Relations.* London: Royal Anthropological Institute of Great Britain and Ireland.

1951 *The Birth of Civilization in the Near East.* Bloomington: Indiana University Press.

1996 *The Art and Architecture of the Ancient Orient* (reprint of 1954 ed.). New Haven & London: Yale University Press .

Garrard, A. N.

1999 Charting the emergence of cereal and pulse domestication in south-west Asia. *Environmental Archaeology* 4: 67–86.

Garfinkel, Y.

1995 *Human and Animal Figurines of Munhata (Israel).* Les Cahiers des Missions Archéologiques Françaises en Israël, Volume 8. Paris: Association Paléorient.

Goff, B. L.

1963 *Symbols of Prehistoric Mesopotamia.* New Haven: Yale University Press.

Goring-Morris, A. N.

2000 The quick and the dead. The social context of aceramic Neolithic mortuary practices as seen from Kfar HaHoresh. In I. Kuijt (ed.) 2000: 103–36.

Gosden, C. (ed.)

2001 Archaeology and aesthetics. *World Archaeology* 33/2.

Haaland, G. and Haaland, R.

1995 Who speaks the Goddess's language? Imagination and method in archaeological research. *Norwegian Archaeological Review* 28: 105–21.

Hamilton, N., Marcus, J., Bailey, D., Haaland, G., Haaland, R. and Ucko, P.J.

1996 Can we interpret figurines? *Cambridge Archaeological Journal* 6/2: 281–307.

Hauptmann, H.

1993 Ein Kultgebäude in Nevali Çöri. In *Between the Rivers and Over the Mountains. Archaeologica Anatolica et Mesopotamica Alba Palmieri Dedicata* (M. Frangipane et al., eds.). Rome:

158 *David Wengrow*

Dipartmento di Scienze Storiche Archeologiche e Antropologiche dell'Antichità, Università di Roma "La Sapienza", 37–69.

Hodder, I.
1990 *The domestication of Europe.* Oxford: Blackwell.

Holland, T. A.
1982 Figurines and miscellaneous objects. In *Excavations at Jericho Vol. 4: the Pottery Type Series and other Finds* (K. M. Kenyon and T. A. Holland, eds.). London: British School of Archaeology, 551–63.

Howes, D. (ed.)
1991 *The Varieties of Sensory Experience. A Sourcebook in the Anthropology of the Senses.* Toronto: University of Toronto Press.

Ingold, T. (ed.)
1988 *What is an Animal?* One World Archaeology Series 1. London: Unwin Hyman.

Kirkbride, D.
1966 Five seasons at the Pre-Pottery Neolithic village of Beidha in Jordan. *Palestine Exploration Quarterly* 98: 8–72.
1968 Beidha: an interim report. *Palestine Exploration Quarterly* 100: 90–6.

Kuijt, I.
2000 Keeping the peace. Ritual, skull caching, and community integration in the Levantine Neolithic. In I. Kuijt (ed.) 2000: 137–64.

Kuijt, I. (ed.)
2000 *Life in Neolithic Farming Communities: Social Organization, Identity and Differentiation.* New York: Kluwer Academic/Plenum Publishers.

Lechevallier, M.
1978 *Abu Ghosh et Beisamoun. Deux gisements du VII* millénaire avant l'ère chrétienne en Israël.* Mémoires et travaux du Centre de Recherches préhistoriques français de Jérusalem 2. Paris: Association Paléorient.

Legge, A. J.
1996 The beginning of caprine domestication in Southwest Asia. In *The Origins and Spread of Agriculture and Pastoralism in Eurasia* (D. R. Harris, ed.). London: UCL Press, 238–62.

Lévi-Strauss, C.
1966 *The Savage Mind (La Pensée Sauvage).* London: Weidenfield & Nicolson.

Mahasne, H. M. and Gebel, H. G. K.
1999 Geometric objects from LPPNB Es-Sifiya, Wadi Mujib, Jordan. *Paléorient* 24/2: 105–110.

McAdam, E.
1997 The figurines from the 1982–5 seasons of excavations at Ain Ghazal. *Levant* 29: 115–45.

Michalowski, P.
1990 Early Mesopotamian communicative systems: art, literature and writing. In *Investigating Artistic Environments in the Ancient Near East* (A. C. Gunter, ed.). Washington DC: Arthur M. Sackler Gallery, Smithsonian Institution, 53–69.
1994 Writing and literacy in early states: a Mesopotamianist perspective. In *Literacy: Interdisciplinary Conversations* (D. Keller-Cohen, ed.). Cresskill, New Jersey: Hampton Press Inc., 49–70.

Moorey, P. R. S.
2001 Idols of the people: miniature images of clay in the ancient Near East. *Schweich Lectures on Biblical Archaeology*, delivered at the British Academy, London, December 2001.

Morphy, H. (ed.)
1989 *Animals into Art.* One World Archaeology Series 7. London: Unwin Hyman.

Morsch, M. G. F.
1998 Die Tonobjekte von Nevali Çöri: Neue Perspektiven in der figürlichen

Plastik des akeramischen Neolithikums. In *Préhistoire d'Anatolie. Genèse des deux mondes, Vol. 2* (M. Otte, ed.). Liège: Eraul 85.

Oates, J.
1973 The background and development of early farming communities in Mesopotamia and the Zagros. *Proceedings of the Prehistoric Society* 39: 147–81.

Rollefson, G. O.
2000 Ritual and social structure at Neolithic 'Ain Ghazal. In I. Kuijt (ed.) 2000: 165–230.

Rollefson, G. O. and Simmons, A. H.
1986 The Neolithic village of 'Ain Ghazal, Jordan: preliminary report on the 1984 season. *Bulletin of the American Schools of Oriental Research* 24: 145–64.

Runnels, C. and Van Andel, T. H.
1988 Trade and the origins of agriculture in the eastern Mediterranean. *Journal of Mediterranean Archaeology* 1/1: 83–109.

Schmandt-Besserat, D.
1974 The use of clay before pottery in the Zagros. *Expedition* 16/2: 11–7.
1977a The earliest uses of clay in Anatolia. *Anatolian Studies* 27: 133–50.
1977b The earliest uses of clay in Syria. *Expedition* 19/3: 28–42.
1992 *Before Writing* Vols. I–II. Austin, Texas: University of Texas Press.
1997 Animal symbols at 'Ain Ghazal. *Expedition* 39/1: 48–58.

Schmidt, K.
1998 Frühneolithische Tempel. Ein Forschungsbericht zum präkeramischen Neolithikum Obermesopotamiens. *Mitteilungen der Deutschen Orient-Gesellschaft* 130: 17–49.
1999 Frühe Tier- und Menschenbilder vom Göbekli Tepe—Kampagnen 1995–1998. Ein kommentierter Katalog der Grossplastik und der

Reliefs. Mit zoologischen Anmerkungen von Angela von den Driesch und Joris Peters. *Istanbuler Mitteilungen* 49: 5–22.
2001 Göbekli Tepe, southeastern Turkey. A preliminary report on the 1995–1999 excavations. *Paléorient* 26/1: 45–54.

Sherratt, A. G.
1981 Plough and pastoralism: aspects of the Secondary Products Revolution. In *Pattern of the Past: Studies in Honour of David Clark* (I. Hodder, G. Isaac and N. Hammond, eds.). Cambridge: Cambridge University Press, 261–305.
1997 *Economy and Society in Prehistoric Europe. Changing Perspectives.* Edinburgh: Edinburgh University Press.
1999 Cash-crops before cash: organic consumables and trade. In *The Prehistory of Food: Appetites for Change* (C. Gosden and J. G. Hather, eds.). One World Archaeology Series 32. London, New York: Routledge, 13–34.

Smith, P. E. L.
1990 Architectural innovation and experimentation at Ganj Dareh, Iran. *World Archaeology* 21/3: 323–35.

Suter, C. E.
2000 *Gudea's Temple Building. The Representation of an Early Mesopotamian Ruler in Text and Image.* Cuneiform Monographs 17. Groningen: STYX.

Ucko, P. J.
1968 *Anthropomorphic Figurines of Predynastic Egypt and Neolithic Crete with Comparative Material from the Prehistoric Near East and Mainland Greece.* Royal Anthropological Institute Occasional Paper No. 24. London: Andrew Szmidla.

Ucko, P. J. (ed.)
1977 *Form in Indigenous Art. Schematisation in the Art of Aboriginal Australia and*

Prehistoric Europe. Prehistory and Material Culture Series 13. Canberra: Australian Institute of Aboriginal Studies.

Ucko, P. J. and Rosenfeld, A.
1967 *Palaeolithic Cave Art*. World University Library. London: Weidenfeld & Nicolson.

Voigt, M. M.
1985 Village on the Euphrates: excavations at Neolithic Gritille, Turkey. *Expedition* 27/1: 10–24.
2000 Çatal Höyük in context. Ritual and early Neolithic sites in central and eastern Turkey. In I. Kuijt (ed.) 2000: 253–93.

Weiner, A. B.
1992 *Inalienable Possessions: the Paradox of Keeping-While-Giving*. Berkeley: University of California Press.

Wengrow, D.
1998 The changing face of clay: continuity and change in the transition from village to urban life in the Near East. *Antiquity* 72: 783–95.

Willis, R. (ed.)
1990 *Signifying Animals. Human Meaning in the Natural World*. One World Archaeology Series 16. London: Unwin Hyman.

Zimansky, P.
1993 Review of D. Schmandt-Besserat, *Before Writing* Vols. I–II. *Journal of Field Archaeology* 20/4: 513–7.

Things fall apart, the centre cannot hold

Ellen McAdam

INTRODUCTION

What can we learn about ancient cultures from objects? Is it possible to interpret what representations of human beings meant to their makers in the absence of documentary records explaining them? If such an interpretation is possible, what questions should we be asking and how can the material answer them?

This paper tries to explore some of these issues by considering human figurines from the Ubaid period. It focuses on the objects themselves, rather than on the growing literature on figurines. Some of the observations are not new: in particular, Ziegler (1962) offered many useful insights in her study of the terracottas from Warka. However, it is based on a study of an assemblage of 88 figurines from five sites in southern Mesopotamia, Al Ubaid, Eridu, Oueili, Ur and Warka,[1] plus comparative examples from Tello and Tepe Gawra. This represents all the published examples from Al Ubaid, Eridu and Ur, all the examples from Oueili available for study in the Iraq Museum in 1985–6 and 32 out of the 77 fragments from Warka published by Ziegler (1962), plus 8 unpublished examples from Warka. Time constraints precluded detailed recording of the complete Warka assemblage in the Vorderasiatisches Museum, Berlin, but a rapid scan of the remaining fragments indicated that those recorded were a representative sample. A small number of figurines from Eridu and Ur were not available for study, but the published accounts contain enough information to permit them to be assigned to type. There may be small numbers of fragments from other sites, but I am not aware of any other substantial assemblages from southern Mesopotamia.

1 The study was carried out between 1983 and 1986 with grants from the British School of Archaeology in Iraq and the Wainwright Trust. All line drawings except Fig. 35 are the work of the author; Figs. 1–34 were expertly inked by Andrew Mclaren. Figures 1, 5 and 9 are published by permission of the University Museum, University of Pennsylvania. Details of figurines from Oueili are reproduced by kind permission of Professor Jean-Louis Huot. Fouilles de Tell el 'Oueili. Délégation Archéologique Française en Iraq. All rights reserved. I am grateful to the staff of the Iraq Museum, the Mosul Museum, the Vorderasiatisches Museum, Berlin, the Louvre and the British Museum for their assistance in facilitating access to the remainder of the figurines in this study. All drawings are reproduced at a scale of 2:3.

These figurines therefore represent around 64% of the published examples and are a good representative sample of the excavated material. It is, of course, impossible to determine how representative they are of all Ubaid figurines that were ever made. They were recorded using a slightly modified version of the system developed by Ucko (1968), producing a 13-page catalogue and a substantial database. What follows is a summary of the results. It is intended to publish the full details of all these figurines as part of a corpus of prehistoric Mesopotamian human and animal figurines.

SIR LEONARD WOOLLEY AND UBAID FIGURINES

Ubaid figurines are among the most familiar images of prehistoric Mesopotamia. They form a staple of textbooks and turn up in such unlikely contexts as a mural representing world culture at Glasgow Airport. This may be partly due to their appearance in Sir Leonard Woolley's best-selling popular account of his excavations at Ur, but there are also good academic reasons for citing the Ur examples. Ur produced the earliest substantial assemblage of Ubaid figurines and the largest number of complete or semi-complete examples of the striking female figurines with shoulder pellets, and Woolley (1955) published his results promptly and comprehensively. Here is his account:

> Most of the figurines are female. These are always represented as nude though bands of paint round waists, wrists and neck may represent belts, bangles and necklaces; there is never any hint of dress. They stand upright, and either the arms are by the sides and the hands resting on the body above the hips, or they are holding an infant to the breast. The bodies are slender to the point of exaggeration and well modelled, with small but prominent breasts and the pudenda conventionally emphasised; the shoulders are unnaturally wide and angular, and on them and on the upper arms there are either spots of black paint or small lumps of clay applied, undoubtedly to represent tattoo-marks, the tattooing being done either in colour, as by the modern Arab of Syria and Iraq, or by cicatrices as by tribes in Arabia and Egypt. To the bodies, which are by no means unpleasing, the heads are in striking contrast. The top of the skull rises in an elongated dome . . . which was originally covered in bitumen to represent hair . . . The rest of the head, unduly large, is absolutely reptilian in character, coming forward to a blunt snout, flat above, with great slit-like eyes emphasised by lids in relief, which are set at a sharp slant; the nostrils are mere holes at either side of the snout and there are no ears.
>
> (Woolley 1955: 12)

Al Ubaid

	Male	Female	Human	Sub-total
Black paint	0	1	0	1

Site unknown, possibly Ur

Black paint	0	1	0	1

Eridu

	Male	Female	Human	Sub-total
Pellets	1	2	0	3
Black paint	1	1	2	4
Undec 'worshipper'	0	0	0	0
Fragment, no decoration	0	3	0	3
Total	2	6	2	10

Oueili

	Male	Female	Human	Sub-total
Pellets	1	2	0	3
Black paint	0	0	0	0
Undec 'worshipper'	1	0	0	1
Fragment, no decoration	0	1	0	1
Total	2	3	0	5

Ur (including Reijibeh)

	Male	Female	Human	Sub-total
Pellets	0	7	0	7
Black paint	1	16	1	17
Undec 'worshipper'	0	0	0	0
Fragment, no decoration	0	2	2	4
Other decoration	1 (brown paint)	0	1 (red paint)	2
Total	2	25	4	31

Warka

	Male	Female	Human	Sub-total
Pellets	1	0	0	1
Black paint	9	16	3	28
Undec 'worshipper'	7	0	0	7
Fragment, no decoration	3	0	1 feet on base	4
Total	20	16	4	40

Overall Total	26	52	10	88

Table 1. Comparison of figurine types at Al Ubaid, Eridu, Oueili, Ur and Warka.

A little later he discusses function:

> I am still convinced that the artist who could so well model the human
> body could have made a far better success, had he wished to do so, than
> appears from these lizard-like grotesques . . . I still hold that we have in
> these figurines a deliberate intention to represent something which was not
> merely human, and that this has an important bearing on the religion of the
> earliest inhabitants of Mesopotamia . . . The association of the figures with
> the dead and the fact that they normally present features emblematic of the
> Underworld support the view that they are chthonic deities.
>
> (Woolley 1955: 13)

Woolley's masterly description, blended with confident interpretation,
has convinced generations of archaeologists. Ubaid figurines are regularly
described as 'lizard-headed' or 'lizard-faced' and many writers have accepted
Woolley's interpretation of them as deities (e.g. Potts 1997: 187). However,
the picture revealed by the assemblage as a whole is more complicated. The
complete Ubaid II female figurines with pellets from Ur represent only one
and possibly the latest strand of a long tradition that can be traced back at
least to the Samarran culture (Oates 1966: 150). Their manufacturing tech-
nique is sophisticated and standardized, and figurines made in this way are
restricted to a confined area in the south of Mesopotamia. And finally, the
subject matter is varied, including men, women and infants, standing, seated
and lying down, undecorated or decorated, and clothed and unclothed.

TYPOLOGY

Four main types of Ubaid human figurine can be identified: male and female
figurines with shoulder pellets and male and female figurines with black
painted decoration. There are also a number of undecorated male figurines
that resemble the black painted males. Finally, there are fragments that can-
not be assigned to any of these types because they are too poorly preserved
or represent a part of the body which does not carry diagnostic information.
Table 1 summarizes the proportions of each. Within these broad categories,
however, there are many variations, some of which may be early forms and
some of which may represent different types.

Figurines with shoulder pellets
There are 14 known examples of the type with shoulder pellets, 3 male and
11 female; 11 are from graves or from definite or possible cemetery areas. A
number of undecorated body fragments may also have belonged to figurines

of this type. Complete or semi-complete examples include six females and two males.

Possibly the best preserved example of the type is Figure 1, one of two figurines from Ur grave PFG/T. Since these objects are hand-modelled, each is slightly different, but many aspects of the manufacturing technique recur throughout the assemblage and it is therefore worth describing this one in detail.

The legs, body, shoulders and central stalk of the head are modelled out of a single unit of clay to which the face, arms, shoulder pellets and breasts were applied. The shoulders are very wide, flat and angular, an effect produced by carving the clay while it was leather-hard, after the arms had been attached. The arms are bent at the elbows so that the hands rest flat on the body below the breasts, with fingers indicated by incisions. This position created tensions within the clay and the wrists have cracked. This was a recurrent problem. In some figurines one or more of the hands has 'sprung'

Fig. 1. Female figurine P31.16.733 U15385 Ur grave PFG/T (with U15379).

Fig. 2. Female figurine with infant IM 8564 U15506 Ur:
from burial at south end of grave PFG/AA.

from the body and in one example from Ur multiple sets of finger incisions
indicate that this happened at least once before firing. There are three ap-
plied pellets of clay on the right front shoulder and two on the back, two on
the left front shoulder and six on the back. Although in both pellet and
painted figurines there seems to be a preference for symmetry between shoul-
ders, with the design on the front of one shoulder mirrored on the back of
the opposite shoulder, it is rarely a precise match. Exact numbers and pattern
matching were not critical.

 The neck is thick, a continuation of the body, and projects forwards
slightly. The facial features are modelled with great care by carving and
incision in a thin strip of clay wrapped around the central stalk. This is a
standard technique in Ubaid figurines although in many cases the strip is
smoothed on so carefully that it is almost impossible to detect the join. The
eyes are long, slanting, excised, subrectangular slits, deeply cut and sharply
defined with heavy rounded ridges above. The cheek line is sharp and formed
by carving (the striations left by the blade are often visible), running around
the face to just below the mouth, which is a single curving incision. The

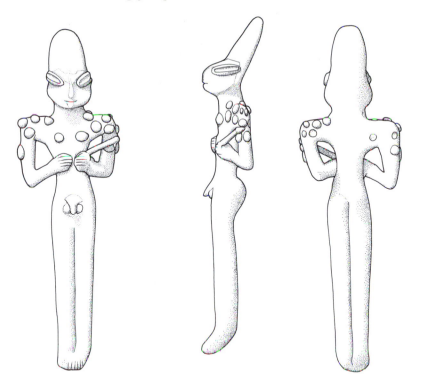

Fig. 3. Male figurine IM54931 Eridu 602-1 Eridu: grave 68.

large, curving, blunted beak-like nose has a circular impression on either side indicating the nostrils. There is another circular impression between the nose and the mouth and two more below the mouth on the chin. These impressions are found on all the pellet figurines where the face survives intact except the Eridu male. They are fairly deep, up to 5 mm, and may have taken organic insertions. After the features had been modelled the pointed crown was covered with bituminous mastic containing small brown inclusions, probably organic, representing hair or a headdress.

The breasts are small, round and pointed and were separately applied. The pubic triangle consists of a series of incised Vs below a horizontal incised line. A shallow circular impression indicates the navel, although this is unusual. The legs are outstretched and indicated front and back by a single incised line. On some examples the legs were modelled separately and applied to the body. A single incised line on the base of the figurine indicates the division of the feet, but like all pellet figurines it will not stand upright.

The only female pellet figurine to diverge markedly from this description is also from a grave at Ur (Fig. 2). She is suckling a small child with similar

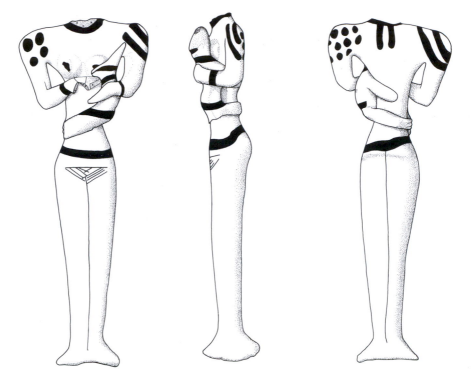

Fig. 4. Female figurine with infant BM122873 U15376 Ur PFG/O.

features and a black painted crown. The Eridu male, however, has several
unusual features (Fig. 3). There are traces of an overall wash of white paint.
The shoulders are wide but not as angular as in the Ur examples and were
clearly hand-modelled, not carved. The left hand holds a baton with a slight
swelling at the top. The crown was free from slip and was perhaps originally
covered with some organic material. Unlike other pellet figurines, the facial
features are shaped out of the clay of the head with rounded, almost bulging
cheeks, and eyes formed from slanting, applied, grain-shaped pieces of clay
with central incised depressions. The nose is sharply modelled and beak-like.
The genitalia were applied to the body, and the legs and buttocks were
modelled individually, pressed together and then attached to the body.

Black painted female figurines
In contrast to the figurines with shoulder pellets, only one black painted
figurine has been found in a grave (Fig. 4) and this is also the only semi-
complete painted female. The head was broken off in antiquity, perhaps
deliberately. The figure is suckling a small child held on the left hip, as in

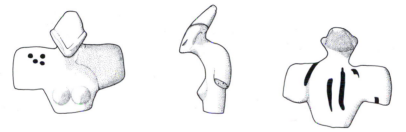

Fig. 5. Female figurine P32.40.21 U18085 Ur surface.

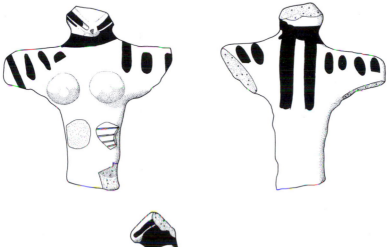

Fig. 6. Female figurine BM123591 U19976 Ur Pit X,
in the rubbish stratum below the JNG graves.

Fig. 7. Female figurine BM122875 U15331 Ur Pit F, level 5.70m.

Fig. 8. Female figurine BM117136 U1405 Ur: found in the filling of
the great Nannar court under the Nebuchadnezzar pavement.

Figure 2, and the black painted decoration on the adult includes a collar
round the neck with two ties running down the back, stripes and dots on
front and back shoulders, nipples, wrist bands and a girdle as well as eyes, a
collar and a girdle on the child. The legs end in a conical base on which the
figurine will stand upright, in contrast to the pellet figurines.

Unfortunately, this is by far the best preserved black painted female figu-
rine and the rest of the evidence consists of small fragments, often badly
worn. These derive from secondary or even tertiary contexts. Those from
Warka are mainly from the large mud bricks with which the archaic Anu
ziggurat was built over soon after the end of the Jemdet Nasr period. Never-
theless, enough survives to provide some basis for comparison. There are
few heads, either attached to bodies or detached.[2] Figure 5 is a surface find
from Ur, damaged by weathering and salt encrustation, but it is clear that the
facial features were carved into an applied strip. The crown was originally
painted black and the irises and brow ridges also show traces of black. Two
stripes down the centre back indicate the presence of a collar and there are
traces of dots and stripes on the shoulders. Figure 6 from Ur is better pre-
served and formed part of a much larger figurine: as with the pellet figurines,
the arms were separately applied to the wide, angular shoulders and must have
been bent at the elbows, the hands resting on the body below the breasts.

All the black painted female figurines from Ur have a collar around the
neck with two ties down the back and decoration on the shoulders: where
any sort of pattern can be made out, a single row of short strokes like those
on Figure 7 is the most frequent, but horizontal wavy lines, dots and diago-
nal bands across the shoulder also occur, as do bands below the breast and

2 The mismatch between numbers of female figurines and heads has often been commented
on: cf. Oates 1966: 151; McAdam 1997: 138.

Fig. 9. Female figurine P31.16.737 U15356b Ur Pit F, sq E7, level 5.50m.

around the wrist. On lower body fragments, the pubic triangle is always indicated by incision and sometimes with impressions and black paint as well. Most have girdles of black paint around the hips just above the pubic triangle. Some have vertical strokes of paint above the girdle (Fig. 8) and one has a stripe running down the centre of the abdomen to meet the girdle; it is also unusual in having modelled and painted knees (Fig. 9). One has bands of black paint around the knees. In some cases the legs were modelled separately from the body and then applied.

Some of the female black painted figurines from Warka have a similar shoulder decoration to those from Ur, although the single row of strokes is

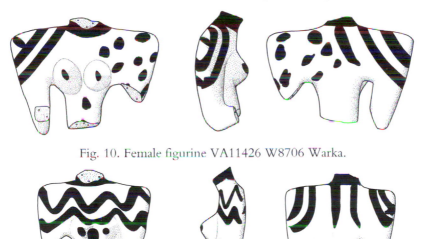

Fig. 10. Female figurine VA11426 W8706 Warka.

Fig. 11. Female figurine VA12265 W16650 Warka.

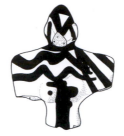

Fig. 12. Female figurine VA14626 W16545a Warka.

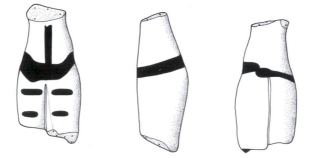

Fig. 13. Female figurine IM28400 MM696 W16593a Warka.

not found (Figs. 10, 11). Heads are also similar (Fig. 12). Black paint indicates nipples and in most cases there is a central dot, stripe or incision on the abdomen. Girdles and knee bands occur, and in one case there is decoration on the upper thighs (Figs. 13, 14). However, some of the female figurines are significantly different. In Figure 15, the arms reached upwards and outwards, and there was a marked hump between the shoulders, a feature found in two other painted female figurines from Warka.

Most of the painted female figurines are carefully made and share many features of manufacturing technique with the shoulder pellet type. Figure 16 from Eridu is exceptionally badly made, with poor modelling and surface finish and unevenly applied paint. This is from a pre-Ubaid level, the earliest stratified example of the painted type. Like two other figurines from Eridu, it has 'coffee bean' eyes.

Black painted male figurines

As Table 1 shows, the Ur and Warka assemblages differ in the relative proportions of male and female figurines. One type dominates the Warka assemblage, the male figurine standing upright on a base. Painted and unpainted versions exist but they have features in common, including their posture and the presence of modelled beards and headdresses. No complete example

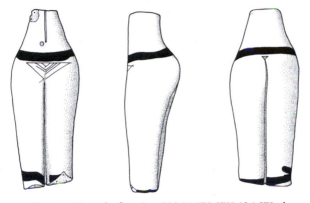

Fig. 14. Female figurine VA11478 W9434 Warka.

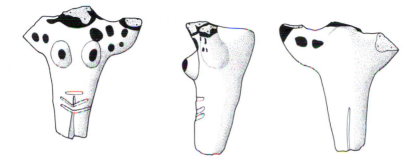

Fig. 15. Female figurine IM28399 MM 693 W16562b Warka.

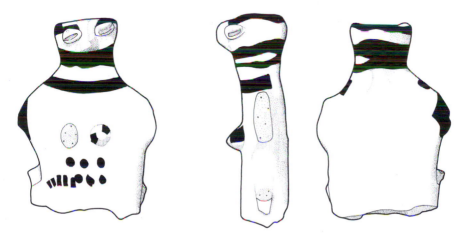

Fig. 16. Female figurine IM54935 Eridu 4 Level XIV of the pre–Ubaid period.

survives of the painted type, but Figures 17 and 18 between them provide a clear idea of what one would have looked like. The arms are simple wing-like projections below sharp, wide, carved angular shoulders. The front of the shoulders is decorated, but not the back. A strip of clay is wound twice round the pointed crown and there are three vertical stripes of black paint down this headdress. The features were carved into an applied strip and picked out in paint: the tip of the nose of Figure 17 is broken, but on both this example and Figure 18 there was a projecting, painted beard. The body is long, slender and cylindrical, flaring to the base. There is a sash of paint running over the left shoulder and a girdle with two frontal ties in the region of the waist.

Undecorated examples include Figures 19 and 20. Figure 19 is one of the most delicately modelled figurines in the entire Ubaid assemblage. The wing-like arms project backwards and downwards and the head is bent

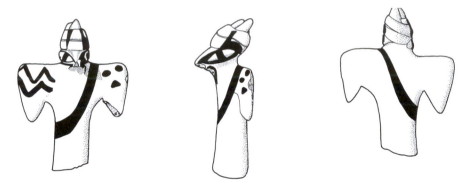

Fig. 17. Male figurine VA11522 W9722 Warka.

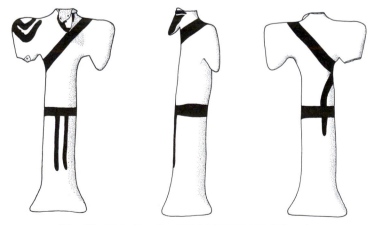

Fig. 18. Male figurine VA11523 W10267 Warka.

Fig. 19. Male figurine VA11521 W10268 Warka.

Fig. 20. Male figurine VA12261 W16551c Warka.

Fig. 21. ?Male figurine Louvre AO 14441 TC 5782 Tello.

forwards slightly in a pose that suggests worship. A strip of clay was origi-
nally coiled around the pointed crown and the nose and beard were
shown by pinching out. Virtually the same attitude is seen in Figure 20. Ur
and Eridu each produced one example of the painted male figurine. Similar
but less well made examples, painted and unpainted, are known from Tello
(Fig. 21) and as far north as Tepe Gawra (Tobler: 1950: Pls. LXXXIV and
CLVII).

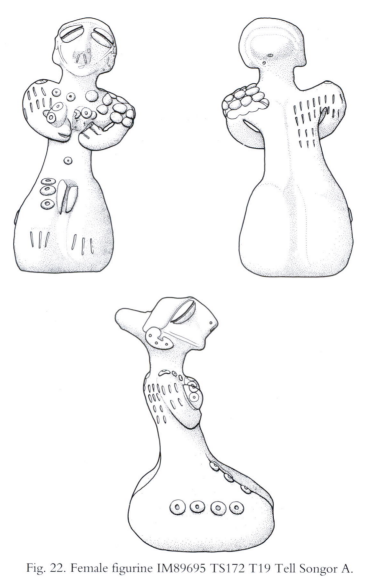

Fig. 22. Female figurine IM89695 TS172 T19 Tell Songor A.

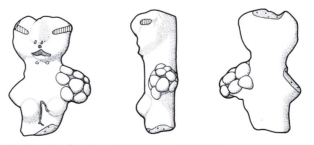

Fig. 23. Female figurine IM25132 U15516 Ur grave PFG/QQ.

Other types

The pellet and painted figurines described so far form a remarkably consistent group in terms of quality, manufacturing technique and decoration. But there are many other fragments that deviate slightly. These may represent chronological development or different strands within the tradition.

The relationship between Samarran and Ubaid figurines is illustrated by a Samarran female figurine from Tell Songor (Fig. 22). Many features of the Ubaid II figurines (high crown with cap, shoulder decoration including pellets, hand position) are already present and it is possible to envisage a process of increasing stylisation that led from this relatively naturalistic depiction of the human face to the later examples that struck Woolley so unfavourably.

One might expect figurines from the early part of the Ubaid period to resemble those of the Samarran period most closely. Figure 23 was found in an Ubaid II grave at Ur, possibly redeposited. The pellets on the short, fin-like left arm are pressed together to form a honeycomb effect like that on the Songor figurine and the face, applied to the stalk of clay forming the neck and crown (now broken), is flat and rounded, unlike the usual wrap–round strip. The eyes are picked out in crimson paint, the nose is large and the mouth is incised. Figure 24 from Eridu may also be early, with closely spaced pellets. In this case the face was not applied to the central stalk as a single piece; the nose and then the eyes were applied separately, with central excised slits picked out in red and traces of black paint on the crown.

Two bearded male figurines from Ur may be early, as both carry painted decoration of close checks, reminiscent of Hajji Muhammed style pottery

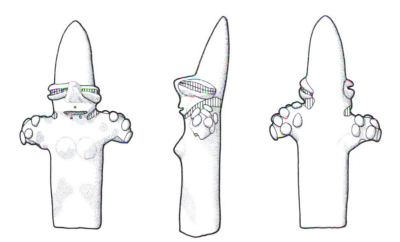

Fig. 24. Female figurine IM54932 Eridu 1 Ubaid house east of cemetery.

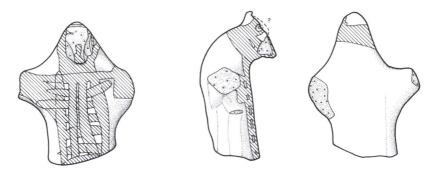

Fig. 25. Male figurine BM123220 U17894 Ur:
against the stone face of the 1st Dynasty ziggurat.

(Fig. 25). Three painted heads (Figs. 26, 27, 28) are unusual. In each case the head curves to form a pointed crown capped with black paint, the eyes are applied with excised slits and picked out in black paint, the surviving noses are pointed and the mouths are also picked out in black paint. The rounded crowns, pointed features and heavy and elaborate painted decoration are unusual and may indicate an early date. A number of individual black painted leg fragments resemble the legs of the seated Samarran females from Choga Mami (Oates and Oates 1976: 76), which are apparently wearing trousers. These fragments may therefore also be early (Fig. 29).

Finally, two painted fragments from Warka are without parallel. The first, Figure 30, depicts a male figure sitting on a couch or litter. The litter consists of a rectangular base with four legs, all now broken. Along each long side a separate strip of clay has been added, the ends of which, also now broken, originally projected beyond the ends of the base, perhaps as carrying handles. The upper surface of the base has raised edges and on it sits the lower body of a naked male, broken off at the waist. The right leg extends into the right corner of the base and is smoothed into the clay of the base. The left leg is broken. On the sides of the base, on either side of the body, are depressions in front of which are incisions, probably representing the position of the elbows and hands respectively.

The second, Figure 31, is certainly a head but not definitely human. The head rises to a black-painted crest like a cock's comb with three circular perforations that may have held organic insertions. A small projecting piece of clay below the features, also painted black, may be the remains of the neck. The long, slanting eyes were excised by carving. The nose is pointed and beak-like, with no indication of a mouth. The overall impression is avian, like Figures 25–27.

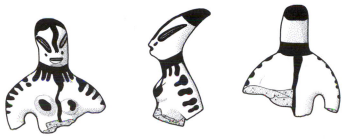

Fig. 26. Female figurine IM25131 U15399 Ur: loose in the soil, Pit F, level 2.0m.

Fig. 27. Female figurine BM116894 1924 9.20 155 Ubaid TO 405.

Fig. 28. Female? figurine BM121002 1929 7-15 43.

Fig. 29. Human figurine IM54936 Eridu 5 Found in Temple XII.

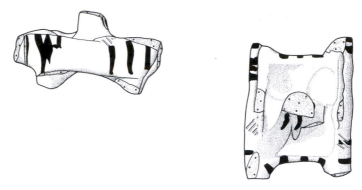

Fig. 30. Male figurine on model couch or litter VA14604 W8109 Warka.

Fig. 31. ?Human figurine VA14606 W10241 Warka.

DISCUSSION

Within the overall assemblage of Ubaid figurines, there is considerable inter-
and intra-site variation. Warka has a much larger proportion of male figurines
than Ur, which has a larger proportion of pellet figurines. Most figurines
with shoulder pellets are from graves or cemetery areas, they cannot stand
upright and they include a high proportion of complete or semi-complete
examples. In contrast, only one semi-complete painted female is known
from a grave and she stands on a base. The best-preserved male examples,
decorated and undecorated, stand upright on conical bases: they are either
definitely male because they have beards or presumed male because of their
close similarities to bearded figurines.

The figurines with shoulder pellets seem to have been made to lie on
their backs or be held in the hands, as in Ur grave PFG/T. The fact that they
cannot stand up might suggest that they are depictions of the dead. How-
ever, one of them is nursing a baby who seems very much alive. It also seems
unlikely that they represent the individual in the grave. The fact that PFG/T
at Ur contained two complete examples would appear to exclude this, as
would the presence of the male figurine from Eridu in a female grave. None
of the pellet figurines appears to be clothed.

What relationship is there between pellets and painted decoration? Pellets
appear on shoulders and on male figurines to indicate nipples. The weak
preference for symmetry between front and back on opposite sides has been

noted. Apart from the three painted leg fragments that may be wearing trousers, all females seem to be nude, although in addition to shoulder decoration, hair/headdresses, facial and anatomical features, paint can be used to show collars with ties running down the back, girdles, garters, anklets, other leg decoration, bracelets and abdominal lines. Even the painted baby is wearing a collar and girdle. Some of these items can be paralleled in Ubaid graves; the Eridu burial accompanied by the male figurine, for example, had a girdle of white and black beads in the region of the pelvis (Lloyd and Safar 1981: 131, Grave 68), and the burial in Ur PFG/T had rows of shells and black beads around the right wrist. Some aspects of female adornment are therefore shown, but the sexual characteristics are never obscured.

All male figurines with shoulder pellets are naked, but only one painted male is unclothed. On male figurines, painted decoration includes shoulder decoration, facial features, headdress decoration, a possible collar, an abdominal line, sashes and a girdle, in some cases with two frontal ties. It seems very likely that these males are represented as being clothed in a long robe or skirt. If the shoulder decoration on females represents tattoos then so, presumably, does the shoulder decoration on males, which includes the same motifs. However, paint is also being used to represent other things, including male dress accessories and female jewellery, which may well have been worn with ordinary clothing. There seems no particular reason to interpret the shoulder decoration as tattooing. It may represent tattooing, but it may equally represent some other form of adornment worn with or without clothing, such as paint. The shoulder decoration is the only part of the ensemble to be considered suitable for figurines intended for burial, but it was suitable only in the altered form of pellets. It seems unlikely that pellets represent cicatrization.

What were these figurines for? Ucko (1968) has argued that most human figurines in the ancient Near East were not 'mother goddesses' but children's playthings. Since Ubaid figurines, where they have any significant archaeological context, are found in graves or, in the case of the Warka figurines, in a sacred precinct, it seems unlikely that they were toys, which are in any case unusual in pre-industrial societies, at least in the sense of objects manufactured by adults for children. Woolley suggested that their extraordinary appearance indicated that they represented chthonic deities, but we have seen the possible traces of a stylistic evolution from the relatively naturalistic features of the Tell Songor Samarran figurine through more round-faced examples from Ur and Eridu to the wrapped and carved features of the Ubaid II figurines. In their final form, the female figurines are certainly highly

Grotesque or gorgeous? Barbie © Mattel Inc 1983, 2002.
The earlier version has a more exaggerated body shape.

stylised both in terms of facial features and body shape: the shoulder width: waist width ratio of pellet and painted females is 3:4 and 3:33, respectively, against a less extreme 2:76 and 2:8 for male types. However, human attractiveness is very largely a cultural construct; compare Figure 1 with the Barbie doll in the plate above, which in addition to its exaggeratedly large eyes and breasts and deformed feet has a shoulder width: waist width ratio of 2:4.

There is no *a priori* reason on grounds of appearance why these objects should represent a deity or deities. However, Postgate has argued (1994: 176–84) that figurines have a limited number of functions. Animals may represent a gift to the deity and human figurines may represent the supplicant, a substitute who would pray unceasingly to the deity or some sort of divine or supernatural being. The painted male figurines, bearded, clothed and standing upright on their bases with their heads slightly bowed, make convincing supplicants. This does not necessarily imply that they are portraits. Do the painted males stand for male worshippers and painted females for female worshippers? This need not follow since, as we have already seen,

the male Eridu figurine was in a female grave. The fact that all females and all pellet figurines are naked may be significant; it is possible that naked figurines are representations of the divine or at least supernatural intermediaries.[3] If this is the case, then we can identify from painted and shoulder pellet figurines not only a popular slender female goddess and a goddess suckling a child but at least one male (and beardless) divinity plus a hump-backed (a sign of old age?) goddess known only from painted examples at Warka. Male and female naked figures might accompany certain individuals to the grave; the bearded and clothed male figures are never found in graves.

Whatever the figurines represent, they are extremely carefully made using remarkably standardized and elaborate manufacturing techniques. This suggests firstly that they were made by people who were highly skilled in both modelling and firing, and secondly that the act of assembling the figurine in the correct way was almost as important as its finished appearance. It is hard to convey through text and two-dimensional illustrations the very high and consistent degree of technical expertise achieved in the best of these figurines.

Fig. 32. Female figurine Louvre AO15327 T885 Tello.

The 'canonical' Ubaid figurine was made by adding body parts to a central stalk, with features created by carving, painting or application. The geographical distribution of this type forms a tight cluster in the extreme south of Mesopotamia (Fig. 35). Figurines from a site as near this cluster as Tello superficially resemble them but are much less skilfully modelled and painted (Figs. 32, 33, 34). It is as if the Tello makers had seen and attempted to copy Ubaid figurines without fully understanding the techniques or, perhaps, the iconography. Within the restricted central area of the Ubaid figurine tradition, a remarkable consistency is achieved; outside it, the tradition seems to fall apart. Does the distribution of the canonical type reflect some sort of religious, political or cultural power structure in the region?

Why were they made? Although 88 figurines is a large assemblage in comparison with what survives from earlier prehistoric periods, it is a small

3 See Westenholz 1998 for a discussion of goddess figurines in the historic periods.

Ellen McAdam

Fig. 33. Female figurine Louvre AO15325 Tello.

Fig. 34. Female figurine Louvre AO15330 T801 Tello.

number from a period that has traditionally been assigned a 1000-year dura-
tion. Even if most of the examples that have survived can be dated directly
or indirectly to the latest phases of the Ubaid, and even if what survives is
only a fraction of the numbers originally made, it seems likely that they were
made only in response to certain circumstances and for certain individuals. It
thus seems likely that not every member of the population had a figurine and
that they were only used in certain places, two of which we know to have
been cemeteries and temple precincts. The right (or need) to have a painted
figurine was restricted to a limited number of people and the right to be
buried with one with pellets was even more restricted. The criteria that
determined the need to make a figurine are unknown, and wider considera-
tion of this question would have to encompass the large number of animal
figurines, including finely modelled bovids, from these sites.[4]

4 Cauvin (1972, 1994) and Hodder (1990, 1995) have written extensively on the symbolism
of figurines in the Neolithic of the Near East and, in particular, on the symbolic ambivalence
of fertile goddesses and wild bulls, the domestic and the wild, reproduction and death.

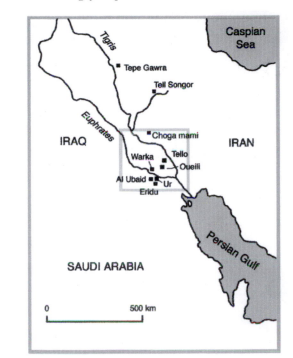

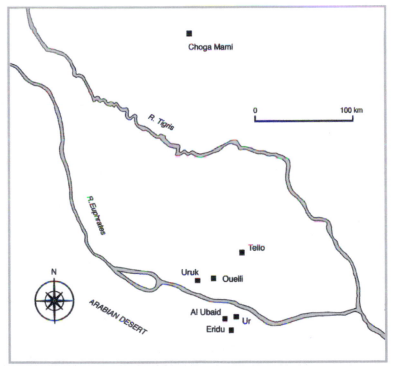

Fig. 35. Map of sites mentioned in the text.

Who were the people who used figurines? It is dangerous to extrapolate backwards from the historical periods to prehistory, but since one of the major assemblages comes from Ur, it is tempting to quote from Moorey's (1984) examination of 'human sacrifice' at Ur:

> ...there is no good reason to believe they belonged, in a secular sense, to the very highest ranks of the ruling group at Ur . . . Their role in the temple establishment and its local cults is more likely to explain the rituals attendant on their burial. From at least the middle of the third millennium at Ur there were people, perhaps no more than half-a-dozen or so in any one generation, who were entitled to be buried with the attendant 'sacrifice' of men, women and children . . .
>
> (Moorey 1984: 17)

There is no suggestion of any connection between human sacrifice and the presence of human figurines in graves. However, the passage is helpful in reminding us that the factors that controlled access to figurines may well have been related more closely to the religious or magical status of the individuals than to what we would consider more straightforward considerations of wealth or political power. Equally, however, some new discovery may completely revolutionize our understanding of the period and overturn the tentative conclusions reached here. It cannot be established, for example, whether the apparent variations between sites reflect real differences in ritual and belief or simply the accidents of discovery. The sample from which we are working is very limited.

One final question remains to be asked. Ubaid figurines represent the stylistically confident and technically accomplished flowering of a long tradition of figurine-making in Mesopotamia. After the Ubaid II period there are no more figurines in this lineage. There are human figurines from the Uruk and Early Dynastic periods, but they cannot be compared to Ubaid figurines in quality of modelling or execution. Why did the tradition come to an end? Did the non-figurine makers take over? Did things fall apart because the centre could not hold?

REFERENCES CITED

Cauvin, J.
1972 *Religions néolithiques de Syro-Palestine.* Publications du Centre de recherches d'écologie et de préhistoire 1. Paris: J. Maisonneuve.
1994 *Naissance des divinités, naissance de l'argiculture: la Révolution des symboles au Néolithique.* Paris: Éditions du Centre national de la recherche scientifique.

Hodder, I.
1990 *The Domestication of Europe: Structure and Contingency in Neolithic Societies.* Oxford: Basil Blackwell.
1995 Material culture in time. In *Interpreting the Past* (I. Hodder, M. Shanks, A. Alexandri, V. Buchli, J. Carman, J. Last and G. Lucas, eds.). London: Routledge, 87–91.

Huot, J.-L. (ed.)
1983 *Larsa (8ème et 9ème campagnes, 1978 et 1981) et 'Oueli (2ème et 3ème campagnes, 1978 et 1981): rapport préliminaire.* Bibliothèque de la Délégation archéologique française en Irak, no. 3. Paris: Éditions Recherche sur les civilisations.

McAdam, E.
1997 The figurines from the 1982–3 seasons of excavations at Ain Ghazal. *Levant* 29, 115–45.

Moorey, P. R. S.
1984 Where did they bury the kings of the IIIrd Dynasty of Ur? *Iraq* 46: 1–18.

Oates, D. and Oates, J.
1976 *The Rise of Civilization.* Oxford: Elsevier-Phaidon.

Oates, J.
1966 The baked clay figurines from Tell es-Sawwan, Iraq. *Iraq* 28: 146–53.

Postgate, J. N.
1994 Text and figure in ancient Mesopotamia: match and mismatch. In *The Ancient Mind: Elements of Cognitive Archaeology* (C. Renfrew and E. B. W. Zubrow, eds.). New York: Cambridge University Press, 168–76.

Potts, D. T.
1997 *Mesopotamian Civilization: the Material Foundatons.* Ithaca, New York: Cornell University Press.

Safar, F., Mustafa, M. A. and Lloyd, S.
1981 *Eridu,* Baghdad: Ministry of Culture and Information, State Organization of Antiquities and Heritage.

Tobler, A. J.
1950 *Excavations at Tepe Gawra, Vol. 2.* Philadelphia: University of Pennsylvania Press.

Ucko, P. J.
1968 *Anthropomorphic Figurines of Predynastic Egypt and Neolithic Crete with Comparative Material from the Prehistoric Near East and Mainland Greece.* Royal Anthropological Institute Occasional Paper 24. London: Andrew Szmidla.

Westenholz, J. G.
1998 Goddesses of the ancient Near East, 3000–1000 BC. *In Ancient Goddesses: the Myths and the Evidence* (L. Goodison and C. Morris, eds.). London: British Museum, 63–82.

Woolley, L.
1955 *Ur Excavations, Vol. 4: The Early Periods.* London and Philadelphia: Trustees of the British Museum and the Museum of the University of Pennsylvania, 12–13

Ziegler, C.
1962 *Die Terrakotten von Warka.* Ausgrabungen der Deutschen Forschungsgemeinschaft in Uruk-Warka Band 6. Berlin: Verlag Gebr. Mann.

Scorpion, fish and nets:
an unusual jar in Canaanite Middle Bronze context[1]

Miriam Tadmor
with an appendix by Yuval Goren

From its beginnings, archaeological research of Palestine focused its efforts on the study of pottery. Nowadays, over a hundred years later, a rich and varied corpus of ancient pottery is in the hands of archaeologists, serving as a reliable and sensitive tool, the basis of modern—often interdisciplinary—research. However, it is precisely because the development of pottery vessels is now so well documented, that only seldom will a new find add an unknown element of shape or decoration. I believe that the Israel Museum pottery jar discussed below (IMJ 68.37.166) belongs to that category of rare vessels. I shall examine the various components of its shape and decoration in the context of comparative finds from the Levant in the first half of the second millennium (comparisons with the Aegean are considered anachronistic in this context). The jar was subjected to petrographic examination by Prof. Yuval Goren of the Tel Aviv University, who kindly appended his results to this paper.

This is a large piriform jar of graceful proportions and remarkable decoration (Figs. 1–4). It is 59 cm in height, its maximum diameter on the upper part of the body is 46 cm and the opening at the rim is 11 cm in diameter. The flat rim, with a very shallow channel in the middle, rises slightly outwards; the neck is short and flaring. The lower part of the body tapers towards a flattened base. The jar is balanced on a tripod of three flat, handle-like loops which surround the base (one has been restored). Its clay is light brown, it is wheel made and wheel marks are clearly discernible on the interior.

The entire surface of the jar was originally covered with a yellowish-brown slip and burnish, now partly rubbed off; the upper part of the body, the neck and the rim are richly painted. Two colours were used: dark red

1 It is a pleasure and an honour to offer this study in appreciation of Roger Moorey, to whom no aspect of ancient civilizations is alien. I wish to express my sincere gratitude to Yuval Goren, Osnat Misch-Brandl, Tallay Ornan, and Uzza Zevulun, who critically read a draft of this paper, offered most welcome remarks and assisted in many ways. I am also very grateful to Prof. Dr. Hans-Günter Buchholz for his interest of many years in this jar and for his helpful remarks (letter of 15.11.2000). I am very grateful for the assistance of the Esther and Simon Geldwerth Foundation, New York.

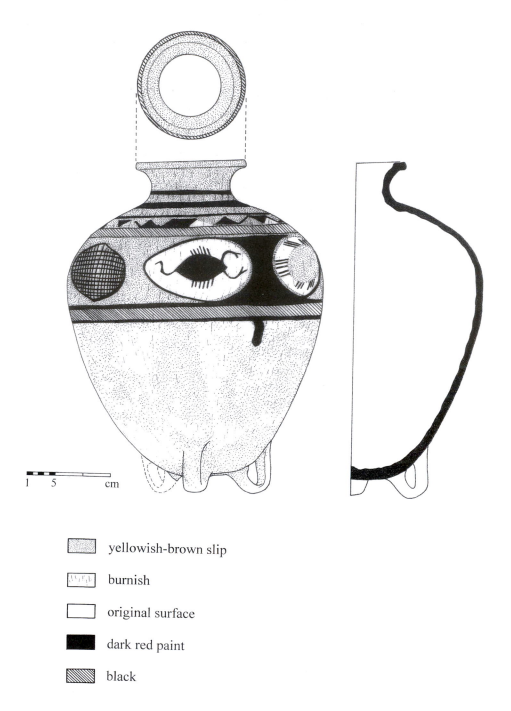

1 5 cm

yellowish-brown slip

burnish

original surface

dark red paint

black

Fig. 1. Drawing of the jar. Scale 1:7. By Pnina Arad, The Israel Museum, Jerusalem.

and black, interplaying with slipped and burnished areas. From the top down, the decoration scheme includes: a line of black paint on the outer perimeter of the rim, now very faded and preserved in some spots only; three horizontal stripes of dark red paint at the base of the neck and on the shoulder, followed by a stripe of triangles of alternating dark red paint and yellowish-brown slip; a few triangles are now without slip. Centrally placed at the jar's widest circumference is a wide band framed by two horizontal black stripes. Enclosed in that area are seven oval medallions: four filled with a criss-cross design of various densities; one containing a scorpion and the remaining two containing fish.

Though its size qualifies the vessel as a storage jar, its elaborate treatment testifies to some other, special purpose; moreover, as we shall see, several elements of its shape and decoration are rare in jars. The shape of the jar has features characteristic of local MB II pottery.[2] The piriform and the flattened base are typical of late MB IIA.[3] Flat rims on jars are attested at Megiddo and Aphek (Ras el-'Ain) in MB IIA, but they differ from our rim in their profiles;[4] the rim in the 'Montet Jar' of early MB IIA seems to be similar both in shape and profile (Tufnell and Ward 1966: 169, Fig. 1, Pl. 11). Handleless jars were found at Tel Rehov in the Beth Shean Valley and at Gesher, south of the Sea of Galilee, dated there to early MB IIA.[5]

The tripod, which surrounds the flattened base, is another prominent MB II feature. Tripods are especially common in kraters and bowls with both flat and ring bases, but they are rather unusual in jars. Though tripods are attested already in MB IIA (Beck 2000: 129, 131, Fig. 8, 20:11) and MB IIA–B (Ilan 1996: 216, Fig. 4.77; Maeir 1997: 307), they gained popularity mainly in MB IIB. The frequency of tripod kraters in Jericho tombs, assigned by Kenyon to her early Group II and Group III, is especially instructive.[6] Vessels on tripods are also occasionally found in the Late Bronze Age and still later, in the first millennium, testifying to the long use of this prac-

2 The following terminology is used: Middle Bronze (MB) IIA (=MB I), and MB IIB (=MB II). For thorough discussions of MB II pottery, see Beck 1975, Gerstenblith 1983; Ward and Dever 1994; however, see Beck and Zevulun 1996.

3 In the course the MB IIA the earlier, globular jars became piriform and in MB IIB they became narrow and elongated, with a pointed base and loop handles (Beck 1975: 52–3; 62, Fig. 9.9; 77, Fig. 14.4; Gerstenblith 1983: 26–8, 40, 53; Amiran 1969: 102–5).

4 Megiddo: Loud 1948: Pl.12.17–19 from tombs ascribed to Str. XIV or XIV–XII; Aphek: Beck 1975: 57, Fig. 5.12, 14; 61, Fig. 7.19, 21; 65, Fig. 9.9.

5 Yogev 1985: 99, 102–3, Fig. 3.2; Garfinkel and Bonfil 1990: Figs. 2.9, 3.1, 4.4, respectively.

6 e.g. Kenyon 1965: Figs. 212.20; 248; 249.1, 2; 251.1, 2; 392.2; see the discussion of Beck and Zevulun (1996: 69–72) on the dating of Jericho tombs.

tical, if somewhat playful device, which widens the base of the jar but has no bearing on its capacity.

As already mentioned, the whole jar is slipped and burnished. After the drab wares of the MB I, the red and brown burnished slips—often brilliant —became a characteristic *par excellence* of the MB IIA, declining in popularity in MB IIB. This is another element more common in small vessels than in jars; surfaces of large jars would often be covered with shallow wheel combing or would simply be wet smoothed.

Painted decoration based on geometric motifs and horizontal lines or, less common, lines and triangles was the harbinger of Middle Bronze Age pottery. The vogue spread from the Khabur valley and beyond, in the north, to Ras el-'Ain (Aphek) on the sources of the Yarkon river in Canaan, in the south. The 'Khabur Ware' painted style became a diagnostic element in comparative studies dealing with its spread to Palestine.[7] Painted decoration appears mainly on jugs and most often on light surfaces but seldom on other types of vessels. Common are hatched triangles but red painted triangles may also be found. The 'Montet Jar' should also be mentioned in this context: similar to our jar in dimensions and shape (59 cm in height, with a flat base), its painted decoration consists of hatched triangles, horizontal and wavy lines and two bands of rope mouldings, but it has not been slipped nor burnished, and has no figurative motifs (Tufnell and Ward 1966: Fig. 1, Pl. XI). A decoration of hatched triangles and a bichrome linear design appears on an unusual MB IIA krater from Megiddo, that has two handles and a wet-smoothed surface (Loud 1948: Pl. 13.11). More recently, examples of vessels with painted decoration were excavated in a tomb at Gesher (a globular jar)

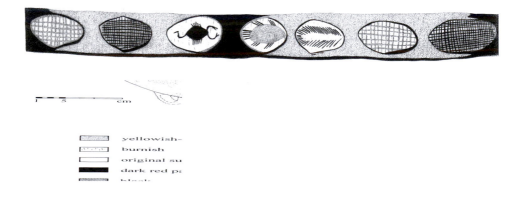

yellowish-
burnish
original su
dark red pi
blac..

Fig. 2. The stripe with painted figurative decoration: scorpion, fish and nets.
Drawing by Pnina Arad, The Israel Museum, Jerusalem.

and at Tell 'Amr in the Akko Plain (a slipped and burnished jug).[8] All these vessels, however, lack the figurative motifs of our jar.

Some especially close parallels to our jar come from Tomb 8 in the cemetery at Ruweisé-Kafer-Garra near Sidon (Guigues 1937: 62–4). One jug is slipped and burnished, with painted red and black bands and criss-cross design; another has two bichrome bands (Guigues 1937: 63, Fig. 23a; 64, Fig. 24; 63, Fig. 23b). Especially similar is a handleless, globular jar on a tripod, with red-slipped and burnished surface (Guigues 1937: 63, Fig. 23c). Another jar, also decorated with red bands—some delineated in black—was found in Tomb 73 (Guigues 1938: 57, Fig. 81).[9] The similarity between the pottery from this cemetery and Palestinian MB II ware has long been recognized in research and these parallels should come as no surprise (Epstein 1974: 23–39; Gersteblith 1983: 42–4). Indeed, it should be pointed out that no better parallels to our jar can be brought from any Palestinian site; even they, however, lack the figurative representations of our jar.

What makes our jar unique is the wide band in the centre. Unusual is the choice of figurative and geometric elements and their inclusion in oval medallions which, though separated, may perhaps be viewed as related components of one theme. The colour scheme within the band is very elaborate. Even before the jar was slipped, the medallions were outlined in red and the band delineated in black (at the bottom in red too); the body of the scorpion, the fins of both fish and two criss-cross motifs are also painted in dark red. The background colour of the surface of the medallions and the narrow body of one fish appear in the original, 'reserved' light-brown clay of the jar. The oval body of the other fish, the remaining two criss-cross motifs and the surface between the medallions are covered with the yellowish-brown slip, with the exception of two dark red areas on both sides of the jar, one opposite the other. The band is burnished like the rest of the jar.

There can be little doubt that the painter intended to emphasize the scorpion as the focal element of his composition. He portrayed the scorpion much more realistically than the fish, depicting the raised flexible tail, the sting armed with poison glands and the large pincers studded with tactile hair, as well as the numerous walking legs (though their number is not cor-

7 Ory 1936: 111–2, 1937: 99, 120; Iliffe 1936: 113–26; Amiran 1969: 113–5; Gerstenblith 1983: 38–70.

8 Garfinkel and Bonfil 1990: 141, Fig. 5.2; Druks 1982: 1–6, Fig. 3.10 (Hebrew), p.1★ (English); Amiran 1969: 106, Photo 106.

9 According to Gerstenblith (1983: 42–3), Tomb 8 was 'probably partially MB I' (= MB IIA) and Tomb 73 was 'probably MB II' (= MB IIB).

rect). In contrast, both fish are depicted very schematically. Dr. D. Golani of the Department of Evolution, Systematics and Ecology of the Hebrew University of Jerusalem, kindly commented that the schematic depiction of the fish prevents an identification even of the species, let alone of the of the specific kind. Dr. Golani doubted whether, in the eyes of a specialist, these would altogether be viewed as depictions of fish (personal information, 28.8.2000). It seems to me, however, that a layman—an archaeologist or an art historian acquainted with the manner in which ancient potters depicted fish—would be less hesitant. Van Buren's assertions that 'from very ancient times onwards an outline, vague but sufficient to indicate the genus fish, was included among the apparently decorative motives on painted pottery' (1948: 102) and that 'representations [of fish] are usually too conventional to permit identification of species' (1939: 104–8), certainly hold true for two- or three-dimensional depictions of fish in second-millennium Levant. In this respect, the fish depicted on our jar are no exception.

When drawing the fish and the scorpion, the painter used two different techniques. He first outlined the body of the scorpion with a thick coat of dark red paint and then applied a thinner coat of the same paint to the enclosed area, resulting in a slightly lighter shade of red. By contrast, no contour lines delineate the body of either fish. One fish has two dorsal fins and two anal fins, each formed by three strokes; the other has continuous fins around the body. The outline of the body of the latter is, in fact, no more than an imaginary line created by the inner tips of the fins. Being brown and pale, both fish blend with the background. The contrast between this paleness and the deep red colour of the scorpion clearly points to the importance of the latter. In addition, the adjacent deep red colour of the background blends with that of the scorpion, further focusing the interest of the onlooker.

Scorpions and fish are native to the whole area between Mesopotamia and Egypt and both have been depicted since prehistory (van Buren 1937: 1–28).[10] Fish could symbolize abundance and beneficence; the meaning of scorpions—which must have been a menace to the population in ancient times even more than today—was apotropaic, their depiction offering protection; moreover, they were worshipped as deities.[11] In the Levant, scorpion

10 Related depictions are those of fish-garbed figures, mermen and mermaids and scorpion people (Black and Green 1992: 82–3, 131–2, 160–2).

11 Undoubtedly, it is because of its symbolic properties that a scorpion was included in the third millennium fragmentary stand from Tell Chuera (Moortgat 1962: Figs. 22–6). Scorpions feature prominently in boundary stones (*kudurrus*) of the Kassite period, as symbols of the

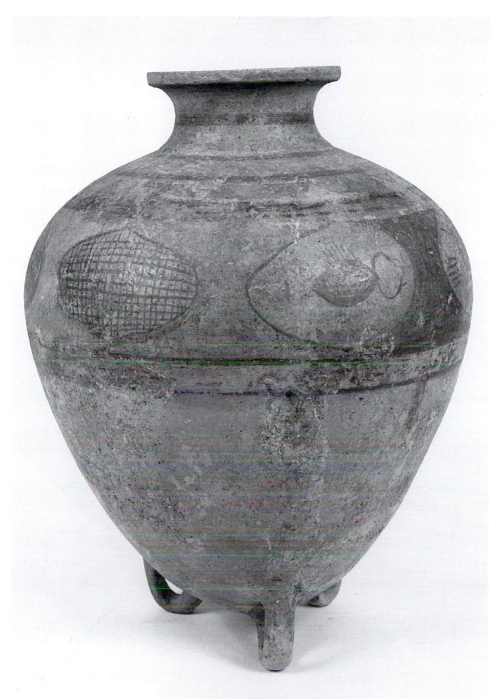

Fig. 3. B/W photograph of the jar: scorpion and net.
By Peter Lanyi, The Israel Museum, Jerusalem.

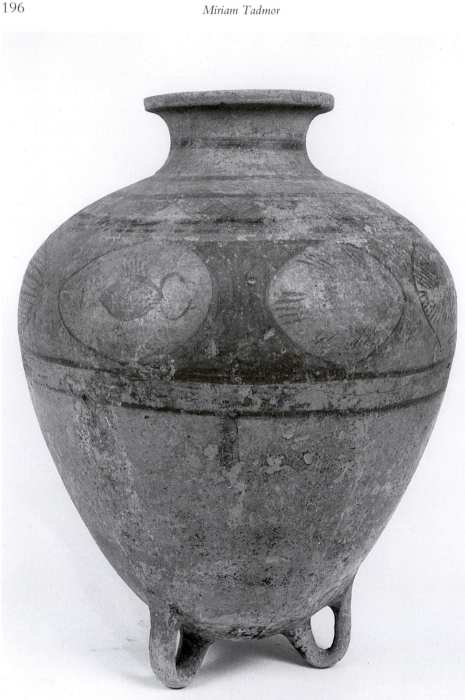

Fig. 4. B/W photograph of the jar: scorpion and fish.
By Peter Lanyi, The Israel Museum, Jerusalem.

and fish motifs were popular in glyptic art of the second millennium. Alalakh and Ugarit may serve as our type sites because of the large assemblages of cylinder seals and sealings excavated there and because of their connections with southern Canaan. Collon notes that at Alalakh small animals, such as scorpions, fish and snakes, were common in seal impressions of Level VII— even feature as the only element of design (Collon 1975: 191)— and that fish and birds, above or below nets, were common in the 15th–14th centuries. (Collon 1975: no. 232; 1982: 64).[12] She also notes the frequency of fish and scorpion motifs in actual seals (Collon 1982: 16). At Ugarit, fish and scorpions appear on seals in a variety of styles throughout the second millennium.[13] On the numerous Mitannian seals, which are mostly dated to Ugarit Récent 1–2, fish were especially frequent, often as the main motif.[14] Both, at Alalakh and at Ugarit, fish and scorpions were either cursorily sketched or carefully depicted in detail.

In southern Canaan, the use of cylinder seals followed a somewhat different path. The demographic and economic changes of the Middle Bronze Age I interrupted the centuries-long use of cylinder seals in the Early Bronze Age and the custom of impressing seals (some of which depicted fish) on jars.[15] There are no MB IIA seals and MB IIB seals are often found in later contexts,[16] a phenomenon also observed by Collon at Alalakh. Of the few seals found in contemporary contexts in early excavations in Palestine, we shall single out one seal from Megiddo in which two scorpions are superimposed, one over the other (Loud 1948: Pl. 160.3 from Tomb 5067 attributed to Stratum XII), and another seal from Shechem with a fish (Sellin 1927: 266, Pl. 30). In her discussion of cylinder seals found in the Jericho tombs,

goddess I√hara, who had close Semitic connections and may have been associated with Dagan (Black and Green 1992: 110, 113–4, 160–1; Wiggerman 1992: 180–1). In Egypt, scorpions were symbols of the goddess Serqet, one of the four protectresses of the dead, and they were also associated with Seth. They were depicted in amulets and magical spells were directed against them (Andrews 1994: 24; Shaw and Nicholson 1995: 253–4; Waterson 1996: 105).
12 See also Collon 1975: Pl. XLII for a synopsis of the various depictions of fish and scorpions on Alalakh seals.
13 e.g. Schaeffer-Forrer 1983: 30 (R.S. 9.300), 41 (10.029), 43 (17.024), 57 (13.049); Amiet 1992, scorpions: e.g. nos. 5, 15, 80, 85, 94, 336, 421–3, 425; fish: nos. 33, 54, 56, 59; both motifs appearing together: e.g. nos. 58, 60, 347, 351. For a synopsis of the various shapes of scorpions and fish on seals from Ugarit, see Schaeffer-Forrer 1983: 197.
14 e.g. Schaeffer-Forrer 1983: 79 (1.001, 2.014), 95 (8.022), 129 (23.11), 136 (24.03) and many others.
15 Ben-Tor 1978: 26 (45, 46), 53 (1–3).
16 e.g. two MB II Syrian style seals from Hazor, dated by Beck to the 18th century, were found in LB II temple (Yadin et al. 1961: Pl. XXXIX.1–2; Beck 1989: 310–21).

Porada noted the scarcity of MB seals and postulated that . . . 'the fact that these cylinders were probably all brought from other places rather than made locally, supports the general assumption concerning seal engraving in Palestine which was probably limited to scarabs until the Late Bronze Age' (Porada 1965: 656–61; see also Beck and Zevulun 1996: 71–3). Indeed, cylinder seals and sealings are still rare in contemporary local MB II sites;[17] however, some more have been discovered in excavations and there is evidence of greater stylistic variety and of some local production (Mazar 1978: 6–14). I believe, therefore, that even though the use of cylinder seals was limited in the MB II period, it was more widespread than was previously been envisaged. For the time being, however, with so little evidence at hand, any conclusions as to the frequency of fish and scorpion motifs in MB II seals from southern Canaan would be premature.

Indeed, it was only during the Late Bronze Age that cylinder seals became more widespread. In common, locally found Mitannian seals, fish motifs were preferred, as is true of that style in general. The amuletic value of these seals with simple designs, which were often made of cheap, man-made material (frit) and were thus within the means of many more people, finds an apt expression in the rows and files of fish that suggested well-being and abundance. Fish frequently appear as the main design, schematically depicted in linear arrangement, together with the 'net' design, guilloche, animals or even human figures.[18] Thus, it seems not merely accidental that scorpions are much less common than fish in local seals. It is also significant that they appear in composite scenes, in association with symbolic nude figures, winged discs and crescents, and griffins.[19]

On pottery vessels of the second millennium, fish were depicted while scorpions were avoided. In southern Canaan, a fish-shaped drinking vessel of an early Tell el-Yahudiyeh ware from Tel Poleg portrays surface details as well as the inside bone (Tadmor 1986: 102), a fish was incised on a juglet with a female head from Jericho (Balensi 1986: 74–5) and on a jug of Canaanite

17 One was unearthed at Kabri (Kempinski 1993: 333–7, Pl. 62), another was excavated in Manahat, Jerusalem (Milevski 1998: 97, Fig. 8.2:1 and a sealing with a fish motif was found at Aphek (Beck 1993: 671–73, Pl. 125).

18 From early excavations in Palestine: Parker 1949: Pl. V.31, IX.63, X.70, XIII.82, XX.129, XXII.144 (all from Beth Shean); Pl. XXVI.185, 186, XXVII.187 (from Gezer). From Hazor: Beck 1989: 318–9, Pl. CCCXXII.1–3.

19 Hamilton 1935: 64, Pl. XXVI.413 from Tell Abu Hawam; Parker 1949: Pl. XXIII.151; Pl. XXVII.193 from Lachish and Tell el-Ajjul. Scorpions were also depicted on seals from the Amman 13th century temple (Hennessy 1985: 102, Fig. 10.18) and from Tel Dor (Stern et al. 1992: 40, Fig. 6 in an Iron Age context).

production from Tell ed-Dab'a (Bietak 1991: 29). The frequent appearance of fish in Bichrome Ware, alongside quadrupeds and birds, is common knowledge: they are boldly drawn, linear and stylized, mostly decorating kraters and jugs but not jars.[20] It seems that the popularity of fish motifs diminished during the Late Bronze Age (Amiran 1969: 61–165). Outstanding is a small, fish-shaped LB vessel from Tell el Ajjul that was carved in beautifully veined alabaster (Tadmor 1986: 121). Towards the end of the second millennium, fish were depicted in Philistine Ware although, again, the motif is relatively rare (Dothan 1982: 203–4).

To the best of my knowledge, the only example of a scorpion motif on a pottery vessel appears on the so-called 'Orpheus Jug' from the 'Residency' ascribed to Stratum VIA at Megiddo dating to the Early Iron Age. A scorpion is depicted there above the shoulder of a man playing a lyre and leading a procession of animals, among them four fish that are each different but schematically drawn. Although the jug belongs to the well-known Canaanite 'beer jug' type, its decoration is unique (Loud 1948: 33–7, Pls. 76.1, 142.20; Dothan 1982: 150–3). The difference between the decorative themes of our jar and the Megiddo jug must, however, be stressed: the components of the decoration on the Megiddo jug combine into one visual narrative, while on our jar the individual images may be connected, but it is hard to detect a continuous story in them.

Last to be discussed here are the four ovals filled with a criss-cross pattern. I would like to suggest, albeit with some caution, that the criss-cross design be interpreted as a depiction of nets, a motif that would accord well with the fish, although it would have little bearing upon the scorpion. If this interpretation is correct, the different density of the lines within the ovals would be viewed as varying mesh sizes. Fish were indispensable in the diet of the inhabitants of the 'Fertile Crescent' and fishing by means of nets was already known in antiquity. Nets are frequently depicted in Egyptian art, although mostly in tomb paintings for which no comparison can be found in the Levant. They were depicted either as an outline enclosing a criss-cross pattern or, more often, as an outline only, with fish or fowl depicted against an empty background.[21] It is thus not surprising that the small ovals on our jar contain the net pattern when they are empty, but omit it when enclosing the depiction of the fish or the scorpion.

20 e.g. Megiddo: Loud 1948: Pls. 48.6, 53.1, 56.3, 6–7; Tell el-Ajjul: Petrie 1931: Pls. XXXI.49–53; 1933: Pls. XXXIII.33, XXXVI.38, XLI.1, 9,13; also Epstein 1966: 28–31.
21 In a Theban wall painting, Houlihan 1996: 156; Erman 1971: 237–8, showing bird traps of varying contours and mesh sizes; Baines and Malek 1980: 192–3.

Criss-cross designs, frequently depicted in second millennium seals, are often described as 'net designs'. In Mitannian seals from Palestinian sites they may be found together with fish, figurative or geometric motifs, or they may be the only motif.[22] The design is usually arranged in horizontal or diagonal stripes and there is no attempt to depict the shape of a net. Thus, the 'net motif' on seals seems to be of little comparative value for the design in our four medallions.

I do not recall any representations of nets on second millennium pottery vessels from the Levant, nor, in fact, from any other period. The only local representation which comes to mind is a net (or a bird trap) depicted on a band of ivory from Tell Fara (Petrie 1930: Pl. LV) in a 'scene of netting birds in the marshes, the men plontering about in the water and mud, to pull the clap net' (Petrie 1930: 19); fish swim in the water below. Petrie identified the subject as 'purely Egyptian in idea' but of Syrian workmanship. There is, however, an important difference between our net and that in the Fara ivory. The latter seems to have been made of some sturdy material, perhaps wood or reed, and appears more like a cage than a net; therefore, it is depicted as having corners as well as horizontal and diagonal supports. The nets on our jar are drawn as ovals; therefore, they must have been flexible and were probably made of rope. I should note, however, that the ovals are pointed in one spot. This could, of course, be expected in a free-hand drawing, but the painter of our jar seems to have been in complete control of his brush. Could it be that here is an attempt to depict the fastener with which the nets were equipped? One recalls the vivid representations of nets which served, in a symbolic way, to imprison enemies and depict the might of the king in Sumerian art. Two magnificent examples of this occur on the victory stele of Eannatum of Lagash and that of Sargon (?) of Akkad (Moortgat 1969: 42–3, 47–8, Pls.118, 127). To judge from the fragments found, the nets were oval and flexible and had a fastener by which they could be held. Knots and weights are realistically depicted in Egyptian nets (Shaw and Nicholson 1995: 192; Erman 1971: 23).

CONCLUSION

The carefully produced and richly decorated vessel bears signs of use, but has survived almost intact. This fact certainly indicates that its ultimate provenance was in a tomb rather than in an occupational stratum. I would assume that it had been used on festive or ceremonial occasions during its owner's

22 e.g. Parker 1949: Pls. VII.46, IX.62–3, XV.96, XVII.115, XXII.145, XXVII.188.

lifetime and that it was buried with him. Petrographic analysis indicates that the jar, acquired by the Israel Museum in 1968, is made of clay typical of the southern hill country (the Shephelah) of Israel. Goren has suggested that it might have originated in the cemetery of Tell Beit Mirsim.

The fact that the jar is made of local clay accords well with our stylistic analysis. Though unique, it matches well with local MB II pottery styles. We should therefore conclude that the jar was a local product of that period. A more specific chronological definition, however, is more difficult. Slip and burnish cannot serve as diagnostic elements; these age-old techniques were of long duration in the MB II as well. The piriform shape, the rather wide base and the tripod point to late MB IIA or early MB IIB. Most indicative in our considerations must be the painted decoration: had it only been linear or geometric, even an early MB IIA dating would be plausible for this jar. However, the inclusion of a competently executed, composite, figurative theme adds a later dimension. Taking all components of shape and style into consideration, I would date the jar to the late MB IIA or the early MB IIB. Given the current debate, the range c. 1750–1700 BC. should merely be viewed as a convenient chronological indicator, allowing for some flexibility on either end.

For the time being, our jar remains unique in its blend of known and new components. We have seen that the potter felt free to include a variety of elements: most were known but are used here in an unconventional way, while some he invented. The decoration of this jar does not belong to the early MB IIA styles mentioned above, nor to the local monochrome painted ware of Intermediate MB IIA–B (e.g. Epstein 1974: 2*–6*, 13–41). It also differs from the Bichrome Ware (Epstein 1966) and from the Lisht 'Dolphin Vase' which has been recognized as Canaanite, originating in the southern "Gaza region" (McGovern et al. 1994: 15–30; Bourriau 1996: 105). In fact, I would not expect this 'scorpion, fish and nets' jar to become part of an established 'style' or 'ware' in the future, but rather remain a product of a creative but individualistic local potter who broke away from stylistic convention.

Appendix: Petrographic examination of a Middle Bronze Age decorated jar at the Israel Museum

by Yuval Goren

The MB II jar (IMJ 68.37.166) was subjected to petrographic examination in an attempt to disclose its production area, using the method explained elsewhere (e.g., Whitbread 1995: 365–96).

RESULTS

Petrographic description: In thin section, the matrix of the vessel is silty (about 10%), carbonatic, tan in PPL, optically inactive due to high firing temperature (estimated at 800–900° C in consideration of mineral changes within the silt and inclusions). The silt is essentially of quartz, but it also contains recognizable quantities of accessory 'heavy minerals' including hornblende, augite, zircon, plagioclase, biotite, muscovite, epidote and rarely tourmaline and garnet (up to 1.6 mm), rounded to subrounded inclusions.

Geological interpretation and provenance: Based on a bulk of published data (Porat 1989: 50–2; Goren 1995, 1996; Goldberg et al. 1986; Rognon et al. 1987) the matrix is readily identified as loess soil. This type of soil occurs in the Levant mainly in the northern Negev and the southern Shephelah regions. It must be stressed, however, that the term "loess" applies here to a set of aeolian and alluvial silty-clay sediments that occur in the northern Negev and the Shephelah but cannot be distinguished petrographically. Our collection of materials from Levantine sites indicates that the overall distribution of sites that doubtlessly produced pottery of the loessial petrographic groups does not extend significantly beyond the limits of the northern Negev – southern Shephelah zones of the southern Levant. These include data and materials collected during the last 20 years from ceramic workshops excavated and surveyed in this region. Loess-made pottery had been produced in the rectangle formed between Lachish or slightly north of it, Ashdod, Gaza and Beersheba in any of the periods between the Pottery Neolithic and Medieval Ages. In pottery assemblages that belong to this group, the inclusions accompanying the loess matrix are variable and indicate different geological environments within the area where loess soil is distributed.

Previous studies of ceramics assigned to the loess petrographic group demonstrated that the composition of the inclusions used in it varied with the geographic location of each site. Consequently, they could be correlated

with sands occurring naturally in its vicinity (Goren 1995: Figs. 3–8). The use of loess with inclusions in which limestone is the dominant component is prevalent mainly at sites northeast to the Beersheba Valley and the southern Shephelah, whereas in the inner southern Shephelah region, chalk and/or nari sand is commonly the dominant or even sole non-plastic component. In the northwestern Negev sites quartz is the major constituent. When quartz sand dominates the inclusions, sand-sized grains of accessory minerals, mainly hornblende, zircon, feldspar and augite commonly accompany it. These indicate a littoral origin due to the presence of mechanically and chemically unstable minerals (like hornblende, pyroxene, rutile, garnet etc.) that appear with the quartz as rounded sand-sized grains.

In conclusion, the production area of this jar should be looked for in the inner southern Shephelah, where sites such as Tell Beit Mirsim and Lachish are located. Though this does not necessarily mean that the vessel was found in this specific region, the possibility that it was found in one of the Middle Bronze Age burial caves around Tell Beit Mirsim must not be ruled out.

REFERENCES CITED

Amiet, P.
1992 *Sceaux-cylindres en hématite et pierre diverses.* Corpus des cylindres de Ras-Shamra–Ougarit II. Ras Shamra-Ougarit IX. Paris: Éditions Recherche sur les Civilisations.

Amiran, R.
1969 *Ancient Pottery of the Holy Land.* Jerusalem: Masada Press.

Andrews, C.
1994 *Amulets of Ancient Egypt.* London: British Museum Press.

Baines, J. and Malek, J.
1980 *Atlas of Ancient Egypt.* Oxford: Phaidon.

Balensi, J.
1986 Cruchette a tete de femme. In *La Voie Royale, 9000 Ans d'Art au Royaume de Jordanie.* Alencon: Imprimerie Alenconnaise.

Beck, P.
1975 The pottery of the Middle Bronze Age IIA at Tel Aphek. *Tel Aviv* 2: 45–85.

1989 Cylinder seals from the temple in Area H. In *Hazor III–IV* (A. Ben-Tor, ed.). Jerusalem: The Israel Exploration Society, The Hebrew University of Jerusalem, 310–21.

1993 A sealing from Tell Aphek, Israel. In *Aspects of Art and Iconography: Anatolia and its Neighbors Studies in Honor of Nimet Özgüç* (M. J. Mellink, E. Porada and T. Özgüç, eds.). Ankara: Turk Tarih Kurumu Basimevi, 310–21.

2000 In *Aphek – Antipatris I* (M. Kokhavi, P. Beck and E. Yadin, eds.), Monograph Series 19. Tel-Aviv: Tel Aviv University Sonia and Marco Nadler Institute of Archaeology.

Beck, P. and Zevulun, U.
1996 Back to square one. *Bulletin of the American Schools of Oriental Research* 304: 64–75.

Ben-Tor, A.
1978 *Cylinder Seals of the Third-Millennium*

Palestine. *Bulletin of the American Schools of Oriental Research,* Research Supplemental Studies No. 22.

Bietak, M.
1991 *Tell el-Dabʻa V.* Österreichische Akademie der Wissenschaften IX. Vienna: Verlag der Österreichischen Akademie der Wissenschaften.

Black, J. and Green, A.
1992 *Gods, Demons and Symbols of Ancient Mesopotamia.* London: British Museum Press.

Bourriau, J.
1996 The Dolphin Vase from Lisht. *Studies in Honor of William Kelly Simpson, Vol. 2.* Boston: Museum of Fine Arts, 101–16.

Buren, E. D. van
1937 Scorpions in Mesopotamian art and religion. *Archiv für Orientforschung* 2: 1–28.
1939 *The Fauna of Ancient Mesopotamia as Represented in Art.* Rome: Pontificium Institutum Biblicum.
1948 Fish Offerings in Ancient Mesopotamia. *Iraq* 9: 101–21.

Collon, D.
1975 *The Seal Impression from Tell Atchana/ Alalakh.* Neukirchen-Vluyn: Neukirchener Verlag.
1982 *The Alalakh Cylinder Seals.* BAR International Series 132. Oxford: British Archaeological Reports.
1987 *First Impressions.* London: British Museum Publication.

Dothan, T.
1982 *The Philistines and Their Material Culture.* Jerusalem: Israel Exploration Society.

Druks, A.
1982 Early tombs on Tel ʻAmr. *ʻAtiqot* (Hebrew Series) 8: 1–6, Fig. 3:10, English summary:1*.

Epstein, C.
1966 *Palestinian Bichrome Ware.* Leiden: Brill.

1974 Middle Bronze Age tombs at Kefar Szold and Ginosar. *ʻAtiqot* (Hebrew Series) 7: 13–39 (Hebrew), English summary: 2*–6*.

Erman, A.
1971 *Life in Ancient Egypt.* New York: Dover Publications.

Garfinkel, Y. and Bonfil, R.
1990 Graves and burial customs of the MB IIA period in Gesher. In *Eretz-Israel* 21 (A. Eitan, R. Gophna and M. Kochavi, eds.). Jerusalem: The Israel Exploration Society, 132–147. (Hebrew), English Summary 106*.

Gerstenblith, P.
1993 *The Levant at the Beginning of the Middle Bronze Age.* Bulletin of the American Schools of Oriental Research. Dissertation Series 5: 23–52.

Goldberg, P., Gould, B., Killebrew, A. and Yellin, J.
1986 Comparison of neutron activation and thin-section analyses on Late Bronze Age ceramics from Deir el-Balah. In *Proceedings of the 24th International Archaeometry Symposium* (J. S. Olin and M. J. Blackman, eds.). Washington D.C., 341–51.

Goren, Y.
1995 Shrines and ceramics in Chalcolithic Israel: the view through the petrographic microscope. *Archaeometry* 37: 287–305.
1996 The southern Levant during the Early Bronze Age IV: the petrographic perspective. *Bulletin of the American Schools of Oriental Research* 303: 33–72.

Guigues, P. E.
1937 Lébéʻa, Kafer-Garra, Qrayé Necropoles de la Région Sidonienne. *Bulletin du Musée de Beyrouth* I: 5–76.
1938 Lébéʻa, Kafer-Garra, Qrayé Necropoles de la Région Sidonienne (suite). *Bulletin du Musée de Beyrouth* II: 27–72.

Hamilton, R. W.

1935 Excavations at Tell Abu Hawam. *Quarterly of the Department of Antiquities in Palestine* IV: 1–69.

Hennessy, J .B.

1985 Thirteenth century B.C. Temple of Human Sacrifice at Amman. In *Phoenicia and its Neighbours* (E. Gubel and E. Lipinski, eds.) Studia Phoenicia III. Louven: Peeters, 85–104.

Houlihan, P. F.

1996 *The Animal World of the Pharaos*. London: Thames and Hudson.

Ilan, D.

1996 The Middle Bronze Age tombs. In *Dan I* (A. Biran, D. Ilan and R. Greenberg, eds.). Annual of the Nelson Glueck School of Biblical Archaeology. Jerusalem: Hebrew Union College-Jewish Institute of Religion, 163–329.

Iliffe, J. H.

1936 Pottery from Ras el-'Ain. *Quarterly of the Department of Antiquities in Palestine* 5: 113–26.

Kempinski, A.

1993 A Syrian cylinder seal from Tomb 984 at Tel Kabri. In *Aspects of Art and Iconography, Studies in Honor of Nimet Özgüç* (M. J. Mellink, E. Porada and T. Özgüç, eds.). Ankara: Turk Tarih Kurumu Basimevi, 333–37, Pl. 62.

Kenyon, K. M.

1965 *Excavations at Jericho, II*. London: The British School of Archaeology in Jerusalem.

Loud, G.

1948 *Megiddo II*. Oriental Institute Publications 62. Chicago: Oriental Institute of the University of Chicago.

Maeir, A. M.

1997 Tomb 1181: a multiple interment burial cave of the transitional Middle Bronze IIA–B. In *Hazor V* (A. Ben-Tor and R. Bonfil, eds.). Jerusalem: The Israel Exploration Society and The Hebrew University of Jerusalem, 295–340.

Mazar, A.

1978 Cylinder seals of the Middle Bronze and Late Bronze Ages in Eretz Israel. *Qadmoniot* 11 (41): 6–14 (Hebrew).

McGovern, P. E., Bourriau, J., Harbottle, G. and Allen, S. J.

1994 The archaeological origin and significance of the Dolphin Vase as determined by neutron activation analysis. *Bulletin of the American Schools of Oriental Research* 296: 31–43.

Milevski, J.

1998 The small finds. In G. Edelstein, I. Milevski and S. Aurant. *Villages, Terraces and Stone Mounds*. Israel Antiquities Reports 33: 94–99. Jerusalem: Israel Antiquities Authority, 94–9.

Moortgat, A.

1962 *Tell Chuera in Nordost-Syrien*. Köln und Opladen: Westdeutscher Verlag.

1969 *The Art of Ancient Mesopotamia*. London and New York: Phaidon.

Ory, J.

1936 Excavations at Ras el-'Ain. *Quarterly of the Department of Antiquities in Palestine* 5: 111–12.

1937 Excavations at Ras el-'Ain II. *Quarterly of the Department of Antiquities in Palestine* 6: 99–120.

Parker, B.

1949 Cylinder seals from Palestine. *Iraq* 11: 1–43.

Petrie, F.

1930 *Beth Pelet I (Tell Fara)*. London: British School of Archaeology in Egypt.

1931 *Ancient Gaza I*. London: British School of Archaeology in Egypt.

1933 *Ancient Gaza III*. London: British School of Archaeology in Egypt.

Porada, E.
1965 Cylinder seals, in K. M. Kenyon, *Excavations at Jericho, II.* London: The British School of Archaeology in Jerusalem, 656–61.

Porat, N.
1989 Composition of Pottery – Application to the Study of the Interrelations between Canaan and Egypt during the 3rd Millennium B.C. Unpublished Ph.D. dissertation. Jerusalem: The Hebrew University.

Rognon, P., Coude-Gaussen, G., Fedoroff, N., and Goldberg, P.
1987 Micromorphology of loess in the Northern Negev (Israel). *Soil Micromorphology*: 631–38.

Schaeffer-Forrer, C. F.-A.
1956 *Corpus I des cylindres-sceaux de Ras Shamra-Ugarit et d'Enkomi-Alasia.* Ugaritica III, Mission de Ras-Shamra VIII. Paris: Éditions Recherche sur les Civilisations, 'synthèse' no.13.
1983 *Corpus I des cylindres-sceaux de Ras Shamra-Ugarit et d'Enkomi-Alasia.* Paris: Éditions Recherche sur les Civilisations, 'synthèse' no. 13.

Sellin E.
1927 Die Ausgrabung von Sichem. *Zeitschrift des Deutschen Palästina-Vereins* 50: 265–74.

Shaw, I. and Nicholson, P.
1995 *The Dictionary of Ancient Egypt.* New York: The British Museum and Abrams.

Stern, E., Gilboa, A. and Sharon, I.
1992 Tel Dor, 1991: Preliminary Report. *Israel Exploration Journal* 42: 34–46.

Tadmor, M.
1986 In *Treasures of the Holy Land, Ancient Art from the Israel Museum.* New York: The Metropolitan Museum of Art, 57–135.

Tufnell, O. and Ward, W. A.
1966 Relations between Byblos, Egypt and Mesopotamia at the end of the third millennium B.C. *Syria* 143: 165–241.

Ward, W. A. and Dever, W. G.
1994 *Scarab Typology and Archaeological Context. An Essay on Middle Bronze Chronology.* Studies on Scarab Seals III. San Antonio Texas: Van Seclen Books.

Waterson, B.
1996 *Gods of Ancient Egypt.* Phoenix Mill: Sutton Publishing.

Whitbread, I.
1995 *Greek Transport Amphorae, a Petrological and Archaeological Study.* Fitch Laboratory Occasional Paper 4. Athens: The British School at Athens.

Wiggerman, F. A. M.
1992 *Mesopotamian Protective Spirits: The Ritual Texts.* Cuneiform Monographs I. Groningen: STYX.

Yadin Y. et al.
1961 *Hazor III–IV.* Jerusalem: Israel Exploration Society and the Hebrew University of Jerusalem.

Yogev, O.
1985 A Middle Bronze Age cemetery south of Tel Rehov. *'Atiqot* 17 (English Series): 90–113.

Symbols of conquest in Sennacherib's reliefs of Lachish: impaled prisoners and booty

David Ussishkin

The siege and conquest of the city of Lachish in Judah was portrayed by Sennacherib in a series of stone reliefs displayed in his royal palace at Nineveh (Paterson 1915; Barnett, Bleibtreu and Turner 1998; Ussishkin 1982). This series is the most elaborate set of reliefs depicting a siege of a city that was erected by Sennacherib or by any other Assyrian monarch. The reliefs are carved in the schematic Assyrian artistic style; nevertheless, in my view, they represent a realistic picture of Lachish under siege and of its inhabitants going into exile (Ussishkin 1980, 1982; for different views see Jacoby 1991; Uehlinger 2003). The 'Lachish reliefs' portray a unique picture of a fortified city and its inhabitants in the period of the kingdom of Judah. The various scenes are shown in detail and it appears that the artist dedicated much thought in order to show accurately every aspect, important and minute alike. The present paper, dedicated to Roger Moorey, an old friend and esteemed colleague, discusses one of these aspects.

The 'Lachish reliefs' combine two scenes which took place at different times: on the left side of the relief series the battle on the city is depicted, while the right side shows an 'after the battle' scene—the deportation of inhabitants and the removal of booty from the conquered city. The two scenes are 'combined' in the centre of the relief series, in the segment of the relief portraying the city gate (Fig. 1). On the one hand, the assault on the gatehouse is represented in detail and a siege machine is shown ramming its upper part, while a large siege ramp is shown to the right of the gatehouse. On the other hand, the inhabitants are shown leaving the conquered city through the city gate. The deported inhabitants walk in a row along a roadway which descends from the city gate and passes near the edge of the siege ramp. The file of deportees advances towards the right-hand side of the relief, where it joins Assyrian soldiers carrying booty in a procession that passes in front of Sennacherib seated on his throne.

Significantly, the siege of the city is positioned symmetrically in the very centre of the relief series, opposite the monumental entrance to the room in which they were exhibited. The city and its fortifications together with the Assyrian siege ramp are rendered on a smaller scale compared with the scenes

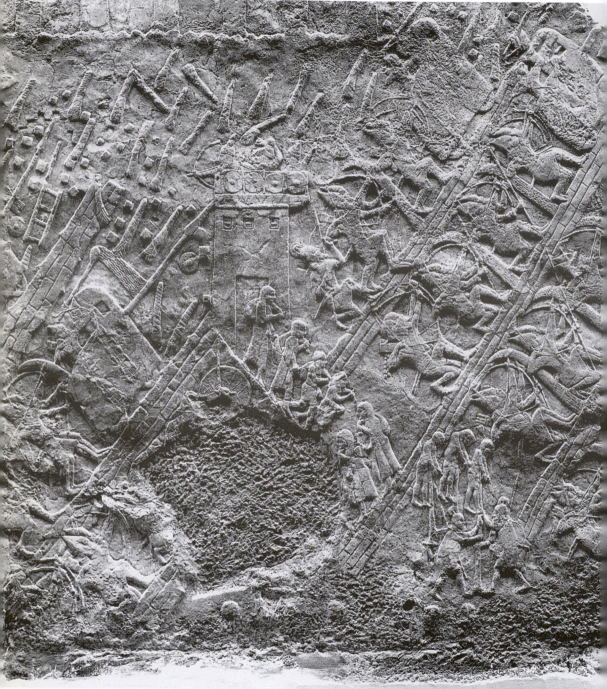

Fig. 1. A segment of the 'Lachish reliefs' depicting the city gate and part of the siege ramp
(Photo: Avraham Hay).

to the left and right of the city, which focus on people rather than structures. This explains the discrepancy in size between the Assyrian fighters and Judean deportees who appear on a larger scale on either side of the siege scene, and the people connected with the siege itself, including those exiting from the city gate, who are comparatively small.

The procession of deportees is well-preserved at the beginning, as it leaves the city gate, and at the end, as it approaches the enthroned king. By contrast, its middle section below the siege ramp at the bottom of the relief is now largely obliterated due to damage at the bottom of the stone slab (Fig. 1). Luckily, the contours of several heads are still visible (Fig. 1) which fill in the gap and indicate that the file of deportees exiting the gatehouse towards the right follows a continuous line that winds left and then right along the bottom of the siege ramp to the very spot where Sennacherib sits enthroned on a hill.

The artist makes a clear distinction between the deported inhabitants of the city, who are shown in family groups with their belongings, and two groups of people who are singled out for torture and execution. The latter include only men who have no belongings and are differently attired: one is shown stabbed by an Assyrian soldier and the other two are being flayed alive (Fig. 2). According to Barnett (1958: 163), these 'must be Hezekiah's men, the Jews who influenced the city to resist,' while the others were the 'native inhabitants of Lachish'. This conclusion, which implies that only a small minority of the native population resisted the Assyrian attack, is interesting but remains speculative until we have further evidence to show that the inhabitants of Lachish were divided at the time of the siege.

In front of the city gate, below the siege ramp and above the row of deportees walking along the bottom of the relief, three prisoners are shown impaled on stakes (Figs. 1, 3). It seems clear that this scene should be associated with the events that transpired after the battle, when the captives and deportees were evicted from the city, rather than with the attack on the walls. As the three prisoners are shown near the city gate, in the centre of the siege scene, they appear on a smaller scale than their fellow captives on the right.

Assuming that the 'Lachish reliefs' present a realistic albeit schematic view of Lachish seen from the southwest, one can roughly pinpoint the spot where the three prisoners were impaled (Fig. 4). The gatehouse shown in the relief corresponds with the outer city gate uncovered in the excavations at the site (Fig. 4.1). The siege ramp shown in the relief is almost certainly the siege ramp uncovered at the southwest corner of the mound (Fig. 4.2). As shown in the relief, the lower edge of the excavated siege ramp reaches the lower

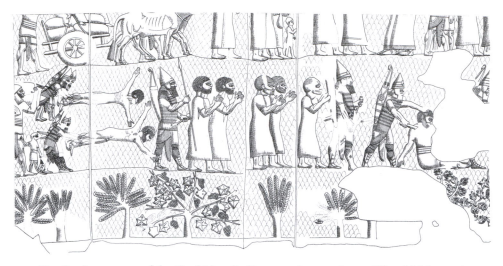

Fig. 2. A segment of the 'Lachish reliefs' portraying captives—'Hezekiah's men'
(Drawing: Judith Dekel).

part of a roadway which descends from the city gate. The procession of
deportees and captives leaving the city gate led to Sennacherib whose throne
was almost certainly placed on the hill to the southwest of the site (Fig. 4.3),
in front of his camp (Fig. 4.4), facing the siege ramp and the conquered city.
It follows that the three prisoners were impaled at the bottom of the road-
way below the siege ramp, in the topographical saddle between the south-
west corner of the city wall and the hill to its southwest (Fig. 4.5). This
particular site of execution was probably chosen so that all captives and de-
portees leaving the city would be forced to witness the terrible punishment
inflicted on the three prisoners as they passed along the road nearby.

If Barnett's conclusions are correct, the impaled prisoners should also be
differentiated from the rest of the deportees as members of 'Hezekiah's men'.
Although, as mentioned above, we lack proof of this identification, details of
iconography to be discussed below suggest that these victims were not just
anonymous participants of the insurrection, whose gruesome death was shown
to demonstrate Assyria's harsh treatment of its foes. One and, by extension,
all three of the impaled men appear to have played a more prominent role in
the insurrection, possibly as the governor or military commander of the city
and his deputies.

The three impaled captives are shown in a row in a conventional, largely
schematic style and, in fact, the portrayal of exactly three prisoners—no
more, no less—may be schematic as well (see below). They are naked and
their heads sag forwards indicating that they are already dead. All three face

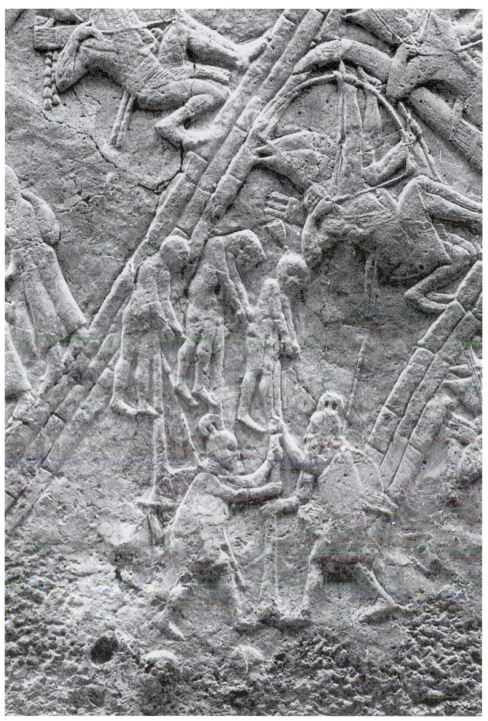

Fig. 3. The impaled prisoners, a detail of Fig. 1, above.

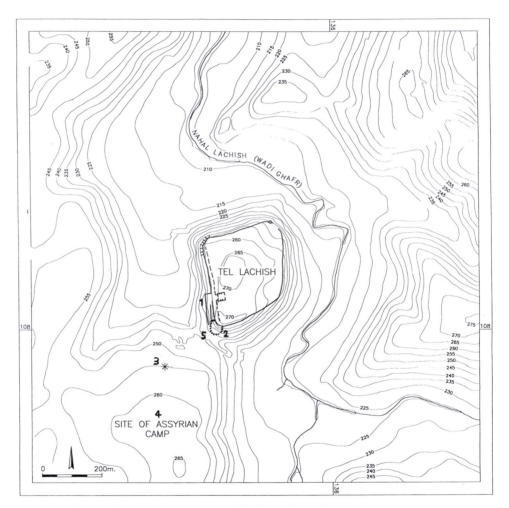

Fig. 4. Topographical map of Tel Lachish and its immediate vicinity:
(1) the outer city gate; (2) the siege ramp;
(3) the assumed place where Sennacherib sat on his throne
reviewing the battle and then the deportees and captives;
(4) the assumed site of the Assyrian camp;
(5) suggested place where the prisoners were impaled.

right, towards Sennacherib on his throne, like all other captives and depor-
tees. Despite these overall similarities, there are few notable differences that
set one captive apart from the rest. The right-hand captive appears in front of
the other two, he is impaled on the tallest stake and two Assyrian soldiers are
shown holding or stabilizing the stake. While it is possible that the Assyrians
may be securing the last stake to be raised, their presence suggests to me that
this right-hand captive was the most important of the three, possibly even
the Judean governor or military commander of Lachish himself.

There is one significant detail in the relief that may lend credence to this
claim. A peculiar object is shown above the head of the right-hand prisoner
(Figs. 3, 5). The upper edge of this object touches a set of arrows that pro-
trude from the quiver of an Assyrian bowman but as the object in question is
oriented diagonally to the quiver, it is certainly not a part of it (compare the
plated fringes hanging vertically from the quiver of another bowman shown
above and to the left of the former bowman [Fig. 3, uppermost bowman
above the impaled prisoners]). Instead, this object is oriented similarly to the
head of the impaled prisoner, suggesting a connection between the two.
The object, as carved by the Assyrian artist, is rendered solely in contour
lines (Fig. 5) and its identification is open to interpretation. It may represent
the long hair of the prisoner which is collected and tied together at the back
of his head. In this case the lower, curved line of the 'hair' represents the
outline of the back of the prisoner's head. This interpretation is difficult to
accept, however, because the uppermost part of the 'object' defies gravity
and stands erect whereas hair that was tied in a pony tail would be expected
to fall onto the prisoner's shoulders. In my view, the 'object' represents the
plume of a helmet, a decoration consisting of feathers or horsehair. Such
helmets were known at that period and even the two soldiers holding the
stake on which the prisoner is impaled wear crested, probably plumed helmets.
This interpretation has one problem: the lower edge of the helmet is blurred
or not shown. However, where helmets are clearly depicted elsewhere on
the relief, as on the Assyrian soldiers shown above and below this prisoner
(Fig. 3), the same lower edge also appears partly or completely blurred.[1]

1 Two bullae from Judah, probably dating to the 7th century BC, are known to bear the
inscription in ancient Hebrew, 'sar-ha'ir'; that is, 'the governor of the city' (Avigad and Sass
1997: 171, no. 402, and further literature there). Above the inscription, two men are shown
facing each other. They have been interpreted as the 'sar-ha'ir' facing the king of Judah. Both
men are bareheaded. It seems doubtful whether the man in the bullae is comparable to the
impaled figure in the Lachish relief because, firstly, the 'sar-ha'ir' probably held a civil office
while the Lachish captive is likely to have been a military functionary and, secondly, it is
unclear whether the man represented in the bullae was, in fact, the 'sar-ha'ir' himself.

Fig. 5. A sketch showing the outlines of the object above the head of the right impaled person.

In summary, it is reasonable to suggest that the right-hand prisoner was the military governor/commander of Lachish, who was impaled while wearing his official helmet. The fact that he was (1) impaled, (2) naked, but (3) wearing his official helmet, signifies not only the severe punishment and humiliation that was inflicted on the conquered but also the end to the independence of the rebellious Judean government. The military governor/commander and his deputies were impaled opposite the city gate—a symbol of independence and strength in the ancient fortified cities—near the path along which all captives and deportees were led.[2]

The portrayal of the impaled officials is harmonious with other aspects of the relief that express the suppression of the rebellious Judean government. As discussed above, the impalement scene ties in with the two groups of 'Hezekiah's men' who are led into captivity or executed (Fig. 2). Indeed, the fact that all 'Hezekiah's men' are shown as equals with no commanders or officers at their head, supports the suggestion that these have been shown separately, impaled near the city gate.

The identification of the helmet as that of a high official, even the governor himself, accords with the kind of booty shown being carted off by nine Assyrian soldiers who have raided the conquered city (Fig. 6). In my view all—or nearly all—the objects that they carry are symbols of state that formed part of the Judean governor/commander's official equipment and were stored in his palace-fort. The first soldier holds a sceptre or mace with its round top pointing downwards, no doubt, deliberately. The second and third soldiers each carry a large ceremonial chalice or incense burner which is probably made of copper or bronze. The objects loosely resemble smaller Iron Age cultic vessels that are made of clay but in this case, they probably served some ceremonial function in the palace-fort. The fourth soldier bears a chair with a rounded top and armrests. Although simple in appearance, it is most likely

2 A different view is expressed by Uehlinger. He considers the impalement scene as 'a kind of double-duty element, which belongs to both phases of the event. As a demonstrative operation conspicuously placed in the central axis of the city . . . it is meant to mark the point where resistance is about to be definitely broken. Moreover, it stresses the contrast of destinies met by those who oppose the Assyrian power and those who acknowledge the bliss of submission to the Assyrian king' (Uehlinger 2003: n. 82).

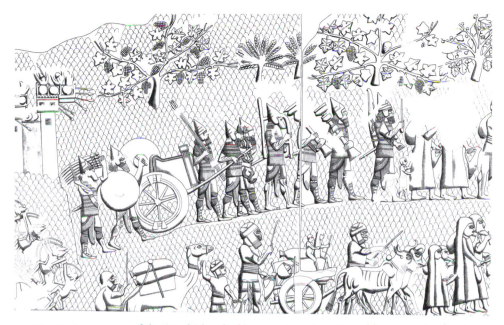

Fig. 6. A segment of the 'Lachish reliefs' portraying Assyrian soldiers carrying booty
(Drawing: Judith Dekel).

the governor's throne. The following two soldiers pull a chariot which must
have been the official vehicle of the governor. Walking beside the chariot is
a soldier with three spears over his shoulder and following behind the chariot,
a soldier carries two round shields. The rear of the procession is taken up by
a soldier who has six swords slung over his shoulders. The spears, shields and
swords could be ceremonial weapons or, alternatively, they may represent
the arsenal from the garrison which was probably located in the palace-fort
complex (see Maeir 1996).

The incense burners carried by the Assyrian soldiers have been inter-
preted by Aharoni (1975: 42) and Na'aman (1999: 404-5) as cultic vessels
which derive from the sanctuary. This suggestion is difficult to accept on
two grounds. First, the context of incense burners should conform with that
of the other objects carried in the procession and these, as stated above, all
appear to be symbols of state that presumably stem from the palace-fort.
Second, if the incense burners belonged to a sanctuary, it would have been
an important central shrine to judge by the size and design of the cult vessels
and the exceptional role of the city. However, no trace has thus far been
found of such a shrine at Lachish despite the discovery of a palace-fort com-
plex and the extensive exposure of its associated Level III, the city level
destroyed by Sennacherib in 701 BC.

Impaled captives are also depicted in a few other Neo-Assyrian reliefs. On the bronze doors of Shalmaneser III from Tell Balawat, six persons are impaled in the scene portraying the attack on Dabigu, a city in the region of Bit-Adini in north Syria (Barnett 1959: Pl. 159; for an excellent photograph see Strommenger and Hirmer 1964: Pl. 211). The taller stakes of the two captives on the right may be an expression of their higher rank although the size of the stakes could result from their relative placement lower down on a sloping terrain. Three people are shown impaled above the walls of a conquered Urartean city (Barnett 1959: Pl. 167, upper row); the apparent amputation of their hands and feet is in keeping with the evidence of decapitated heads shown hanging from the city walls. Finally, two groups of three impaled prisoners appear in a relief of Tiglath-Pileser III that portrays an assault on the city U[pa?] (Barnett and Falkner 1962: 14-15, Pls. XXXVII–XL). According to Barnett, U[pa?] is located to the north or northwest of Assyria (ibid.: xix). Of the group shown to the left of the besieged city, only a drawing survives. Based on this, all three impaled prisoners are rendered in similar fashion, facing left with their back to the city. The right group, which is preserved, shares certain details with the impaled prisoners of Lachish, which suggest that the artist of the latter was following a conventional format. Like Sennacherib's relief, Tiglath-pileser III's relief portrays three impaled prisoners. Here too, the first one appears to be of higher rank as the stake on which he is impaled is higher than the other two. The prisoners all face in one direction, away from the walled city. They are likewise shown naked and, judging by their sagging bodies, dead.

Turning to the Assyrian inscriptions it appears that the impaling of prisoners on a stake *(zaqīpu)* is mentioned relatively few times (*Chicago Assyrian Dictionary,* vol. 'Z': 58). Relevant to the case of Lachish is the statement of Tiglath Pileser III regarding Nabu-ushabshi, the Chaldean king of Bit-Shilani. The Assyrian monarch 'laid waste' and 'despoiled' Sarrabanu, his 'great royal city'; as to the king, Tiglath-Pileser III states, 'I impaled [Nabu-ushabshi] before the gate of his city and exposed him to the gaze of his countrymen' (Tadmor 1994: 123, lines 9–10; 161, line 16).

Summing up, an analysis of the scene of the impaled prisoners at Lachish shows that this cruel scene accords with the general picture presented in the relief series. The relative rarity of such scenes in Neo-Assyrian reliefs once again highlights the uniqueness of the Lachish reliefs and their special importance.

REFERENCES CITED

Aharoni, Y.
1975 *Investigations at Lachish: The Sanctuary and the Residency (Lachish V)*. Publications of the Institute of Archaeology, No. 4. Tel Aviv: Tel Aviv University.

Avigad, N.
1997 *Corpus of West Semitic Stamp Seals* (revised and completed by B. Sass). Jerusalem: Israel Academy of Sciences and Humanities.

Barnett, R. D.
1958 The Siege of Lachish. *Israel Exploration Journal* 8: 161–4.
1959 *Les Reliefs des Palais Assyriens*. Paris.

Barnett, R. D. and Falkner, M.
1962 *The Sculptures of Assur-nasir-apli II, 883–859 B.C., Tiglath-Pileser III, 745–727 B.C., Esarhaddon, 681–669 B.C., from the Central and South-West Palaces at Nimrud*. London: British Museum Press.

Barnett, R. D., Bleibtreu, E. and Turner, G.
1998 *Sculptures from the Southwest Palace of Sennacherib at Nineveh*. London: British Museum Press.

Jacoby, R.
1991 The representation and identification of cities on Assyrian reliefs. *Israel Exploration Journal* 41: 112–31.

Maeir, A.
1996 The "Judahite" swords from the "Lachish" reliefs of Sennacherib. *Eretz-Israel* 25: 210–14 (Hebrew).

Na'aman, N.
1999 No anthropomorphic graven image. *Ugarit-Forschungen* 31: 391–415.

Paterson, A.
1915 *Assyrian Sculptures, Palace of Sinacherib*. The Hague.

Strommenger, E. and Hirmer, M.
1964 *The Art of Mesopotamia*. London: Thames and Hudson.

Tadmor, H.
1994 *The Inscriptions of Tiglath-Pileser III, King of Assyria*. Jerusalem: Israel Academy of Sciences and Humanities.

Uehlinger, C.
2003 Clio in a World of Pictures – Another Look at the Lachish Reliefs from Sennacherib's Southwest Palace at Nineveh. In *'Shut Up like a Bird in a Cage': The Invasion of Sennacherib in 701 BCE* (L. L. Grabbe, ed.). Journal for the Study of the Old Testament Supplement Series No. 363 (European Seminar in Historical Methodology 4): 221–305.

Ussishkin, D.
1980 The 'Lachish reliefs' and the city of Lachish. *Israel Exploration Journal* 30: 174–95.
1982 *The Conquest of Lachish by Sennacherib*. Publications of the Institute of Archaeology, No. 6. Tel Aviv: Tel Aviv University.

The gold plaques of the Oxus Treasure: manufacture, decoration and meaning

John Curtis and Ann Searight
with an appendix by M. R. Cowell

Throughout his career Roger Moorey has written with great distinction on many aspects of the archaeology of the Ancient Near East, but a recurring interest has been the material culture of the Achaemenid period. In this connection, he has inevitably touched on the Oxus Treasure, which is arguably the most important hoard of precious metal to have survived from the Achaemenid period (e.g. Moorey 1985: Figs. 2, 4; 1988: Pls. 41–42, 54, 61–63, 66, 69, 71, 83). He has also studied the polychrome inlays of the type that are found on the famous armlets from the Oxus Treasure (Moorey 1998). This article focuses on the gold plaques that were found with the Treasure[1] and considers questions such as what the plaques were for and who they represent. In addition, we include analyses of some of the plaques.

Before describing and discussing the gold plaques, it is important to see them in context by summarizing what is known about the Oxus Treasure. This preamble is necessary because the Oxus Treasure has not always been regarded as a homogeneous collection (e.g. Muscarella 1980: 26) and its provenance, date and even the authenticity of some of the pieces have been disputed. What we now regard as the Oxus Treasure consists of about 180 objects in gold and silver. In addition to the 50 or so sheet gold plaques with figural representations that are the subject of this paper, the Treasure includes a gold model of a chariot with driver and passenger pulled by four horses; another less complete example; gold and silver figurines; model animals; a gold scabbard for a dagger (*akinakes*) with embossed and chased decoration showing a lion-hunt; gold and silver bowls and other vessels and vessel attachments; embossed discs and plaques and cut-out figures; armlets and bracelets; gold signet rings with engraved bezels, two cylinder seals and a stamp seal; and a number of small miscellaneous pieces of gold.[2]

1 The text is by John Curtis and the drawings are by Ann Searight.
2 The Treasure was published by O. M. Dalton in an exemplary catalogue, which first appeared in 1905 and has been twice updated (most recently Dalton 1964). The only matter for regret is that appended to the catalogue are other examples of early Oriental metalwork, mostly bequeathed to the British Museum by A. W. Franks, that have no connection whatsoever with the Oxus Treasure. This is unfortunate as it has led some scholars mistakenly

Most of the objects in the Treasure seem to be Achaemenid Persian in style and to date from the 5th – 4th centuries BC.[3] Examples of objects that are not of Achaemenid origin might include a silver statuette of a naked youth, exhibiting Greek influence (Dalton 1964: no. 4) and a pair of gold bracelets, a gold finger-ring and some gold plaques and discs that seem to have connections with the animal style art of South Russia (Dalton 1964: nos. 23, 39–40, 42–3, 111, 144–6). But such items are exceptions, and most pieces can be attributed to the Achaemenid Empire by style or iconography. A few items, such as a pair of massive armlets with winged griffin terminals (Dalton 1964: nos. 116–117) and a vase handle in the form of a leaping ibex (Dalton 1964: no. 10) can even be paralleled on the Apadana reliefs at Persepolis amongst the items being presented to the king.

Originally associated with the Treasure were about 1500 coins (Dalton 1964: xvi; Bellinger 1962; Zeymal 1979: 16–23).[4] According to Cunningham (1881: 151–2; 1883a: 64; 1883b: 258), the coins that are linked to the Treasure cover a period of about 300 years from the time of Darius down to the reigns of Antiochus the Great (223–187 BC) and Euthydemus I of Bactria (c. 235–200 BC). Parthian coins are absent. He therefore concludes that the Treasure was sealed or buried in the period c. 200–180 BC. If this is so, the implication seems to be that the Oxus Treasure was gathered together or deposited over a period of about three centuries between c. 500 BC down to c. 200 BC.

Contemporary 19th century sources were in agreement that the Oxus Treasure was found on the north bank of the River Oxus apparently between

to believe that everything included in the catalogue belongs to the Oxus Treasure and thereby to cast doubt on the integrity of the hoard. There is also a shorter catalogue of the Treasure in Russian, prepared by E. V. Zeymal to accompany the exhibition in Leningrad and Moscow in 1979–1980 (Zeymal 1979).

3 A few objects that seem to be later in date, for example a silver figure of a man in a short tunic (Dalton 1964: no. 3) and a silver figure of a bird (Dalton 1964: no. 15), may have been added to the Treasure by dealers after it was discovered.

4 Many of these coins cannot now be traced, but it is believed that just over 200 are now in the British Museum and others are scattered in public collections around the world including the State Hermitage in St Petersburg (pers. comm. E. V. Zeymal). There is some controversy about whether the coins should be definitely associated with the Treasure. Both Percy Gardner (1881) and O. M. Dalton (1964: xvi) were wary of doing so but Sir Alexander Cunningham, who was closer to the source of the discovery than either of the others, was adamant that the coins were part of the Treasure (Cunningham 1881: 185). This was also the opinion of E. V. Zeymal, who argued that later coins that are sometimes associated with the Treasure are probably modern additions. In support of this view, it has to be said that it would be illogical to accept the rest of the Oxus Treasure as a homogeneous group but to reject the coins. The same criteria should apply to both categories of material.

1877 (or even 1876) and 1880.[5] In his first account about the Treasure, Cunningham is quite specific. He wrote that it was found 'on the north bank of the Oxus, near the town of Takht-i Kuwât' (Cunningham 1881: 151). Two years later he repeated this information when he wrote 'the find spot of these relics is on the banks of the Oxus, near a place called Kawat or Kuâd . . . The place is one of the most frequented ferries on the Oxus, and has always been the chief thoroughfare on the road to Samarkand' (Cunningham 1883a: 64).[6] Nineteenth century Russian sources also indicate that the Oxus Treasure was found at Takht-i Kuwad (Zeymal 1979: 11–5; Pichikiyan 1992: 65–7; Litvinsky and Pichikiyan 1994: 47; Bernard 1994: 101–6).[7]

Takht-i Kuwad (the throne or platform of Kavad) is a fortified site on the north bank of the river Oxus (Amu Darya), now in Tajikistan, about 6 km to the south of the confluence of the rivers Vakhsh and Pyandzh (see Fig. 1). Before the Soviet period, when the border was closed, it was an important ferry station. The frontier-post is built on an archaeological site which is about 1 km square, about one quarter of which has been washed away by the river Oxus (Zeymal and Zeymal 1962).

Takht-i Kuwad is about 5 km to the south of another important fortified site known as Takht-i Sangin (Fig. 1). Excavations here, directed by B. A. Litvinsky and the late I. R. Pichikiyan between 1976 and 1991, revealed an enclosure measuring about 2 km x 350 m (c. 75 ha.) with a central citadel containing a building that has been labelled by the excavators a fire temple

5 It seems clear that the Treasure was not all found at the same time (Cunningham 1881: 151, 154; 1883a: 64; Dalton 1964: xiii; Curtis 1997: 234). Nor was it all recovered from *exactly* the same place. Cunningham wrote that 'it was not all found in one spot; but scattered about in the sands of the river' (Cunningham 1881: 152).

6 This location on the banks of the Oxus is supported by near contemporary accounts in *The Graphic* (Birdwood 1881: 538) and the *Proceedings of the Society of Antiquaries* (Franks 1883: 250), and by a statement of General George G. Pearse, now preserved in the archives of the Victoria and Albert Museum, that 'about 1876 a land slip of the river bank (of the Oxus) took place and disclosed quantities of the old treasure'. The only suggestions that the Treasure might have come from a different place seem to have arisen through confusing Takht-i Kuwad with Kobadian, a town about 50 km north of the Oxus. Cunningham himself did this (Cunningham 1883b: 260) and so apparently did Gardner (1879: 1, 3), who despite saying the 'Oxus Find' came from 'eight marches beyond the Oxus', describes 'an old fort, on the tongue of land formed by two joining rivers' which would correspond to Takht-i Kuwad.

7 These record *inter alia* that a railway engineer named N. A. Mayev visited Takht-i Kuwad in 1879 and while waiting for the ferry, carried out a day's excavations. He was told by local inhabitants that a gold tiger and other gold objects had been found there and sold to Indian merchants. Ten years later a Russian officer, N. A. Pokotillo, wrote that in spite of the isolation of the site, there were always lots of people there searching for treasure.

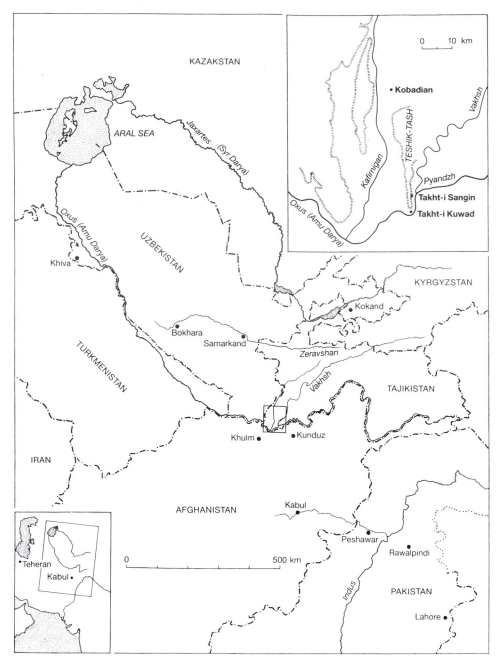

Fig. 1. Maps of Central Asia showing where the Oxus Treasure was discovered.

(Litvinsky and Pichikiyan 1981; 1983; 1994; 2000; Pichikiyan 1992).[8] In the magazines surrounding the central columned hall was found an extraordinarily rich collection of more than 5000 objects which had been dedicated to the temple.[9] These objects from the temple cover a wide period of time, in the view of the excavators extending from the 6th century BC right down to the 2nd or 3rd century AD (Litvinsky and Pichikiyan 1994: 55).

In view of the proximity of the two sites of Takht-i Kuwad and Takht-i Sangin, and some superficial resemblance in the nature of the two hoards, there has naturally been speculation about whether the Oxus Treasure might in fact have derived from Takht-i Sangin. There are, however, some difficulties with this hypothesis. Firstly, it is true that three gold 'votive' plaques have been found at Takht-i Sangin, but neither in style, technique or subject matter are they exactly the same as the Oxus Treasure plaques. One of them is apparently undecorated, another shows a winged creature and the third, which is inlaid with paste and carnelian, depicts a man leading a camel (Litvinsky and Pichikiyan 1992; 1995; Pichikiyan 1992: Pls. 16–17). Secondly, although the dates of the two hoards overlap, the *terminus ante quem* for the Oxus Treasure would seem to be early 2nd century BC, whereas the Takht-i Sangin hoard has material as late as the 2nd or 3rd century AD. Thirdly, it is clear from contemporary accounts, as we have seen, that the Oxus Treasure was found by the banks of the river, whereas the temple at Takht-i Sangin is some distance away from the Oxus. In spite of these difficulties, however, Litvinsky and Pichikiyan (particularly the latter) are adamant that the Oxus Treasure was originally associated with the Oxus Temple at Takht-i Sangin, and in part explain the difficulties by suggesting that in the face of some impending disaster in the early 2nd century BC, the priests took part of the treasure from the temple and buried it by the river bank some way downstream from Takht-i Sangin (Litvinsky and Pichikiyan 1994: 55; 2000: 489).

8 This is disputed by Bernard (1994) who sees it only as a temple dedicated to the river god Oxus. The temple has a square, central hall with four columns, surrounded by long, narrow magazines. Access to the central hall is from a columned *ivan* which opens off a large courtyard. In the view of the excavators, basing themselves on the style of the architecture, the temple was built in the late 4th or early 3rd century BC (Litvinsky and Pichikiyan 2000: 491).

9 The collection includes weapons, coins, jewellery and portrait busts in clay and stucco, and amongst the outstanding items to have been published so far are a miniature altar with a dedicatory inscription surmounted by a figurine of Silenus-Marsyas, the god of the Oxus, an ivory scabbard for an *akinakes* carved with the figure of a lion, an elaborate ivory chape from a scabbard showing a fantastic creature who is part horse and part mermaid (*hippocamp*), an ivory lion protome from a rhyton and so on.

This is a possible scenario, but hardly explains why the Treasure was never recovered in antiquity. Paul Bernard rejects Takht-i Sangin as the probable find-spot and argues that the Oxus Treasure comes from a temple dedicated to the river god Oxus at Takht-i Kuwad, which was superseded by the temple at Takht-i Sangin (Bernard 1994: 106–9). Alternatively, there may have been a temple at Takht-i Kuwad which for a time co-existed with that at Takht-i Sangin and then fell into disuse. In the absence of further evidence, the matter must remain unresolved. It is to be hoped that in due course more research on both the Takht-i Sangin hoard and the Oxus Treasure, combined with a detailed archaeological survey of the whole region, will settle this question. In the meantime, the available evidence seems to favour Takht-i Kuwad as being the probable source of the Oxus Treasure.

After the Oxus Treasure had been found by local villagers as described, it was bought by entrepreneurs and taken, apparently at different times, to Rawalpindi (now in Pakistan) where it was sold.[10] Most of the items were acquired from dealers there by General Sir Alexander Cunningham, Director-General of the Archaeological Survey of India, or were sent directly to Sir Augustus Wollaston Franks, Keeper of British and Medieval Antiquities at the British Museum. In due course, Franks bought Cunningham's collection and after Franks' death in 1897, the Oxus Treasure was bequeathed to the British Museum.

We come on now to the gold plaques, which are the subject of this paper. Altogether there are fifty-one plaques[11] made from thin gold sheet (Figs. 2–6). They are mostly rectangular, except for two examples that are rounded at the top (nos. 45, 51) and one plaque (no. 8) that has a long thin tail, probably for wrapping around whatever the plaque was to be fixed onto. The plaques vary in height from just under 2 cm to almost 20 cm. They differ from being wafer thin to having a thickness of c. 0.5 mm, with weights of between 0.58 gm and 85.2 gm (see Table 1). Generally they have just chased designs that are sometimes carefully drawn and sometimes extremely crude, but at least two of them are clearly embossed in addition to

10 What seems to have been the larger part of the Treasure was bought by three merchants from Bokhara, who in May 1880 were robbed between Kabul and Peshawar. The Treasure was rescued from the thieves, however, by Captain Francis Burton, a British soldier who was a Chief Political Officer based at Sehbaba, about 35 miles east of Kabul. After 'about three-quarters' of the Treasure (Dalton 1964: xiv) had been restored to the merchants, it was taken to Rawalpindi. More information about Burton's life and army career, and about his involvement in this particular exploit, has recently come to light and has been summarized in Curtis 1997: 238–41.

11 One plaque is now in two pieces, with a human representation on each piece (no. 44).

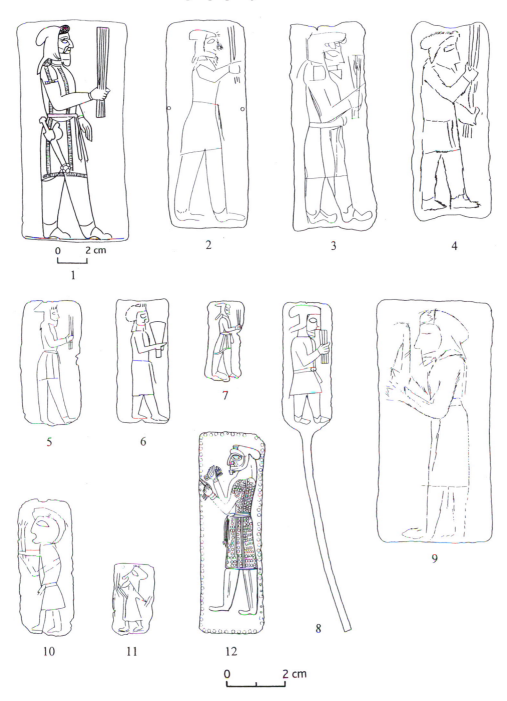

Fig. 2. Drawings of the gold plaques in the Oxus Treasure.

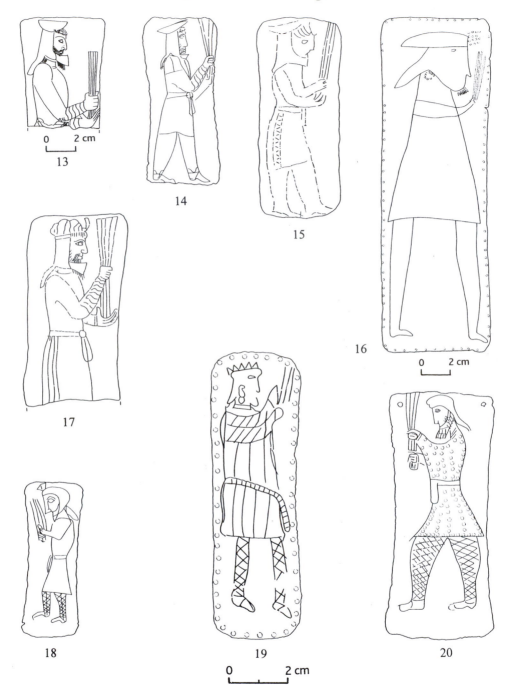

Fig. 3. Drawings of the gold plaques in the Oxus Treasure.

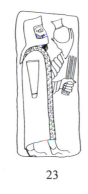

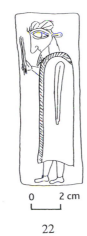

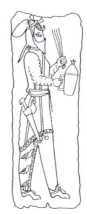

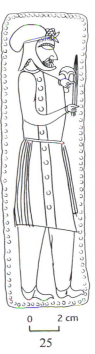

21 22 23 24

0 2 cm

25

0 2 cm

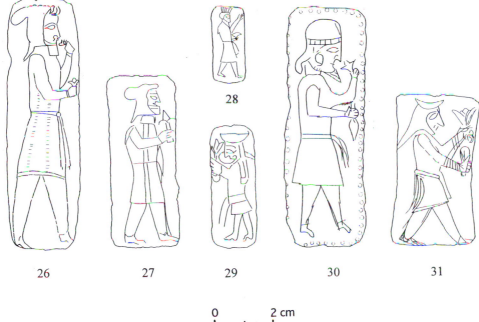

26 27 28 29 30 31

0 2 cm

Fig. 4. Drawings of the gold plaques in the Oxus Treasure.

John Curtis and Ann Searight

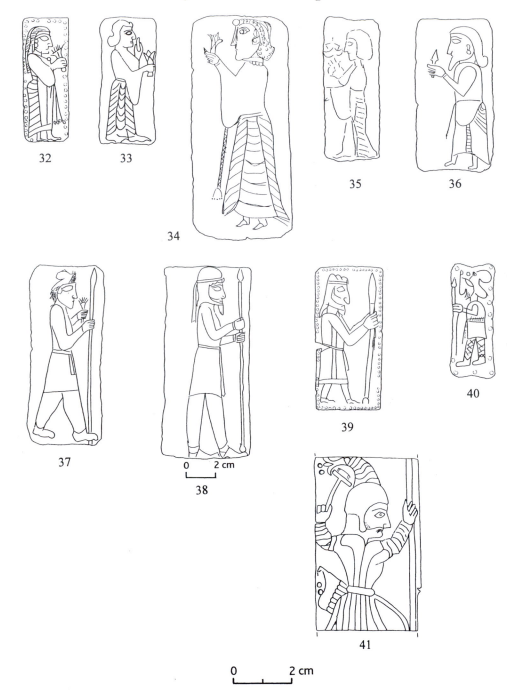

Fig. 5. Drawings of the gold plaques in the Oxus Treasure.

42

43

44

45

46

47

48

49

50

51

0 2 cm

0 2 cm

Fig. 6. Drawings of the gold plaques in the Oxus Treasure.

John Curtis and Ann Searight

Article no.	BM no.	Dalton number	Weight (grammes)	Dimensions
1	123949	48	82.73	max.ht. 15.1 cm, max.w. 7.5 cm
2	123954	53	3.82	max.ht. 7.1 cm, max.w. 2.7 cm
3	123955	54	4.15	max.ht. 7.15 cm, max.w. 2.85 cm
4	123957	56	4.67	max.ht. 6.8 cm, max.w. 2.7 cm
5	123960	59	3.37	max.ht. 4.25 cm, max.w. 2.05 cm
6	123958	57	1.68	max.ht. 4.2 cm, max.w. 1.8 cm
7	123981	58	0.65	max.ht. 2.75 cm, max.w. 1.25 cm
8	123961	60	2.92	max.ht. 11.1 cm, max.w. 1.7 cm
9	123965	64	16.65	max.ht. 8.2 cm, max.w. 4.0 cm
10	123964	63	2.01	max.ht. 4.6 cm, max.w. 1.85 cm
11	123973	72	0.58	max.ht. 2.4 cm, max.w. 1.4 cm
12	123972	71	4.28	max.ht. 6.8 cm, max.w. 2.25 cm
13	123951	50	21.06	max.ht. 7.8 cm, max.w. 5.8 cm
14	123952	51	2.27	max.ht. 5.75 cm, max.w. 2.5 cm
15	123956	55	4.34	max.ht. 6.85 cm, max.w. 2.9 cm
16	123966	65	85.2	max.ht. 22.7 cm, max.w. 7.5 cm
17	123953	52	6.54	max.ht. 6.3 cm, max.w. 3.4 cm
18	123963	62	2.01	max.ht. 5.2 cm, max.w. 2.0 cm
19	123986	85	6.16	max.ht. 9.65 cm, max.w. 3.0 cm
20	123962	61	5.70	max.ht. 8.35 cm, max.w. 3.7 cm
21	123977	76	2.59	max.ht. 6.85 cm, max.w. 2.15 cm
22	123969	68	42.7	max.ht. 11.8 cm, max.w. 4.3 cm
23	123970	69	3.17	max.ht. 5.0 cm, max.w. 2.1 cm
24	123971	70	3.30	max.ht. 6.7 cm, max.w. 2.4 cm
25	123950	49	38.09	max.ht. 20.0 cm, max.w. 5.9 cm
26	123978	77	4.92	max.ht. 8.5 cm, max.w. 2.5 cm
27	123980	79	3.63	max.ht. 5.8 cm, max.w. 2.35 cm
28	123959	80	1.36	max.ht. 2.65 cm, max.w. 1.1 cm
29	123982	81	0.97	max.ht. 4.1 cm, max.w. 1.55 cm
30	123984	83	5.89	max.ht. 8.1 cm, max.w. 2.75 cm
31	123979	78	3.70	max.ht. 5.05 cm, max.w. 2.85 cm
32	123994	93	1.49	max.ht. 4.25 cm, max.w. 1.55 cm
33	123990	89	2.40	max.ht. 4.35 cm, max.w. 1.9 cm
34	123991	90	7.45	max.ht. 7.65 cm, max.w. 3.35 cm
35	123992	91	2.46	max.ht. 4.95 cm, max.w. 1.9 cm
36	123993	92	4.54	max.ht. 5.25 cm, max.w. 2.65 cm
37	123975	74	3.11	max.ht. 6.05 cm, max.w. 2.55 cm
38	123974	73	42.83	max.ht.13 cm, max.w. 6.0 cm
39	123976	75	2.85	max.ht. 4.85 cm, max.w. 2.3 cm
40	123967/123968	66/67	0.97	max.ht. 3.85 cm, max.w. 1.5 cm
41	123985	84	8.42	max.ht. 5.8 cm, max.w. 3.55 cm
42	123987	86	3.24	max.ht. 5.4 cm, max.w. 2.25 cm
43	123995	94	1.62	max.ht. 3.9 cm, max.w. 1.65 cm
44	123983	82	4.0	max.ht. 3.7 cm, max.w. 1.75 cm
	123996	95	3.89	max.ht. 3.65 cm, max.w. 1.7 cm
45	123998	97	3.95	max.ht. 6.35 cm, max.w. 2.55 cm
46	123989	88	1.17	max.ht. 4.1 cm, max.w. 1.45 cm
47	123988	87	1.43	max.ht. 4.7 cm, max.w. 1.5 cm
48	124000	99	38.29	max.ht. 9.4 cm, max.w. 12.5 cm
49	124001	100	0.71	max.ht. 1.4 cm, max.w. 1.75 cm
50	123999	98	10.4	max.ht. 5.6 cm, max.w. 4.25 cm
51	123997	96	1.29	max.ht. 3.1 cm, max.w. 1.85 cm

Table 1. Measurements of gold plaques
and correlation between article numbers and Dalton 1964.

being chased (nos. 1, 41). Some of them have a border of punched dots around the edge. Most of the plaques show human figures. The exceptions are three with representations of animals and one that is plain. Some of the plaques have clearly been folded, probably in antiquity. The first point to consider, in view of the strange appearance and crude workmanship of some of the plaques, is whether they are all genuine. We know that after the discovery of the Treasure some forgeries were certainly being produced. Thus Dalton (1964: xvi) tells us that a chalcedony cylinder seal showing a Persian king vanquishing his enemies (no. 114), a silver disc with a hunting scene, perhaps a shield–boss (no. 24) and a silver vase handle in the form of a leaping goat (no. 10) were all copied in gold, apparently in Rawalpindi.[12] Dalton also regards one of the gold statuettes in the Oxus Treasure as a probable imitation made in Rawalpindi (1964: no. 2a). There is no certain evidence, however, that any of the gold plaques are modern forgeries and this is not suggested by the analyses or stylistic peculiarities. Indeed, the extreme crudity of some of the plaques is a point in their favour, as the 19th century goldsmiths in Rawalpindi were neat and skilful. They would hardly have produced such crude pieces of work, especially if the intention was to pass them off as originals. Nevertheless, we must be on our guard and at least alert to the possibility that some of the gold plaques may be modern forgeries.

In an effort to clarify possible doubts about authenticity, and also to see if the plaques could be divided into groups on scientific grounds, 38 of the plaques were examined in the Department of Scientific Research at the British Museum (see Appendix). On the whole, the results were inconclusive. X–ray fluorescence (XRF) suggested that mostly the plaques were made from alluvial gold alloyed with copper and possibly silver. No groupings suggested themselves. In only one case (no. 48) does a plaque appear to have been made from untreated placer gold. However, microscopic examination revealed substantial platinum group inclusions, that are usually associated with deposits of placer gold, in 20 of the plaques. By contrast, 11 of the plaques had only one visible inclusion and 7 had none, but this is not necessarily to be regarded as significant.

Of the 51 plaques, all but four show human figures. The exceptions are three with animals (nos. 48–50) and one that is undecorated (no. 51). The vast majority of the figures, apparently shown on about 37 of the plaques although some of the representations are so crude it is difficult to be certain,

12 The gold cylinder seal was illustrated in Cunningham 1883b: Pl. XXI A. The design was also reproduced on a sheet of gold now in the Kunsthistorisches Museum in Vienna (Bleibtreu 1998: Figs. 2–3).

are wearing the so-called Median dress. This is a knee-length tunic with belt that is worn in combination with trousers. The accompanying headdress is a helmet, probably of felt, that covers the ears and chin and has a neck guard at the back (sometimes called *abashlyk* or *kyrbasia*). This 'Median' costume is extensively shown on the reliefs at Persepolis (Moorey 1988: 52–3) and in the minor arts of the Achaemenid period, including other items in the Oxus Treasure (e.g. Dalton 1964: nos. 2, 7, 22, 24). In a few cases (nos. 12, 15), the tunics are elaborately patterned and in five instances (nos. 18–20, 40, 44) there are cross-hatched designs on the trousers (perhaps representing garters?). On one plaque (no. 24) there are birds, presumably embroidered, on the trousers. Three of the figures (nos. 21–23) wear the long-sleeved overcoat called the *kandys* over the 'Median' costume; in line with normal practice, the coat is shown draped over the shoulders with empty arms. In contrast to the popularity of the 'Median' costume, only about six of the figures on the plaques (nos. 32–36, 44?) wear the so-called Persian dress. This is a long robe with the folds arranged in a distinctive pattern. Again, this dress is well documented at Persepolis (Moorey 1988: Pl. 52).

On about 25 of the plaques (nos. 1–25) the figures carry bundles of sticks or *barsoms*.[13] All of these figures are apparently male and all wear the 'Median' dress, in three cases with the addition of the *kandys*. Mostly the figures carry only a *barsom*, except for two who carry a vessel in their other hand (nos. 23–24) and one (no. 25), who is also carrying a flower. In most cases when the detail is clear, the barsom is clearly being held in the *right* hand (nos. 1–3, 5–8, 13–17, 22, 25), often with the left hand supporting the bottom of the bundle, but in a few cases the barsom is clearly being held in the *left* hand (nos. 18, 21, 23–24).

Barsoms are associated with Zoroastrian religious ceremonies, but we should not necessarily assume that the figures depicted on the Oxus Treasure plaques belonged to the Zoroastrian religion. Although Ahuramazda is frequently invoked in Achaemenid royal inscriptions, it is not clear how many people at this time were orthodox Zoroastrians. There may have been a number of different religious groups sharing the same basic traditions. For the sake of convenience here, however, we will call them Zoroastrian. The origins of the *barsom* are not completely clear. According to Professor Mary Boyce, the *barsom* (or *baresman*) was originally a bundle of grasses. These grasses were spread around a sacred precinct (*pavi* or 'pure place') prior to an

13 In a few cases (particularly nos. 6, 9 and 25), the *barsom* is not clearly depicted but it seems most probable that this is what is being represented. A silver statuette in the Oxus Treasure (Dalton 1964: no. 1) also carries a *barsom*.

animal sacrifice and after the ceremony, a bundle of them was gathered up by the priest.[14] He then held this bundle of grasses while reciting prayers. In due course, the grasses were substituted by twigs or rods (Boyce 1975: 166–7; Boyce 1982: 38–9).[15] Kanga, however, disputes that the *barsom* was ever made up of grasses, and believes that it consisted of 'twigs of the *haoma* plant or the pomegranate used in certain ceremonies. They (were) first laid out and then tied up in bundles' (Kanga 1989: 825).[16] When *barsoms* are shown in the art of the Achaemenid period, they are often in contexts indicating that the figures holding them are probably priests. For example, a 5th century BC stone relief from Dascylium in Turkey, now in the Archaeological Museum in Istanbul, shows two figures in 'Median' costume holding *barsoms* in their left hand while officiating at an animal sacrifice (Hinnells 1985: 68–9; Moorey 1988: Pl. 45). Both figures have their mouths covered in accordance with Zoroastrian practice in order to prevent their breath from contaminating consecrated objects (Boyce 1979: 67), and are evidently priests. Then there are the representations of a man holding a *barsom* in his right hand and wearing 'Median' dress complete with *kandys* on the sides of a 4th century BC stone altar from Bunyan near Kayseri in Turkey, now in the Ankara Museum (Moorey 1988: Pl. 43). *Barsoms* are sometimes shown on seals of the Achaemenid period. For example, one seal shows a figure in 'Median' dress holding a *barsom* in his right hand and standing by a fire altar (Moorey 1988: Pl. 44c). He is probably a priest. In some other cases, though, it is by no means certain that a priest is being shown. Thus there is a rock sculpture below a tomb at Dokkan-i Daud in Kurdistan showing a man holding a *barsom* in his left hand. He wears a long coat and a 'Median' style headdress (Ghirshman 1964: Pls. 111–112; von Gall 1996: Pl. XXI). This sculpture is usually thought to date from the early Hellenistic period. Its purpose, and whether or not a priest is being depicted, is uncertain. The headgear worn by the figure in the Dokkan-i Daud sculpture is similar to that worn by a figure holding a *barsom* in his right hand on the stone window jamb of a building on the plain below the Persepolis terrace (Herzfeld 1941: Pl. LXXXVI,

14 I understand from Almut Hintze (pers. comm.) that the sacrificial straw is used during the *Yasna* ritual, probably to provide a clean place on which the god can sit. See, e.g., *Yasna* 2.7 (Mills 1887).

15 Nowadays the priests generally hold bundles of metal rods that are about 20 cm long (Boyce 1982: 38).

16 For a photograph showing modern Zoroastrian children carrying bundles of sticks from the *haoma* plant, see Hinnells 1985: 64, see Plate). It is also sometimes suggested that the *barsoms* represent sticks of sandalwood that are put on the sacred fire in the *Jashan* ceremony (see Mistree 1982: 66).

right; Wiesehöfer 1994: 75, Fig. 1). This building, which has been variously identified as a temple or palace, is associated with the Frataraka, who were local dynasts in the Hellenistic and Parthian periods (Frye 1999: 196–7). Mary Boyce originally identified the figure as a Zoroastrian priest, but later suggested that the portrait was secular (Wiesehöfer 1994: 75, n. 96). For Wiesehöfer (1996: 110) the Frataraka 'behaved like devout Zoroastrians, (but) they can hardly be considered as representatives of a religious-nationalistic "party" or as "priestly princes" (Magi)'. In this case, then, it seems unlikely that the *barsom* is the attribute of a priest.

There is also some slight evidence from Persepolis that *barsoms* were not only carried by priests. Thus amongst the flowers being carried by nobles there are some that are so schematic they resemble bundles of stalks and it is not impossible in these cases that *barsoms* are being shown. Examples that may be cited are nobles on the east side of the Apadana and on the north stairs of the Central Building (Roaf 1983: Fig. 49/M25 and Pl. XXXIVa, right).

Significance is sometimes attached to which hand the *barsom* is being held in, especially as in modern religious ceremonies, the *barsom* is held in the left hand (Kanga 1989: 826–7). However, the evidence we have reviewed above does not suggest that this was a significant factor in the Achaemenid period and this is borne out by the Oxus Treasure plaques, where the *barsom* is held in either hand. To conclude, when *barsoms* are shown in ancient representations, we cannot be sure that the figures holding them are necessarily priests. To go further, Herzfeld was probably right when he suggested that holding the *barsom* in one hand with the other hand raised was an attitude of prayer (Herzfeld 1941: 286). The implication, then, is that the *barsom* was an indication of piety rather than an attribute that was exclusive to priests. This would be in line with the view of Kanga, who writes that 'the object of holding the *barsom* and repeating prayers is to praise the Creator for the support accorded by nature and for the gift of the produce of the earth' (Kanga 1989: 826).

To return to the gold plaques, it seems there is no compelling reason to believe that the approximately 25 plaques which show figures with *barsoms* all represent priests. There is also the fact that two of the figures carrying *barsoms* are wearing a short sword (*akinakes*) (nos. 1, 24), which might indicate they are warriors or nobles rather than priests.[17] Lastly, in very few cases

17 But Kurush Dalal informs me (pers. comm.) that there is a class of warrior priests (*Yoazdathregar* priests), who are responsible for protecting the holy fire. Thus, there are often weapons (e.g. swords, shields and maces) hanging inside the shrines of fire temples that the priest is expected to use in emergencies.

is there an obvious attempt to cover the mouth, let alone the nose, which would certainly be expected if they were priests (Boyce 1979: 67).[18] The more probable explanation here, then, is that the *barsom* is a sign of piety or devotion and does not necessarily indicate priestly status. We cannot rule out the possibility that a few of the figures might be priests, but it seems likely that most of the representations are of well-off individuals who wanted to be portrayed as pious. Mary Boyce came to the same conclusion when she wrote that if the gold plaques are votive offerings, 'noblemen might have chosen to have themselves represented on them in devotional manner; but whether in fact these were, individually, "warriors" or priests it seems impossible in the absence of inscriptions to establish' (Boyce 1982: 148).

It is interesting that of the figures carrying vessels, one (no. 23) has only his mouth covered and the other (no. 24), both mouth *and* nose in accordance with priestly tradition. One of them carries a covered beaker with handle and the other one, a vase. It is conceivable that these represent some of the vessels and utensils used in religious services (Boyce 1975: 169–70) but it is impossible to be sure.[19] And even if these are ceremonial vessels, it does not necessarily mean the figures are priests. The strongest candidate for being a priest is the figure with mouth *and* nose covered (no. 24), but the fact that he also wears an *akinakes* might argue against this identification.

One of the *barsom*-bearers is also carrying a flower (no. 25) and there are a further twelve plaques (nos. 26–37) which show figures holding flowers. Where this flower is carefully drawn, it generally resembles a lotus flower but in some instances the depiction is so schematic that it is difficult to be certain that a flower is being represented at all. As well as the figure carrying a *barsom* (no. 25), another flower-bearer holds a spear (no. 37) and some others hold objects that are unidentifiable (nos. 30–31, 33). Eight of the figures holding flowers are apparently wearing 'Median' dress (nos. 25–31, 37) and five seem to be wearing 'Persian' dress (nos. 32–36).[20] Here, the hanging sleeve is clearly visible in most cases. One of the figures in 'Persian' dress (no. 36) has a beard and is clearly male, while another has long hair and body contours which suggest it is female (no. 32). The depiction of a woman

18 Interestingly, on the one plaque where there is a clear attempt to cover the mouth *and* nose (no. 24), the figure is carrying some kind of jug as well as a *barsom* and he wears an *akinakes* at his side.
19 Almut Hintze informs me (pers. comm.) that water plays an important part in the Zoroastrian *Yasna* ritual, but neither of these vessels is obviously a water jug. For a description of the *Yasna* ritual, see Kotwal and Boyd 1977.
20 Nos. 32–33 are illustrated and discussed by Calmeyer in the context of an article about Elamite-Persian costume (Calmeyer 1988: 34–5, 42, Fig. 5).

is noteworthy as representations of women in the art of the Achaemenid period are rare (Brosius 1996: 84–7). They do, however, occur (in one case holding a flower) on a cylinder seal and on three gold signet-rings that are also in the Oxus Treasure (Dalton 1964: nos. 101, 103–4, 115, Pl. XVI), as well as on a few miscellaneous objects and reliefs and on seals of the Achaemenid period.[21] In most cases these women have their hair arranged in a long pigtail at the back. The sex of the three remaining figures in 'Persian' dress on the Oxus gold plaques is enigmatic but as women are so rarely shown in Persian art, they are more likely to be male than female.

Figures holding what appear to be lotus flowers are frequently shown at Persepolis; indeed, they are often held by the king himself when he sits enthroned.[22] When the king is shown with the crown prince, as on the panel that was originally in the centre of the north side of the Apadana, they both hold lotus flowers (Moorey 1988: Pl. 29; Roaf 1983: Fig. 122). However, these flowers are by no means restricted to members of the royal family. According to Michael Roaf, 'these flowers are commonly held by the nobles on the North Stairs of the Central Building and on the north and east sides of the Apadana' (Nicholls and Roaf 1977: 147). It is possible that the flowers being held at Persepolis sometimes represent reproductions in bronze. Thus Walser suggests that a cast bronze lotus flower, formerly in a Swiss private collection, served exactly this purpose (Walser 1966: 43, see Plate, Cat. no. 663).[23] Whether they are real flowers or imitation flowers made in some other material, their function is unclear. Michael Roaf suggests they were a type of pomander (ibid.), presumably intended to ward off evil smells and infections. Walser interprets the bronze flower at least as an 'insigne de pouvoir' (ibid.). Sekunda goes even further and sees the lotus blossoms shown on the Persepolis reliefs as 'bronze tokens handed out by the King as a mark of favour, perhaps in connection with the New Year celebrations' (Sekunda and Chew 1992: 10). For Werner Dutz, the lotus flower is one of the motifs at Persepolis suggesting 'spring, vigour, life and fertility' (Dutz and Matheson 1998: 91). This is probably an oversimplification but such flowers clearly had a symbolic meaning. The flowers may also have had some religious significance. For example, on an Achaemenid period seal showing the figure in the winged disc above figures on either side of an altar, one of them holds what appears to be a lotus (Moorey 1988: Pl. 44a). The lotus flowers may then

21 See also Moorey 1988: nos. 59–60, 78b–c; Wiesehöfer 1996: Pl. XIIIb.
22 Khojeste Mistree suggests (pers. comm.) that these are pomegranate flowers that are needed for the *Jashan* ceremony.
23 Also published in Sekunda and Chew 1992: 6.

have had some religious significance, but generally they are held by nobles. Perhaps they are a mark of rank or a badge of office. As far as the gold plaques are concerned, the only conclusion to be drawn is that people of substance, possibly officials, are being depicted.

We have already noted that one spear bearer is carrying a flower (no. 37). Three more such figures (on plaques nos. 38–40) have only a spear. Spear bearers are commonly shown in the monumental art of the Achaemenid period, for example at Persepolis (Moorey 1988: Pl. 52; Roaf 1983: Pl. IX), on the relief of Darius at Bisitun (Moorey 1988: Pl. 15) and on the glazed brick panels at Susa (Curtis 2000: Fig. 47). Spear bearers were an important element in the Persian army, not least amongst the elite troops known as the Immortals (Sekunda and Chew 1992: 6–7). All of the spear bearers on the Oxus Treasure plaques wear the 'Median' costume and in the smallest and crudest example (no. 40), there is a cross-hatched patterning on the trousers. In two cases (nos. 38–39), the spears clearly have spherical balls or butts at the end of the shaft. Such spear-butts are shown in Persian art and described by Herodotus (VII. 41) who refers to spear butts in the form of gold and silver pomegranates and golden apples. Actual examples of what seem to be spherical spear-butts in bronze have been found in the Achaemenid cemetery at Deve Hüyük (Moorey 1980: 61–3, nos. 181–2; Sekunda and Chew 1992: 6, see Plate).

On a unique plaque (no. 41) a figure, wearing what appears to be a belted 'Median' tunic, brandishes a battle-axe and wears at his side a *gorytus*, a case to carry a composite bow and arrows. Both the battle-axe and the bow case are shown on the Persepolis reliefs, being carried by the king's weapon bearer (Moorey 1988: Pl. 53). The headdress of this figure is very strange and seems to show a helmet surmounted by a crest terminating in a lotus(?) flower.[24]

There is just one further plaque showing a figure holding something (no 42). This is a naked youth grasping a bird in his right hand. If it is genuine, this is a curious scene and its significance, elusive. The nudity would seem to indicate Greek influence. On the remaining plaques showing human figures (nos. 43–47) all appear to be empty-handed. One long plaque (no. 44), now broken into two pieces, shows a figure in 'Median' dress and a female(?) figure in a long robe. Both representations are very crude, as is another

24 This may be an attempt to depict a helmet plume as shown on a stamp seal from the Oxus Treasure with two warriors in the Greek style (Dalton 1964: 31, Fig. 62) or it may even be a version of the winged hat worn by the Greek god Hermes as shown, for example, on a Lydian stamp seal of the 6th century BC (Moorey 1988: Pl. 76a).

plaque (no. 43) which seems to show a woman in a long skirt, who is naked from the waist upwards. Three further plaques (nos. 45–47) have representations that are so crude it is difficult to say much about them, other than that one (no. 45) appears be female, one (no. 47) seems to be male while the sex of the third (no. 46) is indeterminate. What sort of costume these figures are wearing, if any, is impossible to say.

Then we have three plaques with pictures of animals. One shows a horse (no. 48), a very small plaque (no. 49) shows what is obviously a donkey with large ears and the third, fragmentary plaque (no. 50) shows the foreparts of a camel. For Ghirshman, the horse and the camel can be connected with Zoroastrian religious beliefs.

> The representation of a horse may probably be associated with a prayer to the goddess of flocks and herds, perhaps the goddess Ashi, of whom the Avesta (Yasht 17, 12) says: 'Those with whom you go. . . have fearsome horses, swiftly moving in free space'. It should be noted, too, that a similar invocation applies to the camel, for the same Yasht (17, 13) says: 'For those with whom you go, O Ashi Vanuhi, have fearsome camels, with pointed humps, full of mettle, sumpter-camels . . . (Ghirshman 1964: 94)

These are interesting observations, but it seems far-fetched to see such special significance in these images. If, as we shall be arguing shortly, these plaques come from a temple, there is a range of possible explanations. For example, the owners of these animals might be asking the deity for some special favour in relation to them, such as recovery from illness. Or, like the terracotta figurines often found in temples,[25] they could be gifts to the deity. In that case, they might be 'substitutes' for real animals and be a kind of sacrificial offering.[26] In this context, Mary Boyce suggests that the horse would be 'a sacrificial offering appropriate to a river-god' (Boyce and Grenet 1991: 176).

To sum up, the gold plaques from the Oxus Treasure show figures in 'Median' dress carrying *barsoms*, figures in both 'Median' and 'Persian' dress holding flowers, spear bearers in 'Median' dress, a weapon bearer, some miscellaneous plaques with crude depictions of human figures and a few plaques showing animals. It seems most likely that what we have here are representations of nobles, officials and people wealthy enough to commission gold plaques. A few of the people depicted might be priests, but there is

25 The purpose of depositing animal figurines in temples has been discussed in Postgate 1994.

26 I am grateful to Dr A. R. Green for this suggestion.

no compelling evidence to suggest that all the figures holding *barsoms* are actually priests. What, then, was their exact purpose?

In the absence of reliable archaeological information we cannot be sure what sort of context the plaques come from, but the most likely scenario is that they, like the rest of the Oxus Treasure, derive from a temple. The character of the Oxus Treasure, with its mixture of precious objects and coins covering a period of about 300 years, is consistent with a collection of material donated over a period of time to a temple. A similar situation can be found elsewhere in Central Asia, for example at the shrine of Mir Zakah in Afghanistan, where separately discovered deposits contained large numbers of coins and gold and silver objects (Curiel and Schlumberger 1953: 65–98; Bopearachchi 1995: 612–16). For these reasons most authorities believe that the Oxus Treasure came from a temple and Ghirshman was expressing a generally held view when he wrote that the Oxus Treasure belonged to a temple and represented offerings made by the worshippers (Ghirshman 1964: 250). We have referred above to the theory of Litvinsky and Pichikiyan that the Oxus Treasure was originally deposited in the temple at Takht-i Sangin and we have noted Bernard's view that it came from a temple at Takht-i Kuwad. We may never know the truth about the exact provenance of the Treasure, but at least it seems highly probable that it comes from a temple.

It is in this sort of religious context that the plaques are usually interpreted. Dalton believed that the plaques 'may have had a votive significance' (Dalton 1964: 19) and for Ghirshman they are 'votive portraits' which were 'deposited in a temple by worshippers, each of whom was petitioning the god for some particular favour' (Ghirshman 1964: 91). Boyce refers to them as 'votive offerings' (Boyce 1982: 148). This leads on to the question of what we mean by votive offerings, or *ex votos* as they are sometimes called. Votive offerings are usually defined as gifts given to a temple in fulfilment of a promise.[27] Is this the case with the Oxus Treasure gold plaques? In the absence of inscriptions, we simply cannot be sure. However, it seems unlikely that a promise was always or necessarily involved. We might imagine a number of circumstances in which such plaques were given to a temple. For instance, the owner might be asking a favour or giving thanks to the gods for something such as a safe crossing of the river Oxus. Alternatively, the plaques might be intended as a permanent representation of the donor in the eyes of the deity, or they might simply be expressions of piety, intended to impress the gods but also the donor's peer group. Any of these explanations, or a

27 See Postgate 1994: 177, 183, n. 4.

combination of them, is possible. As such, the term 'votive plaques' is probably misleading and they might better be described as dedications.[28]

The practice of making dedications of this kind to a temple is widespread in antiquity. For example, there are a great number of bronze plaques with figural representations allegedly from an Urartian temple at Giyimli in eastern Turkey (Caner 1998). Unfortunately, these plaques do not come from controlled excavations, but while authorized excavation at the site has not produced comparable plaques, it has demonstrated the extent of illegal digging, apparently in 1971 (Erzen 1974). These plaques appear to date from the 8th century BC onwards, possibly continuing beyond the end of the Urartian period. Further afield, there are bronze plaques of the 7th century BC with representations of figures in North Syrian style from Olympia in Greece (Boardman 1980: Fig. 53). In fact, so-called 'votive deposits' are of widespread occurrence at sanctuaries in the Greek world. As examples, we may cite the miniature shields dedicated to the cult of Zeus at the Idaean Cave in Crete (Kunze 1931) and the large number of bronzes, many of them of oriental origin, dedicated to the Sanctuary of Hera at Samos (Jantzen 1972). Nearer to hand is the Iron Age sanctuary of Surkh Dum-i Luri in Western Iran, where hundreds of pins were deposited (Schmidt, van Loon and Curvers 1989).

If there were contextual information about the Oxus Treasure gold plaques, it would of course be possible to say more about their precise function. In the absence of such information, it would be rash to speculate further. There seems to be no doubt, however, about the general purpose of the plaques. Like the rest of the Oxus Treasure, they should continue to be regarded as icons of the Achaemenid period.

28 For a definition of 'dedication', see Black and Green 1992: 62.

Appendix: Analysis of gold plaques from the Oxus Treasure
by M. R. Cowell

EXPERIMENTAL PROCEDURE

Thirty-eight plaques were submitted for analysis in the Department of Scientific Research at the British Museum. Prior to analysis, a small area of each plaque (usually top left corner) was cleaned with acetone. The surface was not abraded. The analysis was performed using energy dispersive X-ray fluorescence spectrometry (XRF) using a molybdenum target tube operating at a voltage of 45 kV. The spectrum obtained was calibrated by reference to that of a standard of known composition.

It must be emphasized that this analytical technique is only a surface method and has only been used to obtain a semi-quantitative elemental composition for the plaques. This is because the analysis is of the surface and, since minimal preparation was carried out to remove possible surface enrichment, patina etc., it may not accurately represent the whole object.

The precisions (i.e. reproducibilities) of the technique are about \pm 1–2% relative for the major elements: silver and gold; 5% relative for copper; and about 25% or more relative for the trace element, lead. The accuracies are not clearly definable and will be inferior to those of a fully quantitative analysis of abraded material due to the reasons outlined above. For example, there may be an overestimation of the gold and silver contents and a corresponding underestimation of the copper, due to surface enrichment during prolonged burial.

The plaques were also examined using a low-power binocular microscope (25–50 times). This was for the detection of platinum-group element inclusions (PGE), which are usually alloys of iridium, ruthenium and osmium. Such inclusions are associated with placer-deposit gold and are usually indicative of early goldwork.

RESULTS

The analytical results are given in Table 2, which also contains notes about the presence or not of PGE inclusions. The results have also been plotted in the form of a ternary diagram (gold-silver-copper) (Table 3).

It was noted that there were traces of iron present at the surface of the plaques, which may possibly be contamination during burial; this is a well-known phenomenon of buried gold. The iron was only present at concentration levels approaching the detection limit: 0.1 % or less. However, there

Article. No.	BM. No.	BMRL No.	Au	Ag	Cu	Pb	Inclusions	No. on plot
1	123949	46640P	93	2.3	5.1	<0.09	<5	1
2	123954	47239S	89	8.6	2.2	0.12	1	6
4	123957	47240V	93	3.6	3.7	0.12	1	7
5	123960	47242R	92	5.7	2.7	<0.09	1	9
9	123965	47243P	88	3.9	7.6	0.05	<5	12
10	123964	46644S	79	12	8.3	<0.09	5 - 10	11
13	123951	46642W	94	5.8	0.6	<0.07	<5	3
14	123952	47237W	85	8.7	6.1	0.16	1	4
16	123966	46645Q	91	4.8	4.1	<0.08	<5	13
17	123953	47238U	90	4.9	5.4	0.14	>20	5
20	123962	46643U	82	16	2.6	<0.07	1	10
22	123969	46646Z	94	5.2	0.6	0.14	5 - 10	14
23	123970	47244Y	91	7.3	1.3	0.05	0	15
24	123971	47245W	94	2.2	3.6	<0.24	>20	16
25	123950	46641Y	84	12	4.1	<0.19	>20	2
26	123978	47249Z	91	4.9	4.3	<0.07	1	20
27	123980	47251P	95	2.4	2.1	<0.05	>20	22
28	123959	47241T	94	1.8	4	<0.06	0	8
30	123984	47253W	86	10	3.7	0.18	<5	24
31	123979	47250R	90	10	0.4	<0.09	0	21
32	123994	47258X	92	6	2.4	<0.07	0	32
33	123990	46649T	90	5.2	4	0.07	<5	29
34	123991	47256Q	90	4.6	5.5	<0.11	0	30
36	123993	47257Z	93	4.3	2.8	<0.06	1	31
37	123975	47247S	92	4.7	3.7	<0.07	1	18
38	123974	47246U	90	6.1	3.8	0.12	5 - 10	17
39	123976	47248Q	97	0.9	2.3	<0.09	1	19
41	123985	47254U	92	7.8	0.3	<0.05	0	25
42	123987	46647X	94	2	4.2	0.16	>20	26
43	123995	46650W	90	6.5	3.4	<0.10	>20	33
44	123983	47252Y	98	1.2	0.3	0.09	1	23
45	123998	46652S	78	18	4.2	<0.07	5 - 10	35
46	123989	46648V	89	4.6	6.8	0.09	5 - 10	28
47	123988	47255S	92	7.6	0.5	0.22	<5	27
48a	124000	46654Z	69	30	0.5	<0.05	5 - 10	37
48b	124000	46654Z	70	29	0.4	<0.07	1	38
49	124001	46655X	88	7	4.8	<0.05	1	39
50	123999	46653Q	89	11	0.4	<0.12	>20	36
51	123997	46651U	88	6.6	5.2	0.22	0	34

Precision: +/- 1-2% relative for major elements (eg gold and silver), +/- 5% for copper and +/- 25% or more for lead.

Note 48a = measured between legs; 48b = measured behind tail

Table 2. Semi-quantitative XRF analyses.

were two exceptions: no. 13 at 0.7% and no. 47 at 0.6%. The presence of iron is unlikely to have a bearing on the origin of the plaques.

DISCUSSION

The results show that the plaques all have a fairly similar composition, which can also be seen from inspection of the plot, and thus, there does not appear to be any significant groupings of the plaques, especially if the experimental errors are considered. It could be suggested that no. 48 shows a slight differ-ence to the remainder by virtue of its somewhat lower gold content. This particular plaque was analysed in two separate areas because there was a very obvious repair within the part bounded by the horse's legs. The analyses (48a

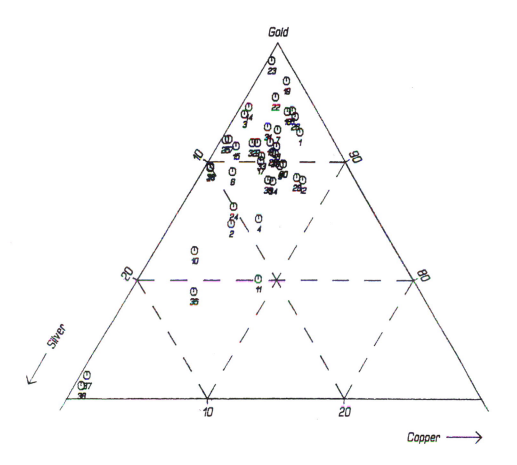

Table 3. Ternary diagram showing gold, silver and copper
contents of plaques in the Oxus Treasure.

and 48b) confirm that in all probability the two parts of the plaque belong together.

The amount of copper present in most of the plaques is higher than that normally present in gold sources. Lead is normally absent from native gold. Placer gold usually contains up to about 30% of silver with under 2% of copper. The copper content indicates that the gold, although derived from placer-deposits, must have been alloyed with copper and probably silver before use and the use of refined gold cannot be ruled out. The exception is no. 44 which is almost certainly of untreated placer gold.

Microscopic examination showed that seven plaques had no visible PGE inclusions (nos. 7, 23, 31–32, 34, 41, 51), but there were also several with only one visible inclusion. There were also seven plaques that contained a very large number of such inclusions (nos. 17, 24–25, 27, 42–43, 50). The plaques containing inclusions are probably ancient, but the absence of inclusions is not necessarily indicative of modern manufacture.

CONCLUSION

Elemental analysis of the gold plaques from the Oxus Treasure has not provided information that will allow the objects to be divided into distinct compositional groups. It does not show whether the plaques were from the same metal source or if there was more than one metal source used to produce them. The composition suggests that alluvial gold, alloyed with a little copper and possibly silver, was used for many of the plaques, although it must be remembered that these are only surface analyses. Microscopic examination has revealed the presence of platinum-group inclusions in the majority of plaques, which provides some support for their authenticity.

REFERENCES CITED

Bellinger, A. R.
1962 The coins from the Treasure of the Oxus. *The American Numismatic Society: Museum Notes* 10: 51–67.

Bernard, P.
1994 Le temple du dieu Oxus à Takht-i Sangin en Bactriane: temple du feu ou pas? *Studia Iranica* 23: 81–121.

Birdwood, G.
1881 Indian Jewelry. *The Graphic* 26th November: 537–8.

Black, J. and Green, A.
1992 *Gods, Demons and Symbols of Ancient Mesopotamia: an Illustrated Dictionary*, London: British Museum Press.

Bleibtreu, E.
1998 Ein Chalzedon-Rollsiegel aus dem Oxus-Schatz und seine Nachahmungen in Gold, *Archäologische Mitteilungen aus Iran und Turan* 30: 145–54.

Boardman, J.
1980 *The Greeks Overseas: Their Early Colonies and Trade* (new and enlarged edition). London: Thames and Hudson.

Bopearachchi, O.
1995 Découvertes récentes de trésors indo-grecs: nouvelles données historiques', *Académie des Inscriptions et Belles-Lettres. Comptes Rendus des Séances de l'Année 1995, Avril–Juin*: 611–30.

Boyce, M.
1975 *A History of Zoroastrianism Vol. 1, The Early Period*. Handbuch der Orientalistik. Leiden: E. J. Brill.
1979 *Zoroastrians: Their Religious Beliefs and Practices*. London: Routledge and Kegal Paul.
1982 *A History of Zoroastrianism Vol. 2, Under the Achaemenians*. Handbuch der Orientalistik. Leiden: E. J. Brill.

Boyce, M. and Grenet, F.
1991 *A History of Zoroastrianism Vol. 3, Zoroastrianism under Macedonian and Roman Rule*. Handbuch der Orientalistik. Leiden: E. J. Brill.

Brosius, M.
1996 *Women in Ancient Persia (559–331 B.C.)*. Oxford: Clarendon Press.

Calmeyer, P.
1988 Zur Genese altiranischer Motive X. Die elamisch-persische Tracht. *Archäologische Mitteilungen aus Iran* 21: 27–51.

Caner, E.
1998 *Bronzene Votivbleche von Giyimli*, Archäologie in Iran und Turan 2. Rahden/Westfahlen.

Cunningham, A.
1881 Relics from ancient Persia in gold, silver and copper. *Journal of the Asiatic Society of Bengal* 50: 151–86.
1883a Relics from ancient Persia in gold, silver and copper: second notice. *Journal of the Asiatic Society of Bengal* 52: 64–7.
1883b Relics from ancient Persia in gold, silver and copper: third notice. *Journal of the Asiatic Society of Bengal* 52: 258–60.

Curiel, R. and Schlumberger, D.
1953 *Trésors Monétaires d'Afghanistan*, Mission de la Délégation archéologique française en Afghanistan 14. Paris: Impr. nationale.

Curtis, J. E.,
1997 Franks and the Oxus Treasure. In *A.W. Franks: Nineteenth-Century Collecting and the British Museum*, (M. Caygill and J. Cherry, eds.). London: British Museum, 230–49.
2000. *Ancient Persia*. London: British Museum (2nd edition).

Dalton, O. M.
1964 *The Treasure of the Oxus*. London: Trustees of the British Museum (3rd edition).

Dutz, W. F. and Matheson, S. A.
1998. *Archaeological Sites in Fars (1): Parsa (Persepolis)*. Tehran.

Erzen, A.
1974 Giyimli bronz definesi ve Giyimli kazisi. *Belleten* 38: 191–213.

Franks, A. W.
1883 Exhibition of a remarkable gold armlet. *Proceedings of the Society of Antiquaries* N.S. 9: 249–50.

Frye, R. N.
1999 Persia/Fars from Alexander to the Sasanians. In *The Iranian World: Essays on Iranian Art and Archaeology Presented to Ezat O. Negahban* (A. Aliazadeh, Y. Majidzadeh and S. M. Shahmirzadi, eds.). Tehran: Iran University Press, 194–99.

Gall, H. von
1996 Dokkan-e Dawud. *Encyclopaedia Iranica* 8: 472–74.

Gardner, P.
1879 New coins from Bactria. *Numismatic Chronicle*, new series 19: 1–12.
1881 Coins from Central Asia. *Numismatic Chronicle* 3rd series 1: 8–12.

Ghirshman, R.
1964 *Persia from the Origins to Alexander the Great*. London: Thames and Hudson.

Hinnells, J. R.
1985 *Persian Mythology* (new revised edition). London: Hamlyn.

Herzfeld, E. E.
1941 *Iran in the Ancient East*. London: Oxford Univeroty Press.

Jantzen, U.
1972 *Ägyptische und Orientalische Bronzen aus dem Heraion von Samos*, Samos 8. Bonn: In Kommission bei Rudolf Habelt.

Kanga, M. F.
1989 Barsom. *Encyclopaedia Iranica* 3: 825–27.

Kotwal, F. M. and Boyd, J.
1977 The Zoroastrian *Paragna* ritual. *Journal of Mithraic Studies* 2: 18–52.

Kunze, E.
1931 *Kretische Bronzereliefs*. Stuttgart: Kohlhammer.

Litvinsky, B. A. and Pichikiyan, I. R.
1981 The Temple of the Oxus. *Journal of the Royal Asiatic Society*, 133–167.
1983 Monuments of art from the sanctuary of Oxus (northern Bactria). *Acta Antiqua Academiae Scientiarum Hungaricae* 28: 25–83.
1992 Gold plates from the Oxus Temple (northern Bactria). *Vestnik Drevnei Istorii* 3: 94–111 (in Russian).
1994 The Hellenistic architecture and art of the Temple of the Oxus. *Bulletin of the Asia Institute* new series 8: 47–66.
1995 Gold plaques from the Oxus Temple (northern Bactria). *Ancient Civilizations from Scythia to Siberia* 2: 196–220.
2000 *The Hellenistic Temple of the Oxus in Bactria (south Tajikistan), I: Excavations, Architecture, Religious Life*. Moscow (in Russian with English summary).

Mills, L. H.
1887 *The Zend-Avesta Part 3, The Yasna, Visparad, Afrinagan, Gahs and Miscellaneous Fragments*. Sacred Books of the East 31, (F. M. Muller, ed.). Oxford: Clarendon Press.

Mistree, K. P.
1982 *Zoroastrianism: an Ethnic Perspective*. Mumbai.

Moorey, P. R. S.
1980 *Cemeteries of the First Millennium B.C. at Deve Hüyük*. BAR International series 87. Oxford: British Archaeological Reports.
1985 The Iranian contribution to Achaemenid material culture. *Iran* 23: 21–38.
1988 The Persian empire. In *The Cambridge Ancient History Vol. 4, Persia, Greece*

*and the Western Mediterranean, c.525
to 479 B.C. Plates* (J. Boardman, ed.).
Cambridge: Cambridge University
Press, 1–94.

1998 Material aspects of Achaemenid poly-
chrome decoration and jewellery.
Iranica Antiqua 33: 155–71.

Muscarella, O. W.

1980 Excavated and unexcavated Achae-
menian art. In *Ancient Persia: The Art
of an Empire* (D. Schmandt-Besserat,
ed.). Malibu, California: Undena,
23–42.

Nicholls, R. and Roaf, M. D.

1977 A Persepolis relief in the Fitzwilliam
Museum, Cambridge. *Iran* 15: 146–
52.

Pichikiyan, I. R.

1992 *Oxos-Schatz und Oxos-Tempel:
achämenidische Kunst in Mittelasien.*
Berlin: Akademie Verlag.

Postgate, J. N.

1994 Text and figure in ancient Mesopo-
tamia: match and mismatch. In *The
Ancient Mind: Elements of Cognitive
Archaeology* (C. Renfrew and E. B.
W. Zubrow, eds.). Cambridge:
Cambridge University Press, 176–84.

Roaf, M. D.

1983 *Sculptures and Sculptors at Persepolis.*
Iran 21.

Schmidt, E. F., van Loon, M. and Curvers,
H. H.

1989 *The Holmes Expeditions to Luristan,*
Oriental Institute Publications 108.
Chicago: University of Chicago
Press.

Sekunda, N. and Chew, S.

1992 *The Persian Army, 560–330 BC,* Lon-
don: Osprey Elite Series 42.

Walser, G.

1966 Des cadeaux pour le grand roi. In
Trésors de l'Iran Ancien, catalogue
of exhibition at the Musée Rath,
Geneva, 8 June – 25 September 1966.
Geneva, 43–9.

Wiesehöfer, J.

1994 *Die 'dunklen Jahrhunderte' der Persis.*
Zetemata: Monographien zur Klass-
ischen Altertumswissenschaft 90.
Munich.

1996 *Ancient Persia: from 550 BC to 650
AD.* Translated by A. Azodi. London:
I. B. Tauris.

Zeymal, E. V.

1979 *Amudarinskii Klad.* Leningrad.

Zeymal, T. I. and Zeymal, E. V.

1962 The find-spot of the Oxus Treasure
reconsidered. *Proceedings of the Acad-
emy of Sciences of the Tadjikistan SSR*
1/28: 40–5 (in Russian).

Hero and worshipper at Seleucia:
re-inventions of Babylonia on a banded
agate cylinder seal of the Achaemenid empire

Margaret Cool Root

My tribute to Roger Moorey revolves around a single artefact: a barrel-shaped banded agate cylinder seal from Seleucia-on-the-Tigris now in the Kelsey Museum of Archaeology, University of Michigan (KM 94527, Fig. 1).[1] I hope in some small way to emulate Roger Moorey's seminal, empirically-based contributions to the field by presenting the first stages of construction of a plausible biographical narrative for an unusual artefact.[2]

The seal in question raises a host of issues about the complexities of visual culture and imperial dynamic in the Near East during the second half of the first millennium BC. In this article I shall thus pursue strategies of stylistic,

1 According to the Field Record books, KM 94527 (= Seleucia Field No. F–5308) was retrieved by the University of Michigan expedition to Seleucia-Tigris led by Professor Leroy Waterman on 10 December 1936 in Block G6 (formerly called Block B). Michigan excavations were carried out under the auspices of the American School of Oriental Research of Baghdad, with funding from the Toledo Museum of Art and the Cleveland Museum of Art. KM 94527 has remained unpublished in any expansive way. A photograph of its impression and preliminary interpretive remarks appear in an exhibition guide (Root 1990: 35 and 50, no. 19). Later in 1990, Mr. David Katz completed an MA thesis for the Department of the History of Art, University of Michigan, entitled 'The Consumption of a Drilled-Style Seal in Neo-Babylonian and Early Achaemenid Times: A Cost-Benefit Analysis' (unpublished). Katz's essay, while now superceded in many respects by new evidence, is an insightful effort which raises enduring questions in an original and informed way. Although David Katz has gone on to become a modernist art historian, his work (and our dialogues together in connection with the MA thesis) is an important source of inspiration in my return to the artefact all these years later. Previous to 1990, basic descriptive entries on the seal had appeared in guides to two other Kelsey Museum exhibitions (Savage 1977: 23; Root 1984: 34). A planned catalogue of all the 'small finds' from the Michigan seasons at Seleucia-Tigris in 1927–32 and 1936–37 (including various seals) was undertaken in the 1930s but never finished (Yeivin n.d.). It is by now obsolete. Thus, a volume on the seal artefacts from Seleucia-Tigris to complement the study of sealings from the site (McDowell 1935) has not yet been published.
2 It is a pleasure to have the occasion here to integrate material that Roger has made accessible in customarily thought-provoking and meticulous fashion over his distinguished career. Thanks in large measure both to his own prodigious scholarly efforts and to his generous facilitation of the publications of others, the state of glyptic research today enables discussion of our focal object in ways that would not have been possible earlier.

Margaret Cool Root

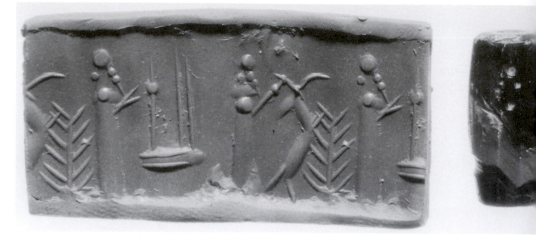

Fig. 1. Original field photograph (dated December 10, 1936) of KM 94527 and its
impression made on site. KM Negative No. 40, F Season. Courtesy of the Kelsey
Museum of Archaeology, University of Michigan. 2:1.

iconographic and material/physical analysis in order to suggest the approxi-
mate date of its creation and its original social context. Issues raised by its
retrieval from the late Parthian level (third century AD) of the palatial area at
Seleucia-Tigris, a late fourth century BC Seleucid royal foundation, I shall
only touch upon briefly.[3]

INTRODUCING THE ARTEFACT

The Kelsey seal measures 2.10 cm in height. With a maximum diameter of
1.20 cm and a minimum diameter of 1.00 cm at each end, the barrel shape is
clearly defined. Its perforation is well-centred and straight. The seal is in
excellent condition except for some minor chipping around both ends. The
surface is well-polished and there is no evidence of re-cutting.

Carved in intaglio on the cylinder is a relatively rare image uniting on
the same seal two usually discrete glyptic motifs that are here equally weighted
in the design. Reading the image from the museum-made impression (Fig.
2), a standing figure facing right grasps one of the curving horns of a rampant
quadruped. The horned animal faces left, but moves away from the hero,
with a front leg raised to touch the branches of a schematic tree that resem-
bles a conifer. The tree becomes a marker between the hero scene and the
adjacent one. To the right of the tree stands a second human figure, a wor-

3 A publication of all the pre-Hellenistic seals from Michigan excavations at Seleucia is
forthcoming.

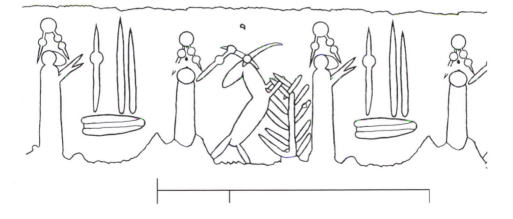

Fig. 2. Drawing after a museum-made impression of KM 94527, by Seth R. Button. Courtesy of the Kelsey Museum of Archaeology, University of Michigan. 2:1.

shipper who extends his arms towards a stand bearing Babylonian cult symbols. In very schematic form, the spade of Marduk and stylus of Nabû emerge from a flat base. To the right of this cult fixture, a narrow unadorned space serves to mark the terminal point of one complete rolling of the design. The width of the terminal space, as measured from the right edge of the base of the cult fixture to the back side of the repeating hero figure, is only a fraction greater than the width of space between the left edge of the cult base and the front side of the worshipper figure.

The hero and the worshipper are carved in the same schematic manner. Each stands in profile wearing a plain long robe which encases a tubular form. Articulation of bodily anatomy is limited to an indication of the outer shoulder as a small drilled hemisphere. At the back of a drilled dome-shaped head, each figure's coiffure is suggested by a small drilled hemisphere. Each beard is formed by a string of two other small drilled hemispheres terminating in a tail-point at the end. From just below the shoulder, the hero extends only one visible arm that seems to have the elbow suggested by drill work. The juncture of the hero's hand in grasping the animal's near horn is also suggested in this manner. Completely missing is the hero's other hand which, in this sub-type of heroic combat scene, would hold a weapon down behind his back.[4] The horned animal stands on the same level as the hero but its

4 For seals used on the Persepolis Fortification tablets, compare numerous compositions of heroic combat encounter where the animal's back is turned to the hero and the hero holds

head reaches only to the hero's shoulder. It has a short tail but no other distinguishing characteristics. Only one of its hind legs is rendered and no modelled or linear detailing elaborates the three schematic, smooth-cut passages that indicate belly, long neck and head. Judging by the horns, this animal ought to be a wild goat (mouflon or ibex), but there is no beard and the horns are uncharacteristically displayed frontally. The animal may instead be meant to represent the gazelle, whose horns are often rendered frontally as a splayed pair. The gazelle had a special symbolic association with kingship in Babylon of the first millennium BC; in heroic combat scenes, the gazelle is frequently represented with its body turned away from the hero, as we see it here (Collon 1995: 71–2).

The spade of Marduk is rendered as a simple vertical pole made by a single cut articulated two-thirds of the distance to its top by a small drilled hemisphere. The stylus of Nabû is indicated by two vertical poles each made by a single cut from bottom to top. Unlike all the other representational elements of the seal design, the symbol-bearing stand is suspended rather high in the field, beginning just under knee-height of the worshipper. The tops of the symbols rise almost level with the top of the worshipper's head. The style of the Kelsey seal resembles a class of glyptic that was produced in certain workshops of Neo-Assyrian and Neo-Babylonian times and then, in a very reductive mode, became especially popular during the late Neo-Babylonian period, after the fall of Assyria. Distinctive formal characteristics are the linear, grooved elements formed by straight wheel-cutting combined with aggressively deep, unmasked drill-work for rounded design elements. The result is a fusion of unadorned masses, as in the draped human bodies and the animal's anatomy, with strong linear features that are punctuated by occasional robust hemispherical modulations, such as for shoulders, coiffure and heads of the human figures. This style is stark and efficient, relying on contours and rhythms rather than on fine detail and intricate layering of planes.

Based on this preliminary examination of our seal, it might be classified as a late Neo-Babylonian product—the cut and drilled carving style together with the image of a worshipper before Babylonian cult symbols immediately triggers this response. But many of its features, taken together, urge further scrutiny. While the seal can hardly have been carved before the late Neo-Babylonian period, it may well have been carved later.

his weapon down behind his back: e.g. Garrison and Root 2001: PFS 149 (Cat. no. 212), PFS 236 (Cat. no. 213), PFS 795 (Cat. no. 214), PFS 815★ (Cat. no. 215), PFS 98★ (Cat. no. 217), PFS 1566★ (Cat. no. 218).

BIOGRAPHY I (A): MATERIAL AND FORM AS INDICES OF DATE

Agate beads

The cut of the barrel-shaped agate bead that hosts the intaglio-carved design of the Kelsey seal reveals that the stone is patterned with a sequence of bands that undulate in three wavy diagonals. The colour pattern shifts, top to bottom, from dark brown to creamy white to light brown.[5] Second only to cornelian among the three most prevalent semiprecious imported stones (with lapis lazuli coming in third), agate was prized in the ancient Near East for beads of various forms—with a particular preference for the barrel shape.[6] Even beyond their obvious significance as aesthetically pleasing, exotic markers of status, the perceived talismanic properties of these semiprecious stones invested them with extraordinary social agency.[7]

Although quite rare in the mid third millennium assemblages of the Royal Tombs at Ur (Pittman 1998: 110, 114, no. 72), later finds demonstrate the widespread appeal and availability of agate as a prestige commodity. This seems to extend from the Akkadian period in the late third millennium BC down through the first millennium BC. It survives the transition from the Neo-Babylonian political floruit, following the end of the Assyrian empire, into the period of Achaemenid hegemony with the definitive take-over of Babylon in 539 BC (Moorey 1994: 99–100). Banded agate beads (sometimes described as onyx, a sub-variety of agate) maintain their popularity through Achaemenid times. This is demonstrated, for instance, by the hoard

5 Prompted by Oppenheim's suggestion (Oppenheim, et al. 1970: 14) that glass imitations of agate may have been made in Mesopotamia, Katz (1990: 4) pursued this possibility. Visual analysis by geologist William Farrand as well as by our conservator in 1990 was followed up by an attempt to analyse the composition of a small sample taken from the perforated interior of the seal under a scanning electron microscope. Unfortunately this test (carried out in the laboratory of Dr Carl Henderson of the University of Michigan) was inconclusive, as the sample seemed to be limited to salt residue. A repeat of the test is planned in conjunction with a program of materials analysis for all the Kelsey's seals. Based upon visual analysis now by several geologists and conservators, KM 94527 seems without any trace of doubt to be neither a glass imitation of agate nor a sardonyx artificially dyed to produce the rich agate hues we see here (viz. Collon 2001: 23–4).

6 Sources for agate occur in the Eastern desert of southern Egypt, at the southern tip of the Arabian peninsula in the region of Oman and along the western coast of the Indian subcontinent (Wartke 1997: 41) and in Iran (http://iranian-agate.freeservers.com).

7 Goff (1956) presents abundant evidence on the magical/medicinal properties of various stones. Unfortunately, the term for agate has not been securely linked to one of the stones mentioned in the cuneiform texts. But the prevalence of agate for certain categories of theriomorphic amulet-seals in the first millennium BC suggests the magical significance of the stone in Mesopotamia and Iran.

in the fourth century Acropole burial at Susa (Tallon 1992: 242–52, nos. 176 and 177).[8] From the Persepolis Treasury, published finds of such banded agate beads are few.[9] This suggests, however, not that the heartland capital was poor in such things, but rather that the looting of the coffers by Alexander's soldiers and by subsequent pilferers at the site was thorough. At Seleucia-Tigris, barrel-shaped beads of banded agate are abundant in the palatial sector of the late-Hellenistic through Parthian levels (III–I) that were excavated most extensively by Michigan. This is the area whence the Kelsey seal was recovered.[10]

Our seal began life as one of these barrel-shaped beads. In theory, the addition of the intaglio-carved design, transforming the bead into a cylinder seal, might have occurred either in the same process as the production of the bead itself or at any time later up until the point of its final deposition in Parthian Seleucia. Without comprehensive data sets on size, stone sources and working techniques of such barrel shaped agate beads, we are unable to determine a *terminus post quem* or *ante quem* for the bead's creation and, thereby, narrow the temporal range for the application of its intaglio embellishment. Even if we could demonstrate that the bead itself was created at a relatively early date, the intrinsic beauty and apparent amuletic value of banded agate beads encouraged life-spans-in-circulation that defy rigid periodization in terms of their maintenance in social use and availability for carving as a seal at some later time (Moorey 1980: 118).

Agate cylinder seals
Although we cannot date the manufacture of the bead qua bead, the use of a barrel-shaped banded agate bead as the vehicle for a cylinder seal does strongly suggest a time-frame for the carving of the *design*, within the period of the Achaemenid Persian empire (c. 550–330 BC). Collon has noted that

8 If the inclusion of two Aradus coins (350–332 BC) can be trusted as neither intrusive nor otherwise mis-associated with the burial assemblage, then this grave must have been closed after 350 BC. Necklace no. 177 consists of 65 agate beads of varying shapes; no. 176 consists of 400 gold beads and 400 beads of various semiprecious stones including agate/onyx.
9 The three published banded agate/'onyx' barrel-shaped beads from the Treasury are: Schmidt 1957: Pl. 34, no. 20 (PT4 926); no. 21 (PT4 559) and no. 22 (PT4 382). No. 21 had remains of a bronze wire in the perforation.
10 Only very limited work on Level IV (the late fourth-century foundation phase of the site) took place before World War II forced the discontinuance of the project. The group of agate beads exhibited at the Kelsey Museum in 1977 (Savage 1997: 13) is only one set out of a great quantity of individual beads as well as groups clearly related as elements of individual necklaces which are noted in the Field Registry books.

agate cylinder seals, particularly but not exclusively barrel-shaped ones, enjoyed a special caché during Achaemenid times (Collon 1987: 93, 102; 1990: 35). This opinion is, no doubt, based in part on a comparison between the British Museum's corpus of Achaemenid cylinders, which are not yet fully published, and its extensive holdings of Neo-Assyrian/Neo-Babylonian cylinders (Collon 2001). A selective survey of collections which contain seals that have been classified as Neo-Assyrian/Neo-Babylonian, on the one hand, and Achaemenid, on the other, consistently reveals the prevalence of agate for Achaemenid cylinder seals and the relative lesser prevalence of this stone for cylinders of the earlier period.[11]

Of the 199 cylinders classified as Neo-Assyrian/Neo-Babylonian in the British Museum, I count only nine made of agate.[12] At least two of these nine agate cylinders are probably better considered products of the Achaemenid period (Fig. 7).[13] The remaining 190 cylinders are made of two other materials: 44 of cornelian and 146 of chalcedony. In Wiseman's selection of Achaemenid style cylinders from the British Museum's collection (Wiseman 1959), four out of a total of nineteen seals are made of agate.[14] Thus, the percentage of agate to other stones used on traditionally classified Neo-Assyrian/Neo-Babylonian cylinder seals in the British Museum is only 4.5%. Based on available evidence, the percentage of agate to other stones used on traditionally classified Achaemenid cylinder seals in the British Museum is 20%.

11 Moorey (1994: 74–6) rightly warns us about the limitations of evidence so far available on the precise identification of seal materials, emphasizing the need for standardized information so that broad-based analyses of material use in particular periods can produce more conclusive results. Visual traits of agate are distinctive enough, however, to make it possible to pursue the present inquiry even in the absence of such standards.

12 With reference to Collon 2001: no. 63 (BM 102064), no. 147 (BM 89470), no. 154 (BM 105122), no. 253 (BM 89810), no. 341 (BM 89362), no. 353 (BM 129561), no. 382 (BM 129098), no. 229 (BM 89789) and no. 393 (BM 89324 – Pl. 3) apparently agate dyed to resemble sardonyx.

13 Both of these agate cylinders portray double scenes. As will be argued below (BIOGRAPHY IB.— *Composition: double-image seals*), double-scene cylinders enjoy a revival in the Achaemenid period. This factor, combined with stylistic anomalies of the two ambiguous seals here, strongly suggest an Achaemenid date. BM 89780 (Collon 1987: no. 771; 2001: no. 229) is an agate cylinder, carved in an unusual quasi-drilled and quasi-modelled style, which displays a double worship scene See below, BIOGRAPHY IB.—*double image seals*). BM 89324 (Collon 1987: no. 418; 2001: no. 393) is an agate cylinder which depicts a worship scene in Babylonian style adjacent to a heroic encounter that clearly manifests an Achaemenid Persian iconography and style (See below, BIOGRAPHY IB. —*composition and meaning*).

14 BM 89132, BM 89696, BM 89529 and BM 89788.

The later predominance of agate is even more pronounced in the Marcopoli Collection, where only one out of 143 seals (7%) attributed to the Neo-Assyrian/Neo-Babylonian period is made of agate compared with nine out of ten seals (90%) in the Achaemenid group (Teissier 1984: 150–84).

The chronological distinction in seal stones is less dramatic in the Pierpont Morgan Collection, as published by Porada in 1948, but the basic pattern remains consistent. Out of a total of 179 Neo-Assyrian/Neo-Babylonian cylinder seals, only four (2.2%) are agate.[15] Two of these agate cylinders may be better considered Achaemenid products, which would reduce the percentage to only 1.1%.[16] But even if we leave these two ambiguous seals in the equation, the large sample clearly shows that agate was an unusual material for Neo-Assyrian or Neo-Babylonian seals. In contrast, Porada publishes a total of five 'proto-Achaemenid' cylinders (1948: nos. 812–816) and seventeen Achaemenid cylinders. In each subcategory there is one cylinder of agate.[17] Thus the percentage of agate to other stones used for cylinders in her 'proto-' and Achaemenid groups is 9%, and it would rise to 18% if we included the two ambiguous seals described as Neo-Assyrian/Neo-Babylonian in this later group.

Work with some 1,162 analytically legible seals used on the Persepolis Fortification tablets, which are dated by their inscribed texts to 509–494 BC, has shown the remarkable capacities of Achaemenid period workshops to produce extraordinary ranges of archaizing seals for a diverse imperial clientele (Garrison and Root 2001). It is clear that numerous extant seal artefacts (as distinct from seals retrieved through ancient impressions) are catalogued as Neo-Assyrian/Neo-Babylonian pieces in many collections. Thus, the relative proportions of Neo-Assyrian/Neo-Babylonian to Achaemenid examples of agate cylinder seals itemized above reveal a conservative picture of Achaemenid output

15 Porada 1948: nos. 723, 749, 769, 785.
16 Porada (1948: 92) expresses the possibility that her no. 769 is Achaemenid (on the basis not of material but of image parallels with sealings in the Murašû archive of the second half of the fifth century BC [now Bregstein 1993]). Based on parallels (this time in the Persepolis Fortification corpus), I would suggest that her no. 785 (a barrel-shaped cylinder in a modelled style depicting a worshipper before a fishman) may be a Babylonianizing seal of the Achaemenid period (Garrison and Root forthcoming).
17 Porada's 'proto-Achaemenid' cylinders (1948: nos. 812–816); her Achaemenid cylinders (1948: nos. 817–829 and 804–843). Of these, nos. 815 ('proto-Achaemenid') and 817 ('Achaemenid') are barrel-shaped agates.

Specifically barrel-shaped agate cylinder seals

Looking to the accepted wisdom that barrel-shaped agate cylinders are a hallmark of Achaemenid period production, we also find verification. Of the agate cylinder seals in the British Museum classified as Neo-Assyrian/Neo-Babylonian, three out of nine (33.3%) are barrel-shaped (not including the barrel-shaped example among the two cylinders I would like to reassign to the Achaemenid period). By contrast, in Wiseman's selection of Achaemenid period seals in the British Museum, two of the four agate cylinders (50%) are barrel-shaped. Again, we await the full catalogue of the corpus to view a more statistically compelling sample, but the results from the small set available so far are certainly suggestive. From the Marcopoli Collection, there is not a single barrel-shaped cylinder in the entire Neo-Assyrian/Neo-Babylonian group of 144 seals, four of which are made of agate. Among the Achaemenid cylinders in this collection, two out of nine cylinder seals made of agate are barrel-shaped. Of the 179 Neo-Assyrian/Neo-Babylonian cylinder seals in the Pierpont Morgan Collection, only four cylinders are agate and three of these are barrel-shaped (Porada 1948: nos. 749, 769, and 785). However, two of these three have already been singled out as probably belonging to the Achaemenid period on independent grounds.

The height of the Kelsey seal (at only 2.10 cm) offers an additional indication of a probable Achaemenid rather than Neo-Babylonian date. In general, Achaemenid cylinders tend to be much shorter than Neo-Assyrian/Neo-Babylonian ones, which usually range from c. 2.25 cm to between c. 3.75 and 4.0+ cm.[18] On the Fortification tablets, the 312 seals of heroic encounter have been analysed for patterns of dimensions. Of the 127 cylinder seals in this subset for which we can reconstruct the height, 81% fall in the height range of 1.4–2.0 cm. The only relatively tall seals in the entire hero subset are PFS 513 (at 2.70 cm), which is the only seal in the hero group considered to be a genuine antique Neo-Assyrian seal, and PFS 7★ (at 3.0 cm), which is in a special category of Achaemenid production as a royal name seal of Darius I (Garrison and Root 2001: 471, 473–78). Thus, the Kelsey seal is near the mainstream of modest heights documented in this important sample of Achaemenid glyptic, while it falls within the low fringe group of seals con-

18 The heights of the Neo-Assyrian/Neo-Babylonian seals in the British Museum are not tabulated separately nor are they broken down by stylistic or thematic groups—either of which might yield interesting statistics, but a perusal of the catalogue entries in Collon 2001 even without doing that effort can give a sense of an overall norm for Neo-Assyrian/Neo-Babylonian cylinders.

ventionally designated Neo-Assyrian/Neo-Babylonian in the representative
collections of the British Museum.

While none of these indices would be definitive by itself, the material,
shape and height of our seal combine to provide strong grounds for favour-
ing an Achaemenid date for the transformation of the agate bead into a
cylinder seal.

BIOGRAPHY I (B): STYLE, ICONOGRAPHY, COMPOSITION—INTERWEAVING
INDICES OF DATE

Style and its implications

There is only one category of glyptic that offers significantly close stylistic
parallels for the Kelsey seal. This is a class of Babylonian stamp seals in which
the reductive cut and drilled carving style is associated with the motif of a
worshipper before Babylonian cult symbols. This seal class (Figs. 3–4) thrusts
us into a very particular realm of production and consumption that begins in
the late Neo-Babylonian environment but persists long after the fall of Babylon
as an independent political entity in 539 BC.[19] The survival of this class into
the Achaemenid empire period has been recognized for almost a century
(e.g. Delaporte 1910: xviii–xix) and has been acknowledged anew in the
literature more recently (e.g. Schmidt 1957: 47; Lambert 1979; Zettler 1979).

The difficulties of determining the parameters of production date of late
Neo-Babylonian type worship seals across their several formal variants with-
out the aide of textual/archival evidence or contextual material evidence
has, however, led some to adopt the terminology 'late Babylonian' to refer
to all such seals. This usage is adopted even by some scholars who acknowl-
edge that many of the seals were certainly *carved* as well as used during the
Achaemenid empire. Thus, for instance, Lambert calls the entire group of
seals in the ex-Percy collection (which includes Neo-Assyrian, Neo-
Babylonian, and dated Achaemenid period seals) 'late Assyrian and late

19 Excavations at Nimrud yielded several examples of this class of stamp seal—all from
graves and fill of the post 612 BC destruction phase at the site. See, e.g., Parker 1955: 8
(ND3383), 108 (ND 3386)—both from the same post 612 BC grave; Parker 1962: 29 (ND
6026)—found in fill above the destruction layer in the courtyard of Ezida. Impressions of
similar seals occur on dated documents that validate the style-motif correlation as a late
phenomenon. Parker 1955: 121–2 (ND 3433, where Parker specifically sees this seal used on
a document dating after 648 BC as a precursor to the fully developed reductive style–image
system that becomes so prevalent later in the century). Parker 1962, 38 (ND 7086) offers an
example of the fully developed style–image mode on a seal ratifying a document dated to
about 615 BC.

Babylonian, c. 750–350 BC.' (Lambert 1979: 35). In so doing, he effectively erases the Achaemenid Persian empire as well as its artistic production and labels its 200-year existence 'late Babylonian'.[20] In common with Ehrenberg (1999: 2), I prefer the option chosen by Buchanan and Moorey (1988: 60). By creating a group called 'Neo-Babylonian and Achaemenid "Drilled" and "Cut" Styles,' they resist the erasure of the Achaemenid empire as an historical period and a cultural phenomenon. In resisting this erasure, they implicitly acknowledge both the cultural permeability of these two phases of political distinctiveness and the significance of that permeability as one that expresses *an assertive rather than a passive* continuity.[21]

The survival of cut and drilled style worship seals after 539 BC is re-flected not only in the continued use of some examples made during the late Neo-Babylonian floruit but also in the *production of new seals* in this tradi-tional Babylonian style during the Achaemenid period. The sheer number of seals of this class in active use in conjunction with dated texts of the Persepolis Fortification archive urges that we accept this conclusion. Out of c. 350 analytically legible seals that display images of human activity other than heroic encounter, there are eighteen Babylonian type worship seals display-ing a worshipper before inanimate cult symbols which are engraved in a cut and drilled style (Figs. 3–4).[22] Some nineteen additional seals display this Babylonian type worship iconography but manifest styles other than the cut

20 The same sort of erasure has permeated the general realm via sales catalogues. Note, for instance, the Christie's London offering for Wednesday, 8 December 1993: 119 (item no. 275): a banded agate cylinder seal displaying an obviously Achaemenid image but labelled 'Assyrian circa 5th century B.C'.

21 Lambert (1989: 534) takes the occasion of his review of Buchanan and Moorey 1988 to reassert his own terminology.

22 The seals of heroic encounter number 312 and are published as a separate category in Garrison and Root 2001. Late Neo-Babylonian type worship stamp seals used on the Persepolis Fortification tablets and carved in a cut and drilled style are: PFS 116s, PFS 186s, PFS 262s, PFS 273s, PFS 279s, PFS 499s, PFS 623s(s), PFS 668s, PFS 1037s, PFS 1068s (with some stylistic hybridity), PFS 1121s, PFS 1140s, PFS 1159s, PFS 1205s, PFS 1333s, PFS 1414s, PFS 1687s. See Garrison and Root 1996 (1998) and ongoing updates at http://achemenet.com for provisional concordance of the seal numbers to the specific tablets on which they occur (those published in Hallock 1969). These worship seals will be published in Garrison and Root forthcoming. I am using the term 'a cut and drilled style' to suggest a range of production using cutting and unmasked drilling techniques to produce seals that maintain the look of the late Neo-Babylonian cut and drilled seal class. Within the group there are micro-distinctions. This is why I use the article 'a' rather than 'the', which might suggest some kind of workshop hegemony that I am not prepared at this point to postulate.

Fig. 3. Composite drawing of PFS 1121s
from multiple impressions on the
Persepolis Fortification tablets. Courtesy of
the Persepolis Seal Project. 2:1.

Fig. 4: Composite drawing of PFS 116s
from multiple impressions on the
Persepolis Fortification tablets. Courtesy of
the Persepolis Seal Project. 2:1.

and drilled style.[23] There are yet more seals used on the Fortification tablets
that feature a Babylonian type worshipper before an animate being such as
the scorpion-man. But even excluding these seals, the Babylonian type wor-
ship image is the numerically predominant type among all the seals in the
corpus, displaying in their main scenes images of worship before an altar or
other focus of cult adoration. This is interesting, since the repertoire that
develops during the Achaemenid empire introduces new worship types with
a distinctively Persian iconography (Moorey 1979a). These new types are
represented in the Fortification corpus (Garrison 2000: 141–43; Garrison in
press). A royal name seal of Darius I (PFS 11★), for instance, shows Achaemenid
Persian worship iconography in the fully developed Persepolitan Court Style
(Fig. 5). But the number of such seals in the corpus is very small in compari-
son with the Babylonian types.

 The Fortification archive shows that a wealth of options was available for
seal commissions in this imperial milieu. Given this wealth of options, it is
particularly intriguing that so many of the worship scenes invoke late
Babylonian tradition. As Garrison has stated, the Fortification tablet seal im-
pressions offer us 'one of the largest collections of such [Babylonian worship]
designs from a contextualized archive; they will impact significantly our un-
derstanding of this category . . .' (Garrison 2000: 143). In the much smaller
Persepolis Treasury archive (492–459 BC), which begins only two years

23 Additional Babylonian type worship stamp seals in styles other than the cut and drilled
style: PFS 143s, PFS 161s, PFS 289s, PFS 451s, PFS 648s, PFS 862s, PFS 958s, PFS 1048s,
PFS 1216s, PFS 1228s, PFS 1271s, PFS 1278s, PFS 1426s, PFS 1576s; additional Babylonian
type worship cylinder seals in styles other than the cut and drilled style: PFS 129, PFS 518,
PFS 813, PFS 1052, PFS 1240.

Fig. 5. Composite drawing of PFS 11★ from multiple impressions on the Persepolis Fortification tablets. Courtesy of the Persepolis Seal Project. 2:1.

after the Fortification corpus ends, two additional Babylonian type worship stamp seals are documented out of a total of 77 seals. One of these is definitely engraved in a reductive cut and drilled style, while the other appears from the published photograph to be cut in a slightly more modelled style.[24] For the purposes of demonstrating the generous presence of late Babylonian type seals (especially the cut and drilled style class) in active use at Persepolis, the Treasury corpus is significant even though its evidence is numerically less dramatic than the Fortification corpus. It raises the total number of cut and drilled style Babylonian type worship seals documented *in active use* at Persepolis during the early fifth century BC to at least nineteen.

It is difficult if not impossible at this point to distinguish on visual criteria alone an heirloom from a new product among the very specific class of cut amd drilled style Babylonian worship seals. But one feature of the subset of these seals in the Fortification archive is highly suggestive: some of the cut and drilled seals seem to have been in pristine condition when they were used on the Fortification tablets (even if a weak seal application or the sealing of an over-hard tablet may sometimes render the impressions difficult to read).[25] It seems improbable that (a) one archive at Persepolis contains such a large sample of genuine antique seals belonging to a very particular class of

24 Schmidt 1957: 47 and Pl. 13: PTS 61s and PTS 62s. The Schmidt publication does not incorporate commentary on style and it is difficult from the photograph of PTS 61s alone to assess the degree to which the cut and drilled style has been infused with a modelled affect. One actual late Babylonian type worship seal (a fragmentary agate stamp) from the Treasury is of the reductive cut and drilled style class we are discussing here: PT5 501 (Schmidt 1957: Pl. 17).

25 I cannot comment upon such nuances in relation to the Treasury corpus. Access to the actual tablets is important for such observations.

Neo-Babylonian glyptic and that (b) many of these antique seals display little or no evidence of wear.[26]

As noted above, there are numerous seals in the Fortification corpus which depict the Babylonian worshipper before cult symbols carved in styles other than the reductive cut and drilled mode that resembles our Kelsey seal. Included in this group are some carved in styles that seem to indicate that hybridizations were taking place in workshops right in the Persepolis milieu. The creative re-invention of the distinctive Babylonian octagonal, pyramidal stamp seal form as a vehicle for a new repertoire of images carved in a local Persepolis style (the Fortification Style) has already been examined (Root 1998). Here, we are moving on to an exploration of related features of hybridization—now involving Babylonian type worship imagery and its specialized stylistic valences. Sometimes this creative re-invention reveals a demand for archaizing products in the traditional manner; other times it reveals an impulse for experimentation that dresses the antique Babylonian worship imagery in new or blended idiom or incorporates it into a very 'modern' visual statement in other ways.[27] One clear example of the latter such blending may be seen in PFS 1501 (Garrison and Root 2001: Cat. no. 238 [Fig. 6]). In this case, a cylinder seal displaying an image of heroic encounter is carved in the Fortification Style, which accounts for fully 51% of the hero seals in the Fortification corpus (Garrison and Root 2001: 14 and *passim*). Adjacent to the heroic encounter are symbols of Marduk and Nabû. We cannot be sure whether the cylinder, which is not preserved for a full rolling, originally incorporated a Babylonian worshipper as well; but for our discussion here, the important point is that the Babylonian cult symbols have been integrated into the design of a seal produced in a mainstream local Persepolitan workshop environment.

26 Wallenfels (1996: 119) has charted for Hellenistic Uruk that the average usage span of a private seal was about eight years, although occasionally a seal that seems to drop out of use is later tracked in the hands of another owner. I do not wish to insist too much on this Hellenistic analogy from Uruk for understanding the practice of individuals sealing as 'private' persons on administrative documents in the Persepolis region in the early fifth century BC. Nevertheless, the comparative data are certainly valuable.

27 See Garrison and Root 2001: 16–21 as well as the many relevant catalogue entries on stylistic variations and on antique imagery recreated in a variety of modes, from archaizing styles to translations into hybrid styles (Diverse Styles) and into the local Persepolitan Fortification Style. These discussions all refer to the subset of seals of heroic encounter (with a preponderance of commentary revolving around re-inventions of Neo-Assyrian/Neo-Babylonian modelled styles) but the issues are relevant to the topic at hand in this article.

This scenario is also operative in Mesopotamian contexts within the temporal embrace of the Achaemenid empire. The seals used on tablets of the Eanna temple archive of Uruk offer important evidence of rich tradition mixed with creative archaizing through 499 BC. Work by Ehrenberg enables us to begin to appreciate the nuances of the material in this aspect (Ehrenberg 1999: 39–44, for example). The later Murašû archive of dated business documents from Nippur (454–404 BC) also includes a large number

Fig. 6. Drawing of PFS 1501 from a partially preserved impression on the Persepolis Fortification tablets. Courtesy of the Persepolis Seal Project. 2:1.

of worshipper seals of various Neo-Babylonian types.[28] One late Babylonian type worship seal used in the Murašû archive is known through the associated text information to have been inaugurated as a replacement seal in 411 BC, the thirteenth year of Darius II (Bregstein 1993: 291–92). Although this particular worship seal is of a different Babylonian type than the reductive cut and drilled class under primary discussion here, the irrefutable evidence of archaizing production in any one of the several traditional Neo-Babylonian worship modes is very significant for our arguments.

In sum, based on analogies from seals used on dated documents, there is good support for the proposal that the Kelsey cylinder was carved during the Achaemenid period in a reductive cut and drilled style. This style was drawn from a class of similar looking late Neo-Babylonian type worship seals that was originally manifested, as far as we now know, only in stamp seal format.

Composition: double-image seals

The Kelsey cylinder seal displays a true double-image scene. It is not a single scene of heroic encounter that deploys cult emblems and/or a worshipper in a clearly isolated terminal field. Cylinder seals with true double-image formats are known among those conventionally classified as Neo-Assyrian/Neo-Babylonian, where they seem to be primarily or even almost exclusively double images involving a heroic encounter (or other action scene) and a

28 Bregstein 1993: nos. 215–246 are classified as worship scenes. Judging by the types represented combined with the occasional sketch, none would seem to be in the cut and drilled style.

worship scene of some type.[29] Double-image seals may, however, be numerically more common in the Achaemenid period. They certainly seem more diversified in their range of combinations in the Achaemenid period. The lively experimentation with double-image seals at this time may be a feature of deliberate archaizing that specifically reaches back to and reworks robust Akkadian and Neo-Sumerian prototypes (Garrison and Root 2001: 255).[30] In the Fortification archive alone, there are six seals of heroic encounter known from their impressions which show double-image scenes with two discrete encounter groups.[31]

To these examples we may add selected actual Achaemenid period seals that combine two action scenes on the same seal. A large chalcedony cylinder from Borsippa, Iraq displays two separate heroic combat encounters (Collon 1987: no. 428, BM WA 89337). Two other double-image seals display pairs of armed attacks by Persians against human opponents: a chalcedony cylinder from the Oxus Treasure (Dalton 1964: no. 114, Pl. XVI; Collon 1987: no. 574, BM WA 124015)[32] and a fragmentary banded agate cylinder in the Newell Collection inscribed in Old Persian invoking Artaxerxes (von der Osten 1934: no. 453, Pl. XXXI; Schmitt 1981: 34–5, Abb. 4).

Moving from double-image seals combining two action scenes on the same seal to other combinations, we can cite an Achaemenid example in which a heroic control encounter and a scene of presentation before a seated personage (rather than seated deity or divine image) come together on one cylinder: Louvre AO 2405 (Collon 1987: no. 659).

29 Examples include: a cylinder seal impression on a document from Nimrud dated to 650 BC showing a heroic combat encounter plus a worshipper before an anthropomorphic deity (Parker 1955: 117, Fig. 8, Pl. XXIV, 6 [ND 3437]); a cylinder seal in the Pierpont Morgan Collection showing a heroic combat plus a complex worship scene focusing upon the 'Assyrian sacred tree' (Porada 1948: no. 773; Wittmann 1992: Pl. 46e); A cylinder in the de Clerq Collection showing a heroic combat plus a worshipper with a winged symbol (Wittmann 1992: 264, Pl. 25, no. 69). To these we might add examples of a heroic encounter plus a worshipper alone—not shown associated with any cult symbol: a cylinder seal impression on a tablet from Nimrud dating after 648 BC showing a heroic encounter plus a worshipper facing toward the hero (Parker 1955: 118, Fig. 9, Pl. XXV, 1 [ND 3463]); and a cylinder seal showing a heroic combat plus a worshipper facing this group (Wittmann 1992: Pl. 46d).
30 e.g., among many others, the cylinder from Ur bearing the name of 'Adda, major domo of Enheduanna,' the famous daughter of Sargon of Akkad (Collon 1987: no. 527, IM 4221).
31 Garrison and Root 2001: PFS 131 (Cat. no. 170), PFS 146 (Cat. no. 275), PFS 152 (Cat. no. 295), PFS 199★ (Cat. no. 305), PFS 757 (Cat. no. 296), and PFS 1249 (Cat. no. 294).
32 See Litvinskii and Pichikian 1994 on the re-contextualization of the Oxus Treasure. The question of the validity of the re-contextualization of the Oxus Treasure artefacts is beyond the scope of this paper.

Another double-image seal that purportedly belongs with the Neo-Assyrian/Neo-Babylonian precursors seems likely to be Achaemenid instead. This is the barrel-shaped agate cylinder mentioned earlier that displays two late Babylonian type worship scenes (Collon 2001: no. 229, BM WA 89780). The cylinder is, predictably and understandably, dated to the Neo-Babylonian period ('seventh or sixth century')—presumably on the basis of the garments worn by the figures and the style, which looks to be a quasi cut and drilled style with a significant modelled aspect. The barrel shape and the agate stone encourage us to entertain the possibility that this is, rather, an Achaemenid period seal (although, admittedly, at 2.9 cm it is quite tall for a 'typical' Achaemenid cylinder).

The garments of the figures can no longer be viewed as diagnostic of a pre-Achaemenid date. The Fortification corpus demonstrates strikingly the perpetuation of a wide range of Mesopotamian garments on new seals (Garrison and Root 2001: *passim* and appendix eight). The double-image format used for two scenes of the same type is solidly at home in Achaemenid production, as we have seen; it must, however. be rare indeed in the immediately preceding era. This seal (BM 89780) has no provenance. Because of that, we would prefer not to place too much weight on it as evidence. But its various qualities bring it close to the Kelsey seal and reinforce the sense noted earlier that a number of seals conventionally classified as Neo-Assyrian/Neo-Babylonian may instead be Achaemenid artefacts. In particular, the cut and drilled style with an infusion of some modelling is a blending we see on some other demonstrably Achaemenid products, such as PTS 61 from the Persepolis Treasury tablets (Schmidt 1957: 47 and Pl. 13).

Seal 'play' observable on the Fortification tablets may offer insight into the issue of double-image seals in the Achaemenid period. We can, for instance track seal application activity between two discrete cylinder seals of heroic encounter to yield an impression of a double-image scene like the images made from double-image hero scenes just reviewed.[33] This suggests a lively environment in the Persepolis region of seal use and activated patron discourse on the re-creative image-making potentials of seals (Root 1999). Such manipulations occur in a variety of ways on the Fortification tablets. On the same tablet surface, we sometimes see the careful manipulation of one seal impressed multiple times to create variant motif combinations, or two separate seals impressed one beside the other in such a way as to create a new image.

33 See Garrison and Root 2001: 304–5, 308: PFS 266★ (Cat. no. 208) and PFS 1181 (Cat. no. 210).

This type of aesthetic discourse may reflect a lively environment of visual engagement at Persepolis. At the same time, the aesthetically-attuned environment of 'seal-play' may have helped shape a revival and flourishing of interest in double images actually carved on single cylinder seals during Achaemenid times. Persepolis was certainly an intensely multicultural environment as we glimpse it through the lens of the Fortification tablets, where we can observe individuals of varying status and background working with their seals (Root 1997). It was also an aggressively creative one in the formulation of official and private mandates in the visual arts (viz. Root 1979, 1998).[34] The two aspects of creative charge seem to have been closely related.

Composition and meaning—the union of hero and worshipper
Some subtle nuances on our seal serve to articulate the discreteness of the two scenes. These nuances also effectively unify their composite association. The placement of the motif of heroic encounter (as determined by the head of the hero) is slightly lower off the top edge of the cylinder than the worship motif. This effect of slightly lower siting on the seal is enhanced by the small size of the animal followed by the small tree. The worshipper's head reaches somewhat higher towards the top edge of the cylinder, with this elevation reinforced by the reach of the divine symbols.

Whether any suggestion of relative status was intended, either between the two complete images or between the hero and the worshipper as individual protagonists, remains an open question. Whatever possible encoding of meaning may exist in this structure, the difference in levelling of the two scenes creates a lively rhythm across the entirety—a strong, visually unifying dynamic. The unity of the two scenes is enhanced by the binding agency of the gazelle rampant against the tree. This element has a pivotal multivalent function. (1) It is, of course, an integral part of the heroic combat encounter here, since this is the animal grasped by the hero. But (2) it is also reminiscent of Achaemenid seals in which a heroic encounter is punctuated by a separate terminal field element of an animal-and-tree/floral image (either

34 It is potentially important as regards specific aspects of multicultural permeability and creative urgency in the Persepolis region being the possible key here that there are no double-image cylinder seals catalogued in Ehrenberg's Eanna corpus (Ehrenberg 1999), but see the proposal made here below for a double-image stamp seal used in this archive. There are none catalogued in Bregstein's Murašû corpus (Bregstein 1993) or in Kaptan's Daskyleion corpus (Kaptan 2002). But at this point, I am not sure how to assess the significance of this fact. There are, for instance, none in the Treasury corpus either. Many potential variabilities (of statistical probability based on size of sample, region, date and type and social scope of archive) need to be considered.

one animal or a heraldic pair).[35] Finally, (3) the motif is reminiscent of seals in which either the animal or the animal rampant before a tree is displayed adjacent to an image of a worshipper before cult emblems (without the addition of the hero).[36] The gazelle rampant before the tree thus encodes the double-scene array on the Kelsey cylinder with a unity borne of co-mingled visual associations as well as formal rhythmic mechanisms.

This formal analysis suggests a calculated effort in the design of the double image on the Kelsey seal. Such an effort entitles us to ponder the potential meaning embedded in the coordinated double-imaging here. In his unpublished preliminary account of our seal close to the time of its discovery, Yeivin (n.d.: 28–9) registered the rarity, indeed the uniqueness, of the presumably Neo-Babylonian artefact. He proposed that the imagery be read as 'a prototype of a scene, which we find reproduced over a thousand years later in a synagogue [Beth-Alpha], in Israel.' Yeivin saw in the Kelsey seal an allusion to the 'testing of Abraham' (*Genesis* 22). He saw the horned animal before the tree as a goat and connected the goat with the ram-in-the-thicket described in the Biblical story. This narrative interpretation may overreach the bounds of credibility on a variety of counts, yet it is thought-provoking. Whatever the shifting valences of heroic encounter across time and social circumstance, it seems that it could indeed encompass profound associations of meaning about cult and the heroic exercise at various phases of Near Eastern history. These associations did not dissolve in Achaemenid times. If anything they flourished anew, charged with fresh meanings (viz. Garrison and Root 2001: 53–60). In the particular imperial environment of the Achaemenid era, there were a great many individuals who might have looked at the same image and received it in diversely nuanced and personally elaborated ways.

A number of Neo-Assyrian/Neo-Babylonian cylinders display a scene of heroic encounter with a terminal field image of worship before cult emblems of various types. Some of these seals specifically deploy the Babylonian cult symbols of Marduk and Nabû as the terminal elements.[37] This format is also

35 See, e.g., an Achaemenid hero seal in the Fortifcation corpus (Garrison and Root 2001: PFS 853 [Cat. no. 204]). For an actual seal that is often illustrated, see the chalcedony cylinder said to have been found at Marathon in Greece (BM 89781: Collon 1987: 90–1, no. 421).

36 See, e.g., a Neo-Assyrian seal of worship before a divine image punctuated by the image of a goat rampant before a tree (BM WA 89846: Collon 2001: no. 238).

37 On the notion of terminal field imagery and criteria for making the distinction, see Garrison and Root 2001: 42 and 51. For Neo-Assyrian/Neo-Babylonian seals with heroic encounter and terminal field motif of cult scene, see, e.g., BM 89763 (Collon 2001: no. 338

found in cylinders of Achaemenid date. PFS 228 (Garrison and Root 2001: Cat. no. 148) is a cylinder seal used on the Fortification tablets that displays a heroic control encounter with the Babylonian altar-with-star cult installation in the terminal field.[38] This seal is carved in the local Fortification Style. Similarly, a cylinder used in the Murašû archive displays a heroic combat encounter with a large spade of Marduk occupying what seems, on the basis of the verbal description, to be the terminal field (Bregstein 1993: 515, no. 121).

When we specifically consider heroic encounter scenes with terminal field images of a worshipper before emblems of Marduk and Nabû, it is interesting to note that some earlier Neo-Babylonian cylinders with heroic encounter imagery had terminal field inscriptions invoking Nabû without the imagery (Seidl 2000). It is possible that there was a gradual shift away from terminal field inscriptions naming the gods and towards imagery fulfilling the same referential purpose. One unprovenanced cylinder, perhaps dating to the first half of the sixth century BC (Wittmann 1992: 214, Pl. 102), may demonstrate a middle zone in such a postulated shift. Here, a heroic combat encounter (where the hero faces right) is punctuated by a terminal field inscription that is enhanced by a worshipper facing left, as if addressing his attention directly to the inscription, which invokes Nabû. By the Achaemenid period, the inscriptions invoking the deity have certainly ceded to imagery in re-inventions of Babylonian tradition.

For seals such as the Kelsey cylinder that display a truly double-image format of heroic encounter and explicit worship activity, the parallels are very limited. This is true whether for Neo-Assyrian/Neo-Babylonian production or for Achaemenid glyptic. Among the Neo-Assyrian/Neo-Babylonian group are seals combining heroic encounter with the worship of the emblems of Marduk and Nabû.[39]

= Collon 1987: no. 856; Wittmann 1992: Pl. 49h): a cornelian Neo-Babylonian cylinder with a reversed inscription reading '(Seal) of Ninurta-aha-usur.' Two heroes combat one kneeling human figure. In the terminal field a worshipper stands before tiny symbols of Marduk and Nabû. Seals with a heroic encounter plus a terminal field motif of the Babylonian cult symbols only (without the actual presence of the worshipper) include: a late seventh century steatite seal from Nimrud (Parker 1962: 30, Pl. IX, 1, ND 5329); a chalcedony cylinder in the Newell Collection (von der Osten 1934: no. 424); one from the Marcopoli Collection (Teissier 1984: no. 286) and two in the Pierpont Morgan Collection (Porada 1948: nos. 759, 760). Similarly, there are examples of the worshipper present without symbols that materialize the focus of his devotion.

38 Compare, e.g., Jakob-Rost 1997: 98, no. 425.

39 For examples classified as Neo-Assyrian/Neo-Babylonian in the British Museum see Collon 2001: no. 208 (BM 89611), no. 209 (BM 89800), and no. 393 (BM 89324). See also

This same combination persists into Achaemenid times alongside other seals that display different worship scene traditions. One Achaemenid double-image seal, which combines a heroic encounter and a worship scene, shows an elaborate tableau of a worshipper before heraldic creatures (winged disc with figure emergent hovering above) plus an equally-weighted image of Bes-as-hero posed atop heraldic winged human-headed creatures (Collon 1987: no. 864, BM WA 89352). Unfortunately, we cannot be sure whether the hero seal used in the Fortification archive discussed earlier (Fig. 6) was a full-fledged double-image seal, complete with worshipper adjacent to heroic image, or whether instead the spade of Marduk and stylus of Nabû existed alone. Similarly with a cylinder partially rolled on a tablet in the Muraŝû archive we see vestiges of what may have been a double-image seal: a non-heroic action scene combined with a worship scene coming very close in spirit to the double-image hero and worshipper scenes. All that can be retrieved of the original seal design in this case is a winged archer aiming to the right and a worshipper facing left (Bregstein 1993: 84 and Pl. 19. 154).

Seal impressions on the Fortification tablets often created tablet land-scapes of imagery in which artistic traditions of various cultures now sub-sumed within the Achaemenid imperial purview were conjoined through the serendipity of the individual seal users, who happened to come together around a given transaction.[40] These tablet landscapes offer an interesting type of evidence for the visual paradigms available at a busy place like Persepolis (Root 1997). One example of this occurs on PF tablets 1178 and 1190 (Garrison and Root 2001: Pl. 126a). Here, two very different types of seals are applied to the same surface. PFS 1122 (a cylinder) displays a scene of heroic control encounter in a modelled style, which owes much to Neo-Assyrian/Neo-Babylonian precedents but may be an archaizing Achaemenid product.[41] PFS 1121s, a stamp seal (Fig. 3), is a cut and drilled style Babylonian

an example in the Danish National Museum: DFa 659 (Wittmann 1992: 265, no. 75, Pl. 26). Here a heroic encounter is coupled with a scene including a small worshipper and diminutive Babylonian cult symbols. A variant of interest is a very crowded cylinder displaying a horseman, who might best be described as a mounted hero, pursuing a fleeing animal with an equally weighted adjacent scene displaying a worshipper before the spade of Marduk. On this large chalcedony seal, there is a terminal field motif as well: the suckling calf motif below a winged symbol. See Collon 2001: no 215, BM WA 89331).

40 This phenomenon should be distinguished from 'seal play' of a deliberately creative nature.
41 Garrison and Root (2001, Cat. no. 228) place this in the Plausibly Antique category of modelled style seals in the corpus, with the rather small size of the seal for a pre-Achaemenid modelled style seal being one factor speaking for its attribution as an archaizing Achaemenid seal.

Fig. 7. Photograph of a plaster cast of BM WA 89324 (Kelsey Museum Bonner Cast Collection, KM 92.2.103). Courtesy of the Kelsey Museum of Archaeology, University of Michigan. 4:1.

type worship stamp seal, probably carved during the Achaemenid empire, not too long before its earliest documented use here in 499/498 BC. It is not difficult to imagine the visual impact engendered by sealing 'events' such as this within the lively arena of Persepolis and other as yet less well-documented imperial contexts.

This tablet landscape brings us back to the problematic double-image cylinder in the British Museum (Collon 2001: no. 393, BM WA 89324 [Fig. 7]). We can now consider it with some new data at our disposal. Collon once placed it in her Period VII ('Medes, Persians and Greeks') and dated it early Achaemenid, as reflecting a transitional phase at a chronological 'overlap between the two styles' of traditional Babylonian production and the emergence of specifically Achaemenid production (Collon 1987: 90, no. 418). Bleibtreu (1997: 102–3) suggested that this seal is a late Babylonian seal, recut in the Achaemenid period. This resolution of the issue has now been adopted by Collon (2001: 195, no. 393). Her catalogue entry for the seal does not, however, mention physical evidence attesting to such re-cutting.[42]

42 There is commentary on the probable dyeing of the seal (Collon 2001: 195), which suggests that if there were additional technical observations pertaining to the theory of re-cutting, then this would have been brought forward simultaneously.

Collon notes that 'It is impossible to establish the chronological gap between the execution of the two scenes [on BM 89324] since both styles were to some extent concurrent.' Her acknowledged difficulty here offers an entrée for new insights to assist the problem she identifies. Armed now with more information from sealed and dated documents of the Achaemenid empire, it is possible to revisit this whole issue of temporal distinction. The Fortification corpus combined with the Murašû corpus allow us to consider alternatives to earlier ways of framing the scenario of production of this particular piece.

We can now appreciate, for instance, that the 'Achaemenid' portion BM 89324 must date well after any initial phase of chronological overlap zone between the inauguration of the Persian empire and the capture of Babylon. Close temporal proximity of the 'Achaemenid' portion to a presumed pre-Achaemenid (Neo-Babylonian) production date for the Babylonian worship motif is not plausible. Rather, this seal reflects a synchronous visual dialogue between two living traditions. The Babylonian segment reaches back ultimately to a pedigree in pre–Achaemenid models. But these models persist in active production well into the reign of Darius II. The other segment displays a form of the Achaemenid Persian Court Style. This stylistic phenomenon begins to emerge, in glyptic art, during the reign of Darius I, not much earlier than about 500 BC (Garrison 1991).

We have already demonstrated that a continued production of Babylonian type worship scenes (in cut and drilled styles and also in the modelled style used on BM 89324) is plausible. There is really nothing that contradicts the likelihood that the seal in the British Museum, like the seal from Seleucia now in the Kelsey Museum, was carved all at the same time just as it looks today. Indeed, as we have seen, there is significant circumstantial evidence that suggests that the British Museum seal represents an expression of creative hybridization within a multicultural arena of the Achaemenid empire. In this case, the British Museum seal (along with the Kelsey seal) would join the ranks of double-image cylinder seals of Achaemenid production date and the ranks of barrel-shaped agate cylinders of a variety of image types produced in the same cultural environment.

The interesting questions these seals raise urge that we continue to press the exploration of the creative backdrop out of which the flourishing of double-image cylinder seals emerges in Achaemenid times. A sealed envelope landscape among the Eanna tablets helps us in this effort. Here, two images are applied to the same envelope: Ehrenberg no.155 (1999: 84 and Pl. 19) shows a heroic combat encounter with the hero facing left; Ehrenberg

no. 81 (1999: 66 and Pl. 10) shows a late Babylonian type worship scene in a somewhat schematic cut style mode with the worshipper facing left. The impressions of no. 81 were made by the carved face of an octagonal, pyramidal stamp seal. Those of no. 155 were made by a carved side face of an octagonal, pyramidal stamp seal. From the dimensions given, it seems that we may well have evidence here of one octagonal stamp seal carved on two separate surfaces.[43] When used together in an artful way, such as we frequently see practised in seal play on the Fortification tablets, the two surfaces of this seal would have created a format quite similar to what we see on the Kelsey double-image cylinder: a hero scene and a worship scene both focusing in the same direction, lined up side by side.[44]

The octagonal, pyramidal stamp seal in question from the Eanna archive is used on an envelope dating to Amel-Marduk (Ehrenberg 1999: 21 for no. 81 and 26 for no. 155). Thus we have here important evidence that already in the late Neo-Babylonian period, shortly before Cyrus' conquest of Babylon in 539 BC, double-image seals could exist in a stamp seal format, closely tied in with the reductive worship seals that were such a hallmark of the late Babylonian floruit. This seal also documents a representation of the hero figure echoing features of stance and affect that are typical worship figures in late Neo-Babylonian type mode. In this as well it offers a precursor to the Kelsey cylinder.

This link is important because the heroic combat encounter as displayed on the Kelsey seal is quite unusual. The heroic image is, of course, well-documented in Neo-Babylonian glyptic (Wittmann 1992) and it enjoys an explosive renaissance in the Achaemenid period (Garrison and Root 2001). Yet the rendering of heroic encounter in the particular idiom we see on the Kelsey seal was rare in both periods.[45] The Eanna octagonal stamp seal that we reconstruct with images of hero and worshipper displayed on two adjacent but separate surfaces offers a secure precedent for the Kelsey hero's affect in

43 There are numerous examples of conoids and pyramidal stamps carved on multiple surfaces. See, e.g., Jakob-Rost 1997: 84–5, nos. 325 and 327; 88–9, no. 360; 90–1, no. 374 (Assur); 106–7, no. 474 (Babylon).

44 In the case of the Kelsey cylinder, the hero and the worshipper both face right in impressed image.

45 Among the 312 discrete hero seals used on the 2,087 Fortification tablets published by Hallock in 1969, there is no heroic encounter image rendered in this cut and drilled style and echoing the worshipper figure type through schematic garment, posture and affect (Garrison and Root 2001). In the Muraŝû archive there seems to be no parallel either (Bregstein 1993), although it is not possible to be definitive on this point until these seals are published in book form with comprehensive visual documentation.

the era immediately before the Achaemenid conquest of Babylon. Another stamp seal in Berlin is also somewhat close in this respect (Jakob-Rost 1997: no. 230). Here, in impression, a hero faces left holding a rampant animal by the horn. The hero wears the plain robe associated with worshippers on typical late Babylonian seals and he stands in full profile. In both these aspects, this hero is thus comparable to the image on the Kelsey seal. Although the animal's form is a less coherent and clarified image than what we see on the Kelsey seal, the overall rough similarity is evident. Unfortunately, this stamp seal in Berlin has no provenance. A couple of excavated cylinder seals in Berlin also hint at stylistic and compositional similarity with the hero image on the Kelsey seal (Moortgat 1940: nos. 736 and 740). In these two seals, the hero is not rendered nearly as close to the worshipper model as he is on the one unprovenanced stamp seal in Berlin. But there is something of the same feel in the cut style of the animal portrayals. Interestingly, the find context of one of these examples suggests the likelihood of an Achaemenid date, while the context of the other leaves this a distinct possibility.[46]

Repeatedly, the comparative evidence seems to point towards Achaemenid times for the manufacture of our seal from Seleucia. At the same time, the octagonal stamp seal used on the Eanna document reminds us that our Kelsey cylinder seal depends for its interpretation upon a legacy of co-mingled and often still elusive evidentiary tracery of glyptic tradition in the first millennium. There is a rich backdrop of experimentation and interest in the valences of hero and worshipper that the carver of the Kelsey seal had to draw upon. Equally, it is now clear that the creative synergies of empire at places like Persepolis were providing fertile ground for re-invention.

BIOGRAPHY II (A): PATRONAGE

An imperial-range clientele for Babylonian worship imagery
Babylonians worked at Persepolis, where they are mentioned, for instance, as scribes and accountants in the Fortification tablets. Some of the Babylonian type worship seals used on these tablets may have been owned by them. It is frequently not possible to determine via sealing protocols the owner of a

46 No. 736, of agate, was excavated at Babylon from the upper layers of deposition between the Nebuchadnezzar phase and the Hellenistic ('oberer Schutt, in dem Funde von der Nebuchadnezzar-Zeit bis in griechischer Zeit gemacht wurden' – Moortgat 1940: 150). Another way of articulating this temporal context might be actually to suggest what happened between Nebuchadnezzar and the Seleucid kingdom: i.e., during the Achaemenid Persian empire! No. 740, of 'quartz', was excavated from the *Perlendepot* at Babylon—a mélange of seals of various periods including the Achaemenid (Moortgat 1940: 150).

Fig. 8. Composite drawing of PFS 262s (used by Uštana on PF 1544 when traveling from the Persepolis region to Egypt with a sealed document of Parnaka) from multiple impressions on the Persepolis Fortification tablets. Courtesy of the Persepolis Seal Project. 2:1.

given seal used on the tablets. In some cases, where we are able to establish a link between the seal and a specific individual, we have a clear case of a person with a Babylonian name using a late Babylonian type worship seal.[47] In some other instances, we find individuals with Iranian names using this type of seal. On the later Murašû archive in the heart of Babylonia, we also glimpse one of these late Babylonian type seals used by an ethnic Persian—to the extent that an Iranian name and patronym may be considered indicative of ethnicity (Bregstein 1993: 614, no. 216). It seems evident from the Persepolis Fortification texts that no effort was made to hamper actual religious practices associated with non-Iranian cults at Persepolis (Koch 1977). This is confirmed by the significant number of seals in the Fortification archive which display non-Achaemenid religious imagery.

Whether use of a seal with Babylonian cult imagery by an Iranian necessarily implied that he had adopted Babylonian religious practices is, of course, another matter. When the full evidence of the Fortification archive can be assessed, it may suggest that strategies of self-identification in this environment were more complex than that. The Achaemenid imperial context seems to have invited a range of options of visual identification through seal imagery and style.[48] The variety of seals relating to traditions of Babylonian worship imagery is an important part of that phenomenon. We can glimpse it not only at Persepolis but elsewhere in the empire as well.[49] It is note-

47 e.g. one Hitibel carrying a sealed document of the king (PFS 1283s on PF 1339 RV); and one Beltin, an accountant (PFS 451s on PF 1258 RV LE), Garrison and Root forthcoming.
48 We can look to the seals of the quintessential 'Persian man' at Persepolis (Parnaka) and see that both his seals are aggressively Assyrianizing works of art. To look at them without knowing who Parnaka was (a Persian and an uncle of Darius I), we might assume that they were owned by an individual of Mesopotamian background who was exercising a cultural resistance to Achaemenid authority through the Assyrian imagery and style chosen for his seals (Garrison and Root 20001: PFS 9★ (Cat. no. 288) and PFS 16★ (Cat. no. 22).
49 I am not attempting an exhaustive survey of occurrences among excavated material here, simply a sampling of major contextualized finds. Clearly new data could alter the picture radically. In the western regions of the empire, note that there is one example of the cut and drilled style class of Babylonian type worship stamp seal preserved via two impressions

worthy that many of the late-Babylonian type seals used on the Persepolis Fortification tablets, even those engraved in the reductive cut and drilled style, were owned by individuals carrying out business on behalf of the highest ranking members of the imperial administration, including the king himself (Fig. 8). We can track several of these owners of Babylonian type worship seals criss-crossing the empire on official court business.[50]

in the corpus of administrative bullae from the satrapy of Daskyleion in Hellespontine Phrygia (Kaptan 2002: no. DS 1 [Erg. 306]). The context of this archive is administrative and thus is related to the archival environments whence emerge the Fortification and Treasury corpora from Persepolis. From Deve Hüyük in north Syria, two Babylonian type octagonal, pyramidal stamp seals of cut and drilled style were recovered apparently from the inhumation cemetery used by an Achaemenid Persian military installation in the region (Moorey 1980: 112 and Pl. II. 469, 470). There are, however, other important bodies of evidence from the western empire that have revealed no examples of Babylonian type worship seals: e.g. the sealed bullae from Wadi-ed Daliyeh in Samaria (Leith 1997); the excavated tombs at Sardis (Curtis 1925)—even though the Achaemenid hero cylinder seal from one of these tombs suggests intricacies of social association of elite members of the Sardis satrapal community with heartland Achaemenid imagery (Dusinberre 1997); the reconstituted Achaemenid period Lydian tomb assemblages (Özgen and Öztürk 1996). In the eastern region of the empire, it is striking to note the occurrence of one agate ('onyx') Babylonian type worship stamp of the variant class of worshipper before scorpion creature from 'a building of the first century A.D.' at the Mahal site in Sirkap (Marshall 1951: 677, Pl. 207.7). Marshall calls it 'from Assyria' and dates it 7th–6th century BC. This seal is likely an heirloom remnant of the eastern Achaemenid imperial horizon. Back in the imperial centre, there are six published late Babylonian type worship stamp seals from Susa (Amiet 1972: nos. 2171–2176, to which add an anomalous-looking seventh in terracotta, no. 2177). These seals unfortunately come with no precise information about their findspots at the site so we cannot use them as definitive proof of the maintenance of Babylonian type worship seals in this particular imperial heartland milieu (but compare the broken agate stamp seal from the Persepolis Treasury: PT5 501, Schmidt 1957: Pl. 17). In addition to numerous Babylonian type worship stamp seals from Ur (Legrain 1951: nos. 655–663) there are impressions of two different Babylonian type worship stamp seals preserved among the late fifth century BC Achaemenid hoard of 'jeweler's models' from Ur (Legrain 1951: x and nos. 743–744). A very large group of Babylonian type worship stamp seals is featured in the collections of the Berlin museum, many coming from the environs of Assur and Babylon, both by purchase and by excavation (Jakob-Rost 1997: 65). Of these, several were retrieved from the *Perlendepot* at Babylon and could thus in theory be Achaemenid: e.g. nos. 279, 285, 289, 318, 319, 321.

50 e.g. PFS 1687s used by Umišduma going to Susa with a sealed document of the king (PF 1408 RV); PFS 1278s used by Umaya, the fast messenger carrying a sealed document of the king from Susa to Persepolis (PF 1335 RV); PFS 289s used by Miramana or another of fifty-two 'gentlemen' carrying a sealed document of the king and drawing supplies in the Persepolis region en route from Susa to Kerman (PF 1398 RV, 1548 UE, 1704 RV UE, 1785 RV UE); PFS 262s used by Uštana the accountant en route from Persepolis to Egypt carrying a document of Parnaka, uncle of King Darius I (PF 1471 RV UE, 1544 RV). See Garrison and Root forthcoming for full publication of these seals.

BIOGRAPHY II (B): NOTIONS OF QUALITY

Given the apparent high status of certain documented individuals deploying Babylonian worship imagery on the Fortification tablets, definitions of quality and value arise in relation to the Kelsey seal. Commentaries frequently note categorically and disparagingly the cursory quality of late Neo-Babylonian type worship seals in cut and drilled styles.[51] This follows widely accepted assumptions across all periods about what constitutes stylistic quality and prestige-invested glyptic. Higher value tends to be assumed for elaborate representations and robustly modelled modes of production. Lesser value and prestige tends to be assumed for geometric patterns, reductive figural imagery and schematic forms. But such generalized notions have occasionally been refuted effectively for specific classes of glyptic production (Stein 1997).

How does the seal from Seleucia fare when examined as a possible prestige item? The banded agate of KM 94527 is beautifully exploited to mesh with the choreography of the images carved around the seal's bulging cylindrical surface. The waves of colouration undulate in a graceful pattern that unites a two-part composition and conveys a fluid sensuous affect to the artefact. With similarly effective artistry, a barrel-shaped agate cylinder in a finely modelled heroic control encounter in the Marcopoli Collection (Teissier 1994: no. 293) exploits concentric circles of banding that site the hero at the centre of a bull's-eye. In terms of correlation of the agate stone with traditionally assumed notions of representation and style in the service of prestige, agate seals of the Achaemenid empire include several incontrovertibly courtly items.[52]

51 One revealing dismissal of these artefacts as a class is found in Lambert's characterization of the good taste indicated by Earl Percy's late nineteenth century collecting: 'One notices the lack of the ubiquitous Late Babylonian octagonal stamps in cut and drilled style, of which he must have seen many . . . In contrast, the periods and areas and styles are distinguished by fine art . . .' (Lambert 1979: 1–2).

52 The lone agate ('onyx') cylinder seal from an elite tomb at satrapal Sardis, which displays a scene of heroic control encounter set atop pedestal creatures (Dusinberre 1997), is a notable excavated example. The famous Darius cylinder reportedly acquired at Egyptian Thebes (BM WA 89132) stands out prominently for its trilingual royal name inscription and elaborate hunting imagery (now Collon 1987: no. 558; Schmitt 1981; Garrison 1991). Other distinguished but unexcavated agate seals of courtly resonance and diverse motifs include: the seal from the Newell Collection (inscribed with the name of Artaxerxes in Old Persian) displaying a doubled combat scene (von der Osten 1934: Pl. XXXI, no. 453; Schmitt 1981) and the Louvre's ex-de Clerq Collection cylinder showing a female deity being approached by two standing females (Collon 1987: 150–151, no. 658, Louvre AO 23359). One of the approaching females wears a crown and thus was hailed long ago as a representation of Atossa

In addition to the beauty and value of the stone itself, we must consider the likelihood that the seal from Seleucia once had an elaborate gold mount like those still preserved on some seals from the Lydian Treasure and the Sardis tombs (Özgen and Oztürk 1996; Curtis 1925). The schematic aspect of the seal's design may seem at odds with the intrinsic beauty of its semi-precious stone, the care taken to exploit the patterning of the stone and the likelihood that the seal originally sported a gold mount. This perceived disjuncture is only an issue if we persist in assuming a connection between schematic style and low prestige. The Kelsey seal invites further contemplation of the question in the context of a wider-ranging study.[53]

The implications of perceived disjuncture between quality of material and form and quality of carving are important on a variety of levels. Aspects of the issue that would need to be dealt with include the under-studied production of lovely theriomorphic seal amulets, that are often made of semiprecious stones, as well as the more common chalcedony and white marble seals, which bear seal designs of very minimalistic drilled or wheel-cut imagery on the seal face, often with astral or magic-related imagery (e.g. Jakob-Rost 1997: 98–99, no. 426 from Babylon). Such seal amulets were on occasion used to make impressions in addition to serving talismanic and decorative functions for their owners (e.g., among many, Herbordt 1992: nos. 6, 17, 22).

Unexcavated seals are, for instance, sometimes suspected of being forgeries solely on that basis.[54] We know that the Kelsey seal is genuine, so we can move on to other questions. One thing we do not know is whether or not it was ever actually used as a sealing device. We could in theory be dealing with an amuletic bead, carved with hero/worship imagery, that was never meant to serve a sealing function. In theory, the carving on the Kelsey cylinder might never have been meant to compete, as it were, with standards of carving that operate for a 'real' seal made of the same beautiful material. The carved design might have been meant specifically to invoke a set of visualized spiritual or magical ideas in a schematic form that operated in some mystical sense.

herself, the mother of Xerxes, straight from the stage-set of Aeschylus' 'Persians' (Moorey 1979a: 224, for a more sober and useful commentary). An interesting seal in Berlin displaying a personage in the Iranian riding garment spearing a boar (VA 6967: Moortgat 1940: no. 772; now Collon 1987: no. 922) suggests the elite realm of courtly male domain and prowess.
53 It is this interesting and uncharted territory that Katz explored (Katz 1990).
54 As with a very large agate cylinder in an odd drilled/linear style depicting frontal females (Collon 2001: 174–5, BM WA 89362). Collon notes that 'it is surprising to find such a handsome seal-stone with such a poorly-executed design.' But she resists the idea that it must therefore be a forgery because of the pedigree of the Rich Collection of which it is a part.

Interesting as this possibility is, we have demonstrated that many seals in this style and representational idiom were used, and certainly intended, as sealing tools. We have also observed that the theriomorphic amulet seals, in which the discrepancy between physical quality and design-carving technique is even more pronounced, were frequently used as sealing tools as well. Thus, it is perhaps futile at this stage to press a categorical functional distinction (amulet or seal?) upon our focal artefact.

BIOGRAPHY III: JUST A HINT ABOUT THE AFTERLIFE

We know that the Kelsey seal remained in circulation in some sense until its final deposition in the Parthian level of the palatial district at the royal city foundation of Seleucia-Tigris. How and where it spent its long life from its production date sometime in the fifth century BC until the third century AD, we of course cannot say. We can, however, say this much: such a long life in circulation does not in itself necessarily mean that the seal survived specifically because of its 'sacred' valence. Other pre-Seleucid seals excavated at Seleucia from a range of contexts offer a variety of types that are demonstrably part of the known corpus of seals that typically functioned as sealing tools regardless of what additional properties of social efficacy they were believed to have.

That said, the Kelsey seal was discovered 'in the brickwork' of a wall of Parthian date (Level II) within the palatial quarter of Seleucia-Tigris (Yeiven n.d. 28). This findspot takes us full circle to the notion of beads as deposited items of value and amuletic charisma. It seems that many artefacts recorded by the excavators as emerging 'from the brickwork' were in fact embedded in the very fabric of the bricks. In other cases, seals described as 'from the brickwork' seem to have originally been placed in little wall niches (e.g. Hopkins 1972: 40, 46, 56, 59 etc.). We can no longer establish with certainty which pertained to our seal, but it is clear that it was not simply an intrusive artefact. The ritual practice of embedding semiprecious beads into the brick fabric of important structures goes way back in Mesopotamian tradition, most notably documented by Mallowan at the Eye Temple of Brak, where 'the foundations . . . were literally sown with beads and even the mud-bricks themselves contained beads within them' (1947: 33). Whatever its original function, at the end our seal from Seleucia experienced a reaffirmation of its aspect as a beautiful barrel-shaped bead (Goff 1956: 2).

CONCLUSION

The biography of the Kelsey seal links the cultural life of the late Neo-Babylonian period, which technically ends with the Persian conquest of Babylon in 539 BC, to the Achaemenid Persian period, with its vast imperial reach and multi-ethnic cultural interactions in which Babylonia and Babylonians maintained a high profile. In broadest terms, the seal has invited us to explore the mechanisms of creative permeability across traditional divisions of periodization in the material record (Root 1994). Close to a quarter of a century ago, Moorey noted cogently that

> Study of the early historic period in Mesopotamia is increasingly hampered by arid discussions of classificatory systems, which are rapidly becoming barriers rather than gateways to understanding.
>
> (Moorey 1979b: 119)

The same potential for aridity exists in work on glyptic of the latest phase of pre-Seleucid Mesopotamia/Iran. The seal in the Kelsey Museum exemplifies the importance of heeding Moorey's message. It seems to have been a creative re-invention of a late Babylonian tradition that was probably commissioned and used by a personage of distinguished status in the Achaemenid imperial milieu of the fifth century BC; perhaps, an ethnic Babylonian but by no means necessarily. It remained in circulation for hundreds of years, in what capacities we cannot say. Ultimately, in Parthian times, it was laid to rest, still in good condition, according to some type of ritual protocol of deposition that was itself a revival or perpetuation of an ancient Mesopotamian cultural expression.

REFERENCES CITED

Amiet, P.
1972 *Glyptique susienne: Des origines à l'époque des perses achéménides*. Mémoires de la délégation archéologique en Iran 43. Paris: Librairie orientaliste. Paul Guethner.

Bleibtreu, E.
1997 Die Siegelinhaber. In *Mit Sieben Siegeln versehen* (E. Klengel-Brandt, ed.). Berlin: Staatliche Museen zu Berlin Vorderasiatisches Museum, 92–104.

Bregstein, L. B.
1993 Seal Use in Fifth Century B.C. Nippur, Iraq: A Study of Seal Selection and Sealing Practices in the Murašû Archive. PhD dissertation, University of Pennsylvania.

Buchanan, B. and Moorey, P. R. S.
1988 *Catalogue of Ancient Near Eastern Seals in the Ashmolean Museum. Volume III: The Iron Age Stamp Seals (c.1200–350 BC)*. Oxford: Clarendon Press.

Collon, D.
1987 *First Impressions: Cylinder Seals in the Ancient Near East*. Chicago: University of Chicago Press.

1990 *Near Eastern Seals*. Berkeley and Los Angeles: University of California Press.

1995 Filling motifs. In *Beiträge zur Kulturgeschichte Vorderasiens. Festschrift für Rainer Michael Boehmer* (U. Finkbeiner, R. Dittmann and H. Hauptmann, eds.). Mainz: Philipp von Zabern, 69–76.

2001 *Catalogue of Western Asiatic Seals in the British Museum. Cylinder Seals V. Neo-Assyrian and Neo-Babylonian Periods*. London: The British Museum Press.

Curtis, C. D.
1925 *Jewelry and Gold Work*. Sardis 13.

Rome: Sindicato Italiano Arti Grafiche.

Dalton, O. M.
1964 *The Treasure of the Oxus* (3rd edition). London: British Museum.

Delaporte, L.
1910 *Catalogue des cylindres orientaux et des cachets assyro-babyloniens, perses et syro-cappadociens de la Bibliothèque Nationale*. Paris: Ernest Leroux.

Dusinberre, E. R. M.
1997 Imperial style and constructed identity: A 'Graeco-Persian' cylinder seal from Sardis. *Ars Orientalis* 27: 99–129.

Ehrenberg, E.
1999 *Uruk. Late Babylonian Seal Impressions on Eanna-Tablets*. Ausgrabungen in Uruk-Warka Endberichte 18. Mainz: Philipp von Zabern.

2000 Babylonian Fortlaben and regionalism in Achaemenid Mesopotamia. In *Variatio Delectat. Iran und der Westen. Gedenkschrift für Peter Calmeyer* (R. Dittmann, B. Hrouda, U. Löw, P. Matthiae, R. Mayer-Opificius and S. Thürwächter, eds.). Münster: Ugarit-Verlag, 313–20.

Garrison, M. B.
1991 Seals and the elite at Persepolis: some observations on early Achaemenid Persian art. *Ars Orientalis* 21: 1–29.

2000 Achaemenid iconography as evidenced by glyptic art: subject matter, social function, audience and diffusion. In *Images as Media. Sources for the Cultural History of the Near East and the Eastern Mediterranean (1st Millennium BCE)*, (C. Uehlinger, ed.). Fribourg and Göttingen: University Press Fribourg and Vandenhoeck & Ruprecht Göttingen, 115–63.

In press Fire altars, survey of sites. *Encyclopedia Iranica*.

Garrison, M. B. and Root, M. C.

1996 *Persepolis Seal Studies: an Introduction with Provisional Concordances of Seal Numbers and Associated Documents on Fortification Tablets 1–2087.* Achaemenid History 9. [reissued with corrections:1998]. Leiden: Instituut voor het Nabije Oosten.

2001 *Seals on the Persepolis Fortification Tablets. Volume I.* Images of Heroic Encounter. Oriental Institute Publications 117. Chicago: Oriental Institute.

Forthcoming *Seals on the Persepolis Fortification Tablets. Volume II. Images of Human Activity.* Chicago: Oriental Institute Publications.

Goff, B.

1956 The role of amulets in Mesopotamian ritual texts. *Journal of the Warburg and Courtauld Institutes* 19: 1–39.

Hallock, R. T.

1969 *Persepolis Fortification Tablets.* Oriental Institute Publications 92. Chicago: University of Chicago Press.

Herbordt, S.

1992 *Neuassyrische Glyptik des 8.–7. Jh. v. Chr.* State Archives of Assyria Studies 1. Helsinki: State Archives of Assyria.

Hopkins, C. (ed.)

1972 *Topography and Architecture of Seleucia on the Tigris.* Ann Arbor: The University of Michigan.

Jakob–Rost, L.

1997 *Die Stempelsiegel im vorderasiatischen Museum Berlin* (2nd edition). Mainz: Philipp von Zabern.

Kaptan, D.

2002 *The Daskyleion Bullae: Seal Images from the Western Achaemenid Empire.* Achaemenid History 12. Leiden: Instituut voor het Nabije Oosten.

Katz, D. S.

1990 The Consumption of a Drilled-Style Seal in Neo-Babylonian and Early Achaemenid Times: A Cost-Benefit Analysis. Unpublished MA thesis, University of Michigan. Ann Arbor.

Koch, H.

1977 *Die religiösen Verhältnissen der Dareioszeit: Untersuchungen an Hand der elamischen Persepolistäfelchen.* Göttinger Orientforschungen 3. Wiesbaden: Harrassowitz.

Lambert, W. G.

1979 Near Eastern seals in the Gulbenkian Museum of Oriental Art, University of Durham. *Iraq* 41: 1–45.

1989 Review of B. Buchanan and P.R.S. Moorey 1988. *Bulletin of the School for Oriental and African Studies* 52: 543–44.

Legrain, L.

1951 *Ur Excavations X. Seal Cylinders.* London and Philadelphia: The British Museum and The University Museum of The University of Pennsylvania.

Leith, M. J. W.

1997 *Wadi Daliyeh I: The Wadi Daliyeh Seal Impressions.* Discoveries in the Judaean Desert 24. Oxford: Clarendon Press.

Litvinskii, B. A. and Pichikian, I. R.

1994 The Hellenistic architecture and art of the Temple of the Oxus. *Bulletin of the Asia Institute* 8: 47–66.

Mallowan, M. E. L.

1947 Excavations at Brak and Chagar Bazar. *Iraq* 9: 1–266.

Marshall, J.

1951 *Taxila. An Illustrated Account of Archaeological Excavations carried out at Taxila under the Orders of the Government of India between the Years 1913 and 1934.* Cambridge: The University Press.

McDowell, R. H.

1935 *Stamped and Inscribed Objects from Seleucia on the Tigris.* Ann Arbor: The University of Michigan.

Moorey, P. R. S.

1979a Aspects of worship and ritual on Achaemenid seals. In *Akten des VII. Internationalen Kongresses für Iranische Kunst und Archäologie, München 1976, (Archäologische Mitteilungen aus Iran, Ergänzungsband 6)*. Berlin: Dietrich Reimer, 218–26.

1979b Unpublished Early Dynastic sealings from Ur in the British Museum. *Iraq* 41: 105–20.

1980 *Cemeteries of the First Millennium B.C. at Deve Hüyük, near Carchemish, salvaged by T. E. Lawrence and C. L. Woolley in 1913 (with a catalogue raisonné of objects in Berlin, Cambridge, London and Oxford)*. BAR International Series 87. Oxford: British Arechaeological Reports.

1994 *Ancient Mesopotamian Materials and Industries. The Archaeological Evidence*. Oxford: Clarendon Press.

Moortgat, A.

1940 *Vorderasiatsichen Rollsiegel*. Berlin: Gebr. Mann.

Oppenheim, A. L., Brill, R., Barag, D. and Saldern, A. von (eds.)

1970 *Glass and Glassmaking in Ancient Mesopotamia*. New York: The Corning Museum of Glass.

Osten, H. H. von der

1934 *Ancient Oriental Seals in the Collection of Mr. Edward T. Newell*. Oriental Institute Publications 22. Chicago: University of Chicago Press.

1936 *Ancient Oriental Seals in the Collection of Mrs. Agnes Baldwin Brett*. Oriental Institute Publications 37. Chicago: University of Chicago Press..

Özgen, I. and Öztürk, J.

1996 *The Lydian Treasure: Heritage Recovered*. With contributions by M. J. Mellink, C. H. Greenewalt, Jr., K. Akbiyikoglu and L. M. Kaye. Istanbul: Ministry of Culture, Republic of Turkey.

Parker, B.

1955. Excavations at Nimrud, 1949–1953: seals and seal impressions. *Iraq* 17: 93–125.

1962 Seals and seal impressions from the Nimrud Excavations, 1955–1958. *Iraq* 24: 26–40.

Pittman, H.

1998 Jewelry. In *Treasures from the Royal Tombs of Ur* (R. L. Zettler and L. Horne, eds.). Philadelphia: University Museum, 87–122.

Porada, E.

1948 *Corpus of Ancient Near Eastern Seals in North American Collections. Volume I. The Collection of the Pierpont Morgan Library*. Bollingen Series 14. New York: Pantheon Books.

Root, M. C.

1979 *The King and Kingship in Achaemenid Art: Essays on the Creation of an Iconography of Empire*. Acta Iranica 19. Leiden: E. J. Brill.

1984 *The Art of Seals. A Gallery Guide*. Ann Arbor: Kelsey Museum of Archaeology.

1990 *Crowning Glories. Persian Kingship and the Power of Creative Continuity*. Ann Arbor: Kelsey Museum of Archaeology.

1994 Lifting the veil: artistic transmission beyond the boundaries of historical periodisation. In *Continuity and Change* (A. Kuhrt, H. Sancisi-Weerdenburg and M. C. Root, eds.), Achaemenid History 8. Leiden: Istituut voor het Nabije Oosten, 9–37.

1997 Cultural pluralisms on the Persepolis Fortification Tablets. *Topoi Supplement* 1: 229–52.

1998 Pyramidal stamp seals—the Persepolis connection. In *Studies in Persian History: Essays in Memory of David M. Lewis* (M. Brosius and A. Kuhrt, eds.),

Achaemenid History 11. Leiden: Instituut voor het Nabije Oosten, 257–98.

1999 Irreverent inversions. Seal play at the Persian court. Paper presented at the symposium 'Visual Humour in World Art'. Warburg Institute, London.

Savage, E.

1977 *Seleucia-on-the-Tigris. An Exhibition of the Excavations at Seleucia, Iraq, by the University of Michigan, 1927–32, 1936–37.* Ann Arbor: Kelsey Museum of Archaeology.

Schmidt, E. F.

1957 *Persepolis. Volume II. Contents of the Treasury and Other Discoveries.* Oriental Institute Publications 69. Chicago: University of Chicago Press.

Schmitt, R.

1981 *Altpersische Siegel-Inschriften.* Sitzungsberichte der Österreichischen Akademie der Wissenschaften, Philosophisch-historische Klasse 381. Vienna: Österriechische Akademie der Wissenschaften.

Seidl, U.

2000 Babylonische und assyrische Kultbilder in den Massenmedien des 1. Jahrtausends v. Chr. In *Images as Media. Sources for the Cultural History of the Near East and the Eastern Mediterranean (1st Millennium BCE),* (C. Uehlinger, ed.). Fribourg and Göttingen: University Press Fribourg and Vandenhoeck & Ruprecht Göttingen, 89–114.

Stein, D. L.

1997 Common Mitannian and pseudo-Kassite: a question of quality and class. In *De Chypre à la Bactriane, les sceaux du Proche-Orient ancien* (A. Caubet, ed.). Paris: Musée du Louvre, 71–115.

Tallon, F.

1992 The Achaemenid tomb on the Acropole. In *The Royal City of Susa. Ancient Near Eastern Treasures from the Louvre* (P. O. Harper, J. Aruz, and F. Tallon, eds.). New York: The Metropolitan Museum of Art, 242–52.

Teissier, B.

1984 *Cylinder Seals from the Marcopoli Collection.* Berkeley: University of California Press.

Wartke, R.-B.

1997 Materialen der Siegel und ihre Herstellungstechniken. In *Mit Sieben Siegeln versehen* (E. Klengel-Brandt, ed.). Berlin: Staatliche Museen zu Berlin Vorderasiatisches Museum, 41–61.

Wallenfels, R.

1996 Private seals and sealing practices at Hellenistic Uruk. In *Archives et sceaux du monde hellénistique* (M.-F. Boussac and A. Invernizzi, eds.), Bulletin de Correspondance Hellénique Suppl. 29, 113–29.

Wiseman, D. J.

1959 *Cylinder Seals of Western Asia.* London: Batchworth Press.

Wittmann, B.

1992. Babylonische Rollsiegel des 11. – 7. Jahrhunderts v. Chr. *Baghdader Mitteilungen* 23: 169–289.

Yeivin, S.

n.d. Preliminary Report on the Excavations at Seleucia. Unpublished manuscript. Ann Arbor: Kelsey Museum of Archaeology.

Zettler, R. L.

1979 On the chronological range of Neo-Babylonian and Achaemenid seals. *Journal of Near Eastern Studies* 38: 257–70.

III. Materials and Manufacture

Michael Roaf

The close examination of objects themselves (as well as their contexts) yields information about the culture in which they were manufactured or utilized. While mute objects such as broken potsherds or chips of flint allow only a limited insight into certain aspects of past societies, archaeologists have frequently stressed how material culture in many respects gives a less biased perspective than that derived from the study of written sources which were often composed with the purpose of influencing the reader rather than of giving an objective description of the facts. In his famous, or as some would say infamous, ladder of inference Christopher Hawkes (1954) described how some aspects of the past are more accessible than others. He asserted that archaeological evidence is particularly suited to the understanding of ancient techniques and technology and can be used with considerable success in the investigation of ancient subsistence economies. With questions of social and political structure and of ideology and spiritual life, different archaeologists will often come to different conclusions based on the same observations. This should not, of course, lead to abandoning the investigation of these important aspects of ancient societies, but one should be aware of the challenges that such investigations pose. The utilization of all potential sources of information including textual sources and scientific techniques combined with ethnographic analogies and experimental archaeology can also help to overcome this difficulty (Moorey 1994: 13–19).

Materials and manufacture have been prime interests of Roger Moorey (1985, 1994), but he has never been content to study merely the technology alone and instead has investigated, as far as possible, how objects were integrated into society. As he has noted (1994: v) it is surprising that the materials and techniques, crafts and craftsmanship of the Near East, unlike those of other regions, such as Egypt and China, have received little scholarly attention. Most archaeological studies of Near Eastern pottery, for example, have been typological and chronological: occasionally technology and trade (particularly provenance studies) have been investigated, but the socio-economic role of this ubiquitous industry, the remains of which are so evident in archaeological excavations, is hardly mentioned. As Roger Moorey commented on his own fundamental study of ancient Mesopotamian materials

and industries (1994: v), 'it will be obvious even to the most casual reader that significant subjects merely touched upon here await adequate research in depth'.

The technical study of objects has been developing at an ever increasing pace in the last 50 years. There have been incredible advances in the analysis of material culture due to the application and development of scientific methods, many of these pioneered in the Oxford Research Laboratory for Archaeology and History of Art, with which Roger Moorey during his employment at the Ashmolean Museum had a very close relationship. These methods now cover a vast range, including relative and absolute dating, remote sensing methods, and particularly the investigation of ancient technology. These advances have also been accompanied, particularly in the 'post-processual' period, by a more sophisticated analysis of archaeological 'facts': in earlier archaeological studies jejune explanations—such as invasion, migration and diffusion—were commonplace. These have been replaced by a more nuanced and less dogmatic viewpoint in which attempts are made to interpret the evidence of the past both in its own terms and in terms of our own preconceptions.

The following seven papers included in this section of the book cover a wide range of subjects and illustrate some of these new approaches to the evidence from the past. All are concerned with the manufacture and use of objects. Some are mainly technological relying almost exclusively on the evidence from natural sciences, while others use not only the evidence from the objects themselves but also evidence from additional sources. They are arranged approximately in the order suggested by Hawkes' ladder of inference, starting with technology and ending with consideration of questions of status and ideology.

The first two papers deal with copper metalworking, which has always been one of Roger Moorey's prime interests. One of his first published articles (1964) and his doctoral thesis submitted in 1966 were on this subject and he has returned to it on numerous occasions (e.g. 1969, 1971, 1972, 1982a, 1982b, 1985, 1988a, 1988b, 1988c, 1994: 242–278). In their contribution Vincent Pigott and Heather Lechtman examine copper objects from Tal-i Iblis in Iran. Through various scientific analyses they have established that the numerous crucibles found at this site were used for the smelting of copper ores and not for the melting of metallic copper in the sixth and fifth millennia BC, thus providing an answer to this question posed by Moorey some years earlier (1994: 243). Copper production is also discussed in Sariel Shalev's paper. Using a variety of analytical techniques he and his colleagues

have been able to propose that a series of small conical pits excavated at an Early Bronze Age I site (c. 3500 BC) in Israel were used for the melting and refining of copper. Remarkable advances in scientific methods have been made in recent years and in this study they are fully exploited: chemical composition of samples (using various techniques), metallurgical investigations, phytolith analysis, radiocarbon determinations, as well as optical dating (OSL) and thermoluminescence dating are combined to give answers to questions that could until recently be posed but not solved.

The next two papers deal with composite vitreous materials, another subject to which Roger Moorey has made valuable contributions (1975, 1985, 1989, 1994: 141–215). In her study of the glazed brick decoration of the Temple of Inshushinak at Susa Annie Caubet introduces us to what is a vital part of the evidence from the ancient Near East, namely the written sources. The inscriptions on glazed and relief decorated bricks found out of context show that they belonged to a temple constructed in the 12th century BC. The analysis of these texts yields valuable information about the appearance of this long vanished monument. It may be noted that Caubet uses the French word faïence to describe glazed clay or siliceous bricks. This is in contrast to the way the term faience is generally used in English, 'a long-standing misnomer for a composite body consisting of a sintered quartz body and a glaze' (Moorey 1994: 167) Faience in this sense as well as other vitreous materials from Ugarit are discussed by Valerie Matoïan and Anne Bouquillon. The sheer quantity of material from the Late Bronze Age at Ugarit (more than 19,000 objects, 93% of faience, 5% of glass, 1.4% of 'Egyptian blue' (a silicate of copper and calcium), and less than 0.14% of glazed pottery) is impressive. The identification of this material is often not possible without scientific analysis and within each category there are variations some of which may perhaps be associated with the place of manufacture.

A welcome attempt to investigate a much ignored topic is the subject of the next paper. Using a wide variety of sources both textual and archaeological, St John Simpson gives an overview of the preparation and consumption of food in the Sasanian empire. Simpson is aware of the dangers of relying on textual sources alone: there is always the possibility that either the author or copyist may have made a mistake or the translation may be in error. Furthermore the classifications inherent in English terminology are not identical with Linnaean taxonomy, nor do they always coincide with the local classifications. For example the myrobalan may refer to the cherry plum (*Prunus cerasifera*) or to various species of *Terminalia* (especially *Terminalia chebula*). This is a particular problem with food because the names of ingre-

dients and dishes frequently change from region to region, as I discovered recently when I ordered egg and sausage for breakfast in the United States, or from period to period, as shown by the changing ingredients in mince-meat over the centuries. By comparing the initial results of analyses of plant remains and animal bones from excavations with the texts some corrobora-tion of the textual sources may be reached. This work is still in its infancy, but eventually it may be possible to obtain insights into regional cookery and 'high' versus 'low' cuisine, which according to Simpson is suggested by the relatively sparse information about the consumption of rice in the Sasanian empire (for the cultivation of rice in earlier periods see also Potts 1991, 1997: 272–3).

The last two papers deal with aspects of artistic production, which is of particular importance as a source of information about materials and manu-facture in ancient Mesopotamia, as the subtitle of Roger Moorey's 1985 book emphasizes. These papers do not attempt art historical or iconographic analyses, but seek to understand the role of works of art within the frame-work of the society in which they were used. A particular difficulty in the study of the numerous finely worked ivory objects from the Near East is that the overwhelming majority were removed from circulation and stored as booty in the storerooms of the Late Assyrian kings. The limited number of pieces found in other contexts allows Georgina Herrmann to investigate the question of whether carved ivory was used outside the royal courts in the first millennium BC. Her conclusion that only the king and his highest offi-cials were equipped with ivory objects is confirmed by Alan Millard's study of the textual sources. Surprisingly it seems that ivory was more appreciated in the Levant than in Assyria, underlining the fact that the prestige of differ-ent materials was not solely dependent on the rarity or the craftsmanship expended on the object. There also is evidence for a change in the apprecia-tion of ivory from the second to the first millennium BC.

The question of value is taken up by Irene Winter, who investigates the difficult question of how manufactured objects were appreciated in ancient Sumer. While the objects of her study are material objects, statues, reliefs, vessels, etc., her primary evidence is the texts which describe these objects. Cross-cultural studies of value are notoriously difficult to pursue: the very words used have a range of meanings which escape the modern researcher and furthermore must be influenced by our own preconceptions. Neverthe-less the surviving works of art and the surviving textual descriptions show that craftsmanship was appreciated no less than the use of precious or rare materials. While the words used in the ancient texts may bear a range of

different interpretations and may well carry cultural implications that are not accessible to us from the limited range of surviving sources, her conclusion that mastery, 'perfection', was more highly valued than other features such as originality is convincing.

These studies make a significant contribution to the study of the culture of the ancient Near East, and at the same time illustrate the potential that is offered by the detailed study of objects for the understanding of its cultures.

REFERENCES CITED

Hawkes, C. F. C.

1954 Archaeological theory and method: some suggestions from the Old World. *American Anthropologist* 56: 155–68.

Moorey, P. R .S.

1964 An interim report on some analyses of 'Luristan Bronzes'. *Archaeometry* 7: 72–80.

1966 An Archaeological and Historical Examination of the 'Luristan Bronzes'. D.Phil. Thesis, University of Oxford (deposited in the Bodleian Library, Oxford).

1969 Prehistoric copper and bronze metallurgy in western Iran (with special reference to Luristan). *Iran* 7: 131–53.

1971 *Catalogue of the Ancient Persian Bronzes in the Ashmolean Museum, Oxford.* Oxford: Oxford University Press.

1972 (with F. Schweizer) Copper and copper alloys in ancient Iraq, Syria and Palestine: some new analyses. *Archaeometry* 14: 177–98.

1975 (with R. E. M. Hedges) Pre-Islamic ceramic glazes at Kish and Nineveh in Iraq. *Archaeometry* 17: 25–43.

1982a Archaeology and pre-Achaemenid metalworking in Iran: a fifteen year retrospective. *Iran* 20: 81–101.

1982b The archaeological evidence for metallurgy and related technologies in Mesopotamia, c. 5500–2100 B.C. *Iraq* 44: 13–38.

1985 *Materials and Manufacture in Ancient Mesopotamia: the Evidence of Art and Archaeology: Metals and Metalwork; Glazed Materials and Glass.* BAR International Series, 237. Oxford: British Archaeological Reports.

1988a Early metallurgy in Mesopotamia. In *The Beginning of the Use of Metals and Alloys* (R. Maddin, ed.). Cambridge, Mass.: MIT Press, 28–33.

1988b New analyses of Old Babylonian metalwork from Tell Sifr. *Iraq* 50: 39–49.

1988c The Chalcolithic hoard from Nahal Mishmar, Israel, in context. *World Archaeology* 20: 171–89.

1989 The Hurrians, the Mittani and technological innovation. In *Archaeologia Iranica et Orientalis: Miscellanea in Honorem Louis Vanden Berghe I* (L. de Meyer and E. Haerinck, eds.). Gent: Peeters, 273–86.

1994 *Ancient Mesopotamian Materials and Industries: The Archaeological Evidence.* Oxford: Oxford University Press (re-issued with minor corrections in 1999, Winona Lake, Indiana, U.S.A: Eisenbrauns).

Potts, D. T.

1991 A note on rice cultivation in Mesopotamia and Susiana. *Nabu* 1991: 1–2 No. 2

1997 *Mesopotamian Civilization: The Material Foundations.* Ithaca, New York: Cornell University Press.

Chalcolithic copper-base metallurgy on the Iranian plateau: a new look at old evidence from Tal-i Iblis[1]

Vincent C. Pigott and Heather Lechtman

In 1932 Aurel Stein, in the process of surveying archaeological sites in Iran and beyond, located and documented the prehistoric mound of Tal-i Iblis in the Bard Sir Valley in the southern reaches of the central Iranian desert, the Dasht-i Lut (Fig. 1). Stein, who conducted test excavations at the site, mentioned that (1937: 168) 'a few small shapeless fragments of copper or bronze were also picked up on the surface.' Iblis is located in a region of Iran particularly rich in copper deposits (Fig. 2).

However, it was not until 1964 that the site was encountered on survey again, this time by a team led by Joseph R. Caldwell, a United States archaeologist whose previous research had been exclusively in North America. Caldwell mentioned that he was led to Iblis by Stein's report. Iblis was one of the few prehistoric sites that Caldwell's team had been able to locate in the region (Caldwell 1967, see also 1968; Caldwell and Shahmirzadi 1966; Dougherty and Caldwell 1966). Regrettably, upon arrival at the site he found that much of it had been removed for fertilizer by local villagers. Originally the mound stood at least 118 m across and 11 m high (Dougherty and Caldwell 1967: 17, contour map, Fig. 3; Stein 1937: Pl. 55 for photo of the mound). A sample of crucible fragments stained with copper dross was obtained from stratigraphic sections that were cleaned by Caldwell's team and radiocarbon dated. Radiocarbon dating has positioned Iblis firmly in the Chalcolithic period on the plateau. The site's sequence spans c. 5200–3500 BC.[2]

In 1964 such crucible fragments comprised an unusual find and even today the number of fragments ultimately recovered (300+) may well constitute the largest quantity known from any prehistoric site on the Iranian

1 The authors are pleased to join with the other contributors to this volume in honouring P.R.S. Moorey's lifetime of scholarly achievements. His publications have consistently proved invaluable to study of the archaeology of the materials industries of the Ancient Near East, and in particular to study of the metals and metallurgy of ancient Iran.

We also take this opportunity to thank Prof. Ernst Pernicka for his review of our manuscript and for his informative comments on issues concerning the trace element composition of native copper.
2 For an updated and revised sequence for the site see discussion in Voigt and Dyson 1992: Vol. 1, 143–47; Vol. 2, 126, 131.

plateau. Their presence served as partial impetus to proceed with a field season in 1966, despite the significant destruction of the site (see Caldwell 1967: 10, Pl. 1).

Coinciding with the 1966 field season at Iblis, Theodore A. Wertime, an historian of ancient metallurgy, was leading a 'Metallurgical Expedition through the Persian Desert' (Wertime 1968). His colleagues included the eminent metallurgist, Cyril Stanley Smith (MIT, Cambridge, MA), Radomir Pleiner (Institute of Archaeology, Prague), an authority on ancient iron metallurgy, and Gholam-Hossein Vossoughzadeh (Ministry of Economy, Tehran) (Wertime 1968: 927). This team paid a visit to Iblis and undertook metallurgical investigations at the site.

In addition, Caldwell arranged for C. S. Smith to obtain a group of Iblis metallurgical artefacts for laboratory analysis at MIT. Table 1 lists these items, which included bits of ore mineral, crucible sherds and small metal artefacts. Lechtman has examined the copper-base artefacts that Smith received but never studied. Her analytical results are presented here.

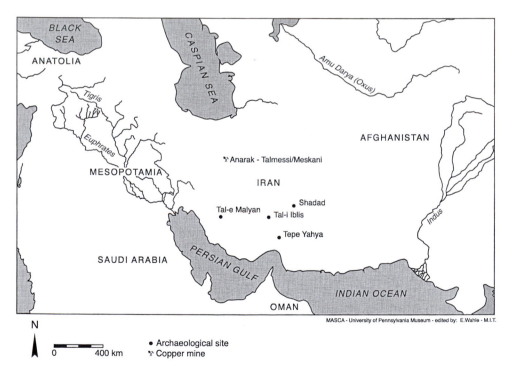

Fig. 1. Map of prehistoric sites on the Iranian plateau,
including those mentioned in the text.

Cat. No.	MIT No.	Caldwell's description †	Period †	Find spot †
79	—-	copper ore?	Bard Sir	structure B 3–8; floor of room 4
326	242★	litharge? antimony?	Bard Sir	structure B 3–8; corner of room 4, bottom of clay construction
173	247	copper pin	Bard Sir	floor of B 13
199	243★★	lead ore?	Bard Sir	B-19
99	248	copper pin	Late Bard Sir	Area E, section F level 4
295	249	copper pin	Iblis	7–11E, 25–30N level 2, Area C
—	241	crucible fragments	Iblis	west profile; levels 1 & 2
—	244	fragments of ore and slag	Iblis	west profile; level 1
51	250	copper pin with flattened end	Aliabad	2–7E, 25–30 N level 5b, 70 cm
63	245	crucible fragment, different in size and shape from earlier crucibles	Aliabad	2–7E, 25–30N level 5a, 110 cm
—	—	copper ore	Aliabad	2–7E, 23–30N level 5b
—	246	copper oxide?	Aliabad	7–11E, 30–32.5N level 5b
—	252	ore?	Unknown; from dirt pile	Area B
?	240‡	crucible fragment, level 1; collected by CSS from Caldwell rejects	?	?
—	251‡	fused cupriferous bead	?	?

† The items, their descriptions, find spots and period are given here as they appear in a letter written to Cyril S. Smith by Joseph R. Caldwell on 15 March 1967 (except MIT Nos. 240 and 251).
‡ The last two items (MIT Nos. 240 and 251) do not appear in Caldwell's list. These are materials C. S. Smith collected separately, apparently in the field in 1966.
★ Robert Ogilvie analysed this material by x-ray diffraction at MIT in August 1968. He determined it to be haematite (α-Fe_2O_3).
★★ Robert Ogilvie's X-ray diffraction analysis of this material in 1968 determined it to be haematite. H. Lechtman confirmed the haematite identification through XRD analysis (September 2001). The haematite is admixed with a small amount of quartz.

Table 1. Tal–i Iblis artefacts in the collections of the
Laboratory for Research on Archaeological Materials, MIT.

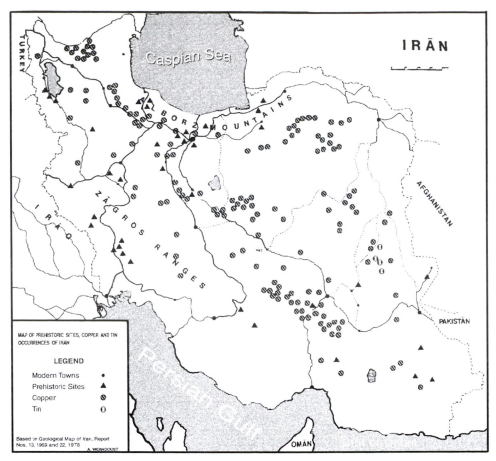

Fig. 2. Map of copper ore deposits on the Iranian plateau (after Vatandoost 1999: 123, Fig. 2).

THE ARCHAEOLOGICAL EVIDENCE FOR COPPER–BASE METALLURGY AT IBLIS[3]

Large quantities of ceramic crucible fragments were excavated at Iblis in association with some slag, ore and copper-base artefacts. The latter comprised mostly pins, hand tools (possibly awls) and rings, all small artefacts simply shaped (see, e.g., Chase et al. 1967: Figs. 32, 35–38). Chalcolithic metalworkers from the site, probably the first individuals to exploit local copper deposits on any scale, could have been mining surface deposits rich in oxidic ores and native copper. The ores excavated at the site and identified subsequently were primarily malachite, with some azurite and one piece of chalcocite, a copper sulphide ore (Caldwell 1967: 19–20). Additional information comes from Dennis Heskel (1982) who analysed several pieces of ore

3 Pigott has discussed this evidence elsewhere (1999a: 74–7; 1999b: 110).

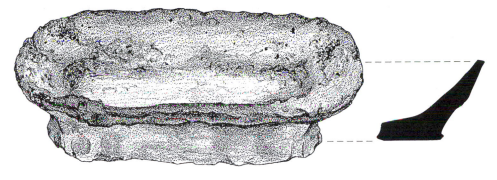

Fig. 3. Drawing of a reconstructed Tal-i Iblis crucible and crucible cross-section (after Chase et al. 1967: Fig. 37 and Dougherty and Caldwell 1966: Fig. 1).

that he surface collected at the site. Heskel identified several copper arsenates[4] (erinite and lindackerite), a copper selenide (klockmannite), a copper chloride (atacamite), as well as the copper carbonate, azurite.

Excavated evidence strongly suggests the use of ceramic crucibles for melting or smelting copper ore at Iblis. Of the more than 300 crucible fragments recovered with slagged interiors, a number were found in a dumping area measuring c. 60 cm thick by 100 m long. Dougherty and Caldwell (1966: Fig. 1; Caldwell 1967: 18, Fig. 1) provide a cross section rendering of an Iblis, level 1 crucible. In Fig. 3 we combine this cross section with a drawing of an entire crucible restored from several large sherds (see Chase et al. 1967: Fig. 37.10). Note that there is no evidence of a pouring spout from this example or from any other Iblis crucible sherd.

Additional archaeological evidence corroborating the possible practice of crucible-based copper production comes from a good context in Iblis Area G where a shallow fire pit was excavated (Evett 1967: 252, Pl. 3). The fire pit contained a crucible fragment and fragments of oxidized copper. The excavator of Area G offered a reconstruction of this smelting locus. A shallow pit was dug, it was not lined, 'crucibles filled with copper ore were placed in the pit and packed in a matrix of charcoal. Contents were then covered with a mass of chaff-tempered clay, presumably for a bellows or to allow for

4 The presence of arsenates, which would have had to be brought to the site, offers the possibility that such ores could have been smelted at Iblis. See research of Richard Thomas on low-temperature copper arsenate smelting which consistently yields arsenical copper with arsenic concentrations below 5 % by weight (Budd et al. 1992; Budd 1993). Arsenate smelting may have been conducted at late 4th /early 3rd millennium BC (Banesh phase) Tal-e Malyan in Fars Province, Iran (Pigott et al. 2003).

oxygen to enter and hot gases to escape' (Evett 1967: 252–4). Caldwell's alternative interpretation (1967: 254, footnote 1) is that a small clay super-structure might have been in place above the pit. Three other fire pits, located on the same level, contained no metallurgical debris, only charcoal. They may have been located in a courtyard area, perhaps where domestic garbage was being discarded. Caldwell interpreted copper production at Iblis as a household-based cottage industry, one craft among several being practised.

Though Caldwell mentions finding slag at Iblis, he gives no indication of the quantity encountered nor reports on having undertaken compositional analyses of any slags. During an extensive survey of ore bodies and ancient metalworking sites in Iran, Afghanistan and Oman, Thierry Berthoud and his collaborators (Berthoud 1979; Berthoud et al. 1982) surface collected a single piece of slag ('scorie') at Iblis which Berthoud later analysed by mass spectrometric techniques (Berthoud 1979: Annexe Tableau 7). That his team collected but one slag sample at the site suggests that slag was an uncommon surface feature. Its scarcity lends support to the likelihood that native copper and/or rich oxidic ores comprised the primary raw materials for copper pro-duction at Iblis. Little slag would be anticipated from the crucible processing of either material. We discuss this further below.

Experimental copper smelting at Iblis, 1966

During the 1966 field season at Tal-i Iblis, Radomir Pleiner and his col-leagues conducted an experimental reduction of copper mineral in a crucible modelled on the Iblis type.[5] This attempt at reconstructing the prehistoric process of smelting copper in a crucible may well represent the first such recorded experiment undertaken in a Near Eastern context and followed on from earlier experiments carried out in Europe.

At Iblis they smelted fragments of malachite gathered from the surface of the site. The crucible was placed in a shallow fire pit like that excavated at Iblis (see diagram in Pleiner 1967: 369, Fig. 11.3). Using a simple bellows the team recorded a temperature of 1100°C at the tuyere tip. Pleiner (1967: 375) comments that 'the refractory qualities of the crucibles proved to be very low, and perhaps the ore samples were not of the best, perhaps rejected by the early metallurgists.' After one-half hour some reduced grains of cop-

5 It is of interest to note that the crucible was made by Hildegard Wulff, an experienced potter. Both Wulffs were visitors to the Iblis project and stayed on to work at the site during the 1966 season. Hans Wulff published *The Traditional Crafts of Persia* (1966) which is a mine of information about traditional metalworking processes and other technologies.

per were found entrapped in slag. Pleiner felt that a single Iblis crucible could have yielded a quantity of copper sufficient to produce the small size artefacts known from the site.

ANALYSIS OF A SINGLE IBLIS CRUCIBLE FRAGMENT, 1966

Caldwell arranged for the analysis of one crucible fragment by Joseph E. Dougherty at the Argonne National Laboratory. Dougherty's results indicated that the ceramic fabric would tolerate temperatures up to just below 1000°C, sufficient for reduction of copper ores but not for the melting of native copper (Dougherty and Caldwell 1966: 984). The fragment was composed of a predominantly kaolinite clay. The melting points of the crucible's inner and outer surfaces, measured with an optical pyrometer, were similar, c. 990 ± 50°C. When melted on a tungsten filament in flowing nitrogen the samples yielded clear glasses (Dougherty and Caldwell 1966: 984). Dougherty adds:

> If the crucible had been used for melting native copper there should have been no difference in the... melting points because the metal-working process would not have appreciably altered the composition of the ceramic. The fact that the unaltered ceramic melted at about 1000°C makes it seem unlikely that the crucible was used for melting copper in any form. The temperature required to melt copper would probably have reduced the crucible to a glass.
>
> (Dougherty and Caldwell 1966: 984–5)

Dougherty's spectrochemical analysis of copper stains on the interior surface of the crucible sherd yielded, besides copper, concentrations of cobalt, nickel, phosphorus and tin significantly higher than in the ceramic body or the surface dross (Dougherty and Caldwell 1966: 984).

THE MIT ANALYTICAL PROGRAM, 2001

We intend to examine the entire group of Tal-i Iblis materials that Joseph Caldwell supplied to Cyril Smith (see Table 1) in an effort to clarify the extractive metallurgical processes and metalworking techniques practised at the site. The four copper-base artefacts: two hand tools, possibly awls[6] (MIT Nos. 248, 250), a tack (MIT No. 249), and a 'pin' (MIT No. 247), illustrated

6 For some informative comments on copper awls as punches and/or perforators from the context of the prehistoric North American Old Copper Complex see the discussion in Susan R. Martin's *Wonderful Power* (1999: 229–33).

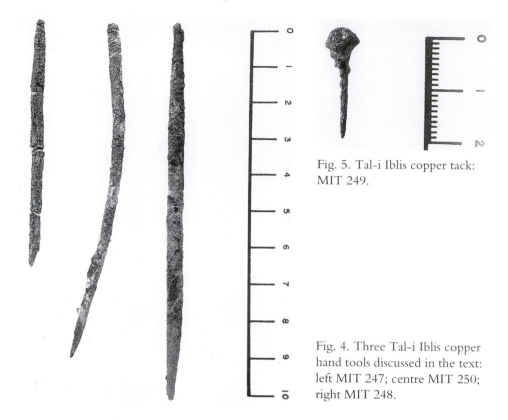

Fig. 5. Tal-i Iblis copper tack: MIT 249.

Fig. 4. Three Tal-i Iblis copper hand tools discussed in the text: left MIT 247; centre MIT 250; right MIT 248.

in Figs. 4, 5 and 6, were the initial focus of study. Lechtman examined objects 248–250 metallographically. Fig. 6 indicates the location at which a metallographic sample was removed from each artefact and the orientation of the prepared section in the microscope. The elemental compositions of these artefacts were determined by a combination of neutron activation analysis (INAA), inductively coupled plasma-mass spectrometric analysis (ICP-MS), and elecron microbeam probe analysis (EMPA) (see Table 2). No micro-structural or elemental analyses were performed on object No. 247 which is in fragments and completely mineralized.

Composition of the metal

All three artefacts are made of copper. The high purity of the metal in hand tool No. 248 and in tack No. 249 (see Table 2) is consistent with a native copper source. For example, the low cobalt and especially the low nickel trace element concentrations in both artefacts are characteristic of native copper (Pernicka 1993, 1997), and some native coppers from Bulgaria have been analysed with high gold concentrations in the range determined for

Analytical Mode

Object	Cat. No.	MIT No.	INAA (ppm)							ICP-MS (ppm)					
			Ag	As	Au	Br	Co	Fe%	Sc	Bi	Fe%	Ni	Pb	Se	Sn
Hand tool	L-1/99	248	140	164	n.d	14.3	10	0.07	0.2	5.0	n.d.	1	6.6	n.d.	121
Tack	L-1/295	249	515	7.6	434	107	12	0.06	0.2	1.2	n.d.	5	11.8	4	1.2

Analytical Mode

Object	Cat. No.	MIT No.	ELECTRON PROBE (ppm)				ELECTRON PROBE (% by weight)					
			Ag	As*	Ni**	S***	Ag	As	Cu	Pb	S	Sb
Tack	L-1/295	249	125	n.d.	n.d.	~32						
Hand tool: metal inclusions	L-1/51	250			n.a.	n.a.	n.d.	3.03	7.38	78.56	0.67	10.38

Key

*	limit of detection of As = 81 ppm
**	limit of detection of Ni = 1 ppm
***	limit of detection of S = 32 ppm

	n.d.	not detected	
	n.a.	not analysed	
INAA	Instrumental neutron activation analysis	ICP-MS	Inductively coupled plasma mass spectrometry

Table 2. Composition of Tal-i Iblis copper artefacts

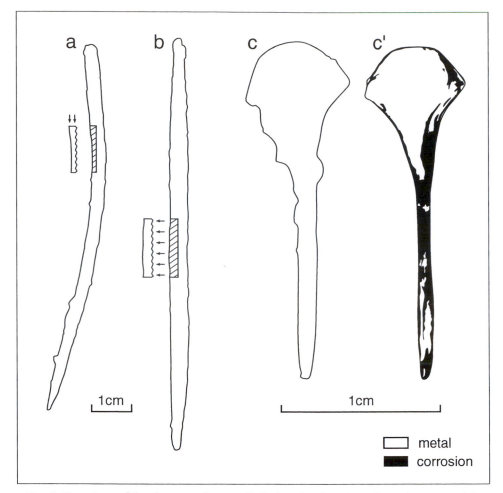

Fig. 6. Drawings of the three artefacts studied, showing location of sample removed for metallographic analysis. Arrows point to the sample cross section examined in the microscope. a. MIT 250; b. MIT 248; c. MIT 249; c'. longitudinal section through the entire tack (MIT 249).

hand tool No. 248 (Pernicka 1997, personal communication, September 2001). On the other hand, Maddin and his colleagues (1980) have argued that smelting pure oxide ores or even pure chalcopyrite ($CuFeS_2$) can produce copper metal with trace element concentrations not unlike those determined for Iblis artefacts Nos. 248 and 249.

Microstructural study of the metal in these two objects, presented below, indicates that the copper was melted, allowed to solidify as a small button or blank, then worked and annealed to produce the final forms. Melting native copper obliterates its characteristic and readily identifiable microstructure

(Smith 1968; Schroeder and Ruhl 1968; Maddin et al. 1980). In the case at hand, melting the copper prior to working it destroyed the micromorphological features that would likely have allowed identification of native metal.

The copper in hand tool No. 250 seems definitely to have been smelted from ore. As Table 2 indicates, the metal itself is quite pure, with silver the only trace element present in any appreciable concentration. But the photomicrograph illustrated in Figure 7 shows that the copper in this artefact is full of metallic inclusions distributed fairly uniformly throughout the section. These polymetallic inclusions, comprised principally of lead, antimony, and arsenic (see Table 2), are present in the copper at a volume fraction of 17%. Whereas trace amounts of arsenic and antimony are not uncommon in native coppers, lead is rarely present in concentrations above about 1 ppm (Pernicka 1997). The high trace element concentration of lead in this copper and its presence as a polymetallic phase with arsenic and antimony constitute strong evidence that the metal was smelted from ore, likely a copper oxide.

Fabrication techniques

Hand tool, with flattened end (see Figs. 4 and 6)
MIT No. 250 / Iblis Cat. No. 51 [illustrated in Chase et al. 1967: fig. 38.3]
Period: Iblis IV (Aliabad), c. mid 4th millennium BC (see [14]C below)
Excavation context: 5.5 m excavation square: 2–7 E, 25–30 N, Level 5 b, 70 cm (from stratigraphic fill)
Related [14]C date: 3570–3365 CRD 1σ BC (P–928)[7]

One end of this object (the upper 2.3 cm in Fig. 4) was hammered flat to a rectangular cross-section; the remainder of the tool has a round cross-section. The sample for metallographic examination was taken at a location where the circular stem changes to a rectangular end (see Fig. 6). The microstructure of the transverse section captured in Figs. 7 and 8 is characterized by fully recrystallized grains that contain annealing twins. The grains are somewhat elongated at the centre of the section (which corresponds roughly to the middle of the tool) and are more markedly elongated, with bent annealing twins, at the corners of the section (along the exterior edges of the tool). The metallic inclusions visible in Fig. 7 are not only aligned in the direction of metal flow, they are also elongated.

7 The method of reporting the Iblis radiocarbon dates is that used in Ehrich 1992. See the detailed discussion in Ehrich's Volume I Introduction, pages viii – x. The individual radiocarbon dates from Tal-i Iblis were produced by the laboratories at the University of Pennsylvania (e.g. P–928) and at Geochron Laboratories, Massachusetts (e.g. Gx–865).

Fig. 7. Artefact MIT 250. Photomicrograph showing the dense and fairly homogeneous distribution of high-lead polymetallic inclusions in the copper. Some inclusions are elongated; all are aligned in the direction of metal flow as are the fully recrystallized, highly distorted copper grains. Magnification 60; Etchant: potassium dichromate.

This object was hammered to shape from a small piece of copper that had solidified from a melt. It was probably annealed more than once to facilitate shaping. The metal was left largely annealed, but the presence of bent annealing twins in the near-surface grains indicates some final hammering along the edges of the implement to perfect its form. The metallographic sample was not taken close enough to either end of the tool to determine if the ends were deliberately work hardened.

Hand tool (see Figs. 4 and 6)
MIT No. 248 / Iblis Cat. No. 99 [illustrated in Chase et al. 1967: fig. 36.9]
Period: Iblis I–II, early to mid–5th millennium BC (see [14]C below)
Excavation context: Area E, Section F, Level 4 (from stratigraphic fill in area used as a dump)
Related [14]C date: 5040–4555 CRD 1σ BC (Gx–865)

The tool maintains a circular section along its full length. Both ends appear to have been pointed, but whether the points were sharp or rounded can no longer be determined. A 1.39 cm long section was cut along the longitudinal axis of the tool (see Fig. 6). The polished longitudinal section exhibited large zones of cuprous oxide (Cu_2O) inclusions. These were present originally as

Fig. 8. Artefact MIT 250. The transverse section (see Fig. 6) exhibits recrystallized grains with annealing twins. The grains at the centre of the section are equiaxed; those at the upper right corner, corresponding to one edge of the tool, are elongated and oriented in the direction of metal flow. Hammering the tool along the edge, after the final annealing event, resulted in plastic deformation and grain distortion. Magnification 30; Etchant: postassium dichromate.

Fig. 9. Artefact MIT 248. Photomicrograph of the longitudinal section shown in Fig. 6. The grains throughout are equiaxed with annealing twins, indicating that the tool was left in the annealed condition. The grains at the surface are considerably smaller than those at the centre, having undergone more severe plastic deformation as the tool was shaped. Long, narrow bands of Cu_2O particles are strung out in the direction of metal flow. Magnification 40; Etchant: potassium dichromate.

pools of the Cu_2O–Cu eutectic microconstituent, indicating that oxygen was introduced into the copper when it was in a molten state. Individual oxide particles are large and undistorted (i.e. fairly round).

The photomicrograph in Fig. 9 shows the microstructure of the metal after etching. The grains are equiaxed and contain annealing twins. The copper is fully recrystallized as a result of having been worked (hammered) and annealed to shape the tool. The grains near the surface of the section are considerably smaller than those deeper within the body of the tool, indicating that during manufacture the surfaces of the tool were worked more extensively than metal at the interior.

Plastic deformation of the copper resulted in breakup of the eutectic microconstituent. Islands of cuprous oxide particles became extended and oriented in the direction of metal flow. In Figure 9, several long bands of these oxide particles traverse the section. The presence of dense accumulations of oxide inclusions near the surfaces of the metal may have inhibited grain growth there and resulted in the recrystallization of smaller grains.

Tack (see Figs. 5 and 6)
MIT No. 249 / Iblis Cat. No. 295
Period: Late Iblis II – early 5th millennium BC (see ^{14}C below)
Excavation context: 5.5 m excavation square: 7–11 E, 25–30 N, Level 2, Area C (from stratigraphic fill)
Related ^{14}C date: 4925–4685 CRD 1σ BC (P–926)

This particular artefact is not illustrated in Caldwell 1967, but drawings of other, similar tacks appear there in the chapter by Chase, Caldwell and Fehévári (1967: Figs. 32.1, 32.10, 36.1 and 37.4). Given the relatively small size of the tack (2.17 cm long) it was possible to cut a longitudinal section through its entire length, as illustrated in Figure 6 (c'). The tack was hammered to shape from a single piece of copper. The microstructure throughout the section, in the head and in the stem, exhibits fully recrystallized grains with annealing twins (see Fig. 10). The slightly smaller size of the equiaxed grains at the crown of the tack, compared with those deeper within the head (see Fig. 11), indicate that the top of the head experienced heavier working before the tack received the final anneal.

The only extensive plastic deformation that took place subsequent to the final anneal occurred in two areas.

(1) Head of the tack, near its equator. In this zone, the metal was hammered severely to effect the sharp change in plane at the equator. The surface grains

Fig. 10. Artefact MIT 249. Etched photomicrograph through the entire head and the upper portion of the stem of the tack (see Fig. 6). The fissures at the left and the right of the head resulted from severe hammering of the metal back onto itself, to thicken the head and to produce the abrupt change of plane at the equator. Magnification 8; Etchant: potassium dichromate.

in this region are highly elongated in the direction of metal flow but contain no deformation lines. The absence of deformation lines is expected in heavily deformed, high purity copper.

(2) Intermediate zone, where the head grades into the stem. The photomicrograph of this zone, illustrated in Fig. 12, reveals heavily worked metal to a depth of about half the thickness of the stem. Here the grains are highly deformed, elongated, and aligned in the direction of metal flow. Fig. 12 also shows the presence of occasional non–metallic inclusions, similarly elon-

Fig. 11. Artefact MIT 249. Photomicrograph detail of Fig. 10. The upper surface of the section corresponds to the crown of the head. The grains throughout the section are equiaxed with annealing twins. They are only slightly smaller at the crown than at the centre, indicating that the crown underwent a modest amount of heavier work during shaping of the head. Magnification 200; Etchant: potassium dichromate.

gated and oriented but etched dark in the micrograph. Electron microbeam probe analysis identified these inclusions as copper sulphide (Cu_2S). The entire section of the tack is inclusion-free except for a few Cu_2S particles in the upper stem and in the intermediate zone, shown in Fig. 12. The probe did not detect sulphur in the copper metal (see Table 2).

The presence of a few copper sulphide inclusions in copper of this purity does not eliminate the native metal as a possible source for manufacture of the tack. Native copper can be produced through the weathering and breakdown of primary copper sulphide ores. In such cases, small, irregular particles of copper sulphide may be entrapped in the native ore. Maddin and colleagues (1980: 221–2) examined a native copper specimen from Australia that exhibited copper sulphide inclusions, and Rapp (1982) reports analyses of native coppers from the Americas to Australia with sulphur concentrations ranging from 18 to 915 ppm.

Fig. 12. Artefact MIT 249. Photomicrograph detail of Fig. 10. This section corresponds to the transition zone between head and stem of the tack. In forming the stem, the metal below the head was heavily worked to reduce its thickness. This zone was hammered extensively after the final anneal, causing the grains to elongate and align in the direction of metal flow. Several highly elongated Cu_2S inclusions are also present. Magnification 50. Etchant: potassium dichromate.

Pin (classification made by J.R. Caldwell, 1967)

MIT No. 247 / Iblis Cat. 173

Period: Iblis I, late 6th/early 5th millennium BC (see [14]C date below)

Excavation context: On floor of Room B 13; part of a building destroyed by fire

Related [14]C date: 5290–4945 CRD 1σ BC (Gx–867)

This artefact is completely mineralized. We took no samples for elemental analysis or microstructural interpretation.

CONCLUDING OBSERVATIONS ON COPPER PRODUCTION AND WORKING AT IBLIS

Current evidence suggests that the crucible played a primary role in copper production on the Iranian plateau during the Chalcolithic (Pigott 1999a, 1999b)[8]. Excavations at Tal-i Iblis have provided some of the supporting evidence. Crucible sherds numbering around 300 were found at the site which, at the time of excavation, had been heavily damaged. There is evidence of fire pits where metallurgical activities occurred and Caldwell (1967: 254, footnote 1) suggested the presence of some sort of clay superstructure at one of the fire pits. There was no indication of multiple, fixed furnace installations.

Looking at the crucibles (Fig. 3), their long, shallow, open shape argues for their role as containers in some primary process for producing metal: containers either for melting native copper or for the extraction (smelting) of copper from rich, oxidic ores such as malachite or azurite, both of which are found at the site. No crucible sherds were identified with pouring spouts that would have facilitated the pouring of molten metal during casting. Furthermore, no casting molds were found at Iblis. The absence of intact or reasonably intact crucibles suggests they might have been broken apart to retrieve the copper produced.

Virtually no slag has been found at Tal-i Iblis. However, the smelting of rich, oxidic copper ores need not produce much slag (Tylecote 1974; Craddock 2001). In his review of the development of copper smelting during the first three thousand years of metallurgy in the Middle East, Paul Craddock (2001) discusses the high correlation between the low iron content (Fe \leq 0.01–0.05 % by weight) in copper artefacts from this period and the production of such almost iron-free copper by non-slagging crucible smelting processes. 'The suggestion that the low iron content indicates an essentially non-slagging process is supported archaeologically by the absence of slag scatters even at mine sites such as Feinan, known to have been in operation through the Chalcolithic period' (Craddock 2001: 154). In addition, the heavily eroded interiors of the crucible sherds suggest exposure to sustained high temperatures such as those associated with smelting. Melting metallic copper takes less time than smelting copper ore, and melting often leaves a 'watermark' of copper dross. There is no recorded mention of such watermarks on the Iblis crucible sherds.

8 For discussions of the Bronze Age role of the crucible in ancient Southwest Asian metal smelting see Yener and Vandiver 1993 and Vandiver et al. 1993.

We cannot say with certainty what kind of material was being processed in the Iblis crucibles. Whereas the purity of two artefacts (Nos. 248 and 249) analysed in the MIT program would suggest they are made from native copper that was melted, their low iron content could have resulted from the crucible smelting of rich copper oxide ore. Analysis of a third artefact (No. 250) strongly suggests that the metal derived from smelting, probably of a copper oxide ore. Moreover, the refiring experiment conducted by Dougherty on a single Iblis crucible sherd suggests that the fabric could not sustain itself at the temperatures required for the melting of native copper (minimally 1083°C). Pleiner commented that his experimental crucible, made from local Iblis clay, had poor refractory properties. The temperatures necessary to reduce rich, oxidic ores to copper in a non-slagging regime need not exceed 1000°C. Iblis crucibles would have tolerated these lower temperatures.

One further point merits mention. Preliminary examination of the crucible sherds at MIT indicates that their exterior surfaces are virtually unaltered by high temperature. This observation suggests that the crucible *exteriors* were never exposed to temperatures sufficient for melting or for smelting copper, because they were shielded in the fire pit from whatever directed air stream may have been introduced, for example by bellows, blow-pipe, or a focused natural draft. If the *interior* surfaces of the crucible were heavily eroded during processing, the integrity of the container would be compromised only under prolonged high temperature processing. We expect to measure the thermal gradient along cross-sections cut through the walls of Iblis crucible sherds in the MIT collection. The sections may also provide data about the metallic mineral and/or metal contained by the crucibles during heating. These data, together with experiments designed to replicate the processing regime, should help determine whether melting or smelting of copper was the process of choice at Tal-i Iblis.

Caldwell saw production at Iblis as present at the level of a cottage industry (1967). Production would have entailed obtaining the copper-base raw materials and fuel, digging clay and gathering chaff for the manufacture of crucibles, selecting a processing location at the site, excavating fire pits and undertaking the extraction process. The copper metal obtained was worked to shape in a series of hand hammering and annealing (gentle heating) sequences. The relatively small volume of the copper stock obtained from the crucibles may have constrained the shape and size of the finished items, such as awls and tacks (Pleiner 1967: 375).

We do not know if copper from Iblis was circulating beyond the immediate vicinity of the site. Given the number of crucible sherds found, people

at Iblis were devoting some effort to processing copper, probably for local consumption. At the same time, Iblis was a site with connections (ceramic) to Tepe Yahya and Shahdad, sites in the Kirman region, and also to the west, to sites in the provinces of Fars and Khuzistan along the south and western borders of Iran (Voigt and Dyson 1992: 143–6).

Evidence from Tepe Yahya, in reasonable proximity to Iblis, deserves mention, since Yahya has provided one of the few stratigraphic sequences on the Iranian plateau with early evidence of metal artefacts (Heskel and Lamberg-Karlovsky 1980). The Yahya evidence, while contemporaneous with that from Iblis, is distinct. In the Chalcolithic occupation at Yahya, roughly from 4500 to 3200 BC, artefact metal first appears in the form of hammered native copper awls. There are no indications of similar production methods at Iblis at these early dates and the Yahya finds stand in marked contrast to the evidence of early crucible-based production methods apparent at Iblis. In fact, at Yahya it is not until c. 3600 BC and later that evidence of copper smelting of complex ores, in the form of an ingot, slag, and ore appears, together with a diverse array of artefact types (pins, spatulas, tacks, needles, chisels, blades) often of arsenical copper.

Those who used and/or worked metal at sites like Iblis and Yahya were the forerunners of a tradition of copper production which was to characterize the Kirman region of southern Iran from the Chalcolithic onwards. Copper production in this part of Iran reached its apogee during the Bronze Age. A prime example is the remarkable metalworking evidence from the site of Shahdad (see Fig. 1). Its multiple workshops house in situ smelting furnaces, and the local necropolis has yielded a broad repertoire of items produced in arsenical copper (Hakemi 1992; Vatandoost 1999: 128–131; Pigott 1999a, 1999b). Such metallurgical finds (and associated materials) link this site and others in the Kirman region as well as elsewhere on the Iranian plateau to a larger international network of cultural contact ranging from the Indus Valley to the east, to the Bactrian-Margiana Complex of Central Asia to the north, the Gulf to the south and to Elam and Mesopotamia to the west during the 3rd millennium B.C. How the excavated material culture from the plateau establishes the presence of this network is demonstrated in no better fashion than in P. R. S. Moorey's (1994) *Ancient Mesopotamian Materials and Industries*.

REFERENCES CITED

Bazin, D. and Hübner, H.
1969 *Copper Deposits in Iran*. Geological Survey of Iran Report 13. Tehran.

Berthoud, T.
1979 Étude par l'Analyse de Traces et la Modelisation de la Filiation entre Minerai de Cuivre et Objets Archéologiques du Moyen-Orient (IV^ème et III^ème millénaires avant notre ère). Doctoral Thesis, Université Pierre et Marie Curie, Paris VI.

Berthoud, T., Cleuziou, S., Hurtel, L. P., Menu, M., and Volfovsky, C.
1982 Cuivres et alliages en Iran, Afghanistan, Oman au cours des IV^e et III^e millénaires. *Paléorient* 8/2: 39–54.

Budd, P.
1993 Recasting the Bronze Age. *New Scientist* (Oct. 23): 33–7.

Budd, P., Gale, D., Pollard, A. M., Thomas, R. G., and Williams, P. A.
1992 The early development of metallurgy in the British Isles. *Antiquity* 66: 677–86.

Caldwell, J. R.
1968 Tal-I-Iblis and the beginning of copper metallurgy in the fifth millennium. *Archaeologia Viva* 1: 145–50.

Caldwell, J. R. and Shahmirzadi, S. M.
1966 *Tal-I-Iblis: The Kerman Range and the Beginning of Smelting*. Illinois State Museum Preliminary Reports No. 7. Springfield.

Caldwell, J. R. (ed.)
1967 *Investigations at Tal-I-Iblis*. Illinois State Museum Preliminary Reports No. 9. Springfield.

Chase, D.W., Caldwell, J.R. and Fehévári, I.
1967 The Iblis sequence and the exploration of Excavation Areas A, C, and E. In Caldwell ed. 1967: 111–201.

Craddock, P. T.
2001 From hearth to furnace: Evidences for the earliest metal smelting technologies in the eastern Mediterranean. *Paléorient* 26/2: 151–165.

Dougherty, R. C. and Caldwell, J. R.
1966 Evidence of early pyrometallurgy in the Kerman Range in Iran. *Science* 153: 984–5.
1967 Evidence of early pyrometallurgy in the Kerman Range in Iran. In Caldwell ed. 1967: 17–20.

Evett, D.
1967 Artifacts and architecture of the Iblis I Period: Areas D, F, and G. In Caldwell ed. 1967: 202–25.

Hakemi, A.
1992 The copper smelting furnaces of the Bronze Age at Shahdad. In *South Asian Archaeology 1989* (C. Jarrige, ed.). Monographs in World Archaeology No. 14. Madison, Wisconsin, 119–32.

Hauptmann, A., Pernicka, E., Rehren, T. and Yalçin, Ü. (eds.)
1999 *The Beginnings of Metallurgy*. Der Anschnitt, Beiheft 9. Bochum: Deutsches Bergbau-Museum.

Heskel, D. L.
1982 The Development of Pyrotechnology in Iran during the Fourth and Third Millennia B.C., Ph.D. Dissertation, Dept. of Anthropology, Harvard University. Ann Arbor: University Microfilms.

Heskel, D. L. and Lamberg-Karlovsky, C. C.
1980 An alternative sequence for the development of metallurgy: Tepe Yahya, Iran. In *The Coming of the Age of Iron* (T. A. Wertime and J. D. Muhly, eds.). New Haven Connecticut: Yale University Press, 229–65.

Maddin, R., Wheeler, T. S., and Muhly, J. D.
1980 Distinguishing artifacts made of native copper. *Journal of Archaeological Science* 7/3: 211–26.

Martin, S. R.
1999 *Wonderful Power. The Story of Ancient Copper Working in the Lake Superior Basin*. Detroit: Wayne State University Press.

Moorey, P. R. S.
1994 *Ancient Mesopotamian Materials and Industries.* Oxford: Clarendon Press.

Pernicka, E., Begemann, F., Schmitt-Strecker, S. and Wagner, G. A.
1993 Eneolithic and Early Bronze Age copper artefacts from the Balkans and their relation to Serbian copper ores. *Prähistorische Zeitschrift* 68/1: 1–54.

Pernicka, E., Begemann, F., Schmitt-Strecker, S., Todorova, H. and Kuleff, I.
1997 Prehistoric copper in Bulgaria: Its composition and provenance. *Eurasia Antiqua* 3: 41–180.

Pigott, V.C.
1999a The development of metal production on the Iranian plateau: An archaeometallurgical perspective. In *The Archaeometallurgy of the Asian Old World* (V.C. Pigott, ed.). MASCA Research Papers in Science and Archaeology 16. Philadelphia: The University Museum, University of Pennsylvania, 73–106.

1999b A heartland of metallurgy. Neolithic/Chalcolithic metallurgical origins on the Iranian plateau, In Hauptmann et al. eds. 1999: 109–22.

Pigott, V. C., Rogers, H. C. and Nash, S. K.
2003 Archaeometallurgical investigations at Tal-e Malyan: The Banesh period. In *Proto-Elamite Civilization in the Land of Anshan* (W. A. Sumner, ed.). Malyan Excavation Reports 3. Philadelphia: University of Pennsylvania Museum, Chicago: The Oriental Insitute.

Pleiner, R.
1967 Preliminary evaluation of the 1966 metallurgical investigations in Iran, In Caldwell ed. 1967: 340–405.

Rapp Jr., G.
1982 Native copper and the beginning of smelting: Chemical studies, In *Early Metallurgy in Cyprus. Acta of the International Archaeological Symposium, Larnaca Cyprus* (J. D. Muhly, R. Maddin and V. Karageorghis, eds.). Nicosia, 33–8.

Schroeder, D. L. and Ruhl, K. C.
1968 Metallurgical characteristics of North American prehistoric copper work. *American Antiquity* 33/2: 162–9.

Smith, C. S.
1968 Metallographic study of early artifacts made from native copper. *Actes du XI^e Congrès International d'Histoire des Sciences (Warsaw)* Vol. 6, 237–52.

Stein, M. A.
1937 *Archaeological reconnaissance in northwestern India and southeastern Iran.* London: Macmillan.

Tylecote, R. F.
1974 Can copper be smelted in a crucible? *Journal of the Historical Metallurgy Society* 8/1: 54.

Vandiver, P. B., Yener, K. A. and May, L.
1993 Third millennium tin processing debris from Göltepe (Anatolia) In *Materials Issues in Art and Archaeology* III (P. B. Vandiver, J. Druzik and G. S. Wheeler, eds.) Pittsburgh: Materials Research Society, 545–69.

Vatandoost, A.
1999 A view on prehistoric Iranian metalworking: Elemental analyses and metallographic examinations. In Hauptmann et al. eds.: 121–40.

Voigt, M. M. and Dyson, R. H.
1992 The chronology of Iran, c. 8000–2000 BC. In *Chronologies in Old World Archaeology* (R. W. Ehrich, ed.). 2 Vols. 3rd edition. Chicago: The University of Chicago Press, Vol. 1, 122–78; Vol. 2, 125–53.

Wertime, T. A.
1968 A metallurgical expedition through the Persian desert. *Science* 159 (3818): 927–35.

Wulff, H. E.
1966 *The Traditional Crafts of Persia.* Cambridge, MA: MIT Press.

Yener, K. A. and Vandiver, P. B.
1993 Tin processing at Göltepe, an Early Bronze Age site in Anatolia. *American Journal of Archaeology* 97: 207–38.

Early Bronze Age I copper production on the coast of Israel: archaeometallurgical analysis of finds from Ashkelon–Afridar[1]

Sariel Shalev

INTRODUCTION

In order to understand archaeological data the archaeologist, by using his or her human logic and imagination, strives to combine together all the silent fragmentary evidence to form one sensible picture of past events. Anthropological and historical analogies serve as a major source for his or her logical assumptions (i.e. Moorey 1985) and as a major restriction to his or her imagination. In recent decades, scientific analytical tools have come to be utilized to the great benefit of archaeology. Chemical, physical and mechanical analyses of archaeological finds (Pollard and Heron 1996; Lambert 1997) are enabling the archaeologist to reconstruct specific aspects of ancient human cultures with more clarity and certainty.

In this paper I will try, following the pioneering example of Moorey and Schweizer (1972) to demonstrate both the potential and the problems of utilizing scientific tools in archaeology. In this case, with what accuracy can we reconstruct a reliable picture of the original activities that were conducted in an open-air site where the only architectural remains are poorly preserved man-made holes in the ground, totally cleaned and detached from the archaeological artefacts and residues?

1 I would like to thank the many research participants and contributors who have assisted in this research project: in particular the excavators Amir Golani (1996, the Israel Antiquities Authority) and Yuval Yekutieli (1998, Ben Gurion University) and the research participants Michal Palatnik (research assistant), Rosa M. Albert (Phytoliths analysis), Elisabetta Boaretto and Eugenia Mintz (^{14}C dating), Eugenia Klein (EDS analysis) and Steve Weiner (FTIR analysis, all from the Weizmann Institute, Dorothy I. Godfrey-Smith (TL & OSL dating), Kevin Vaughan (Technical assistant, Luminescence measurements), Dalhousie University Halifax, Canada. Special thanks are due to Yuval Yekutieli, Zvi Gopher and Amir Sandler for their helpful comments concerning specific aspects of this study.

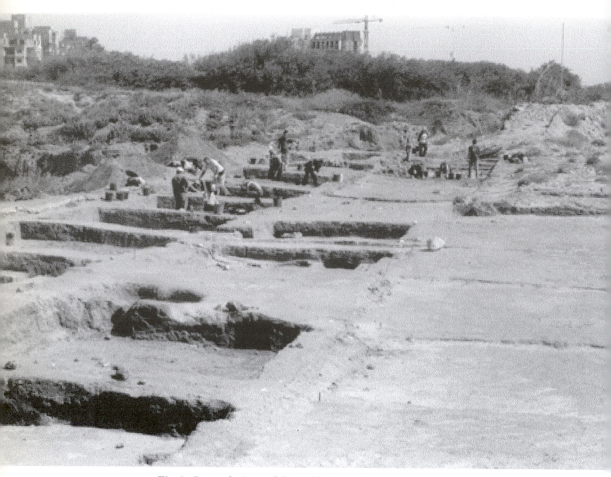

Fig.1. General view of the Ashkelon Marina archaeological site.

THE ARCHAEOLOGICAL FINDS

In 1996 an Early Bronze Age (EBI) site was uncovered above the Marina Beach in Ashkelon (Fig.1) in rescue excavations directed by A. Golani of the Israel Antiquities Authority. In 1998 excavations were resumed, conducted this time by Y. Yekutieli and S. Hermon from Ben-Gurion University. During both seasons, rich remains of human activity were unearthed. Beside the pottery vessels, stone and flint tools and the floral and faunal remains, a significant amount of metal objects, amorphous small metal lumps and droplets, slag and crucible fragments were found. The architectural features unearthed included an exceptionally large number of pits of various sizes and types, several badly preserved fragments of installations built of fieldstones, and some scatters of small cone-shaped shallow holes in the ground. These

small man-made pits (Fig. 2) were filled with sediment but completely empty of artefacts or any other evidence of human activity. A red coloured earth around and a thin whitish layer inside the small holes suggested the possibility that these pits underwent severe heating caused by burning wood or charcoal. No objects or other archaeological remains were found in direct association with these pits, although they are an integral part of the activity layer at the site. Because of the imminent destruction of the archaeo-

Fig. 2. Detailed view of the preserved base of a pit and its surroundings.

logical site by modern construction activity, several of these man-made installations were removed from the site. They were then studied in the archaeometallurgical lab at the Center for Archaeological Science, Weizmann Institute of Science, together with a representative collection of other finds, mainly metals and metal related artefacts from the site. The controlled excavations of four installations, the field sampling and the preliminary analysis of the archaeological material were performed by M. Palatnik (1999).

THE ANALYTICAL RESULTS

What activities were carried out at this site during its occupation?
The various finds at the site suggest that it served as an open air industrial zone, surrounded by an Early Bronze Age I (EBI) village of temporary dwellings (huts, tents, etc.) with refuse and/or storage pits. In addition to basic olive and grain agriculture and animal husbandry, the inhabitants practised certain forms of metallurgical activity and were connected to areas beyond the site's limits through trade. In order to study the unique metallurgical activity at the site during EBI, a representative selection of slags, crucible fragments, metal lumps and droplets and metal objects was analysed. The analyses were conducted using an Olympus PME3 optical inverted microscope and a JEOL 6400 scanning electron microscope (SEM) with Oxford Link energy dispersive spectrometer (EDS) at the Weizmann Institute. The metallurgical and metallographic results were then compared with a previous study of similar material from Golani's excavation. The previous metallurgi-

cal research was conducted by I. Segal, L. Halicz and A. Kaminski (1997) in the laboratories of the Geological Survey of Israel. The analytical results show that copper melting and refining was a major activity in the site.

The analysed slags (Fig. 3), both detached and attached to crucible fragments, are all residual remains from the melting and refining of copper. The quantity of copper in the slag is relatively high, comprising 10 to 40% of the total slag material. Copper prills are trapped in the slag matrix either in their original metallic form or corroded (Fig. 4). The amount of iron in the copper prills is relatively low, usually less than 1%, representing probably the melting of already refined copper (Fig. 5). Higher quantities, still not exceeding 5%, of iron were only measured in rare cases and perhaps represent the refining of smelted copper. In several cases, inclusions of copper sulphides, remains of the original ore, were detected in the copper prills. The slag matrix is composed of solidified melted silica with iron oxides (mainly fayalite) and/or copper-iron oxides (delafossite), sometimes in the same slag. All other elements in the slag matrix—quartz and lime grains, traces of magnesium and potassium and in rare cases grains of titanium oxide—derived probably from the local ground and rock as well as the crucible material.

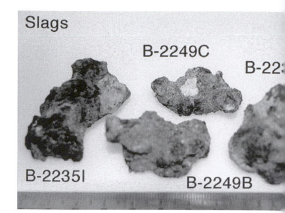

Fig. 3. A selection of copper slags (as found).

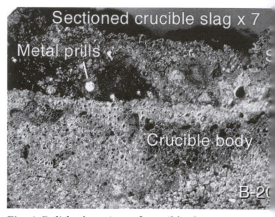

Fig. 4. Polished section of crucible slag B-2058a × 7.

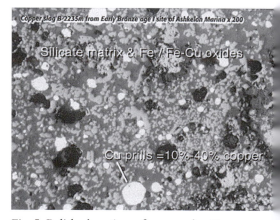

Fig. 5. Polished section of copper slag B-2235m × 200.

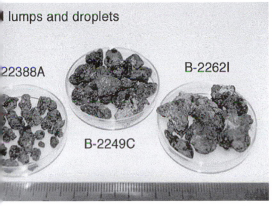

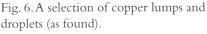

Fig. 6. A selection of copper lumps and droplets (as found).

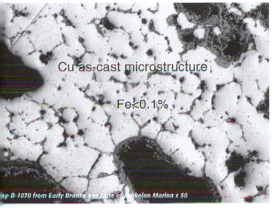

Fig. 7. Polished section of copper lump B–1070 × 50.

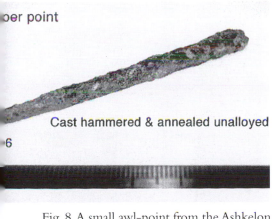

Fig. 8. A small awl–point from the Ashkelon Marina excavations.

All the analysed amorphous metal lumps and droplets (Fig. 6) show structural porosity caused by gasses trapped in the melt during solidification. They are all made of copper with very low impurity (Fig. 7). In several lumps small inclusions of copper sulphide were detected and rare lead or silver inclusions as well. The amount of iron measured in the copper lumps is usually very low, below 0.1%. In rare cases iron was measured in higher quantities, still not exceeding 3%. The metal lumps and droplets are probably the remains of the same copper melting and refining processes described above. They could represent copper leftovers of these operations as well as a possible source material.

The majority of the metal objects found on the site are small hammered copper points and plaques (Fig. 8) and very rarely a broken piece of what had originally been a larger object. All the analysed objects were made of unalloyed copper. Only in rare cases were other elements measured above trace level. In the ICP analyses of I. Segal (et al. 1977) less than 1.3% arsenic was found in a broken tang, probably of a blade. Less than 1.3% iron was detected in one of the ten analysed points. In the two cases where lead was detected in quantities of c. 3%, inclusions of segregated lead were probably analysed. The metallography of all the analysed objects, except one, present a micro-

structure typical of thermal (homogenization and annealing) and mechanical (hammering) treatment after being cast. This is evident by the equiaxed grain structure caused by annealing and re-crystallization, as well as the slip-bands caused by final cold work (i.e. Shalev 1996: 12, Fig. 1a–b).

When and for how long was the site occupied?

Two organic samples, one of wood-ash mixed with burnt seeds and one of charred olive seeds, both from sealed archaeological debris near the man-made pits, were submitted for [14]C dating. The method and its limitations are discussed in detail by Mook and Waterbolk (1985) and Bowman (1990). The samples, prepared in the radiocarbon laboratory at the Weizmann Institute of Science, were analysed in the accelerator (AMS) of the Institute of Physics, University of Aarhus, Denmark. The calibrated results (with 1 sigma standard deviation) are 3630–3380 BC and 3500–3350 BC, respectively. The [14]C dates confirm the typological dating of the occupation of the site based on pottery remains to the Early Bronze Age I (EBI), and are later than the previous [14]C results of c. 3700 BC obtained in the first stage of the excavation (Golani and Milevsky 1997). The difference in the two sets of [14]C deserves special attention beyond the scope of this paper and is discussed in details by Braun (in press).

Were the empty cleaned pits connected to the archaeological finds nearby?

The only man-made features found in the site that could have served in the metallurgical process are the small shallow holes (Fig. 2), which may exhibit possible evidence of exposure to heating. However there is no archaeological proof for this hypothesis since neither metals nor any residues of metal-working activity were found within or in direct association with these pits. Therefore, in order to determine how, when and for what purpose were these installations made, we had to independently study the features themselves, and attempt, using scientific analyses, to establish a possible technological and chronological connection between the installations and the EBI metallurgical activity in the region. For that purpose, seven out of the dozens of these installations were transferred from their original location (Fig. 9) to the archaeometallurgical lab at the Weizmann Institute of Science for further study. All the installations had the same pattern (Fig. 10) composed of an inner thin white lining (1–1.5 mm thick) on a red clay-like layer (c.19 mm thick) surrounded by natural brown soil. The features were found scattered over the excavated area, clustered in groups and in varied degrees of preservation. All the installations have a rounded conical shape

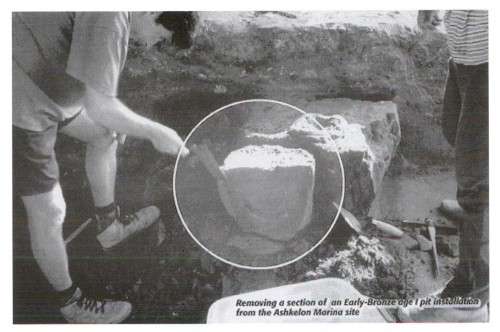

Removing a section of an Early-Bronze age I pit installation from the Ashkelon Marina site

Fig. 9. Cutting and removing a sectioned pit from the site.

altering in their diameter according to depth: from 90–120 mm in diameter 40–45 mm above the base, to c.180 mm diameter at a height of 110–120 mm, reaching a diameter of 235 mm in the deepest preserved pit at the height of 175 mm.

To determine and compare the major mineral components of each layer in the installations, samples from the three distinct parts of each representative pit were analysed by Midac Fourier Transform Infrared Spectroscope (FTIR). The results revealed a consistent spectrum for each of the three structural variables in all the analysed pits. The white thin inner layer (Fig. 10) is composed mainly of calcite with some quartz, while the red ring surrounding the thin white layer is composed of hydrous aluminum silicates (i.e. clay minerals) with some quartz and calcite, similar to the spectrum of the earth matrix. The change in colour was, therefore, probably caused by the burnt organic matter in the soil between 200° and 500° C with a possible further oxidation of the iron Fe_3O_4 to Fe_2O_3. The results show very clearly that all the analysed installations were made and used in a similar way. The composition of the red body of the pit confirms that it was an integral part of the original ground into which these installations were dug and not an artificial addition, but it still needs to be examined to determine whether the visible changes in colour and plasticity were actually caused by heat.

Fig 10. Detailed view of the preserved base of a pit and its surroundings.

What was the original purpose of these pits and how could they have been made and used? In order to examine whether the calcite, which is the most common mineral in fresh ash (Albert et al. 2000: 934), was derived originally from ash produced by burning wood or charcoal, the relative quantity of the preserved phytoliths was studied. The samples were prepared by M. Palatnik and analysed by R. Albert in a method described by Albert et al. (2000: 937–8). Four samples were submitted to a quantitative and qualitative phytolith analysis. Three of these were calcite linings from different installations and one, a control from the natural infill of the best-preserved installation No. 6 (Fig. 9). Phytoliths were found in the white lining of all three installations in amounts much larger (52,000; 115,000; 529,000) than in the control (11,500), in ratios ranging from 1:5 to 1:50. The above numbers represent the counted number of phytoliths in one gram of acid insoluble fraction (AIF). In all the calcite samples many irregular shaped phytoliths were observed, indicating wood ash (Albert et al. 2000), while in the sample with the highest phytolith count an additional, significant number of grass phytoliths was observed as well. The results show that the white lining of these installations (Fig. 10) is derived, most probably, from ash of burnt wood or charcoal. On the basis of these results, we have established that ash was present in these installations. To find out whether the ash was produced *in situ* through burning rather

than *introduced* as a deliberate coating of the pit, for example through a slurry of ash and water, we investigated how the red material beneath the thin calcite layer was produced.

In order to determine whether the red lining of the pit features actually represents baked earth, a phenomenon resulting from an extensive exposure to heat during the use of these features as fire pits, we applied optical dating (OSL) and thermoluminescence (TL) dating to the hardened red layer (ASHK-1) and the overlying fill sediments (ASHK-2) of installation No. 6 (Fig. 9). These measurements permit one to deduce the date that these two components of the feature were last fired and/or exposed to sunlight. The premise driving our investigations is the fact that heated sediments will give the correct TL age. In contrast, unheated sediments will give an incorrect TL age far in excess of the depositional age, but will give a correct optical dating age. In addition to the above, we also predicted that, if the rim sample had indeed been exposed to a high temperature, and if the infilling was reasonably rapid following the abandonment of the pits, as may be expected on the highly exposed coastal plain of the eastern Mediterranean Sea, then the optical age of the fill should closely match the TL age of the rim.

D. Godfrey-Smith carried out the measurements at the TOSL/ESR Laboratory of Dalhousie University on 90–125 µm quartz grains extracted from each of the samples. The TL analyses yielded ages of 5180 BP ± 380 years for the hardened rim, and an age of 24,600 ± 1,600 years for the fill (Godfrey-Smith and Shalev in press). The apparent TL age of the fill is 4.5 times older than that of the underlying rim, even though their dose rates are very nearly identical. Based on the simple natural laws of stratigraphic succession, such a result is clearly not a reasonable one if the two samples had identical thermal and depositional histories. Thus, we must conclude that sample ASHK-1 experienced a different thermal history than ASHK-2. While ASHK-1 had only the radiation dose accrued since it was heated, sample ASHK-2, which had not been exposed to heat, also carried a large residual dose of 28 Gy due to the unbleachable TL signal always present in unheated quartz sediments. Single aliquot optical dating of the fill yielded an age of 5260 ± 380 years (=3260 BC ± 380) and is in excellent agreement with the 5180 ± 380 years (=3180 BC ± 380) TL age of the rim, indicating that the infilling of the pit feature rapidly followed its creation and abandonment. These ages are also in agreement with the radiocarbon chronology. These results fulfill the hypothesized results precisely. On this basis, we conclude that the pit features at the Ashkelon Marina archaeological site were fire pits used in Early Bronze Age I copper melting technology.

SUMMARY

What could be the socio-economic meaning of such activity in the cultural context of the period?

Scientific analysis can, as demonstrated above, clarify the original purpose and use of the fragmentary archaeological finds and, therefore, contribute to the reconstruction of human activities, in this particular case, on the Marina coast of Ashkelon in the pre-urban culture of Early Bronze I. This episode fits very well and add some more weight to the reconstruction of metal technology as a contributor and a reflector of socio-economic developments and changes in the Eastern Mediterranean at the end of the fourth millennium BC (i.e. Shalev 1994, 1995; Hauptmann et al. 1999). The metallurgical activity of melting and refining copper in Ashkelon is part of the overall changes in metal production of the Early Bronze. During this period unalloyed copper, similar in composition and production mode to the Chalcolithic one, continued to be used, this time on a larger, more industrialised scale. All points and blades, including the traditional awls, adzes, axes and chisels (Shalev and Braun 1997: 93, 94), as well as the new products of daggers and swords (Shalev 1996: 12, Fig. 1), were produced from hammered and annealed unalloyed copper. Even jewellery was produced by the same method as hammered plaques and wires. Copper was, at that time, mined and smelted in Faynan, Jordan, and southern Sinai, Egypt, on a large industrial scale (see Shalev 1994: 633–636 for summary and references). Amorphous lumps and prills of smelted and refined copper have been found in two more EB sites, Jericho in the southern Jordan Valley (Khalil 1975: 142–144) and Palmahim Quarry on the Mediterranean coast, north of Ashkelon (an unpublished cache of 250 g amorphous copper lumps with two EB I axes, analysed by S. Shalev). The copper could have come from scrapped Chalcolithic objects like the cache of five typical Chalcolithic shaped axes/adzes found in EBI strata at Meser (Dothan 1957: 220, Pl. 37; Shalev and Braun 1997: 94, note 4). A slag of melting copper was found beside a typical EBI dagger (Shalev 1996) in the EBI site of Afridar (Brandl and Gophna 1994) several hundred metres north of Ashkelon Marina. Light grey clay crucibles, shaped like cups, c. 100 cc in volume, with a socket for inserting a handle, were found in several EBI sites: Meser (Tylecote 1976: 20, Fig. 13.H), Yiftah'el (Shalev and Braun 1997: 92–93) and Lachish (Tufnell 1958: 145–6, Pl. 57.71 similar in shape and size but dated to the end of EB). In these crucibles 670–450 g of copper could have been melted, assuming the copper melt occupied between three-quarters and half of the overall crucible volume. The molten copper from a

single melt was, therefore, sufficient for casting: one big axe/adze (690 g in Palmahim Quarry and 403 g in Yiftah'el); three to four small axes/adzes (149 g in Palmahim Quarry); or, seven to ten daggers (64 g in Afridar and 113 g in Tell Nazbeh). The exact use and purpose of these EBI copper points and blades is still unknown and they need to be thoroughly studied in order to be better defined on less subjective criteria.

REFERENCES CITED

Albert, R., Weiner, S., Bar-Yosef, O. and Meignen, L.

2000 Phytoliths in the Middle Palaeolithic deposits of Kebara Cave, Mt Carmel, Israel: Study of the plant materials used for fuel and other purposes. *Journal of Archaeological Science* 27: 931–47.

Bowman, S.

1990 *Radiocarbon Dating.* Los Angeles: University of California Press / London: British Museumress.

Brandl, B. and Gophna, R.

1994 Ashkelon, Afridar. *Excavations and Surveys in Israel* 12: 89.

Braun, E.

In press Proto and Early Dynastic Egypt and Early Bronze I–II of the Southern Levant: some uneasy [14]C correlations. In *Proceedings of the 17th International Radiocarbon Conference,* (I. Carmy, ed.). Tucson.

Dothan, M.

1957 Excavations at Meser 1956. *Israel Exploration Journal* 7: 217–28.

Godfrey-Smith, D. and Shalev, S.

In press Determination of usage and absolute chronology of a pit feature at the Ashkelon Marina, Israel, Early Bronze I archaeological site. *Geochronometria.*

Golani, A. and Milevsky, Y.

1997 Ashkelon Afridar. Archaeological News *107: 118–20.*

Hauptmann, A., Begemann, F. and Schmitt-Strecker, S.

1999 Copper objects from Arad – their composition and provenance. *Bulletin of the American Schools of Oriental Research* 314: 1–17.

Lambert, J. B.

1997 *Traces of the Past: Unraveling the Secrets of Archaeology through Chemistry.* Helix Books Reading, MA: Perseus Books / Addison-Wesley.

Mook, W. G. and Waterbolk, H. T.

1985 *Radiocarbon Dating.* Groningen: The European Science Foundation.

Moorey, P. R. S.

1985 *Materials and Manufacture in Ancient Mesopotamia,* British Archaeological Reports International Series 237. Oxford: British Archaeological Reports.

Moorey, P. R. S. and Schweizer, F.

1972 Copper and copper alloys in ancient Iraq, Syria and Palestine: some new analyses. *Archaeometry* 14: 177–98.

Palatnik, M.

1999 5,500 years old metal production in Ashkelon. Unpublished M.Sc. Thesis. The Weizmann Institute of Science, Rehovot, Israel.

Pollard, A. M. and Heron, C.

1996 *Archaeological Chemistry.* Cambridge: The Royal Society of Chemistry.

Segal, I., Halicz, L. and Kaminski, A.
1997 A Study of the Metallurgical Remains from Ashkelon Afridar Areas E, G and H. Jerusalem: Geological Survey of Israel.

Shalev, S.
1994 The change in metal production from the Chalcolithic period to the Early Bronze age in Israel and Jordan. Antiquity 68: 630–7.
1995 Metals in ancient Israel: Archaeological interpretation of chemical analysis. Israel Journal of Chemistry 35: 109–16.
1996 Archaeometallurgy in Israel: The impact of the material on the choice of shape, size and colour of ancient products. In Archaeometry 94, The Proceedings of the 29th International Symposium on Archaeometry. Tubitak, Ankara, 11–5.

Shalev, S. and Braun, E.
1997 The metal objects from Yiftah'el II. In Yiftah'el: Salvage and Rescue Excavations at a Prehistoric Village in the Lower Galilee, Israel (E. Braun, ed.). Israel Antiquities Authority Reports No. 2. Jerusalem, 92–6.

Tufnell, O.
1958 Lachish IV: The Bronze Age. London: Oxford University Press.

Tylecote, R. F.
1976 A History of Metallurgy. London: Metals Society.

Le temple d'Inshushinak de Suse et l'architecture monumentale en «faïence»

Annie Caubet

Introduction[1]

L'emploi le plus célèbre des matières vitreuses dans l'architecture monumentale de Suse vient incontestablement de palais de Darius, érigé à côté de la salle hypostyle de l'Apadana. Ce palais de type «babylonien» était orné notamment de parements de briques siliceuses (ci-après désignées comme briques de faïence par commodité, les divers auteurs employant aussi les termes équivalents et tout aussi impropres de briques vernissées). Le décor n'a pas été retrouvé en place mais les éléments ont permis de reconstituer des défilés d'archers porteurs de lance qui constituaient la garde du grand roi, des frises de monstres mythologiques et de lions ainsi que des motifs floraux stylisés.

Le caractère grandiose du palais perse obscurcit quelque peu les essais antérieurs des Elamites dans le domaine de l'emploi des faïences ou matières vitreuses appliquées à l'architecture. Pourtant des décors utilisant la faïence à glaçure colorée ont été mis en œuvre dès la période médio-élamite. Les vestiges en sont très fragmentaires, en raison de la destruction de Suse par les

1 Le département des Antiquités Orientales du musée du Louvre poursuit depuis plusieurs années une étude sur les «faïences» et matières dures vitreuses de l'Orient ancien. Cette recherche, conduite avec l'aide du Centre de Recherche et de restauration des Musées de France (C2RMF) a été entreprise à l'initiative d'Alexandre Kaczmarczyk qui souhaitait ainsi compléter ses propres travaux antérieurs sur ces techniques dans l'Egypte ancienne (Kaczmarczyk and Hedges 1983). Les résultats seront publiés par la Réunion des Musées Nationaux et seront accompagnés d'une présentation temporaire au musée du Louvre en 2005. Durant toutes ces années, les divers membres de l'équipe engagée dans cette recherche de longue haleine ont été inspirés par les travaux de Roger Moorey, auprès de qui nous avons toujours trouvé de fructueux avis lors de nos diverses rencontres à Oxford ou ailleurs dans le monde. Nous avons choisi de lui rendre hommage par deux aperçus d'inégale longueur sur les résultats obtenus. Le plus complet est une synthèse des productions de matières vitreuses à Ras Shamra Ougarit par Valérie Matoïan, qui a soutenu sa thèse sur les objets en matière vitreuse d'Ougarit, et par Anne Bouquillon, ingénieur au C2RMF, est responsable de la filière céramique et pierre (voir infra leur contribution «Vitreous materials in Ugarit: new data»). Pour ma part, me souvenant des conversations que j'ai eu le privilège d'avoir avec Roger Moorey, j'ai souhaité lui offrir quelques éléments de clarification dans le très complexe dossier des «faïences» architecturales de Suse. Nous espérons ne pas être trop indignes du haut niveau d'exigence scientifique établi par le discret savant d'Oxford.

Assyriens, mais il subsiste un très grand nombre de briques de construction, de pommeaux, carreaux de sols en faïence. Les conditions et les méthodes de la fouille rendent très difficile la localisation précise des vestiges et il n'est pas non plus aisé de distinguer les vestiges remontant à la dynastie des Shutrukides du 2ᵉ millénaire de ceux de leurs successeurs néo-élamites: Amiet, à qui l'on doit les principales études sur ces décors, a changé plusieurs fois d'opinion sur la date de certains (1966, 1967, 1976, 1988) en se fondant sur des critères de style; Heim, dans sa thèse consacrée à l'architecture élamite en matière vitreuse (1989), a préféré traiter ensemble les périodes médio et néo-élamites. Le catalogue systématique des briques inscrites de Suse (Malbran-Labat 1995), fondé sur les traductions pionnières du père V. Scheil, permet désormais d'associer plus aisément le témoignage des textes à celui des vestiges matériels. Des briques de construction en faïence, notamment, portent une inscription ou un élément d'inscription qui permet de les dater de la dynastie des Shutrukides (1190–1120 av. J.C.). Des divers monuments élevés par ces souverains en l'honneur du grand dieu de Suse, Inshushinak, on peut énumérer quelques éléments:

LES VESTIGES PROVENANT DU SUD-OUEST DE L'ACROPOLE

Les travaux de J. de Morgan (1900) ont mis au jour dans la zone sud-ouest du tell de l'Acropole des briques de faïence, à pâte siliceuse blanchâtre, recouverrte d'une glaçure de couleur jaune ou verte. Ces briques sont moulées, la face avant comportant un élément en relief et/ou une inscription courant d'une brique à l'autre. Amiet (1976) a proposé d'y voir une procession de personnages de la famille royale. Lambert (1978), étudiant le texte de vingt quatre des briques du Louvre, observe de nombreuses variantes et reconstitue ainsi la teneur de l'inscription:

> [...] Aimé d'Inshushinak [...] il avait enclos la ville haute et comme il [le bâtiment] avait été bâti en briques crues et menaçait de crouler, Shutruk-Nahhunte et Kutir-Nahhunte avaient enclos la ville haute, disant: «nous le reconstruirons en briques cuite et [...] ils étaient morts [...]et ils ne l'avaient pas construit. Moi, Shilhak-Inshushinak je l'ai construit en briques cuites; au maître de la ville haute [...] je l'ai donné.

Un fragment inscrit à gauche de l'élément cassé d'une jupe (Lambert 1978: n° 24 inventaire S.Acr.II 75–1285.I)) donne cette information capitale, l'emploi de briques *u-pa-at ak-ti-in-ni-ma,* que Lambert traduit par briques vernissées (voir aussi infra *upat aktiya* pour les briques de la porte du temple):

les effigies de Shutruk Nahhunte mon père chéri, de Kutir-Nahhunte, mon frère aîné, de la mienne et de Dame Nahhunte-Utu, ma femme chérie, en briques vernissées.

Deux autres fragments de briques de faïence (Lambert 1978: n° 11 Sb 11479 et n° 21 Sb11864) mentionnent «*les effigies des rois anciens*».

Enfin une brique à glaçure jaune (Sb 11487, Lambert 1978: 12 n° 9) précise le nom du bâtiment:

Moi Shilhak-Inshushinak, fils de Shutruk-Nahhunte, serviteur chéri de Inshushinak, comme le *kumpum-kiduia* avait été construit en briques crues [...]

Ce terme de *kumpum kiduya* est généralement traduit par «chapelle extérieure» (Malbran-Labat 1995); cette chapelle comportait un *suhter*, peut-être une petite pièce, une niche ou un autel associé de près à la famille royale (Grillot 1983). Lambert reconstitue ainsi les opérations: Shutruk-Nahhunte (1190–1155) décide de réédifier un édifice ancien, qui était peut-être déjà ou qui allait devenir le *kumpum kiduya*. A la mort de son père, Kutir-Nahhunte (1155–1150) continue les travaux (texte chez Malbran-Labat 1995: n° 35) qui furent terminés par son frère Shilhak-Inshushinak (1150–1120). Les variantes graphiques s'expliqueraient par les reprises sous différents règnes et la longueur des travaux. L'édifice est construit en l'honneur du dieu Inshushinak, appelé «maître de la ville haute» (Lambert 1978), «seigneur de l'Acropole» (Malbran-Labat 1995: 103). Shilhak y installe les effigies de ses prédécesseurs, «les rois anciens» et celles de sa propre famille. Enfin le dernier souverain de la dynastie, Hutelutush-Inshushinak (vers 1120), intervient dans le temple d'Inshushinak pour reconstruire le *kukunnum* (peut-être identique au *suhter*? voir Grillot 1983) et un autel d'or orné de portes d'argent et d'or (texte chez Malbran-Labat 1995: n° 53).

Les effigies royales que mentionne Shilhak semblent bien correspondre aux reliefs de briques en faïence identifiés par Amiet (1976), interprétation qui a été largement reprise et développée depuis (Grillot 1983; Heim 1989: chapitre XXVI ; Malbran-Labat 1995: n° 46). On comparera cependant l'information que donnent les briques avec la mention «d'effigies de pierre» que Shilhak fait par ailleurs dans le texte de sa grande stèle:

O Inshushinak seigneur, grand seigneur de...moi, Shilhak-Inshushinak une stèle en pierre je fis et des images de ma personne, des images de Nahhunte-Utu, ma chère femme, et des images de notre famille, en pierre je fis.

(Scheil 1911: 53)

L'explication est soit qu'il existait une série différente de portraits royaux, réalisés en pierre, soit que Shilhak désigne ainsi les reliefs de briques siliceuses qui ont une apparence de «grès» (Lambert 1978: 8, voir aussi infra, appendice).

LES VESTIGES RETROUVÉS SOUS L'APADANA

Sur le flanc nord-est du tell de l'Apadana, Mecquenem (1922: 127) a dégagé, à proximité de tombeaux élamites voûtés, des briques d'argile cuite remployées dans des «aqueduc» du palais achéménide. Ces briques comportent un élément en relief dont la juxtaposition montre les motifs répétés représentant un homme taureau tenant un palmier et une déesse d'intercession vue de face (Unvala 1928); à hauteur du ventre des personnages, une inscription gravée dans la brique mentionne la fondation d'un *kumpum kiduya* dans le sanctuaire du dieu Inshushinak par deux souverains successifs, Kutir-Nahhunte (1155–1150) et Shilhak-Inshushinak (1150–1120):

> Moi, Kutir-Nahhunte, fils de Shutruk-Nahhunte, serviteur bien aimé d'Inshushinak, comme la chapelle extérieure *[kumpum kiduya]* avait été bâtie en briques crues et qu'elle menaçait ruine, je l'ai remise en état et reconstruite en briques cuite; je l'ai consacrée à Inshushinak, mon dieu. O Inshushinak, mon dieu, que l'œuvre que j'ai réalisée te soit agréable en offrande et puisses-tu rendre prospère le pouvoir qui est représenté.
>
> (Malbran-Labat 1995: n° 35)

> Moi, Shilhak-Inshushinak, fils de Shutruk-Nahhunté, roi d'Anzan et de Suse : Kutir-Nahhunte avait fait fabriquer des représentations de brique cuites et avait décidé «dans le temple d'Inshushinak, je les édifierai» ; mais il ne l'avait pas fait, comme il était mort avant; moi, placé sur le trône, quant aux représentations de briques, je l'ai suppléé. Je les ai réalisées et j'ai ainsi édifié la chapelle extérieure *[kumpum kiduya]*. Je l'ai consacrée à Inshushinak mon dieu. O Inshushinak, que l'œuvre que j'ai réalisée te soit agréable en offrande!
>
> (Malbran-Labat 1995: n° 41)

Existait-il un ou deux *kumpum kiduya,* pouvait-il exister deux sanctuaires d'Inshushinak à Suse? Sur ce secteur de l'Apadana, les informations de Mecquenem sont pour le moins ambiguës; sa première impression semble indiquer que les briques argileuses à relief sont des éléments de remploi sous ou dans les fondations de l'Apadana: «de nombreux aqueducs et pans de murs renfermant dans leurs matériaux des briques inscrites, des briques à reliefs, un grand dallage. [qui ont permis de] reconstituer trois motifs et leur frise appartenant à un panneau de mur» (Mecquenem 1922: 127–129: une

première reconstitution de ces panneaux est donnée dans la planche reliée entre les pages 128 et 129). Puis il indique

> il a été procédé au déblaiement complet du grand dallage carré découvert en 1922 et qui d'après les briques à relief inscrites recueillies devait appartenir à un sanctuaire dédié au dieu Chouchinak. Il avait une vingtaine de mètres de côté et était orienté comme le palais achéménide. Nous avons trouvé plusieurs éléments des panneaux à relief... en particulier deux exemplaires de la brique qui donne les épaules et la barbe de l'homme taureau.
>
> (Mecquenem 1924: 115)

La plupart des auteurs, à commencer par Unvala (1928: 181), ont conclu de ces indications à la présence d'un deuxième sanctuaire dédié à Inshushinak sur le tell de l'Acropole. L'existence de ce deuxième complexe favorise l'interprétation du terme *kumpum kiduya* comme «temple extérieur ou chapelle extérieure», c'est à dire hors de l'Acropole (Grillot 1983; Amiet 1988). Cette interprétation a été reprise par Heim (1989), Tallon (1992: 126) enfin Malbran-Labat (1995: 189), cette dernière concluant prudemment: «l'archéologie montre qu'il a dû en exister deux, l'une sur l'Acropole, et l'autre dans le quartier royal.» La présence de tombeaux élamites à proximité de ce bâtiment peut en effet faire penser au caractère souterrain et caché du dieu Inshushinak tel que le décrit le prisme d'Assurbanipal (Aynard 1957).

Si l'on examine de près les indications de Mecquenem, on verra qu'en fait les éléments épars des deux ensembles ont probablement été trouvés aussi bien sous l'Apadana que sur le tell de l'Acropole. Bien qu'il ne s'en explique jamais très précisément, Mecquenem a mêlé les origines des fragments appartenant à chacun des deux ensembles (**a:** frise en brique argileuse représentant une séquence homme taureau tenant un palmier – déesse d'intercession **b:** frise en faïence représentant des personnages royaux). Pour l'ensemble **a**, Mecquenem dit tout d'abord (1922) n'avoir retrouvé que les fragments de l'épaule et la barbe de l'homme taureau, alors que le Louvre conserve plusieurs exemplaires complets de chacun des panneaux. Unvala (1928: 179) indique que les fouilles ultérieures sur le tell *de la cité royale* (c'est à dire l'Acropole) et sur le tell *de l'Apadana* ont livré la suite de la frise **a**, tandis que des briques à glaçure de l'ensemble **b**, majoritairement découvert sur l'Acropole, auraient été aussi retrouvées au voisinage du bâtiment de vingt mètres de côté repéré sous l'Apadana (Unvala 1928: 181).

Tout indique que les éléments retrouvés sous l'Apadana, briques d'argiles de la frise **a** et probablement quelques briques en faïence de la frise **b**, sont bien des éléments de remplois. Ils ne proviennent sans doute pas de struc-

tures sous-jacentes mais ont probablement été transportés depuis l'Acropole où d'autres éléments du même ensemble sont restés. On imagine que ces matériaux ont pu être déménagés en masse du vieux complexe sacré d'Inshushinak détruit après la conquête assyrienne; ils ont été utilisés lors de la reconstruction d'époque perse à la fabrication de ces «aqueducs et dallages» retrouvés dans les infrastructures du palais de Darius sur l'Apadana. Si «chapelle extérieure» il y a, elle s'élevait à proximité immédiate du vieil emplacement du temple d'Inshushinak. Il n'y a eu à Suse qu'un seul complexe sacré consacré au dieu Inshushinak, érigé de toute antiquité et mainte fois agrandi et transformé, sur le tell de l'Acropole.

La porte du temple d'Inshushinak sur l'Acropole

Nous connaissons encore un élément de ce temple d'Inshushinak, une porte magnifique ornée d'or. Il reste de cette porte, construite ou restaurée par Shilhak-Inshushinak, soixante sept briques de fondation en argile cuite (Malbran-Labat 1995: 97–99, n° 43) et une grande série de briques siliceuses (Malbran-Labat 1995: 114–117, n° 50). Le texte des briques d'argile spécifie que le souverain a utilisé des briques *aktiya*, ou *upat aktiya*, terme que Lambert (1978: n° 24) et Malbran-Labat traduisent par «briques émaillées» (voir aussi Malbran-Labat 1995: 153):

> Le temple d'Inshushinak avait été construit en briques crues, et comme il menaçait ruine, je l'ai reconstruit en briques cuites et la structure de la porte je l'ai construite en briques émaillées et je l'ai enserrée de montants d'or.
>
> (Malbran-Labat 1995: 97)

Cette traduction du terme *aktiya* est clairement confortée par la technique employée pour les briques siliceuses, plus de 150 briques dans deux formats (les unes inscrites sur une face, les autres sur cinq faces) recouvertes d'une glaçure bleuâtre aujourd'hui très effacée. Le texte en est beaucoup plus long et mentionne les ascendants et la descendance du souverain, y compris son épouse Nahhunte-Utu et ses enfants, notamment son successeur Hutelutush-Inshushinak. On retrouve là les préoccupations familiales qui ont présidé à l'érection du *kumpum kiduya* évoqué ci-dessus:

> Moi Shilhak-Inshushinak fils de Shutruk-Nahhunte serviteur bien-aimé d'Inshushinak roi d'Anzan et de Suse: les rois mes prédécesseurs avaient bâti cette Porte en briques cuites, moi Shilhak-Inshushinak je l'ai faite en briques émaillées. J'y ai inscrit mon nom et pour ma vie, celle de Nahhunte-Utu, celle de Hutelutush-Inshushinak, celle de Shilhina-hamru-Lakamar, celle de Kutir-Huban, celle de Temti-tur-katash, celle d'Ishnikarab-huhun, celle

d'Urutuk-El-halahu et celle d'Utu-ehih-Pinigir, c'est à cette intention que pour notre sauvegarde, j'ai bâti cette Porte, la «Porte d'Inshushinak, mon dieu»; O Inshushinak, mon dieu, pour moi et pour Nahhunte-Utu, nous qui avons établi une lignée, qu'il n'y ait pas d'extinction de sa descendance (quand elle sera) jugée et qu'il n'y ait pas d'extinction de notre descendance quand elle sera jugée et que l'œuvre que j'ai accomplie te soit agréable en offrande!

<div align="right">(Malbran-Labat 1985: n° 50)</div>

De l'étude de ces différents vestiges, il ressort clairement que les Elamites maîtrisaient parfaitement l'emploi de la faïence et autres matières vitreuses dans l'architecture monumentale. A Tchoga Zanbil, Untash-Napirisha (1340–1300) a recours à cette technique colorée pour le décor rapporté: animaux gardiens, carreaux, pommeaux et éléments d'applique (Amiet 1966: n° 260 et suiv.). La dynastie des Shutrukides (1190–1120) inaugure à Suse la technique de la construction directe en briques de faïence, moulées en pâte siliceuse, dont l'éclatante glaçure évoquait l'or et le lapis. Cette tradition fut poursuivie par leurs successeurs néo-élamites (Malbran-Labat 1995: n° 54 et suiv.). Il faut attendre le règne de Darius (522–486) pour que les frises de briques portent un décor polychrome, dont l'origine remonte autant aux traditions locales qu'à l'apport des maçons Babyloniens mentionnés par les textes de fondation de Darius.

APPENDICE

Les souverains Shutrukides ont laissé à Bender Bouchir, sur le Golfe persique, les traces de leur activité de bâtisseur, une construction en l'honneur de la déesse Kiririsha, «Dame de Liyan». Les inscription de fondation de Shilhak-Inshushinak, sur briques d'argile, mentionnent un ou peut-être deux autres termes en rapport avec l'artisanat des matières vitreuses (Pézard 1914: 80, n° 34):

Moi, Shilhak-Inshushinak, fils de Shutruk-Nahhunte, roi d'Anzan et de Suse; comme le temple de Kiririsha, la Dame cachée de Liyan, que Humbanumena avait construit, menaçait ruine, je l'ai remis en état: j'ai décidé sa restauration et je l'ai reconstruit en briques cuites; je l'ai orné en (briques) glaçurées★ et j'ai décidé sa rénovation en gypse† [...].

<div align="right">(Malbran-Labat 1995: 95–6, n° 42)</div>

Les termes employés sont ★*kuramma karrah* et †*kulamma sahtirmah*: deux sens différents sont proposés qui reposent sur le choix entre deux homophones *kula* «gypse» et *kula* «prier» donnant la traduction «ayant prié j'ai offert un sacrifice».

BIBLIOGRAPHIE

Amiet, P.
1966 *Elam.* Auvers sur Oise.
1967 Eléments émaillés du décor architectural néo-élamite, avec un appendice de M. Lambert, *Syria* 44: 27–51.
1976 Disjecta Membra Aelamica: le décor architectural en briques émaillées à Suse. *Arts Asiatiques* 32: 13–28.
1988 *Suse 6000 ans d'histoire.* Paris: Réunion des Musées Nationaux.

Aynard, J.–M.
1957 *Le prisme du Louvre AO 19.939.* Bibliothèque de l'École des Hautes Études. Section des sciences historiques et philologiques. fasc. 309. Paris: Champion.

Carter, E., and Stolper, M. W.
1984 *Elam. Surveys of Political History and Archaeology.* Berkeley.

Grillot, F.
1983 Le «Suhter» royal de Suse. *Iranica Antiqua* 18: 1–23.

Heim, S.
1989 Glazed Architectural Elements from Elam and related Materials from Luristan, Ph.D. Diss. Institute of Fine Arts, NYU, New York (UMI Dissertation Service, Ann Arbor, Michigan, 1990).
1992 Royal and religious structures and their decoration; Glazed objects and the Elamite glaze industry. In *The Royal City of Susa: Ancient Near Eastern Treasures in the Louvre* (P. Harper, J. Aruz and F. Tallon, eds.). New York: Metropolitan Museum of Art, 123–127 and 202–210.

Kaczmarcyk, A. et Hedges, R. E. M.
1983 *Ancient Egyptian Faience. An Analytical Survey of Egyptian Faience from Predynastic to Roman Times.* Warminster, London: Aris and Phillips.

Lambert, M.
1978 Inscriptions du décor architectural construit par Shilhak-Inshushinak. *Arts Asiatiques* 34: 3–27.

Malbran-Labat, F.
1995 *Les inscriptions royales de Suse. Briques de l'époque paléo-élamite à l'Empire néo-élamite.* Paris: Musée du Louvre, Département des Antiquités Orientales, Réunion des Musées Nationaux.

Matoïan, V.
2000 *Ras Shamra Ougarit (Syrie) et la production des matières vitreuses au Proche-Orient au II^e millénaire avant Jésus-Christ.* Thèse de l'Université de Paris I, Panthéon-Sorbonne.

Mecquenem, R. de
1922 Fouilles de Suse. Campagnes 1914–1921–1922. *Revue d'Assyriologie* 19: 109–40.
1924 Fouilles de Suse (campagnes 1923–1924). *Revue d'Assyriologie* 21: 105–18.

Moorey, P. R. S.
1994 *Ancient Mesopotamian Materials and Industries.* Oxford: Clarendon Press.

Morgan, J. de
1900 *Recherches Archéologiques.* Mémoires de la Délégation en Perse 1. Paris: E. Leroux.

Pézard, M.
1914 *Mission à Bender-Bouchir: Documents Archéologiques et Épigraphiques.* Publications de la Mission Archéologique de Perse 15. Paris: E. Leroux.

Scheil, V.
1911 *Textes Élamites-Anzanites Quatrième Série.* Mémoires de la Délégation en Perse 11. Paris: E. Leroux.

Unvala, J. M.
1928 Three panels from Susa. *Revue d'Assyriologie* 25: 179–85.

Vitreous materials in Ugarit: new data

Valerie Matoïan and Anne Bouquillon

INTRODUCTION

Defined by its form, colour and material, the archaeological object is, for the archaeologist and historian, one of the most tangible expressions of the culture to which it belongs. It is a direct source, a time machine, the analysis of which augments its importance. We focus here on objects in vitreous materials, luxury objects which were characteristic of the Near East and the eastern Mediterranean in the Bronze Age.[1] These artificial materials, products of the mastery of pyrotechnology, have excited growing interest in the international scientific community over the last few decades. Our efforts lie specifically within the field of P. R. S. Moorey's research on Mesopotamian material (Moorey 1994), combining social science with material science.

The production of vitreous materials in the Near East shows a remarkable development during the Bronze Age (Moorey 1994: 141–215; Peltenberg 1987) and reached a peak in the Late Bronze Age in the second half of the second millennium BC. Within the context of the Near East, the Levant is particularly interesting because of its location between Mesopotamia, Egypt and the Aegean.

Our work is based upon the study of the material culture of one of the civilizations that flourished on the shores of the eastern Mediterranean, that of Ugarit. This kingdom, located on the coast of northern Syria, lies in a strategic position at the crossroads of international exchange in this period (Yon 1997). The study of the vitreous materials from the site of Ras Shamra–Ugarit, capital of the kingdom, and from its principal port at Minet el-Beida, throws new light on this subject for the second millennium BC.

1 We address our most sincere thanks to A. Caubet (Keeper of the Department of Oriental Antiquities of the Louvre Museum), J.-P. Mohen (Director of the Centre de Recherche et de Restauration des Musées de France (C2RMF) Paris), Y. Calvet (CNRS, Lyon) and B. Jammous (Directorate of Antiquities and Museums of Syria), Directors of the archaeological mission of Ras Shamra-Ugarit, M. Yon (CNRS, Lyon), M. Yabroudi (Keeper of the Department of Antiquities at the National Museum of Damascus), M. Menu (responsible for research department), J. Salomon, A. Duval and S. Pagès-Camagna (engineers), D. Bagault (photographer at C2RMF), and C. Florimont (Louvre Museum) and L. Volay (Ras Shamra mission) (draughtsmen).

The material in 'faience',[2] 'Egyptian blue',[3] glass and glazed pottery is represented by an exceptional group of nearly 20,000 pieces, recovered since the end of the 1920s. This reference corpus, unpublished for the most part,[4] is one of the most important in the Near East.

The majority of the finds come from Ras Shamra, with less than 2% from Minet el-Beida. They are mainly manufactured objects. We count some 18,000 pieces in 'faience', a thousand in glass, 266 in 'Egyptian blue', and 27 in glazed pottery. The material dating to the late Middle Bronze Age (18th to beginning of the 16th century BC) represents less than 1% of the corpus (179 objects in 'faience' and a bead in 'Egyptian blue'). Most of the objects thus date to the Late Bronze Age, to a period between the 14th and 12th centuries BC.

The material is representative of the different sectors excavated on the two sites. The variety of the discovered contexts indicates that these objects were both used by the living and intended to accompany the dead in the afterlife. In the areas of daily life, the objects in vitreous materials were found in private homes as well as in the palace sector. The palace produced most of the blocks of raw material (glass and 'Egyptian blue') (Matoïan in press).

The very great typological variety of the material in 'faience', in 'Egyptian blue' and in glass is of particular interest. There are beads (the most common type), pendants, rings, cylinder seals, stamp seals, scarabs, gaming pieces, elements for inlay, decorative pieces, figurines and vessels. The technique of glazed pottery is represented only by vessels, all the forms being closed. Although these materials are closely related, the formal and decorative repertoires of the objects are mostly quite different from each other.

A typological, stylistic and technical study of all the material has enabled an integration of the vitreous materials of Ugarit into the history of technology and culture in the Near East and eastern Mediterranean.[5] In this article

2 Objects in 'faience' have a body of quartz or sand grains cemented by a vitreous phase and covered by an alkaline glaze.
3 By 'Egyptian blue' we mean a complex mixture which consists of crystalline phases, among which are cuprorivaite but also quartz, tridymite, wollastonite, as well as a vitreous phase. The mixture is obtained after a series of fritting, crushing and firing procedures in an oxidizing atmosphere (between 876° and 1050°C) of an initial mixture of sand, calcite, copper compounds and alkalis.
4 Some series of objects have been published; see in particular Schaeffer 1983; Caubet 1985, 1987; Caubet and Kaczmarczyk 1987, 1989; Matoïan 1999, 2000c; Matoïan and Bouquillon 1999, 2000.
5 Matoïan 2000a. This work will be published in the collection *Bibliothèque archéologique et historique* de l'Institut Français d'Archéologie du Proche-Orient, Beirut.

Fig. 1. Ugarit powdered glass: detail of the raw material. The different grey levels reveal different chemical compositions. The whitish zones are characterized by an important concentration of copper oxides.

we present the main results of the archaeometric study. Several series of objects have been analysed at the Centre de Recherche et de Restauration des Musées de France. Three lines of research have been developed and carried out by the authors of this article. These studies are mainly concerned with the material in 'Egyptian blue', glazed pottery, and to a lesser extent, glass (Bouquillon and Matoïan 1998; Matoïan 2000a; Matoïan and Bouquillon 1999, 2000). The main goals of the research were to define the physico-chemical and structural characteristics of the materials and to discuss the origin of the raw materials and the places of manufacture.

These programmes are a continuation of the research carried out by A. Kaczmarczyk on glazes of the ancient Near East in the collections of the Department of Oriental Antiquities of the Louvre Museum, under the direction of A. Caubet, for which the data concerning the material from Ugarit have already been published[6]. Certain points will be compared with our own results.

6 The reader may refer to the following publications: Caubet and Kaczmarczyk 1987, 1989; Caubet et al. in press. The X–ray fluorescence method was used for the analysis of the glazes.

CHARACTERIZATION AND DEFINITION OF THE MATERIALS

Many researchers have pointed out the problems of the identification of ancient vitreous materials. There is a double difficulty: first, the complex nature of the materials and second, their state of conservation, as they are often highly altered. A simple visual examination is insufficient to define these materials precisely: physical and chemical analyses are necessary.

Glass is represented at Ugarit by about a thousand objects dated to the Late Bronze Age: beads of various forms (which form the majority, some 900 specimens), but also pendants, elements for inlay, gaming pieces, vessels, knobs, scarab forms, rings, as well as an element of statuary. These objects are monochrome for the most part. A small number of objects are polychrome, the effect being achieved by thin decorative lines applied to a single-colour background. The colours recognized on this material are blue, green, yellow, white, and to a lesser extent, orange, brown, ochre, amber, and amethyst.

Besides these manufactured objects, twenty blocks of raw material, all blue, were also recovered. Our laboratory analyses were concerned only with the latter. Naked-eye examination of the glass blocks revealed different tones of blue and different textures. Two main groups were distinguished: in the first, the material of the blocks has a sugary aspect and a turquoise blue colour; in the second, it is homogenous (often with bubbles visible on the surface), the aspect is vitreous and the colour is dark turquoise blue, sometimes almost black.

One block of each type was analysed using an electron scanning microscope coupled with an EDS system. The results indicate two different materials. The chemical composition of the block with a sugary appearance was dominated by silica and its morphology is typical of an altered vitreous phase. The heterogeneity of the components (recrystallized quartz, copper-enriched zones at the quartz/vitreous phase interface, ghosts of vitreous inclusions) (Fig. 1) indicates that this was a glass which was initially very heterogenous or a fritted material. The other block, dark blue in colour, is very well preserved. Only the surface presents iridescence typical of the first stages of alteration. The composition is that of a glass with high sodium and calcium content, coloured as a whole by cobalt. The material contains calcium antimoniate, a traditional opacifier of ancient glasses.

'Egyptian blue' is represented at Ugarit by almost two hundred and fifty manufactured objects, small in size, and a series of twenty small blocks of raw material. Except for one bead discovered in a late Middle Bronze Age context, the whole of the corpus dates to the end of the Late Bronze Age. The

Fig. 2a. Detail of the main components of an 'Egyptian blue' bead. The main chemical composition is 60.5% SiO_2, 14.2% CaO, 17% CuO. Cup = Cuprorivaite, Q = quartz, AGP = altered glassy phase, Sn = small tin residues.

Fig. 2b. Detail of a 'faience' body coloured by 'Egyptian blue'. The chemical composition is characterized by high amounts of silica 78% SiO_2, associated with 7.5% CaO, 8.9% CuO.

material divides into different categories: beads (176), cylinder-seals (47), scarabs and scarab forms (13), disc fragments (4), vessels (3), gaming pieces (2) and a stamp seal.

Analyses were made on a representative selection of the objects, equivalent to about 10% of the corpus. This consists of twenty-five manufactured objects and two blocks of raw material.[7] After characterization of the materials, two groups of objects were differentiated according to mineralogy, chemistry and structure of the material (Figs. 2a and 2b).

The first group consists of eighteen pieces, of which two are blocks of raw material, all of a strong blue colour (Fig. 3). It is characterized by a chemical composition which is completely compatible with what we know as 'Egyptian blue' (Tite et al. 1984; Tite 1986; Pagès-Camagna et al. 2000). From a mineralogical point of view, cuprorivaite dominates and is associated with quartz. Finer observations of the structure of the material reveal great heterogeneity in the sizes and in the states of preservation of the tabular crystals of cuprorivaite and the presence of highly altered interstitial vitreous phases, enclosing quartz grains which are unmelted or recrystallized as

7 The techniques used were X-ray diffraction, electron scanning microscope with X-ray analysis system, analysis by PIXE ions (Particle-induced X-ray emission). The use of these methods is described in the following articles: Bouquillon and Matoïan 1998; Matoïan and Bouquillon 2000. It is to be noted that PIXE is a non-destructive method, which gives here the composition of the surface of the objects.

trydimite. Metallic oxides (copper, arsenic, tin) are also sometimes present. These oxides suggest the use of bronze as a source of copper. This phenomenon is frequently mentioned for 'Egyptian blue' from the Nile valley,[8] and has already been observed by A. Kaczmarczyk for the Ugarit material (Caubet and Kaczmarczyk 1987: 52).

The second group consists of seven pieces, light blue in colour (Fig. 4), in which the dominant mineral is quartz (more than 70% in the bulk chemical analysis) sometimes associated with trydimite and more scattered crystals of cuprorivaite. The structures are homogenous and the quartz grains constitute a simple matrix in which the grains of cuprorivaite are distributed.

An archaeometric approach is thus necessary. It has enabled the identification of two types of artificial material. We have two different uses for 'Egyptian blue': as a raw material in the objects of the group called solid 'Egyptian blue' and as a colouring for the 'faience'[9] for the second group. In general these two materials are observed in the different recognized typological categories. However there are exceptions, such as the objects of Egyptian style, all having a strong blue colour, that is a solid 'Egyptian blue'.

Glazed pottery is represented by twenty-seven vessels of closed form (Fig. 5), dated to the end of the Late Bronze Age. They are wheel-made and decorated with a monochrome glaze that has become greatly altered. The large majority of the vessels are bottles with ovoid bellies, short narrow necks and pedestal bases. There are also some rare gourd-like forms with rounded bases, as well as a vase with a spherical belly on a ring base.

Analyses using mainly petrographic and electron scanning microscopy (Matoïan and Bouquillon 1999) were carried out on a selection of eleven vessels, representative of the different typological groups. The material of Ugarit is homogenous from a technological viewpoint. The pottery itself consists of a fine marl containing some quartz grains, feldspath, mica and occasional crystals of brown amphibole. Imprints of plant fragments remain visible. The fibres were carbonized during firing, estimated at about 1000°C, because of the presence of diopside and gehlenite in the clay body (Echallier and Méry 1992) (Table 1).

The glaze covers the interior and the exterior of the objects, leading to the supposition that the vessels were immersed in a bath of glazing mixture. The study of this material is rendered more complicated because of the great alteration of the vitreous components. In all the examples, it consists of a

8 Kaczmarczyk and Hedges 1983: 78–94, Figs. 11–12; Tite et al. 1984: 218; Tite et al. 1986: 40; El Goresy et al. 1995; Pagès-Camagna 1998: 169 and 173.
9 The body of the 'faience' consists of quartz or sand grains cemented by a vitreous phase.

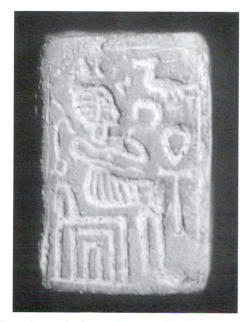

Fig. 3. Bead with Egyptian-style decoration in solid 'Egyptian blue', Minet el–Beida
(Louvre Museum, AO 30758, photograph V. Matoïan).

Fig. 4. Gaming piece with a body of 'faience' coloured by 'Egyptian blue', Ras Shamra
(Museum of Ras Ibn Hani Excavation, photograph D. Bagault C2RMF). Scale c. 1:2.5.

	Na$_2$O	MgO	Al$_2$O$_3$	SiO$_2$	SO$_3$	Cl	K$_2$O	CaO	TiO$_2$	Fe$_2$O$_3$
Mean	2.1	6.4	13.1	48	1	0.4	1.4	18.2	0.8	8.7
Std.dev	0.6	0.7	0.6	2.8	0.5	0.5	0.4	1.9	0.1	1.2

Table 1. Chemical composition of the glazed ceramics from Ugarit in percentages by weight. Data obtained with MEB-EDS.

calco-alkaline vitreous cover, often thick (more than 250 microns on the exterior and close to 200 microns on the interior). It was applied directly onto the surface of the ware without an intermediate slip. The colour, mainly blue-green, is achieved by the addition of copper and iron oxides, as is often the case in the glasses and glazes of this period.

THE QUESTION OF THE ORIGIN OF THE RAW MATERIALS
AND THE CENTRES OF PRODUCTION

Research is essential for the study of the material culture of Ugarit where cosmopolitanism often left its mark on artistic production. Moreover, the period is characterized by the development of international exchanges which concerned humans as much as raw materials and manufactured objects. Unfortunately the data from the excavations do not inform us about a possible site at Ugarit or nearby of a workshop producing vitreous materials. The results of the archaeological and archaeometric study of the discovered objects present a body of evidence which enables the recognition of local productions and probable imports.

The evidence for imports

Imports are perceptible beginning in the Middle Bronze Age (from Egypt and Anatolia). Their number rises in the Late Bronze Age. Then the origins become more varied (Mycenaean world, Cyprus, inner Syria, Mesopotamia) although Egypt represents the main source. Our archaeometric study seems to confirm the presence, among the glass and the 'Egyptian blue' material, of products imported from the Nile valley.

As we have mentioned, the presence of the two different materials within the group of raw glass blocks has been ascertained. One of them corresponds to a glass, the composition of which is very close to that of Egyptian glasses of the New Kingdom. It is coloured by cobalt containing impurities (manganese, nickel, copper, aluminium), typical of the minerals of the oases of the Egyptian desert (Kaczmarczyk 1986) (Table 2). The hypothesis of an import from the Nile valley is therefore not impossible (Matoïan 2000b) and could be correlated with the finds from the shipwreck of Uluburun, found

Fig. 5. Two bottles in glazed pottery from Minet el–Beida (left, Louvre Museum, AO 15749, drawing by C. Florimont) and Ras Shamra–Ugarit (right, National Museum of Damascus, 7304, drawing by L. Volay). Scale c. 1:4.

off the southern coast of Turkey. It contained glass ingots of an intense blue coloured with cobalt, the composition of which is similar to those of Egyptian glasses (Bass et al. 1989; Nicholson et al. 1997) and that of the Ugarit block. The cargo of this ship, dated to about 1300 BC, is exceptional evidence for trade in glass in the eastern Mediterranean at the end of the Late Bronze Age.

This Egyptian cobalt is also found in a series of small objects (beads, pendants, ring, etc.) found at Ugarit made in a monochrome 'faience'

		MgO %	Al_2O_3 %	SO_3 %	Cl %	CoO ppm	As_2O_5 ppm	SrO ppm
Egyptian style objects	Mean	0.45	2.7	0.9	0.7	238	1156	1539
	Std. dev.	0.4	0.8	0.4	0.4	87	368	498
Mittanian style seals	Mean	2.6	5.8	3.3	2.3	149	105	6198
	Std. dev.	1.7	2	1.3	1.1	97	99	173

Table 2. Variations of some chemical elements measured in some Egyptian–style objects and some Mitannian–style seals.

characterized by a grey-blue glaze, covering a body of the same colour. Their forms and styles are typically Egyptian, and also the technique used, as was demonstrated in the works of A. Caubet and A. Kaczmarczyk (1987).

The indicators of origin are more complex for 'Egyptian blue'. The typological and stylistic study of the material in 'Egytian blue' from Ras Shamra and Minet el-Beida has revealed a large variety, with a predominance of undecorated beads in simple forms (about 70% of the corpus). The remaining 30% is divided mainly between two groups: a small series of Egyptian-style objects (beads, scarabs, a vessel and a gaming piece), and some forty cylinder seals which belong to the Mitannian 'common style' tradition.

Within the group of objects in solid 'Egyptian blue', the comparison of different results has enabled a new hypothesis to be proposed concerning the origin of Egyptian-style objects found at Ugarit. The chemical compositions present clear differences for some minor elements (Al, Mg, S) and for trace elements (Mn, Co, As, Sr, Sn). All the objects of Egyptian style present proportions typical of those of pigments used in Egypt in the New Kingdom (Tite et al. 1984; Tite 1986; El-Goresy et al. 1995), which reinforces the hypothesis of import from the Nile Valley (Fig. 6).

Indications of local production
The existence of a local (or regional) production is particularly complex to define in the absence of evidence from workshop(s). The hypotheses rest on

Fig. 6. Two seals, a pendant and a vessel in solid 'Egyptian blue', Minet el-Beida and Ras Shamra (Louvre Museum, AO 14725 and AO 14726, drawings by C. Florimont and National Museum of Damascus, 5758 and 7192, drawings by L. Volay). Scale of seals and pendant 1:1. Scale of vessel 1:2.

Fig. 7. Cup and beaker in 'faience' with 'Egyptianizing' decoration, Minet el-Beida (Louvre Museum, AO 15727 and AO 14918, drawings by C. Florimont). Scale c. 1:4.

a body of indications from typological, sylistic and archaeometric analysis, to which the numerical importance of the corpus should be associated.

For the glass, the existence of a primary workshop is proposed. The blocks of raw material, sugary in texture and turquoise in colour, could correspond to a fritted material, used in an intermediate stage in the manufacture of glass, indicating a possible production of the raw material at Ugarit.

The existence of secondary workshop(s) is possible for the 'Egyptian blue', the 'faience' and the glazed pottery. For the 'Egyptian blue', the state of alteration of the blocks of raw material does not yet allow us to discuss their origin without complementary analyses. On the other hand, for the manufactured objects, we have observed the use of 'Egyptian blue' for colouring small pieces made in a body of 'faience'. In the present state of knowledge, this usage seems to have occurred only at Ugarit for the period under consideration. We can therefore reasonably consider this to be a local production.

For 'faience', non-Egyptian recipes are known, indicating once again a possible local (or regional) production. Thus, the study by A. Caubet and A. Kaczmarczyk presented, among the Egyptian-style objects, a series of vessels

decorated with Egyptian motifs painted in black on a background of blue glaze, of non-Egyptian manufacture. The chromophore elements (magnesium oxide and iron oxide) are the same as in Egypt, but the formula used appears to be different. The ratio of manganese to iron is higher than in Egypt (Caubet and Kaczmarczyk 1987: 49; 1989: 211–212 and 214, Figs. 27.2 and 27.4). Moreover, the presence of barium has been detected in the black glaze of some objects (a cup with *wadjat*-eye decoration, a lotiform beaker (Fig. 7) and a box). The presence of this element could indicate for the manganese a source other than that used by New Kingdom Egypt, such as psilomelane (which contains barium) instead of pyrolusite (which does not). These productions have been classified by the authors as 'Egyptianizing' (Caubet and Kaczmarczyk 1987).

The case of the glazed clay pottery is different, as this material was not known in Egypt during the Bronze Age, and was very rare in the southern Levant. A particular difficulty lies in the great similarity between the corpus of Ugarit and those of the sites of the southern and southeastern coasts of Cyprus (Kition, Kition-Bamboula, Enkomi, Maa-Palaekastro, etc.). The northern Levant and Cyprus are areas where cross-cultural blending occurred and reached its peak at the end of the Late Bronze Age in the production of luxury objects. The archaeometric study has demonstrated the homogeneity of the corpus of Ugarit. Moreover, all the mineral components observed in the wares during examination by petrographic microscope can be found in the geological environment near Ras Shamra, which supports the hypothesis of a local production. Some laboratory analyses which were carried out seem to indicate that the mineralogical compositions of the Ugarit wares and those of Cyprus differ slightly, but this observation must be confirmed on a larger scale (Matoïan and Bouquillon 1999).

An understanding of manufacturing processes is indispensable for the study of ancient societies and the broadening of our knowledge concerning these technologies necessitates the development of archaeometric studies. The site of Ugarit is exceptional for understanding urban and palace civilization in the Bronze Age. The results of our research support in particular the hypothesis of imports from the Nile Valley and of a local production of objects in 'Egyptian blue', in 'faience' and in glazed pottery. The northern Levant thus takes its place as a source of production for vitreous materials, as much as the large known centres of Egypt, the Aegean and Mesopotamia.

REFERENCES CITED

Bass, G. F., Pulak, C., Collon, D. and Weinstein, J.

1989 The Bronze Age shipwreck at Ulu Burun: 1986 Campaign. *American Journal of Archaeology* 93: 1–29.

Bouquillon, A. and Matoïan, V.

1998 Deux perles syriennes en 'bleu égyptien': savoir-faire local ou matériau importé? *Techne* 7: 21–2.

Caubet, A.

1985 Poterie tournée à glaçure du Bronze Récent: Syrie et Chypre. In *De l'Indus aux Balkans, Recueil Jean Deshayes*, (J. L. Huot, M. Yon and Y. Calvet, eds.). Paris: Éditions Recherche sur les Civilisations, 191–8.

1987 Les objets en matière vitreuse: fritte, faïence, verre. In *Le Centre de la Ville, Ras Shamra-Ougarit III, 38e–44e campagnes (1978–1984)*, (M. Yon, ed.). Paris: Éditions Recherche sur les Civilisations, 329–42.

Caubet, A. and Kaczmarczyk, A.

1987 Bronze Age faience from Ras Shamra (Ugarit). In *Early Vitreous Materials* (M. Bimson and I. C. Freestone, eds.). British Museum Occasional Paper 56. London, 47–56.

1989 Trade and local production in Late Cypriot faience. In *Early Society in Cyprus* (E. J. Peltenburg, ed.). Edinburgh University Press, 209–15.

Caubet, A., Kaczmarczyk, A., Matoïan, V. and Bouquillon, A.

In press *Faïences et verres de l'Orient ancien*. Notes et Documents. Paris: Réunion des Musées Nationaux.

Échallier, J.-Cl. and Méry, S.

1992 L'évolution minéralogique et physico-chimique des pâtes calcaires au cours de la cuisson: expérimentation en laboratoire et application archéologique. *Institut Géologique Albert Lapparent, Documents et Travaux* 16: 87–120.

El-Goresy, A., Schiegl, S. and Weiner, K. L.

1995 A precise chronological scheme for the technological evolution of copper from arsenical copper to bronze and tin–lead bronze in ancient Egypt. In *International Conference on Ancient Egyptian Mining and Conservation of Metallic Artefacts*, Cairo, December 1995, 2–25.

Kaczmarczyk, A.

1986 The source of cobalt in ancient Egyptian pigments. In *Proceedings of the 24th International Archaeometry Symposium* (J. S. Olin and M. J. Blackman, eds.). Washington: Smithsonian Institution Press, 369–76.

In press Compositions et variations historiques et régionales. In *Faïences et verres de l'Orient ancien* (A. Caubet, A. Kaczmarczyk and V. Matoïan). Paris: Réunion des Musées Nationaux.

Kaczmarczyk, A. and Hedges, R. E. M.

1983 *An Analytical Survey of Egyptian Faience from Predynastic to Roman Times*. Warminster: Aris and Phillips.

Matoïan, V.

1999 L'art des objets en matériaux vitreux. In Dossier *Le mystère Ougarit* (F. Mébarki and M. Yon, eds.), *Le Monde de la Bible* 120, juillet–août 1999: 56–7.

2000a *Ras Shamra-Ougarit et la production des matières vitreuses au Proche-Orient au second millénaire avant Jésus-Christ*. Thèse de l'Université de Paris I, Panthéon-Sorbonne.

2000b Matières premières—matériaux vitreux, Données récentes. *Orient-Express* 2000–2: 41–2.

2000c Données nouvelles sur le verre en Syrie au IIe millénaire av. J.-C.: le cas de Ras Shamra-Ougarit. In *La*

Route du Verre: ateliers primaires et secondaires du second millènaire av. J.C. au Moyen Age (M.-D. Nenna, ed.). Lyon: Maison de l'Orient Méditerranéen-Jean Pouilloux, 57–82.

In press Le matériel du Palais royal d'Ougarit: un nouveau programme de recherche. In Actes de la table ronde internationale *Ras Shamra-Ougarit (Syrie): du Bronze moyen au Bronze récent, nouvelles perspectives de recherche*, 30 nov.–1er déc. 2001 (Lyon, M. Yon and Y. Calvet, eds.). Lyon: TMO.

Matoïan, V. and Bouquillon, A.

1999 La céramique argileuse à glaçure du site de Ras Shamra–Ougarit (Syrie). *Syria* 76: 57–82.

2000 Le 'bleu égyptien' à Ras Shamra-Ougarit (Syrie). In *Proceedings of the First International Congress on the Archaeology of the Ancient Near East (Rome, 18–23 mai 1998)*, (P. Matthiae, A. Enea, L. Peyronel and F. Pinnock, eds.). Rome: Università degli Studi di Roma, La Sapienza, 985–1000.

Moorey, P. R. S.

1994 *Ancient Mesopotamian Materials and Industries. The Archaeological Evidence.* Oxford: Clarendon Press.

Nicholson, P. T., Jackson, C. M. and Trott, K. M.

1997 The Ulu Burun glass ingots, cylindrical vessels and Egyptian glass. *Journal of Egyptian Archaeology* 83: 143–53.

Pagès-Camagna, S.

1999 *Propriétés physico-chimiques d'un pigment vert synthétique égyptien. Couleur, structure. Recherche des techniques d'élaboration.* Thèse de l'Université de Marne-la-Vallée, Laboratoire de Recherche des Musées de France, Paris.

Pagès-Camagna, S., Colinart, S. and Menu, M.

2000 Le bleu et le vert égyptien, pigments synthétiques de l'Égypte pharaonique. In Actes de l'École de Printemps. Chromophore: Lumière, Matière, Perception 14–19 mars 2000. Roussillon, 103–11.

Peltenburg, E. J.

1987 Early faience: recent studies, origins and relations with glass. In *Early Vitreous Materials* (M. Bimson and I. C. Freestone, eds.). British Museum Occasional Paper 56. London: 5–29.

Schaeffer, C.

1983 *Corpus des cylindres-sceaux de Ras Shamra-Ugarit et d'Enkomi-Alasia* I. Recherche sur les grandes civilisations. Synthèse 13. Paris: Éditions Recherche sur les Civilisations.

Tite, M. S.

1986 Egyptian Blue, faience and related materials: technological investigations. In *Science in Archaeology. Proceedings of a meeting held at the British School at Athens, January 1985* (R. E. Jones and H. W. Catling, eds.). Fitch Laboratory Occasional Paper 2: London: Leopard's Head Press, 39–41.

Tite, M. S., Bimson, M., and Cowell, M. R.

1984 Technological examination of Egyptian Blue. In *Archaeological Chemistry* III (J. B. Lambert, ed.). Advances in chemistry series 205. Washington D.C., 215–42.

Yon, M.

1997 *La Cité d'Ougarit sur le Tell de Ras Shamra.* Guides archéologiques de l'Institut français d'archéologie du Proche-Orient 2. Paris: Ministère des affaires étrangères; Recherche sur les civilisations.

From Mesopotamia to Merv:
reconstructing patterns of consumption in Sasanian households

St John Simpson

INTRODUCTION

In the words of one Byzantine chronicler, the royal table of Khusrau II (591–628) boasted golden dishes on which were served 'savouries, joints from royal hunting, choice cuts of antelope, gazelle, and wild ass, fragrant wines and preparations of elaborate aperitifs, carefully baked bread, milk, cakes, and anything else that is preserved for the festive board of gluttonous tyrants'(Theophylact Simocatta, *History* iv, 7.2). Was this pure rhetoric or is it an accurate reflection of Persian court cuisine?

Food historians have been attracted increasingly to the civilizations of antiquity in attempts to categorize and chart the characteristics and chronological developments in food culture from prehistoric Europe to Egypt, Mesopotamia and the Classical world. In contrast, despite the fame of Persian cookery, there have been surprisingly few attempts at exploring the evidence from Iran beyond the Achaemenid Court or the popularity of winedrinking (e.g. Sancisi-Weerdenburg 1995; Gunter 1988). The following remarks draw on literary and historical sources to flesh out the range of archaeological evidence from one of the greatest phases of Iranian history, that of the mighty Sasanian empire: much of this derives from a combination of old and new excavations from Mesopotamia in the west to Merv in the east.

This empire was characterized by a huge range of ecozones and patterns of agriculture and subsistence from the great cultural and agricultural resources of Mesopotamia to the high Iranian plateau and the humid lowlands of the southern Caspian shore. Any survey from this period should also take account of religious dietary laws and social taboos. In addition, ethnic and religious groups doubtless prepared meals to suit their own customs, special social events from weddings to births and circumcisions called for special meals, and the calendar cycle of festivals, holy days and national rites of passage such as coronations and victories must have had an impact on diet.

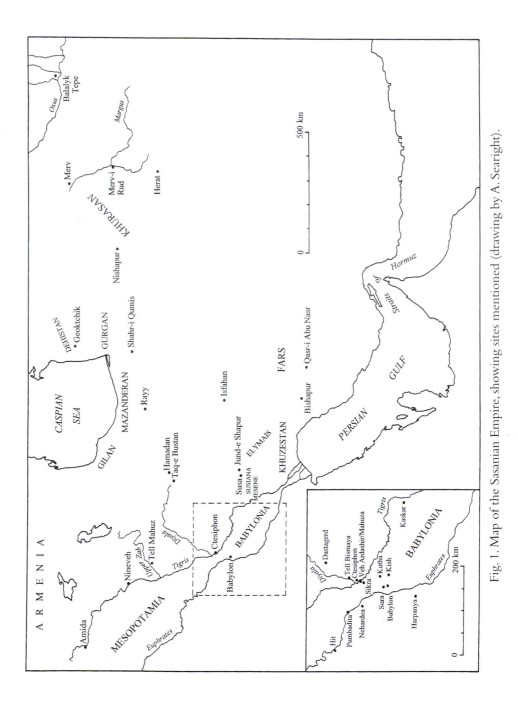

Fig. 1. Map of the Sasanian Empire, showing sites mentioned (drawing by A. Searight).

The highly developed Sasanian economy must have relied on the canal systems of lower Mesopotamia and south-west Iran, as well as the Persian Gulf, in order to transport commodities to different markets. However, despite the conurbation around the capital at Ctesiphon and the existence of towns and cities across the empire, the overwhelming bulk of the population was rural and the variety and quantity of food available was governed by seasonal as well as regional factors. Milk and cheese were among the foods consumed at the great Zoroastrian spring festival of Nōwrūz whereas ripe fruits and nuts were offered at the equivalent autumnal festival of Mihragān (Boyce 1983: 798, 802). This range must have led to the recognition of regional specialities for which Early Islamic accounts provide an apt illustration:

> May He let me eat of the apples of Syria, the fresh dates of Iraq, the bananas of the Yemen, the nuts of India, the beans of Kufa, the sugar-cane of al-Ahwaz, the honey of Isfahan, the sugar-cane syrup (*fanidh*) of Maskan, the dates of Kirman, the date-syrup of Arrajan, the figs of Hulwan, the grapes of Baghdad, the jujubes of Gurgan, the plums of Bust, the pomegranates of Ray, the pears of Nihawand, the quinces of Nishapur, the apricots of Tus, the *mulabban* confectionery of Merv and the melons of Khwarazm.
>
> (Bosworth ed. 1968: 145–6)

Cookery and cuisine: literary sources for Sasanian food and drink

> Sabur thereupon said to her, 'Tell me then, what did your father give you to eat?' She replied, 'Cream, marrow from bones and honey from virgin bees, together with the choicest wine!' (Bosworth ed. 1999: 36)

Despite the scarcity of primary sources, let alone the depictions, cookery books or household accounts which enable reconstructions of Roman or post-medieval European food, the names of a number of Sasanian dishes, meals and varieties of bread survive in Pahlavi sources and Islamic cookery books. Some Sasanian rulers were popularly associated with particular recipes or types of food. Queen Buran, who reigned for a year from 629–630, was said to be so partial to yoghurt accompaniments that the name *boorāni* was given to these (Shaida 1994: 238). Another recipe known as *sikbaj* from the Persian for *sik,* 'vinegar', and *baj,* 'a kind, or sort of' was described in the 13th century by al-Baghdadi who claimed that it had been a favourite of Khusrau I (531–579) who called it 'the queen of dishes'. It consisted of chopped lamb stewed with Syrian leeks, white onions, carrots and aubergines in a wine vinegar containing saffron and date juice or honey seasoned

with fresh and dry coriander, cinnamon bark and salt, and served with dried fruit on the top (Waines 1989: 76–7).[1] There were, in addition, 'a dish for the King', consisting of hot and cold meats, rice jelly, stuffed vine leaves, marinaded chicken and a sweet date puree, all familiar Middle Eastern foods; and a variety of rice pudding known as a 'Greek dish' and made with eggs, honey, milk, butter, rice and sugar (Christensen 1936: 471–2). Finally, according to Tabari 'delicacies for the king' prepared by the royal baker included 'a variety of sweet dishes and crystallised honey' (Friedmann ed. 1992: 91) and the *Shāh-Nāmeh* refers to the consumption of plain and sugared almond, walnut, chickpea and cardamom rice biscuits, honey almond brittle, and *baqlava* during Nōwrūz.

The most important source, however, is the Pahlavi story *Khusrau and his Boy*, which survives in two versions (Unvala [1921]: 17–26, 43–4; cf. Christensen 1936: 472). In this tale the page describes a wide variety of other choice meals, including two-month-old lamb nourished on the milk of its mother and that of a cow (roasted after pre-boiling according to one version); meat of a young fat goat 'cooked in its own broth'; breast of a young fat cow cooked in vinegar; offal basted with olive oil;[2] and breast of a fattened ox in a spinach and vinegar sauce thickened with wheat flour and served (garnished?) with sugar.[3] Marrow was served with egg yolk. Poultry dishes included fat pheasant, hen, winter partridge, fattened young pigeon, lark, male crane, black starling, waterfowl, and spitted chicken fattened on wheat and/or hemp seeds, oil and olive butter and briefly hung after being 'chased and frightened'; the lower backbone of this bird was considered to be the most savoury part and continues to be known as the 'mother-in-law's morsel'. The reference to 'frightening' the bird may suggest awareness that animals exhausted or terrified at the time of slaughter tend to have a leaner taste (Tannahill 1988: 161). Fine jellied meats included beef, onager, boar, one-year-old camel, buffalo and pork but one of the most highly prized was tame male onager fattened on alfalfa and barley, and served in spiced clotted milk.[4] Other highly prized cold meats were veal prepared with strong vinegar and mustard, and the meat of a young gazelle cut into long thin strips and mari-

1 Carrots are also described from Khurasan but Laufer (1919: 453–4) concludes that these were only introduced by the Arabs as they lack an Iranian name.
2 Olives (Middle-Persian *zeitun*) appear to have been cultivated in Iran but sesame oil was more commonly used according to the Babylonian Talmud (Laufer 1919: 288–93, 415–9).
3 This supports claims for a Persian origin for spinach, which is otherwise considered problematic (Laufer 1919: 392–8).
4 The use of alfalfa as a fodder crop is discussed by Laufer (1919: 208–19).

naded with vinegar, mustard, brine, dill, garlic, caraway and cumin. Stews were made from hare which was described as 'the most tender', horse and sable offal (said to be the most flavoursome and savoury respectively) and pheasant's head ('the most digestible'). The fat of a female gazelle, cooked in a nut butter sauce according to one version, is described as being without equal.

According to the same source, sweets were seasonal: summer dishes consisted of almond and walnut pastries, walnut buns, finger-shaped pastries and other cakes including one prepared with the fat of a female gazelle cooked in nut butter; whereas winter delicacies included almond, peach and puff-pastries and sugar-candy. Syrup, rose water and crystalline sugar were added to the dough. The best preserves were made from apples and silver quinces; prickly lemons, quinces, myrobalans,[5] fresh walnuts, lemons and Chinese ginger were eaten as stewed fruits. Hemp seeds from Nishapur which were fried in ibex fat are described as being 'fine to eat, flavoury for the mouth, well digestible for the stomach, and also excellent for other purpose'. Coconuts ('Indian walnuts') served with sugar, roasted Gurgan pistachios, lentils eaten with olive oil, Herat dates stuffed with walnuts, fresh pistachios, Armenian peaches, rice-flour pastries, sugared acorns and chestnuts complete the list of delicacies. Some of these resemble the newly popular desserts of 16th-century Italy and Tudor England which were considered to have digestive and carminative properties, as was the Sasanian royal dish of hemp seeds cooked in ibex fat (cf. Day ed. 2000: 56).

These sources confirm a highly sophisticated Court cuisine where conspicuous consumption was the norm, not only of quantity but also variety, and doubtless served with great ceremony and ostentatious use of tablewares. Some of the dishes rely on achieving the characteristic sweet-and-sour or sweet-and-savoury flavours of traditional Persian cuisine, explaining a reference to the 'sweetening of meat for eating' in a Mandaic incantation bowl text (McCullough 1967: 32). The making of jam preserves enabled the preservation of seasonal fruits for sweet dips and an additive to sauces; the rich variety of desserts amplifies the well-known statement on earlier Persian food by Herodotus (*History* i, 133) that 'their courses are few, the dainties that follow are many and not all served together'. Enhancing the aesthetic appearance of dishes through colour and garnish also appears to have been considered important, as do the medicinal side-effects of some dishes: both features are explicitly commented on by subsequent Islamic food writers

5 Imported from Afghanistan or India according to Laufer (1919: 378).

(e.g. Marin 1994). The Sasanian royal recipes generally combine readily procured ingredients with exotic imports and the fruits of the hunt. The Late Sasanian grotto at Taq-e Bustan illustrates the royal hunt of deer and boar, the carcasses of which were presumably consumed as they are shown being transported away on camel-back.[6] The royal hunting of lions, tigers, bears, antelopes, gazelles, and 'corn-fed' ostriches and onagers, and the occurrence of pheasants and peacocks in the royal parks, are likewise described in the Babylonian Talmud and by Byzantine historians (Cohen 1937: 163, 184; Ammianus, *Res Gestae* xxiv, 5, Theophylact Simocatta, *History* iv, 7.2; Greatrex and Lieu eds. 2002: 215). Most of these doubtless ended up on the royal table but direct provisioning by professional hunters is also indicated by references to one Gadono supplying 'wild animals and partridge and fish' to the Persian general Glon stationed at Amida in 503 (Greatrex and Lieu eds. 2002: 70).

Household cooks within the urban middle classes must have created equivalent recipes using more easily obtained ingredients, for instance substituting chicken for wild fowl. The name of a so-called '*Dēhkān's* dish' of slices of salted mutton with pomegranate juice served with eggs reflects the title of a class of landlord and a reference to a 'Khurasan Dish' consisting of spit-grilled meat fried in butter with a sauce must reflect a popular recipe, perhaps even a rarified fast-food, consumed in this north-east Iranian province (Christensen 1936: 471–2). Allusions to offal stews which required careful cleaning and a reference in the *Shāh-Nāmeh* to the sale of sheep's heads hints at the existence of specialized urban cookshops offering tripe as well as soups and meaty broths, as in Iran or Turkey today (Levy ed. 1985: 343; cf. Fragner 1994: 66; Chase 1994: 79). Thick noodle and spinach soups and barley porridge are also believed to have been popular and continue to feature in Afghan cooking (Shaida 1994: 159–61, 167–8, 171–2). The addition of fruit, nuts and large quantities of herbs to dishes are a hallmark of traditional Persian cuisine: eating meat, drinking wine and 'enjoying the fragrance of aromatic herbs' were considered pleasures so great that the deprivation of any was regarded as a terrible punishment (Bosworth ed. 1999: 390). It is suggestive to find that al-Tabari, describing an incident during the Arab Conquest, refers to the consumption of a stew made of meat and grapes as 'very whole-

6 The Persian use of camels as military beasts of burden to carry waterskins, etc. is mentioned by Theophylact Simocatta in connection with campaigning in northern Mesopotamia (*History* ii, 2.4, 8.1); Zosimus describes the consignment of 'several camels loaded with wine, and an abundance of meat' (Dodgeon and Lieu eds. 1991: 148) and camel-drivers are recorded in the Babylonian Talmud (Cohen 1937: 252).

some and beneficial' in summer, a description which surely alludes to a variety of *khoresht*, a Persian meat sauce or stew with a tangy flavouring derived from unripe grapes, citrus, tamarind, barberries or sour green plums (Bosworth ed. 1999: 297; cf. Shaida 1994: 120–1). Another passage in al-Tabari's *History* illustrates the contrast between the plain food of the Arabs and the refined dishes of the Persians and describes the latter as including 'roast meat and mustard. And pastry thin like sheets rolled up on bits of meat in which are herbs and young pigeon' (Blankinship ed. 1993: 187).

Some information is available about everyday diet in Mesopotamia. Late Sasanian Aramaic and Mandaic incantation bowls mention cattle along with camels, horses, asses, donkeys, goats, pigs, property, family members, handmaids and slaves, implying that livestock were considered valuable household assets (Yamauchi 1967: 257–9, 263, 277–9, 281; Isbell 1975: 112–3, 125; Segal 2000: 49, 85, 117–8, 138). The herding of cattle, sheep and goats are regularly described in the Babylonian Talmud although cattle were most highly prized as a source of traction, and flock sizes seem to have been much larger in the steppe regions and pastures of northern Mesopotamia (Newman 1932: 112–24). The consumption of fish is less well attested although 'a large fish' was delivered to one prisoner, and salted and roasted fish are described as foodstuffs which were occasionally transported by boat in Babylonia (Dodgeon and Lieu eds. 1991: 148–9; Oppenheimer 1983: 178–9, 345, 402–4). Doubtless fish played a more important role in the diet of the Persian Gulf and Caspian provinces, as it has in recent times, but these are regions from which there is no equivalent textual evidence at this period.

Salt collected from salines was widely used in the seasoning of venison and vegetable dishes as well as being thought to have medicinal powers (Simpson 2001). Pickles must have been a more commonly used method of preserving vegetables and *mūrri*, 'brine', a bitter black cereal-grain based mixture similar to soy sauce, was a famous speciality of Merv by the 10th century if not before (Bosworth ed. 1968: 135; cf. Waines 1989: 25). Pickles still form a strong element of Iranian and Iraqi food and blue or green glaze-lined jars with narrow mouths (now replaced by plastic containers of the same form and colour) are a familiar sight in these countries: they belong to a tradition extending back as early as the Abbasid, if not Sasanian, period for which the wide distribution of so-called 'Sasano-Islamic' turquoise-glazed and lined jars may plausibly represent the sale and transport of pickles.

Viticulture was well established across the Sasanian empire. Wines of Kang, Arang, Merv-i Rud (on the upper Murghab), Bust, Mount Alvand (Hamadan) and Assyria are mentioned in *Khusrau and his Boy* (Unvala [1921]:

26–7). Babylonia was another centre of the Sasanian wine industry where 'black' and 'white' grapes were distinguished, and red wine was considered to be the best (Newman 1932: 93–5). To Pliny (*Natural History* vi, 131), Ctesiphon was 'ennobled with palm groves and equally with orchards of olives, apples and other fruits' whereas Ammianus (*Res Gestae* xxiv, 6) describes the Ctesiphon area as 'a rich territory, abounding in orchards, vineyards and green cypress trees. In its midst was a pleasant and shady dwelling'.[7] Vineyards and orchards in the Ctesiphon area are also mentioned at the time of the Arab Conquest (Bosworth ed. 1999: 297). In addition, the Talmud specifically refers to viticulture in the vicinity of Ctesiphon, Nehardea and Pumbadita (both on the middle Euphrates), Kafri and the district of Sura (near Babylon) Pum Nahara, where a 'path of vineyards' is mentioned, and Harpanya (both situated in the Kufa area) (Newman 1932: 96–7; n.d.: 56; Oppenheimer 1983). With the exception of Ctesiphon, all of these lie on the Euphrates. The 'fermenting, sweetening and keeping' of wine are mentioned on an Aramaic magic bowl from Babylonia (Naveh and Shaked 1993: 134–5) and according to Chinese sources some Persian wines were flavoured with rose petals (Shaida 1994: 49). 'Fragrant wines' were drunk at the court of Khusrau II (Theophylact Simocatta, *History* iv, 7.2) and different strengths were created through watering down (Newman 1932: 95–6; Greatrex and Lieu eds. 2002: 66). These measures were intended to overcome the problem of continued fermentation of the wine which Roman writers describe as involving the addition of salt, pitch and imported Oriental spices. Some of these wines may have resembled the sweet wines made from semi-dried grapes favoured by these writers and the popularity of spices in Persian cooking suggests that mulled wines may also have been consumed. Doubtless raisins were also popular as snacks and cooking ingredients.

The transport and sale of wine within Mesopotamia is illustrated by a reference in the Talmud to a wine market at Sikra, possibly near Mahuza (Oppenheimer 1983: 401–5). Another illustration of the wine trade is provided by the supply of *gulfe* ('wine jars') for refilling in Harpanya by one Rava, a merchant from Mahuza in the early/mid fourth century (Oppenheimer 1983: 295, 299, n. 23).[8] Further references are made in connection with wine exports from Harpanya using narrow perforated wine jars which

7 Ammianus described Mesene in similar fashion: 'In these regions there are many fields, planted with vineyards and various kinds of fruits' (*Res Gestae* 24. 3).
8 Some 'barrels' may indeed, as Newman suggested, have been ceramic although records of 'a barrel floating in the river' at Hit and the opening up by soldiers of 'casks' at Nehardea imply that at least some were made of wood (Oppenheimer 1983: 165, 277).

were stacked in threes and known as *dequre* (Oppenheimer 1983: 294–5, 299–300). These are likely to describe the tall torpedo-shaped jars with rolled rims, asphalt lining and pointed 'spitzfuss' bases which appear to have been used in Mesopotamia as the Partho-Sasanian equivalent of Roman transport amphorae and which have been found in the Persian Gulf as far as the straits of Hormuz. These jars are typically perforated with a single hole part-way up the body which must originally have held a bung (Adams 1981: 234). However, these were not the only types of transport amphora to be used. It is likely that a distinctive class of stamped Late Sasanian jar which is found throughout northern Mesopotamia was also used for the transport and storage of wine and/or oil (cf. Simpson 1996: 98, 124: Fig. 1). Other containers were made of perishable materials including wineskins (Oppenheimer 1983: 82–3; Bosworth ed. 1999: 291), 'oxhide containers' and 'gourd wine containers' (Levy ed. 1985: 284, 364). Skins of wine were said to be imported from Fars province into eastern Arabia on behalf of Khusrau I's workmen (Bosworth ed. 1999: 291) and leather wine bottles were used in vineyards (Newman 1932: 97), some of which are depicted on metalwares.

The fruit (but often not the outsides) of almonds, apples, white apricots, chestnuts, citrons, coconuts, dates, filberts, figs, grapes, lote-plums, mulberries, myrtle, peaches, pears, pistachios, pomegranates, quinces and walnuts were listed as permissible for consumption in chapter XXVII of the Bundahishn (Asmussen 1970; Laufer 1919: 192–3). Among these the history of the citrus is not well understood yet: the Greeks referred to it as the 'Median apple' and the Byzantine Greek word for bitter orange, *narántzi*, was a loan word from the Middle-Persian *nārang* (Shahbazi 1990: 594); the 'honey of Ifridhin [Rayy/Nishapur area] mixed with citrons of Kutha' are mentioned by al-Tabari (Juynboll ed. 1989: 11). The addition of citron juice to many dishes ranging from savoury stews and sauces to yoghurts and salads is one of the hallmarks of Persian cuisine, evidently then as now (Shaida 1993). Quinces ('golden apples') grow wild in northern Iran but were cultivated in Mesopotamia, and in Roman Crete were used for a quince-wine industry. The popularity of quince jam (Greek *kydonaton*) in sixth-century Byzantium coincides with its mention in *Khusrau and his Boy*. Pomegranates are regularly depicted in Sasanian art, for instance on the 'Merv vase'; pomegranates and 'fiery-coloured' and 'smooth-skinned' peaches were later known as specialities of Rayy (Bosworth ed. 1968: 129). Both Chinese and Roman sources refer to peaches and walnuts as 'Persian' although walnut also grows wild in the Mediterranean region; Chinese texts also refer to almonds, dates, figs, grapes, pistachio, shallots and spinach as being 'Persian' crops, thus grouping

together highland Iranian fruits and nuts with Mesopotamian classics (Laufer 1919: 220–45, 254–75, 303–4, 379, 385, 392–8, 405–9, 412; Schafer 1985: 147). A Persian dish consisting of crushed almonds in sugar was regarded in later tradition as symbolic of the great prosperity that the Arabs enjoyed after the Conquest (Friedmann ed. 1992: 49, n. 192). Dates and figs were important foodstuffs in Mesopotamia since the fifth and third millennia BC respectively. Dates were a useful sweetener, particularly as dried dates added concentrated flavour in cooking. According to al-Tabari, 10 varieties of date-palms were classified for tax purposes in the reign of Khusrau I and advice was given in the Babylonian Talmud to regard date-palms as a permanent investment offering a steadier return even to vines (Newman 1932: 99–100); Chinese writers referred to dates as 'Persian jujube' (Laufer 1919: 385, 391).

Vegetables are described less frequently but the traditional Mesopotamian favourites of cucumbers, garlic, leeks, lentils, melons and onions must have continued to be popular. Cress, horse beans and pumpkins are mentioned in the Babylonian Talmud; this source also suggests that market gardeners were generally poor and vegetable gardens were usually found on the edges of towns (Cohen 1937: 174, 249–50; Newman 1932: 106–7). Cucumbers, leeks, pulses, vetch and watercress were listed as permissible foodstuffs in the Bundahishn (Laufer 1919: 192–3) and the best cress was stated by Dioscorides (*Materia Medica* II, 185) to come from Babylonia. Early Islamic sources also list aubergines, beans, cucumbers, radishes and rhubarb (Middle-Persian *rewās*) among famous products of Gurgan and Khurasan (Bosworth ed. 1968: 130–1).

In January 628 Heraclius seized pepper, sugar and ginger among other luxuries in Khusrau II's (591–628) palace complex at Dastagerd (Greatrex and Lieu eds. 2002: 215) and Sasanian kings are said to have partaken of 'white sugar with fresh Indian nuts pared' during the first day of Nōwrūz (Boyce 1983: 798). These are some of the earliest references in the Near East to the use of sugar which was now used as a more expensive alternative to the traditional local sweeteners of date syrup (an Iraqi speciality), honey (for which Rayy/Nishapur, Isfahan and Mosul were famed in the Early Islamic period) and fruit preserves. The origins of the sugar cane industry are Indian or south-east Asian yet the fifth-century Armenian historian Moses of Khorene refers to its cultivation near Jund-e Shapur in Elymais and Chinese writers refer to the Sasanian export of two types of hard sugar, literally 'stone honey' mixed with milk and 'half honey' (Laufer 1919: 376–7; Schafer 1985: 152–5; Simpson 2000: 62–3); by the 10th century it was cultivated in Iraq and Gurgan as well as in Susiana (Bosworth ed. 1968: 126, 128–30; cf. Watson 1983: 26–30).

Spices appear to have been added liberally to food and were probably valued also for their medicinal effects. Pepper, ginger, mustard, and 'hot spices which they call herbs of the sun' are also alluded to in the Babylonian Talmud and on Aramaic incantation bowls (Cohen 1937: 164–5; Newman 1932: 111; Isbell 1975: 91). Ginger was probably imported from south-east Asia via India whereas black pepper came from the Malabar coast of south-west India. The use of these hints at the impact of Indian and Far Eastern imports and methods of food preparation which must have been particularly marked in the major cities, ports and along the Persian Gulf coast. Cardamom is mentioned in the Bundahishn (Laufer 1919: 193) and judging by references in Roman and Islamic cookery, other likely imports from or via South Asia were cassia, cinnamon, cloves (imported to Mesopotamia as early as the third millennium BC), galangal, nutmeg, tamarind, tejpat, turmeric and zedoary. However, other herbs and spices were local including anise, basil (likened to 'the scent of those of high position' in *Khusrau and his Boy*), bay, capers, caraway, coriander (mentioned in the Bundahishn), cumin (referred to earlier in Cyrus' inscription from Persepolis), dill, fennel, mint, mustard, nigella, poppy seeds, rocket, sage, sesame, sumac and thyme. Saffron was one of the most highly prized cultigens in Babylonia according to the Talmud (Newman 1932: 110–1) and was exported to China and Rome, as was Bactrian asafoetida which was an ingredient of 'Parthian chicken' in *De Re Coquinaria*, the fourth/fifth-century Roman compilation attributed to Apicius (Saberi 1993; Dalby and Grainger 2000: 108).

The existence of a spice trade implies specialist merchants and markets. Fairs and markets are regularly referred to in the Babylonian Talmud as a place of purchase and the word 'bazaar' is derived from the Middle-Persian. The appearance of these markets appears to have varied hugely. They included open areas either within or outside the city walls, presumably set with awnings stretched over stalls, to accommodate nearby villagers bringing their wares to town (cf. Greatrex and Lieu eds. 2002: 71; Newman n.d.: 33–7) to the equally familiar Middle Eastern scene of streets specializing in particular products, a scene designated in the eighth book of the *Dēnkard* that 'every trade had its own series of shops in the bazaar' (Simpson 2000: 64).

Rice was used as a luxury ingredient for desserts although the discovery of carbonised rice grains in a first-century AD Parthian context at Susa, Talmudic references to the consumption of rice-bread in Khuzestan and, according to later Islamic accounts, its taxation and transport in the Late Sasanian period suggests that it may already have been treated as a staple in the marshy regions of southern Iraq and south-west Iran, including the province of Kaskar

which appears to have specialized in the cultivation of barley and rice (Oppen-
heimer 1983: 297, n. 11). During the Early Islamic period there is written
and/or archaeobotanical evidence for its cultivation slightly more widely,
namely in Gilan, Mazanderan and the middle Euphrates valley (Samuel 2001),
but the heavy demands on water resources which rice cultivation requires as
a summer crop ensured that a choice had to be made with its major eco-
nomic competitor, cotton: it was a preference for the latter which enabled a
major textile industry at Sasanian-Islamic Merv (Nesbitt and O'Hara 2000).

EXCAVATED ENVIRONMENTAL EVIDENCE

Combined flotation and wet-sieving recovery of carbonized plant remains
from fourth- to seventh-century contexts at Merv provide the first archaeo-
botanical assemblage from a major Sasanian site. In addition to evidence for
cultivation of cotton as a fibre and oil-seed crop, they indicate the consump-
tion of cultivated bread wheat, emmer wheat, six-row hulled barley and
broomcorn millet as staples plus lentil, pea, cucumber or melon, almond,
jujube, peach, grape and hackberry (Nesbitt 1993, 1994; Boardman 1995,
1997).[9] Among these species, jujubes—still a local favourite—were regarded
as a speciality of Gurgan province in the Early Islamic period (Bosworth ed.
1968: 130). Charcoal analysis also suggests the use of pistachio, vine, peach/
apricot and apple/hawthornwood, and thus probably orcharding of these
trees in the vicinity of the city (Gale forthcoming). The scarcity of millet at
Merv supports a seventh-century Chinese assertion that the Persians 'have
no rice or millet' (Miller 1959: 15): perhaps for this very reason measured
quantities of millet and wheat are referred to among gifts listed on a Middle-
Persian ostracon from Merv (Nikitin 1992: 117–8). Barley and wheat are
listed as permissible food plants in the Bundahishn (Laufer 1919: 192–3),
cereals were widely cultivated in Mesopotamia and the accidental impres-
sions of barley grains in bricks from Tell Bismaya on the Diyala illustrate the
use of chaff temper after the harvesting season (Jacobsen 1982: 23). Isolated
finds from other Sasanian sites on the Iranian plateau support the importance
of fruit in the diet as they include carbonized almonds and figs at Qasr-i Abu
Nasr (Whitcomb 1985: 168), and almond and pomegranate at Shahr-i Qumis
(Hansman and Stronach 1970: 148–51).

Excavations at Merv likewise offer the first archaeological glimpse into
patterns of meat consumption in a Sasanian city (Smith 1997, forthcoming).

9 The identification of cucumber (MP *vātran*) or melon is significant given the uncertain
early history of both plants (cf. Laufer 1919: 300–1, 438–45).

The preliminary results suggest that mutton and goat were widely consumed, plus beef, pork and equid in significant quantities. Butchered bird bones are represented in small quantities, as is chicken eggshell. The sheep and goat carcasses appear to have been delivered whole and butchered within the household. This purchase of whole carcasses ensured that every part of the animal—from the meat to the offal and the marrow—could be used in the preparation of dishes and, where not destined for immediate use, could be preserved through salting or pickling. Small amounts of camel, pig or boar and fish were also consumed within the citadel. Extensive traces of butchery marks were found and the number of splintered bones suggests that marrow was widely consumed; furthermore the infrequency of charring suggests that stewing was preferred over roasting. These results are now supported by analyses of Sasanian faunal remains from the smaller site of Geoktchik in Dehistan which indicate the hunting of small numbers of equids and large-sized wild boar although domesticated animals provided most of the meat supply. The bulk of this was from sheep/goat, which were mostly slaughtered below the age of three years but cattle were also slaughtered for their meat and lower numbers of pig and camel bones illustrate dietary supplements (Mashkour 1998).

BREAD, OVENS AND COOKING

> Bring the cauldron and some fire from indoors; throw grain of all kinds into
> the water. (Levy ed. 1985: 311)

We still cannot reliably reconstruct the appearance of a Sasanian kitchen although a cooking area has been identified in rooms B6–8 next to the monumental west mosaic hall (B1–2) in the palace at Bishapur and part of what may have been a kitchen with a hearth and benches along the walls was identified in rooms XXV–XXVI at the rear of a Buddhist monastery at Merv (Pugachenkova and Usmanova 1995: 56, Fig. 4). Excavated houses at Merv show that food preparation included the use of small circular domed ovens (*tannūrs*) and small circular ceramic-lined sunken cooking installations which may be akin to modern Persian *čāla korsi* or *tabūns* (cf. Šahri 1990). Bread must have been a staple food. It accounts for an average of 70% of daily calorific intake in modern Iran and was included among compulsory daily food offerings at the fire temple prescribed by Shapur I (240–272) as well as other Middle-Persian, Manichaean, Aramaic and Mandaic texts, some of which refer to 'the bread of life' and eating from a 'basket of bread' (Desmet-Grégoire 1990; cf. Segal 2000: 76, 92, 109). Barley rations were issued to

Persian soldiers, and bread, wine, date wine and oil were said to have been issued to freed captives by Varahran IV (388–399) (Greatrex and Lieu eds. 2002: 17). The addition of herbs to the dough is suggested by a reference in the Bundahishn to 'whatever is welcome in eating of bread, as torn shoots of the coriander, watercress, the leek, and others of this genus' (Laufer 1919: 192–3).

The form of the excavated domestic ovens implies the consumption of flat bread but Talmudic references to purchase from large communal bakeries raises the possibility of other varieties of bread and, as in the Middle East today, the hiring of these shared facilities to cater for festive occasions (Newman 1932: 144–9). Further Talmudic references to millstones being a standard piece of Sasanian household equipment are supported by the frequent discovery of rotary quernstones made of imported andesite, basalt, quartz, fused sandstone and granite in domestic contexts at Merv (Ajzenberg 1958). In addition, archaeological survey evidence suggests the popularity of large, carefully made basalt grinding stones, presumably imported from sources in north-east Syria, at Sasanian sites in the Nippur region of southern Iraq (Adams 1981: 211).

In addition to baking flat bread, *tannūrs* may be used for preparing a variety of different foods as the top can support a cooking pot and other dishes can be cooked in the embers at the base or left to stew overnight. The *Shāh-Nāmeh* refers to the use of 'brazen cauldrons' (Levy ed. 1985: 267–9) yet metal Sasanian cooking pots do not survive. A Babylonian incantation bowl text refers to sprinkling salt on 'fire-pans' (Segal 2000: 86) but the material of these is unclear. Al-Baghdadi recommended the use of softstone cooking wares and indeed heavily blackened handmade softstone cooking ware sherds predominate in eighth-century and later domestic contexts at Kush and Merv. However although there is evidence for a fine lathe-turned softstone vessel industry in south-east Arabia during the Parthian and Sasanian periods there is no evidence for this material being used to make cooking wares (cf. Mouton 1999; Potts et al. 1978: 18, Pl. 10: 48). Instead, ceramic cooking wares were the norm.

Future chemical residue analyses are likely to offer a better understanding of exactly what these pots were used for yet Sasanian cooking pots fall into several distinct and regionally specific classes. The first consists of coarse-tempered thick-walled handmade wares. These were the sole type at Merv where two principal varieties were present, either tempered with calcite or crushed fragments of vitrified clay presumably acquired from a nearby ceramic or brick-making quarter. Another type of cooking ware, which was the

most popular at Veh Ardashir, was thrown and characterized by a coarse-tempered calcareous clay body lined with glaze extending over the rim, neck, upper shoulder and handles (Venco Ricciardi 1984: 52, Fig. 4: 5). The function of this glaze was to reduce stick and facilitate cleaning after use. This use of glaze underlines the strength of glazed ware production in the Ctesiphon region which is also reflected in the unusually high proportion of other glazed forms of ceramic at Veh Ardashir compared to sites such as Kish. Another major category of cooking ware appears to have been limited to northern Mesopotamia and represents a specialized form originally developed in northern Syria during the Hellenistic period (Wilkinson and Tucker 1995: 106; cf. Bartl, Schneider and Böhme 1995). This type consisted of light brown vessels with slightly everted rims, two handles and walls averaging 0.5 cm in thickness with light exterior ribbing. In common with the first type described above, these have rounded bases well suited to resisting the repeated thermal shocks endured by cooking wares.

SERVING WARES AND EATING IMPLEMENTS

It is unclear how different varieties of food and drink were served but bowls are a particularly common Sasanian vessel form in art and excavation. These vary from hemispherical forms, particularly in glass and ceramic, to oval 'boat shapes' in metal, sometimes fluted and with a high foot. Some of these were for drinking and the faceted walls of metal, glass and presumed crystal versions were ideally suited to comfortable handling. However, representations indicate some bowls to be filled with what appear to be grapes or what

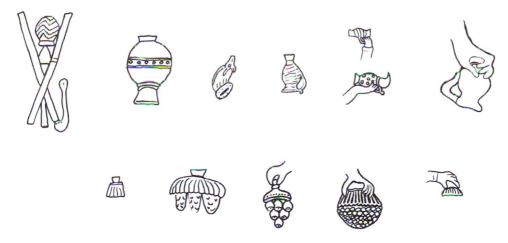

Fig. 2. Selected representations of vessels on Sasanian silverwares.

Carter (1974: 192) suggested were 'perhaps equivalent to gumdrops or hard candies'. Examination of deep (so-called *tagara*) bowls with pseudo-metallic handles found in fourth- and fifth-century contexts at Merv sometimes reveals heavy abrasion in the interior which suggests regular scouring after use: thus they probably contained cooked food rather than liquids or fruit. There is also some evidence for large flat painted or cut-glass plates for which the plain blown equivalents may have simply perished as thin blown glass is prone to heavy weathering in the damp salty ground conditions of many excavated Sasanian sites. The use of cutlery on the other hand was strictly limited: fingers and flat bread usually sufficed, as in earlier periods and indeed up to the present day in the Middle East. The exceptions were oval spoons and long metal forks with two tines, both usually with ergonomic twisted grips and animal-headed ends. These forks were widely used judging by

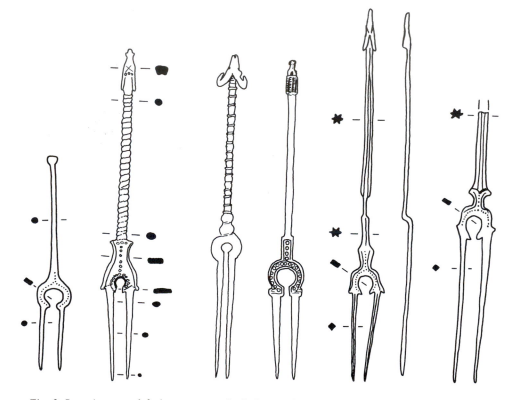

Fig. 3. Sasanian metal forks, not to scale (left to right): National Museum Tehran, inv. no. 2740, Qasr-i Abu Nasr; The British Museum, ANE 91326, Nineveh; after Ghirshman 1964, *7000 Years of Iranian Art*; private collection; National Museum Tehran, inv. no. 2741, Susa; National Museum Tehran, inv. no. 19673, ex-Foroughi collection.

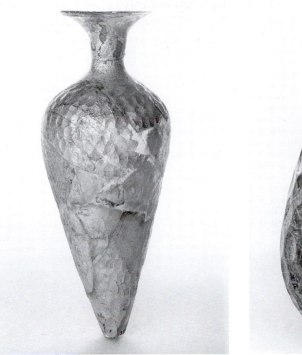

Fig. 4. Sasanian faceted glass amphora-shaped pourer, H. 27.8 cm, complete (photograph courtesy of The British Museum, ANE 1972-5-16, 2 = 135712).

Fig. 5. Sasanian faceted glass vase-shaped pourer, H. 23.2 cm, restored (photograph courtesy of The British Museum, ANE 1972-5-16, 1 = 135711).

finds excavated at sites as far apart as Nineveh, Susa, Qasr-i Abu Nasr and Merv (e.g. Simpson 1996: 98), and others are known from the art market (e.g. Batmanglij 1999: 11): their size suggests that they may have been used for help in cutting or serving rather than eating.

Water, milk, yoghurt, fruit juices, pickle brine, barley-meal, beer and distilled alcohol featured among drinks consumed within the Sasanian household: pitchers of water feature in Aramaic incantation bowl texts (Segal 2000: 76, 92), 'iced water which resounds in a new jar of clay' is described in al-Tha'alibi's interpolation to *Khusrau and his Boy* (Unvala [1921]: 45) and milk churns have been identified among the Merv ceramics. However, it is wine which usually features in the historical and literary sources. It was apparently consumed using pourers and drinking bowls or, from the fifth century onwards, stemmed goblets of glass (and presumably metal, as in the Roman empire). This use of goblets marks Western influence although the occurrence of faceted, mould-blown reblown and painted decoration on some

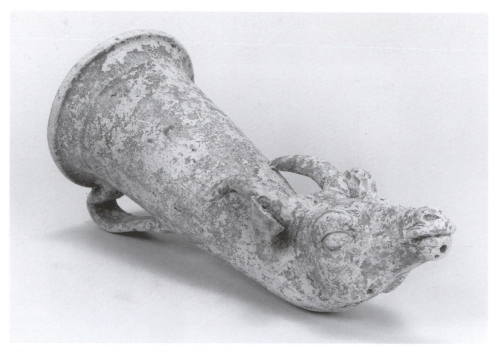

Fig. 6. Sasanian red-painted horn-shaped ceramic rhyton with animal's head protome, H.
28.3 cm, complete (photograph courtesy of Arthur M. Sackler Gallery, Smithsonian
Institution, Washington, D.C.: Gift of Arthur M. Sackler, S1987.31).

examples marks a significant difference with Late Roman versions. In con-
trast, the combination of pourers and bowls began in Iran at least as early as
the Achaemenid period although contemporary illustrations of Sasanian horn-
shaped rhyta are rare, leading Harper (1991: 96) to conclude that 'the rhytons
are probably not representations of actual vessels in current use but rather
symbolic images of the type described above'. However this scarcity instead
reflects the rarity of banqueting scenes in Sasanian royal imagery: a rare ex-
ception on a personal seal appears to depict a horn-shaped rhyton placed on
the floor next to a bowl of fruit and below a couch on which a reclining man
holding a drinking-cup is being waited on by a woman holding a second
drinking cup and a ewer.

 Archaeological evidence indicates that there were as many as six different
types of Sasanian rhyton, some made of silver and others of ceramic or glass.
Twin-spouted amphorae have been excavated in early/mid Sasanian con-
texts at Tell Mahuz and Merv (Haerinck 1980). Amphora-shaped flask-rhyta
were adapted by Sasanian glass workers to make a second type. These re-
tained the earlier form, sometimes with a pair of twisted handles linking the

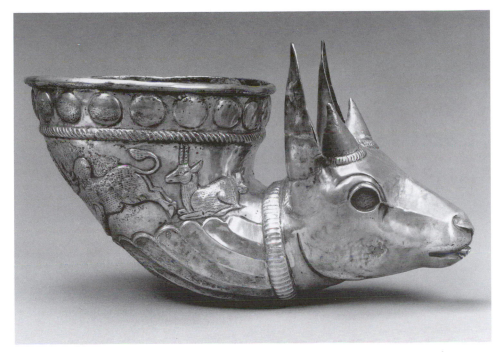

Fig. 7. Sasanian silver rhyton with gazelle's head protome, L. 15.5 cm, complete
(photograph courtesy of Arthur M. Sackler Gallery, Smithsonian Institution, Washington,
D.C.: Gift of Arthur M. Sackler, S1987.33).

shoulder to the rim, but also equipped with a single hole in the centre of the
base (Harper 1978: 153, no. 76). A third type consisted of a thick-walled
pear shaped glass vase decorated on the exterior with rows of circular facets
and with a single hole drilled through the centre of the base. Examples have
reportedly been found in graves in north-west Iran (Fukai 1977: 54–5). Three
other types of rhyton are attested in ceramic. Horn-shaped rhyta with animal
protomes are the longest-lived variety and represent continuity of a type
which began in the Iron Age. A complete example, said to come from Iran,
exists in the Arthur M. Sackler Gallery. Xeroradiography indicates that the
protome was modelled by hand whereas the upper portion had been coiled
(Vandiver and Tumosa 1995). The pourer was originally covered with red
slip which may have been a deliberate attempt to evoke the effect of gold or
bronze and suggests a fourth- to fifth-century date when this technique was
popular in the eastern part of the Sasanian Empire. Another type of Sasanian
rhyton was animal-headed and represented by sherds found at Veh Ardashir
(Negro Ponzi 1966: 88; Venco Ricciardi 1967: 95), two examples excavated
at Kish (Moorey 1978) and a complete example found with Sasanian glass in

a grave at Babylon (Reuther 1926: 264–5, Fig. 120, Pl. 95).[10] It is to the latter type that a well-known silver example with a gazelle protome in the Freer Gallery of Art belongs (Gunter and Jett 1992: 205–10, no. 38). The final type of rhyton appears to have been relatively short-lived within the third century: using a combination of techniques, including throwing, moulding and modelling, potters within one or more specialized ateliers in Mesopotamia produced elaborate horn-shaped rhyta decorated with stylized portraits above high-relief depictions of female faces—possibly representing Anahita—and ending in ibex-headed spouts (Harper 1978: 161–3; Simpson 1997: 75). The complex method by which these were made indicates that they were an attempt to copy sheet-metal versions. The fact that no metal examples have yet been recovered underlines the scarcity of metalwares from archaeological contexts as silver or indeed any other form of metal was generally considered to be too precious and/or easily recyclable as scrap to be deliberately discarded.

TABLE MANNERS AND VESSEL TYPES IN IMAGERY AND LITERATURE

Banqueting halls are mentioned in connection with feast days and the palace of the Exilarch or head of Babylonian Jewry (Boyce 1983: 792–3; Newman 1932: 28), yet although banqueting scenes occur in Parthian art, on Sasanian glyptic, a Late Sasanian vase popularly known as the 'Merv vase' and post-Sasanian silverware, they do not appear on Sasanian silver (nor are they a subject of Achaemenid imperial art). The reason may be that meals were regarded as spiritual solemn events and this imagery thus may have been inappropriate on tablewares (Harper 1991). The available evidence nevertheless suggests that the method of dining was through reclining on cushioned couches or sitting cross-legged on floor coverings. In this respect there was little difference from Assurbanipal's court or the Greek *symposion*. Excavated Sasanian houses at Veh Ardashir and Merv indicate limited use of fixed furniture in the form of plastered benches, presumably originally covered with mattresses and cushions, which lined the walls of reception *iwāns* and some other rooms (Cavallero 1966: 77, 79, Pl. VIII). Archaeological evidence for furniture is scanty and limited to bronze table legs of Roman inspiration with lions' paws and griffins' heads and a folding stool found in a grave in north-west Iran whereas representations and literary sources confirm the use of cushioned couches, portable thrones and folding stools (Curtis 1996).

10 Also illustrated by Erdmann (1935: 72), Ettinghausen (1938: vol. IV, Pl. 184D) and Koldewey (1914: 251–2, 254, Figs. 168, 171).

References in the Shāh-Nāmeh to 'cavaliers nurtured on war and acquainted with the customs of feasts', the education of Shapur in 'the drinking of wine . . . and the ordering of a feast', cupbearers and table attendants suggest that there was a highly developed and complex table etiquette as they refilled drinking bowls and cleared away courses (Levy ed. 1985: 267, 269, 276, 307, 351, 380; Newman 1932: 28–9). Comparison with Assyrian or other Court environments implies that an entire hierarchy of officials, cooks and servants must have been necessary to service the royal table which was probably set up and dismantled before and after each meal, and the capture of 'the king's baker' in Year 14 of the Arab Conquest was recorded with glee by al-Tabari (Friedmann ed. 1992: 91). Ammianus (Res Gestae xxiii, 6) claims that 'Only the king has a set hour for dining . . . No

Fig. 8. Late Sasanian painted vase, Merv, complete
(photograph courtesy of The International Merv Project)

servant who waits on them at table is allowed to open his mouth, speak, or spit; once the cloth is spread everyone's lips are sealed'. The solemnity of the occasion is reiterated by Theophylact Simocatta (*History* v, 5.9) who affirmed that 'it is not the custom for Persians to speak while feasting'. Tablecloths appear to have been made of skin according to references in the *Dēnkard* (Tafazzoli 1974: 196). Other writers refer to formal invitations to attend the daily royal banquet (Thomson and Howard-Johnston eds. 1999: vol. I, 41; Greatrex and Lieu eds. 2002: 21), an expectation that guests stood when the host entered the room (Dodgeon and Lieu eds. 1991: 147, 149) and that the hands were washed after eating, which is perhaps unsurprising given that diners normally ate with their hands (Levy ed. 1985: 310). The conclusion of a victory feast held by Khusrau II in 591 was marked by the 'drenching' of the banqueters in perfume, their presentation with flowery wreaths and toasting to a recent victory (Theophylact Simocatta, *History* v, 5.10).[11]

11 The various scents of different flowers are described in *Khusrau and his Boy* (Unvala [1921]: 31–4).

There is a contrast between those types of vessels depicted in Sasanian art, which are presumed to be of precious metal, and those silver vessels which do survive, many of which are considered to be 'prestigious dynastic symbols not wine cups or vessels for use at the royal table' (Harper 1991: 96). One reason for this may lie in the fact that many of the vessels shown on monumental rock reliefs at Bishapur and Taq-e Bustan are items of tribute offered by eastern nations, as in the case of two-handled kantharos-like vessels and fluted trays or large bowls depicted on Bishapur III or the horn rhyta depicted on Bishapur VI. The wavy-fluted ewer held by Anahita on the taller grotto at Taq-e Bustan 'resembles but is not identical to the late Sasanian ewers that are preserved. A notable difference is the attachment of the handle at the base to a point below the widest extension of the body. At this point the handle turns in at a right angle to join the body of the vessel' (Harper 1991: 98). Likewise, fluted bowls held by winged figures on the same grotto resemble cups depicted on Sogdian wall-paintings at Balalyk Tepe (Tanabe 1984: 42–3). However these forms are probably not sufficiently diagnostic to exclude the possibility of Sasanian prototypes rather than the depiction of foreign forms of vessels circulating as a class of elite wares within the Sasanian Empire.[12]

Other written sources add detail about the types and materials of vessels used, particularly among the higher levels of society. Gold 'goblets', 'jars' and 'dishes' are mentioned in connection with the Persian court (Theophylact Simocatta, *History* iii, 6.14, iv.7.2), whereas 'all [kinds of] serving vessels in gold' were among gifts presented by Khusrau II (591–628) to Smbat Bagratuni II, *marzbān* of Tabaristan, to celebrate a victory over enemy forces in 601 (Thomson and Howard-Johnston eds. 1999: vol. I, 47) and a passage in the Babylonian Talmud questions the possession of a silver cup by the son of a rabbi in Nehardea (Oppenheimer 1983: 282). Gold and silver ewers, and 'a goblet of white crystal' being used at a wedding feast are mentioned in other passages in the Talmud (Cohen 1937: 169). The *Shāh-Nāmeh* is rich with later literary allusions to 'goblets', 'wine bowls', 'bowls', 'jewelled gold drinking vessels', 'yellow jacinth goblets', 'crystal cups', 'crystal wine-cups' and 'silver drinking vessels', 'beakers', 'wine-cups', 'goblets', 'wine jugs', shoulder-carried jars, and 'trays' or 'bowls of food' of unspecified materials being used during this period (Levy ed. 1985: 259, 266, 268, 271, 287, 307, 309, 311, 336–7, 356, 381–2, 387, 399, 408). The use of precious materials was a

12 Theophylact mentions the use of 'Turkish' goblets at the Persian Court during the late sixth century (*History* iii, 6.10–14, v, 14.10).

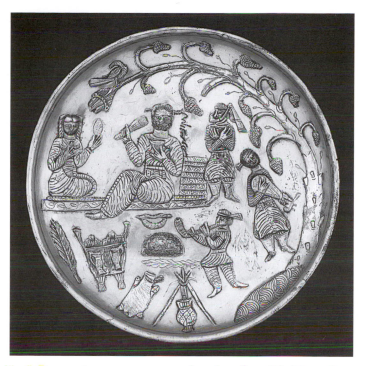

Fig. 9. Banqueting scene on a post–Sasanian silver dish, Mazanderan,
diam. 19.7 cm, complete (Franks bequest, photograph courtesy of
The British Museum, OA 1963.12-10.3).

privilege of royalty and the upper classes, yet more affordable versions, some-
times copying the same shapes and made of cheaper metals, glass, ceramic
and wood were used by other levels of society. Understandably fewer men-
tions are made of these, although one Rav Papi ruled that 'Those clay vessels
from Be Mikse may be used after being rinsed in water, as they do not absorb
much', implying that the pitchers from this unidentified place in Babylonia
were permissible amongst the Jewish community as the lower porosity re-
duced the chance of contamination (Oppenheimer 1983: 91, n. 14).

CONCLUSIONS

'You are what you eat' and what you eat is governed by what is available and
how it can be prepared within the constraints of society and technology.
Highly diverse ecozones and regional seasonal specialities must have played
an important role in defining eating habits and cultural boundaries within
the Sasanian empire, yet the relative shortage of written sources renders it
less easy to detect these variations.

Persian cookery is one of the most distinctive haute cuisines of the Middle East and is characterized by the use of saffron, lemon, huge quantities of herbs, fenugreek and tarragon, fruit and nuts, flavoured rice, sweet-and-sour or sweet-and-savoury combinations, specific varieties of kebab, fruit and meat, and nan bread. Several of these characteristics already appear in the Sasanian period. The frequency of Persian names suggests that the Abbasid court substantially inherited rather than originated the rich culinary culture for which it was famous. This evidence, particularly when combined with that of excavated plant remains (e.g. Samuel 2001), implies that the impact of the so-called 'medieval green revolution' has been overstated (cf. Ahsan 1979; Waines 1989; Watson 1983). Theophylact's comment quoted above is therefore a fair reflection of the Sasanian high table. The continuity at the heart of Mesopotamia of the political capital, seat of the Court and royal patronage from the Sasanian to Abbasid periods must have helped ensure this transfer of taste. It must also have contributed to a fusion of highland 'Persian' recipes with those of Mesopotamia itself. It is from the latter region, a bread-basket and major source of taxable revenue to the state, that the best economic sources derive, although it is to Iran proper and to the Court that most of the literary sources refer.

However there is certainly one major difference between Sasanian and modern Persian cookery and that is the role of rice. Although popularly regarded as being as typical of Middle Eastern food as the tomato is to Italian cookery or the potato to northern European dishes, it shares with these the characteristic of being a relatively late introduction. It was initially considered a sweetmeat outside those limited areas where it was cultivated and it is arguable how far back the tradition of rice cookery exemplified by Safavid cookery books therefore extends in Iran (Zubaida 1994). Rice was therefore part of 'high' rather than 'low' cuisine. Archaeological and environmental evidence offer glimpses into other aspects of 'low' cuisine which are inevitably less well documented in the written sources. However even these do not allow reconstruction of recipes, courses or table settings. There is a risk of under-estimating how societies respond to new ingredients and cooking technologies. Anthropological comparisons also confirm the complexity of culinary culture from gender-specific meals to the critical nuances of meaning between different dishes. The reconstruction of patterns of consumption in antiquity is not a hopeless task, but caution should be exercised and the full range of archaeological and environmental evidence should be employed wherever possible as a benchmark for literary or other written sources.

REFERENCES CITED

Adams, R. McC.

1981 *Heartland of Cities: Surveys of Ancient Settlement and Land Use on the Central Floodplain of the Euphrates*. Chicago: The University of Chicago Press.

Ahsan, M. M.

1979 *Social Life Under the Abbasids 170–289 AH, 786–902 AD*. London, New York: Longman.

Ajzenberg, Y. B.

1958 Iz istorii ispol'zovaniya estestvennogo kamhya. Petrograficheskaya obrabotka arkheologicheskogo kamennogo materiala s mervskogo gorodishch Gyaur-Kala I poseleniya Kara-depe u Artyka. *YuTAKE Reports* 8: 366–73.

Asmussen, J. P.

1970 The list of fruits in the Bundahishn. In *W.B. Henning Memorial Volume*, (M. Boyce and I. Gershevitch, eds.). London: Lund Humphries, 14–9.

Bartl, K., Schneider, G. and Böhme, S.

1995 Notes on 'brittle wares' in northeastern Syria, *Levant* 27: 165–77.

Batmanglij, N. K.

1999 *A Taste of Persia*. London: Mage.

Blankinship, K. Y. (ed.)

1993 *The History of al-Tabari, Vol. 11, The Challenge to the Empires*. New York: State University of New York.

Boardman, S.

1995 Archaeobotanical progress report. In The International Merv Project. Preliminary report on the third season (1994), (G. Herrmann, K. Kurbansakhatov et al.). *Iran* 33: 31–60.

1997 Archaeobotanical report. In the International Merv Project. Preliminary report on the fifth season (1996), (G. Herrmann, K. Kurbansakhatov, St J. Simpson, et al.). *Iran* 35: 1–33.

Bosworth, C. E. (ed.)

1968 *The Book of Curious and Entertaining Information. The Lata'if al-ma'arif of Tha'alibi*. Edinburgh: Edinburgh University Press.

1999 *The History of al-Tabari. Vol. 5, The Sasanids, the Byzantines, the Lakhmids, and Yemen*. New York: State University of New York.

Boyce, M.

1983 Iranian festivals. *The Cambridge History of Iran* (E. Yarshater, ed.). Cambridge: Cambridge University Press, vol. 3/2, 792–815.

Carter, M. L.

1974 Royal festal themes in Sasanian silverwork and their Central Asian parallels. *Acta Iranica* I (première série): 171–202, Pls. III–XIV.

Cavallero, M.

1966 The excavations at Choche (presumed Ctesiphon)—area 2. *Mesopotamia* 1: 63–80, Pls. V–X, Figs. 16–25.

Chase, H.

1994 The *Meyhane* or McDonald's? Changes in eating habits and the evolution of fast food in Istanbul. In *Culinary Cultures of the Middle East* (S. Zubaida and R. Tapper, eds.). London, New York: I. B. Tauris, 73–85.

Christensen, A.

1936 *L'Iran sous les sassanides*. Copenhagen: Levin & Munksgaard.

Cohen, A.

1937 *Everyman's Talmud*. London: Dent.

Curtis, V. S.

1996 Parthian and Sasanian furniture. In *The Furniture of Western Asia, Ancient and Traditional* (G. Herrmann, ed.). Mainz: Philipp von Zabern, 233–44, Pls. 78–82.

Dalby, A. and Grainger, S.
2000 *The Classical Cookbook.* Revised ed. London: BMP.

Day, I. (ed.)
2000 *Eat, Drink, & Be Merry: The British at Table 1600–2000.* London: Philip Wilson.

Desmet-Grégoire, H.
1990 Bread. *Encyclopaedia Iranica,* (E. Yarshater, ed.), vol. 4, 444–7.

Dodgeon, M. H. and Lieu, S. N. C. (eds.)
1991 *The Roman Eastern Frontier and the Persian Wars AD 226–363. A Documentary History.* London, New York: Routledge.

Erdmann, K.
1935 Partho-Sasanian ceramics. *Burlington Magazine* 67/389: 71–7.

Ettinghausen, R.
1938 Parthian and Sasanian pottery. In *Survey of Persian Art* (A. U. Pope, ed.). London, New York: OUP, vol. 1, 646–80, vol. 4, Pls. 179–96.

Fragner, B.
1994 Social reality and culinary fiction: the perspective of cookbooks from Iran and Central Asia. In *Culinary Cultures of the Middle East* (S. Zubaida and R. Tapper, eds.). London, New York: I. B. Tauris, 63–71.

Friedmann, Y. (ed.)
1992 *The History of al-Tabari, Vol. XII. The Battle of al-Qadisiyyah and the Conquest of Syria and Palestine.* New York: State University of New York.

Fukai, S.
1977 *Persian Glass.* New York, Tokyo, Kyoto: Weatherhill/Tankosha.

Gale, R.
Forthcoming The charcoal remains. In *Late Sasanian Remains at Erk-Kala, Merv* (St J. Simpson, ed.), London.

Greatrex, G. and Lieu, S. N. C. (eds.)
2002 *The Roman Eastern Frontier and the Persian Wars, Part II. AD 363–630.*

A narrative sourcebook. London, New York: Routledge.

Gunter, A. C.
1988 The art of eating and drinking in ancient Iran. *Asian Art* 1/2: 7–54.

Gunter, A. C. and Jett, P.
1992 *Ancient Iranian Metalwork in the Arthur M. Sackler Gallery and the Freer Gallery of Art.* Washington: Arthur M. Sackler Gallery and the Freer Gallery of Art.

Haerinck, E.
1980 Twinspouted vessels and their distribution in the Near East from the Achaemenian to the Sasanian periods. *Iran* 18: 43–54, Pl. I.

Hansman, J. and Stronach, D.
1970 A Sasanian repository at Shahr-i Qumis. *JRAS*: 142–55 Pls. I–IV.

Harper, P. O.
1978 *The Royal Hunter. Art of the Sasanian Empire.* Washington, D.C.: The Asia Society.

1991 Luxury vessels as symbolic images: Parthian and Sasanian Iran and Central Asia. In *Histoire et Cultes de l'Asie Centrale préislamique* (P. Bernard and F. Grenet, eds.). Paris, 95–100, Pls. XL–XLI.

Isbell, C. D.
1975 *Corpus of the Aramaic Incantation Bowls.* Missoula, Montana: Society of Biblical Literature and Scholars Press.

Jacobsen, T.
1982 *Salinity and Irrigation Agriculture in Antiquity. Diyala Basin Archaeological Projects: Report on Essential Results, 1957–58.* Malibu: Undena.

Juynboll, G. H. A. (ed.)
1989 *The History of al-Tabari. Vol. 13, The Conquest of Iraq, Southwestern Persia, and Egypt.* New York: State University of New York.

Koldewey, R.
1914 *The Excavations at Babylon.* Trans. A. S. Johns. London: Macmillan.

Laufer, B.

1919 *Sino-Iranica. Chinese Contributions to the History of Civilization in Ancient Iran with Special Reference to the History of Cultivated Plants and Products.* Chicago: Field Museum of Natural History.

Levy, R. (ed.)

1985 *The Epic of Kings.* London: Routledge and Kegan Paul.

Marin, M.

1994 Beyond taste: the complements of colour and smell in the medieval Arab culinary tradition. In *Culinary Cultures of the Middle East* (S. Zubaida and R. Tapper, eds.). London, New York: I. B. Tauris, 205–14.

Mashkour, M.

1998 The subsistence economy in the rural community of Geotchik Depe in southern Turkmenistan: preliminary results of the faunal analysis. In *Archaeozoology of the Near East III* (H. Buitenhuis, L. Bartosiewicz and A. M. Choyke, eds.). Groningen: Centre for Archaeological Research, 200–20.

McCullough, W. S.

1967 *Jewish and Mandaean Incantation Bowls in the Royal Ontario Museum.* Toronto: University of Toronto.

Miller, R. A. (ed.)

1959 *Accounts of the Western Nations in the History of the Northern Chou Dynasty.* Berkeley, Los Angeles: University of California.

Moorey, P. R. S.

1978 *Kish Excavations 1923–1933.* Oxford: Clarendon Press.

Mouton, M.

1999 Le travail de la chlorite à Mleiha. In *Mleiha I. Environnement, stratégies de subsistance et artisanats* (M. Mouton, ed.). Paris: Boccard, 227–43.

Naveh, J. and Shaked, S.

1993 *Magic Spells and Formulae: Aramaic Incantations of Late Antiquity.* Jerusalem: Magnes Press, The Hebrew University.

Negro Ponzi, M. M.

1966 The excavations at Choche (presumed Ctesiphon)—area 1. *Mesopotamia* 1: 81–8, Pls. XI–XVI, Figs. 26–34.

Nesbitt, M.

1993 Archaeobotanical remains. In The International Merv Project. Preliminary report on the first season (1992), (G. Herrmann, V. M. Masson, K. Kurbansakhatov, K. et al.). *Iran* 31: 39–62.

1994 Archaeobotanical research in the Merv Oasis. The International Merv Project. Preliminary report on the second season (1993), (G. Herrmann, K. Kurbansakhatov et al.), *Iran* 32: 53–75.

Nesbitt, M. and O' Hara, S.

2000 Irrigation agriculture in Central Asia: a long-term perspective from Turkmenistan. In *The Archaeology of Drylands: Living at the Margin* (G. Barker and D. Gilbertson, eds.). London, New York: Routledge, 103–22.

Newman, J.

1932 *The Agricultural Life of the Jews in Babylonia between the Years 200 CE and 500 CE.* London: OUP.

n.d. *The Commercial Life of the Jews in Babylonia between the Years 200 CE and 500 CE.* London: OUP.

Nikitin, A. B.

1992 Middle Persian Ostraca from South Turkmenistan. *East and West* 42/1: 103–29.

Oppenheimer, A.

1983 *Babylonian Judaica in the Talmudic Period.* Wiesbaden: Ludwig Reichert.

Potts, D., Mughannam, A. S., Frye, J. and Sanders, D.

1978 Comprehensive archaeological survey program. a. Preliminary report

on the second phase of the eastern province survey 1397/1977. Atlal 2: 7–27, Pls. 1–17.

Pugachenkova, G. A. and Usmanova, Z. I.
1995 Buddhist monuments in Merv. In *The Land of the Gryphons. Papers on Central Asian Archaeology in Antiquity* (A. Invernizzi, ed.). Firenze: Casa Editrice Le Lettere, 51–81.

Reuther, O.
1926 *Die Innenstadt von Babylon (Merkes).* Leipzig: J. C. Hinrichs.

Saberi, H. J.
1993 Rosewater, the flavouring of Venus, goddess of love and asafoetida, devil's dung. In *Spicing up the Palate: Studies of Flavourings—Ancient and Modern, Proceedings of the Oxford Symposium on Food and Cookery 1992* (H. Walker, ed.). Oxford: Prospect Books, 220–35.

Šahri, J.
1990 Brazier. ii. In Modern Times. *Encyclopaedia Iranica* (E. Yarshater, ed.), vol. 4, 444.

Samuel, D.
2001 Archaeobotanical evidence and analysis. In *Peuplement rural et aménagements hydroagricoles dans la moyenne vallée de l'Euphrate fin VII*ᵉ*–XIX*ᵉ *siècle* (S. Berthier, ed.). Damascus: Institut Français d'Études Arabes de Damas, 343–481.

Sancisi-Weerdenburg, H.
1995 Persian food: stereotypes and political identity. In *Food in Antiquity* (J. Wilkins, D. Harvey, and M. Dobson, eds.). Exeter: Exeter University Press, 286–302.

Schafer, E. H.
1985 *The Golden Peaches of Samarkand: A Study of T'ang Exotics* (reprint). Berkeley, Los Angeles, London: University of California.

Segal, J. B.
2000 *Catalogue of the Aramaic and Mandaic Incantation Bowls in the British Museum.* London: BMP.

Shahbazi, A. S.
1990 Byzantine-Iranian Relations. *Encyclopedia Iranica* (E. Yarshater, ed.), vol. 4, 588–99.

Shaida, M.
1993 The sometimes sweet but mostly sour flavour of many Persian dishes today. In *Spicing up the Palate: Studies of Flavourings—Ancient and Modern, Proceedings of the Oxford Symposium on Food and Cookery 992* (H. Walker, ed.). Oxford: Prospect Books, 243–6.
1994 *The Legendary Cuisine of Persia.* London: Penguin.

Simpson, St J.
1996 From Tekrit to the Jaghjagh: Sasanian sites, settlement patterns and material culture in northern Mesopotamia. In *Continuity and Change in Northern Mesopotamia from the Hellenistic to the Early Islamic Period* (K. Bartl and S. R. Hauser, eds.). Berlin: Dietrich Reimer, 87–126, Pls. 1–2.
1997 Partho-Sasanian ceramic industries in Mesopotamia. In *Pottery in the Making: World Ceramic Traditions* (I. Freestone and D. Gaimster, eds.). London: BMP, 74–9.
1998 Gilt-silver and clay: a Late Sasanian skeuomorphic pitcher from Iran. In *Entlang der Seidenstrasse: Frühmittelalterliche Kunst zwischen Persien und China in der Abegg-Stiftung* (K. Otavsky, ed.). Riggisberg: Abegg-Stiftung, 335–44.
2000 Mesopotamia in the Sasanian period: settlement patterns, arts and crafts. In *Mesopotamia and Iran in the Parthian and Sasanian Periods: Rejection and Revival c. 238 BC–AD 642* (J. Curtis, ed.). London: BMP, 57–66, Pls. 30–34, Col. Pls. XI–XIII.

2001 Salt in Mesopotamia: some evidence from the Seleucid–Sasanian periods. *Al-Rafidan* 22: 65–9.

Smith, I.

1997 Preliminary animal bone assessment. In the International Merv Project. Preliminary report on the fifth season (1996), (Herrmann, G., Kurbansakhatov, K., Simpson, St J. et al.). *Iran* 35: 1–33.

Forthcoming The zooarchaeological remains. *Late Sasanian Remains at Erk-Kala, Merv,* (St J. Simpson, ed.), London.

Tafazzoli, A.

1974 A list of trades and crafts in the Sasanian period. *Archäologische Mitteilungen aus Iran* (NS) 7: 191–6.

Tanabe, K.

1984 Descriptions of the rock-cut reliefs of taller grotto. In *Taq-i Bustan IV: Text* (S. Fukai, K. Horiuchi, K. Tanabe, and M. Domyo, eds.). Tokyo: University of Tokyo, 41–7.

Tannahill, R.

1988. *Food in History.* (revised ed.) Harmondsworth: Penguin.

Thompson, R. W. and Howard-Johnston, J. (eds.)

1999 *The Armenian History attributed to Sebeos.* 2 vols. Liverpool: Liverpool University Press.

Unvala, J. M.

[1921] *The Pahlavi Text 'King Husrav and his Boy'.* Paris: Paul Geuthner.

Vandiver, P. B. and Tumosa, C. S.

1995 Xeroradiographic Imaging. *American Journal of Archaeology* 99: 122–3.

Venco Ricciardi, R.

1967 Pottery from Choche. *Mesopotamia* 2: 93–104, Figs. 131–91.

1984 Sasanian pottery from Choche (artisans' quarter) and Tell Baruda. In *Arabie Orientale, Mésopotamie et Iran méridional de l'âge du fer au début de la période islamique* (R. Boucharlat and J-F. Salles, eds.). Paris: Éditions Recherche sur les Civilisations, 49–57.

Waines, D.

1989 *In a Caliph's Kitchen. Mediaeval Arabic Cookery for the Modern Gourmet.* London: Riad El-Rayyes.

Watson, A. M.

1983 *Agricultural innovation in the early Islamic world. The diffusion of crops and farming techniques, 700–1100.* Cambridge: Cambridge University Press.

Whitcomb, D. S.

1985 *Before the Roses and Nightingales. Excavations at Qasr-i Abu Nasr, Old Shiraz.* New York: Metropolitan Museum of Art.

Wilkinson, T. J. and Tucker, D. J.

1995 *Settlement Development in the North Jazira, Iraq. A study of the archaeological landscape.* Warminster: Aris and Phillips.

Yamauchi, E. M.

1967 *Mandaic Incantation Texts.* New Haven: American Oriental Society.

Zubaida, S.

1994 Rice in the culinary cultures of the Middle East. In *Culinary Cultures of the Middle East* (S. Zubaida and R. Tapper, eds.). London, New York: I. B. Tauris, 93–104.

Who used ivories in the early first millennium BC?

Georgina Herrmann and Alan Millard[1]

THE ARCHAEOLOGICAL EVIDENCE[2]

More ivory has been found in Iron Age contexts than from any other time in the ancient Near East. Since ivory survives in such quantity and diversity, it should be possible to examine questions of use and distribution rather than just style, function and regionalism. As is made evident in numerous texts, the material was highly valued and regularly formed part of the tribute given to the Assyrian king or booty seized during campaign.[3] But did they use it, or simply store it in their treasuries?

A study of ivory use by Jacqueline Gachet (1992) at Late Bronze Age Ugarit suggested that, while the richest and rarest ivory objects were reserved to members of the royal entourage, lesser citizens also used the material. Equally, the Middle Assyrian tomb of a wealthy citizen of Ashur contained fine ivory objects decorated in the Assyrian style, suggesting a similar spread of usage (Harper et al. 1995: 81–97). Unfortunately very few ivory objects have been found in domestic contexts in the Neo-Assyrian period: this partly reflects excavation practices. However, such evidence as does exist suggests that ivory use in Assyria may have changed from the Late Bronze Age. It is possible that the material was restricted in distribution to the king and members of his entourage. If so, this might reinforce the theory that the varied styles of carving, so evident among the first millennium ivories of the Levant, reflect the different 'state arts' or 'Machtkunst' of the minor polities of the time rather than the purchase or commissioning of ivories for personal use by wealthy individuals.

1 Georgina Herrmann contributed the section on the archaeological evidence, Alan Millard that on the textual evidence.
 The following bibliographical abbreviation is used in this article:
CAD The Assyrian Dictionary of the University of Chicago. Chicago: The Oriental Institute.
2 I am very grateful to Michael Roaf and Dirk Wicke, who both kindly found time to read and comment on an earlier version of this paper. I would also like to thank Dirk Wicke for his fine drawings of the Assyrian ivories illustrated below.
3 For instance, Tukulti-Ninurta II collected an ivory couch and three ivory chests from Suhu, and Ashurnasirpal II acquired dishes, chests and couches of ivory decorated with gold from Bit Zamani and an ivory dish, ivory couches and ivory thrones decorated with silver and gold from Bit Adini (Grayson 1976: 471, 574, 584). For a list of such material see Bär 1996.

Unfortunately the archaeological evidence is sparse and uneven, since Iron Age ivories are rarely recovered from domestic rather than palatial or temple contexts. The recent discoveries of ivories at Til Barsib in a house near the town wall (Bunnens 1997) has prompted this essay, a small tribute to my friend, colleague and adviser of many years, Roger Moorey. The Til Barsib house is still relatively impressive in scale and construction, although it was not palatial. A more 'domestic' context is the Town Wall Houses at Nimrud. These were lived in by what seem to be urban professionals rather than courtiers, as shown by an archive from Level 3 of House 3, which belonged to a man called Shamash-sharru-usur. He enjoyed a varied career as a moneylender and a merchant, selling birds (Mallowan 1966: Vol. 1, 188). The luxuries available to a high court official can be glimpsed from the burnt and broken ivories found in the *rab ekalli*'s suite in Fort Shalmaneser.

This paper will compare these different assemblages in an attempt to define the social distribution of ivory in the Iron Age, although it will exclude the famous collection of Arslan Tash ivories (Thureau-Dangin et al. 1931). This unusually coherent collection of furniture panels, including bedframes, was found in the 'Bâtiment aux ivoires' adjacent to, but at a lower level than, the palace of the Assyrian governor: it is, therefore, difficult to determine whether this building was contemporary with the Assyrian palace or to establish the status of its owner. There will, however, be an attempt to define Assyrian royal preferences by examining the ivories found in the Residency at Fort Shalmaneser and the gifts deposited in the royal tombs.

The Town Wall Houses at Nimrud

Ivories were only found in two of the six houses built against the walls of the citadel (Mallowan 1954: 129–52; 1966, Vol. 1, 184–97). The most numerous group was found in Level 2 of House 6, while Level 3 ivories were found in House 2.[4] Unfortunately, the House 6 ivories were almost certainly out of context, so only the few House 2 ivories may have been from a primary context. A terminus post quem for Level 3 is provided by tablets from Shamash-sharru-usur's archive in the adjacent House 3: these range in date from 660 BC to the reign of Sin-shar-ishkun (Wiseman 1953; Whiting 1994: 77, note 20). Level 3 ended in a major conflagration, probably when Nimrud was sacked in 614 BC.

4 I have profited from consulting Clemens Reichel's unpublished M.A. dissertation on the Town Wall Houses, Reichel 1990, a copy of which he kindly gave me.

Fig. 1. Assyrian incised panel fragments (ND 3336) from a cache under the Level 3 pavement of Room 12, House 2, Town Wall houses, Nimrud.

House 2 was the largest of the TW houses, and its owner lived and conducted his business there. The most securely dated assemblage was a small cache, found buried under paving slabs in Court 12. In addition to a gold earring and a few beads, it contained an ivory lion leg (ND 3380) and fragments of Assyrian style ivories (ND 3336, Fig. 1). The latter were varied in scale and subject. The largest fragment (Fig. 1a, Mallowan and Davies 1970: no. 82) showed part of a tributary wearing an unusual type of floppy hat and formed part of a panel with a frame with crenellations with the brickwork indicated–this type of frame is unusual and can be compared with a fragment from the Residency of Fort Shalmaneser (ND 7745, Fig. 12a, Mallowan and Davies 1970: no.13); other fragments showed parts of bearded courtiers wearing garments with a rosette design on the upper arm (Fig. 1b), similar to fragments from the Nabu Temple (ND 5612 and 4193, Mallowan

and Davies 1970: nos. 62 and 67); a fragment from a larger panel (Fig. 1c) showed part of the familiar design of a row of courtiers, like fragments from the Nabu Temple and the Residency (Fig. 12a, Mallowan and Davies 1970: nos. 68 and 13). Other fragments with part of a procession of tributaries cut to a smaller scale are different in style and can be compared with fragments found in the court in front of Gate E of the North West Palace (ND 1049–51, Mallowan and Davies 1970: nos. 93–96). One piece depicted the front of a winged sphinx (Mallowan and Davies 1970: no. 185). These fragments obviously belonged to different items. The principal reception room was probably Room 11: an ivory foot on a pedestal (ND 3281) and a knob (ND 3377) were found there, and fragments of an arm and fist (ND 3268) and arm and elbow (ND 3278) in Rooms 3 and 5. Also from Room 5 was part of a panel with cows and calves (ND 3306, Fig. 2). None of these pieces are impressive and they were surely salvaged rather than proving that 'the wealthy householder coveted ivories and collected them, no doubt for their intrinsic as well as for their ornamental value' (Mallowan 1966: Vol. 1, 196).

There is, however, a possibility that one better piece may have been found in this house. The register records that the Assyrian plaque with a winged genie (ND 3506, Fig. 3), now in the Ashmolean Museum, was found in Level 3 of the Town Wall Houses: unfortunately it does not identify the room or house. If the level of ND 3506 was correctly recorded, the winged figure may have come from House 2. Its presence would not, however, alter our view of the householder's ivories, for this piece too was damaged in antiquity.

More and better ivories were found in Room 43 of Level 2. However, this level was otherwise considered to be 'an impoverished occupation' (Mallowan 1954: 131). The ivories were again a fragmentary and mixed

Fig. 2. Panel fragment once showing a row of cows suckling their calves (ND 3306) from Level 3 of Room 5, House 2, Town Wall houses, Nimrud.

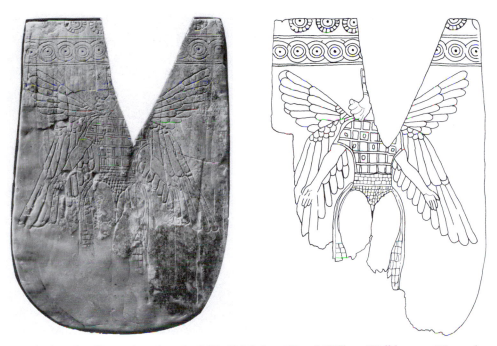

Fig. 3. Assyrian four-winged genie (ND 3506) from 'Level 3' Town Wall houses, Nimrud.

collection, found 'lying in confusion on a beaten mud floor of level 2 against the eastern wall and were clearly out of place' (Mallowan 1954, 148). The most unusual piece consists of fragments of a curving element, ND 3599 (Fig. 4), incised with a remarkable scene of a warrior and a walled fortress with women clashing cymbals, now in the Metropolitan Museum, New York (Mallowan 1966: Vol. 1, 195, fig. 132; Mallowan and Davies 1970:

Fig. 4. Parts of an Assyrian circular element (ND 3599) from Level 2,
Room 43, House 6, Town Wall houses, Nimrud.

Fig. 5. Assyrian incised panel fragments, a. ND 3612 and 3611 and b. ND 3612,
from Level 2, Room 43, House 6, Town Wall houses, Nimrud.

Fig. 6. Assyrian incised panel fragments, a. ND 3610 and ND 3636 and b. ND 3610, from
Level 2, Room 43, House 6, Town Wall houses, Nimrud.

no. 6). Other Assyrian fragments included parts of rows of courtiers (ND 3611 and 3612, Fig. 5a, Mallowan and Davies 1970: nos. 34 and 63), a soldier leading a horse (ND 3612, Fig. 5b, Mallowan and Davies 1970: no. 63), the arm of a courtier against an unusual frame decorated with large rosettes (ND 3610, Fig. 6a, Mallowan and Davies 1970: no. 57), part of the hat of a genie (ND 3636, Fig. 6b, Mallowan and Davies 1970: no. 178), and two plaques, one with a bull and the other with an ostrich (ND 3600 and 3603, Fig. 7, Mallowan and Davies 1970: nos. 157 and 125). Finally, there is a modelled fragment showing the hind leg and tail of a horse (ND 3636, Fig. 8, Mallowan and Davies 1970: no. 156). Like the material from Level 3, these fragments are varied in scale and subject.

A more coherent find was five bull silhouettes: these were carved on a curve and the backs were left rough. Originally they would have been attached to a circular frame, one of which (ND 3587, Fig. 9a) still is. The frame had deep rectangular slots excised for inlays. The bulls originally decorated two different circular elements, since four were recovered advancing to the right (ND 3586–7 and 3590–91) and one to the left (ND 3588) (Fig. 9, Mallowan 1954: Pls. XXXIII–XXXIV). These circular fitments and numerous other

Fig. 7. Assyrian incised plaques, a. ND 3600 (bull) and b. ND 3603 (ostrich), from Level 2, Room 43, House 6, Town Wall houses, Nimrud.

Fig. 8. A modelled fragment with the hind leg and tail of a horse (ND 3636) from Level 2, Room 43, House 6, Town Wall houses, Nimrud.

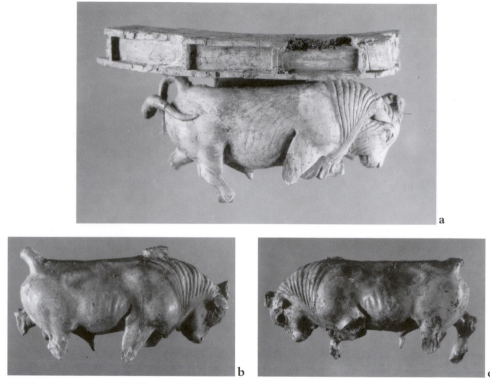

Fig. 9. Curving bull silhouettes from furniture fittings, a. ND 3587, b. ND 3590 and
c. ND 3588, from Level 2, Room 43, House 6, Town Wall houses, Nimrud.

Fig. 10. An openwork hawk (ND 3602) from Level 2,
Room 43, House 6, Town Wall houses, Nimrud.

examples like them would probably have decorated the legs of tables or beds (Herrmann 1996: 161). They were a standard type of fitting, which was regularly decorated with registers of bulls, either openwork silhouettes like the Town Wall bulls or carved in high relief on a solid element or sets of curving plaques making up a circle (Herrmann 1996: Pls. 41–42).

Other fragments from House 6 include a fine hawk (ND 3602, Fig. 10, Mallowan 1966: Vol.1, 127), a pin ending in a hand (ND 3592, Mallowan 1966: Vol. 1, 128), rosettes including some silhouettes (ND 3602, Fig. 11a), of which numerous examples are known in ivory, faience and other materials, and a fragment from a panel (ND 3614, Fig. 11b) similar to some from Room SW37 (Herrmann 1986: nos. 875–79).

Mallowan considered that the 'fine quality of the luxury goods owned by these wealthy householders is best illustrated by a number of remarkable ivories, many of which were found out of place in a disturbed upper level of room 43' (1966: Vol. 1, 193). However, David and Joan Oates have suggested that these ivories were rubbish from the North West Palace, dumped in the ruins of the TW houses when the citadel was being restored after the 614 sack, and certainly this fragmented material bears out such a hypothesis. This theory is reinforced by the fact that a sherd found in the TW houses joined a fine alabaster vase with quasi-hieroglyphic inscriptions (ND 3556) found in Room 26 of Area ZT of the North West Palace (Oates and Oates 2001: Fig. 21 on p. 41, 44, 138, 273 note 5, 278 note 65; Mallowan 1966: Vol. 1: 170–71, Fig. 103). The TW ivories, therefore, do not prove that the householders actually owned ivories. It is possible that the occupant of House 2 salvaged a few ivories, but those from House 6 were probably simply dumped there.

Fig. 11. A silhouette rosette (ND 3602) and a panel fragment with rosette (ND 3614) from Level 2, Room 43, House 6, Town Wall houses, Nimrud.

The Til Barsib ivories

The Til Barsib ivories were found in a large domestic building (C1) not far from the town wall (Bunnens 1997a). This courtyard building consisted of a range of long halls and may initially have been erected as the 'residence of a wealthy person' (Bunnens 1997a: 21), although its function was soon changed and it was employed for industry, perhaps weaving and dyeing, with an adjacent residential courtyard building (C2). However, even this secondary courtyard building was of higher status than the rambling rooms of the Town Wall houses at Nimrud.

Eight ivories were found in Phase C destruction debris in Room XV of C1, which is dated by an archive from the nearby Rooms XI and XII. 'The tablets seem to come from the archive of a person named Hanni, whose profession is not specified. The dates of the Assyrian eponyms mentioned in the texts range from 683 BC (Mannu-ki-Adad) to "post-canonical" times (Shamash-da"inanni)' (Bunnens 1997b: 437). Another ivory was found in Room I and others near, but not in, an empty vaulted tomb. Bunnens neatly summarizes the characteristics of his ivories with their astonishing variety of styles within well-defined limits.

> All the ivories seem to belong to the Syrian[5] tradition, with no recognizable representative of the Assyrian style nor any unquestionably Phoenician specimen. But, within the Syrian tradition, the Til Barsib ivories display great diversity. Also remarkable is the fact that all the styles attested at Til Barsib are already known from the Nimrud collections. Regrettably, no distinctive Til Barsib style is emerging. Lastly, all the carved ivories seem to have been used in different contexts. No two of them, with the possible exception of the friezes of linked palmettes, could have been used together.
> (Bunnens 1997b: 450)

The Til Barsib ivories, like those from Arslan Tash, were made to decorate furniture, although their variety makes it unlikely that they decorated a single piece. It is noteworthy that there is no sign of small usable artefacts, just furniture panels. This emphasis on furniture panels resembles the assemblages found at Arslan Tash and in the storerooms of Fort Shalmaneser. The Til Barsib ivories are unusual pieces and were presumably assembled as a collection.

5 Or Intermediate tradition. For a brief description of ivory traditions and workshops, see Herrmann 1992b and 2000.

The rab ekalli'*s suite in Fort Shalmaneser*

Turning to the heavily burnt remains of the *rab ekalli*'s suite, even the fragmentary ivories from this area may give an indication of the domestic equipment and personal preferences of a highly-placed Assyrian courtier (Herrmann 1992a: 1–2, 13–15). This residential suite belonged to the principal officer of the Fort and remained in use until the 614 sack, for tablets from his archive include the name of the *limmu* Nabu-tapputu-alik from the reign of Sin-shar-ishkun. Ivories were found in nearly every room (Herrmann 1992a: nos. 229–290) and consisted of the burnt and broken remains of high quality pieces from furniture and from small boxes, caskets or stands. The majority belonged to the Intermediate and Phoenician traditions, although there was one piece from a North Syrian style-group (ND 7561, Herrmann 1992a: no. 205). There were also a few Assyrian incised fragments (Herrmann 1992a, nos. 202, 220 and 229), parts of statuettes (Herrmann 1992a: nos. 203–04, 221 and 249), two silhouettes (Herrmann 1992a: nos. 220 and 223) and floral and geometric pieces (Herrmann 1992a: nos. 287–288). They include figures of genii and kneeling bulls between floral elements but no narrative scenes.

Let us examine these fragments more closely to try to reconstruct some idea of what ivories the *rab ekalli* owned. Starting with what he did not have: he lacked any bridle harness blinkers or frontlets, whisks or fan handles. He had none of the pyxides with lids decorated with calves, of which good examples have been found in Well AJ (Safar and al Iraqi 1987: nos. 9–11), although he did have a number of plaques from stands, wider at the base than the top, which may have served as cupstands (Herrmann 1986: 8–9 and figs. 1 and 2): these include pairs of plaques from three sets, possibly from a single workshop (Herrmann 1992a: nos. 203–31, 232–33 and 234–35). Fragments from two larger trapezoidal plaques (Herrmann 1992a: nos. 236–237) also possibly formed a pair from such a set.

He owned a number of furniture panels, which included the 'Crown and Scale' set from SE10 (Herrmann 1992a: nos. 240–43), the elegant sphinxes and genie of the 'Wig and Wing' group (Herrmann 1992a: nos. 207, 219 and 226), the 'Ornate Group' kneeling boy and lady (Herrmann 1992a: nos. 224 and 208), and the Egyptianizing no. 225. There were remains of 'Ladies at the Windows' (Herrmann 1992a: nos. 251–258), and of windows without the ladies (Herrmann 1992a: nos. 259–262). The *rab ekalli* also owned two large furniture finials(?) (Herrmann 1992a: nos. 205 and 206) and fragments of statuettes, as well as Assyrian incised panels and silhouettes. In all, despite its burnt and broken state, this rich and varied collection provides an excellent illustration of the luxuries belonging to a high official at the Assyrian

court. Some may actually have been used as tableware or furniture, while other pieces may have formed part of the *rab ekalli*'s 'collection'.

Evidence from residential areas in Nimrud and Til Barsib thus suggests that, while at least in the seventh century BC court officials and wealthy citizens owned ivories, it seems unlikely that 'urban professionals' did. The *rab ekalli* even possessed ivories in Assyrian style, although the use of these was clearly controlled. Ivories with Assyrian narrative or figurative scenes rather than animal or floral friezes were generally confined to areas with a distinct ceremonial purpose, being found in or adjacent to the ceremonial areas of the North West Palace, the Nabu Temple and Fort Shalmaneser (Fig. 12, Herrmann 1997: 287). Assyrian ivories with more run-of-the-mill animal, floral or geometric friezes were more widely distributed, which suggests that only Assyrian ceremonial furniture was decorated with narrative scenes. The use of such narrative scenes may have been a royal prerogative and it is possible that there was a two-tier use of Assyrian iconography.

Such a scenario is dissimilar from that established by Gachet in her analysis of the distribution of ivories at Late Bronze Age Ugarit (1992), where ivories were found in a wide range of contexts, private houses, tombs of 'people of high social level and/or wealthy tradesmen' (Gachet 1992, 74), cult buildings and the 'Palais Royale'. Not surprisingly ivories unique in size and quality of workmanship were found in the palace and were the exclusive property of the king. However a standardized range of types was represented in all contexts, social hierarchy being 'reflected only in the more frequent use of ivory for whole objects and of elephant ivory for large pyxides'(Gachet 1992, 75).

Ivories in burials

At Ugarit and in Middle Assyrian Ashur ivories were placed in tombs. Recent research has demonstrated that Ashur's rich Tomb 45 was not associated with the nearby Temple of Ishtar, as previously thought, but was the family vault of a wealthy private individual, Babu-aha-iddina. It was equipped with a fine ivory pyxis and comb decorated in the Assyrian incised style, as well as an ivory pin (Harper et al. 1995: 81–8). Ivories have also been found in royal burials at Tell Halaf (Moortgat 1955: 15–9), presumably to be dated not later than the mid ninth century and the Assyrian conquest of Bit Bahiani. A superb ivory pyxis, decorated with guilloche bands, was found in the 'grave-tower' below the terrace-platform of the Kapara *bit hilani*, together with gold grave-goods (Oppenheim 1933: 219–22; Moortgat 1955: 5–7, Figs. 1–2; Hrouda 1962: 3–4, 19, Pl. 1). The box had served as a cosmetic container,

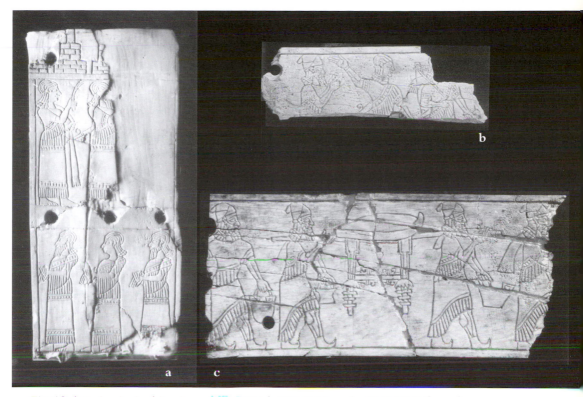

Fig. 12. Assyrian incised ivories, a. ND 7745; b. ND 8011; and c. ND 7744, from the throne-room of the Residency, S5, Fort Shalmaneser, Nimrud.

with the remains of rouge in one of its compartments and a silver spatula nearby (Oppenheim 1933: 222). 'Flame and frond' ivories (Herrmann 1989: 100) were also recovered from the cremation burials in the shaft-graves under the two throned goddesses in front of the City Gates (Oppenheim 1933: 222; Hrouda 1962: 3–4, 19, Pl.1).

At Neo-Assyrian Nimrud, in contrast, there is a near absence of ivory in burial vaults. Not only is there none in the burial vaults either of Shamash-sharru-usur (Town Wall house 3, room 18) or the other vault, room 34 with its beautiful clay rhyton (Mallowan 1966: Vol. 1, 189–93), which may have been for economic reasons, but there is also a noticeable absence of ivories from the recently discovered Royal Tombs in the North West Palace (Damerji 1999). As far as is known, no ivory was found in these tombs, except for the handle of a mirror inlaid with strips of ivory (Damerji 1999: Abb. 21) and a small and poor quality 'Woman at the Window' (personal memory) in the Tomb of Yaba, wife of Tiglath Pileser III. The burials found by Mallowan in Room DD also lacked ivories (Mallowan 1966: Vol. 1, 114–5).

This absence of ivories in the Royal Tombs does not reflect lack of access to the material, for ivories were plentiful throughout the North West Palace and the Well AJ ivories included numerous toilet articles such as pyxides, fan handles and a 'cosmetic palette' (Safar and al Iraqi 1987), any of which might have been considered to be suitable gifts for the tombs of the royal wives, even if furniture was not normal tomb equipment. The absence of ivories from the tombs must, therefore, reflect deliberate choice, the rejection of ivory as a material for deposition. The reason for this cannot have been because most of the ivories found at Nimrud were imported pieces and only Assyrian artefacts were considered suitable as royal burial gifts, for the tombs included the superb 'Phoenician' gold bowl in Tomb 2 (Damerji 1999: Abb. 23). This raises the question of whether ivory itself as a material was highly valued in the Assyrian court or not. Were imported ivories used, or simply stored as a collection or form of wealth, or were they collected simply to ensure that others did not own these symbols of prestige and power? Certainly the bulk of the ivories found at Nimrud was found in the storage magazines of Fort Shalmaneser, but imported ivories have been recovered from both the North West and Burnt Palaces, as well as from occupied areas of Fort Shalmaneser.

Royal preferences
A clue to royal preferences might be provided by material from the Queen's apartments or the Residency in Fort Shalmaneser with its reception rooms, suites and storeroom. Unfortunately, these rooms were poorly maintained in the final years of the Fort's occupation and were occupied by squatters at a higher level (Mallowan 1966: Vol. 2, 432). However, despite their disturbance it is worth examining the ivories found there.

Ivories in the reception suite (S3–5) were all Assyrian in style (Herrmann 1992a: 8–9) and many are decorated with narrative scenes of courtiers and tribute bearers, which may have been used to decorate furniture reserved for the king's or queen's personal use (Fig. 12, Herrmann 1997). Many of the ivories found in the two principal residential suites (S 17–19 and 30 and S 16, 28 and 29, Herrmann 1992a: 9; 1997) are also decorated with Assyrian narrative scenes, but they include a few imported pieces, such as a magnificent sphinx belonging to the Intermediate tradition (ND 7559, Mallowan 1966: Vol. 2, Pl. IX and Fig. 504) and a Phoenician fragment of a hero (ND 7672, Mallowan 1966: Vol. 2, Fig. 557; Herrmann 1992a: no. 90). Predictably the quality of these pieces is exceptional.

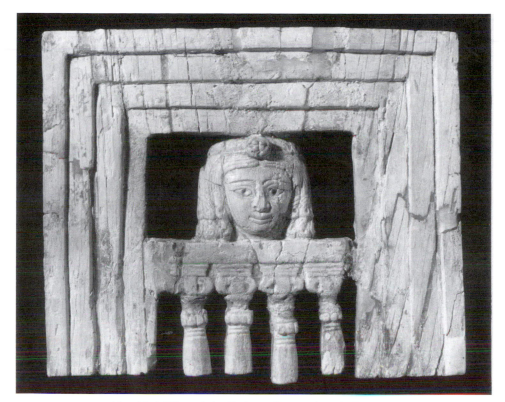

Fig. 13. A 'Phoenician' lady at the window (ND 7754)
from the queen's treasury, S10, Fort Shalmaneser, Nimrud.

In contrast to the main royal areas, no pieces in Assyrian style were found in Corridor E, the corridor leading to S10, and only one fragment in S10. Five ivories were recovered from the corridor, the most impressive of which is a furniture leg with rows of bulls (ND 7560, Herrmann 1992a: no. 96) and a fragment of a Phoenician version of the concave, unusually shaped pieces (ND 7585, Herrmann 1992a: no. 97).

The storeroom S10 was filled with debris, including cereals, beads, glass and smashed ivories, as well as the archive of the royal housekeeper, which included a tablet with the name of the post-canonical eponym, Sin–alik–pani (Dalley and Postgate 1984: 10). S10 was destroyed by fire and it may be that material was assembled here for burning (Mallowan 1966: Vol. 2, 434). Not surprisingly, the ivories are varied (Herrmann 1992a: nos.101–170). One interesting fragment is part of the head of a statuette of an Assyrian lady (ND 8215, Herrmann 1992a: no. 162). Sets of furniture panels include a fine openwork series of 'Ladies at the Windows' from a Phoenician style group (Fig. 13, Herrmann 1992a: nos. 102–108). The faces show fascinating

evidence of variability, as can be seen by comparing the crudely worked no. 107 with the others. It may have been carved by an apprentice or may have been a replacement. Intermediate versions of the same subject show interesting variations from the Phoenician 'ladies'. 'Phoenician' window frames have four reveals rather than three; the ears of the 'Phoenician' ladies are concealed by their ringlets, those belonging to Intermediate style groups are exposed to reveal massive earrings; and the hair of the 'Phoenician' ladies is bound with a fillet embellished with a central flower instead of the rectangular jewel with pendants worn by the others (Herrmann 1992a: nos. 109–12).

The subjects of other furniture panels include males associated with trees or flowering plants (Herrmann 1992a: nos. 115–118 and 119–120), and animal subjects, bovids, sphinxes and caprids (Herrmann 1992a: nos.125–139), most of which belong to style groups of the Intermediate tradition. The collection also includes fragments of smaller articles. The finest is a cosmetic palette and it is significant that this attractive and presumably usable piece was found in S10 rather than the residential suites (ND 7648, Fig. 14, Herrmann 1992a: no. 140). There are also pieces for decorating small boxes of varying forms and types (Herrmann 1992a: nos. 141–154). Remains of three or possibly four sets of plaques probably belonged to cup-stands (Herrmann 1992a: nos. 141–43, 144, 145–46 and 147).

The quality of the S10 ivories is universally high and suggests that they may have been the fractured remains of royal property, although whether they were used, formed a royal collection or were simply stored remains uncertain. However, surprisingly once again, there is no trace of fans, fly whisks or pyxides, all richly represented in the Burnt Palace (Barnett 1975: Pls. LXXII–XCIV, XVI–XXXI). The variety of the Levantine ivories in S10 contrasts with the preponderance of Assyrian ivories in the principal reception and residential suites and may indicate an Assyrian preference for their own imperial style, with 'objets d'art' stored in a special treasury or museum.

Other ivory collections

Variety is one of the few factors common to ivory assemblages whether from Nimrud or from other centres. We can be reasonably certain that the smashed remains from, say, Hasanlu (Muscarella 1980), Samaria (Crowfoot and Crowfoot 1938) or the Idaean Cave (Sakellarakis 1992) will not belong to a single style group, nor even to one tradition, but will be mixed and likely to include pieces from at least two of the three principal traditions of ivory

carving, the North Syrian, Intermediate and Phoenician traditions (Herrmann 1992b; 2000). Furthermore, most pieces will be comparable to ivories known from Nimrud.

Mixed assemblages from sanctuaries (Strom 1992), such as the Idaean Cave in Crete (Sakellarakis 1992), the Heraion at Samos[6] or the Artemision at Ephesus (Bammer 1992), are understandable, for these were offerings, given and preserved over time. There would have been no deliberate selection, being random gifts by worshippers, united only by the intention of honouring, thanking or propitiating the deity. However, the consistent variety of assemblages in residential contexts cannot be purely accidental. The range of ivories found, for instance, at Samaria suggests an element of deliberate choice, whatever the mechanism of collection. There are pieces from all three Levantine traditions, the Phoenician, Intermediate and North Syrian, but no Assyrian ivories. There would have been no diplomatic imperative for Assyria to

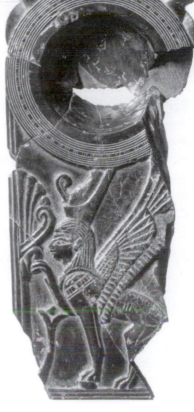

Fig. 14. A 'cosmetic palette' (ND 7648) from the queen's treasury, S10, Fort Shalmaneser, Nimrud.

provide 'gifts' to the kingdom of Israel. Phoenician style groups include the Egyptianizing and Ornate groups (Crowfoot and Crowfoot 1938: Pls. I–IV) and champ levé pieces (Crowfoot and Crowfoot 1938: Pls. XIV–XV), while Intermediate style groups include 'beaky nose' and 'triple flower' groups among others (Crowfoot and Crowfoot 1938: Pl. V). A range of animal combat scenes may include examples from a North Syrian style-group (Crowfoot and Crowfoot 1938: Pl. VIII), although not all such scenes are necessarily North Syrian (see for instance Crowfoot and Crowfoot 1938: Pl. X, nos. 1 and 2). Unfortunately, the Samaria ivories were found out of context, smashed and partially burned in rub-

6 Freyer-Schauenberg 1966; Furtwängler 1981: 107–17; Sinn 1982; and Brize 1992.

bish pits (Dayagi-Mendels 1986: 165), so their provenance is of little use in establishing their original context.

A similar variety of style, subject and form can be seen in the well-known late second millennium collection from Megiddo, which was found on the floor of a palace basement attributed to Level VIIA (Loud 1939: 7–9).[7] This consists of nearly 300 ivories, found with gold jewellery and alabaster. In 1956 Kantor classified the ivories into five principal groups (1956: 153–74), while Barnett (1982: 25–28) suggested that there were at least ten groups, including actual Egyptian and Hittite imports, as well as ivories in Egyptianizing, Canaanite, Late Mycenaean and Syro-Canaanite styles.

Apart from the Nimrud collections, the Megiddo ivories were the first really mixed assemblage to be excavated. Their excavator (Loud 1939: 9) suggested that ivory collecting at Megiddo was the 'hobby of an eccentric Canaanite prince of the Late Bronze Age', since it was scarcely credible that 'the ivories were at the time of invasion still attached to the furniture for which they may originally have been intended . . . So much furniture could not have been stored in such cramped quarters'.[8] Barnett (1975: 25) suggested that ivory collecting was 'an important form of wealth, in which perhaps either the local prince or princess traded, or acted as distributor for the Pharaoh or more likely on his or her own behalf . . . Consequently, the hoarding of ivory began and the "ivory rooms" formed part of his or her Treasure or bank.'

Barnett's hypothesis that 'ivory rooms' might have formed part of a royal treasury is an interesting one. In her stimulating *The Phoenicians and the West,* Maria Aubet discusses processes of elite exchange, well illustrated in the Amarna letters. 'Within the process of presents and counter-presents, the grades or relationships of equivalency vary from a balanced and equitable exchange between equals to an asymmetrical reciprocity that conceals relationships of power or gain' (Aubet 1997: 108). This practice was characteristic of the Late Bronze Age in Mesopotamia, Canaan and Egypt and was inherited by the Phoenicians from their predecessors, the Canaanites

7 See also 'Ivories from Megiddo' in Dayagi-Mendels 1986: 147. For a recent suggestion that the 'Treasury' at Megiddo was actually a tomb see Hachmann 1996: 225–7. I am grateful to Alan Millard for drawing my attention to this reference.

8 The donation of individual ivory plaques as grave goods could perhaps explain the presence of the two 'loose' plaques found in Tomb 79 at Salamis. These are usually restored as part of the ivory chair found in the tomb (e.g. Karageorghis 1969: Pls IV–VI): a complete set of this type of ivory would, however, have consisted of three plaques, a pair of sphinxes flanking the stylized tree.

(Aubet 1997, 107–8). To this mechanism should be added that of gifts in the form of dowries and forced 'gift-giving' either as 'tribute' or booty.

Within a more peaceful framework Aubet discusses 'the circulation of reciprocal gifts among social elites', such as a chased silver crater 'that the king of Sidon had offered as a gift to Menelaus when he was a guest in his house (Odyssey 4: 615–19). In this case, the practice of gifts seems to be associated with that of hospitality.' (Aubet 1997: 107). The remarkable story of another great silver crater is also relevant:

> on the occasion of the funeral of Patroclus, Achilles offered a large silver crater, a 'masterpiece of Sidonian craftsmanship', as a prize. The vessel, 'the loveliest thing in the world', was shipped by Phoenician traders across the misty seas' and displayed in various ports until it finally arrived in the port of Lemnos, and was offered as a gift to the king, Thoas. Later the same silver vase served as a ransom for one of Priam's daughters, captured by Achilles, and thus finally came into his hands.
>
> (Aubet 1997: 106)

In such a case the history of the crater added value and increased its social status.

> This circulation of valuable objects among social elites must be fitted into the model of gift exchanges. These goods always have a high social and economic value and occasionally they figure in genuine operations of buying and selling.
>
> (Aubet 1997: 106)

With these thoughts in mind, perhaps the very eclecticism of the contents of our sacked and ravished 'ivory rooms' reflects the complexity of ancient gift giving and royal exchange, with another factor being the increased value of the onward transmission of a rare object. Indeed, if such a scenario is relevant, we should be surprised to find coherent collections, unless complete pieces of furniture are found, as at Salamis, Arslan Tash and Room SW7 of Fort Shalmaneser.

THE TEXTUAL EVIDENCE

The material remains described above show clearly that ivory work was usually the perquisite of kings and their companions in the ancient Near East. The textual sources complement that picture.

In the earlier half of the second millennium a few ivory pieces are mentioned: Ibalpiel II of Eshnunna donated a chair of ivory and gold to the

temple of Ishtar and in the palace at Mari was equipment decorated with ivory.[9] One tablet from Ur and another from Susa list ivory combs.[10] Later in the millennium more numerous references to ivory-ornamented furniture appear in royal contexts. Inventories from Nuzi (c. 1400 BC), cited by Armas Salonen and in the *Chicago Assyrian Dictionary* (Salonen 1963: 67–68, 255–57; CAD S.3: 51, 52) which list ivory-decorated furniture—beds, chairs and tables—were found in the palace. Two came from Room L27, one from Room R81 and two from unspecified rooms (Mayer 1978:, nos. 106, 107; Lacheman 1955: 130, 132, no. 461; Pfeiffer and Lacheman1942: 435, nos. 550, 551; Lacheman 1955: 131, 133). The term expressing the application of ivory, *uhhuzu*, is too wide in meaning to indicate how the ivory ornamentation was done. The various renderings of this term in the *Chicago Assyrian Dictionary* include 'overlaid', 'edged with ivory', and 'inlays' (CAD S:3, 51–52; A.1: 179b; K: 150a.), so the amounts of ivory may have been small, as inlays, or more extensive, as overlays.

To the west, in the el-Amarna letters, ivory-ornamented furniture occurs several times amongst the gifts sent from one king to another, for example, Amenophis III sent a bed decorated with ivory and gold and footstools 'of ivory overlaid with gold' for Kadashman-Enlil's new palace (EA5), and ebony beds with ivory embellishment to the king of Arzawa (EA 31), while Tushratta of Mitanni sent many small objects adorned with ivory to Egypt on the marriage of his daughter Tadu-khepa (EA 25).

Middle Assyrian texts from Ashur do not record ivory-decorated furniture. However, two letters from the thirteenth century magnate Babu-aha-iddina refer to 'a box of ivory' (*quppu ša šinni*), which may mean made of ivory or adorned with ivory (Schroeder 1920: 99.25, 109.14). The texts are consistent with the ivory objects—a pyxis and bowl, combs and pins—laid in Tomb 45 at Ashur, which was probably the family vault of Babu-ahu-iddina (see above). These are small precious artefacts of fine workmanship in the hands of wealthy and important members of society.

In the west again, the discoveries of ivory furniture panels and inlays at Ugarit are mirrored in the texts (for a summary account of the ivories see Courtois 1979: cols. 1225–26). The princess Ahatmilku had three beds adorned with ivory and an ebony chair with ivory decoration, as well as toilet boxes of ivory, in her trousseau when she went from Amurru to marry a king of Ugarit in the thirteenth century BC (Nougayrol 1955: 182–86, lines 14, 17, 42).

9 Ebeling 1938: 195: see Salonen 1963: 48, 255; 'pot stands' or 'racks' (*kannu*) at Mari, Bottéro 1957: 288.
10 Figulla and Martin 1953: no. 678, 12; Scheil 1932: 310.9.

Moving into the first millennium, the numerous times ivory furniture is mentioned are all found in Assyrian royal inscriptions boasting of ivory, raw and worked, transported to the capitals from the palaces of conquered or subject rulers. Some examples are depicted on the reliefs (listed in Bär 1996: 236). Furniture occasionally appears in documents relating to the affairs of Assyrian citizens, but not with ivory decoration (e.g. in a dowry recorded on a tablet from Nimrud (ND 2307, Parker 1954: 37–9) were a bronze bed, stool, table and chairs).

Simultaneously, Hebrew writers reported similar uses of ivory in the Levant. The 'ivory house' which king Ahab of Israel built in Samaria (c. 850 BC; 1 Kings 22:39) was evidently intended to display his majesty, and the Psalmist portrayed a splendid messianic king coming from 'ivory palaces' for the royal wedding (Psalm 45: 8[9]). Such lavish buildings were condemned in the eighth century by the prophet Amos (3:15), who also castigated the wealthy for lying on ivory couches (6:4). King Solomon's throne was of ivory, overlaid with gold (1 Kings 10:18; 2 Chronicles 9:17), in the manner attested by a few scraps of gold foil still adhering to ivories at Nimrud (ND 8027, Mallowan 1966: Vol. 2, 574–6). In the early sixth century, the prophet Ezekiel tells of proud Tyre's trade, ivory tusks reaching her from afar (27:15).[11] The lyric poet who wrote the Song of Songs was familiar with the appearance of ivory and obviously expected his audience to appreciate his similes for the girl's neck, 'like an ivory tower', and the belly of her beloved, 'like polished ivory' (Song of Songs 7:5; 5:14).

Perhaps it is the biblical texts which give the clearest answer to the question of our title: kings' palaces decorated or furnished with ivory and mansions of the elite were the places where carved ivory work would be seen, the fulminations of the prophet Amos, who was informed about it, implying that it was a costly and useless luxury. What is lacking from the Semitic texts of the first millennium is any account of 'gift-exchanges' like those of the Amarna period or of prizes and presents comparable with the Homeric reports. The Hebrew histories note one major gift, from the Queen of Sheba to Solomon, but ivory did not figure in it.

11 Block 1998: 66, 74. On the deletion of 'ivory' from the description of the ship in verse 6 see Block 1998: 56, 59, 60, following earlier commentators.

CONCLUDING REMARKS

The Neo-Assyrian kings acquired ivory in bulk, as is proved both in Assyrian texts and by the quantities found at Nimrud. More ivory certainly awaits the archaeologist at Nimrud, at Khorsabad and especially at Nineveh, as well as doubtless in other centres. What is less clear are their reasons for collecting all this material, for, as discussed above, there is little evidence to prove that the Neo-Assyrian kings and queens actually liked it. Its near total absence from the recently discovered tombs of the queens, in contrast to the over-whelming wealth of jewellery, clothing and vessels of all materials, is marked. There is a similar absence of ivory from Neo-Assyrian non-royal burials discovered to date, in contrast to Middle Assyrian practice and to the royal tombs at Aramaean Tell Halaf.

The great majority of Levantine ivory from Nimrud was found in the storerooms in Fort Shalmaneser (SW7, SW12 and SW37) and consisted of furniture panels and elements, 'cup-stands' and bridle harness. Further out-standing pieces were, of course, found in the wells of the North West Palace, and in the Burnt Palace, and those groups were notable for a wider variety of small objects such as fan handles, pyxides, bridle harness and statuary, in addition to furniture elements. In comparison to the quantity in storage, that scattered through the rooms of the Fort and palaces is relatively limited.

The distribution and quantity of Assyrian ivories is equally instructive, for not only is none found in the storerooms of Fort Shalmaneser, but its use appears to have been strictly controlled, with panels showing narrative scenes being confined to ceremonial areas, for instance the fine incised series of plaques almost certainly from the throne equipping the throne-room, S5, of the Residency in Fort Shalmaneser (Fig. 12, Herrmann 1992: Pls. 1, 2–9). However, even these Assyrian ivories, carved on fragile, thin panels, make little use of the outstanding virtues of this versatile material. The incised or lightly modelled designs, often miniature in scale, must have been barely visible, even when highlighted with colour, particularly when compared to the impact that must have been made by North Syrian furniture, such as that found in SW7. Furthermore, comparatively little Assyrian ivory has been recovered: the Assyrian decorator probably preferred to overlay wooden panels with bright bronze, silver or gold and to decorate it with lively narra-tive scenes worked in repoussé (Curtis 1996: 172–8).

It seems possible that there was a very different appreciation and use of ivory in the Levant and in Assyria in the Iron Age. Ivory, as noted above, was highly prized in the Levantine states, for the furnishing of kings' palaces.

Ivory was also deposited in royal burials. The range of ivory found at sites such as Samaria suggests that 'collecting' ivory from different cities may have been fashionable, although just how widely ivory objects were distributed through Levantine society in the Iron Age as opposed to the Late Bronze Age cannot yet be determined. Cheaper versions in bone, metal and ceramic may have been available to the less wealthy.

In contrast to Middle Assyrian Ashur, in Neo-Assyrian Assyria there is little evidence to suggest an appreciation of ivory. Indeed, bronze seems to have been preferred for many artefacts worked in the imperial style. What we do have is the listing of ivory, worked and raw, removed from conquered cities as tribute and booty, particularly by the earlier Neo-Assyrian monarchs. Often, however, lists simply record the removal of the 'treasure of his palace' rather than providing an inventory. So why did the Assyrians assemble so much ivory? Much of the impetus may have been their determination to remove the essential attributes of royalty from those whom they had defeated, as this would form a potent impediment to their restoration. Indeed, when Ashurbanipal reinstated Niku as king in Sais he boasted:

> I spared his life and laid an oath, more drastic than the former upon him. I clothed him in splendid garments, laid upon his (neck) a golden chain, as the emblem of his royalty. I put rings of gold upon his fingers, gave him an iron girdle dagger, set in gold—having written my name upon it. Chariots, horses and mules I presented him for his royal riding.
>
> (Luckenbill 1989: Vol. 2, 774)

In effect, Assurbanipal re-equipped Niku with the necessary symbols of power in order that he could be re-instated as king.

This suggestion of relative Assyrian indifference to ivory is necessarily based principally on negative evidence. It will be interesting to see whether fresh discoveries and analyses alter this tentative picture of a difference in the appreciation of ivory in the Levant and Assyria in the Iron Age.

REFERENCES CITED

Aubet, M. E.
1997 *The Phoenicians and the West, Politics, Colonies and Trade*, (M. Turton, trans.). Cambridge: Cambridge University Press.

Bammer, A.
1992 Ivories from the Artemision at Ephesus. In Fitton 1992: 185–204.

Bär, J.
1996 *Der assyrische Tribut und seine Darstellung.* Alter Orient und Altes Testament 243. Neukirchen-Vluyn: Neukirchener Verlag.

Barnett, R. D.
1975 *Catalogue of the Nimrud Ivories with other Examples of Ancient Near Eastern Ivories in the British Museum* (2nd enlarged ed.). London: British Museum.
1982 *Ancient Ivories in the Middle East and Adjacent Countries.* Qedem 14. Jerusalem: Institute of Archaeology, Hebrew University.

Block, D. I.
1998 *The Book of Ezekiel.* Grand Rapids, Michigan / Cambridge: Eerdmans.

Bottéro, J.
1957 *Textes économiques et administratifs.* Archive Royale de Mari 7. Paris: Imprimerie Nationale.

Brize, P.
1992 New Ivories from the Samian Heraion. In Fitton 1992: 163–72.

Bunnens, G.
1997a Til Barsib under Assyrian domination: A brief account of the Melbourne University excavations at Tell Ahmar. In *Assyria 1995* (S. Parpola and R. M. Whiting, eds.). Helsinki, 17–28.
1997b Carved ivories from Til Barsib. *American Journal of Archaeology* 101: 435–50.

Courtois, J.-C.
1979 Ras Shamra, Archéologie. In *Supplément au Dictionnaire de la Bible* (H. Cazelles and A. Feuillet, eds.). Paris:

Letouzey and Ané, Fasc. 35, cols. 1225–26.

Crowfoot, J. W. and G. M.
1938 *Early Ivories from Samaria.* London: Palestine Exploration Fund.

Curtis, J.
1996 Assyrian furniture: the archaeological evidence. In Herrmann ed., 1996: 167–80.

Dalley, S. and Postgate, J. N.
1984 *Cuneiform Texts from Nimrud III, The Tablets from Fort Shalmaneser.* London.

Damerji, M. S. B.
1999 *Gräber Assyrischer Königinnen aus Nimrud.* Jahrbuch des Römisch-Germanischen Zentralmuseums 45/1. Mainz.

Dayagi-Mendels, M.
1986 Ivories from Samaria, Ivories from Megiddo. In *Treasures of the Holy Land, Ancient Art from the Israel Museum.* New York: Metropolitan Museum of Art, 147–50, 165–9.

Ebeling, E.
1938 Daten von Aschiâly. In Datenlisten (Ungnad, A.). In *Reallexikon der Assyriologie und Vorderasiatischer Archäologie* 2 (E. Ebeling and B. Meissner, eds.), 195–6.

Figulla, H. H. and Martin, W. J.
1953 *Letters and Documents of the Old Babylonian Period, Ur Excavations Texts* V. London, The British Museum.

Fitton, J. L. (ed.)
1992 *Ivory in Greece and the Eastern Mediterranean from the Bronze Age to the Hellenistic Period.* British Museum Occasional Paper 85. London.

Freyer-Schauenberg, B.
1966 *Elfenbeine aus dem samischen Heraion: Figürliches, Gefässe und Siegel.* Abhandlungen aus dem Gebiet der Auslandskunde 70. Hamburg: Cram, De Gruyter

Furtwangler, A.E.

1981 Heraion von Samos. Grabungen im Südtemenos 1977, II. Kleinfunde. *Mitteilungen des Deutschen Archäologischen Instituts; Athenische Abteilung (A.M.)* 96: 73–138.

Gachet, J.

1992 Ugarit Ivories: Typology and distribution. In Fitton ed. 1992: 67–89.

Grayson, A. K.

1976 *Assyrian Royal Inscriptions* 2. Wiesbaden: Harrassowitz.

Hachmann, R.

1996 Das Königsgrab von Kâmid el-Lôz und die Königsgräber der mittleren und späten Bronze- und frühen Eisenzeit im Küstengebiet östlich des Mittelmeeres und in Mesopotamien. In *Kamid el-Loz 16. 'Schatzhaus'-Studien* (R. Hachmann, ed.) Bonn: Dr. Rudolf Habelt, 203–88.

Harper, P. O., Klengel-Brandt, E., Aruz, J. and Benzel, K. (eds.)

1995 *Assyrian Origins, Discoveries at Ashur on the Tigris, Antiquities in the Vorderasiatisches Museum, Berlin*. New York: Metropolitan Museum of Art.

Herrmann, G.

1986 *Ivories from Nimrud IV, Ivories from Room SW37 Fort Shalmaneser*. London.

1989 The Nimrud Ivories 1: The Flame and Frond School. *Iraq* 51: 85–109.

1992a *Ivories from Nimrud V, The Small Collections from Fort Shalmaneser*. London.

1992b The Nimrud Ivories 2: A survey of the traditions. In *Von Uruk nach Tuttul, eine Festschrift für Eva Strommenger* (B. Hrouda, S. Kroll and P. Z. Spanos, eds.). Münchener Vorderasiatische Studien. Munich and Vienna: Profil, 65–79.

1996 Ivory furniture pieces from Nimrud. In Herrmann, ed. 1996.

1997 The Nimrud Ivories 3: The Assyrian Tradition. In *Assyrien im Wandel der Zeiten. XXXIXᵉ Rencontre Assyrio-logique Internationale Heidelberg 6. – 10. Juli 1992* (H. Waetzoldt and H. Hauptmann, eds.). Heidelberger Studien zum alten Orient 6. Heidelberg: Heidelberger Orientverlag, 285–90.

2000 Ivory carving of first millennium workshops, traditions and diffusion. In *Images as Media, Sources for the Cultural History of the Near East and the Eastern Mediterranean (1st millennium BCE)*, (C. Uehlinger, ed.). Fribourg, 267–82.

Herrmann, G. (ed.)

1996 *The Furniture of Western Asia, Ancient and Traditional*. Mainz: Philipp von Zabern,

Hrouda, B.

1962 *Tell Halaf IV, Die Kleinfunde aus Historischer Zeit*. Berlin: Walter de Gruyter.

1972–75 Halaf, Tell. In *Reallexikon der Assyriologie und Vorderasiatischer Archäologie* 4 (D. O. Edzard, ed.). Berlin/New York: Walter de Gruyter, 54.

Kantor, H. J.

1956 Syro-Palestinian ivories. *Journal of Near Eastern Studies* 15: 153–74.

Karageorghis, V.

1969 *Salamis in Cyprus, Homeric, Hellenistic and Roman. New Aspects of Antiquity*. London: Thames and Hudson.

Lacheman, E. R.

1955 *Excavations at Nuzi VI, The Administrative Archives*. Harvard Semitic Series 15. Cambridge, MA: Harvard University Press.

Loud, G.

1939 *The Megiddo Ivories*. Oriental Institute Publication 52. Chicago.

Luckenbill, D. D.

1989 *Ancient Records of Assyria and Babylonia* Vol. 2. (reprint) London.

Mallowan, M. E. L.

1954 The excavations at Nimrud (Kalhu), 1953, continued. *Iraq* 16: 115–63.

1966 *Nimrud and Its Remains.* 2 vols. London: British School of Archaeology in Iraq.

Mallowan, M. E. L. and Davies, L. G.

1970 Ivories from Nimrud II, *Ivories in Assyrian Style*. London.

Mayer, W.

1978 *Nuzi-Studien* I. *Die Archive des Palastes und die Prosopographie der Berufe.* Alter Orient and Altes Testament 205/1. Neukirchen-Vluyn.

Moortgat, A.

1955 *Tell Halaf* III, *Die Bildwerke*. Berlin: Walter de Gruyter.

Muscarella, O. W.

1980 *Catalogue of Ivories from Hasanlu, Iran*. University Museum Monograph 40. Philadelphia.

Nougayrol, J.

1955 *Le Palais royal d'Ugarit* 3, *Mission de Ras Shamra* 6. Paris: Imprimerie Nationale.

Oates, J. and Oates, D.

2001 *Nimrud: An Assyrian Imperial City Revealed*. London: British School of Archaeology in Iraq.

Oppenheim, Max von

1933 *Tell Halaf, A New Culture in Oldest Mesopotamia*, (translated by G. Wheeler). London and New York: G. P. Putnam's Sons.

Parker, B. H.

1954 The Nimrud Tablets 1952—Business documents. *Iraq* 16: 29–58.

Pfeiffer, R. H. and Lacheman, E. R.

1942 *Excavations at Nuzi* IV, *Miscellaneous Texts from Nuzi* I. Harvard Semitic Series 13. Cambridge, MA: Harvard University Press.

Reichel, C.

1990 The Town Wall Houses in Nimrud/Kalhu: An Archaeological and Historical Reconsideration. Unpublished MA thesis, University of London.

Safar, F. and Sa'id al-Iraqi, M.

1987 *Ivories from Nimrud*. Baghdad. (in Arabic)

Sakellarakis, J.

1992 The Idaean Cave ivories. In Fitton 1992: 113–40.

Salonen, A.

1963 Die Möbel des alten Mesopotamien. Helsinki: Suomalainen Tiedeakatemia

Scheil, V.

1932 *Actes juridiques susiens*. Mémoires de la Délégation en Perse 23. Paris: Leroux.

Schroeder, O.

1920 *Keilschrifttexte aus Assur verschiedenen Inhalts.* Wissenschaftliche Veröffentlichung der Deutschen Orient-Gesellschaft 35. Leipzig: Heinrichs.

Sinn, U.

1982 Ein Elfenbeinkopf aus dem Heraion von Samos. Zur ostionischen Plastik im 3. Viertel des 6. Jh. v. Chr. *Mitteilungen des Deutschen Archäologischen Instituts; Athenische Abteilung (A.M.)* 97: 35–55.

Strom, I.

1992 Evidence from the sanctuaries. In *Greece between East and West 10th–8th centuries BC,* Papers of the Meeting at the Institute of Fine Arts, New York University, March 15–16, 1990 (G. Kopcke and I. Tokumaru, eds.). Mainz: Philipp von Zabern, 46–60.

Thureau-Dangin, F., Barrois, A., Dossin, G. and Dunand, M.

1932 *Arslan Tash*. Paris.

Whiting, R.

1994 The Post-Canonical and Extra-Canonical Eponyms. In A. Millard, *The Eponyms of the Assyrian Empire 910–649 B.C.* State Archives of Assyria Studies 2. Helsinki: Helsinki University Press, 72–8.

Wiseman, D. J.

1953 The Nimrud Tablets, 1953. *Iraq* 15: 135–60.

'Surpassing work': mastery of materials and the value of skilled production in ancient Sumer

Irene J. Winter

In 1985, with the publication of *Materials and Manufacture in Ancient Mesopotamia*, Roger Moorey noted the potential of textual evidence in contributing to our understanding of ancient Mesopotamian material culture (Moorey 1985: x). Although he himself made a conscious decision to focus on the archaeological record (1985: vii, x–xi), it was clearly not possible to avoid texts altogether. Throughout the introduction to this important volume, he pointed to the need to integrate the material remains with relevant documentary evidence, especially with respect to the socio-economic context in which works were produced and consumed (e.g. 1985: ix).[1]

This is no less true when considering the socio-cultural context of value—properties deemed worthy of positive evaluation when assessing the overall worth of materials and individual specimens of material culture. Similarly, in a study dealing with aesthetics for the anthropologist, Warren d'Azevedo (1958) observed that every (artistic) object has two social co-ordinates: the context of production and the context of appreciation. What has become increasingly clear is that if we are to pursue the meaning(s) attached to major works of material culture in antiquity, and in particular meaning(s) attached to appreciation, this can only be accessed with reference to a combination of evidentiary sources that include both the archaeological and the textual record.

Moorey chose to begin his own introduction to ancient Mesopotamian materials with a quote from Leo Oppenheim (1978: 646) to the effect that the notable lack of attention to technological achievements in the past was directly proportionate to a lack of scholarly interest in material culture. Indeed, Oppenheim's own manuscript on material culture of ancient Mesopotamia languishes unpublished to this day, although happily, the scholarly environment has changed significantly since Oppenheim wrote: several conferences

1 It is a privilege to be able to present this tentative inquiry into the attributes of and values attached to works of various media as a tribute to Roger Moorey who has, throughout his career, contributed complex questions, and oftentimes answers, to our field of discourse. The following bibliographical abbreviations are used in this article:

CAD *The Assyrian Dictionary of the University of Chicago.* Chicago: The Oriental Instututute

PSD *The Sumerian Dictionary of the University Museum of the University of Pennsylvania.* Philadelphia: University of Pennsylvania.

directly concerned with approaches to the material production of societies have taken place (for example, Appadurai ed. 1986; Lubar and Kingery eds. 1993) and theoretical attention to the role of material culture in socio-political, economic and symbolic systems has significantly altered the ways in which we view the archaeological landscape (Giddens 1992; Helms 1993). In addition, with the continuing publication of the textual corpus in both Sumerian and Akkadian (e.g. Frayne 1990: Edzard, 1997), and the appearance of a number of archival studies that have provided information on specific aspects of craft production (Loding 1974, 1981; Neumann 1987; Mieroop 1987), it is now possible for the non-philologist to have access to vocabulary for, descriptions of, and context of usage appropriate to the materials and works so masterfully presented by Moorey—both in 1985 and subsequently in 1994. Interestingly, the latter study, whether dealing with resource procurement or craft production, does place considerably greater reliance upon textual evidence than the former.

Nevertheless, a synthetic study of the place of different artisan traditions within Mesopotamian culture that exploits equally the artefactual and the textual evidence has yet to be written. In the paper that follows, I should like to pursue one aspect of this subject: the 'economy of value' beyond the socio-economic—that is, the environment of (aesthetic) appreciation—in which early Mesopotamian production flourished. A pioneering study in this direction was undertaken by Jack Sasson for artisans and artefacts from Mari (Sasson 1990), which laid out several avenues for the pursuit of meaning and value; and at his behest, I myself began an inquiry into these issues (Winter 1995). In the present study, I would like to expand a bit on the question of value associated with qualities usually tied to production: mastery, embellishment and claims of 'perfection'—particularly with respect to the period from the mid-third to the early second millennium B.C.[2] Once Sumerian works of the Early Dynastic through the Ur III period are put together with Sumerian textual references to similar or related works, it becomes clear that a high degree of mastery is not only evident retrospectively as *we* examine the objects (consistent with works we would designate 'art' in our terms); the attributes noted above—mastery, embellishment and perfection—along with the resultant high-quality works that bore these attributes were also celebrated in their own time.

2 That the materials used were also perceived as possessing 'value', both symbolic and material, goes without saying (see, for example, Dijk 1983: Ross 1999: Winter 1999), but that is not the subject of inquiry here.

Fig. 1. Detail, Gudea Statue 'B', found Tello, c. 2110 BC. Diorite; ht. 93 cm (Louvre AO2).
Photo courtesy Département des Antiquités Orientales, Musée du Louvre.

It will come as no surprise that a complex culture with a specialist labour force and sophisticated material production will have developed a complex vocabulary for the making of works and the assessment thereof. Fortunately in the textual record we may distinguish a variety of verbs in Sumerian, along with their Akkadian counterparts from lexical lists and bilinguals, that differentiate drawing (Sum. **hur**, **šab**; Akk. *eṣēru*), carving (Sum. **bal**, **gul**; Akk. *naqāru*), mounting in precious metal (Sum. **gar**; Akk. *uḫḫuzu*), and building (Sum. **du₃**; Akk. *raṣāpu*). These verbal forms correspond to the production of classes of works referred to in text: the production of images in paint, relief, and/or free-standing sculpture; of metal vessels, divine and royal insignia, and ornaments; and of buildings and their appointments. There also occur more general verbs that refer to the act of creation/production (Sum. **dim₂**, **ak**, **kin**; Akk. *banû, bašāmu, patāqu,* meaning 'to make, create, fashion, form') and substantives that suggest formal plans and/or execution according to a plan (Sum. **giš.hur**; Akk. *šuteṣbû*, particularly with respect to architecture).

This last is evident in the written account by Gudea of Lagash of the building of the Eninnu temple for the god Ningirsu, where the god Ea/ Enki, known in later Akkadian texts as *bêl nēmeqi*, 'Lord of Wisdom/Skill/ Craft', is presented as overseeing the plan for the temple Gudea has de-

signed. We are told explicitly that 'Enki "straightened out" the plan of the temple for him,' **e₂-a ᵈen-ki-ke₄ giš-hur-bi si mu-na-sa₂** (Edzard 1997: 80: Cyl. A. xvii:17); and it is assumed to be this 'plan' that Gudea holds on his lap in the well-known Statue 'B' from Tello (Fig. 1).[3]

The lexicon for acts of artisan production and for a variety of finished products (e.g. Foxfog 1980) would have little utility for us in establishing value as distinct from process, were it not that often descriptions of work employing such verbs also include references to the skill or wisdom employed in carrying out the endeavour or as manifest in the finished work. An elaborate vocabulary exists for conveying this expertise, both in Sumerian and Akkadian: Sum. **nam-ku₃-zu**, Akk. *nēmequ*, literally 'knowledge(ably), skilful(ly), expert(ly-made)'; Sum. **galam**, Akk. *nakliš, nikiltu*, 'masterful, artful, ingenious'. These terms can be employed metaphorically, as in a Sumerian love song, in which the beloved is compared to expertly-crafted works of art:

nig₂ nagar ku₃-zu dim₂-ma-mu
My (awesome) thing, made by the skilled carpenter;
tibira ku₃-zu kin aka-a-mu
My (great) work fashioned by the skilled metal/inlay-worker.[4]

3 On the GIŠ-HUR as wooden writing board on which a 'plan' or anything else would be drawn, see also Veenhof 1995; and see also CAD G: 101, *gišhuru*. Dolce (2001: 372) has recently argued that actual architectural plans incised on clay tablets are more likely to have been records of existing structures than working drawings for construction. For the verb **ak**, see now PSD AIII: 72–73, **ak** 3, 'to make, fashion, construct;' also 120–123: lexical section, for meanings, 'to form, mold, erect, set up.' Note also that with respect to the production of human and divine statues, the verb most frequently employed is not **dim₂**, but rather **tu(d)**, signifying creative 'birthing' as opposed to more material manufacture (e.g. Early Dynastic period Urnanše text (Steible 1982: 89 Urn. 24, 2.2) Gudea Statue 'B' (Steible 1991: 170 7.13; Enmerkar and the Lord of Aratta (Cohen 1973: 318), cited in PSD AIII, 166 and see discussion in Winter 1992: 21–3).

4 Alster 1985: 131, 133 r. I:9–10, who translates the same passage: 'piece (of art) shaped by the skilled carpenter, my (beloved) manufactured by the skilled coppersmith' [cited also in Ross 1999: 1065 and translated: 'my thing fashioned by the expert carpenter, my (thing) worked by the expert inlayer']. The two lines are in direct apposition to one another: **kin** and **nig₂** as paired products, synonyms for made objects; verbs of making, **dim₂** and **ak**, similarly paired. While the literal meaning of **ku₃** is 'pure', it is suggested that in this context **ku₃-zu**, as in **nam-ku₃-zu**, conveys perhaps a ritually pure, but surely also an appropriately skilled or expert, worker/ craftsman. For **tibira** see Flückiger-Hawker's discussion of this as a craftsman working in metal and wood, possibly a cabinet maker (1999: 174; reference also in Dumuzi and Inanna 47, cited in PSD AIII, 90: **ak** 8: **tibira-ku₃-zu kin ak-a-mu**, 'my clever **tibira**-craftsman, who executes the work...'). I wonder whether it might not convey one who works in several media or materials at once, particularly characteristic of the various inlaid works from the Royal Cemetery of Ur—for example, the musical instruments (e.g.

The same vocabulary is also employed by rulers who claim divine merit or historical credit for the production of valued works, pointing to their own, often divinely inspired, ingenuity or to the skills of craftsmen employed in their undertakings. Instances also abound in which adjectives denoting skill, mastery and/or ingenuity are attached directly to the substantive work being commemorated. A text attributed to Ur-Namma of Ur, for example, describes his construction of the sanctuary Ekišnugal, speaking of it as **galam**, 'skillfully built' (Flückiger-Hawker 1999: 266-7 Urnamma E/F, l. 3'), while an Old Babylonian version of the Sumerian myth Enki's Journey to Nippur provides actual details of a skillfully-made temple facade, as we are told that the god built his house of precious metal and lapis lazuli, 'its artful facade emerging from the Abzu,' **muš₃-ku₃ galam du₁₁-ga abzu-ta e₃-a** (cited in Ross 1999, 1090).[5] In another text, dating to the Early Dynastic period, Enannatum I of Lagash tells us that he built the Ibgal for Inanna, decorating it and furnishing it, and making it 'surpassing (**diri**) over the land'.[6]

The whole array of terms is called forth in a single Sumerian text describing a statue of silver and a precious stone that Abî-Sarē, the king of Larsa, has had made. We are first told that in the past no such statue had existed, but that the god Enki gave to the ruler the great intelligence to do a surpassing job (Frayne 1990: 122: i 28'-31'; ii 1'-3'—**diri geštu₂-mah nig₂-nam-ma diri-ga**). Finally, the work itself is assessed, and the terminology employed comes as close as can be to the Western concept of 'master work':

nam-ku₃-zu ak	. . . it is expertly fashioned;
me-dim₂-bi₃	this work (is)
me-dim₂-ma diri-ga	(a) surpassing work,
nig₂-ar-eš dib-b[a]	a thing of (beyond?) praise.[7]

Fig. 2), where gold and other precious metals are combined with precious stones, such as lapis lazuli and carnelian, as well as shell, and this is indeed how Ross has translated the term (see also the text of 'Enki and the World Order' [cited in Ross 1999: 1082, ll. 408], in which the goddess Nin-mu(g) is called the 'inlay worker of the land,' **tibira kalam-ma**). For emphasis in this context, I have included '. . . (awesome) thing . .', as this is indeed how the term **nig₂** is inflected in many usages; then, in parallel, '. . . (great) work . . .' corresponds to the value implied by the lover for her beloved in the text.

5 See Steinkeller 2002:360, n. 7 for a different reading: **suh galam du₁₁-ga abzu-ta e₃-a**, 'it is (like) a skillfully made head-band (reading **muš₃-ku₃** as **suh**) rising from the Abzu. For the complexity of the meaning of **muš₃** in architecture, see discussion by Sjöberg (Sjöberg and Bergmann 1969: 17, 53 and 55), where it is often translated as 'crown', although facade or upper works is probably preferable.

6 Steible 1982: 187 En. I, 10: 1.9. The text can be read: 'higher than (or surpassing) the mountains', **kur-kur-ra mu-na-diri-ga-a**, but the context suggests the less literal reading.

7 Frayne 1990: 122 Abî-Sarē 1:ii.6'–10'.

While one might think of these words as referring more to reception than to a description of manufacture, what I would call attention to is the emphasis on skill and expertise in the process of making that is recorded as part of the value of the end product. Surely, when one is confronted with works of quality from the archaeological record, especially works in which various materials have been skillfully joined to produce striking representations, such as the rearing goats or various of the musical instruments from the Royal Cemetery of Ur (e.g. Fig. 2), this is a vocabulary we would be comfortable with today.

In the various city-states of ancient Sumer, including Lagash, Ur and Isin, such works were often deemed of sufficient import that their construction and/or dedication became the signature event in a number of regnal year-names. For example, Gudea named his third year 'the year the lyre, "Great Predator of the Land", was fashioned'; one of his successors, Ur-Baba, named a year after the construction of the temple of the goddess Baba; Ur-Namma of Ur named his sixth year after the construction of the Ninsun temple in Ur; his son Šulgi named his third year the year in which 'the chariot of Ninlil was built', his fourth the year in which the foundation of the temple of Ninurta was laid, and his sixteenth the year in which the bed of the goddess Ninlil was made; Amar-Sin of Ur called his third year 'the year the king . . . joyfully made the divine throne of Enlil'; Išbi-Erra of Isin called his sixth year 'the year a bed for Inanna was fashioned', his eighteenth 'the year . . . the king fashioned a great emblem for Enlil and Ninurta', his 20th 'the year . . . the king fashioned . . . the great emblem of Inanna' and his 25th 'the year . . . the king fashioned a dais/throne for Ninurta;' and finally, his successor, Šu-ilišu, commemorated the fashioning of a great emblem for Nanna, an exalted throne for An, a dais for Ninisin, a magur-boat for Ninurta, and a dais for Ningal in his years 2, 5, 7, 8, and 9, respectively.[8] In the later reigns of the Isin Dynasty, more graphic description is provided, as, for example Bur-Sîn's year 'D': 'Year Bur-Sîn the king fashioned for Nin-Isin a copper stand . . . (representing) an overflowing stream and a lofty copper platform for offerings,' or his year 'E': 'Year Bur-Sîn the king made for Ninurta . . . a three-headed gold mace with heads of lapis-lazuli as a great emblem for Ninurta;' his successor Lipit-Enlil called his year 'A': 'Year Lipit-Enlil the king fashioned for the temple of Enlil a large golden vase with handles called "Enlil is exalted" '; and, most important, Enlil-bani's year 'J' is called: 'Year Enlil-bani the king fashioned a couch decorated with gold and silver, a work for

8 See *PSD* 'B': 75: **balag A**; also Sigrist and Gomi 1991: 317, 318, 319, 321 and 325; Sigrist 1988: 13, 17, 19, 22 and 23.

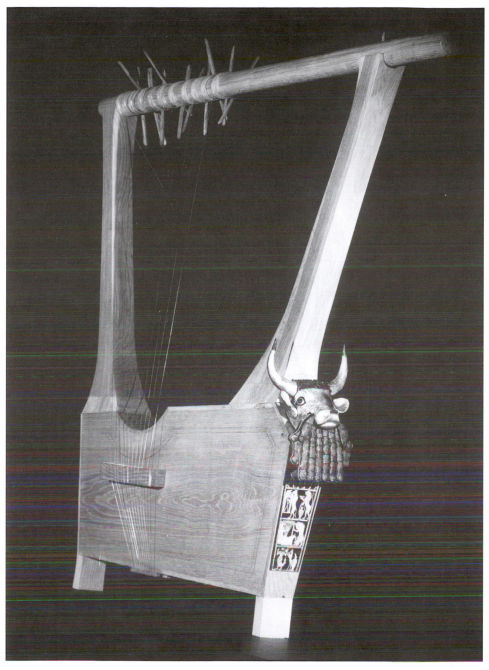

Fig. 2. Bull-headed 'Great Lyre,' from Tomb PG 789, Royal Cemetery of Ur, c. 2500 BC.
Gold, lapis lazuli, shell on wooden reconstruction; ht. of head 35.6 cm,
ht. of plaque 33 cm (UM B17694. Photo courtesy
The University Museum of the University of Pennsylvania).

the great sanctuary of (the god) Enki'— **mu ᵈen-lil-ba-ni lugal-e ᵍⁱˢgu-za zag-be₂-us₂ ku₃-sig₁₇ ku₃-babbar-ta kin-gal-eš ᵈen-ki-ra mu-na-dim₂** .⁹

These year names provide a glimpse of the value attached to, and the precious materials and investment in craftsmanship likely to have been characteristic of, the works commemorated. Although they represent but selected examples, the message is clear: sharing the calendar with other important markers of a ruler's reign such as victory in battle, the dedication of canals, road construction, the introduction of deities into new temples and the installation of en-priestesses and priests, we must conclude that the objects mentioned in the year names were perceived as works of great value. And just as the statue made for Abî-Sarē of Larsa, discussed above, we would expect works like the couch for Enki mentioned by Enlil-bani and the other objects designated in year-names to have been described in more discursive texts with similar designations—'surpassing works,' 'expertly fashioned,' and 'worthy of praise.' Such designations would be consistent also with references to thrones and daises for the gods Nanna, Ningal and Utu recorded by Warad-Sin of Larsa, and a rock crystal vase with gold rim and silver base recorded by Rim-Sin I of Larsa (Frayne 1990: 220–2 and 306), all of which were made of precious materials and clearly highly valued by their commissioning rulers.¹⁰

Often, judgments of quality are inherent in the addition of terms of value to the work, as in Sum. **me-dim₂-sa₆** or **kin-sa₆-ga**, as markedly 'good' or

9 Sigrist 1988: 30, 31 and 34. See also discussion by Selz 1997: 198, n. 197 and passim of the god-like status of statues and other cultic objects mentioned in year names.
10 Of the crafts employed in the making of such works, we have several enumerations (for example, in the myth of Inanna and Enki), where carpentry, inlay work, leather work, metal-smithing, architecture and reed work are mentioned in sequence (Farber-Flüge 1973: 22–3, I. ll. iii. 8'–11' and iv. 10'–17', cited in Ross 1990: 1042). Studies such as Loding (1974) and van de Mieroop (1987), as noted above, have begun to look at particular third and second millennium workshop archives in terms of craft activities; indeed, their works and others are summarized in Moorey (1994: 14–7). More needs to be known, however, about any hierarchy of Sumerian craftsmen producing such works, before one can get at a sense of expertise and 'quality' in manufacture. Sasson (1990: 22–23) implied such a hierarchy when he noted distinctions in the Akkadian texts from Mari differentiating some craftsmen as 'competent' and others as 'reliable/experienced' (see also Moorey 1994: 15). In later, particularly Neo-Assyrian, texts craftsmen are occasionally referred to as *ummânu*, literally 'master' or 'expert' (on which, see Parpola 1983: 270, who identifies them as 'highly trained experts of specific crafts'; see also Parpola 1983: xx and Ataç 2000 for the association of representative 'experts' with scribal and sacerdotal practice; also PSD AIII, 108: **dub-sar umum ak**, 'expert scribe'). Lanfranchi and Parpola (1990: 50: No. 56) further discuss an Assyrian text describing architectural work in which 'master builders' are distinguished from juniors/apprentices. Loding (1974: 142–4) proposed Sum. **giš-kin-ti** as an Ur III equivalent

'auspicious' work.[11] The sense behind that distinction, along with the under-
lying qualities expressed by the Sumerian terms **galam** and **nam-ku₃-zu**,
comes quite close to a 'work of art' in our terms, or at least in comparable
terms to the Medieval European notion of expert production: that is, things
expertly, masterfully, artfully, knowledgeably made and valued accordingly.[12]
Thus, it is not uncommon in the Sumerian temple hymns to speak of temples
built, or established, in an artful fashion. For example, in the hymn to the
temple of Nin-isina in Isin, it is declared that 'its interior is built in an artful

for *ummânu*; Thureau-Dangin (1921, cited in Ross 1999, 1069) noted Sum. ᶦᵘ²**dumu-meš
um.man**, 'experts,' in a late bilingual text on the Akitu-festival; and Glassner (1995: 1815)
cites **UM.ME.A** = *ummânu* as 'a possessor of specialized knowledge or craft, scribe, artist,
artisan'. In the late bilingual, the generic reference to (expert) craftsmen comes immediately
after the designation of individual craft specialists, jewellers and workers in precious metal
(ᶦᵘ²**ku₃-dim₂**), carpenter (ᶦᵘ²**nagar**) and weaver (ᶦᵘ²**uš-bar**). Other texts, such as the Gudea
Cylinder A, the Curse of Agade and the Lugalbanda Epic, provide terms for lapidaries and
coppersmiths (**za-dim₂, simug**) (Edzard 1990: xvi, 25–30, cited by Ross 1999: 830; Ross
1999: 1084 l. 41, 1094 ll. 409–410; discussion also in Loding 1974: 271–275); and for
sculptor (ᶦᵘ²**alam**), see *PSD* AIII: 170: **alam**. Such expert craftsmen were clearly valued
sufficiently that they are expressly mentioned in Lugalbanda as having been transferred to
Uruk after the destruction of Aratta, while earlier, as reflected in Enmerkar and the Lord of
Aratta, craftsmen from Aratta were requested to be sent to Sumer along with precious raw
materials such as gold, silver and lapis lazuli (Cohen1973; Zaccagnini 1993: 38). Several Old
Akkadian references to a 'lieutenant of the metalworkers,' **nu-banda₂** ᶦᵘ²**ku₃-dim₂**, seem to
suggest some ranked hierarchy or achieved status within individual craft specializations, at
least in that period (see Ross 1990, 894 and 1020). In Gudea Cylinder A, the combination
of terms **sanga simug** has led to the translation: 'chief of the (copper) smiths' (Edzard 1997:
xvi, 29); and one would want to know more about the status of individuals designated as
ugula (Sum. 'overseer'). Although various craftsmen are documented for the Inanna Temple
of Nippur in the Ur III period, including metalworkers in copper/bronze and gold (Zettler,
1992: 226–31), craftsmen tend to be referred to as individuals, without reference to hierar-
chy. As noted by Moorey (1994: 16), the textual tradition preserved to us is not likely to
provide a coherent account of an artisan's craft and there is much we do not know to date
about the organization of workshops, the training of craftsmen and the actual practice of the
various crafts that would have gone into the production of works referred to as of high value
in the public texts we have been citing.

11 Other terms seem also to convey fine/quality work, as in the epic Enlildiriše, l. 300
(cited *PSD* AIII, 161: **alam** 1), where copper statues are referred to as **nig₂-kala-ga**, 'mighty
things.' But more than that, there is further indication that manufacture of certain works,
particularly those intended for cultic use, were not just the products of secular labour. In
Enmerkar, for example, mention is made of 'a golden statue fashioned on a propitious day',
alam-ku₃-sig₁₇-ga u₄-du₁₀-ga tu-da, literally 'birthed on a good/sweet day', suggesting
that some sort of ritual selection of the auspicious attended the consecration.

12 See on this the introduction by J. G. Hawthorne and C. S. Smith to *On Divers Arts: The
Treatise of Theophilus* (1963: ii, xxxiv), which chronicles various crafts recorded by a
Benedictine monk of the 12th century. Also Koerner 1999, for a discussion of the power
and meaning of 'making' in the later Middle Ages and early Renaissance.

fashion', **ša₃-bi galam-kad₅-am₃** (Sjöberg and Bergmann 1969: TH 30, 380; also TH 15, 187, TH 36, 461).[13] Indeed, references of this sort are applied to the full range of elite works, including temples, cult implements and statuary.

In this sense, craftsmanship is frequently recognized as 'artful' and/or 'ingenious', attesting to the skill, inspiration and inventiveness required as part of the creative process and then perceived as part of the value inherent in the work. It will be noted in consulting the translations of a number of scholars that words like Sum. **galam** or **nam-ku₃-zu** are frequently rendered as 'artistic,' or 'artistically made'. This I would avoid, substituting 'artful' as a term better conveying the sense of mastery or skill (as at the root of Latin *ars*, Greek *techne*, as per Vickers and Gill 1996) that I believe is implied, without assuming an autonomous category of 'art' work, hence the 'artistic,' so far undemonstrated for Mesopotamia—that is, works valued as members of a class of art as such, independent of the intended context of use.[14]

In addition to skill and mastery as general terms of value, there are a number of references to the quality of 'embellishment' or 'decoration' per se applied to works—viewed always as a positive attribute. Here, I would argue even further that the fact of decoration or embellishment is perceived as an inseparable artefact of skilled making. Once again the vocabulary is well-developed. Verbs such as Sum. **šu ... tag** and **šerkan ... du₁₁**, 'to decorate, adorn', embellish' or the quality of being adorned or decorated (Sum. **šerkandi**) are frequently included in descriptions of important works, particularly in the case of elite buildings and precious, often cultic, objects.[15] As examples, both Entemena and Gudea of Lagash (c. 2400 and 2110 BC, respectively) make reference to the decorative programs of the Ningirsu temple in Girsu:

13 Since **kad₅** has posed somewhat of a problem of interpretation (see Sjöberg & Bergmann 1969: 122), it may be useful to pursue the meaning through an Akkadian lexical equivalent to *kasāru*, which relates to some sort of weaving, or tying of knots, binding together and also joining in architecture (CAD 'K': 258 *kasāru* 1b), hence the possible sense of 'artfully constructed/put together'.

14 This would not preclude an argument that, even without a word for 'art', Mesopotamian works meet the criteria for 'art', as discussed by Denis Dutton (2000: 233–6), including requisite skill, rules of form and fashioning, a critical language of judgement, consciousness of the 'special' nature of the works and of charged experience for both producers and audiences. In this, Dutton's enterprise to examine the status of 'tribal' works must be expanded to include all 'others', that is, non- as well as pre-Western enlightenment artistic production associated with state organization.

15 For a study of the terms for and forms of geometric designs in Sumerian and Akkadian that would describe non-figural elaboration, see Kilmer 1990.

guškin ku₃-babbar₂-ra
šu mu-na-ni-tag

> (having built the Antasurra-temple of Ningirsu), with gold and
> silver he (Entemena) decorated it.

gu₃-de₂-a še-er-zi-an-na-ka šu-tag ba-ni-du₁₁

> Gudea decorated it (the temple) with the splendour of heaven.[16]

Other references include the attention paid to separate parts of buildings
and cultic objects, such as a ceremonial chariot for the god Ningirsu, a
processional boat and stone and metal cult vessels. Gudea, for example,
described the chariot he had been instructed to make for the Ebabbar:
ᵍⁱˢgigir-bi ku₃.ɴᴇ za-gin₃-na šu u₃-ma-ni-tag, 'this chariot would
you (Gudea) decorate with silver and lapis' (Edzard 1997: 73: Cyl. A, vi:19),
while Šulgi of Ur referred to the ceremonial magur–boat he has constructed
as **an-gim mul-a še-er-ka-an mi-ni-ib₂-du₁₁**, 'decorated with stars like
heaven' (Klein 1981: 12, 86).[17] Another text of the Ur III period, attrib-
uted to the father of Šulgi, Ur–Namma, refers to temple door-lintels 'deco-
rated (**še-er-ka-an...du₁₁**) with electrum and pure silver', on which 'the
Anzû-bird has spread its talons' (Flückiger-Hawker 1999: 191 ll. 22–24).
This certainly calls to mind the copper/bronze door lintel plaque recovered
from the Temple of Ninhursag at al-Ubaid, dated to the Early Dynastic
Period (Fig. 3), masterfully executed as three-dimensional figures of the
Imdugud/Anzû-bird between two stags, encased within a rectangular frame,
which permits us to visualize what a decorated door lintel would have looked

16 Steible 1982: 219 Ent. 16:2.3–4; Edzard 1997: 86 Cyl. A. xxviii:1–2. I resist Edzard's
translation of 'painted', preferring the more generic rendering of 'decorated', even if the
most likely medium of decoration would have been paint, since we cannot rule out other
media, such as carved elements or appliqués of precious metal. See also Klein 1989 re Ur-
Namma and Šulgi making similar claims. Note also that in Enannatum I's description of his
building of the Ibgal for Inanna, he also spoke of having decorated it for her with gold and
silver, **ᵈinanna-ra ib-gal mu-na-du₃...ku₃-sig₁₇ ku₃-babbar₂-ra šu mu-na-ni-tag** (Steible
1982: 185 En. I 9, ll. 3.3–9), while in the text known as Enki's Journey to Nippur, of Old
Babylonian date, we are told that the god's house/temple was built with silver, coloured
with lapis lazuli and 'lavishly decorated with gold', **gal-le-eš ku₃-sig₁₇-ga šu-tag ba-ni-
in-du₁₁** (cited in Ross 1990: 1090).
17 It is interesting that a later Ur III king, Šu-Sin, also had a magur–boat built, commemorated
in the name for his eighth regnal year: **mu ᵈšu-ᵈen.zu...ma₂-gur₈ mah ᵈen-lil₂ ᵈnin-lil₂-
ra mu-ne-dim₂** 'the year Šu-Sin . . . constructed the exalted magur-boat for Enlil
and Ninlil' (Sigrist and Gomi 1991: 327).

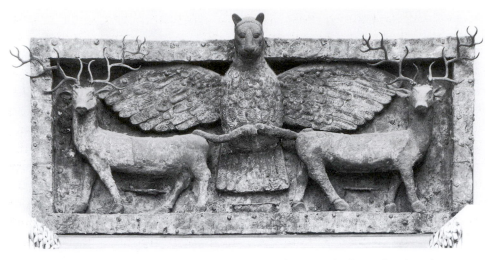

Fig. 3. Relief of lion-headed eagle and two stags, from lintel of Temple of Ninhursag,
Tell al-Ubaid, c. 2450 BC. Copper; ht. 106 cm, l. 238 cm (WAA 114308.
Photo courtesy of The Trustees, The British Museum).

like.[18] In another Ur III text, precious stones and metals are used 'to
decorate the statue of the ruler Šu-Sin, [ala]m-ᵈšu-ᵈen.zu [šu d]u₇-du₇-
de₃ (cited PSD AIII: 167: **alam** 1.6.4). And finally, a text of the late Ur III
ruler, Ibbi-Su'en, speaks of a gold vessel, likely an ointment jar, that seems to
possess all of the properties we have been discussing:

> **bur-šakan-ku₃-sig₁₇ kin ga-lam kad₅! [=pap?]**
> **gu₄-alim-muš-ba šeg₃-gi₆-ni₂-ɪʟ₂ [=gur₃?]**
> **še-er-ga-an-du₁₁-ga-bi u₆-di nu-til-le-dam**
>> gold šakan-vessel, work (of) artful/ingenious construction,
>> bearing wild bulls and serpents, its decoration of unending
>> admiration[19]

18 That the elaboration of the temple gate constituted an important aspect of its visual
impact is further reflected in the description of the destroyed sanctuary of Ur, in which 'the
great *door ornament* of the temple was felled, its parapet destroyed; the wild animals that were
intertwined on its left and right lay before it like fallen warriors' (Michalowski 1989: 63 ll.
420–2).
19 Steible 1991: 286: Ibbi-Suen 9/10 ll. 17–22; also presented in transliteration with
translation in the dissertation of Mark Hall (1985: 123); see also discussion in Selz 1996.
Note that adornment is also referenced metaphorically in poetry, as in the love song 'Dumuzi
and Inanna' (Sefati 1998: 129–130 l. 32), in which the beloved is alluded to as 'alabaster
figurine, adorned with the lapis diadem, sweet is your allure', **dim₃-giš-nu₁₁-gal ★suh-za-**
gin₃ keš₂ hi-li-zu ze₂-ba-am₃.

This last must surely evoke the well-known silver vase of Entemena, found at Tello (ancient Girsu), which stands upon a copper base (Fig. 4). Around the collar is a dedicatory inscription commemorating the ruler and his presentation of the vessel to Ningirsu and identifying it as a gurgur-vessel for monthly offerings to the deity (Steible 1982: Ent. 34 l. 15; Selz 1993; for other cult vessels, see Braun-Holzinger 1989; Selz 1996). It is decorated on the shoulder with incised designs of couchant calves and, around the body, as on the door lintel from al-Ubaid mentioned above, heraldic motifs of the lion-headed Imdugud/Anzû, bird of the thunderstorm, his talons sunk into the backs of four pairs of animals—caprids, lions, bull calves and more lions. Moorey (1985: 115) has aptly called this vase 'the outstanding silver object to have survived from Early Dynastic Mesopotamia'. That such a vessel would have been viewed in its own time as representing masterful/ingenious work, and consequently, would have been appreciated as an object of unending admiration, seems entirely appropriate. What is important for our purposes is the linkage established in the text, as reflected in the actual the silver vase, between quality of work and response: from masterful and ingenious object, to its decoration and the resultant unending admiration.

A similar correlation can be found in a text of the reign of Rim-Sin of Larsa (Frayne 1990: 303 ll. 23–24), in which the ruler speaks of a diorite water vessel or trough he has dedicated to the goddess Inanna, which is deemed to be:

šu-tag-ga-še₃ tum₂-ma
nig₂ u₄-bi-ta nin-igi-du-mu-ne ba-ra-an-dim₂-ma-a
 fitting for adornment, a thing no previous queen had fashioned

What may be concluded from the above references and discussion is that ornament, or embellishment, is essential—not merely additive—to the value and efficacy of the final product. This is entirely in keeping with what was described by A. K. Coomaraswamy (1946: 85 and 96) for the traditional arts of Sanskritic India, in which ' "ornament" and "decoration" are, properly speaking, integral factors of the beauty of the work . . ., essential to their utility . . . and their perfection as such'.

Similarly, it is clear from the Sumerian sources that objects receive the crowning degree of praise when they are deemed to have been 'perfected' (Sum. **šu...du₇**) through their craftsmanship and embellishment. One such instance is to be found in the hymn known as Ur-Namma A, 'The Death of Ur-Namma', in which the Ur III ruler is said to bring gifts to various deities of the Netherworld. The gifts include a **bur-šagan šu du₇-a**, 'a šagan-vessel

of perfect make' and **gil-sa šu du₇-a**, 'perfectly-wrought jewellery' (Flückiger-Hawker 1999: 118–120 ll. 97 and 106).[20]

Such an appraisal of 'perfection' for finely crafted works fits well with the insistence of anthropologist Franz Boas in his fundamental study of non-Western art (1955: 10–11) that 'the judgment of perfection of technical form is essentially an esthetic judgment . . . Since a perfect standard of form can be obtained only in a highly developed and perfectly controlled technique, there must be an intimate relation between technique and a feeling for beauty.' Underlying Boas' argument is an insistence upon the principle that in the value systems and (aesthetic) responses of many cultures around the world, one cannot separate perception and/or judgement of form from an underlying conception of the 'class' to which the work belonged and a standard of measure according to which the immediate example's place in the universe would be assessed.

Clearly, in formulating this position, Boas was in dialogue with Western aesthetic theory, such as that put forward by Immanuel Kant in the late 18th century. Kant's inquiry into the nature of aesthetic judgment quite explicitly precluded such a relationship between a 'pure' judgement of beauty and an assessment of technique, or perfection. In his *Third Critique*, for example, Kant stated that 'the judgement of taste is entirely independent from the concept of perfection', since to include such a concept would be to necessarily introduce a prior concept of the object's intended utility, which, he claimed, must remain separate from any response to its 'beauty' (Kant/Guyer 2000: 111 §15). I have attempted to deal elsewhere with the futility of such a separation for the art of non-Western or even pre-modern Western cultures (Winter in press), specifically for that of ancient Mesopotamia; but I insist upon it here, because I would argue that the claims of early Mesopotamian rulers that they were responsible for the *production* of elaborately embellished, skilled or masterful works is directly linked to the *description* of the various attributes of such works, which then occasioned an aesthetic response. What is remarkable is precisely the fact that, as we have seen, Sumerian rulers thought it necessary to stress the process of making and the attributes of skilled production as part of the larger picture of aesthetic and cultural value.

20 The Susa version of this same text further describes such a piece of jewellery: 'a pin made of gold and silver, whose head/finial (is) that of a bison' (Flückiger-Hawker 1999: 161 l. 98'). This last corresponds well to actual objects found in the Early Dynastic graves at Ur (e.g. Woolley 1934: pl. 145 (gold pin with lapis head) and pl. 231 (copper/bronze pin with horned head)) and one rather wishes we had intact graves of the rulers of the Third Dynasty of Ur preserved as well.

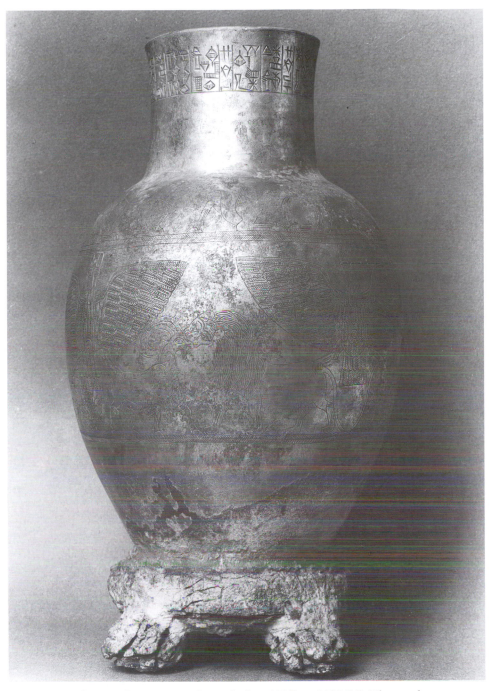

Fig. 4. Cult vase of Entemena of Lagash, found Tello, c.2400 BC. Silver and copper; ht. 35 cm (Louvre AO2674. Photo courtesy Département des Antiquités Orientales, Musée du Louvre).

In conclusion, ascriptions of mastery, embellishment and perfection, insofar as these properties were asserted to be manifest in individual works, served to confer 'quality' upon the finished product. In claiming these properties for works of royal patronage, rulers may be seen to anticipate/beg the question of the audience's response for their own rhetorical purposes; however, in the absence of more objective contemporary critical records, we must see those properties related to production as inseparable from, and part of, the overall stimulus leading to aesthetic response itself. This comes close to what Kant ultimately defined as 'adherent' or 'dependent' beauty (Kant/Guyer 2000: 114–116 §16), a property that, unlike 'pure' beauty, could be measured against a standard of perfection. For ancient Sumer, then, mastery, embellishment and perfection not only constitute perceptible affective properties that contributed to aesthetic experience at the highest cultural level; they also represent necessary attributes of works that qualify as 'great'.

REFERENCES CITED

Alster, B.
1985 Sumerian Love Songs. Révue d'Assyriologie et d'Archéologie Orientale 79: 127–59.

Appadurai, A. ed.
1986 The Social Life of Things: Commodities In Cultural Perspective. Cambridge: Cambridge University Press.

Ataç, M.-A.
2003 Visual Decorum and the Agency of Scribal and Sacerdotal Personnel in the Production of the Neo-Assyrian Palace Reliefs. Ph.D. dissertation, Harvard University.

Azevedo, W. d'
1958 A structural approach to esthetics: Toward a definition of art in anthropology. American Anthropologist 60: 702–14.

Boas, F.
1955 Primitive Art. New York, Dover.

Braun-Holzinger, E. A.
1989 REC 445.LÁ = Libationsbecher. Zeitschrift für Assyriologie und Vorderasiatische Archäologie 79: 1–7.

Cohen, S.
1973 Enmerkar and the Lord of Aratta. Unpublished PhD dissertation. University of Pennsylvania.

Coomaraswamy, A. K.
1946 Figures of Speech or Figures of Thought: Collected Essays on the Traditional or 'Normal' View of Art. London: Luzac.

Dijk, J. van
1985 Lugal ud me-lám-bi Nir-gál. Leiden: Brill.

Dolce, R.
2000 Some architectural drawings on clay tablets: Examples of planning activity or sketches?. In Proceedings of the 1st International Congress on the Archaeology of the Ancient Near East, Rome,

18–23 May, 1998 (P. Matthiae, A. Enea, L. Peyronel and F. Pinnock, eds.). Rome: Università degli Studi di Roma, La Sapienza, Vol. 1, 365–95.

Dutton, D.

2000 'But they don't have our concept of Art'. In *Theories of Art Today* (N. Carroll, ed.). Madison: University of Wisconsin Press, 217–40.

Edzard, D. O.

1997 *Gudea and his Dynasty.* Royal Inscriptions of Mesopotamia. Early Periods. Vol. 3/1. Toronto, University of Toronto Press.

Farber-Flügge, G.

1973 *Der Mythos 'Inanna und Enki' unter besonderer Berücksichtigung der Liste der m e.* Studia Pohl 10. Rome: Biblical Institute Press.

Flückiger-Hawker, E.

1999 *Urnamma of Ur in Sumerian Literary Tradition.* Orbis Biblicus et Orientalis 166. Fribourg, Switzerland: Fribourg University Press.

Foxfog, D. A.

1980 Funerary furnishings in an early Sumerian text from Adab. In *Death in Mesopotamia* (B. Alster, ed.). Mesopotamia 8, Copenhagen: Akademisk Forlag, 67–75.

Frayne, D.

1990 *Old Babylonian Period (2003–1595 BC).* Royal Inscriptions of Mesopotamia, Early Periods Vol. 4. Toronto: University of Toronto Press.

Giddens, A.

1992 Sociology and the Explanation of Human Behaviour. In *Human Societies: An Introductory Reader in Sociology* (A. Giddens, ed.). Cambridge: Polity Press, 362–65.

Glassner, J.-J.

1995 The uses of knowledge in ancient Mesopotamia. In Sasson ed. 1995: Vol. 3, 1815–23.

Hawthorne, J.G. and Smith, C. S. transl.

1963 *On Divers Arts: The Treatise of Theophilus.* Chicago: University of Chicago Press.

Helms, M. W.

1993 *Craft and the Kingly Ideal: Art, Trade and Power.* Austin: University of Texas Press.

Kant, I.

2000 (1790) *Critique of the Aesthetic Power of Judgment,* (P. Guyer, ed. and translator). Cambridge: Cambridge University Press.

Kilmer, A. D.

1990 Sumerian and Akkadian names for designs and geometric shapes. In *Investigating Artistic Environments in the Ancient Near East* (A. C. Gunter, ed.). Washington, DC: Smithsonian Institution, 83–91.

Klein, J.

1981 *Three ulgi Hymns. Sumerian Royal Hymns Glorifying King ulgi of Ur.* Bar Ilan Studies in Near Eastern Languages and Cultures. Ramat Gan: Bar Ilan University.

1989 Building and Dedication Hymns in Sumerian Literature. *Acta Sumerologica* 11: 27–67.

Koerner, J.

1999 Factura. *Res* 36: 5–19.

Lanfranchi, G. and Parpola, S.

1990 *The Correspondence of Sargon II,* Pt.2: *Northern and Northeastern Provinces.* State Archives of Assyria 5. Helsinki: University of Helsinki Press.

Loding, D.

1974 *Craft Archive from Ur.* Ann Arbor: University Microfilms.

1981 Lapidaries in the Ur III Period. *Expedition* 23: 6–14.

Lubar, S. and Kingery, W. D. eds.

1993 *History from Things: Essays on Material Culture.* Washington and London: Smithsonian Institution.

Michalowski, P.
1989 *The Lamentation over the Destruction of Sumer and Ur.* Winona Lake: Eisenbrauns.

Mieroop, Marc van de
1987 *Crafts in the Early Isin Period.* Orientalia Lovaniensia Analecta 24. Louvain: Departement Orientalistiek.

Moorey, P. R. S.
1985 *Materials and Manufacture in Ancient Mesopotamia: The Evidence of Archaeology and Art. Metals and metalwork, glazed materials and glass.* BAR International Series, 237. Oxford: British Archaeological Reports.

1994 *Ancient Mesopotamian Materials and Industries: The Archaeological Evidence.* Oxford: Clarendon Press.

Neumann, H.
1987 *Handwerk in Mesopotamien,* Schriften zur Geschichte und Kultur des Alten Orients 19. Berlin: Akademie Verlag.

Oppenheim, A. L.
1978 Man and Nature in Mesopotamian Civilization. *Dictionary of Scientific Biography* 15. New York: Scribner, Supplement 1, 634–666.

Parpola, S.
1983 *Letters to Assyrian Scholars,* Part II: *Commentary and Appendix.* Alter Orient und Altes Testament 5/2. Neukirchen-Vluyn: Neukirchener Verlag.

Parrot, A.
1948 *Tello, vingt campagnes de fouilles (1877–1933).* Paris: Editions Michel.

Ross, J. C.
1999 *The Golden Ruler: Precious Metals and Political Development in the Third Millennium BC Near East.* Ann Arbor: University Microfilms.

Sasson, J. M.
1990 Artisans...Artists: Documentary perspectives from Mari. In *Investigating Artistic Environments in the Ancient Near East* (A. C. Gunter, ed.) Washington, DC: Smithsonian Institution, 21–7.

Sasson, J. (ed.)
1995 *Civilizations of the Ancient Near East.* New York: Scribner.

Sefati, Y.
1998 *Love Songs in Sumerian Literature: Critical Edition of the Dumuzi-Inanna Songs.* Ramat Gan: Bar Ilan University Press.

Selz, G.
1993 Beobachtungen zur 'Silbervase' des Entemena. *Aula Orientalis* 11: 107–11.

1996 NE-SAG, BUR-SAG und GU₂-NE (-SAG-GA₂): Zu zwei Gefässbezeichnungen, ihren Bedeutungsentwicklungen und einem sumerischen Wort für (Gefäss)schrank. *Studi Epigrafici e Linguistici* 13: 3–8.

1997 'The Holy Drum, the Spear, and the Harp': Towards an understanding of the problems of deification in third millennium Mesopotamia. *Sumerian Gods and their Representations,* (I. L. Finkel and M. J. Geller, eds.). Cuneiform Monographs 7. Groningen: STYX: 167–213.

Sigrist, M.
1988 *Isin Year Names.* Institute of Archaeology Publications, Assyriological Series Vol. 2. Berrien Springs, MI: Andrews University Press

Sigrist, M. and Gomi, T.
1991 *The Comprehensive Catalogue of Published Ur III Tablets.* Bethesda, MD: CDL Press.

Sjöberg, A. W. and Bergmann, E.
1969 *The Collection of Sumerian Temple Hymns.* Texts from Cuneiform Sources 3. Locust Valley, NY: J. J. Augustin.

Steible, H.
1982 *Die altsumerischen Bau- und Weih-*

inschriften. Freiburger Altorientalische Studien 5. Wiesbaden: Steiner Verlag.

1991 *Die neusumerischen Bau- und Weih-inschriften*. Freiburger Altorientalische Studien 9. Stuttgart: Steiner Verlag.

Steinkeller, P.

2000 Stars and stripes in ancient Mesopotamia: A note on two decorative elements of Babylonian doors. *Iranica Antiqua* 37: 357–69.

Veenhof, K. R.

1995 Old Assyrian *işurtum*, Akkadian *eşērum* and Hittite GIŠ.HUR. In *Studio Historiae Ardens: Ancient Near Eastern Studies Presented to Philo H. J. Houwink ten Cate on the Occasion of his 65th Birthday* (T. van den Hout and J. de Roos, eds.). Istanbul: Nederlands Historisch-Archaeologisch Instituut, 311–32.

Vickers, M. and Gill, D.

1996 *Artful Crafts: Ancient Greek Silverware and Pottery*. Oxford: Oxford University Press.

Wilson, E. J.

1994 *Holiness and Purity in Mesopotamia*. Alter Orient und Altes Testament 237. Berlin: Neukirchener Verlag.

Winter, I. J.

1992 'Idols of the King': Royal images as recipients of ritual action in ancient Mesopotamia. *Journal of Ritual Studies* 6: 13–42.

1995 Aesthetics and Mesopotamian Art. In Sasson ed.1995: Vol. 4, 2569–2580.

1999 The Aesthetic Value of Lapis Lazuli in Mesopotamia. In *Cornaline et pierres précieuses: La Méditerranée de l'Antiquité á l'Islam* (A. Caubet, ed.). Paris: Musée du Louvre, 43–58.

In press Defining 'Aesthetics' for non-Western studies: The case of ancient Mesopotamia. In *Clark Institute Symposiumon Aesthetics, Art History and Visual Culture* (M. Holly, ed.).

Woolley, C. L.

1934 *The Royal Cemetery. Ur Excavations* 2. London: Trustees of the British Museum.

Zaccagnini, C.

1993 Ideological and procedural paradigms in ancient Near Eastern long distance exchanges: the case of Enmerkar and the Lord of Aratta. *Archiv für Orientforschung* 20: 34–42.

Zettler, R. L.

1992 *The Ur III Temple of Inanna at Nippur: The Operation and Organization of Urban Religious Institutions in Mesopotamia in the Late Third Millennium B.C.* Berlin: Dietrich Reimer Verlag.